The Cultural Studies Reader

Second Edition

The Cultural Studies Reader is the ideal introduction for students to this exciting discipline. A revised introduction explaining the history and key concerns of cultural studies brings together important articles by leading thinkers to provide an essential guide to the development, key concerns, and future directions of cultural studies. This expanded second edition offers:

- thirty-eight essays including eighteen new articles
- an editor's preface succinctly introducing each article
- comprehensive coverage of every major cultural studies method and theory
- an updated account of recent developments in the field
- articles on new areas such as science and cyberculture, globalization, post-colonialism, public spheres, and cultural policy
- a fully revised introduction and an extensive guide to further reading
- suggestions for further reading at the end of each article and a comprehensive bibliography

Combining major thinkers from other disciplines with cultural studies pioneers such as Raymond Williams and key contemporary figures, *The Cultural Studies Reader* is essential reading for any student wanting to know how cultural studies developed, where it is now, and its future directions.

Contributors: Ackbar Abbas, Theodor Adorno, Arjun Appadurai, Roland Barthes, Tony Bennett, Lauren Berlant, Homi K. Bhabha, Pierre Bourdieu, Judith Butler, Rey Chow, James Clifford, Michel de Certeau, Teresa de Lauretis, Richard Dyer, David Forgacs, Michel Foucault, Nancy Fraser, Nicholas Garnham, Stuart Hall, Donna Haraway, Dick Hebdige, bell hooks, Max Horkheimer, Eric Lott, Jean-François Lyotard, Angela McRobbie, Meaghan Morris, Hamid Naficy, Janice A. Radway, Andrew Ross, Eve Kosofsky Sedgwick, Edward Soja, Gayatri Chakravorty Spivak, Peter Stallybrass, Carolyn Steedman, Will Straw, Michael Warner, Cornel West, Allon White, Raymond Williams.

Simon During is Robert Wallace Professor of English at the University of Melbourne. His articles have appeared in numerous journals including *Cultural Studies*, *Textual Practice* and *Critical Inquiry*, and he is the author of *Foucault and Literature* (Routledge 1992) and *Patrick White* (Oxford 1994).

The
Cultural Studies
Reader

Second Edition

Edited by

Simon During

London and New York

First published 1993
by Routledge
11 New Fetter Lane, London EC4P 4EE

Simultaneously published in the USA and Canada
by Routledge
29 West 35th Street, New York, NY 10001

Routledge is an imprint of the Taylor & Francis Group

Second edition first published 1999 by Routledge

© 1993, 1999 Simon During – the collection

© 1993, 1999 the contributors – individual chapters

Typeset in Perpetua and Bell Gothic by
The Florence Group, Stoodleigh, Devon

Printed and bound in Great Britain by
TJ International Ltd, Padstow, Cornwall

British Library Cataloguing in Publication Data
A catalogue record for this book is available from the British Library

Library of Congress Cataloging in Publication Data

The cultural studies reader / edited by Simon During. — 2nd ed.
 p. cm.
 Includes bibliographical references and index.
 1. Culture. 2. Culture—Study and teaching. 3. Popular culture.
 I. During, Simon
 HM101.C8928 1999
 306—dc21 98–51656
 CIP

ISBN 0-415-13753-5 (hbk)
 0-415-13754-3 (pbk)

Contents

PART TWO
Space and time

PART THREE
Nationalism, postcolonialism and globalization

PART FOUR
Ethnicity and multiculturalism

PART EIGHT
Consumption and the market

PART NINE
Leisure

PART TEN
Culture – political economy and policy

PART ELEVEN
Media and public spheres

Acknowledgments

I would like to thank Lisa O'Connell and Chris Healy for helping me clarify and organize the introduction to this collection; Rebecca Barden at Routledge for her encouragement and patience; and my helpful colleagues, too many to name, whom I consulted throughout the project.

Most of the essays in this collection have been edited both for reasons of space and to make them more accessible for readers new to cultural studies. Permission given by the following copyright holders and authors is gratefully acknowledged.

Ackbar Abbas, 'Building on disappearance: Hong Kong architecture and colonial space,' extracted from *Hong Kong: Culture and the Politics of Disappearance* (Minneapolis: Minnesota University Press, 1997). © the Regents of the University of Minnesota 1997.

Theodor Adorno and Max Horkheimer, 'The culture industry: Enlightenment as mass deception,' extracted from *Dialectic of Enlightenment*, trans. John Cumming (New York: The Seabury Press, 1972). © S. Fischer Verlag GmbH 1969; translation © Herder & Herder Ltd 1972.

Arjun Appadurai, 'Disjuncture and difference in the global cultural economy,' in *Global Culture: Nationalism, Globalization and Modernity* (London: Sage, 1990). © Arjun Appadurai 1990.

Roland Barthes, 'Dominici, or the triumph of literature,' from *Mythologies* (London: Jonathan Cape, 1972). © Editions du Seuil, Paris 1957; translation © Jonathan Cape 1972.

Tony Bennett, 'Culture and policy,' extracted from *Culture: A Reformer's Science* (St Leonards, NSW: Allen & Unwin, 1998). © Tony Bennett 1998.

Lauren Berlant and Michael Warner, 'Sex in Public,' *Critical Inquiry*, 24/2 (winter 1998). © University of Chicago Press 1998.

Homi K. Bhabha, 'The postcolonial and the postmodern: the question of agency,' extracted from *The Location of Culture* (New York: Routledge, 1994). © Homi K. Bhabha 1994.

Pierre Bourdieu, 'How can one be a sports fan?,' extracted from *Social Science Information*, 17/6 (1978). © the author and Sage Publications 1978.

Judith Butler, 'Subjects of sex/gender/desire,' in *Gender Trouble: Feminism and the Subversion of Identity* (New York: Routledge, 1994). © Routledge, Chapman & Hall 1994.

Rey Chow, 'Listening otherwise, music miniaturized: a different type of question about revolution,' from *Discourse*, 13/1 (winter 1990–1). © Rey Chow 1990.

James Clifford, 'On collecting art and culture,' extracted from *The Predicament of Culture* (Cambridge, Mass.: Harvard University Press, 1988). © the President and Fellows of Harvard College 1988.

Michel de Certeau, 'Walking in the city,' extracted from *The Practice of Everyday Life* (Berkeley, Ca.: University of California Press, 1984). © Regents of University of California Press 1984.

Teresa de Lauretis, 'Upping the anti (*sic*) in feminist theory,' extracted from *Conflicts in Feminism*, ed. Marianne Hirsch and Evelyn Fox Keller (New York: Routledge, 1990). © Routledge & Kegan Paul 1990.

Richard Dyer, 'Entertainment and Utopia,' from *Movie*, 24 (spring 1977). © Richard Dyer and *Movie* 1977.

David Forgacs, 'National-popular: genealogy of a concept,' from *Formations: Of Nations and Peoples* (London: RKP, 1984). © Formations Editorial Collective 1984.

Michel Foucault, 'Space, power and knowledge,' an interview with Paul Rabinow translated by Christian Hubert, extracted from *The Foucault Reader,* ed. Paul Rabinow (New York: Pantheon, 1984). © Paul Rabinow 1984.

Nancy Fraser, 'Rethinking the public sphere: a contribution to the critique of actually existing democracy,' extracted from *Habermas and the Public Sphere*, ed. Craig Calhoun (Cambridge, Mass.: MIT Press, 1992). © Massachusetts Institute of Technology 1992.

Nicholas Garnham, 'Political economy and cultural studies: reconciliation or divorce?' in *Critical Studies in Mass Communication*, 1995. © the Speech Communication Association 1995.

Stuart Hall, 'Encoding, decoding,' extracted from *Culture, Media, Language,* (London: Unwin Hyman, 1990). © Stuart Hall 1990.

Stuart Hall, 'Cultural studies and its theoretical legacies,' from *Stuart Hall: Critical Dialogues in Cultural Studies*, ed. David Morley and Kuan-Hsing Chen (London: Routledge, 1996). © Routledge & Kegan Paul 1996.

Donna Haraway, 'A cyborg manifesto,' extracted from *Simians, Cyborgs, and Women: The Reinvention of Nature* (New York: Routledge, 1991). © Donna Haraway 1991.

Dick Hebdige, 'The function of subculture,' extracted from *Subculture: The Meaning of Style* (London: Methuen, 1979). © Dick Hebdige 1979.

bell hooks, 'A revolution of values: the promise of multicultural change,' in *Teaching to Transgress: Education as a Practice of Freedom* (New York: Routledge, 1994). © Gloria Watkins 1994.

Eric Lott, 'Racial cross-dressing and the construction of American whiteness,' in *Cultures of United States Imperialism*, ed. Amy Kaplan and Donald E. Pease (Durham, NC: Duke University Press, 1993). © Duke University Press 1993.

Jean-François Lyotard, 'Defining the postmodern,' from *Postmodernism ICA Documents,* ed. Lisa Appignesi (London: Free Association Books, 1989). © Jean-François Lyotard 1989.

Angela McRobbie, 'The place of Walter Benjamin in cultural studies,' in *Postmodernism and Popular Culture* (London: Routledge, 1994). © Angela McRobbie 1994.

Meaghan Morris, 'Things to do with shopping centres,' extracted from *Grafts: Feminist Cultural Criticism*, ed. Susan Sheridan (London: Verso, 1988). © Meaghan Morris 1988.

Hamid Naficy, 'The making of exile cultures: Iranian television in Los Angeles,' extracted from *The Making of Exile Cultures: Iranian Television in the United States* (Minneapolis: University of Minnesota Press, 1993). © the Regents of the University of Minnesota 1993.

Janice A. Radway, 'The institutional matrix of romance,' extracted from *Reading the Romance: Women, Patriarchy and Popular Literature* (Chapel Hill: University of North Carolina Press, 1984). © University of North Carolina Press 1984.

Andrew Ross, 'The challenge of science,' in *Disciplinarity and Dissent in Cultural Studies*, ed. Cary Nelson and Dilip Parameshwar Gaonkar (New York: Routledge, 1996). © Routledge 1996.

Eve Kosofsky Sedgwick, 'Axiomatic,' extracted from *Epistemology of the Closet* (Berkeley, Ca.: University of California Press, 1990). © Regents of University of California Press 1990.

Edward Soja, 'History: geography: modernity,' extracted from *Postmodern Geographies: The Reassertion of Space in Critical Social Theory* (London: Verso, 1989). © Edward Soja 1989.

Gayatri Spivak, 'Scattered speculations on the question of cultural studies,' extracted from *Outside in the Teaching Machine* (London: Routledge, 1993). © Routledge, Chapman & Hall 1993.

Peter Stallybrass and Allon White, 'Bourgeois hysteria and the carnivalesque,' extracted from *The Politics and Poetics of Transgression* (London: Methuen, 1986). © Peter Stallybrass and Allon White 1986.

Carolyn Steedman, 'Culture, cultural studies and the historians,' in *Cultural Studies*, ed. Lawrence Grossberg *et al.* (New York: Routledge, 1992). © Routledge, Chapman & Hall 1992.

Will Straw, 'Characterizing rock music culture: the case of heavy metal,' in *On Record: Rock, Pop and the Written Word*, ed. Simon Frith and Andrew Goodwin (London: Routledge, 1990). © Will Straw 1990.

Cornel West, 'The new cultural politics of difference,' extracted from *October*, 53 (summer 1990). © Massachusetts Institute of Technology and *October* magazine 1990.

Raymond Williams, 'Advertising: the magic system,' extracted from *Problems in Materialism and Culture* (London: Verso, 1980). © Raymond Williams 1980.

Introduction

■ Simon During

THIS BOOK COLLECTS REPRESENTATIVE essays in cultural studies as an introduction to this increasingly popular field of study. Yet, as will become clearer after the essays have been read, cultural studies is not an academic discipline quite like others. It possesses neither a well-defined method-ology nor clearly demarcated fields for investigation. Cultural studies is, of course, the study of culture, or, more particularly, the study of *contemporary* culture. But this does not take us very far. Even assuming that we know precisely what "contem-porary culture" is, it can be analyzed in many ways – sociologically, for instance, by "objectively" describing its institutions and functions as if they belong to a large, regulated system; or economically, by describing the effects of investment and marketing on cultural production. More traditionally, it can be studied "crit-ically" by celebrating either large forms (like literature) or specific texts or images (like *Waiting for Godot* or an episode of *Cheers*). The question remains: does cultural studies bring its own orientation to these established forms of analysis?

There is no easy answer, but to introduce the forms of analysis developed by the discipline we can point to two features that characterized it when it first appeared in Great Britain in the 1950s. It concentrated on "subjectivity" which means that it studied culture in relation to individual lives, breaking with social scientific positivism or "objectivism." The book that is often said to inaugurate the subject, Richard Hoggart's *The Uses of Literacy* (1957), is a very personal work: it describes changes in working-class life in postwar Britain through Hoggart's own experiences. Hoggart wanted to show how those changes affected an individual's "whole way of life." For him culture was an important category because it helps us recognize that one life-practice (like reading) cannot be torn out of a large network constituted by many other life-practices – working, sexual orientation, family life, say.

The second distinguishing characteristic of early cultural studies was that it was an engaged form of analysis. Early cultural studies did not flinch from the fact that societies are structured unequally, that individuals are not all born with the same access to education, money, health care etc., and it worked in the interests of those who have least resources. In this it differed not only from the (apparently) objective social sciences but from the older forms of cultural criticism, especially literary criticism, which considered political questions as being of peripheral relevance to the appreciation of culture. For cultural studies, "culture" was not an abbreviation of a "high culture" assumed to have constant value across time and space. Another founding text of cultural studies, Raymond Williams's *Culture and Society, 1780–1950* (1958), criticized the consequences of uncoupling "culture" from "society," and "high culture" from "culture as a whole way of life," although Williams also conceded that it was through this uncoupling that modern culture acquires its particular energy, charm and capacity to inform.

These two defining features of early cultural studies were closely connected because it is at the level of the individual life that the cultural effects of social inequality are most apparent. Most individuals aspire and struggle the greater part of their lives and it is easier to forget this if one is just interpreting texts rather than thinking about reading as a life-practice, for instance. Cultural studies insists that one cannot just ignore – or accept – division and struggle. We can ask, how did an engaged discipline of this kind emerge within higher education? This is the question that lets us approach cultural studies most effectively, so let us turn to the historical conditions which made the discipline possible.

A brief history of cultural studies

Cultural studies appeared as a field of study in Great Britain in the 1950s out of Leavisism, a form of literary studies named after F. R. Leavis, its most prominent member. Leavisism was an attempt to re-disseminate what is now commonly called, after Pierre Bourdieu, "cultural capital" – though this is not how it saw itself. Leavis wanted to use the educational system to distribute literary knowledge and appreciation more widely. To achieve this, the Leavisites argued for a very restricted canon, discarding modern experimental works like those of James Joyce or Virginia Woolf, for instance. Instead they primarily celebrated works directed towards developing the moral sensibility of readers such as the works of Jane Austen, Alexander Pope or George Eliot – the "great tradition." Leavisites fiercely insisted that culture was not simply a leisure activity; reading "the great tradition" was, rather, a means of forming mature individuals with a concrete and balanced sense of "life." And the main threat to this sense of life came from the pleasure offered by so-called "mass culture." In this, Leavisism was very much in tune with what cultural studies has come to call the "social-democratic power bloc" which dominated postwar Britain. After the war, Britain was administered by a sequence of governments that intervened in the private sector both socially (in areas like health and housing) and culturally (in education and the arts). When

the education system expanded radically through the 1950s and 1960s, it turned
to Leavisism to form citizens' sensibilities.

Cultural studies developed out of Leavisism through Hoggart and Williams,
whose writings were taken up in secondary schools and tertiary colleges soon after
they were written. Both came from working-class families; both had worked as
teachers in post-compulsory education though, importantly, in workers' education.
Thus they experienced Leavisism ambivalently. On the one hand, they accepted
that its canonical texts were richer than contemporary so-called "mass culture"
and that culture ought to be measured in terms of its capacity to deepen and widen
experiences; on the other, they recognized that Leavisism at worst erased, and at
the very least did not fully come into contact with, the communal forms of life
into which they had been born. So Hoggart's *The Uses of Literacy* in particular
is a schizophrenic book. Its first half contains a heartfelt evocation of traditional
industrial working-class communities, relatively untouched by commercial culture
and educational institutions, while its second half mounts a practical-critical attack
on modern mass culture. When Hoggart went on to found the Birmingham Centre
for Contemporary Cultural Studies (henceforth CCCS), a postgraduate and research
institute designed to further his work, it began by having to deal with this tension.

Hoggart was able to believe that the celebration of old high culture could fit
alongside an evocation of the culture of his youth because both stood apart from
contemporary commercial popular culture and, so, were under threat. The threat
to, and final disappearance of, traditional British working-class life needs to be
considered at a little length because it was crucial for the early development of
cultural studies. (See Laing 1986 for a good account of this history.) Before the
war, since the early 1920s, the British economy had been dominated by unem-
ployment – there were never fewer than a million people unemployed over the
period. This was the background of Hoggart's "traditional" working class. By the
end of the 1940s, however, Britain had a full employment economy, and by the
end of the 1950s further shifts in the British economy were well under way. Jobs
were moving into the state sector (in 1955 government expenditure had been 36.6
per cent of GDP as against 52.2 per cent in 1967 [K. Robbins 1983: 369]); small
plants were being replaced by larger ones using "Fordist" production techniques
– that is, simplifying workers' tasks on assembly lines – which meant that labor
became increasingly deskilled (between 1951 and 1973 the percentage of the work-
force working in plants which employed over 1500 people increased by 50 per cent
[Wright 1979: 40]). Simultaneously, the differential between lower-paid white-
collar and blue-collar workers was decreasing, and large-scale immigration from
the colonies during the 1950s meant that many indigenous workers were no longer
called upon to take the least desirable jobs. Workers, then, were becoming increas-
ingly "affluent" (to use a media term of the time) at least in so far as they were
increasingly able to buy consumer goods like cars (numbers of which increased
fivefold between 1950 and 1975), clothing, washing machines, refrigerators, record
players, telephone services (they increased fourfold between 1945 and 1970) and,
most important of all, television sets (commercial television did not become widely
available in Britain until 1957, the year Hoggart's book was published). Finally

the large state rehousing program, compulsory national service in the army (which ended in 1958) and, to a lesser extent, educational reform making higher education available to a fraction of the working class also helped to break up the culture that Hoggart described.

As the old working-class communal life fragmented, the cultural studies which followed Hoggart's *The Uses of Literacy* developed in two main ways. The old notion of culture as a whole way of life became increasingly difficult to sustain: attention moved from locally produced and often long-standing cultural forms (pub life, group-singing, pigeon-fancying, attitudes to "our mum," dances, holidays at camps, and close-by seaside resorts etc.) to culture as organized from afar – both by the state through its educational system, and by what Theodor Adorno and Max Horkheimer (in the essay included here) called the "culture industry," that is, highly developed music, film, and broadcasting businesses. This shift of focus could lead to a revision of older paradigms, as when Stuart Hall and Paddy Whannel in *The Popular Arts* (1964) gave the kind of status and attention reserved by the Leavisites for canonical literature to new forms (such as jazz and film) while devaluing others (especially television and rock music). Much more importantly, however, the logic by which culture was set apart from politics, already examined by Raymond Williams, was overturned. The historian E. P. Thompson, in his seminal book *The Making of the English Working Class* (1968) and elsewhere, had pointed out that the identity of the working class *as* working class had always had a strongly political and conflictual component – that identity was not just a matter of particular cultural interests and values. But the fragmentation of the old proletarian culture meant that a politics based on a strong working-class identity was less and less significant: people decreasingly identified themselves as workers (see Roberts *et al.* 1977). It was in this context that cultural studies theorists began seriously to explore culture's own political function and to offer a critique of the social democratic power bloc which was drawing power into the state. From the early 1970s, culture came to be regarded as a form of "hegemony" – a word associated with Antonio Gramsci, an Italian Marxist of the 1920s and 1930s. "Hegemony" is a term to describe relations of domination which are not visible as such. It involves not coercion but consent on the part of the dominated (or "subaltern"). Gramsci himself elaborated the concept to explain why Mussolini's fascism was so popular even though fascism curtailed the liberty of most Italians. For him, hegemonic forces constantly alter their content as social and cultural conditions change: they are improvised and negotiable, so that counter-hegemonic strategies must also be constantly revised. In the same spirit, if somewhat less subtly, culture could also be seen as what Michel Foucault was beginning to think of as a form of "governmentality," that is, a means to produce conforming or "docile" citizens, most of all through the education system.

As culture was thought about less as an expression of local communal lives and more as an apparatus within a large system of domination, cultural studies offered critiques of culture's hegemonic effects. At first such critique leant heavily on forms of semiotic analysis (represented in this collection in a sophisticated form by Stuart Hall's and James Clifford's essays). This meant in effect that

culture was broken down into discrete messages, "signifying practices" or "discourses" which were distributed by particular institutions and media. To take a rather simplified example: a semiotic analysis of cigarette-smoking among workers would analyze smoking not as a life-practice, that is, in terms of its importance as a rite of passage, its use in structuring the flow of time and so on, but in terms of its being a signifier produced by images like the "Marlboro Man," which connote masculinity, freedom and transcendence of work-a-day life. Semiotics' capacity to extend its analysis beyond particular texts or signs is limited: it remained an analysis of "codings" and "recodings" not of uses, practices or feelings (though Stuart Hall's essay included here, which emphasized the concept "decoding," has been influential because it articulates relations between uses and meanings).

It would be wrong to insist too strongly on the purity of, and opposition between, what were called the "culturalist" (emphasizing forms of life) and "structuralist" (or semiotic) strands within the cultural studies of the period. But in the 1970s, a hard form of structuralism did emerge, one that called upon the work of Louis Althusser, backed up by psychoanalytic notions developed by Jacques Lacan. For this theory, individuals were constructs of ideology, where ideology means not beliefs we disapprove of (as in "racist ideology") but the set of discourses and images which constitute the most widespread knowledge and values – "common sense." Ideology, so the argument went, is required so that the state and capitalism can reproduce themselves without the threat of revolution. Here, as for Hoggart and Williams, the state's claim to neutrality is false, but this time for more classically Marxist reasons – because it protects the exploitative "relations of production" (i.e., class differences) necessary to capitalism. For Althusser, dominant ideology turned what was in fact political, partial and open to change into something seemingly "natural," universal and eternal. However, dominant ideology is not limited to politics or economics so, though it may present a particular view of economic relations (as in the common idea that trade unionism is a brake on economic competitiveness), its primary role is to construct an imaginary picture of civil life, especially the nuclear family as natural and, most of all, each individual as "unique" and "free." Ideology fragments real connections and interdependencies, producing a picture of social relations which overemphasizes individual freedom and autonomy. For Althusser, individuals can be sucked into ideology so easily because it helps them make sense of the world, to enter the "symbolic order" and ascribe power to themselves. They identify with ideology because they see themselves pictured as independent and strong in it – as an adolescent boy (or, indeed, adult) might picture himself, in a fantasy, as the Marlboro Man. Dominant social values are internalized through this kind of identification. At this point, psychoanalysis was called upon to gird the theory. Once again to state the argument very simply: individuals see themselves mirrored in dominant ideology and identify with it as a way of "taking the father's place" in a process which is fuelled by the "fear of castration," that is, anxieties that true autonomy or unique individuality can never be reached. So ideology provides a false resolution to private, familial tensions, a resolution that is, for Lacan if not for Althusser,

finally made possible by the fact that no symbolic structure can offer final meaning or security. Its lure is always imaginary: the promise of a full "I-ness" which can exist only where "I am not."

But politico-psychoanalytical structuralism of this kind never made as much headway in cultural studies as it did in film studies, say. It did not concede enough space to the capacity of the individual or community to act on the world on their own terms, to generate their own meanings and effects. It was too theoretical in the sense that it offered truths which took little or no account of local differences; indeed, its claims to be scientifically true lacked support from scientific method. And it did not pay enough heed to the actual techniques and practices by which individuals form themselves and their lives. But another strand of semiotic thought was able to enter the culturalist tradition with more vigor. This emphasized the concept of polysemy. "Polysemy" is a technical word for the way in which a particular signifier always has more than one meaning, because "meaning" is an effect of differences within a larger system. This time the argument went: it is because meanings are produced not referentially (by pointing to specific objects in the world) but by one sign's difference from another, that signs are polysemous. One sign can always both be replaced by another (in what is called the "paradigmatic" relation), and enter a sequence of other signs (the "syntagmatic" relation). More loosely, a sign can "connote" any number of others: the Marlboro Man, for instance, connoting "toughness" in one context and "cancer" in another.

The notion of polysemy remains limited in that it still works at the level of individual signs as discrete signifying units. It did, however, lead to more dynamic and complex theoretical concepts which help us to describe how cultural products may be combined with new elements to produce different effects in different situations. In this way, cultural production is conceived of as a process of "hybridization," "re-production," and "negotiation." For instance, the Marlboro Man might be made into a shiny, hard-edged polythene sculpture à la Jeff Koons to achieve a postmodern effect in an expensive Manhattan apartment; an ad using the image might be cut out of the magazine and used to furnish a poor dwelling in Lagos as an image of Western affluence and liberty, or parodied on a CD or album cover. Concepts like hybridization, as they developed out of the notion of "polysemy," return us to a renewed culturalism because they enable us to see how particular individuals and communities can actively create new meanings from signs and cultural products which come from afar. Yet a concept like "hybridization" still does not account for the way that the meanings of particular signifiers or texts in a particular situation are, in part, ordered by material interests and power relations. The tobacco industry, the medical profession and a certain stream within the women's movement might *struggle* over the meaning of "Marlboro Man" for political and commercial reasons: the first in order to sell more product; the second to promote health, as well as their own status and earning power; the last to reject an insensitive mode of masculinity. Cultural studies has been, as we might expect, most interested in how groups with least power practically develop their own readings of, and uses for, cultural products – in fun, in resistance, or to articulate their own identity.

This brief historical account of cultural studies' key concepts has not focused on particular works at particular dates. The richness of the research promoted by the CCCS during the 1970s makes that research impossible adequately to represent here. But three particularly influential texts – Paul Willis's *Learning to Labour* (1977), David Morley's *The "Nationwide" Audience* (1980) and Stuart Hall and Tony Jefferson's *Resistance through Rituals: Youth Subcultures in Postwar Britain* (1976), each of which was written from a different space in the spectrum thrown open by the history I have just sketched – can rewardingly be described. First, Paul Willis's *Learning to Labour*. Willis used participant observer techniques to describe a group of disaffected boys in a working-class school (the "lads"). He showed how they create a "counter-school culture" in which they reject the official logic which legitimizes their education, that is, "you obey the teachers because they teach you knowledge which will help you get a better job." They reject this exchange for several reasons: partly because "better jobs" (i.e., low-paid white-collar or apprentice jobs as against unskilled laboring jobs) involve moving out of the traditions of mateship, hard drinking, excitement and strong male-bonding passed down in their families; partly because those jobs were not necessarily "better" financially at least in the short and medium term, and didn't require the kind of knowledge on offer at school anyway; and partly because the lads had a strong sense that the economic system ultimately required the exploitation of some people's labor power so that the "shit jobs" they would take were in fact necessary rather than worthless. Willis's work remains close to Hoggart's in that it involves a certain celebration of traditional working-class culture and it shows how that culture contains a quite accurate political understanding of the conditions of life, even though the lads have little conventional class-consciousness and absolutely no interest in formal political institutions. What is striking about the study, though, is how important both sexism and racism remain to this segment of British working-class culture. Unfortunately, Willis does not address this head-on.

Whereas Willis's *Learning to Labour* is a culturalist book in the traditional sense, David Morley's *The "Nationwide" Audience* is one of the first ethnographic studies not of a community (defined in terms of locale and class) but of an audience (defined as a group of viewers or readers), in this case the audience of *Nationwide*, a BBC news-magazine program widely watched through the late 1960s and 1970s, and which broadcasted mainly local, rather than national or international, stories, somewhat like a US breakfast show. Morley's study was ethnographic in that he did not simply analyze the program, he organized open-ended group discussions between viewers, with each group from a homogeneous class or gender or work background (trade unionists, managers, students etc.). Indeed his book begins by contesting that image of a large audience as a "mass" which had often been assumed by earlier sociological theorists of the media. His ethnographic approach was all the more a break within cultural studies work on media because, along with Charlotte Brunsdon, he had offered a conventional semiotic "ideology-critique" of the program in an earlier study, *Everyday Television: "Nationwide."* There, he and Brunsdon had argued that the program presented an image of the world in which gender, class and ethnic differences were massively downgraded,

and which assumed that "we" (the program's implied audience) possess a shared "common sense" based on a practical view of the world, as against "intellectual," political or culturally adventurous views. The program's style or "mode of address" was anchored in authoritarian but chatty presenters who embodied its values.

For Morley the textualist approach began to seem limited because it could not fully deal with polysemy. He had to go out into the field to discover what people actually thought about *Nationwide*. But this does not mean that, for him, the program can be interpreted anyhow, precisely because its ideological orientation – that "everyday life" view of the world – is the code which the program itself presents as "preferred." To use Stuart Hall's phrase, the program is "structured in dominance" because it skews and restricts its audience's possibilities for interpreting the material it claims to present without bias. Though viewers need not accept the preferred code, they must respond to it in some way. Morley divides the possibilities of decoding *Nationwide* into three categories: first, an acceptance of the preferred reading, second, flat opposition to it (mainly, as it turned out, by being extremely bored by it); and third, negotiation with it. His fieldwork findings were somewhat unexpected, though: there was no clear correlation between the socio-cultural position of the groups and their response to the program although those, like a group of Caribbean young women, furthest away from the common sense "we" embodied in the white (and mainly male) presenters, were least able to respond to it. Also some groups (especially students and trainee managers) understood that the program was biased (or "structured in dominance") but still accepted its dominant code. Knowing how it worked, not being "cultural dupes," did not mean refusal of its values. And last, those groups with least social and cultural capital – like the Caribbean women – found the program too distant from their own lives, preferring less newsy programs with more "human" stories – like those transmitted by the more market-orientated ITV companies. Though Morley makes little of it, for these groups it was the market rather than the state (through the state-funded BBC) that provided them with what they wanted. In a paradox that helps us understand certain problems at work at the heart of the social-democratic power bloc, those who are most vulnerable to market forces respond most positively to its cultural products.

The third, and earliest, book, *Resistance through Rituals: Youth Subcultures in Postwar Britain*, is a collection of essays, each by different authors, each of which comes to grips with the fragmentation of traditional working-class culture in a different way. In general, the authors accepted that the working class was being split: one section being drawn into skilled jobs that would enable them to live like certain elements of the middle classes, another into deskilled, low-status and often service jobs. However, they argued that jobs of this latter kind were especially taken by disadvantaged youth, who, inheriting neither a strong sense of communal identity nor values transmitted across generations in families, develop subcultures. These subcultures negotiate with, and hybridize certain hegemonic cultural forms as modes of expression and opposition. Dick Hebdige (in an earlier essay than the one included here), for instance, shows how the Mods fetishized style itself as an element of life, borrowing elements from fashions, old and new,

turning cultural consumption (the crucial element in the life-practices of the "affluent" worker) to their own ends. These subcultures are much more creative than Willis's lads or Morley's audience, and, at least in some cases, they use commodities, the primary products of the system that disadvantages them, as forms of resistance and grounds on which to construct a communal identity. Yet while *Learning to Labour* allowed the "lads'" voices a great deal of space in the text, and Morley too transcribed actual voices, *Resistance through Rituals* is primarily concerned to develop a *theory* of hegemony under the conditions it encounters. This more theoretical approach, characteristic of an earlier phase of cultural studies, has its limits. It means that the writers find resistance to "hegemony" in subcultural styles rather too easily. The book does not emphasize the way in which newly developed "youth markets" influenced and promoted subcultural systems – especially in the music and fashion businesses. It also underestimates the impact of the education system which streamed children after eleven and kept them at school until they were fifteen (sixteen after 1972), generating intense inter-generational bondings unknown before the war. Neither are the Mods, Teds, Hippies and so on seen as trying to have fun or to construct a mode of life for them-selves; they are primarily viewed as being engaged in symbolic struggle with the larger social system. But, as we are about to see, categories like "struggle" and resistance against the "dominant" become increasingly difficult for cultural studies to sustain.

Despite their use of semiotic and Gramscian concepts, *Learning to Labour*, *The "Nationwide" Audience* and *Resistance through Rituals* remain within the tradition established by Hoggart's *The Uses of Literacy*. In the late 1970s things changed. Cultural studies came increasingly under the influence of forms of thought associated with French theorists, in particular Pierre Bourdieu, Michel de Certeau and Michel Foucault. I will present their work in a general model – though it is important to remember that this model is an abstraction and presents no specific individual's work.

For French theory, individuals live in a setting constituted by various institu-tions, or what we can call, following Bourdieu, "fields" – families, work, peer groups, educational apparatuses, political parties, and so on. Each field takes a particular material form, most having a characteristic space and time attached to them (the private home for family life and most media reception, weekdays for work etc.). The relation of space to social fields is the theme of the essays by Foucault and Edward Soja collected here. Each field is future-directed and contains its own "imaginary," its own promise and image of satisfaction and success, its own possibilities for pleasure. Family life, for instance, depends upon images of the perfect family (mum, dad and a newborn baby, say) and members may feel pleasure when they reproduce that image, even if only for a moment. This "imaginary" *is* imaginary because of the limits and scarcities which organize fields – family life is constrained by finances, aging and intergenerational conflict, for example. Because of these limits too, fields are suffused by power relations and tend to be structured hierarchically. After all, not everyone can have equal

experience, knowledge, money or authority. Very hierarchical fields (like schools and offices) are most disciplined and rationalized: in them all activities are directed to a fixed purpose – education in a school, profit in a business. Further, each field has characteristic signifying practices more or less tightly attached to it: the same person may well talk, walk and dress differently at school (or work) to the way they do in the family, and differently again when socializing with their peers. These signifying practices are structured through scarcity as well. Dick Hebdige has pointed out that punks worked on their body rather than consumption as a means of expression because it was one of the few materials that they could afford.

Each field also contains a variety of styles of belonging: one can be this kind of student or that kind, for instance, a casual filmgoer or a film buff. These fields, then, contain choices of "self-formation" or what Foucault called "self-government," though in highly disciplined and rationalized fields like schools or businesses these choices are more directed from above than in others. Likewise individuals can work out strategies by which to advance in a field or to reconcile themselves to their current position: Bourdieu famously showed how members of the working class, unable to afford certain goods or tastes, made a virtue of necessity by saying that they didn't like them anyway. On the other hand, possibilities exist for "transgressive" undermining or "festive" overturning of routines and hierarchies through passive resistance, ironical mimicry, symbolic inversion, orgiastic letting-go, even daydreaming – as the essays by Richard Dyer, Allon White and Peter Stallybrass, and Michel de Certeau here show. Especially in societies where hierarchies in many fields are rigid, these forms of transgression may themselves become institutionalized – as in Brazil today with its carnival samba schools, or early capitalist Europe with its pantomimes. Finally, each field, to some degree, both defines itself against and is suffused by others: for instance, relations in the workplace may be modeled on the family ("paternalism") though the family is simultaneously a "haven" from work. However, highly rationalized fields (like schools and factories) interact least directly with other fields – they form their own "world." None the less it is where fields are most rationalized and disciplined that positions held in one internal hierarchy may be converted into a position held in another. Reaching the "top" of the education system helps you start "higher" in the world of work.

What about subjectivity in this schema? The important point is that actual individuals are not "subjects" wholly positioned by the system these fields constitute or the strategies the fields provide. There are several reasons for this: in theory at least individuals can always make choices which take into account, and thus avoid, the forces they know to be positioning them. Also, because human beings exist as "embodied social subjects" (as Teresa de Lauretis puts it in her essay in this volume), an individual's relation to the fields continually incorporates and shifts under the impact of contingent givens (skin color, physical appearance and so on) and material events (weather, illness, technological breakdowns and so on) which are not simply determinants of social or cultural forces. Third, language itself intervenes between the individual and the socio-cultural fields that construct his or her positions. Our sense of uniqueness is grounded on our sense that we can

say what we like – at least to ourselves – and we have that sense because language is both a resource that costs nothing (a basic but often ignored point) and complex enough to make possible an infinite number of individual speech acts. As deconstructive theorists have pointed out, this is true because of, rather than despite, the fact that private discourse always comes from somewhere else and its meanings cannot be wholly mastered by those who use it. Last, given that individuals live first, in symbolic structures which let them (within limits) speak for themselves; second, in bodies that are their own but not wholly under control; third, in a temporality which flows towards the unknowable and uncontainable, they may find in themselves "deep" selves which cannot be reduced either to the managerial self that chooses styles, strategies, and techniques of self-formation or to the subject positioned by external fields and discourses. Modern Western culture in particular has given a great deal of value to this form of subjectivity, and cultural studies' insistence that subjectivity primarily consists of practices and strategies has been targeted against it.

The French model breaks from earlier forms of cultural studies. To begin with, it downgrades the way that economic scarcities operate systematically across *many* fields. Because it conceives of social fields as "partially autonomous," the French model cannot affirm a central agency that might direct a number of fields to provide a more equitable distribution of resources. In this, it is remote from traditional social-democratic politics. Instead there is a drift to affirm both culture's utopian force and those forms of resistance (such as de Certeau's "walking in the city" in this collection) possible only in the cracks and gaps of the larger, apparently impregnable, system. Somewhat paradoxically, that system is impregnable just because it is less centered on an isolatable and "dominant" set of institutions or ideology. Why did cultural studies accept relatively depoliticized analyses of this kind? The reasons are to be found in the decline of the social-democratic power bloc from the mid-1970s onwards which made possible the so-called "new right's" emergence – in the US under Ronald Reagan (1981) and in the UK under Margaret Thatcher (1979). Furthermore, it was in the context of the new right's emergence that (as we shall see), after absorbing French theory, the discipline orientated itself towards what Cornel West in his essay here calls the "culture of difference" and became a genuinely global movement.

The new right (or "Thatcherism" as I shall often call it, following Stuart Hall) countered the social democrats by arguing, first, that the state should intervene in citizens' lives to the minimum possible extent so that market forces can structure as many social relations and exchanges as possible, and, next, that internal differences (especially between classes, ethnic groups, and genders) were threats to national unity. The nation was defined in terms of traditional and popular national-cultural images of "Englishness" in Thatcher's case and "Americanness" in Reagan's. This was a politics that appealed at least as much to the "affluent worker" as to traditional Conservative (in the US, Republican) voters. As long ago as 1957 Richard Hoggart had noted how, with increased spending power, the working class were increasingly evaluating the world in economic, rather than

class, terms. Thatcherism was also the product of the social-democratic interventionist state's failure to manage the economy without playing inflation off against unemployment, a failure which itself followed increasing economic globalization (especially of the financial sector) and the appearance of economic powers outside the West. (The most prominent events in the process of economic globalization were the 1971 end of the old Bretton Woods agreement by which all major currencies had been pegged against the US dollar; the 1973–4 OPEC cartel; the radical increase of Japanese competitiveness in key consumer-durable markets; the increased movement of Western manufacturing "off-shore" through the 1970s and 1980s, and the immense increase of capacity for information about commodity and money markets to be disseminated quickly and globally.) In these terms, Thatcherism is the political reflex of an affluent but threatened first-world society in a postcolonial world order. As Stuart Hall pointed out (Hall 1988), it was able to counter a widespread sense of fragility by taking advantage of a mass of "popular knowledge" which put the family, respectability, hard work, "practicality," and order first – a "popular knowledge" which, as Morley demonstrated, had been, for years, transmitted in shows like *Nationwide* and its US equivalents. At this level at least, Thatcherism does not draw on the values of traditional high culture; instead it appeals to the social imaginary produced by the market-orientated media.

Thatcherism contains an internal contradiction – between its economic rationalism and its consensual cultural nationalism. The more the market is freed from state intervention and trade and finance cross national boundaries, the more the nation will be exposed to foreign influences and the greater the gap between rich and poor. Thatcherite appeals to popular values can be seen as an attempt to overcome this tension. In particular, the new right gives the family extraordinary value and aura just because a society organized by market forces is one in which economic life expectations are particularly insecure (as well as one in which, for some, rewards are large and life exciting). In the same way, a homogeneous image of national culture is celebrated and enforced to counter the dangers posed by the increasingly global nature of economic exchanges and widening national, economic divisions. The new right image of a monoculture and hard-working family life, organized through traditional gender roles, requires a devaluation not just of other nations and their cultural identities but of "enemies within": those who are "other" racially, sexually, intellectually. It was in this situation that the Birmingham school focused more intensely, on the one hand, on feminist work (as by Charlotte Brunsdon, Angela McRobbie, and Dorothy Hobson) as well as on the analysis of racism and a counter-celebration of black cultures (most painstakingly in Paul Gilroy's *There Ain't No Black in the Union Jack,* 1987); and, on the other hand, to a more straightforward critique of Thatcherism itself, as in the essays collected in Stuart Hall's *The Hard Road to Renewal* (1988) as well as the earlier collectively written *Policing the Crisis* (1979). This last book latches on to the mechanisms by which law-and-order issues and racism were gaining ground in the last days of the social-democratic power bloc, convincingly demonstrating that law-and-order panics in Britain in the 1970s were produced by tacit alliances between the media and the police – being, in that sense, organized.

As cultural studies responded to the conditions surrounding the new right's emergence, the discipline became internationalized. The main reasons for this are simple: analyses of racism, sexism, and the culture industry possessed a wider appeal than analysis of the British working-class culture, particularly in the US or Australia ("new world" states which fancied themselves relatively "classless" societies). But, when cultural studies gave up its Marxian and classist approach, it began to approach, if in a different spirit and register, certain Thatcherite themes. After all, both movements were strongly anti-statist; both affirmed, within limits, a decentered view of social organization. What were the analogies between Thatcherism and cultural studies, politically so opposed to one another? Perhaps most importantly, where new-right discourse argued that no state institution could transcend particular interests and legitimately control individual choices best represented in the market, cultural studies criticized the notion that any theory could stand outside the field it claimed to tell the truth about as if it were a "meta-discourse." For French theory, "theory" itself was a discursive practice produced in a particular field with particular power effects: it offers, for instance, the ability rhetorically to master other people's values and "common sense." That there could be no transcendental "meta-discourse" was a crucial thesis in what is sometimes also called theoretical "postmodernism" – the end of any appeal to those "grand narratives" by which institutions and discourses bearing the modernizing values of universal liberty, equality, and progress were affirmed in the name of a transhistorical, meta-discursive subject. (See the essay by Lyotard below for a description of postmodernism.)

The new mode of cultural studies no longer concentrated on reading culture as primarily directed against the state. Mainly under the impact of new feminist work at first, it began to affirm "other" ways of life on their own terms. Emphasis shifted from communities positioned against large power blocs and bound together as classes or subcultures to ethnic and women's groups committed to maintaining and elaborating autonomous values, identities, and ethics. This moment in cultural studies pictured society as much more decentered than either the CCCS had in its earliest work or than the French theorists had, as they focused on discipline, rationalization, and institutional fields. However, an immediate problem confronted this new model as it broke society down into fractions united by sexuality, gender, or ethnicity: how to conceive of relations between these dispersed communities? Two solutions were offered, both rather utopian and future-directed: first, new "rainbow" alliances and cross-identifications could be worked out for particular and provisional social or "micro-political" ends; second, relations between these groups would be "dialogic" – a concept borrowed from Mikhail Bakhtin and in which the otherness of each interacting participant remains intact. Whatever the effectiveness of these solutions, celebrations of the "other" sounded a powerful oppositional note where governments attempted to encourage or enforce monoculturalism and traditional gender models on the nation. None the less the affirmation of "otherness" and "difference" in what is sometimes called a "politics of survival" belongs to a looser, more pluralistic and postmodern, conceptual model than those which insist that capitalism and the free market produce interests that are *structurally*

unequal and in conflict with each other. Unlike social-democratic thought, the new cultural studies no longer aimed at a radical transfiguration of the whole system of social fields.

Cultural studies' affirmation of otherness and negation of meta-discourse must be understood also in terms of the accelerated globalizing of cultural production and distribution from the 1970s on. This is the theme of the essay by Arjun Appadurai (as well as, less explicitly, those by Gayatri Spivak and Hamid Naficy) in this volume, and, at the very least, they show how multidirectional the process of "globalization" has been. In some areas, it has involved a breakdown of distinctions between "first" and "third" world nations: new technologies (such as satellite broadcasting) produced international audiences as for Bob Geldof's "LiveAid" 1985 concert in the emergence of what might be called the "global popular" while, to similar ends, and on the back of the global popular, non-governmental organizations like Greenpeace established new transnational networks and interfaces. The globalization of the media had one especially important consequence: it accelerated the concentration of the cultural industry largely because the global market requires increased investment in marketing and distribution. By the early 1990s, for instance, the international recording industry was an oligopoly consisting of six majors: three European, one American and two Japanese. But in other ways globalization has produced new local "vertical" differences – as where, for instance, first-world encouragement to modernize and develop led not just to massive third-world indebtedness and an increase in poverty but to urbanization, severe ecological degradation, and deculturalization, as in rainforest areas around the world. In other ways still, however, globalization has generated diversity and autonomy – as when sophisticated cultural and media industries began to develop outside the West in places as different as Brazil and Hong Kong (increasing the amount of local news worldwide, for instance) or when, as James Clifford points out in his essay in this collection, non-Western communities were able creatively to commodify or museumify their cultures. One effect of the large and very various process of globalization has been especially important to cultural studies: Eurocentric concepts of "primitive," "underdeveloped" or superstitious peoples (that is, so-called "fourth-world" people) became difficult to sustain on a variety of registers. In his influential essay "On ethnographic authority" (Clifford 1988b), Clifford again showed that anthropologists' "native informants" could now speak for themselves to "us" without the mediation of the anthropologists and their "science." To somewhat similar ends, Edward Said drew attention to "Orientalism" – the history of those images of the "Orient" produced to help the West dominate the East, and in which what non-Westerners said about themselves was systematically discounted. As cultural studies became the voice of the other, the "marginal" in the academy, it absorbed a radical wing of anthropology, just as it had earlier absorbed a wing of sociology in Britain. The literary world threw up another case in which the processes of globalization were shown to trouble any simplistic or conventional analysis: protests against Salman Rushdie's The Satanic Verses (started by migrant communities in Britain) undercut assumptions about the naturalness (or dominance) of Western notions of how particular cultural formations relate to one

another, in particular the Western sense of literature's transcendence of religion and politics. In sum, globalization meant that the role that subcultures and the working class played in earlier cultural studies began to be replaced and transformed by communities outside the West or migrant (or "diasporic") communities within the West – in a move which involved new theoretical and political problems and intensities.

Conceiving of cultural studies as the academic site for marginal or minority discourses had another, very different but no less visible and globalizing consequence, one which took it further from its original attack on mass culture. The discipline began to celebrate commercial culture, in a move we can call, following Jim McGuigan, "cultural populism" (McGuigan 1992). Cultural populism became possible within the cultural studies anti-hegemonic tradition because, despite the new right's reliance on values disseminated through the cultural market, the right also buttressed its monoculturalism by traditionalist appeals to the canon. (This play between popular knowledge and celebration of the canon marks another tension within contemporary conservative thought.) In its turn, cultural populism helped cultural studies to become global just because, as we have seen, commercial culture has an increasingly transnational reach. What form has cultural populism taken in cultural studies? It too turned away from the highly theoretical attacks on hegemony so important in the 1970s, this time by arguing that at least some popular cultural products themselves have positive quasi-political effects independently of education and critical discourse. For instance, in his 1987 essay, "British cultural studies and television," John Fiske, after reading the television show *Magnum P.I.* through the classic distinction between "preferred," "negotiated" and "oppositional" readings developed by Hall and Morley, goes on to claim that Madonna (circa 1986) offered fans her own form of feminist ideology-critique. Madonna "calls into question" "binary oppositions as a way of conceptualizing women" (Fiske 1987a: 275). Elsewhere Fiske emphasized that popular culture provided "pleasure in the processes of making meanings" (Fiske 1987b: 239) in a move that relied on Roland Barthes's later view that markedly polysemous texts generate particularly intense and liberating pleasures. Such work is refreshing because it rejects the hierarchies that support monocultures, as well as because, unlike the "hegemony" theorists, it does not condescend to actual popular-cultural practices. But it leaves many questions open. The theorist is still telling the "popular" audience how their pleasure works in terms which owe much more to the history of theory than they do to what people actually say or think. It also passes over the question of co-option too rapidly. For instance, Madonna's later work shows us that "needs of capital" (i.e., the requirement for investments to make profits) have not been exactly irrelevant to her career. By calling herself a "material girl," by daring to screen us some familial truths in *Truth or Dare/ In Bed with Madonna* she once again goes to show that what is daring and transgressive in the context of media oligopolies makes money. But as Madonna keeps the industry working, her transgression becomes blander. That is what co-option is. In this light a comparison between Madonna and even a star as musically mainstream as Sinead O'Connor, who has sinned more openly against American

patriotism, might be revealing. It would help to show how a "cultural populism" which can celebrate Madonna (whom the industry loves) as transgressive is subtly, if unconsciously, connected to the new right with its promotion of market forces. This is not to say that we can equate entry into cultural markets with co-option in any rigid or formal manner. But cultural populism requires a very nuanced account of the relations between cultural markets and cultural products in order convincingly to celebrate (some) popular culture as "progressive" – perhaps along the lines taken by Will Straw and Janice Radway in their essays in this collection.

Finally, another kind of cultural studies, which has recently emerged under the title "cultural policy studies," responds to the decline of the social-democratic power bloc in yet other ways (see Tony Bennett's essay in this volume which mounts the case for this mode of cultural studies). Cultural policy studies itself takes two distinguishable forms, one economically orientated and pragmatic, the other more theoretical. The first, economic cultural policy analysis, starts from the recognition that much cultural production and distribution requires allocation of scarce resources – the limits to the number of stations that can operate in the radio spectrum for instance. It also takes account of the fact that cultural labor and consumption are increasingly important to national economies, especially those of highly "advanced" post-industrial countries. For reasons like this, governments are called upon to set parameters for cultural production and distribution – to provide public broadcasting for instance, or to protect local workers against imported labor or products. (See Collins, Garnham and Locksley 1988 for an excellent example of a policy document in this spirit aimed at the debate over UK public television.) At the micro-level, local communities too may need policy advice, in order, for instance, to establish a museum that best provides for both local and tourist needs. Cultural policy studies helps us think about the frameworks and methods of articulating policy in such situations.

The other branch of cultural policy theory derives from Michel Foucault's later work, though Foucault himself, despite advising a number of French governments, was ambivalent about this development of his thought. He encouraged intellectuals to be more critical than is possible when offering policy advice. (Ian Hunter's *Culture and Government* [1988] is the book which theorizes this form of neo-Foucauldianism in most detail; see Foucault's essay "Practicing criticism" in Foucault 1988 for a rejection, in advance, of the position.) In its most radical guise, the neo-Foucauldian thesis argues that culture is neither an end in itself nor the product of autonomous agents – whether individuals or communities – but a mechanism for transmitting forms of "governmentality," for ordering how we act, think, live. Indeed, so the argument goes, cultural work and effects exist only in relation to other governmental structures. Thus Tony Bennett has argued that "policy and governmental conditions and processes should be thought of as constitutive of different forms and fields of culture" (Bennett 1992a: 25). The implication is that the least mystified task of the cultural studies analyst is to enter into alliances with, and attempt to influence, the processes of governmentality.

A number of strong arguments can be urged against neo-Foucauldian cultural policy theory. In particular, such theory possesses a rudimentary account of subjectivity. For it, the individual tends to be just a product of "governmental" protocols or of "techniques of self-formation." This matters because questions of pleasure, corporeality, fantasy, identification, affect, desire, critique, transgression, and so on disappear – which is crippling to rich analysis of cultural work and reception. The theory also relies on a reductive sense of politics. "Policy" becomes a word which, almost magically, neutralizes the more stubborn, conflictual, and critical relations between the various individuals and groups which constitute the social fields in which culture is produced, disseminated, and received.

Leaving these important theoretical difficulties aside for a minute, we can say that both forms of cultural policy studies mark an acceptance of the state hitherto unknown in cultural studies. It traditionally resisted the state's hegemony. There is, indeed, a sense in which cultural policy studies resists new right thinking by returning to statism. Cultural policy studies also breaks with the history of cultural studies in that the discipline has not traditionally produced neutral expertise. Here the difficulties just noted return. It is all the harder to see how cultural studies might provide (apparently) neutral expertise when one considers the kinds of case that cultural policy characteristically addresses. How much "local content" should a particular television industry have? What kind of museum should be constructed in this locality? From the bureaucratic point of view, questions like these require information to be gathered, costs and benefits to be projected, various economic models to be debated. In this, individuals trained in cultural studies (and in other disciplines) might, of course, have a productive role to play. But apart from that, such questions are best argued over not by experts but by (representatives of) interested parties – that is, democratically and politically. As a transnational academic discipline, cultural studies itself does not represent such an interest. And, in fact, policy advice does not uncover truths which can be immediately used and applied. On the contrary, outside the academy it tends to become a pawn in wider political engagements between such interests.

Cultural studies now: some directions and problems

So cultural studies is a discipline continuously shifting its interests and methods both because it is in constant and engaged interaction with its larger historical context and because it cannot be complacent about its authority. After all, it has taken the force of arguments against "meta-discourses" and does not want the voice of the academic theorist to drown out other less often heard voices. As we have begun to see, the discipline's turn to ethnography in particular was motivated by the desire to move beyond theoretical discourses which, however insightful, have been restricted to higher education institutions. Ethnography of the kind developed by Willis and Morley was important to cultural studies because it provided a method by which the discipline could escape such restrictions, and it remains crucial to an understanding of the current and future directions of the discipline. It is

crucial just because the turn to ethnography highlights the difficulty of *either* claiming *or* disclaiming academic and, more especially, ethnographic authority. For if we accept that the academic humanities are a field in which power and cultural capital are generated and transmitted and so do not simply articulate "true" meta-discourses, we must also accept that non-academic or "popular" cultural institutions require critique from a distance because they have their limits and power effects as well. To put it another way, cultural studies today is situated between its pressing need to question its own institutional and discursive legitimation and its fear that cultural practices outside the institution are becoming too organized and too dispersed to appeal to in the spirit it has hitherto appealed to subcultures, the women's movement, and other "others" in its (always somewhat compromised) repudiation of statism and the new right.

In this situation, we need to consider the question of ethnographic or academic authority a little more carefully. Of course ethnography has a long history in the positive social sciences. Social scientists and market researchers have traditionally employed three modes of ethnographic investigation: first, large-scale "surveys" (or "quantitative research") using formal questionnaires on a sample large enough to provide "correlation coefficients" or measures to the degree one variable (like a taste for reading Charles Dickens) relates to another (like one's parents' jobs); second, "qualitative research" or in-depth or "focus" interviews which claim no statistical validity (though they are often used alongside large-scale surveys) and do not rely on formal questionnaires but on (usually group) discussion; third, "participant observation" in which researchers live alongside their subjects – this having been most common in anthropology. Cultural studies ethnography, particularly of media audiences, has mainly used qualitative research in order to avoid the pitfalls of sociological objectivity and functionalism and to give room to voices other than the theorist's own. The problem of representativeness has been discounted. For cultural studies, knowledge based on statistical techniques belongs to the processes which "normalize" society and stand in opposition to cultural studies' respect for the marginal subject.

In early cultural-studies ethnographic work like Morley's *The "Nationwide" Audience*, the researcher played the role of a neutral narrator – using research subjects as the basis upon which to elaborate theory. Later researchers, like Paul Willis, tried to articulate their subjects' perceptions into a more abstract and rigorous lexicon: for Willis good theory was continuous with the "practical consciousness" of those he studied. The bonding between ethnographer and subject became even more crucial when women began working with women – of which Dorothy Hobson's work on the soap opera *Crossroads* is a well-known early instance (Hobson 1982). To think about the importance of the ethnographer's gender, consider how difficult it would have been for a woman to have had Willis's relation to the "lads"! A sense of shared values, identities and purposes between the researcher and the researched often elicits richer responses and transactions in the field. When, in a well-known ethnographic study, Ien Ang invited letters from Dutch *Dallas* viewers, she positioned herself as a fan (as she was) so as to encourage engaged replies (Ang 1985). But – and here we strike a crucial problem – the

ethnographer is not simply a fan; there is an irreducible rift between the position of being-a-researcher and that of being-a-fan, though of course a single individual can be both. There are two ways of dealing with this: one is to accept it and the ambivalence or contradiction it generates as productive – as Meaghan Morris does in her essay collected here; the other is for the researcher simultaneously to ethnographize herself in relation to her subjects and to allow her subjects as much exposure as possible to her own, more academic discourses. At this point ethnography can involve two-way transmission of information and maybe even passion.

With the category "being a fan," the question of populism reappears. But now we need to draw a distinction between cultural populism and that form of academic populism which (like Paul Willis) argues that, in cultural studies, academic knowledge ought to formalize what is already popularly known. A difficulty for both these populisms is that, when we think of either a "culture of differences" engaged in a "politics of survival" or a society as structured by various, interacting fields through which various discursive or cultural practices are transmitted, then the *binary* opposition "popular" versus "elite" begins to fall way. The assault on this form of binary thinking has been all the stronger because recent historical research has shown that the separation between popular and elite culture has historically been more fluid than cultural historians have believed. (See Levine 1988 and Collins 1989.) Nevertheless the "popular" as a category is unlikely to fall out of sight in cultural studies. To begin with, as we have seen, the distribution networks of concentrated cultural markets are increasingly gaining access to communities from different localities, ethnicities, and cultural backgrounds to produce ever-larger popular audiences: now some stars and brands (Coke, Michael Jackson, Nike, McDonald's . . .) belong to the global popular, at least for a while. At a more local level, notions of popular wants and desires are powerfully appealed to both by national politicians (nowhere more so than in Thatcherism) and by managers of large-scale cultural industries as they attempt to organize consumers' tastes, desires, and pleasures. As Meaghan Morris in her essay in this collection notes, politicians construct an imaginary through figures such as "the silent majority," or the "man (less often "woman") in the street." These figures are sometimes literally fake: in the 1930s and 1940s, Hollywood habitually produced "documentaries" using actors as supposedly "real" interviewees. Fake or not, these figures become *embodied* in our national social imaginary. For the politicians, it is as if a certain kind of individual possesses the opinions, tastes, and values which polls, charts, ratings, and elections reveal to be popular. In the culture industries, the figure of the "popular" mediates between producers and audiences. Using its own sophisticated ethnographic techniques, the industry attempts to produce what the public (or at any rate the more affluent sections of it) wants. But at the same time it generates public desire by marketing its products (both hardware and software) as if they were always already popular. That "nothing sells like a hit" is more than a tautology, it is the most successful formula for cultural marketing. People will buy what other people love and desire. Through these political and commercial tactics and logics, the popular is constantly pushed towards the normal, even the universal.

Yet, as a concept like the global popular makes apparent, no single kind of person embodies the popular. Cultural studies can provide space for, and knowledge of, the multiple audiences and communities who, in various combinations, vote, buy records, watch television and films, etc, without ever fitting the "popular," "ordinary," or "normal." This is another reason to examine the techniques by which social values, attitudes, and desires are measured, as well as to demystify the political uses of representations like the "silent majority" and "ordinary American." In this way, cultural studies can begin to intervene on the cultural market's failure to admit full cultural multiplicity – particularly if (going with cultural populism) it accepts that, in principle, cultural markets can provide a variety of products, pleasures, and uses, including transgressive and avant-garde ones. Although cultural multiplicity is appealed to by many theoretical articles in this anthology, especially bell hooks's and Cornel West's, it is useful to cite a well-known recent example of how audience measurement affects cultural production and images of the "popular" within a particular nation state. When, in the US, *Billboard* stopped producing its music charts by measuring radio play and sales in an unrepresentative sample of shops and began using information based directly on bar-coded sales, it immediately became apparent that "genre" music – country, rap, heavy metal – was selling much better than anyone had suspected. These music forms began to enter a redefined mainstream. The sense of what was "popular" shifted. This is not to say that these new techniques perfectly represent public preferences: *Billboard*'s measurement of purchase doesn't measure real consumption, let alone tastes. For example, not all social groups have the same capacity to turn their taste into purchases, not all sold products are listened to as often as others, and some music genres are more often taped than others. Images of "popular listening" based on *Billboard*'s information would still be awry – though this information will also allow the music-business oligopolies to restructure their production and hence (within limits) popular tastes and desires.

The deeper question that quantitative market research and ratings fail to answer is how cultural products are valued and used – this is especially important because this failure, too, has important effects on our construction of the popular. Take television, for instance. Ratings are still mainly produced by measuring how many televisions are turned on each channel at any particular moment, though techniques to measure actual audience attention are also employed, including videoing viewers! But (leaving the question of VCR recorders aside) we know that television is watched in many ways: for information, for comforting background noise and flicker, as a neutral flow which helps to reduce (or increase) family tensions, for relaxation after working hours, for fans to watch a favorite program intensely, to produce a sense of cultural superiority through a careful, but ironical and distanced, mode of viewing, as a medium for programs which are received as great art, and so on. At any one time any program is available for many of these viewing practices. However, at certain times of the week certain such practices dominate. "Prime time" is the period in which most people watch for relaxation, for instance. What the ratings measure then is not *one* kind of viewing: like is not being compared to like. Rather a good rating is a sign that a particular

television use-value dominates at a particular moment within the larger rhythms of the working or schooling week. It is not the simple index of popular will or taste. Again, by turning a good rating into an expression of the "popular," less widespread practices and preferences are marginalized as "unpopular."

Partly because the notion of the "popular" carries with it these problems, cultural studies is increasingly drawing attention to another, closely connected, category, one which does not compound divisiveness for the simple reason that (at least apparently) no one, anywhere, can avoid it. This category is "everyday life." Ironically, however, cultural studies (as in the essay by Michel de Certeau collected here) derives the notion from an avant-garde tradition which turned to everyday life not as a basis for reassuring consensus but as an arena capable of radical transformation just because it was being increasingly disciplined, commodified, and rationalized in so-called "modernity." In particular, Henri Lefebvre believed that intellectuals could drive the "organized passivity" and banality out of everyday life, drawing attention to its tragedies, sublimity, and magic (Lefebvre 1971 and 1991a). This was to be achieved by showing, first, that everyday life is *constructed* as the sphere in which, as the writer Maurice Blanchot put it, "nothing happens" (Blanchot 1987: 15), and, then, by writing about it carefully and affectionately, to defamiliarize it and reaffirm its true value. Lefebvre's desire to play everyday life against modernity was elaborated by Michel de Certeau, who found a dream-like logic or "grammar" in overlooked and habitual acts (like walking) which countered disciplining routines. Given de Certeau's and Morris's marvellous essays, there can be little doubt that everyday life does provide an area where imaginative intellectual analysis and description may produce liberating effects. Partly by bringing academic analysis closer to the aims and techniques of older, non-academic essay-writing, the textualizers of everyday life help us to accept academic authority at the same time as they loosen and disseminate it. None the less, theory which grounds itself on a sense of the everyday does not avoid the problems associated with populism. Most relevantly, within a discipline that has globalized itself through affirming otherness, it is important to remember the obvious point that everyday life is not everywhere the same, despite those modernizing effects of uniformity that Lefebvre was obsessed by. Think about walking in the city: doesn't it make a difference if one walks in Paris, downtown Detroit, Melbourne, Mexico City or Hong Kong just for starters? And, in each of these places, does a woman have the same experience as a man, a gay as a straight, a young person as an old one? The everyday, too, is produced and experienced at the intersection of many fields by embodied individuals; at times and in places it may also be a limit that cultural practices, especially those that attempt to move across cultures, aim to escape. And, as Meaghan Morris's essay reminds us, it does not possess a single history. It exists within multiple histories, many of which escape the way the past is remembered and stored officially — in universities, for instance. Here, perhaps more than elsewhere, cultural studies merges into cultural histories which reconnect us to the world in ways that cannot be taken for granted. So it is not as though appeal to everyday life can avoid the intractable questions as to relations between social differences, life-practices and cultural expression which cultural

studies began by addressing. But the fact that textualizing everyday life, with all its seduction, leads to these kinds of difficulties is another sign that the discipline has real vitality. There remains much work to do.

Bar minor modifications, the introduction above was written in 1992. Despite its now being over five years old, it continues to provide a useful preface for the eighteen new essays added to this edition, though they were mostly written since. This is not to say, however, that cultural studies in 1999 is what it was in 1992. Not at all. To begin with, the topics it deals with have changed, or, at least, emphases have shifted. For instance, highly theorized work, especially from a structuralist or semiotic perspective, has moved to the background. So have topics like subcultures and media reception. However, a few of the new areas, scattered across the field, are worth noticing in a little more detail.

First, science. Work on science has intensified in response to the increasing technologization of nature and the human body. As technology and nature merge, the upholding of a hard division between science and culture by insisting that science remains off-limits to non-scientists helps to disenfranchise those whose lives are most affected by scientific and technological innovations (or, otherwise put, by science's colonization of the lifeworld). On the other hand, leaving science to the experts may also allow too much scope amongst non-scientists for technophobes and those who fetishize a nature out of reach of human work and intervention. Hence the interest of cultural studies intellectuals in the topic (see the essays by Andrew Ross and Donna Haraway collected here).

Second, and of no less importance, sex. Sex has partly displaced gender as an area of debate and contestation (see the essay by Lauren Berlant and Michael Warner). This has happened within queer theory which, in insisting that the regime of compulsory heterosexuality (or heteronormativity) shapes gender difference, has effectively rejected the earlier feminist bracketing off of sexual desire from critique of gender "roles." Notwithstanding its avowed political program, and despite its capacity to help assemble a constituency ("queer nation"), queer theory tends to be more philosophical, and more distant from public culture as it happens in the media or official politics, than most previous work in cultural studies (see the essay by Judith Butler). At best the queer academic post-structuralist can be thought of as a vanguardist intellectual within queer nation (an "organic" intellectual in Gramsci's sense even as she dismantles organicist thinking); at worst, unremittingly academic work in the post-structuralist vein can seem insensitive or irrelevant to the twists, wonders, and shocks of lesbian, gay, queer life over the past decade – with its political wins and losses, the ongoing carnage of the AIDS epidemic; an increasing (popular-) cultural acceptance, confidence, and inventiveness . . .

Indeed the function of the cultural studies teacher in relation to "public culture" or the public sphere more generally has been much discussed. At least since Andrew Ross's pathbreaking book, *No Respect: Intellectuals and Popular Culture* (1989), such discourse has often taken the form of arguments over intellectuals. What's an intellectual these days? Are they just professionalized voices within the academy

or the media; are they spokespersons for specific interest groups or communities? Can the notion of the *critical* intellectual survive the fragmentation of culture into an assemblage of institutions, and the professionalization and specialization of academic knowledge? For instance, are Noam Chomsky and Stuart Hall both "intellectuals," or is Hall, who rarely appears on television, just an "academic" or "professor," with Chomsky, for all his fame, only a media intellectual because he's tied to old left causes, having failed to attend to contemporary academic media or cultural or social theory as expressed in cultural studies? How about Judith Butler and Camille Paglia? Cultural studies has increasingly concerned itself with such cases and questions (B. Robbins 1990 and 1993a).

But perhaps the most profound topical change in cultural studies has been its focusing on cultural *flow*. The field is much less focused on discrete, filiative national or ethnic cultures, or components of such cultures, than it was in its earlier history, in work by Raymond Williams and the early Birmingham school, say. Cultural studies' objects are decreasingly restricted or delimited by distance and locality at all. Rather, they move across national borders (as in the global "scapes" described by Arjun Appadurai in his essay included here); or they belong to scattered, diasporic groups (like the television shows watched by Hamid Naficy's Los Angeles Iranians in his piece); or they are products of fluid, transnational regions like Paul Gilroy's Black Atlantic, peopled by men and women without "pure" identities or traditions and all the more able to improvise within their situation for that reason; or they inhabit faultlines between global powers and processes like those who live in Ackbar Abbas's Hong Kong, as he describes it in his essay in this volume, caught at the interface between the communist People's Republic of China and global capitalism.

Cultural studies which addresses such cases is often called "transnational cultural studies." It's eroding so-called "postcolonialism," first nurtured in literary studies, which was so important a feature of the late 1980s and early 1990s intellectual landscape. Much critiqued on the grounds that it prematurely celebrated the end of colonialist relations of exploitation and dependency, postcolonialism increasingly has had to come to terms with "globalization" – a word often heard, rarely clearly understood. What's globalization, then? Not simply, as it often seems, Thatcherism writ large, globalization is best understood as the development of global markets and capital so as to skew highly capitalized national economies towards service, information, financial instruments, and other high value-added products away from traditional primary commodities and mass-production industries. Globalization also means more organized cross-national or "diasporic" labor-force movements, along with the amazing growth of export culture industries, including tourism. And, last, it means the accelerated development of communication technologies like the Internet which escape the tyranny of distance. Globalization has both undermined the autonomy of nation states and reduced state intervention in society and the economy – sometimes as a cause, other times as an excuse. It has also drastically transformed and punctured the old metropolitan/colony, center/periphery, north/south divisions, enabling new regions to invent themselves (notably "Asia Pacific") alongside new cosmopolitanisms, elite and popular (see

Cheah and Robbins 1998). Because it unifies the world *and* divides it, the problem of how to evaluate the consequences of globalization or transnationalism has become a central cultural studies issue (see the essays by Gayatri Spivak and Homi Bhabha).

This problem is not to be posed in the traditional fashion, i.e. "is globalization reducing global cultural differences?" – the answer to that being increasingly clearly "no, at least not in any simple way" since globalization is articulating all cultures and communities to one another in a process which also makes for new fragmentations and mixes, new niche and local markets; new opportunities for self-expression and alliance. Nor is the question "is globalization the same as Westernization?" – to which again it is generally agreed that the answer is "no, not in any simple way" – less because the technologies and capital driving globalization are not wholly owned in the West than because globalization brings benefits and power as well as costs to most localities around the world. Rather, the crucial questions are "is globalization creating new inequalities and depleting resources too unevenly and rapidly?" and, more complexly, "is globalization depriving individuals and communities of the capacity to control and know their own interests as they are increasingly called upon to produce and consume for markets driven from afar?" These questions have especial force for those – whether they live in rich or poor nations or regions – who have least capacity to direct or produce for global or national markets and flows, and hence are most likely to miss out on remunerative employment, becoming subject to demoralization and physical hardship, and objects of media stories, ethnographical research, touristic gazes, state, military or aid-organization attention ... Transnational cultural studies attempts to produce academic knowledge and testimony across political and cultural borders which are not complicit with these gazes, stories, and attentions.

For all that, it is not cultural studies' *topics,* but its status in the education system which has changed most radically. And in this process cultural studies has become a soft target in the Western media. Risking academic self-absorption, I want to end this introduction by examining this crucial development a little more closely.

Since the early 1990s, there has been a cultural studies boom, especially in anglophone universities. Or there seems to have been. In fact we need to distinguish between, on the one hand, a general "turn to culture" (or "cultural turn") in the social sciences and humanities, and, on the other, the expansion of cultural studies conceived of as a discrete mode of analysis – as it is in this collection, for instance – and which, for convenience's sake, I'll call "engaged cultural studies."

As to the cultural turn: most, maybe all, humanities and social science disciplines have increasingly emphasized culture over the past decade or so. Cultural history has become the hot area in history; the cultural construction of space, in geography. Within criminology, representation of crime (i.e., crime's cultural face) has flourished. Cultural anthropologists are almost as likely to do fieldwork in urban, metropolitan communities (on shopping, say) as in the world's outposts, leaving little space to distinguish them from cultural studies ethnographers. Books

with titles like *From Sociology to Cultural Studies* raise few eyebrows. In many of the most exciting research areas of the last few years – the study of museums is a good example – historians, literary critics, anthropologists, and geographers collaborate and compete with minimal disciplinary or methodological differences apparent – more often than not they are all doing "cultural studies" as far as publishers and bookshops are concerned. Foreign-language departments now routinely (if not uncontroversially) think of themselves as introducing students to cultures rather than languages and literatures. English departments around the world have developed courses in non-literary cultural forms. When, in 1997, the Modern Languages Association published a number of short opinion pieces on the relation between literary studies and cultural studies, most respondents were of the opinion that cultural studies was another wave within literary studies, and that the distinction between the two, being artificial, was to be downplayed.

This general turn to culture has helped to disseminate cultural studies as a form of knowledge with its own histories, methods, and programs ("engaged cultural studies") but it also threatens to overwhelm and dilute it. In this situation, for those of us with a commitment to engaged cultural studies, it would seem that three tasks become particularly urgent: first, clearly to articulate engaged cultural studies' specific project; second, to analyze the conditions which underpin the general turn to culture just described; third, to develop strategies to maintain engaged cultural studies as a discrete formation inside the larger cultural turn. These tasks are all the more compelling because, as I say, cultural studies, in becoming established in the academy, has been the object of public attacks – a player (and pawn) in the "culture wars" – on the grounds that it fails both to disseminate cultural value (for cultural studies, so it's alleged, Mickey Mouse is as good as Shakespeare), and that it disrupts cultural unity (conservatives complain that cultural studies is on a mission for a multiculturalism which will undermine national pride, heritage, and consensus). Such attacks ring especially hollow when they fail to enquire into the reasons why cultural studies is expanding in the academy, both in its radical and in its more traditional forms.

This is not the place to begin working through these matters in any detail – that belongs to the ongoing work I wrote of at the end of my 1992 introduction. However a very brief (and partial) indication of directions to be taken is useful.

The first of these three tasks – addressing the issue of what is specific to engaged cultural studies – is probably the easiest to deal with. As this book hopes to persuade its readers, engaged cultural studies is academic work (teaching, research, dissemination, etc.) on contemporary culture from non-elite or counter-hegemonic perspectives ("from below") with an openness to the culture's reception and production in everyday life, or, more generally, its impact on life trajectories. Engaged cultural studies encourages and takes notice of culture's capacity to express and invoke less restricted (more "other," counter-normative) ways of living. So it does not simply "teach the conflicts" (Graff 1992) – that is, it does not neutrally present the debates over canons, cultural value, multiculturalism, identity-thinking, and so on for students, rather it aims to produce knowledge from perspectives lost to and in dominant public culture, and to listen to far-off or marginalized voices.

Yet, importantly, engaged cultural studies also examines its own constitutive borders and divisions – or, more simply, the relation between what it includes and what it excludes. It examines its temporal border: the separation of past from present (asking, what the role of history is in contemporary cultural studies). It examines the power barriers it assumes and contests: the division between hegemonic ("above") and counter-hegemonic ("below") – or, to swap terms, the borders between margins and centers. And it examines structural divisions: the boundaries between "culture" on the one hand, and "society" or the "economy" on the other (asking, for instance, to what degree is culture shaped by economic structures – see Nicholas Garnham's essay for a discussion of this). We might add to these problems concerning boundaries, though it's been much less discussed, that cultural studies also addresses the basic distinction between the political (or the engaged) and the non-political (or the disengaged) where it touches culture – a topic to which I will return in a moment.

The second of my three tasks faces a more difficult challenge. Why has the study of culture recently become so popular across the whole range of the humanities, and even the social sciences? To sum up a very complicated situation: the turn to culture would seem to be best understood as an effect of three entangled events, each on a very different scale. First, the increasing importance of cultural industries to post-industrial national economies such as the US and the UK; second, the rise in the use of cultural heritages and cultural consumption to maintain or stabilize identities by nations, ethnic groups, and individuals (partly because socialism has been delegitimized, and people cease to identify with a class); and, finally, at the micro-level of the education system, the downsizing of the academic humanities and the social sciences relative to other faculties inside a still expanding post-compulsory education sector.

To put the case in a nutshell: even in highly developed, post-industrial countries, more and more students are entering post-compulsory institutions without having, or wishing for, traditional European elite taste preferences and without the desire to form themselves ethically through their consumption or knowledge of canons. Their own everyday-life culture is increasingly that of popular culture or niches within it – this is their starting point for exploring the past, for instance. Many students from so-called "minority" communities, often the first members of their family ever to attend university, wish to affirm and learn about their own neglected or repressed cultural heritages. At the same time, many students take humanities and social sciences courses in preparation for professional graduate training or (in the case of the humanities) to enter the broader cultural industries – in both cases, courses on culture, especially contemporary culture, provide especially efficient and pertinent use-value or training. All this within an education system decreasingly supported by state funding and increasingly managed in business-sector terms of "efficiencies" and "performance" so that areas of study without high student demand are gradually likely to be diminished or let go. These pressures finally have an impact even on rich institutions, especially at graduate school level, because such graduate schools train teachers, and, despite inertia, ultimately have to be responsive to projected student demand in the rest of the

system. To move from the general to the particular, this is the larger logic within which books, articles, and courses on, say, the politics of seventeenth-century France or monographs on canonical literary authors tend to decrease, while books, articles, and courses on global media systems, or even, say, magical thinking in the construction of modernity, tend to increase.

The last of the three proposed tasks – the need to develop strategies to maintain engaged cultural studies as a specific field, as against the turn to culture in general – is perhaps the most contentious. A main reason for this is that it exposes anxieties over avowedly political knowledge and teaching within the supposedly "objective" academy. In practice engaged cultural studies is rapidly becoming another area of speciality – a discipline, a field – able to be housed in any one of a number of departments, though most frequently in literature or communications departments. The tactic of adding speciality after speciality to departments, faculties, or disciplines, and thereby avoiding dealing with controversial intellectual-pedagogical issues, has been well discussed by Gerald Graff in his *Professing Literature* (1987). But because engaged cultural studies is expressly political, it does not settle easily into a pattern of accretion and liberal tolerance. So we need to spell out that there are compelling reasons why students, not least those from elite backgrounds, might be exposed to it. As a field, it accepts that studying culture is rarely value-free, and so, embracing clearly articulated, left-wing values, it seeks to extend and critique the relatively narrow range of norms, methods, and practices embedded in the traditional, past-fixated, canon-forming humanities. It does so in order to provide students (in this case, especially elite students) with a point of entry into the contemporary world they are unlikely to have learned from their families, their secondary schooling or from the media, and it helps make a less blinkered and hierarchical, a fairer and more open culture for that very reason. Of course, it also often provides non-elite students and scholars with an approach they can recognize and own.

None the less, I'd suggest that, for both practical and theoretical reasons, in the current situation, we need to think of cultural studies not as a traditional field or discipline, nor as a mode of interdisciplinarity, but as what I will call a field within multidisciplinarity. This means that cultural studies should aim to monopolize its students or, indeed, its teachers and intellectuals, as little as is possible within the academic-bureaucratic structures we have. Within the academy it is best regarded as an area to work in alongside others, usually more highly institutionalized disciplines – Spanish, geography, politics, economics, literature ... whatever. The point is not so much to dismantle disciplinary boundaries as to be able to move across them; the aim is to transport methods and attitudes from cultural studies to other disciplines where they are appropriate, but also to be able to forgo them where they are not.

Pragmatically, thinking of cultural studies as a field within multidisciplinarity increases its reach inside institutions committed, however problematically, to objectivity – institutions, I suspect, which are coming under mounting pressure to close down on cultural dissidence from community and media interests. We need also to recognize that a great deal of the material studied in the humanities does not

invite political engagement, let alone political engagement which can be easily translated into the current situation. To give just one cultural–historical example: amongst Elizabethan playwrights, if we have an interest in them at all, we may prefer Christopher Marlowe to Ben Jonson on political grounds because of the way that Marlowe rebels against the sexual and religious codes of his time. But what about debates between the Stoics and the Epicureans, so important for early modern Western political and philosophical thought? What's the current political valency there? And if these debates have little or no political valency now, is that a reason not to study them alongside engaged cultural studies?

That kind of question is gaining force because the downsizing of the humanities is transforming the political force and meaning of the academic humanities. Let's put it like this: in a situation where globalized market forces and government policy are demanding that universities should provide economically relevant practical training so as to increase productivity and efficiency, where calls for academics to make themselves over as "public intellectuals" within the restricted parameters of the mainstream media are commonplace, is studying the Stoics and Epicureans, or, for that matter, technical aspects of the seventeenth-century English lyric, simply obscurantist or (in the case of the lyric) elitist? Such studies have a political charge, however faint, in their very incapacity to contribute to the market or media culture. (This is a version of the political charge that Theodor Adorno assigned to modernist art under industrial capitalism in his *Aesthetic Theory* and elsewhere.) Multidisciplinarity, which thinks of engaged cultural studies less as an academic specialism than as a critical moment within a larger, dispersed, not wholly politicized field, is, then, a way of shoring up differences and counter-hegemony inside the humanities in an epoch of global managerialism. So I'm arguing that global managerialism underpins the academic turn to culture in ways which mean that engaged cultural studies best situates itself into the humanities and social sciences as a fluid and critical moment, neither weighted down by disciplinarity nor blanded out into the interdisciplinarity of the wider cultural turn. Whether or not engaged cultural studies accommodates to globalization and managerialism in quite the way I am proposing is up to readers of this book as much as anyone to decide.

Theory and method

Theodor Adorno and Max Horkheimer

THE CULTURE INDUSTRY
Enlightenment as mass deception

EDITOR'S INTRODUCTION

ADORNO AND HORKHEIMER'S ESSAY, published in the mid-1940s, remains the classic denunciation of the "culture industry." It offers a vision of a society that has lost its capacity to nourish true freedom and individuality – as well as the ability to represent the real conditions of existence. Adorno and Horkheimer believe that this loss results from the fact that cultural production has moved from an artisanal stage, which depended on individual effort and required little or no investment, to an industrial stage. For them, the modern culture industry produces safe, standardized products geared to the larger demands of the capitalist economy. It does so by representing "average" life for purposes of pure entertainment or distraction as seductively and realistically as possible. Thus, for them, Hollywood movies, radio, mass-produced journalism, and advertising are different only at the most superficial level. Furthermore, the culture industry has become so successful that "art" and "life" are no longer wholly separable – which is the theme later theorists of postmodernity took from the essay. (See Jameson 1990; and the Lyotard essay in this volume.) Of course "high" art still exists as "mass culture"'s opposite, but for Adorno, in a famous phrase, these are two halves of a whole that do not add up.

Debate about the essay continues, but it is important to remember the situation in which it was written. The Second World War had not quite ended, and Adorno and Horkheimer were refugees from Nazi Germany living in the US. Hitler's totalitarianism (with its state control of cultural production) and the American market system are fused in their thought – all the more easily because, for them as members of the German (or rather the secularized German-Jewish) bourgeoisie, high culture, particularly drama and music, is a powerful vehicle of civil values.

It is also worth emphasizing that when this essay was written the cultural industry was less variegated than it was to become, during the 1960s in particular. Hollywood, for instance, was still "vertically integrated" so that the five major studios owned the production, distribution, and exhibition arms of the film business between them; television was still in its infancy; the LP and the single were unknown; the cultural market had not been broken into various demographic sectors – of which, in the 1950s, the youth segment was to become the most energetic. This helps to explain how Adorno and Horkheimer neglect what was to become central to cultural studies: the ways in which the cultural industry, while in the service of organized capital, also provides the opportunities for all kinds of individual and collective creativity and decoding.

Further reading: Adorno 1991; Berman 1989; Connerton 1980; Jameson 1990; Jay 1984a; Kracauer 1995; Pensky 1997.

The sociological theory that the loss of the support of objectively established religion, the dissolution of the last remnants of precapitalism, together with technological and social differentiation or specialization, have led to cultural chaos is disproved every day; for culture now impresses the same stamp on everything. Films, radio and magazines make up a system which is uniform as a whole and in every part. Even the aesthetic activities of political opposites are one in their enthusiastic obedience to the rhythm of the iron system. The decorative industrial management buildings and exhibition centres in authoritarian countries are much the same as anywhere else. The huge gleaming towers that shoot up everywhere are outward signs of the ingenious planning of international concerns, towards which the unleashed entrepreneurial system (whose monuments are a mass of gloomy houses and business premises in grimy, spiritless cities) was already hastening. Even now the older houses just outside the concrete city centres look like slums, and the new bungalows on the outskirts are at one with the flimsy structures of world fairs in their praise of technical progress and their built-in demand to be discarded after a short while like empty food cans. Yet the city housing projects designed to perpetuate the individual as a supposedly independent unit in a small hygienic dwelling make him all the more subservient to his adversary – the absolute power of capitalism. Because the inhabitants, as producers and as consumers, are drawn into the centre in search of work and pleasure, all the living units crystallize into well-organized complexes. The striking unity of microcosm and macrocosm presents men with a model of their culture: the false identity of the general and the particular. Under monopoly all mass culture is identical, and the lines of its artificial framework begin to show through. The people at the top are no longer so interested in concealing monopoly: as its violence becomes more open, so its power grows. Movies and radio need no longer pretend to be art. The truth that they are just business is made into an ideology in order to justify the rubbish they deliberately produce. They call themselves industries; and when their directors' incomes are published, any doubt about the social utility of the finished products is removed.

Interested parties explain the culture industry in technological terms. It is alleged that because millions participate in it, certain reproduction processes are necessary that inevitably require identical needs in innumerable places to be satisfied with identical goods. The technical contrast between the few production centres and the large number of widely dispersed consumption points is said to demand organization and planning by management. Furthermore, it is claimed that standards were based in the first place on consumers' needs, and for that reason were accepted with so little resistance. The result is the circle of manipulation and retroactive need in which the unity of the system grows ever stronger. No mention is made of the fact that the basis on which technology acquires power over society is the power of those whose economic hold over society is greatest. A technological rationale is the rationale of domination itself. It is the coercive nature of society alienated from itself. Automobiles, bombs, and movies keep the whole thing together until their levelling element shows its strength in the very wrong which it furthered. It has made the technology of the culture industry no more than the achievement of standardization and mass production, sacrificing whatever involved a distinction between the logic of the work and that of the social system. This is the result not of a law of movement in technology as such but of its function in today's economy. The need which might resist central control has already been suppressed by the control of the individual consciousness. The step from the telephone to the radio has clearly distinguished the roles. The former still allowed the subscriber to play the role of subject, and was liberal. The latter is democratic: it turns all participants into listeners and authoritatively subjects them to broadcast programmes which are all exactly the same. No machinery of rejoinder has been devised, and private broadcasters are denied any freedom. They are confined to the apocryphal field of the 'amateur', and also have to accept organization from above. But any trace of spontaneity from the public in official broadcasting is controlled and absorbed by talent scouts, studio competitions and official programmes of every kind selected by professionals. Talented performers belong to the industry long before it displays them; otherwise they would not be so eager to fit in. The attitude of the public, which ostensibly and actually favours the system of the culture industry, is a part of the system and not an excuse for it. If one branch of art follows the same formula as one with a very different medium and content; if the dramatic intrigue of broadcast soap operas becomes no more than useful material for showing how to master technical problems at both ends of the scale of musical experience – real jazz or a cheap imitation; or if a movement from a Beethoven symphony is crudely 'adapted' for a film soundtrack in the same way as a Tolstoy novel is garbled in a film script: then the claim that this is done to satisfy the spontaneous wishes of the public is no more than hot air. We are closer to the facts if we explain these phenomena as inherent in the technical and personnel apparatus which, down to its last cog, itself forms part of the economic mechanism of selection. In addition there is the agreement – or at least the determination – of all executive authorities not to produce or sanction anything that in any way differs from their own rules, their own ideas about consumers, or above all themselves.

In our age the objective social tendency is incarnate in the hidden subjective purposes of company directors, the foremost among whom are in the most powerful

sectors of industry – steel, petroleum, electricity, and chemicals. Culture monopolies are weak and dependent in comparison. They cannot afford to neglect their appeasement of the real holders of power if their sphere of activity in mass society (a sphere producing a specific type of commodity which anyhow is still too closely bound up with easygoing liberalism and Jewish intellectuals) is not to undergo a series of purges. The dependence of the most powerful broadcasting company on the electrical industry, or of the motion picture industry on the banks, is characteristic of the whole sphere, whose individual branches are themselves economically interwoven. All are in such close contact that the extreme concentration of mental forces allows demarcation lines between different firms and technical branches to be ignored. The ruthless unity in the culture industry is evidence of what will happen in politics. Market differentiations such as those of A and B films, or of stories in magazines in different price ranges, depend not so much on subject matter as on classifying, organizing, and labelling consumers. Something is provided for all so that none may escape; the distinctions are emphasized and extended. The public is catered for with a hierarchical range of mass-produced products of varying quality, thus advancing the rule of complete quantification. Everybody must behave (as if spontaneously) in accordance with his previous determined and indexed level, and choose the category of mass product turned out for his type. Consumers appear as statistics on research organization charts, and are divided by income groups into red, green, and blue areas; the technique is that used for any type of propaganda.

How formalized the procedure is can be seen when the mechanically differentiated products prove to be all alike in the end. That the difference between the Chrysler range and General Motors products is basically illusory strikes every child with a keen interest in varieties. What connoisseurs discuss as good or bad points serve only to perpetuate the semblance of competition and range of choice. The same applies to the Warner Brothers and Metro Goldwyn Mayer productions. But even the differences between the more expensive and cheaper models put out by the same firm steadily diminish: for automobiles, there are such differences as the number of cylinders, cubic capacity, details of patented gadgets; and for films there are the number of stars, the extravagant use of technology, labour, and equipment, and the introduction of the latest psychological formulas. The universal criterion of merit is the amount of 'conspicuous production' of blatant cash investment. The varying budgets in the culture industry do not bear the slightest relation to factual values, to the meaning of the products themselves. Even the technical media are relentlessly forced into uniformity. Television aims at a synthesis of radio and film, and is held up only because the interested parties have not yet reached agreement, but its consequences will be quite enormous and promise to intensify the impoverishment of aesthetic matter so drastically, that by tomorrow the thinly veiled identity of all industrial culture products can come triumphantly out into the open, derisively fulfilling the Wagnerian dream of the *Gesamtkunstwerk* – the fusion of all the arts in one work. The alliance of word, image, and music is all the more perfect than in *Tristan* because the sensuous elements which all approvingly reflect the surface of social reality are in principle embodied in the same technical process, the unity of which becomes its distinctive content. This process integrates all the elements of the production, from the novel (shaped with

an eye to the film) to the last sound effect. It is the triumph of invested capital, whose title as absolute master is etched deep into the hearts of the dispossessed in the employment line; it is the meaningful content of every film, whatever plot the production team may have selected.

The whole world is made to pass through the filter of the culture industry. The old experience of the movie-goer, who sees the world outside as an extension of the film he has just left (because the latter is intent upon reproducing the world of everyday perceptions), is now the producer's guideline. The more intensely and flawlessly his techniques duplicate empirical objects, the easier it is today for the illusion to prevail that the outside world is the straightforward continuation of that presented on the screen. This purpose has been furthered by mechanical reproduction since the lightning takeover by the sound film.

Real life is becoming indistinguishable from the movies. The sound film, far surpassing the theatre of illusion, leaves no room for imagination or reflection on the part of the audience, who are unable to respond within the structure of the film, yet deviate from its precise detail without losing the thread of the story; hence the film forces its victims to equate it directly with reality. The stunting of the mass-media consumer's powers of imagination and spontaneity does not have to be traced back to any psychological mechanisms; he must ascribe the loss of those attributes to the objective nature of the products themselves, especially to the most characteristic of them, the sound film. They are so designed that quickness, powers of observation, and experience are undeniably needed to apprehend them at all; yet sustained thought is out of the question if the spectator is not to miss the relentless rush of facts. Even though the effort required for his response is semi-automatic, no scope is left for the imagination. Those who are so absorbed by the world of the movie – by its images, gestures, and words – that they are unable to supply what really makes it a world, do not have to dwell on particular points of its mechanics during a screening. All the other films and products of the entertainment industry which they have seen have taught them what to expect; they react automatically. The might of industrial society is lodged in men's minds. The entertainments manufacturers know that their products will be consumed with alertness even when the customer is distraught, for each of them is a model of the huge economic machinery which has always sustained the masses, whether at work or at leisure – which is akin to work. From every sound film and every broadcast programme the social effect can be inferred which is exclusive to none but is shared by all alike. The culture industry as a whole has moulded men as a type unfailingly reproduced in every product. All the agents of this process, from the producer to the women's clubs, take good care that the simple reproduction of this mental state is not nuanced or extended in any way.

The art historians and guardians of culture who complain of the extinction in the West of a basic style-determining power are wrong. The stereotyped appropriation of everything, even the inchoate, for the purposes of mechanical reproduction surpasses the rigour and general currency of any 'real style', in the sense in which cultural *cognoscenti* celebrate the organic precapitalist past. No Palestrina could be more of a purist in eliminating every unprepared and unresolved discord than the jazz arranger in suppressing any development which does not conform to

the jargon. When jazzing up Mozart he changes him not only when he is too serious or too difficult but when he harmonizes the melody in a different way, perhaps more simply, than is customary now. No medieval builder can have scrutinized the subjects for church windows and sculptures more suspiciously than the studio hierarchy scrutinizes a work by Balzac or Hugo before finally approving it. No medieval theologian could have determined the degree of the torment to be suffered by the damned in accordance with the *ordo* of divine love more meticulously than the producers of shoddy epics calculate the torture to be undergone by the hero or the exact point to which the leading lady's hemline shall be raised. The explicit and implicit, exoteric and esoteric catalogue of the forbidden and tolerated is so extensive that it not only defines the area of freedom but is all-powerful inside it. Everything down to the last detail is shaped accordingly. Like its counterpart, avant-garde art, the entertainment industry determines its own language, down to its very syntax and vocabulary, by the use of anathema. The constant pressure to produce new effects (which must conform to the old pattern) serves merely as another rule to increase the power of the conventions when any single effect threatens to slip through the net. Every detail is so firmly stamped with sameness that nothing can appear which is not marked at birth, or does not meet with approval at first sight. And the star performers, whether they produce or reproduce, use this jargon as freely and fluently and with as much gusto as if it were the very language which it silenced long ago. Such is the ideal of what is natural in this field of activity, and its influence becomes all the more powerful, the more technique is perfected and diminishes the tension between the finished product and everyday life. The paradox of this routine, which is essentially travesty, can be detected and is often predominant in everything that the culture industry turns out. A jazz musician who is playing a piece of serious music, one of Beethoven's simplest minuets, syncopates it involuntarily and will smile superciliously when asked to follow the normal divisions of the beat. This is the 'nature' which, complicated by the ever-present and extravagant demands of the specific medium, constitutes the new style and is a 'system of non-culture, to which one might even concede a certain "unity of style" if it really made any sense to speak of stylized barbarity'.

The universal imposition of this stylized mode can even go beyond what is quasi-officially sanctioned or forbidden; today a hit song is more readily forgiven for not observing the thirty-two beats or the compass of the ninth than for containing even the most clandestine melodic or harmonic detail which does not conform to the idiom. Whenever Orson Welles offends against the tricks of the trade, he is forgiven because his departures from the norm are regarded as calculated mutations which serve all the more strongly to confirm the validity of the system. The constraint of the technically conditioned idiom which stars and directors have to produce as 'nature' so that the people can appropriate it, extends to such fine nuances that they almost attain the subtlety of the devices of an avant-garde work as against those of truth. The rare capacity minutely to fulfil the obligations of the natural idiom in all branches of the culture industry becomes the criterion of efficiency. What and how they say it must be measurable by everyday language, as in logical positivism. The producers are experts. The idiom demands an astounding productive power, which it absorbs and squanders. In a

diabolical way it has overreached the culturally conservative distinction between genuine and artificial style. A style might be called artificial which is imposed from without on the refractory impulses of a form. But in the culture industry every element of the subject matter has its origin in the same apparatus as that jargon whose stamp it bears. The quarrels in which the artistic experts become involved with sponsor and censor about a lie going beyond the bounds of credibility are evidence not so much of an inner aesthetic tension as of a divergence of interests. The reputation of the specialist, in which a last remnant of objective independence sometimes finds refuge, conflicts with the business politics of the church, or the concern which is manufacturing the cultural commodity. But the thing itself has been essentially objectified and made viable before the established authorities began to argue about it. Even before Zanuck acquired her, St Bernadette was regarded by her latter-day hagiographer as brilliant propaganda for all interested parties. That is what became of the emotions of the character. Hence the style of the culture industry, which no longer has to test itself against any refractory material, is also the negation of style. The reconciliation of the general and particular, of the rule and the specific demands of the subject matter, the achievement of which alone gives essential, meaningful content to style, is futile because there has ceased to be the slightest tension between opposite poles: these concordant extremes are dismally identical; the general can replace the particular, and vice versa.

Nevertheless, this caricature of style does not amount to something beyond the genuine style of the past. In the culture industry the notion of genuine style is seen to be the aesthetic equivalent of domination. Style considered as mere aesthetic regularity is a romantic dream of the past. The unity of style not only of the Christian Middle Ages but of the Renaissance expresses in each case the different structure of social power, and not the obscure experience of the oppressed in which the general was enclosed. The great artists were never those who embodied a wholly flawless and perfect style, but those who used style as a way of hardening themselves against the chaotic expression of suffering, as a negative truth. The style of their works gave what was expressed that force without which life flows away unheard. Those very art forms which are known as classical, such as Mozart's music, contain objective trends which represent something different to the style which they incarnate. As late as Schoenberg and Picasso, the great artists have retained a mistrust of style, and at crucial points have subordinated it to the logic of the matter. What Dadaists and Expressionists called the untruth of style as such triumphs today in the sung jargon of a crooner, in the carefully contrived elegance of a film star, and even in the admirable expertise of a photograph of a peasant's squalid hut. Style represents a promise in every work of art. That which is expressed is subsumed through style into the dominant forms of generality, into the language of music, painting, or words, in the hope that it will be reconciled thus with the idea of true generality. This promise held out by the work of art that it will create truth by lending new shape to the conventional social forms is as necessary as it is hypocritical. It unconditionally posits the real forms of life as it is by suggesting that fulfilment lies in their aesthetic derivatives. To this extent the claim of art is always ideology too. However, only in this confrontation with tradition of which style is the record can art express suffering. That factor in a work of art which enables it to transcend reality certainly cannot

be detached from style; but it does not consist of the harmony actually realized, of any doubtful unity of form and content, within and without, of individual and society; it is to be found in those features in which discrepancy appears: in the necessary failure of the passionate striving for identity. Instead of exposing itself to this failure in which the style of the great work of art has always achieved self-negation, the inferior work has always relied on its similarity with others – on a surrogate identity.

In the culture industry this imitation finally becomes absolute. Having ceased to be anything but style, it reveals the latter's secret: obedience to the social hierarchy. Today aesthetic barbarity completes what has threatened the creations of the spirit since they were gathered together as culture and neutralized. To speak of culture was always contrary to culture. Culture as a common denominator already contains in embryo that schematization and process of cataloguing and classification which bring culture within the sphere of administration. And it is precisely the industrialized, the consequent, subsumption which entirely accords with this notion of culture. By subordinating in the same way and to the same end all areas of intellectual creation, by occupying men's senses from the time they leave the factory in the evening to the time they clock in again the next morning with matter that bears the impress of the labour process they themselves have to sustain throughout the day, this subsumption mockingly satisfies the concept of a unified culture which the philosophers of personality contrasted with mass culture.

The culture industry perpetually cheats its consumers of what it perpetually promises. The promissory note which, with its plots and staging, it draws on pleasure is endlessly prolonged; the promise, which is actually all the spectacle consists of, is illusory: all it actually confirms is that the real point will never be reached, that the diner must be satisfied with the menu. In front of the appetite stimulated by all those brilliant names and images there is finally set no more than a commendation of the depressing everyday world it sought to escape. Of course works of art were not sexual exhibitions either. However, by representing deprivation as negative, they retracted, as it were, the prostitution of the impulse and rescued by mediation what was denied. The secret of aesthetic sublimation is its representation of fulfilment as a broken promise. The culture industry does not sublimate; it represses. By repeatedly exposing the objects of desire, breasts in a clinging sweater or the naked torso of the athletic hero, it only stimulates the unsublimated forepleasure which habitual deprivation has long since reduced to a masochistic semblance. There is no erotic situation which, while insinuating and exciting, does not fail to indicate unmistakably that things can never go that far. The Hays Office [the film censor of the time] merely confirms the ritual of Tantalus that the culture industry has established anyway. Works of art are ascetic and unashamed; the culture industry is pornographic and prudish. Love is downgraded to romance. And, after the descent, much is permitted; even licence as a marketable speciality has its quota bearing the trade description 'daring'. The mass production of the sexual automatically achieves its repression. Because of his ubiquity, the film star with whom one is meant to fall in love is from the outset a copy of himself. Every tenor voice comes to sound like a Caruso record, and the 'natural' faces of Texas girls are like the successful models by whom Hollywood has typecast them. The mechanical reproduction of beauty, which reactionary cultural

fanaticism wholeheartedly serves in its methodical idolization of individuality, leaves no room for that unconscious idolatry which was once essential to beauty. The triumph over beauty is celebrated by humour – the *Schadenfreude* that every successful deprivation calls forth. There is laughter because there is nothing to laugh at. Laughter, whether conciliatory or terrible, always occurs when some fear passes. It indicates liberation either from physical danger or from the grip of logic. Conciliatory laughter is heard as the echo of an escape from power; the wrong kind overcomes fear by capitulating to the forces which are to be feared. It is the echo of power as something inescapable. Fun is a medicinal bath. The pleasure industry never fails to prescribe it. It makes laughter the instrument of the fraud practised on happiness. Moments of happiness are without laughter; only operettas and films portray sex to the accompaniment of resounding laughter. But Baudelaire is as devoid of humour as Hölderlin. In the false society laughter is a disease which has attacked happiness and is drawing it into its worthless totality. To laugh at something is always to deride it, and the life which, according to Bergson, in laughter breaks through the barrier, is actually an invading barbaric life, self-assertion prepared to parade its liberation from any scruple when the social occasion arises. Such a laughing audience is a parody of humanity. Its members are monads, all dedicated to the pleasure of being ready for anything at the expense of everyone else. Their harmony is a caricature of solidarity. What is fiendish about this false laughter is that it is a compelling parody of the best, which is conciliatory. Delight is austere: *res severa verum gaudium*. The monastic theory that not asceticism but the sexual act denotes the renunciation of attainable bliss receives negative confirmation in the gravity of the lover who with foreboding commits his life to the fleeting moment. In the culture industry, jovial denial takes the place of the pain found in ecstasy and in asceticism. The supreme law is that they shall not satisfy their desires at any price; they must laugh and be content with laughter. In every product of the culture industry, the permanent denial imposed by civilization is once again unmistakably demonstrated and inflicted on its victims. To offer and to deprive them of something is one and the same. This is what happens in erotic films. Precisely because it must never take place, everything centres upon copulation. In films it is more strictly forbidden for an illegitimate relationship to be admitted without the parties being punished than for a millionaire's future son-in-law to be active in the labour movement. In contrast to the liberal era, industrialized as well as popular culture may wax indignant at capitalism, but it cannot renounce the threat of castration. This is fundamental. It outlasts the organized acceptance of the uniformed seen in the films which are produced to that end, and in reality. What is decisive today is no longer puritanism, although it still asserts itself in the form of women's organizations, but the necessity inherent in the system not to leave the customer alone, not for a moment to allow him any suspicion that resistance is possible. The principle dictates that he should be shown all his needs as capable of fulfilment, but that those needs should be so predetermined that he feels himself to be the eternal consumer, the object of the culture industry. Not only does it make him believe that the deception it practises is satisfaction, but it goes further and implies that, whatever the state of affairs, he must put up with what is offered. The escape from everyday drudgery which the whole culture industry promises may be compared to the daughter's abduction in the cartoon:

the father is holding the ladder in the dark. The paradise offered by the culture industry is the same old drudgery. Both escape and elopement are predesigned to lead back to the starting point. Pleasure promotes the resignation which it ought to help to forget.

Amusement, if released from every restraint, would not only be the antithesis of art but its extreme role. The Mark Twain absurdity with which the American culture industry flirts at times might be a corrective of art. The more seriously the latter regards the incompatibility with life, the more it resembles the seriousness of life, its antithesis; the more effort it devotes to developing wholly from its own formal law, the more effort it demands from the intelligence to neutralize its burden. In some revue films, and especially in the grotesque and the funnies, the possibility of this negation does glimmer for a few moments. But of course it cannot happen. Pure amusement in its consequence, relaxed self-surrender to all kinds of associations and happy nonsense, is cut short by the amusement on the market: instead, it is interrupted by a surrogate overall meaning which the culture industry insists on giving to its products, and yet misuses as a mere pretext for bringing in the stars. Biographies and other simple stories patch the fragments of nonsense into an idiotic plot. We do not have the cap and bells of the jester but the bunch of keys of capitalist reason, which even screens the pleasure of achieving success. Every kiss in the revue film has to contribute to the career of the boxer, or some hit song expert or other whose rise to fame is being glorified. The deception is not that the culture industry supplies amusement but that it ruins the fun by allowing business considerations to involve it in the ideological clichés of a culture in the process of self-liquidation. Ethics and taste cut short unrestrained amusement as 'naïve' – naïveté is thought to be as bad as intellectualism – and even restrict technical possibilities. The culture industry is corrupt; not because it is a sinful Babylon but because it is a cathedral dedicated to elevated pleasure. On all levels, from Hemingway to Emil Ludwig, from Mrs Miniver to the Lone Ranger, from Toscanini to Guy Lombardo, there is untruth in the intellectual content taken ready-made from art and science. The culture industry does retain a trace of something better in those features which bring it close to the circus, in the self-justifying and nonsensical skill of riders, acrobats and clowns, in the 'defence and justification of physical as against intellectual art'. But the refuges of a mindless artistry which represent what is human as opposed to the social mechanism are being relentlessly hunted down by a schematic reason which compels everything to prove its significance and effect. The consequence is that the nonsensical at the bottom disappears as utterly as the sense in works of art at the top.

In the culture industry the individual is an illusion not merely because of the standardization of the means of production. He is tolerated only so long as his complete identification with the generality is unquestioned. Pseudo individuality is rife: from the standardized jazz improvization to the exceptional film star whose hair curls over her eye to demonstrate her originality. What is individual is no more than the generality's power to stamp the accidental detail so firmly that it is accepted as such. The defiant reserve or elegant appearance of the individual on show is mass-produced like Yale locks, whose only difference can be measured in fractions of millimetres. The peculiarity of the self is a monopoly commodity determined

by society; it is falsely represented as natural. It is no more than the moustache, the French accent, the deep voice of the woman of the world, the Lubitsch touch: finger prints on identity cards which are otherwise exactly the same, and into which the lives and faces of every single person are transformed by the power of the generality. Pseudo-individuality is the prerequisite for comprehending tragedy and removing its poison: only because individuals have ceased to be themselves and are now merely centres where the general tendencies meet, is it possible to receive them again, whole and entire, into the generality. In this way mass culture discloses the fictitious character of the 'individual' in the bourgeois era, and is merely unjust in boasting on account of this dreary harmony of general and particular. The principle of individuality was always full of contradiction. Individuation has never really been achieved. Self-preservation in the shape of class has kept everyone at the stage of a mere species being. Every bourgeois characteristic, in spite of its deviation and indeed because of it, expressed the same thing: the harshness of the competitive society. The individual who supported society bore its disfiguring mark; seemingly free, he was actually the product of its economic and social apparatus. Power based itself on the prevailing conditions of power when it sought the approval of persons affected by it. As it progressed, bourgeois society did also develop the individual. Against the will of its leaders, technology has changed human beings from children into persons. However, every advance in individuation of this kind took place at the expense of the individuality in whose name it occurred, so that nothing was left but the resolve to pursue one's own particular purpose. The bourgeois whose existence is split into a business and a private life, whose private life is split into keeping up his public image and intimacy, whose intimacy is split into the surly partnership of marriage and the bitter comfort of being quite alone, at odds with himself and everybody else, is already virtually a Nazi, replete both with enthusiasm and abuse; or a modern city-dweller who can now imagine friendship only as a 'social contact': that is, as being in social contact with others with whom he has no inward contact. The only reason why the culture industry can deal so successfully with individuality is that the latter has always reproduced the fragility of society. On the faces of private individuals and movie heroes put together according to the patterns on magazine covers vanishes a pretence in which no one now believes; the popularity of the hero models comes partly from a secret satisfaction that the effort to achieve individuation has at last been replaced by the effort to imitate, which is admittedly more breathless. It is idle to hope that this self-contradictory, disintegrating 'person' will not last for generations, that the system must collapse because of such a psychological split, or that the deceitful substitution of the stereotype for the individual will of itself become unbearable for mankind. Since Shakespeare's *Hamlet*, the unity of the personality has been seen through as a pretence. Synthetically produced physiognomies show that the people of today have already forgotten that there was ever a notion of what human life was. For centuries society has been preparing for Victor Mature and Mickey Rooney. By destroying they come to fulfil.

Roland Barthes

DOMINICI, OR THE TRIUMPH OF LITERATURE

EDITOR'S INTRODUCTION

THIS ESSAY, WHICH ORIGINALLY appeared as a column in a newspaper, was first published in book form in *Mythologies* in 1957.

Mythologies has been such an important book because it begins to examine, concretely, how ideology works. It is the founding text of practical ideology-critique. And "Dominici, or the triumph of literature" is especially interesting because it points forward to a later-period Barthes, for whom the concept of "mythology" would be replaced by that of discourse (see Barthes 1977). Here Barthes shows that "literature" is not separate from everyday life and its power-flows. On the contrary, he analyzes a case in which an inarticulate rural laborer is condemned in terms of a discourse which is profoundly literary: the judges describe Dominici's motives in terms borrowed from literary clichés; they gain their sense of superiority because they speak "better" French than he – where "better" means more like written prose. And, in reporting the trial, the journalists turn it into more literature – where "literature" does not just mean the literary canon but the conventional system of writing and representation in which the canon remains uncontested.

Although the essay does not use the term, this remains a classic account of how hegemony is produced through interactions between various institutions and discourses – in this case, literature, the law, and journalism – over the body of those who can hardly talk back. In a later overview of his journalistic columns, published at the end of *Mythologies*, Barthes theorized the mode of analysis he had used. He argues that the way discourse (or "mythology") is circulated through society makes a particular representation of the world seem natural and universal, so that an outside to it cannot be imagined except as "unnatural," "perverse," "exotic," "abnormal," "stupid," and so on. This analysis is finally of a piece with

Adorno and Horkheimer's line of thought, though, in his description of the Citroën also published in *Mythologies*, the young Barthes expressed his belief that mass-produced commodities can be beautiful. One cannot imagine Theodor Adorno, in particular, conceding that.

Further reading: Barthes 1972, 1977; Belsey 1980; Bennett and Woollacott 1988; Ray 1984; Williamson 1978.

The whole Dominici trial[1] was enacted according to a certain idea of psychology, which happens to be, as luck would have it, that of the Literature of the bourgeois Establishment. Since material evidence was uncertain or contradictory, one had to resort to evidence of a mental kind; and where could one find it, except in the very mentality of the accusers? The motives and sequence of actions were therefore reconstituted off-hand but without a shadow of a doubt; in the manner of those archaeologists who go and gather old stones all over the excavation site and with their cement, modern as it is, erect a delicate wayside altar of Sesostris, or else, who reconstitute a religion which has been dead for two thousand years by drawing on the ancient fund of universal wisdom, which is in fact nothing but their own brand of wisdom, elaborated in the schools of the Third Republic.

The same applies to the 'psychology' of old Dominici. Is it really his? No one knows. But one can be sure that it is indeed that of the Presiding Judge of the Assizes or the Public Prosecutor. Do these two mentalities, that of the old peasant from the Alps and that of the judiciary, function in the same way? Nothing is less likely. And yet it is in the name of a 'universal' psychology that old Dominici has been condemned: descending from the charming empyrean of bourgeois novels and essentialist psychology, Literature has just condemned a man to the guillotine. Listen to the Public Prosecutor:

> Sir Jack Drummond, I told you, was afraid. But he knows that in the end the best way to defend oneself is to attack. So he throws himself on this fierce-looking man and takes the old man by the throat. Not a word is spoken. But to Gaston Dominici, the simple fact that someone should want to hold him down by both shoulders is unthinkable. It was physically impossible for him to bear this strength which was suddenly pitted against him.

This is credible like the temple of Sesostris, like the Literature of M. Genevoix. Only, to base archaeology or the novel on a 'Why not?' does not harm anybody. But Justice? Periodically, some trial, and not necessarily fictitious like the one in Camus's *The Outsider*, comes to remind you that the Law is always prepared to lend you a spare brain in order to condemn you without remorse, and that, like Corneille, it depicts you as you should be, and not as you are.

This official visit of Justice to the world of the accused is made possible thanks to an intermediate myth which is always used abundantly by all official institutions, whether they are the Assizes or the periodicals of literary sects: the transparence and universality of language. The Presiding Judge of the Assizes, who reads *Le Figaro*,

has obviously no scruples in exchanging words with the old 'uneducated' goatherd. Do they not have in common the same language, and the clearest there is, French? O wonderful self-assurance of classical education, in which shepherds, without embarrassment, converse with judges! But here again, behind the prestigious (and grotesque) morality of Latin translations and essays in French, what is at stake is the head of a man.

And yet the disparity of both languages, their impenetrability to each other, have been stressed by a few journalists, and Giono has given numerous examples of this in his accounts of the trial. Their remarks show that there is no need to imagine mysterious barriers, Kafka-like misunderstandings. No: syntax, vocabulary, most of the elementary, analytical materials of language grope blindly without ever touching, but no one has any qualms about it (*'Êtes-vous allé au pont? – Allée? il n'y a pas d'allée, je le sais, j'y suis été'*).[2] Naturally, everyone pretends to believe that it is the official language which is common sense, that of Dominici being only one of its ethnological varieties, picturesque in its poverty. And yet, this language of the president is just as peculiar, laden as it is with unreal clichés; it is a language for school essays, not for a concrete psychology (but perhaps it is unavoidable for most men, alas, to have the psychology of the language which they have been taught). These are in actual fact two particular uses of language which confront each other. But one of them has honours, law and force on its side.

And this 'universal' language comes just at the right time to lend a new strength to the psychology of the masters: it allows it always to take other men as objects, to describe and condemn at one stroke. It is an adjectival psychology, it knows only how to endow its victims with epithets, it is ignorant of everything about the actions themselves, save the guilty category into which they are forcibly made to fit. These categories are none other than those of classical comedy or treatises of graphology: boastful, irascible, selfish, cunning, lecherous, harsh, man exists in their eyes only through the 'character traits' which label him for society as the object of a more or less easy absorption, the subject of a more or less respectful submission. Utilitarian, taking no account of any state of consciousness, this psychology has nevertheless the pretension of giving as a basis for actions a pre-existing inner person, it postulates 'the soul': it judges man as a 'conscience' without being embarrassed by having previously described him as an object.

Now that particular psychology, in the name of which you can very well today have your head cut off, comes straight from our traditional literature, that which one calls in bourgeois-style literature of the Human Document. It is in the name of the human document that the old Dominici has been condemned. Justice and literature have made an alliance, they have exchanged their old techniques, thus revealing their basic identity, and compromising each other barefacedly. Behind the judges, in curule chairs, the writers (Giono, Salacrou). And on the prosecution side, do we see a lawyer? No, an 'extraordinary story-teller', gifted with 'undeniable wit' and a 'dazzling verve' (to quote the shocking testimonial granted to the Public Prosecutor by *Le Monde*). Even the police are here seen practising fine writing:

Police Superintendent: 'Never have I met such a dissembling liar, such a wary gambler, such a witty narrator, such a wily trickster, such a lusty

septuagenarian, such a self-assured despot, such a devious schemer, such a cunning hypocrite . . . Gaston Dominici is an astonishing quick-change artist playing with human souls, and animal thoughts . . . This false patriarch of the Grand' Terre has not just a few facets, he has a hundred!'

Antithesis, metaphors, flights of oratory, it is the whole of classical rhetoric which accuses the old shepherd here. Justice took the mask of Realist literature, of the country tale, while Literature itself came to the court-room to gather new 'human' documents, and naively to seek from the face of the accused and the suspects the reflection of a psychology which, however, it had been the first to impose on them by the arm of the law.

Only, confronting the literature of repletion (which is always passed off as the literature of the 'real' and the 'human'), there is a literature of poignancy; the Dominici trial has also been this type of literature. There have not been here only writers hungering for reality and brilliant narrators whose 'dazzling' verve carries off a man's head; whatever the degree of guilt of the accused, there was also the spectacle of a terror which threatens us all, that of being judged by a power which wants to hear only the language it lends us. We are all potential Dominicis, not as murderers but as accused, deprived of language, or worse, rigged out in that of our accusers, humiliated and condemned by it. To rob a man of his language in the very name of language: this is the first step in all legal murders.

Notes

1 Gaston Dominici, the eighty-year-old owner of the Grand'Terre farm in Provence, was convicted in 1952 of murdering Sir Jack Drummond, his wife and his daughter, whom he found camping near his land.
2 'Did you go to the bridge? – A path? There is no path, I know, I've been there!' *Allé* = 'gone', *allée* = a path, but Dominici uses *été*, 'been'.

Carolyn Steedman

CULTURE, CULTURAL STUDIES
AND THE HISTORIANS

EDITOR'S INTRODUCTION

IN THIS PAPER, first delivered at the 1991 Illinois conference which helped to trigger the US cultural studies boom, Carolyn Steedman, speaking as historian, poses a series of crucial questions. How historical is cultural studies? If it is historical, what historical methods will it use? Can it take account not just of texts (that is, writing, like novels, deemed to "represent" external, historical reality) but of documents (archival material, constitutive of history)? Does the turn to culture and cultural history as against political, economic, social history iron out the past by erasing important material transformations? Is cultural studies' rather reductive narrativization of its own past a sign that the discipline is historically crippled — more interested in consciousness-raising than in truth-telling?

While Steedman does not claim fully to answer these questions, her sympathies are clear. Cultural studies requires a historical sense — this it inherits from its Marxian legacy. And, for Steedman, history is to be encountered in the archives not just in texts. It is in the archives that abstracted narratives, like those provided by Raymond Williams, can be tested and contested so that, to take the instance that Steedman gives, Williamsesque stories about the formation of modern culture can be rewritten in ways that acknowledge the centrality of women and children. And (though this is not a point she makes) it is in the archives that alternatives to history as presented in the increasingly powerful heritage or "public memory" industries can be uncovered.

But the big question remains unanswered. How today does the past engage the present? Cultural studies is not a nostalgic, heritage-orientated discipline — not concerned to maintain old ways and traditions or to shore up inherited identities, or to succumb to the fascination of the antiquarian, or even to follow the path of

"new historicism" which has dominated literary history over the past decade. It's a discipline determined to remain active in, and sensitive to, the cultural flows and ruptures of the contemporary world system. So what has history, and especially scholarly history, to do with it? As Steedman reminds us, at the very least the answer is not "nothing."

Further reading: Abu-Lughod 1989; Chakrabarty 1994; Denning 1997; During 1996; K. Jenkins 1997; Ohmann 1991; Pickering 1997; Prendegast 1995; Steinberg 1996a.

This paper is about the idea of 'culture' itself; about cultural studies in Britain now, and in the recent past; and about the connection of both of these to the practice and writing of history. The account I give (the story I tell) will be partly institutional in focus, to do with forms of school-based and higher education in Britain since the last war; and it will also be text-based. Here, I follow a historio-graphical tradition laid down by British cultural studies itself: histories of cultural studies, written by its practitioners, usually organize themselves in a particular way, rendering up *their* own account in terms of the books – always three key-texts: Richard Hoggart's *The Uses of Literacy* (1957); Raymond Williams's *Culture and Society* (1958) and E. P. Thompson's *The Making of the English Working Class* (1963).

To make this observation is to use the most compelling device in the historian's rhetorical repertoire: the historian can always, in this manner, present a plot that seemingly *had* to be shaped in a particular way, according to what the documents used for its composition authorized, or what they forbade: can always present herself as the invisible servant of her material, merely uncovering what already lies there, waiting to be told. It is as well that readers are alerted to the fact that the historian is able in this way to appropriate to herself the most massive authority as a narrator. And of course, I have not innocently followed these histories of British cultural studies along their textual path; rather, have chosen to do so, so that I am enabled to say something about text-based studies of history, within cultural studies, and without; and about the text as a historical reality, not simply a representation of an alterior reality, but also constituting a reality, in and of itself.

As I complete this prolegomenon, I should make two other points. First, I *am* one of those whom the definite article in my title so rudely excludes, one of them 'the historians'; and as one of them I know that there is nothing deader and colder than old history. We can read Gibbon, or Thierry, or Michelet for the elegance of their prose, in order to observe their rhetorical structures of explanation and persuasion, in order perhaps, to see in Gibbon's work the very mark of that late eighteenth-century historical purpose: philosophy teaching by example; or in Michelet, watch the Romantic historian insert himself in the text in order to convey that great distance that separates the living from the dead. But we cannot read any of it as we read the new secondary source published last week, as an account that informs about its overt subject matter. The life of the written history is not very

long; the written history is the most unstable of written forms. The historical component of the trinity of texts that formed British cultural studies – *The Making of the English Working Class* – is in its transitional stage now, between being a quarry of information about class formation, the actual meeting of actual men under cover of darkness on moors six miles beyond Huddersfield, and the language they used in consciousness of their making a new political world – to being (among all these other things, which it still, of course, remains) an epic telling of a history that we watch with wonder and pity, that is also now, in our reading, about *us*, and our lost past. Too much has happened for this to operate as a simple historical source; there are too many new items of information – about what women were doing, at that moment, back in Huddersfield, about all the men who were not present at their own class formation, all those who did not especially want it to happen; about recent events in Eastern Europe; about all our lost socialisms.

This is to say that history is the most impermanent of written forms: it is only ever an account that will last a while. The very practice of historical work, the uncovering of new facts, the endless reordering of the immense detail that makes the historian's map of the past, performs this act of narrative destabilization, on a daily basis. The written history does, of course, reach narrative closure all the time, for manuscripts have to be delivered to publishers and papers given; but that is only its formal closure. Soon, the written history rejoins – has to rejoin – the insistent, tireless, repetitive beat of a cognitive form that has no end. The written history is a story that can be told only by the implicit understanding that *things are not over*, that the story isn't finished, can never be finished, for some new item of information may alter the account that has been given. In this way, history breaks the most ordinary and accepted narrative rule, and in this way also, the written history is not just *about* time, doesn't just *describe* time, or take *time as its setting*; rather, it embeds time in its narrative structure. And it really doesn't matter how much historians may know this, or not know this; know or do not know that at the center of the written history is the invitation to acknowledge its temporariness and impermanence. It may matter, however, when text-based historical knowledge is removed from the narrative and cognitive frame of historical practice, and used within another field.

It has been observed before what can happen to the written history in these circumstances: it loses its impermanence (and the potential irony that derives from its impermanence). The historical item (the bit of written history) taken out of its narrative setting in order to explain something else (an event, a development, a structure) is stabilized, made a building block for a different structure of explanation. This has been observed, for the main part, in the use of the written history within sociological explanation. It is probably the case that within British cultural studies, formed and shaped within undergraduate degrees in polytechnics and universities (and dramatically historical as a pedagogy in comparison with cultural studies in the US, as far as I can tell), that history meets the same fate as it has within sociology.

That was the prolegomenon. Now I shall proceed for a few minutes by way of illustrative anecdote: I spent a strange year, this last academic year. In the hours of gloomy reflection accompanying the reading I did for this conference, it occurred to me that I passed it doing nothing more than producing long, elaborate,

historical footnotes to Raymond Williams's accounts of 'culture' in his *Culture and Society*, *Keywords*, and *Marxism and Literature*. I published a book, which is a description of the use and development of nineteenth-century cultural theory within British socialism, and the reorganization of its key components around the figure of the child and the idea of childhood, in the period 1890–1920. I was thus able at the end of the book, and with some satisfaction, to suggest that Williams's radical philology is missing something: that an explosion of growth studies from the middle years of the century and a consequent theorization of those social subjects – children – who demonstrate growth (who *embody* growth), within many forms of writing (from the novel to neurological physiology), may align a late nineteenth-century understanding of 'culture' with an older one, with that earlier meaning that Williams outlines in *Keywords* (1983), of the actual material improvement and cultivation of bodies and minds in society. There are those blank pages at the end of the 1983 edition of *Keywords*, the sign, as Williams wrote, 'that the inquiry remains open'; but my notes of contribution are three hundred pages long . . . (In order, as a good Freudian, to deal with my very deep anxieties about what I might *really* be up to, I tell a joke to myself about this obsessive footnoting of Williams: I have invented an all-girl backing group of the very early 1960s: the Rayettes, who accompany Raymond's now disembodied voice . . .). My other footnote to Williams's work of the academic year 1989–90 was planning, with a colleague, a new undergraduate option course at the University of Warwick, where I teach. The course is called 'Learning Culture', and takes as its central preoccupations first, a history of subjectivity (a history of the kinds of subjectivity that people have felt obliged to construct for themselves over the last three hundred years or so); and, second, the connection of subjectivity to the idea of culture; and, third, the organization of both of these around women, particularly, in a wide variety of texts, around the figure of the teacher. Again and again, we have returned to those passages in *Marxism and Literature* (1977), where Williams describes, first, 'the notion of "civilising"', as bringing men within a social organisation, then the way in which the aim of 'civilisation' was expressed in the adjective '"civil," as orderly, educated, or polite.' We have returned to the pages that tell how '"civilisation" and "culture" . . . were . . . in the late eighteenth century, interchangable terms', how their eventual divergence came through the attack on 'civilisation' as superficial, on all things 'artificial' as distinct from those in a 'natural' state.

We have returned the students to those texts (which Williams does not mention) in which the ideas he works with were actually carved out: to Locke's *Thoughts Concerning Education*, and his *Two Treatises on Government*, to Rousseau's *Emile*, and to other strange hybrids of the eighteenth century which have not achieved their canonical status: to conduct books, household and educational and etiquette manuals, chap-books, folk and fairy tales. We have tried hard to make the students see that the attack on artificiality through into the nineteenth century, was indeed, as Williams claims, 'the basis of one important alternative sense of "culture" – as a process of "inner" or "spiritual" as distinct from "external" development.' We have expressed our astonishment (there is the teaching of response as much as there is of content) at this description of an actual historical process that is inexplicable without some knowledge of this history of women and children in European society,

but that never, ever mentions women and children. 'The primary effect of this alternative sense of the term "culture,"' says Williams, 'was to associate it with religion, art, *the family and personal life*' In those five words, we have said, is occluded a whole history: of women and children in English society, between about 1680 and the middle of this century. But without the history, Williams still manages to say that through these processes, 'culture' came to be related to 'the "inner life" in its most accessible, secular forms; came to be related to "subjectivity," to "the imagination."' At points like these, and because there is simply nothing else to be done at the moment, in our present state of knowledge, we have boldly followed Nancy Armstrong, in asserting out of the pages of her *Desire and Domestic Fiction* that the first bourgeois individual was not 'economic man' but rather 'domestic woman,' and that she – this figure, born of the conduct books, educational manuals and maybe, above all, from Samuel Richardson's pen – was the first to possess a subjectivity: a consciousness of depth and space within, a sensibility, an interiority.

One of my worries about all of this is of course, the edgy but certain knowledge that writing footnotes to Raymond Williams (being a Rayette) is not at all what a girl ought to be doing with her life. A more serious worry is my very strong suspicion that Raymond Williams was probably right. What I mean by the problem of his probably being right is this: in *Marxism and Literature*, in *Keywords*, and in his many other discussions of 'culture,' it is impossible to tell if Williams is giving us an account that has been abstracted away from the history that informs it, or whether it has been constructed in some other manner. I can put the problem in another way: it is quite possible (indeed, I have spent since October 1989 doing this) to insert (re-insert?) the history – *Some Thoughts Concerning Education*, its authorship, its readership, a sociology of the gendered reader of the first half of the eighteenth century, a history of the family and childcare, the many imitations of Locke, the startling appearance of this particular text of Locke in the very last part of Richardson's *Pamela* – to put all of this and more into Williams's account, and still end up with the same one. I can turn the problem around, talk in the future tense, and say that in the same way, it is quite possible to draw up a program of reading and archive research that will track down the historicized subjectivity, locate it first in the feminine; then move on, see Freud at the end of the last century, as one of the first to theorize human inwardness, interiority: the lost past within each one of us – which he did by using the many nineteenth-century rewritings of the child-figure that were available to him from sources as diverse as neurological physiology and realist fiction: to see Freud writing a theory of history in his account of repression and childhood sexuality. It would (it will) take some years to do the historical work (and I have to do it, otherwise I will not, in my terms, know it) but it will then still be possible to extract from the detail that will have been amassed the schema that Williams published in 1977, in *Marxism and Literature*, and probably in the same words (though I think that by 1995 the words 'woman' and 'child' will be there too; and so, I guess, the account might be most profoundly changed).

Patient friends and colleagues to whom I have confessed this worry have not been able to understand what I'm bothering my head about; or have told me that there is anyway 'the connectedness of everything' to explain Williams's rightness: that because everything is joined up to everything else, it really does not signify

that Raymond Williams may never have read *Some Thoughts Concerning Education*, because the ideas it contains (which are expressed in schematic form in his accounts of culture) would be available from the very historical air he breathed, the moment he set to write about the late seventeenth century (and this holds even though he might not have known he was writing about the late seventeenth century).

On the question of the connectedness of everything, I have brooded a lot on the 1990 issue of *New Literary History* where Carolyn Porter writes about what might happen 'After the New Historicism.' In order to expose the underlying *formalism* of a critical practice that purports to be *historical*, she comments on the tendency of the new historicists to deploy 'riveting anecdotes' in their explorations of texts and contexts. This anecdotal technique, she claims, reflects a principle of arbitrary connectedness, by which it is assumed that any one aspect of a society is related to any other. This is what Dominick LaCapra (1985), in different manner, and being rude about social historians rather than literary historicists, has called their trance-like reliance on the concept of culture in their work, where everything connects to everything else and 'culture' is the primordial reality in which all historical actors have their being, do their thing, share discourses, world-views, 'languages' where everyone (I repeat the joke because I enjoy it so much) 'is a mentalité case'; and where it is not possible to write the exception: to write about the thing, event, relationship, entity, that does not connect with anything else.

The social historian's reliance on the notion of 'culture' as the bottom line, the real historical reality, has, of course its own (rather short) history, and can be seen in the academy's elevation of nineteenth-century historians like Burkhardt and de Tocqueville to canonical status in the post-Second-World-War period. What Burkhardt's history did was to put together the disparate and fragmented elements of social life under the heading of cultural coherence. I know from experience that his work provided the first alluring figure of cultural totality in many undergraduate history courses of the early 1960s in Britain; and Carl Schorske, writing in the same issue of *NLH* as Carolyn Porter, tells me that this attention to nineteenth-century texts of cultural history started earlier here, in the US of the 1950s. He says of Burkhardt's and de Tocqueville's writing, that 'time did not stop' in it, 'but it was . . . slowed down. Not transformation but cultural coherence became the focus of attention.' For LaCapra this particular concept of 'culture' – 'the culture concept' – shatters chronology and dissolves the very ordinance of time.

Cultural studies in Britain has intersected with these questions of culture, the culture concept, history, and time. I want to consider some of these intersections now, intersections that actually reveal (in a historical sense) a more general social and institutional shaping of history and historical knowledge in Britain over the last thirty years. The following account shows British cultural studies shaped by teachers and taught, by their particular educational histories and their purchase on different forms of historical knowledge, quite as much as a shaping by theoretical questions. I shall start where I started before, by considering cultural studies' writing of its own history.

Cultural studies in Britain is extremely nervous of what Richard Johnson (1987: 38) has called 'codification of methods of knowledges', and of attempts at institutionalization. Alan O'Connor (1989) in his interpretation of the British field

for academics in the United States, calls it a practice, a cultural form, an intel-
lectual tradition (never, ever, a discipline). Tony Dunn (1986) starts out by refusing
any position for cultural studies at all, by celebrating its polymorphic perversity:
'Cultural studies,' he wrote, 'is a whirling and quiescent and swaying mobile which
continuously repositions any participating subject. Cultural studies is a project
whose realization – absolute integrity through fragmentation and disassembly – is
forever deferred' (Dunn 1986: 71). They all *start* like that, but within a few para-
graphs are well into that most conventional claim for disciplinary orthodoxy – the
writing of their own history. (What they are also doing, the historiographically
informed observer notes, is defining themselves, finding themselves, through an
act of consciousness-raising: telling their own story, reaping all the social and
psychic benefits of autobiography and oral history.)

The story goes like this: sprung from native texts, the account of its evolu-
tion propelled by key theoretical moments (the existence of the Communist Party
Historians Group, from 1946 to 1956; Perry Anderson's editorship of *New Left
Review* from 1962 onwards), institutionally established at the Centre for Contem-
porary Cultural Studies in Birmingham, cultural studies is 'interrupted by the
arrival on the intellectual scene of the "structuralisms"'. This historical account of
the early period, and of later accommodations made to continental theory, is avail-
able from many secondary sources, and I do not intend to rehearse it for you here.
I want instead to explore some of the history that is missing from the account so
far, by making some observations about forms of teaching and learning that have
been embodied in the cultural studies degrees institutionalized at British poly-
technics (to a far lesser extent, at British universities), and about the connection
of this educational practice in higher education with 'the culture concept' in schools.
I suspect that 'the culture concept' in England has much to do with the organi-
zation of historical knowledge for young children and adolescents in the British
school system, at least since the 1950s; and I want to suggest too, that organiza-
tion of historical knowledge in British cultural studies has been about questions of
education, a question of accommodation to constituencies of learners and the allure
of certain models of teacher–student relationship that higher education saw oper-
ating in the schools, in the 1970s. Moreover, the teaching force in cultural studies
has had its own relationship to historical knowledge orientated by the economics
of a historical education, and by the cost of historical research.

I want to deal with the schools, but I shan't start there. Rather, I shall begin
at the other end, with the practice of history in university-based cultural studies
– on the MA program at Birmingham – from the late 1960s onwards. When Alan
O'Connor (1989) tells North American audiences that 'the characteristic cultural
form of cultural studies is a certain kind of collectively produced book', and that
'the best examples of English cultural studies are all of this kind', he is describing
work done at the Birmingham Centre, and work that was, at least on a reading of
the texts produced out of it and various descriptions of their production available,
inimical to the conventional practices of historical research. The Centre's Popular
Memory Group, on its own account, spent a good deal of time wrestling with his-
tory's empiricism and resistance to 'Theory'. What the historian must do with this
account, in the historian's prosaic and deflationary way, is point out that the educa-
tional form within which they did their wrestling is actually inimical to conventional

historical practice, particularly to the processes of archive research. Group practice is collective; archive research involves the lone historian, taking part in an undemocratic practice. Archive research is expensive, of time and of money, and not something that a group of people can do practically, anyway. Within this educational form, it is not surprising to find historical work at the Centre based on the analysis of text. The *kind* of text generally used (government documents and fictions) does deserve some comment, as do the structuralist models of reading that were a major influence on their analysis. The use of structuralist linguistics, and the notion of 'discourse' itself (which had among its enticements a ready critique of empiricism) dictated a particular choice of texts for the purposes of historical analysis.

Government reports, printed and widely distributed in the nineteenth century, are the most readily available of British historical documents; fictions (prose fictions) from the past get put on reading lists everywhere because they are available in mass-produced paperbacks; and every person growing up literate in twentieth-century Britain has massive experience of reading continuous fictional prose, brings to it a most sophisticated (though unarticulated) repertoire of reading techniques. These are good (and necessary) reasons for concentrating on these particular kinds of texts; but if there really is no 'connectedness of everything' (if there were this connectedness, then the Report of a Commission of Inquiry would give access to the same primordial whole of reality as a cookery book, and one bit of writing does as well as another) then a textual reading of the nineteenth century that omits other forms of writing (poetry, for instance, and an understanding of the meaning of different poetic forms to different audiences) is going to produce a very odd account. The model of language available in these textual approaches was, as well, quite inadequate to the task in hand, first, making no distinction between spoken and written language; and second, having no recognition of language as a form of cognition and a process of development that is actively acquired by human beings in a social and psychological process; and, third, also being without a range of strategies for analyzing the literary form as a negotiated form, wrought, used, written, read, abandoned within specific societies. (All of this must be seen as a pointer to future and necessary work, rather than as a digression.) The structuralist model of language was quite inadequate for the historical task it was set. History's most urgent need is indeed, for an adequate model of both spoken and written language; and whether this model is developed within historical studies, or by students of cultural studies working on the past, does not seem to me to matter half as much as the fact that it might be done.

There are many accounts of curriculum change in systems of national education by which to interpret the particular use of texts and choice of methodology that I have been discussing. In Britain, the establishment of English literature as the foundation of a national system of education between 1880 and 1920 was also the getting of education on the cheap, for each child already had his or her own resource in the possession of the English language, and a long and expensive linguistic training of teachers was unnecessary (Baldick 1983; Doyle 1989). Practical criticism in the universities in Britain after 1930 (for which each undergraduate had a resource in his own sensibility) and New Criticism in the US – its capacity, in Porter's words, 'to provide a pedagogically functional solution to the problems posed by the numbers and kinds of new college students poured into the American

academy by the G. I. Bill after World War Two' (Porter 1990) – are only two recent examples of the reorganization of education in terms of cheapness and practicality, and around accessible texts. A historical education in Britain was never as expensive as a linguistic one, but the patient laying down of a fantastically detailed historical map over the ten years before a student entered higher education at the age of eighteen, demands a teaching force in the schools that is able to do the laying down: the amount of history taught in British society has steadily diminished over the last thirty years – a point to which I shall return in a moment.

The cheapness and practicality of text-based historical inquiry could also be seen as a theoretical propriety. The academy observed the last great flowering of English progressive education in the schools in the 1970s, and in some cases, certainly within cultural studies, tried to take that flowering as its own. This flowering was seen to take place in both the English departments of secondary schools, and in the practice of integrated topic work in many primary schools. The breaking down of barriers between teachers and taught, common involvement in a common project, a text or groups of texts making enquirers of them all – all of this was most movingly described throughout the 1970s, particularly in the journal of the National Association of the Teaching of English, and in the journals *Teaching London Kids*, and *The English Magazine*.

This is to suggest what the influence of pedagogical forms on the organization of historical knowledge in the early days of British cultural studies might have been. I would make suggestions as well, about the practice of history (which could also be called the disappearance of history) in the primary school and in the lower forms of the secondary school as exercising a particular shaping force. Here, I have to rely on government publications (those most easily obtained of historical documents) and the series of reports by Her Majesty's Inspectors of Schools, which chart the virtual disappearance of history as a subject taught to children, its integration into topic and project work, and the abandonment of the cognitive form of the chronology, from the late 1960s onwards. Particular theories of the child-mind and application of Piagetian psychology dictated that children should 'discover' the past through a study of its artefacts (clothes, houses, food) and through their identification and empathy with people living in the past. Was 'the culture concept' as used by historians, and in some of the models for acquiring historical knowledge within cultural studies, actually invented in the schools, between about 1955 and 1975? In Britain, we do not even have a social and cultural history of education that allows us to think that this might be a question.

Recently, the focus of cultural studies has moved from Masters teaching to the undergraduate degree. If the history of history in cultural studies is to be written, it will involve taking account of the institutional setting yet again, the particular alignment of humanities subjects under departmental reorganization in the polytechnics, and the need of historians for students to teach. At the same time, those historians are bound to do less history, as recession (which recession? – all our recessions) imposes constraints of time as well as money on conventional historical practice. Existing history courses and options have fitted into many new cultural studies degrees in the polytechnics, and we need to ask particular questions of them, about the interface of different knowledges, brought together in undergraduate teaching. Super-ordinate to all these reorganizations of pedagogy

and the uses of historical knowledge within a particular society over a span of some thirty years is a paradigm shift observable across all academic culture (and in the commonplace and secular world of which the academy is a part) in the way in which, since the 1950s, 'one discipline after another in the human sciences [has] cut its ties to history, strengthened its autonomy with theory, and produced its meanings without that pervasive historical perspective that in the 19th century had permeated the self-understanding of almost every branch of learning' (Schorske 1990: 416). The discipline of history itself has taken part in this general flight from the historical: in the abandonment of time in favor of 'the culture concept'; or in favor of what Raymond Williams (1983) noted in *Keywords* when he wrote of a specific twentieth-century form of the term 'history' as a tale of 'accidents, unforeseen events, frustration of conscious purpose . . . an argument especially against hope.'

It is in this particular historical moment – to be intensely parochial for a moment – that British cultural studies needs to think about what it will *do* with history, and what kind of historical thinking it will ask its students to perform. It has no choice, I think, but to *have* history, for by my reckoning, very soon more history (historical topics, history options) will be taught to undergraduates taking interdisciplinary degree courses than to those doing history in the conventional manner, in polytechnics and universities. And this will be – strange conjunction – in a dehistoricized intellectual world in which *all* children in the society (including that very small percentage of eighteen-year-olds who enter higher education in the UK) will be taught exactly the same set of historical knowledges, from the age of five to sixteen.

Then, after the parochialism, I was going to be polite, for I wanted to be polite, as a guest of the conference and of cultural studies. It was going to be a politeness that would be, in its turn, a response to the politeness that historians often experience: for there is a common and accommodating reflection that is found in many moments of disciplinary niceness where they will tell you this: that any rigorous theoretical form or mode of enquiry needs a historical perspective, a proper historicity. So, knowing that this would be said, and wanting to be polite, I was going to say something like this:

If British cultural studies really does operate in the 'reflexive and even self-conscious mood' that Richard Johnson claims for it, then it seems to me that it just might, in these times, be able to achieve what history cannot; for the history of a pedagogical practice and educational forms (in Britain at least) puts cultural studies in a position to do its own historiography (to deconstruct itself?) as it goes along.

But I came to understand that I was thinking about a British situation, a situation of enforced cross-disciplinarity, in times of economic hardship for the academy. Instead, after those conference days I would ask – politely – a series of questions: Why does cultural studies *want* history? What does wanting it mean? What new acts of transference will items from the past help cultural studies – or make it – perform? How will it be done? How taught? Will there be any room for detailed historical work; or are students of cultural studies bound to rely on great schematic and secondary sweeps through time? Will there be any room for the historical case study in its pedagogy? What good is it all to you, anyway? Perhaps no good at all . . .

W. H. Auden had a conversation with Clio, sometime in the 1930s, in his 'Homage to Clio'; or rather, not a conversation at all, for the blank-faced girl said nothing back to him. He watched her watch the world's alteration, unique disaster, *longue durée*, everything, all of it, and commented: 'You had nothing to say and did not, one could see / Observe where you were, Muse of the unique / Historical fact.' What all our students will need is an understanding that the texts and documents that they use for historical study are themselves historical facts, not just repositories of facts . . . and that the past that the texts and sources configure is not carved in stone simply because texts and sources go on being used as representatives of a real historical reality. They need to grasp its impermanence even as they read it, and write it. 'Observe where you are,' but that is the historian's instruction to herself, as much as a suggestion made to you.

James Clifford

ON COLLECTING ART
AND CULTURE

EDITOR'S INTRODUCTION

J AMES CLIFFORD'S BRILLIANT ESSAY describes an "art–culture"
system in which art, as something to be possessed and collected by individ-
uals, becomes the pivot around which culture, as a seemingly communal and
transcendental tradition, turns. He analyzes the system using both structural
and historical techniques and comes to the conclusion that it has been crucial to
the formation of "Western subjectivity." For him, however, the system is supris-
ingly open and fluid. Though it transforms sacred and utilitarian objects from
distant cultures into art to be owned and contemplated, it also exoticizes home
cultures. Further, the system allows all kinds of groups to use art for their own
ends: for instance, new kinds of museums are being created by postcolonized peoples
all over the world.

 This is a much more optimistic and vibrant representation of cultural prac-
tices than Adorno's or Barthes's. But it is worth asking: what has happened to
categories like exploitation or even power here? – or, in the particular case of
collecting so-called "tribal artefacts," what about the sacred? After all, the Maori
exhibition Clifford mentions took place only against protests against the exporta-
tion of sacred *taonga* (treasures) to foreign museums. As an essay at the forefront
of contemporary cultural studies it demands more study and debate.

Further Reading: Appadurai 1986; Bourdieu 1993, 1996; Clifford 1988a, 1988b;
Haraway 1984; Karp and Lavine 1991; Michaels 1994.

> There is a Third World in every First World, and vice-versa.
> Trinh T. Minh-ha, 'Difference', *Discourse*, 8

This chapter is composed of four loosely connected parts, each concerned with the fate of tribal artefacts and cultural practices once they are relocated in Western museums, exchange systems, disciplinary archives and discursive traditions. The first part proposes a critical, historical approach to collecting, focusing on subjective, taxonomic, and political processes. It sketches the 'art–culture system' through which in the last century exotic objects have been contextualized and given value in the West. This ideological and institutional system is further explored in the second part, where cultural description is presented as a form of collecting. The 'authenticity' accorded to both human groups and their artistic work is shown to proceed from specific assumptions about temporality, wholeness, and continuity. The third part focuses on a revealing moment in the modern appropriation of non-Western works of 'art' and 'culture', a moment portrayed in several memoirs by Claude Lévi-Strauss of his wartime years in New York. A critical reading makes explicit the redemptive metahistorical narrative these memoirs presuppose. The general art–culture system supported by such a narrative is contested throughout the chapter and particularly in the fourth part, where alternative 'tribal' histories and contexts are suggested.

Collecting Ourselves

Entering
You will find yourself in a climate of nut castanets,
A musical whip
From the Torres Straits, from Mirzapur a sistrum
Called Jumka, 'used by Aboriginal
Tribes to attract small game
On dark nights,' coolie cigarettes
And mask of Saagga, the Devil Doctor,
The eyelids worked by strings.

James Fenton's poem 'The Pitt Rivers Museum, Oxford', from which this stanza is taken, rediscovers a place of fascination in the ethnographic collection. For this visitor even the museum's descriptive labels seem to increase the wonder ('attract small game / On dark nights') and the fear. Fenton is an adult–child exploring territories of danger and desire, for to be a child in this collection ('Please sir, where's the withered / Hand?') is to ignore the serious admonitions about human evolution and cultural diversity posted in the entrance hall. It is to be interested instead by the claw of a condor, the jaw of a dolphin, the hair of a witch, or 'a jay's feather worn as a charm / In Buckinghamshire'. Fenton's ethnographic museum is a world of intimate encounters with inexplicably fascinating objects: personal fetishes. Here collecting is inescapably tied to obsession, to recollection. Visitors 'find the landscape of their childhood marked out / Here in the chaotic piles of souvenirs . . . boxroom of the forgotten or hardly possible'.

Go
As a historian of ideas or a sex-offender,
For the primitive art,
As a dusty semiologist, equipped to unravel
The seven components of that witch's curse
Or the syntax of the mutilated teeth. Go
In groups to giggle at curious finds.
But do not step into the kingdom of your promises
To yourself, like a child entering the forbidden
Woods of his lonely playtime.

Do not step in this tabooed zone 'laid with the snares of privacy and fiction / And the dangerous third wish'. Do not encounter these objects except as *curiosities* to giggle at, *art* to be admired, or *evidence* to be understood scientifically. The tabooed way, followed by Fenton, is a path of too-intimate fantasy, recalling the dreams of the solitary child 'who wrestled with eagles for their feathers' or the fearful vision of a young girl, her turbulent lover seen as a hound with 'strange pretercanine eyes'. This path through the Pitt Rivers Museum ends with what seems to be a scrap of autobiography, the vision of a personal 'forbidden woods' – exotic, desired, savage, and governed by the (paternal) law:

He had known what tortures the savages had prepared
For him there, as he calmly pushed open the gate
And entered the wood near the placard: 'TAKE NOTICE MEN
MEN-TRAPS AND SPRING-GUNS ARE SET ON THESE
PREMISES.'
For his father had protected his good estate.

Fenton's journey into otherness leads to a forbidden area of the self. His intimate way of engaging the exotic collection finds an area of desire, marked off and policed. The law is preoccupied with *property*.

C. B. Macpherson's classic analysis of Western 'possessive individualism' (1962) traces the seventeenth-century emergence of an ideal self as owner: the individual surrounded by accumulated property and goods. The same ideal can hold true for collectivities making and remaking their cultural 'selves'. For example Richard Handler (1985) analyses the making of a Québécois cultural 'patrimoine', drawing on Macpherson to unravel the assumptions and paradoxes involved in 'having a culture', selecting and cherishing an authentic collective 'property'. His analysis suggests that this identity, whether cultural or personal, presupposes acts of collection, gathering up possessions in arbitrary systems of value and meaning. Such systems, always powerful and rule governed, change historically. One cannot escape them. At best, Fenton suggests, one can transgress ('poach' in their tabooed zones) or make their self-evident orders seem strange. In Handler's subtly perverse analysis a system of retrospection – revealed by a Historic Monuments Commission's selection of ten sorts of 'cultural property' – appears as a taxonomy worthy of Borges's 'Chinese encyclopedia': '(1) commemorative monuments;

(2) churches and chapels; (3) forts of the French Regime; (4) windmills; (5) road-side crosses; (6) commemorative inscriptions and plaques; (7) devotional monuments; (8) old houses and manors; (9) old furniture; (10) "les choses disparues"'. In Handler's discussion the collection and preservation of an authentic domain of identity cannot be natural or innocent. It is tied up with nationalist politics, with restrictive law, and with contested encodings of past and future.

Some sort of 'gathering' around the self and the group – the assemblage of a material 'world', the marking-off of a subjective domain that is not 'other' – is probably universal. All such collections embody hierarchies of value, exclusions, rule-governed territories of the self. But the notion that this gathering involves the accumulation of possessions, the idea that identity is a kind of wealth (of objects, knowledge, memories, experience), is surely not universal. The individualistic accumulation of Melanesian 'big men' is not possessive in Macpherson's sense, for in Melanesia one accumulates not to hold objects as private goods but to give them away, to redistribute. In the West, however, collecting has long been a strategy for the deployment of a possessive self, culture, and authenticity.

Children's collections are revealing in this light: a boy's accumulation of miniature cars, a girl's dolls, a summer-vacation 'nature museum' (with labelled stones and shells, a hummingbird in a bottle), a treasured bowl filled with the bright shavings of crayons. In these small rituals we observe the channellings of obsession, an exercise in how to make the world one's own, to gather things around oneself tastefully, appropriately. The inclusions in all collections reflect wider cultural rules – of rational taxonomy, of gender, of aesthetics. An excessive, sometimes even rapacious need to *have* is transformed into rule-governed, meaningful desire. Thus the self that must possess but cannot have it all learns to select, order, classify in hierarchies – to make 'good' collections.

Whether a child collects model dinosaurs or dolls, sooner or later she or he will be encouraged to keep the possessions on a shelf or in a special box or to set up a doll house. Personal treasures will be made public. If the passion is for Egyptian figurines, the collector will be expected to label them, to know their dynasty (it is not enough that they simply exude power or mystery), to tell 'interesting' things about them, to distinguish copies from originals. The good collector (as opposed to the obsessive, the miser) is tasteful and reflective. Accumulation unfolds in a pedagogical, edifying manner. The collection itself – its taxonomic, aesthetic structure – is valued, and any private fixation on single objects (rule-governed possession) presupposes a 'savage' or deviant relation (idolatry or erotic fixation). In Susan Stewart's gloss, 'The boundary between collection and fetishism is mediated by classification and display in tension with accumulation and secrecy' (1984: 163).

Stewart's wide-ranging study *On Longing* traces a 'structure of desire' whose task is the repetitious and impossible one of closing the gap that separates language from the experience it encodes. She explores certain recurrent strategies pursued by Westerners since the sixteenth century. In her analysis the miniature, whether a portrait or doll's house, enacts a bourgeois longing for 'inner' experience. She also explores the strategy of gigantism (from Rabelais and Gulliver to earthworks and the billboard), the souvenir, and the collection. She shows how collections,

most notably museums, create the illusion of adequate representation of a world by first cutting objects out of specific contexts (whether cultural, historical, or intersubjective) and making them 'stand for' abstract wholes – a 'Bambara mask', for example, becoming an ethnographic metonym for Bambara culture. Next a scheme of classification is elaborated for storing or displaying the object so that the reality of the collection itself, its coherent order, overrides specific histories of the object's production and appropriation (162–5). Paralleling Marx's account of the fantastic objectification of commodities, Stewart argues that in the modern Western museum 'an illusion of a relation between things takes the place of a social relation' (165). The collector discovers, acquires, salvages objects. The objective world is given, not produced, and thus historical relations of power in the work of acquisition are occulted. The *making* of meaning in museum classification and display is mystified as adequate *representation*. The time and order of the collection erase the concrete social labour of its making.

Stewart's work brings collecting and display sharply into view as crucial processes of Western identity formation. Gathered artefacts – whether they find their way into curio cabinets, private living rooms, museums of ethnography, folklore, or fine art – function within a developing capitalist 'system of objects' (Baudrillard 1968). By virtue of this system a world of *value* is created and a meaningful deployment and circulation of artefacts maintained. For Baudrillard collected objects create a structured environment that substitutes its own temporality for the 'real time' of historical and productive processes: 'The environment of private objects and their possession – of which collections are an extreme manifestation – is a dimension of our life that is both essential and imaginary. As essential as dreams' (1968: 135).

A history of anthropology and modern art needs to see in collecting both a form of Western subjectivity and a changing set of powerful institutional practices. The history of collections (not limited to museums) is central to an understanding of how those social groups that invented anthropology and modern art have *appropriated* exotic things, facts, and meanings. (*Appropriate*: 'to make one's own', from the Latin *proprius* 'proper', 'property'.) It is important to analyse how powerful discriminations made at particular moments constitute the general system of objects within which valued artefacts circulate and make sense. Far-reaching questions are thereby raised.

What criteria validate an authentic cultural or artistic product? What are the differential values placed on old and new creations? What moral and political criteria justify 'good', responsible, systematic collecting practices? Why, for example, do Leo Frobenius's wholesale acquisitions of African objects around the turn of the century now seem excessive? How is a 'complete' collection defined? What is the proper balance between scientific analysis and public display? (In Santa Fe a superb collection of Native American art is housed at the School of American Research in a building constructed, literally, as a vault, with access carefully restricted. The Musée de l'Homme exhibits less than a tenth of its collections; the rest is stored in steel cabinets or heaped in corners of the vast basement.) Why has it seemed obvious until recently that non-Western objects should be preserved in European museums, even when this means that no fine specimens are visible in

their country of origin? How are 'antiquities', 'curiosities', 'art', 'souvenirs', 'monuments', and 'ethnographic artefacts' distinguished – at different historical moments and in specific market conditions? Why have many anthropological museums in recent years begun to display certain of their objects as 'masterpieces'? Why has tourist art only recently come to the serious attention of anthropologists? What has been the changing interplay between natural-history collecting and the selection of anthropological artefacts for display and analysis? The list could be extended.

The critical history of collecting is concerned with what from the material world specific groups and individuals choose to preserve, value, and exchange. Although this complex history, from at least the Age of Discovery, remains to be written, Baudrillard provides an initial framework for the deployment of objects in the recent capitalist West. In his account it is axiomatic that all categories of meaningful objects – including those marked off as scientific evidence and as great art – function within a ramified system of symbols and values.

To take just one example: 'the *New York Times* of 8 December 1984 reported the widespread illegal looting of Anasazi archaeological sites in the American Southwest. Painted pots and urns thus excavated in good condition could bring as much as $30,000 on the market. Another article in the same issue contained a photograph of Bronze Age pots and jugs salvaged by archaeologists from a Phoenician shipwreck off the coast of Turkey. One account featured clandestine collecting for profit, the other scientific collecting for knowledge. The moral evaluations of the two acts of salvage were sharply opposed, but the pots recovered were all meaningful, beautiful, and old. Commercial, aesthetic, and scientific worth in both cases presupposed a given system of value. This system finds intrinsic interest and beauty in objects from a past time, and it assumes that collecting everyday objects from ancient (preferably vanished) civilizations will be more *rewarding* than collecting, for example, decorated thermoses from modern China or customized T-shirts from Oceania. Old objects are endowed with a sense of 'depth' by their historically minded collectors. Temporality is reified and salvaged as origin, beauty, and knowledge.

This archaizing system has not always dominated Western collecting. The curiosities of the New World gathered and appreciated in the sixteenth century were not necessarily valued as antiquities, the products of primitive or 'past' civilizations. They frequently occupied a category of the marvellous, of a present 'Golden Age'. More recently the retrospective bias of Western appropriations of the world's cultures has come under scrutiny (Fabian 1983; Clifford 1986). Cultural or artistic 'authenticity' has as much to do with an inventive present as with a past, its objectification, preservation, or revival.

Since the turn of the century objects collected from non-Western sources have been classified in two major categories: as (scientific) cultural artefacts or as (aesthetic) works of art. Other collectables – mass-produced commodities, 'tourist art' curios, and so on – have been less systematically valued; at best they find a place in exhibits of 'technology' or 'folklore'. These and other locations within what may be called the 'modern art–culture system' can be visualized with the help of a (somewhat procrustian) diagram.

A. J. Greimas's 'semiotic square' (Greimas and Rastier 1968) shows us 'that any initial binary opposition can, by the operation of negations and the appropriate syntheses, generate a much larger field of terms which, however, all necessarily remain locked in the closure of the initial system' (Jameson 1981: 62). Adapting Greimas for the purposes of cultural criticism, Fredric Jameson uses the semiotic square to reveal 'the limits of a specific ideological consciousness, [marking] the conceptual points beyond which that consciousness cannot go, and between which it is condemned to oscillate' (1981: 47). Following his example, I offer the following map (see diagram) of a historically specific, contestable field of meanings and institutions.

Beginning with an initial opposition, by a process of negation four terms are generated. This establishes horizontal and vertical axes and between them four semantic zones: (1) the zone of authentic masterpieces, (2) the zone of authentic artefacts, (3) the zone of inauthentic masterpieces, (4) the zone of inauthentic artefacts. Most objects – old and new, rare and common, familiar and exotic – can be located in one of these zones or ambiguously, in traffic, between two zones.

The system classifies objects and assigns them relative value. It establishes the 'contexts' in which they properly belong and between which they circulate. Regular movements toward positive value proceed from bottom to top and from right to left. These movements select artefacts of enduring worth or rarity, their value normally guaranteed by a 'vanishing' cultural status or by the selection and pricing mechanisms of the art market. The value of Shaker crafts reflects the fact that Shaker society no longer exists: the stock is limited. In the art world work is recognized as 'important' by connoisseurs and collectors according to criteria that

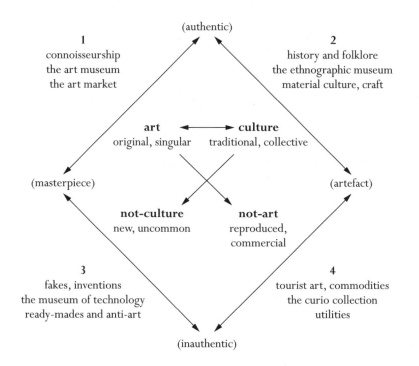

are more than simply aesthetic (see Becker 1982). Indeed, prevailing definitions of what is 'beautiful' or 'interesting' sometimes change quite rapidly.

An area of frequent traffic in the system is that linking zones 1 and 2. Objects move in two directions along this path. Things of cultural or historical value may be promoted to the status of fine art. Examples of movement in this direction, from ethnographic 'culture' to fine 'art', are plentiful. Tribal objects located in art galleries (the Rockefeller Wing at the Metropolitan Museum in New York) or displayed anywhere according to 'formalist' rather than 'contextualist' protocols move in this way. Crafts (Shaker work collected at the Whitney Museum in 1986), 'folk art', certain antiques, 'naive' art all are subject to periodic promotions. Movement in the inverse direction occurs whenever art masterworks are culturally and historically 'contextualized', something that has been occurring more and more explicitly. Perhaps the most dramatic case has been the relocation of France's great Impressionist collection, formerly at the Jeu de Paume, to the new Museum of the Nineteenth Century at the Gare d'Orsay. Here art masterpieces take their place in the panorama of a historical-cultural 'period'. The panorama includes an emerging industrial urbanism and its triumphant technology, 'bad' as well as 'good' art. A less dramatic movement from zone 1 to zone 2 can be seen in the routine process within art galleries whereby objects become 'dated', of interest less as immediately powerful works of genius than as fine examples of a period style.

Movement also occurs between the lower and upper halves of the system, usually in an upward direction. Commodities in zone 4 regularly enter zone 2, becoming rare period pieces and thus collectables (old green glass Coke bottles). Much current non-Western work migrates between the status of 'tourist art' and creative cultural–artistic strategy. Some current productions of Third World peoples have entirely shed the stigma of modern commercial inauthenticity. For example Haitian 'primitive' painting – commercial and of relatively recent, impure origin – has moved fully into the art–culture circuit. Significantly this work entered the art market by association with zone 2, becoming valued as the work not simply of individual artists but of *Haitians*. Haitian painting is surrounded by special associations, with the land of voodoo, magic and negritude. Though specific artists have come to be known and prized, the aura of 'cultural' production attaches to them much more than, say, to Picasso, who is not in any essential way valued as a 'Spanish artist'. The same is true, as we shall see, of many recent works of tribal art, whether from the Sepik or the American North-west coast. Such works have largely freed themselves from the tourist or commodity category to which, because of their modernity, purists had often relegated them; but they cannot move directly into zone 1, the art market, without trailing clouds of authentic (traditional) culture. There can be no direct movement from zone 4 to zone 1.

Occasional travel occurs between zones 4 and 3, for example when a commodity or technological artefact is perceived to be a case of special inventive creation. The object is selected out of commercial or mass culture, perhaps to be featured in a museum of technology. Sometimes such objects fully enter the realm of art: 'technological' innovations or commodities may be contextualized as modern 'design', thus passing through zone 3 into zone 1 (for example, the furniture, household machines, cars, and so on displayed at the Museum of Modern Art in New York).

There is also regular traffic between zones 1 and 3. Exposed art forgeries are demoted (while none the less preserving something of their original aura). Conversely various forms of 'anti-art' and art parading its unoriginality or 'inauthenticity' are collected and valued (Warhol's soup can, Sherrie Levine's photo of a photo by Walker Evans, Duchamp's urinal, bottle rack or shovel). Objects in zone 3 are all potentially collectable within the general domain of art: they are uncommon, sharply distinct from or blatantly cut out of culture. Once appropriated by the art world, like Duchamp's ready-mades, they circulate within zone 1.

The art–culture system I have diagrammed excludes and marginalizes various residual and emergent contexts. To mention only one: the categories of art and culture, technology and commodity are strongly secular. 'Religious' objects can be valued as great art (an altarpiece by Giotto), as folk art (the decorations on a Latin American popular saint's shrine), or as cultural artefact (an Indian rattle). Such objects have no individual 'power' or mystery – qualities once possessed by 'fetishes' before they were reclassified in the modern system as primitive art or cultural artefact. What 'value', however, is stripped from an altarpiece when it is moved out of a functioning church (or when its church begins to function as a museum)? Its specific power or sacredness is relocated to a general aesthetic realm.

While the object systems of art and anthropology are institutionalized and powerful, they are not immutable. The categories of the beautiful, the cultural, and the authentic have changed and are changing. Thus it is important to resist the tendency of collections to be self-sufficient, to suppress their own historical, economic, and political processes of production. Ideally the history of its own collection and display should be a visible aspect of any exhibition. It had been rumoured that the Boas Room of Northwest Coast artefacts in the American Museum of Natural History was to be refurbished, its style of display modernized. Apparently (or so one hopes) the plan has been abandoned, for this atmospheric, dated hall exhibits not merely a superb collection but a moment in the history of collecting. The widely publicized Museum of Modern Art show of 1984, '"Primitivism" in Twentieth-Century Art', made apparent (as it celebrated) the precise circumstances in which certain ethnographic objects suddenly became works of universal art. More historical self-consciousness in the display and viewing of non-Western objects can at least jostle and set in motion the ways in which anthropologists, artists and their publics collect themselves and the world.

At a more intimate level, rather than grasping objects as cultural signs and artistic icons, we can return to them, as James Fenton does, their lost status as fetishes – not specimens of a deviant or exotic 'fetishism' but *our own* fetishes. This tactic, necessarily personal, would accord to things in collections the power to fixate rather than simply the capacity to edify or inform. African and Oceanian artefacts could once again be *objets sauvages*, sources of fascination with the power to disconcert. Seen in their resistance to classification they could remind us of our *lack* of self-possession, of the artifices we employ to gather a world around us.

Culture collecting

Found in *American Anthropologist*, n.s. 34 (1932): 740:

> Note from New Guinea
> Aliatoa, Wiwiak District, New Guinea
>
> *April 21, 1932*
>
> We are just completing a culture of a mountain group here in the lower Torres Chelles. They have no name and we haven't decided what to call them yet. They are a very revealing people in spots, providing a final basic concept from which all the mother's brothers' curses and father's sisters' curses, etc. derive, and having articulated the attitude toward incest which Reo [Fortune] outlined as fundamental in his Encyclopedia article. They have taken the therapeutic measures which we recommended for Dobu and Manus – having a devil in addition to the neighbor sorcerer, and having got their dead out of the village and localized. But in other ways they are annoying: they have bits and snatches of all the rag tag and bob tail of magical and ghostly belief from the Pacific, and they are somewhat like the Plains in their receptivity to strange ideas. A picture of a local native reading the index to the *Golden Bough* just to see if they had missed anything, would be appropriate. They are very difficult to work, living all over the place with half a dozen garden houses, and never staying put for a week at a time. Of course this offered a new challenge in method which was interesting. The difficulties incident upon being two days over impossible mountains have been consuming and we are going to do a coastal people next.
>
> *Sincerely yours,*
> Margaret Mead

'Cultures' are ethnographic collections. Since Tylor's founding definition of 1871 the term has designated a rather vague 'complex whole' including everything that is learned group behaviour, from body techniques to symbolic orders. There have been recurring attempts to define culture more precisely (see Kroeber and Kluckhohn 1952) or, for example, to distinguish it from 'social structure'. But the inclusive use persists. For there are times when we still need to be able to speak holistically of Japanese or Trobriand or Moroccan culture in the confidence that we are designating something real and differentially coherent. It is increasingly clear, however, that the concrete activity of representing a culture, subculture, or indeed any coherent domain of collective activity is always strategic and selective. The world's societies are too systematically interconnected to permit any easy isolation of separate or independently functioning systems. The increased pace of historical change, the common recurrence of stress in the systems under study, forces a new self-consciousness about the way cultural wholes and boundaries are constructed and translated. The pioneering *élan* of Margaret Mead 'completing a culture' in highland New Guinea, collecting a dispersed population, discovering its key customs, naming the result – in this case 'the Mountain Arapesh' – is no longer possible.

To see ethnography as a form of culture collecting (not, of course, the *only* way to see it) highlights the ways that diverse experiences and facts are selected, gathered, detached from their original temporal occasions, and given enduring value in a new arrangement. Collecting – at least in the West, where time is generally thought to be linear and irreversible – implies a rescue of phenomena from inevitable historical decay or loss. The collection contains what 'deserves' to be kept, remembered, and treasured. Artefacts and customs are saved out of time. Anthropological culture collectors have typically gathered what seems 'traditional' – what by definition is opposed to modernity. From a complex historical reality (which includes current ethnographic encounters) they select what gives form, structure, and continuity to a world. What is hybrid or 'historical' in an emergent sense has been less commonly collected and presented as a system of authenticity. For example in New Guinea Margaret Mead and Reo Fortune chose not to study groups that were, as Mead wrote in a letter, 'badly missionized'; and it had been self-evident to Malinowski in the Trobriands that what most deserved scientific attention was the circumscribed 'culture' threatened by a host of modern 'outside' influences. The experience of Melanesians becoming Christians for their own reasons – learning to play, and play with, the outsiders' games – did not seem worth salvaging.

Every appropriation of culture, whether by insiders or outsiders, implies a specific temporal position and form of historical narration. Gathering, owning, classifying, and valuing are certainly not restricted to the West; but elsewhere these activities need not be associated with accumulation (rather than redistribution) or with preservation (rather than natural or historical decay). The Western practice of culture collecting has its own local genealogy, enmeshed in distinct European notions of temporality and order. It is worth dwelling for a moment on this genealogy, for it organizes the assumptions being arduously unlearned by new theories of practice, process, and historicity (Bourdieu 1977; Giddens 1979; Ortner 1984; Sahlins 1985).

A crucial aspect of the recent history of the culture concept has been its alliance (and division of labour) with 'art'. Culture, even without a capital *c*, strains toward aesthetic form and autonomy. I have already suggested that modern culture ideas and art ideas function together in an 'art–culture system'. The inclusive twentieth-century culture category – one that does not privilege 'high' or 'low' culture – is plausible only within this system, for while in principle admitting all learned human behavior, this culture with a small *c* orders phenomena in ways that privilege the coherent, balanced, and 'authentic' aspects of shared life. Since the mid-nineteenth century, ideas of culture have tethered up those elements that seem to give continuity and depth to collective existence, seeing it whole rather than disputed, torn, intertextual, or syncretic. Mead's almost postmodern image of 'a local native reading the index to *The Golden Bough* just to see if they had missed anything' is not a vision of authenticity.

Mead found Arapesh receptivity to outside influences 'annoying'. *Their* culture collecting complicated hers. Historical developments would later force her to provide a revised picture of these difficult Melanesians. In a new preface to the 1971 reprint of her three-volume ethnography *The Mountain Arapesh* Mead devotes several pages to letters from Bernard Narakobi, an Arapesh then studying law in

Sydney, Australia. The anthropologist readily admits her astonishment at hearing from him: 'How was it that one of the Arapesh – a people who had had such a light hold on any form of collective style – should have come further than any individual among the Manus, who had moved as a group into the modern world in the years between our first study of them, in 1928, and the beginning of our restudy, in 1953?' (Mead 1971: ix). She goes to explain that Narakobi, along with other Arapesh men studying in Australia, had 'moved' from one period in human culture to another as 'individuals'. The Arapesh were 'less tightly bound within a coherent culture' than Manus (ix–x). Narakobi writes, however, as a member of his 'tribe', speaking with pride of the values and accomplishments of his 'clans-folk'. (He uses the name Arapesh sparingly.) He articulates the possibility of a new multiterritorial 'cultural' identity: 'I feel now that I can feel proud of my tribe and at the same time feel I belong not only to Papua–New Guinea, a nation to be, but to the world community at large' (xiii). Is not this modern way of being 'Arapesh' already prefigured in Mead's earlier image of a resourceful native paging through *The Golden Bough*? Why must such behavior be marginalized or classed as 'individual' by the anthropological culture collector?

Expectations of wholeness, continuity, and essence have long been built into the linked Western ideas of culture and art. A few words of recent background must suffice, since to map the history of these concepts would lead us on a chase for origins back at least to the Greeks. Raymond Williams provides a starting point in the early nineteenth century – a moment of unprecedented historical and social disruption. In *Culture and Society* (1960), *Keywords* (1983), and elsewhere Williams has traced a parallel development in usage for the words *art* and *culture*. The changes reflect complex responses to industrialism, to the spectre of 'mass society', to accelerated social conflict and change.[1]

According to Williams, in the eighteenth century the word *art* meant predominantly 'skill'. Cabinet-makers, criminals, and painters were each in their way artful. *Culture* designated a tendency to natural growth, its uses predominantly agri-cultural and personal: both plants and human individuals could be 'cultured'. Other meanings also present in the eighteenth century did not predominate until the nineteenth. By the 1820s *art* increasingly designated a special domain of creativity, spontaneity, and purity, a realm of refined sensibility and expressive 'genius'. The 'artist' was set apart from, often against, society – whether 'mass' or 'bourgeois'. The term *culture* followed a parallel course, coming to mean what was most elevated, sensitive, essential, and precious – most uncommon – in society. Like art, culture became a general category; Williams calls it a 'final court of appeal' against threats of vulgarity and levelling. It existed in essential opposition to perceived 'anarchy'.

Art and culture emerged after 1800 as mutually reinforcing domains of human *value*, strategies for gathering, marking off, protecting the best and most inter-esting creations of 'Man'. In the twentieth century the categories underwent a series of further developments. The plural, anthropological definition of culture (lower-case *c* with the possibility of a final *s*) emerged as a liberal alternative to racist classifications of human diversity. It was a sensitive means for understanding different and dispersed 'whole ways of life' in a high colonial context of unprece-dented global interconnection. *Culture* in its full evolutionary richness and

authenticity, formerly reserved for the best creations of modern Europe, could now be extended to all the world's populations. In the anthropological vision of Boas's generation 'cultures' were of equal value. In their new plurality, however, the nineteenth-century definitions were not entirely transformed. If they became less elitist (distinctions between 'high' and 'low' culture were erased) and less Eurocentric (every human society was fully 'cultural'), nevertheless a certain body of assumptions were carried over from the older definitions. George Stocking (1968: 69–90) shows the complex interrelations of nineteenth-century humanist and emerging anthropological definitions of culture. He suggests that anthropology owes as much to Matthew Arnold as to its official founding father, E. B. Tylor. Indeed much of the vision embodied in *Culture and Anarchy* has been transferred directly into relativist anthropology. A powerful structure of feeling continues to see culture, wherever it is found, as a coherent *body* that lives and dies. Culture is enduring, traditional, structural (rather than contingent, syncretic, historical). Culture is a process of ordering, not of disruption. It changes and develops like a living organism. It does not normally 'survive' abrupt alterations.

In the early twentieth century, as *culture* was being extended to all the world's functioning societies, an increasing number of exotic, primitive, or archaic objects came to be seen as 'art'. They were equal in aesthetic and moral value with the greatest Western masterpieces. By mid-century the new attitude toward 'primitive art' had been accepted by large numbers of educated Europeans and Americans. Indeed from the standpoint of the late twentieth century it becomes clear that the parallel concepts of art and culture did successfully, albeit temporarily, comprehend and incorporate a plethora of non-Western artefacts and customs. This was accomplished through two strategies. First, objects reclassified as 'primitive art' were admitted to the imaginary museum of human creativity and, though more slowly, to the actual fine arts museums of the West. Second, the discourse and institutions of modern anthropology constructed comparative and synthetic images of Man drawing even-handedly from among the world's authentic ways of life, however strange in appearance or obscure in origin. Art and culture, categories for the best creations of Western humanism, were in principle extended to all the world's peoples.

It is perhaps worth stressing that nothing said here about the historicity of these cultural or artistic categories should be construed as claiming that they are false or denying that many of their values are worthy of support. Like any successful discursive arrangement, the art–culture authenticity system articulates considerable domains of truth and scientific progress as well as areas of blindness and controversy. By emphasizing the transience of the system I do so out of a conviction (it is more a feeling of the historical ground moving underfoot) that the classifications and generous appropriations of Western art and culture categories are now much less stable than before. This instability appears to be linked to the growing inter-connection of the world's populations and to the contestation since the 1950s of colonialism and Eurocentrism. Art collecting and culture collecting now take place within a changing field of counterdiscourses, syncretisms and reappropriations originating both outside and inside 'the West'. I cannot discuss the geopolitical causes of these developments. I can only hint at their transforming consequences, and stress that the modern genealogy of culture and art that I have been sketching increasingly appears to be a local story. 'Culture' and 'art' can no longer be simply

extended to non-Western peoples and things. They can at worst be *imposed*, at best *translated* – both historically and politically contingent operations.

Before I survey some of the current challenges to Western modes of collection and authentication, it may be worth portraying the still-dominant form of art and culture collecting in a more limited, concrete setting. The system's underlying historical assumptions will then become inescapable. For if collecting in the West salvages things out of non-repeatable time, what is the assumed direction of this time? How does it confer rarity and authenticity on the varied productions of human skill? Collecting presupposes a story; a story occurs in a 'chronotope'.

A chronotope for collecting

> Dans son effort pour comprendre le monde, l'homme dispose donc toujours d'un surplus de signification.
>
> <div align="right">Claude Lévi-Strauss</div>

The term *chronotope*, as used by Bakhtin, denotes a configuration of spatial and temporal indicators in a fictional setting where (and when) certain activities and stories *take place*. One cannot realistically situate historical detail – putting something 'in its time' – without appealing to explicit or implicit chronotopes. Claude Lévi-Strauss's pointed, nostalgic recollections of New York during the Second World War can serve as a chronotope for modern art and culture collecting. The setting is elaborated in an essay whose French title, 'New York post-et préfiguratif' (1983), suggests its underlying spatio-temporal predicament more strongly than the published English translation, 'New York in 1941' (1985). The essay falls within a microgenre of Lévi-Strauss's writing, one he developed with virtuosity in *Tristes tropiques*. Specific places – Rio, Fire Island, new Brazilian cities, Indian sacred sites – appear as moments of intelligible human order and transformation surrounded by the destructive, entropic currents of global history.

In what follows I have supplemented the essay on New York with passages from other texts written by Lévi-Strauss either during the war years or in recollection of them. In reading them as a unified chronotope, one ought to bear in mind that these are not historical records but complex literary commemorations. The time–space in question has been retrospectively composed by Lévi-Strauss and recomposed, for other purposes, by myself.

A refugee in New York during the Second World War, the anthropologist is bewildered and delighted by a landscape of unexpected juxtapositions. His recollections of those seminal years, during which he invented structural anthropology, are bathed in a magical light. New York is full of delightful incongruities. Who could resist

> the performances that we watched for hours at the Chinese opera under the first arch of the Brooklyn Bridge, where a company that had come long ago from China had a large following. Every day, from mid-afternoon until past midnight, it would perpetuate the traditions of

classical Chinese opera. I felt myself going back in time no less when I went to work every morning in the American room of the New York Public Library. There, under its neo-classical arcades and between walls paneled with old oak, I sat near an Indian in a feather headdress and a beaded buckskin jacket — who was taking notes with a Parker pen.

(1985: 266)

As Lévi-Strauss tells it, the New York of 1941 is an anthropologist's dream, a vast selection of human culture and history. A brief walk or subway ride will take him from a Greenwich Village reminiscent of Balzac's Paris to the towering skyscrapers of Wall Street. Turning a corner in this jumble of immigrants and ethnic groups, the stroller suddenly enters a different world with its own language, customs, cuisine. Everything is available for consumption. In New York one can obtain almost any treasure. The anthropologist and his artistic friends André Breton, Max Ernst, André Masson, Georges Duthuit, Yves Tanguy, and Matta find masterpieces of pre-Columbian, Indian, Oceanic or Japanese art stuffed in dealers' closets or apartments. Everything somehow finds it way here. For Lévi-Strauss New York in the 1940s is a wonderland of sudden openings to other times and places, of cultural matter out of place:

> New York (and this is the source of its charm and its peculiar fascina-tion) was then a city where anything seemed possible. Like the urban fabric, the social and cultural fabric was riddled with holes. All you had to do was pick one and slip through it if, like Alice, you wanted to get to the other side of the looking glass and find worlds so enchanting that they seemed unreal.

(261)

The anthropological *flâneur* is delighted, amazed, but also troubled by the chaos of simultaneous possibilities. This New York has something in common with the early-century Dada–Surrealist flea market — but with a difference. Its *objets trouvés* are not just occasions for reverie. This they surely are, but they are also signs of vanishing worlds. Some are treasures, works of great art.

Lévi-Strauss and the refugee surrealists were passionate collectors. The Third Avenue art dealer they frequented and advised, Julius Carlebach, always had several North-west Coast, Melanesian or Eskimo pieces on hand. According to Edmund Carpenter, the surrealists felt an immediate affinity with these objects' predilec-tion for 'visual puns'; their selections were nearly always of a very high quality. In addition to the art dealers another source for this band of primitive-art connois-seurs was the Museum of the American Indian. As Carpenter tells it:

> The Surrealists began to visit the Bronx warehouse of that Museum, selecting for themselves, concentrating on a collection of magnificent Eskimo masks. These huge visual puns, made by the Kuskokwim Eskimo a century or more ago, constituted the greatest collection of its kind in the world. But the Museum Director, George Heye, called them 'jokes' and sold half for $38 and $54 each. The Surrealists bought the

best. Then they moved happily through Heye's Northwest Coast collec-
tion, stripping it of one masterwork after another.

(Carpenter 1975: 10)

In 1946 Max Ernst, Barnett Newman, and several others mounted an exhibit of
North-west Coast Indian painting at the Betty Parsons Gallery. They brought
together pieces from their private collections and artefacts from the American
Museum of Natural History. By moving the museum pieces across town, 'the
Surrealists declassified them as scientific specimens and reclassified them as art'
(Carpenter 1975: 1).

The category of primitive art was emerging, with its market, its connois-
seurship, and its close ties to modernist aesthetics. What had begun with the figure
for *l'art nègre* in the 1920s would become institutionalized by the 1950s and1960s;
but in wartime New York the battle to gain widespread recognition for tribal
objects was not yet won. Lévi-Strauss recalls that as cultural attaché to the French
Embassy in 1946 he tried in vain to arrange a trade: for a massive collection of
American Indian art a few Matisses and Picassos. But 'the French authorities turned
a deaf ear to my entreaties, and the Indian collections wound up in American
museums' (1985: 262). The collecting of Lévi-Strauss and the Surrealists during
the 1940s was part of a struggle to gain aesthetic status for these increasingly rare
masterworks.

Modern practices of art and culture collecting, scientific and avant-garde, have
situated themselves at the end of a global history. They have occupied a place –
apocalyptic, progressive, revolutionary or tragic – from which to gather the valued
inheritances of Man. Concretizing this temporal set-up, Lévi-Strauss's 'post- and
prefigurative' New York anticipates humanity's entropic future and gathers up its
diverse pasts in decontextualized, collectable forms. The ethnic neighbourhoods,
the provincial reminders, the Chinese Opera Company, the feathered Indian in
the library, the works of art from other continents and eras that turn up in dealers'
closets: all are survivals, remnants of threatened or vanished traditions. The world's
cultures appear in the chronotope as shreds of humanity, degraded commodities,
or elevated great art but always functioning as vanishing 'loopholes' or 'escapes'
from a one-dimensional fate.

In New York a jumble of humanity has washed up in one vertiginous place
and time, to be grasped simultaneously in all its precious diversity and emerging
uniformity. In this chronotope the pure products of humanity's pasts are rescued
by modern aesthetics only as sublimated art. They are salvaged by modern anthro-
pology as consultable archives for thinking about the range of human invention.
In Lévi-Strauss's setting the products of the present-becoming-future are shallow,
impure, escapist, and 'retro' rather than truly different – 'antiques' rather than
genuine antiquities. Cultural invention is subsumed by a commodified 'mass
culture'.

The chronotope of New York supports a global allegory of fragmentation
and ruin. The modern anthropologist, lamenting the passing of human diversity,
collects and values its survivals, its enduring works of art. Lévi-Strauss's most
prized acquisition from a marvellous New York where everything seemed

available was a nearly complete set of volumes 1–48 of the *Annual Reports* of the Bureau of American Ethnology. These were, he tells us in another evocation of the war years, 'sacrosanct volumes, representing most of our knowledge about the American Indians . . . It was as though the American Indian cultures had suddenly come alive and become almost tangible through the physical contact that these books, written and published before these cultures' definite extinction, established between their times and me' (Lévi-Strauss 1960: 50). These precious records of human diversity had been recorded by an ethnology still in what he calls its 'pure' rather than 'diluted' state. They would form the authentic ethnographic material from which structuralism's meta-cultural orders were constructed.

Anthropological collections and taxonomies, however, are constantly menaced by temporal contingencies. Lévi-Strauss knows this. It is a disorder he always holds at bay. For example in *Tristes tropiques*, he is acutely aware that focusing on a tribal past necessarily blinds him to an emergent present. Wandering through the modern landscape of New York, far from encountering less and less to know, the anthropologist is confronted with more and more – a heady mix-and-match of possible human combinations. He struggles to maintain a unified perspective; he looks for order in deep 'geological' structures. But in Lévi-Strauss's work generally, the englobing 'entropological' narrative barely contains a current history of loss, transformation, invention, and emergence.

Towards the end of his brilliant inaugural lecture at the Collège de France, 'The Scope of Anthropology', Lévi-Strauss evokes what he calls 'anthropological doubt', the inevitable result of ethnographic risk-taking, the 'buffetings and denials directed at one's most cherished ideas and habits by other ideas and habits best able to rebut them' (1960: 26). He poignantly recalls a Kwakiutl visitor, hosted in New York by Franz Boas, transfixed by the freaks and automats of Times Square, and he wonders whether anthropology may not be condemned to equally bizarre perceptions of the distant societies and histories it seeks to grasp. New York was perhaps Lévi-Strauss's only true 'fieldwork': for once he stayed long enough and mastered the local language. Aspects of the place, such as Boas's Kwakiutl, have continued to charm and haunt his anthropological culture collecting.

But one New York native sits with special discomfort in the chronotope of 1941. This is the feathered Indian with the Parker pen working in the Public Library. For Lévi-Strauss the Indian is primarily associated with the past, the 'extinct' societies recorded in the precious Bureau of American Ethnology *Annual Reports*. The anthropologist feels himself 'going back in time' (1985: 266). In modern New York an Indian can appear only as a survival or a kind of incongruous parody.

Another historical vision might have positioned the two scholars in the library differently. The decade just preceding Lévi-Strauss's arrival in New York had seen a dramatic turnaround in federal policy. Under John Collier's leadership at the Bureau of Indian Affairs a 'New Indian Policy' actively encouraged tribal reorganization all over the country. While Lévi-Strauss studied and collected their pasts, many 'extinct' Native American groups were in the process of reconstituting themselves culturally and politically. Seen in this context, did the Indian with the Parker pen represent a 'going back in time' or a glimpse of another future? That is a different story.

Other appropriations

To tell these other stories, local histories of cultural survival and emergence, we
need to resist deep-seated habits of mind and systems of authenticity. We need to
be suspicious of an almost-automatic tendency to relegate non-Western peoples
and objects to the pasts of an increasingly homogeneous humanity. A few exam-
ples of current invention and contestation may suggest different chronotopes for
art and culture collecting.

Anne Vitart-Fardoulis, a curator at the Musée de l'Homme, has published a
sensitive account of the aesthetic, historical, and cultural discourses routinely used
to explicate individual museum objects. She discusses a famous intricately painted
animal skin (its present name: M.H. 34.33.5), probably originating among the Fox
Indians of North America. The skin turned up in Western collecting systems some
time ago in a 'cabinet of curiosities'; it was used to educate aristocratic children
and was much admired for its aesthetic qualities. Vitart-Fardoulis tells us that now
the skin can be decoded ethnographically in terms of its combined 'masculine' and
'feminine' graphic styles and understood in the context of a probable role in specific
ceremonies. But the meaningful contexts are not exhausted. The story takes a new
turn:

> The grandson of one of the Indians who came to Paris with Buffalo Bill
> was searching for the [painted skin] tunic his grandfather had been forced
> to sell to pay his way back to the United States when the circus
> collapsed. I showed him all the tunics in our collection, and he paused
> before one of them. Controlling his emotion, he spoke. He told the
> meaning of this lock of hair, of that design, why this color had been
> used, the meaning of that feather . . . This garment, formerly beautiful
> and interesting but passive and indifferent, little by little became mean-
> ingful, active testimony to a living moment through the mediation of
> someone who did not observe and analyze but who lived the object
> and for whom the object lived. It scarcely matters whether the tunic
> is really his grandfather's.
>
> (Vitart-Fardoulis 1986: 12)

Whatever is happening in this encounter, two things are clearly *not* happening.
The grandson is not replacing the object in its original or 'authentic' cultural context.
That is long past. His encounter with the painted skin is part of a modern recollec-
tion. And the painted tunic is not being appreciated as art, as an aesthetic object.
The encounter is too specific, too enmeshed in family history and ethnic memory.
Some aspects of 'cultural' and 'aesthetic' appropriation are certainly at work, but
they occur within a *current tribal history*, a different temporality from that governing
the dominant systems I diagrammed earlier. In the context of a present-becoming-
future the old painted tunic becomes newly, traditionally meaningful.

The currency of 'tribal' artefacts is becoming more visible to non-Indians.
Many new tribal recognition claims are pending at the Department of the Interior.
And whether or not they are formally successful matters less than what they make
manifest: the historical and political reality of Indian survival and resurgence, a

force that impinges on Western art and culture collections. The 'proper' place of many objects in museums is now subject to contest. The Zuni who prevented the loan of their war god to the Museum of Modern Art were challenging the dominant art–culture system, for in traditional Zuni belief war god figures are sacred and dangerous. They are not ethnographic artefacts, and they are certainly not 'art'. Zuni claims on these objects specifically reject their 'promotion' (in all senses of the term) to the status of aesthetic or scientific treasures.

I would not claim that the only true home for the objects in question is in 'the tribe' – a location that, in many cases, is far from obvious. My point is just that the dominant, interlocking contexts of art and anthropology are no longer self-evident and uncontested. There are other contexts, histories, and futures in which non-Western objects and cultural records may 'belong'. The rare Maori artefacts that in 1984–5 toured museums in the United States normally reside in New Zealand museums. But they are controlled by the traditional Maori authorities, whose permission was required for them to leave the country. Here and elsewhere the circulation of museum collections is significantly influenced by resurgent indigenous communities.

What is at stake is something more than conventional museum programmes of community education and 'outreach'. Current developments question the very status of museums as historical-cultural theatres of memory. Whose memory? For what purposes? The Provincial Museum of British Columbia has for some time encouraged Kwakiutl carvers to work from models in its collection. It has lent out old pieces and donated new ones for use in modern potlatches. Surveying these developments, Michael Ames, who directs the University of British Columbia Museum, observes that 'Indians, traditionally treated by museums only as objects and clients, add now the role of patrons'. He continues: 'The next step has also occurred. Indian communities establish their own museums, seek their own National Museum grants, install their own curators, hire their own anthropologists on contract, and call for repatriation of their own collections' (Ames 1986: 57). The Quadra Island Kwakiutl Museum located in Quathraski Cove, British Columbia, displays tribal work returned from the national collections in Ottawa. The objects are exhibited in glass cases, but arranged according to their original family ownership. In Alert Bay, British Columbia, the U'mista Cultural Centre displays repatriated artefacts in a traditional Kwakiutl 'big house' arranged in the sequence of their appearance at the potlatch ceremony. The new institutions function both as public exhibits and as cultural centres linked to ongoing tribal traditions (Clifford 1997 provides a fuller account). Two Haida museums have also been established in the Queen Charlotte Islands, and the movement is growing elsewhere in Canada and the United States.

Resourceful Native American groups may yet appropriate the Western museum – as they have made their own another European institution, the 'tribe'. Old objects may again participate in a tribal present-becoming-future. Moreover, it is worth briefly noting that the same thing is possible for written artefacts collected by salvage ethnography. Some of these old texts (myths, linguistic samples, lore of all kinds) are now being recycled as local history and tribal 'literature'. The objects of both art and culture collecting are susceptible to other appropriations.

Note

1 Although Williams's analysis is limited to England, the general pattern applies elsewhere in Europe, where the timing of modernization differed or where other terms were used. In France, for example the words *civilisation* or, for Durkheim, *société* stand in for *culture*. What is at issue are general qualitative assessments of collective life.

Angela McRobbie

THE PLACE OF WALTER BENJAMIN
IN CULTURAL STUDIES

EDITOR'S INTRODUCTION

WALTER BENJAMIN, PART MYSTIC, part Marxist, part modernist, was a German-Jewish victim of Nazism, who continues to cast a spell. In her response to Susan Buck-Morss's English account of Benjamin's major project, the *Passagenwerk* (an incomplete, experimental, montage-like history of nineteenth-century urbanism in Paris), Angela McRobbie carefully ponders Benjamin's possibilities for cultural studies. She argues that his value lies as much in his relation to the world, his example as a cultural intellectual, as in what he wrote.

Benjamin's work pivots around four poles: first, his rejection of history as rationally cumulative or progressive; second, his messianic faith that human endeavors exist in relation to the promise of eternal redemption; third, his acceptance that culture, as the world people make, is a form of mortal dreaming, a phantasmagoria in which death, ruin, and redemption cannot be separated from one another, but which may be renewed by revolution; fourth, his thesis that modern technologies like film and photography are to be welcomed because of their democratic force, and because, in them, nature becomes increasingly absorbed into culture.

On the face of it, these propositions run counter to the spirit of contemporary cultural studies. McRobbie makes the point that "living people" are eerily absent from Benjamin's work. And yet Benjamin is seductive because he took his intellectual work so seriously. For him, research and critical writing were not a profession, not a career, not a vocation even, but a form of activism aimed, despite everything, at bridging revolutionary practice, his Jewish spiritual heritage, his elite philosophical and literary tastes and the cultural life of the populace. All this in a context where, as a freelance Jewish exile, he came to have almost no

audience, and hence accountability, at all. Unlike an English contemporary such as George Orwell, with a nation to preach at, he was able to engage in the European avant-garde; unlike his colleagues Max Horkheimer and Theodor Adorno he was not circumscribed by the conventions of academic philosophy and social science. Thus he came to revalue the detritus of the modern world. And, as McRobbie suggests, it is for his spiritual and political revaluation of what's left out of, or behind by, official or chic culture that he matters most for cultural studies.

Further reading: Buck-Morss 1989; Friedberg 1993; G. Smith 1988; Steinberg 1996b.

Walter Benjamin has occupied an ambivalent place in cultural studies since the early 1970s when his two seminal essays written in the 1930s, 'The artist as producer' and 'The work of art in the age of mechanical reproduction', were first published in English. They were rightly hailed as key contributions to the development of Marxist theories of art, as well as to what has since become known as cultural politics. The influence of Brecht is particularly noticeable in 'The artist as producer'; and in cultural studies generally, as well as in journals like the *New Left Review*, the names of Brecht and Benjamin were frequently mentioned together. Both writers were looked to for their committed but unaligned Marxism which was far removed from that of the official Marxism of the communist parties of the 1930s and later of the Stalinist era. Both Benjamin and Brecht recognized, with some urgency, the need to extend the role of the intellectual in order to engage with the people and to do this through transforming the existing mass media while simultaneously making use of their technological advances. While this might seem commonplace now in the 1990s, the simple insistence by Benjamin (who was writing against the backdrop of Nazism with all that entailed politically and culturally) that 'The rigid, isolated object [of art] . . . is of no use whatsoever. It must be inserted into the context of living social relations' (Benjamin 1970: 52) was a remarkably radical statement even in the early 1970s when in the British university system there were almost no interdisciplinary studies in the humanities, where politics was still something which rarely if ever entered the seminar room or lecture theatre, where the social sciences were narrowly positivistic and empirical, and where theory was equated with the history of ideas.

That moment in the 1970s when Benjamin's writings were warmly embraced, albeit in the marginalized enclaves of cultural studies in Birmingham, did not last long. What was available of Benjamin's other work was too obscure and mystical, or else too literary, to be of much use to those areas of study such as film or television which were rapidly developing and which found instead in Althusser's writing a much more useful set of concepts, particularly ideology. This was followed, a couple of years later, by the interest in Gramsci's work and in the concept of hegemony. It was left to the Marxist literary critic Terry Eagleton (1981) to explore in greater depth Benjamin's less accessible writings and at the same time to reclaim him as an impeccable Marxist theorist, despite the messianic threads running through much of his work. Apart from Eagleton's book, the bulk

of Benjamin scholarship has been carried out in Germany and in the US. With the exception of Dick Hebdige (1979, 1988) and Iain Chambers (1985, 1986), both of whom have consistently looked to Benjamin for the exceptionally lucid, even poetic flashes of insight found in many of his less well-known essays, and who have also perhaps empathized with Benjamin's intellectual sadness, his despair at the outcome of events around him, Walter Benjamin had throughout the 1980s been more or less laid to rest in cultural studies.

Recently, in the 1990s, there has, however, been a flicker of renewed interest. This has involved returning to Benjamin through a highly circuitous route. Two things have happened at once. There has been a shift away from the kind of foundational vocabulary established in cultural studies in the 1970s and summarized under the twin headings of *culturalism* and/or *structuralism* (Hall 1981b) and with this there has been a critique of the assumptions which underpinned the Marxism which played such a key role in cultural studies during that time, including the working class as an emancipatory force, the notion of history as moving inexorably to socialism, the belief in social progress and the leadership role of the organic intellectual. In place of these there has emerged (also under the influence of post-structuralist critiques of meaning) a much looser, even literary vocabulary. Cultural studies has shown itself able to read across the signs of everyday life without having to restrict itself to the search for pure or perfect meaning (Grossberg, Nelson and Treichler 1992). At the same time, the loss of faith in Marxism has been replaced by a concern for the previously uninvestigated broad cultural setting for the texts and images whose analysis took up so much time precisely because they were seen as being the privileged sites of ideology. The two terms *modernity* and *postmodernity* have been taken up as supplying the framework for this broader context. Whether or not they are opposing or interrelated concepts, they have each insisted on the integrated experience of everyday life including the urban environment, architecture, consumer culture and the 'passage' of the individual at whatever precise historical moment in time through these forms, whether he or she, for example, is the *flâneur* of urban modernity, or the insulated walkman of postmodernity.

To the extent that Walter Benjamin can be understood as responding to modernity as it moved towards social catastrophe, and where some of his work other than the two essays mentioned above can be seen as feeding directly into the documentation of urban modernity, it is not surprising that cultural studies might now look back to *One Way Street* or *Illuminations*. What interest there has been in the UK is also very much thanks to the cultural sociology of the journal *Theory, Culture and Society*, which has been responsible for the renewed theoretical interest in figures like Georg Simmel, Norbert Elias and Siegfried Kracauer as well as Walter Benjamin. Finally, it should be remembered that it was feminism which insisted on the place of biography and autobiography in cultural studies. This too has accounted for a different kind of object of study emerging in the field of culture, one which makes it possible to incorporate into the field a piece of autobiographical writing like 'A Berlin chronicle' (published in *One Way Street*, Benjamin 1979).

In Germany we find an unbroken interest in Benjamin since the late 1960s, including the publication of letters, manuscripts and catalogue material to accompany exhibitions drawing on his life and work. In German scholarship, particularly

in social history, we find the continual influence of Benjamin's writings on histo-
riography and on the practice of history. And in both Germany and the USA there
is a great interest in Benjamin's contribution to 'modern Jewish Messianism'
(Rabinbach 1985). Alongside this, for those working in the field of German studies
on both sides of the Atlantic, there is Benjamin's work itself as a literary and
historical object of study. *One Way Street*, for example, is generally seen as a kind
of literary montage strongly influenced by the visual work of John Heartfield [a
communist artist who helped to invent photomontage] rather than a critical essay
in the traditional sense. There is also Benjamin's critical writing, on Baudelaire,
Kafka and Proust, on the historian and collector Edward Fuchs, on Karl Krauss,
as well as the essays on literary and cultural practices and pursuits such as trans-
lating, collecting books, and telling stories. Finally there are the few fragments of
autobiographical material. Memory for Benjamin was a struggle to recall, not a
process of remembering or a linear development, but a set of flickering images.
The work of remembering, and the form that memory takes, shows Benjamin to
be engaging with Proust, whom he translated, and less directly with Freud. The
non-linearity of memory and the availability, as a prompt to memory, of the repro-
duced image were to prove vital in Benjamin's understanding of history and in the
method of writing he tried to develop in the *Passagenwerk*.

The question to be asked is what more sustained value this body of work has,
or might now have, for those working in the field of cultural analysis, particularly
in Britain where cultural studies has defined itself as more separate from other
related fields (such as social history, literary studies, sociology, European studies,
and even film and television studies). Why was Benjamin important but marginal?
Why did he suddenly drop from the reading lists of cultural studies? One of the
most straightforward reasons for this is that the mode of writing employed by
Benjamin, including the autobiographical fragments, was not considered as
somehow appropriate to the methods of cultural studies as they developed through
the 1970s and into the 1980s. While Benjamin continued to possess a kind of
subterranean image as a figure of historical interest, he belonged somewhere else.
This somewhere else lay in the history, not of the cultural left in Britain but of
the European cultural left. (It might be suggested that, even regarding Europe,
British cultural studies has displayed the kind of narrow Anglocentrism many black
critics now accuse it of (Gilroy 1994).)

I want to suggest that a more detailed reconsideration of Benjamin's work is
long overdue. What we find is a model for the practice of being a cultural intel-
lectual. This comprises an inability to conform to the traditional requirements of
the scholarly mode. Whatever personal pain his failure to get a tenured post might
have caused Benjamin, it positioned him on the edge of intellectual life. (It is
unlikely, for example, that any university appointments committee would have
taken seriously his interest in the photographic image, the shopping arcades of
Paris, or the fashions displayed in the windows of the new department stores.)
There is nothing comfortable about anything Benjamin ever wrote. Instead it is
shot through with difficulty and urgency. He was, of course, writing in a time
more overshadowed by fear than our own. But what he was doing was new and
inventive in every way. He was not a writer of fiction, or, like his friend Brecht,
a playwright. Within the realms of what might be called non-fiction or the essay

form, he was, however, an experimentalist. (I will say more on this later.) Equally important was the passion Benjamin displayed politically. As his 'A Berlin chronicle' records, he was, as a student, as much an activist as a young intellectual, organizing debates and making speeches in the meeting house which he and his friends in the youth movement rented. Later on he never got the permanent job he so much needed in a university and this consigned him to great financial insecurity. It also pushed him into the world of freelance writing which in turn meant that he had to be responding quite immediately to changes in the world around him. He was writing, from a critical perspective, about culture, and, in an underdeveloped field of study, he was grappling for the kinds of concepts and vocabulary which would best serve this purpose. What we find in this work is by no means restricted to journalistic comment, or indeed to what today might be called cultural journalism. There is instead a sustained critique of culture as a great unfolding history of ideas, and we also find a critique of culture as something cut off and separate from everyday life, which can be parcelled off for study in the traditional mode of, say, art history. In 'The artist as producer' Benjamin is using and extending an explicitly Marxist vocabulary in an attempt to understand not just how art relates to the world of production but how it *is* a form of production. He wants to demystify art by demonstrating those skills and practices which constitute the work of the artist. New technology also provides the means of overcoming the traditional boundaries which have separated the artist from the audience. It is here, in this space, that art can change itself. These ideas were immensely influential to critics and writers of the new left like John Berger, Hans Magnus Enzensberger and, in the US, Susan Sontag, and they also prefigured much of Barthes's early writing, particularly his concern with the photographic image, with aspects of popular culture and of course with 'the death of the author'.

There are other small but important ways in which Benjamin opened up for study areas which had been ignored as having little if any cultural value. In this way too his work can be seen as an important precursor of cultural studies. In the essay on Edward Fuchs, the historian and collector (Benjamin 1979), Benjamin argues that Fuchs's interest in caricature, erotic art and 'manners' (what we would now call popular taste) pushed him into developing a language which was at odds with the official language of art criticism. The objects which Fuchs was interested in were not reconcilable with the vocabulary of high art. Fuchs's hobby (he had 'a Rabelaisian joy in quantity' (1979: 373) as a collector allowed him insight into the world of the trivial, the popular, the subordinate world of mass culture. 'It was the collector who found his way into grey areas . . . caricature, photography' (1979: 361). And, because he was also a powerful editor of an influential journal, Fuchs was able to undertake the 'popularization of knowledge' by using the mass media to address the masses. The way in which Fuchs's work reflected on culture as a living historical process encouraged Benjamin to develop a clearer conception of historical materialism as a critical force which 'conceives historical understanding as an after-life of that which is understood, whose pulse can still be felt in the present' (Benjamin 1970: 62).

'A small history of photography' (Benjamin 1979) is equally packed with the kind of insight and analysis which have been so influential on cultural studies.

In less than eighteen pages and with astonishing density Benjamin introduces what were to become the major thematics in the analysis of photography in the 1970s, including the destruction of 'aura' as a result of reproducibility of the image, the challenge of art which photography mounts and the extent to which it poses the question, not whether it counts as an art but if art can itself still exist after photography. Benjamin also considers the relation between the photograph and the caption anticipating Barthes's seminal work on text and image (Barthes 1977) and even the title of John Berger's *Ways of Seeing* is taken from this essay, when Benjamin suggests that photography brings about a revolution in how we see. The close attention to the technology of photography and its effect on the image also foreshadows much of Barthes's later work in *Camera Lucida*, and the whole curious, fascinated and even enchanted tone of the essay proved inspirational to Susan Sontag's *On Photography* (1979).

Most important perhaps is Benjamin's refusal to be constrained by the kind of academic mode which insists on conventional scholarship, on precise periodization, on the accumulation of facts, on naming, dating and conferring value. Instead Benjamin ruminates on photography. He explores the world of the photograph, not only suggesting the way in which the image could now be mass produced and could thus be everywhere in culture, but also evoking his own pleasure in the photographic image, the sense in which, as he was later to explain in the *Passagenwerk*, it epitomizes his notion of the 'dialectical image'. 'It is the illumination of these sparks that the first photographs emerge, beautiful and unapproachable, from the darkness of our grandfathers' day' (Benjamin 1979: 257). The photograph connects the past with the present by supplying the 'pulse', the rhythm and the motion of historical process, not as an unbroken chain but as a jumble of fragments and 'snapshots'. History is therefore connective but not linear, contingent but not without a pattern, a momentum, a force which could be challenged or transformed.

Many of these ideas are further developed in 'The work of art in the age of mechanical reproduction'. The cult of genius and of creativity is exposed and the emergence of a mass market for art, as a result of technological reproducibility, allows Benjamin to celebrate the final sundering of the ties which have linked ideas of art with those of ritual, originality, aura and eternal value. From now on, argues Benjamin, the work of art can be designed for, rather than against, reproducibility. Benjamin in effect created here the possibility of a non-canonic language of cultural criticism which, set against the rapid rise of fascism, also recognized the urgency of attempting to understand the politics of mass art and mass communication. In such circumstances there is no looking back with nostalgia for a moment when art could afford to be socially or politically unconnected, and when value could be debated in a more leisurely academic mode.

Finally there is in Benjamin's work a thread which is perhaps more evident now, in retrospect, than it was in the 1970s. As 'A Berlin chronicle' shows with great clarity, Benjamin was himself politicized not just by the broad social events which were happening around him, by the growth of anti-Semitism, for example, but by the constraints and the hypocrisies of bourgeois society as they imposed themselves on the life of the young adult. The youth movement which Benjamin belonged to was greatly concerned with the 'brutalities' of middle-class family life,

with the absurdities of sexual decorum which made it impossible for young people of both sexes to mix freely together and with the rigid authoritarianism of the education system. In this context the city itself (and the public sphere of freedom which it opens up in the form of entertainment and display), the prostitute, and the proletariat, play the role of the 'other' to whom and to which Benjamin inclines himself. He describes the pleasures of crossing the 'threshold of one's class' by procuring the services of a prostitute on the street for the first time. Later, in the *Passagenwerk*, this is an image and an experience which is at the heart of Benjamin's understanding of modernity. But in 'A Berlin chronicle' it is a fleeting, symbolic escape from his class of origin. It acquires heroic stature in his writing just as the prostitute and the brothel are key landmarks in his mapping of the modern metropolis.

Both of these identifications and inclinations, for the proletariat and the prostitute, had meaning and significance for the new left of the late 1960s. That is to say, they registered in the dominant political vocabulary of the moment. But on both counts, it is a good deal more complicated now. Benjamin's relationship to the world of prostitution might be seen, after twenty years of feminist debate and scholarship, as no different from that of any of his middle-class counterparts of the period. The prostitute remains a shadowy, anonymous figure in his writing. As in the writing of Baudelaire (on whom Benjamin wrote at least one volume and copious articles and notes) she is, at most, a fellow deviant, another outsider. Benjamin notes that she is a commodity, a 'mass article', but he takes this no further, preferring to remember the more pleasurable function of the prostitute and the even greater excitement of seeking her out. In 'The image of Proust' he writes, 'Anyone who has tried to get the address of a brothel in a strange city and has received the most long-winded directions . . . will understand what is meant here . . . and last but not least Proust's intransigent French spirit' (1969: 209).

The critique of bourgeois society (and Benjamin shows no influence of feminism in his writing); the turning to the proletariat and to the politics of class as a means of overthrowing the old order; the links with the Communist Party particularly through the influence of his lover Asja Lacis but the rejection of the party in preference for a concern with culture and with political independence; the refusal to side with those on the left who underestimated the power of fascism, and the recognition on his part of the 'powers of enchantment' which Nazism offered; the refusal perhaps to believe in Marxism as a redemptive force which could at the last moment change the tide of history as it was slowly closing in upon him; the small pleasures which could rally his spirits and rescue him, if temporarily, from despair and helplessness; the forms of these pleasures (small objects, fleeting sexual encounters), the place of these pleasures (in the city, on long walks, surrounded by the signs, landmarks and technologies of modernity) and the sheer excitement and sociability of these excursions: all of these describe not just a man, but the makings of a left culture, very different from the one we now inhabit, but one which we none the less have inherited and which we have looked to for a sense of our own place in history. It is, then, as a cultural intellectual that Benjamin plays so important a role, a figure who in every way experienced, sought to understand, and suffered at the hands of modernity. As Zygmunt Baumann has recently argued, the Holocaust

and the rise of Stalin were as much part of modernity as the palaces of consumption (Baumann 1989). Walter Benjamin occupies the space of modernity. White, male, middle-class and European, he is both a representative of and a critic of that moment which was so formative for the new left generation of the late 1960s who turned away from the anti-intellectualism of the 1950s and 1960s, and away from the conservative world of establishment high culture, and went back instead to the time of Brecht and Benjamin where the politics of art was fiercely debated, and where low culture was already recognized as a powerful force offering many opportunities for political intervention.

Precisely because none of the 'advantages' of being white, middle-class and male saved Benjamin from the forces of history and from fascism, he might be seen as a symbol of European modernity in all its complexity. While some might now argue that the entire edifice of cultural studies was erected around the Eurocentric values of a small number of writers and intellectuals who had no interest in or understanding of their sexual or ethnic subordinates, this should not mean that we expunge their work from our own intellectual history and formation. To do so would be to refuse the challenge and the contradictions of history and to participate in the same kind of wilful forgetfulness which Benjamin frequently warns us against.

The *Passagenwerk* and *The Dialectics of Seeing*

Benjamin offered a more constructive way forward for the study of mass culture and popular culture than many of his counterparts, particularly Adorno (Adorno 1967). Despite the difficult circumstances of his life, he displayed, in his writing, a distinct enjoyment of the pleasures of urbanism, a particular enjoyment of place, and of getting lost or straying in the city, a love of café culture as well as a fascination with shop windows and with the commodities they so proudly displayed. This capacity for enjoyment intensified rather than blunted his critical faculties and led him to examine the historical processes which gave the items, the objects and the urban areas or districts, their cultural meaning. Benjamin was also pioneering a new way of writing about culture characterized by a sense of uncertainty, a welcome rejoinder to the more emphatic Marxist orthodoxy on art and culture which held sway at that moment. Looking back, this sense of uncertainty, this force of prevarication, could be seen, not as pessimism or faint-heartedness but rather as an unwillingness to profess a *faith* in Marxism, to embrace it as something which would somehow come to his rescue. A major part of Benjamin's critique of commoditization lay in the way in which it naturalized the process of its own production and presented itself as synonymous with progress. Benjamin disputed the idea of progress, historically and philosophically. He could not therefore participate in that account of Marxism which saw history as moving, progressively, towards socialism. As a result, his writing bears the mark, almost always, of the present or of the recent past. As many critics have since pointed out, it is the discarded ruins, the recent remains, the small trinkets and souvenirs of consumer capitalism and modernity which interested Benjamin and which were his raw materials. Benjamin sought out the older shops and café corners and the

crumbling arcades of the cities in which he lived, rather than the magnificent boule-
vards or great buildings which so clearly expressed the bold modernist confidence
of their architects. From watching and walking 'botanizing on the asphalt' (Benjamin
quoted in Buck-Morss 1989) he developed a cultural vision of the city as layered
and labyrinthine rather than as being simply the highest expression of bourgeois
civilization. It is this circumspect, convoluted and sometimes seemingly perverse
mode of analysis which makes Benjamin a figure towards whom writers on post-
modernity have recently turned.

Susan Buck-Morss's *The Dialectics of Seeing: Walter Benjamin and the Arcades Project*
(1989) is, as she points out, a work of reconstruction. For over thirteen years,
between 1927 and 1941, Walter Benjamin had thought about, talked about and
prepared in note form what was to be one of his major pieces of work. The arcades
project was to be a theory of modernity, a philosophy of history, a verbal montage
of urban imagery, and a reflection on the meaning of consumer culture from the
viewpoint of memory and experience. But this ambitious project which also came
to represent a kind of unifying umbrella for Benjamin's entire *oeuvre* was destined
not to come to fruition but to remain as fragments, notes, ideas and a series of
longer pieces. What remains of the arcades project has been known about and
discussed among Benjamin scholars in the UK, in the US and in Germany for some
time, but the work of translation and publication has been hindered by precisely
the difficulty in assembling the material in book form. In Germany, it is available,
but US and British publishers have been less certain of a market for this kind of
work. The *Passagenwerk* notes and fragments were first brought together and edited
by Rolf Tiedemann in 1982. Susan Buck-Morss set herself the task of assembling
these fragments for publication in English while retaining a commitment to the
original fragmented 'montage' method of argument.

It is in the arcades project that Benjamin's more ambitious theoretical aims
are pursued. As various critics have pointed out, a good many of the ideas in this
work owe more to his earlier work on German baroque tragedy than to the Marxist
ideas found in the two seminal essays mentioned earlier, 'The work of art in the
age of mechanical reproduction' and 'The artist as producer'. The arcades project
has to be seen as a work which not only remained incomplete but which shifted
and changed over the years in which it was being formulated. In some ways it is
more like a diary, or a record of Benjamin's responses to history, philosophy,
modernism and surrealism, as well as an attempt to theorize aspects of mass culture
in the context of Europe on the brink of fascism.

What we find in Buck-Morss's book is an exposition not just of the *Passagenwerk*
but also of the other fragments and shorter pieces which have been referred to by
critics but not as yet put into the context of Benjamin's larger project. Buck-Morss
achieves an admirable balance between coherence and looseness in her reworking
of the *Passagenwerk* material. She has managed to remain faithful to the method
pioneered by Benjamin while also extending it into a commentary on contempo-
rary urban life in the late 1980s, by drawing on images, photographs and other
source material including advertisements which reflect now what Benjamin
described then as 'dialectical images'.

There is a point, however, beyond which Buck-Morss goes no further. While
Benjamin exists as a writer in *The Dialectics of Seeing*, his work is not seen as it

might be, that is, as a kind of performance art. Precisely because his work resists the search for meaning and understanding which might be expected in more conventional cultural writing or literary criticism, it is, I would suggest, more productive to see Benjamin as fulfilling the role of the writer in the Barthesian sense (Barthes 1977), as one who moves beyond and between genres, and who quite consciously breaks with the distinction between art and criticism, rather as Barthes himself does, who ushers in a new way of writing and a new way of seeing writing.

Without this *The Dialectics of Seeing* is forced into seeking some kind of intellectual resolution in the concepts and ideas found in the *Passagenwerk* which the work itself is incapable of providing. This is particularly true of the 'dialectical image' which Benjamin developed as a means of condensing, into a verbal flash, a few brief sentences or phrases which are simultaneously a representation of and a critique of a cultural event or item. This ambition grew out of Benjamin's admiration for montage techniques in the arts and in photography, and especially in the work of John Heartfield. As his notes suggest, he was as much interested in exhibiting as in writing: 'Method of this work: literary montage. I have nothing to say, only to show' (Benjamin quoted in Buck-Morss 1989: 73). This illustrates Benjamin's aim to create a visual image out of words. The transcendent quality of these verbal images, the possibility of creating in a few words the kind of complex analysis and statement which John Heartfield produced in his photomontage work, requires on the part of the critic a conceptual leap. It means seeing Benjamin not only as a cultural theorist and as a historian but as a cultural practitioner. Benjamin is creating and practising a new and more active mode of cultural analysis and criticism. The analysis takes place inside his verbal images and aphorisms.

The problem is that even if we demystify art from notions of talent or genius, doing 'art work' still requires its own techniques and skills, learned and practised over the years. In the case of Benjamin, sometimes his method works with quite startling results – for example, in the image of the angel of history; but just as often it results in infuriatingly pretentious and self-important sets of statements. Despite this, a case can none the less be made for Benjamin as an experimentalist, a writer endlessly trying to adjust in language to the irreversible advances which have taken place in the visual mass media. It seems as though Benjamin wants to work with words as though they were images. This has repercussions for how we respond to the work. If the *Passagenwerk* is in part a compilation of prose images, then the conventional work of exposition and critique is no longer appropriate. The *Passagenwerk* instead asks of us that we sit back and read it as a series of often disconnected fragments, an exhibition or a performance, not as a conventional academic text.

That Benjamin became a practitioner in words of the kind of art work whose methods and strategies he most enjoyed and discussed at great length, should be no real surprise. He disliked the academy even though he sought, unsuccessfully, to earn a living there. His closest friends and the figures who influenced him most were creative artists. He occupied exactly that space of the writer which Barthes was later to espouse and himself represent where, as a point of principle, criticism and creative writing merge into each other and dissolve as separate categories, where fiction and non-fiction also overlap, and where the death of the author coincides with the birth of a different kind of writing and writer. The *Passagenwerk*

should be read then like a modernist novel whose major influences were the growth of the cinema and photography, a series of speculations and reveries on urban culture, a surrealist documentary, a creative commentary.

This still leaves the critic with the difficult job of trying to evaluate the work. Buck-Morss reminds us of Adorno's disappointment with the project and his hostility to its unconventional methods. It is certainly difficult, if not impossible, to categorize it neatly as philosophical history, or as a sociology of consumer culture, or even as a lengthy piece of journalistic reportage. At many points in Buck-Morss's text there are repetitions and passages that simply do not make sense. The value that the work might have for cultural studies depends therefore on how we view it. While it certainly yields no unified account of modernity, it does exist, in my opinion, as a text of modernity, a lengthy, rambling, unedited piece of footage with a repetitious, irritating but compelling voice-over.

The form which Buck-Morss's compilation document of the *Passagenwerk* takes is as follows. Parts One and Two trace through the appearance in the work of four main threads. These are the fossil, the fetish, the wish-image and the ruin. Part Three examines the broader context of the work including its political and philosophical achievement, and Part Four takes the form of a visual homage to Benjamin's work comprising images and art work drawing on the contemporary world of mass culture. In Part One, Buck-Morss considers the temporal and the spatial origins of the *Passagenwerk* project. First there is the context within which Benjamin embarked on the arcades work. *One Way Street*, first published in German in 1928, is seen as a key influence on what he was going to do. *The Origin of German Tragic Drama* also reflects what was to be for Benjamin a lifelong interest in the idea of allegory. In the second chapter Buck-Morss describes the cities in which he lived during the late 1920s and the way in which he wrote about them. She shows him to be strongly influenced by Proust, by the work and ideas of his friend Franz Hessel, by the work of the Surrealist movement, and by the politics of his Russian lover Asja Lacis who at the time was working for an experimental children's theatre in Moscow and was also a colleague of Brecht. Part Two of the book brings the reader more directly into the heart of the arcades project, with Buck-Morss acting as a guide and interpreter. In 'Natural history: fossil', the fossil is where, according to Benjamin, nature and history merge together so that they cannot be prised apart. The symbiotic way in which historical change is subsumed under the guise of natural change also leads Benjamin to reflect on the real rather than the mythic relation between the two. This interest in natural history was to run through the arcades work, in part a reflection of Benjamin's concern with the recent past, and in particular with the late nineteenth century when a more widespread fascination with natural history created a profusion of 'natural' images whose reproduction was made possible by advances in technology. Two additional concerns arise here: the notion of how Germany's 'natural history' might be alternatively constructed and the way in which John Heartfield's photomontage work represented an example of such a non-linear historical method, i.e. the creation of a modern-day emblematics, a visual rendering of the 'natural history' of Germany by allegorical means. Benjamin then takes up and adapts the photomontage form for his own purposes in the arcades project by pointing to the presence of the 'montage effect' already in existence in the cities through the 'piling

up' and layering of neon and advertising which in turn become part of the architecture, and part of the visual experience of urbanism. As in so much of his work, Benjamin sees, in what has recently come into existence through new technology (what Buck-Morss calls the 'new nature'), a kind of dialectics at work. The effect is both fettering and emancipatory. Technology secures old relations while unleashing new ones which are as yet unimagined and hence unincorporated into the existing social arrangements. Drawing also perhaps on Brechtian ideas, Benjamin claims montage (itself the product of technological innovation) to be progressive because it 'interrupts the context into which it is inserted'.

In the section on the 'fetish', Buck-Morss introduces the complexity of Benjamin's thought in relation to consumerism. It is the vision of urban brilliance which pushes Benjamin to compare the city with the 'enchanted forest' of children's fairy tales. The new consumer goods displayed in abundance, as well as the new urban experiences dreamt up to celebrate these forms, including the world expositions, the arcades, the panoramas and the lavish window displays, transform the city beyond the realms of the imagination and at the same time create a new public sphere produced not by artists and writers but by designers, commercial artists, copywriters, photographers, engineers and technicians. The sheer scale of their work (the toothpaste advertising billboard 'toothpaste for giants') contributes to the grandeur of this new dream world, a monumentalism which for the first time incorporates at a 'dream level' not just the aspirations of the ruling classes but also, in the form of the mass-produced commodity, a kind of popular utopia.

The contents of the wish-images of consumer capitalism (outlined in chapter 5 of *The Dialectics of Seeing*) are similar to the utopias of pre-industrial folklore or fairy tales. Their dialectical character exists in the way they are, on the one hand, products of a class-divided society, but on the other they also look forward to a more equal society free from scarcity and conflict. Benjamin's aim is to find a way of making conscious this 'desire for utopia' by somehow unleashing the potential of technology to make it work for social transformation rather than working as it does at present merely for the maintenance of the soporific 'dream state' brought about by the fairy-tale luxury of this new image world. The dialectic exists in that space between what Buck-Morss labels the sign and the referent. Fashion, for example, is a ritual of commodity worship, yet it is also progressive in its irreverent attitude towards tradition and in its vivid dramatization of change. Similarly, as Buck-Morss describes later in the book, the dream state cuts the individual off from others while at the same time creating a shared or collective experience by virtue of the mass availability of the dream material.

The ruin, the fourth of Benjamin's thematics, reminds us of the other side of consumer splendour, that which is deadly, repetitious and even hellish in its endless evocation of novelty. The image of the 'ruin' is also a symbol of the fragility of capitalist consumer culture; the transitoriness of fashion, for example, precisely because of its increasingly desperate attempts to preserve youthfulness and thus also halt the flow of time, ends up evoking death and decay. There is then a ruinous quality lurking just beneath the surface smiles of the fashionably dressed mannequins, the show girls and of course the prostitutes. Capital festers and decays from within and, as it does so, so also does it continually attempt to 'tart itself up'. Much of this section draws on a combination of Baudelaire's poetry and

Benjamin's work on the baroque. If, as Buck-Morss says, 'Dialectical images are a modern form of emblematics' then 'in the *Passagenwerk* the devaluation of the new nature and its status as ruin becomes instructive politically. The crumbling of the monuments that were built to signify the immortality of civilisation become proof rather of its transiency' (Buck-Morss 1989: 170).

Of the remaining chapters of Buck-Morss's volume it is the 'Dream world of mass culture' which draws together the fragments of the argument. She suggests that the *Passagenwerk* does indeed manage to convey the quality of historical experience through the dialectical image and the theory of montage even though the work itself frequently takes a literary or poetic rather than a critical or analytical mode. This 'mode of enchantment' which comes through in Benjamin's writing is also central to his argument which is that underneath the rationalization which creates the possibility of urban modernity, underneath the planning and the bureaucracy, lies a much more mythical landscape, a kind of undergrowth of chaos and abundance, of new consumer goods which quickly take on the character of ancient, pre-industrial symbols to the extent that the whole landscape can be viewed as a series of heavily iconographic signs and symbols. It was both the mundane objects and the extraordinarily endowed 'stars' of mass culture which the Surrealists brought together in their own unique dream landscapes. Benjamin seeks to do something else with these same evanescent objects and images. He wants to use them as a means of waking up the masses from the slumber which, in their conventional representation, these wish-images invoke. With some difficulty Benjamin embarks on the work of explaining how, with the help of these objects (already overloaded with historical and mythical meaning), 'the collective' can empower itself by 'reconstructing the capacity for experience'. It is never quite clear in Benjamin's work how this can happen. But there are, however, the potentialities for change, including first, that 'technical reproduction gives back . . . what technical production takes away', second, that the availability of technically produced images allows a 'new capacity to study modern existence reflectively', third, that the unconscious wish-images hidden deep in the structure of the objects of consumer culture can be somehow brought to the surface, and, fourth, that it is also possible to read into and from the other discarded images, those which have only recently gone out of fashion, something useful and important about the conditions of their historical production. The potential for unlocking a kind of 'popular memory' lies in the substance and materiality of the childhood toy, or the now old-fashioned item of clothing.

There is, of course, a huge amount of other material included in *The Dialectics of Seeing* which cannot be summarized here. What remains to be done is to assess the significance for cultural studies of the highly condensed, heavily imagistic, highly imaginative but frequently cryptic ideas put forward by Benjamin in the *Passagenwerk*. Part of Benjamin's plan was to challenge the immediacy of the present and the 'dream state' which mass culture induced, by recovering a sense of history. But what history and how? Benjamin was well aware of the power of what we would now call the ideologies of history, transmitted through culture and through generations, and of the role these play in creating a mystified understanding of contemporary reality. Without the aid of the concept of ideology but with a clear sense of the need for constructing an alternative history and an alternative

historiography, Benjamin proposed that the everyday objects of industrial culture, particularly those entering a kind of twilight age in terms of their usefulness or attractiveness, could be rediscovered and rendered useful again in what he envisaged as a project of remembering and understanding the dynamics of the moment of their creation. This was indeed a radical proposal reflecting an outright rejection of conventional history in favour of a non-linear history, one which corresponded to the definition of history offered by his friend and colleague Bloch: 'A polyrhythmic and multi-spatial entity, with enough unmastered and as yet by no means revealed corners'. For Benjamin the task was to unravel the meanings of the discarded items lying in these dusty corners.

The Paris arcades, already in Benjamin's time well past their 'sell-by date' and replaced in grandeur by the new and luxurious department stores, could be looked to as a 'precursor of modernity', a set of buildings which the everyday life of the present rendered almost invisible in their unfashionable status but which precisely because of this eclipsing by progress could be returned to and dwelt upon afresh. In this sense the arcades become emblems, icons of an 'unmastered' past moment not yet defined as historical. The arcades become Benjamin's symbol for not one but a variety of social processes. The grandiosity and scale of their architecture tell us something about the confident way in which premodernity anticipated the rise of consumerism, at the same time their cathedral-like ceilings, the dim light from the windows, and the long passageways like church aisles, flanked on either side not by small chapels to pray in but by chapels of consumption, demonstrated exactly what Benjamin recognized as a recurring theme in the conception of new cultural forms; that is, the tendency to incorporate at some unconscious level familiar and comforting reminders of those things which new technology and social progress and indeed which the new object itself make redundant. This looking back to the non-contemporary signifies not simply nostalgia but rather a stirring of discontent or dissatisfaction with the present, a deeper anxiety which cannot be extinguished even by the brilliance, the luxury and the apparent mass availability of the new.

This dimension does indeed draw us into a deeper level of thought, one which is continually present in Benjamin's work but which remains difficult to extrapolate. Benjamin is concerned with the way in which the present bears traces of the recent past within it and with how popular sentiments are embedded into the materiality of the objects which themselves are evidence of and embody the process of historical change. His interest is not then in how great architects, urban planners and designers combine their imaginative skills with the technology and political and ideological power at their disposal, but rather with a more dispersed, more general 'structure of feeling' (Williams 1965) which brings to bear on these forms and environments a more popular strain, a vernacular. But this is not a question of bricolage, it is not just how 'they' (the collective) add their imprint to an environment, an economy, and a mode of production not of their own choosing. Instead it is about how utopian hopes for emancipation come to be embedded right inside the cultural objects and artefacts, from the point of their inception and design, and how these 'wishes' have to be heeded in the act of refashioning the future.

Benjamin is here providing us with a kind of prehistory of urban modernity through the currency of the commodity. There is, in the commodity form and underneath the glossy packaging and all the promises of the new, a pre-history

which includes a 'backward' anti-capitalistic impulse. It is only very recently that theorists like John Fiske and Michel de Certeau have attempted to unravel a similar dynamic in contemporary consumer culture. As Fiske writes, 'The commodities produced and distributed by the culture industries that are made into popular culture are those that get out of control, that become undisciplined . . . The economic needs of the industries can be met only if the people choose their commodities as adequate resources for popular culture . . . and they will choose only those texts that offer opportunities to resist, evade, or scandalise' hegemony (1989: 104–5).

Modernity desperately seeks to deny the presence of volatile and unstable elements. One way of doing this is by attempting to stifle their memory by simply producing more and more objects for more and more people. It is this aspect, along with the simultaneous rapid change and deadly repetition brought about by modernity, which leads Benjamin to describe it as 'hell'. Fashion, according to Benjamin, is hellish because, despite its irreverent attitude towards tradition (mentioned above), it intensifies and accelerates the act of social forgetting, indeed is predicated on it. Benjamin returns repeatedly to fashion, though it is significant that he links fashion with prostitution and that he also takes it as emblematic of the trivial and of course of the feminine. Fashion, he claims, is both the invention and the archetypal symbol of modernity. Its denunciation of the recent past (i.e., of last season's styles) must be challenged if we are to understand the way in which utopian or emancipatory ideals manage to find some latent expression in mass culture.

There are problems and inconsistencies in Benjamin's ideas on fashion, as there are in his whole understanding of the cultural meaning of the commodity form. There is no point in pretending these can be easily explicated and then found a place in cultural studies alongside existing work on this area. In Benjamin's favour, however, it could be said that in his own way he recognized, long before popular culture existed as a topic of any academic or political debate in Britain, what since has been called the 'multi-accentuality' of the sign, the instability of meaning, its capacity for change and the extent to which historical change itself was condensed and encapsulated in the forms and the meanings of the consumer goods which filled the display shelves of the shops and arcades. He also recognized that the commodity worked, for the mass of the people, primarily as an image. They could look but not buy, or at least the rate of buying lagged far behind the opportunities for looking. What they were looking at, whether 'window-dressed' or photographed and put on the pages of the magazines, were texts replete with meanings which were activated, however, only at the point of reception. In fashion Benjamin also, and not surprisingly, brings to bear the baffled, fascinated but also patronizing gaze of the male writer. He looks in bewilderment, finds some cause to retrieve positive elements, but remains more firmly on the side of disapproval as bourgeois culture celebrates itself by so lavishly renewing itself in fashion each season. Benjamin's uneasy relation to women, the absence of any sense of sexual politics in his writing and the constant references to the charms of the prostitute, make it unlikely that in discussing fashion he might consider the fact that here 'disruptive' elements exist all the more forcefully. Benjamin does not consider, for example, that, for women, fantasies of emancipation might well take shape in and through the language of fashion.

Benjamin's aim in the *Passagenwerk* remained incomplete. It is, in effect, to develop a theory of culture, which is also a form of cultural practice. But the people or the masses possess only a metaphorical presence here. Even as a *flâneur* (the emblem of the emptiness of modernity) Benjamin exists in a strangely depopulated urban landscape where only the prostitutes, pathetic in their state of physical decay, and as such entirely appropriate to their chosen business environment, the upper floors of the deserted arcades, hang out. They too are discarded 'mass articles'. Benjamin's turning away from the people or from the interactive dimension of consumer culture was no doubt a philosophical as well as a methodological decision. His cultural theory is one of objects rather than of social relations. As a consequence it makes it even more difficult to unravel or extend the meaning of this shadowy presence of living people and their utopian impulses in everyday goods and artefacts. Where exactly do these come from, what do they mean? Is it the idea of an abundance where there is enough for everybody, which provides the anti-elitist, democratic spark? If so, is this a kind of nascent or transcendent class consciousness? Or is it a historical residue, a reminder of an earlier folk culture where the fruits of the land were not entirely controlled by the laws of bourgeois property? Or, is Benjamin relying on the Marxist idea that capitalism contains within it the seeds of its own destruction and that signs of this transcendence can indeed be caught sight of in everyday life? The problem of clarity here is compounded not just by the note form in which so many of the *Passagenwerk* ideas are jotted down but by the fact that, having gone so far, Benjamin leaves off and continues his analysis by casting his gaze back to childhood.

There is the way in which consumer culture enters into our unconsciousness by providing the raw material for our dreams. We do not just dream of any old tie or any old pair of shoes, but of those shoes or ties which are themselves emblematic of a particular social moment. In this sense fashion enters into and gives shape to our internal and unconscious thought processes. Likewise in memory, the fondly remembered moment where the child is clutching at the mother's skirt, contains not just some archetypal skirt but a skirt of that moment, a commodity of consumer capitalism for which the passage of time is as merciless as it is for its wearer. It is like saying that commodities chart part of our lives, they constitute our reality, they are the fabric of the culture in which we live, they are not just commodities.

But it is to childhood which Benjamin repeatedly returns, and to many of the ideas and experiences recorded in his 'Berlin chronicle' which are given a more theoretical treatment. These include remembering the shopping expeditions with his mother, the huge variety of luxury goods delivered to their Berlin apartment as a result of his father's business contacts, and also the way in which his family was socially positioned at the forefront of modernity, a position which was later to prove so tragic for them. Before the rise of Nazism, Benjamin's father had a financial stake in the first artificial ice rink in Berlin which Benjamin also remembered as being both an 'ice palace' and a nightclub where he caught sight of a prostitute dressed in a sailor suit, a figure who subsequently became a source of fantasy and desire.

Benjamin was fascinated by the often unnoticed but daily signs of contemporary urban life, the sandwich men, the gas stations, the neon signs, the women's fashions, the brightly lit shop windows. He was most drawn by those recently

discarded objects existing still in what Buck-Morss describes as a 'half-life'. Such commodities seemed to be emblematic of the passing of time which was peculiar to modern capitalism. To Benjamin their place in the history of modernity was particularly important in that they represented an earlier moment, where modernity was just in sight, and where it was more possible, as a result, to recognize some of those utopian elements which existed alongside, but were not as yet wholly taken over by, consumer capitalism. It was these impulses which gave Benjamin some hope that through the object and the commodity form there could be expressed wishes and ideals other than those merely of acquisition, wealth and private property.

In approaching consumer culture from this angle Benjamin was also trying to pull back from the grip of 'bourgeois capitalism' its hegemony over all that it produced and the historical conditions of that production. If the objects possessed the ability to enchant and be forgotten, then Benjamin would describe another mode of enchantment which occurred in and through these same objects and which in the process of being revealed and remembered could play an active role in the re-enchantment of society (i.e., through the revolutionary process). Benjamin therefore offers another history of place, space and culture through reading its objects backwards. Hence the arcades project itself. By the 1920s and 1930s the arcades existed as exemplary symbols of the ever-changing experience of modernity. Their crumbling façades, their ornate glass ceilings, the lavish iron-work, the atmosphere of the luxury of the recent past, the forlorn items left standing in the windows, once the epitome of fashion but now hopelessly old-fashioned, all of these provide Benjamin with a rich source of raw materials from which he was to produce his verbal slide show of 'cognitive images'.

There are a number of points which remain to be made in relation to Benjamin as looked at from the perspective of cultural studies. Some of these have been mentioned already, in passing, and require a few further words, others are more open-ended, questions which Benjamin, in his own indirect way, might ask of cultural studies now. Benjamin's distinctive and imaginative mode of argument coheres around the idea of 'looking back'. While he too is entranced by many of the signs and sights of urban modernity, he obstinately insists that we hold the tide of rapid change at bay by looking at the recent past. However, he is not proposing a full or a linear historical account of the late moment of pre-modernity. Instead, his method is to work in and through the 'dialectical image'. Thus he chooses the painting by Paul Klee titled *Angelus Novus* as an opportunity to reflect on the process of historical change. Where capitalism celebrates itself and its achievements and victories with 'great monuments to mythic progress' (Buck-Morss 1989: 93) Benjamin looks to this painting as a representation of a different way of seeing. Here the 'angel of history' who 'looks as if he were about to move away from something at which he is staring' sees not a 'chain of events' but a series of catastrophes which appear like a pile of wreckages in a scrapyard. Progress is that 'storm' which is carrying the angel forward through space and time, against his will. With his back towards the future he fixes resolutely on the scale of the damage below him. It is characteristic of Benjamin to look to a small, delicate and modernist work, like Klee's painting, to demonstrate the power of the image itself and to use it as a means of illustrating his historiographical approach.

Not only does Benjamin continually remind us of the need for history but his method proves particularly appropriate to cultural studies. A more radical use of history like that developed by Benjamin would complement existing work on popular images and textuality. If the precise way in which this might be done is clouded by his use of poetic language, where his own 'text' is condensed almost to the point of obscurity, then this should not, as perhaps it has in the past, lead us to dismiss the value of Benjamin's 'other work'. Of course he was influenced by Baudelaire, of course he was sitting in the street cafés of Paris and Berlin composing prose images which he then set to work in the name of cultural history, theory, or philosophy. What he was doing was a kind of archaeology on the commodities and images of consumer culture. But this is not so far removed from our own contemporary practice of semiology. It is a cultural history in the most literal of senses, a style of writing and a mode of work which could perhaps be compared with Dick Hebdige's many 'readings' of images drawn from the world of contemporary pop culture, in particular the skinheads photograph which is the focus of attention in the essay entitled 'Hiding in the light' (Hebdige 1988). It is also strongly reminiscent of Hebdige's use of the image of the car in his run-down inner-city street, transformed by its owner into a kind of temple, 'a cathedral among hovels'.

The second way in which Benjamin's interest in history is of value to cultural studies in the 1990s is in the challenge he poses to the way in which history is actually done. He is arguing for a sense of recent history to be continually with us in our inhabiting of the present. This requires some effort for the reason that we live in a consumer culture predicated on forgetting or else on highly selective remembering, e.g. through nostalgia or the 'heritage industry'. But it also raises a number of additional questions. Which recent history? How is that history to be chosen? According to what criteria? The *Passagenwerk* is a history and documentation of selected items drawn from the 'window' of urban life as seen by Benjamin. What characterizes his chosen images is that they have become less visible as a result of their age. However, they are by no means old. It is rather that the pace of historical change has accelerated as a result of the technological and social changes brought about by this later stage of industrialization. These 'emblematic' goods have been outmoded by the abundance of the new. History is then doubly a fiction. It is not the passing of time but the pacing of capitalist production manifest in the language of consumer culture.

Most important to Benjamin's work is the immediate history of the time in which he himself was writing. Fascism too had an unnatural, almost magical ability to naturalize itself. It had quickly understood the power of the mass media and the power of myth and ritual. Benjamin's historical method was also a riposte to the grandiosity of fascism, to its claims of universalism, to its monumental vision. Declining the redemptive, grand narrative of communism, Benjamin persevered against the odds with his modest, *imagistic* practice of cultural history.

Benjamin tightly grips on to the past, like a child clinging on to his mother's hand. He carefully records and analyses the small pleasures and enjoyments of the present in which he feels the 'pulse' of the past. Benjamin's best work is fuelled by a love of culture, a love of collecting cultural items, including books and picture postcards, and by a love of those urban experiences which are not conventionally

the subject of academic study (e.g. walking, café culture). These strands of thinking put him at odds with the left in Germany at the time (with a few exceptions, including Bloch, to whom he owed a great deal in his conception and writing of the *Passagenwerk*).

It often seems as though he was writing against the inexorable forces of history and fascism rather than in favour of socialist revolution. Uncertain of Marxism as a political practice or as a theory of history, Benjamin pursues his own singular path, drawing on Marxist ideas, and influenced by Brecht and Lacis on questions of art and culture, but concerning himself in the *Passagenwerk* with modernity as a multi-layered social reality, one which could be grasped only in the form of the philosophical fragment, the 'dialectical image', or in the note form itself. This kind of writing was also a literary experiment, an attempt to create a new practice of theory, history and philosophy which could be compressed into a series of tightly worked prose images. These fragments become the hallmarks of Benjamin's style. For the *Passagenwerk* to be of use to cultural studies it would be necessary for those working in cultural studies to remember the value of experimentation, the importance of interdisciplinarity, the breaking down of the distinctions not just between philosophy, history, literary criticism and cultural analysis, but also between art and criticism, not for the sake of the new, but for social change and transformation.

During the time I was living in Birmingham, one of my closest friends and neighbours was the feminist Soviet historian Lizzie Waters. Because she was married to a Soviet citizen Lizzie was able to travel to and from Moscow regularly, although she had to publish her work under an assumed name. After a long winter in Moscow Lizzie returned to Birmingham with stories of queues and no fruit or vegetables for months. One day she had waited several hours because she had heard that there were frozen chickens available. When she got home with the chicken, a treat for academic friends visiting from Australia, she discovered from the small print on the wrapping that it had come from Germany and that its sell-by date had expired two weeks earlier.

A few weeks later (and still many years before *perestroika*, never mind the coup of August 1991), I dreamed that I did eventually make it to Moscow to visit Lizzie. But when I arrived the city centre was thronged with smiling, well-dressed men and women. There was a festive feel in the air. The architecture was dark and magnificent, like the great gloomy tenements and municipal buildings of my childhood in Glasgow. The shops were full of clothes and domestic gadgetry, but most of all it was the cafés whose light flooded out through the frosty windows on to the street, which seemed like the heart of the city. I eventually caught sight of Lizzie, who waved me over to join the group of friends she was with. The place was awash with colour and warmth. Steaming coffee, hot chocolate and cakes were ordered.

I remember this as a profoundly political dream. The so-called socialist society which I was visiting, contrary to my expectations, provided me with many of the consumer goods and items around which I organise my own everyday life: coffee, for instance, city lights and clothes. (In *Moscow Diary* Benjamin also writes: 'The scarcity of living quarters here creates a strange effect: unlike in other cities, here the streets in the evening are lined with large and small houses with almost every

window lit up . . . you might imagine you were looking at an illumination.'
Sociability and friendship also flourished in this loud, crowded dream environment.
There was no fear, no silence, no guarded words.

Perhaps, in the end, it is not insignificant that one of the ways Benjamin exists
for left intellectuals today is, as Susan Sontag has shown, as an image. We look
back to the many photographs of him, and see what looks like a stubborn scholar,
a reluctant refugee, a critical intellectual. Benjamin understood the pressing need
for change and, more immediately, for the struggle against fascism, but he was
not politically didactic. He was non-dogmatic and non-authoritarian in his thinking
and in his practice. One of the values of his work to cultural studies today is that
while Benjamin, like the contemporary postmodernists, rejects the notion of
progress and rejects history as a straight line, he argues all the more forcibly for
the place of history in the study of culture. For this reason, the sadness and the
suicide are not simply biographical notes. They are part of a recent history which
cultural studies must continue to remember.

Stuart Hall

CULTURAL STUDIES AND ITS
THEORETICAL LEGACIES

EDITOR'S INTRODUCTION

THIS SHORT EXERCISE in intellectual autobiography by Stuart Hall, arguably the most influential figure in contemporary cultural studies, is surprisingly downbeat. That's because it was written at the moment when cultural studies was taking off as an academic discipline in the US, attracting money and notoriety, and triggering an extraordinary theoretical "fluency" or textual "ventriloquism" as Hall puts it. This called into question the discipline's seriousness – read its political commitment – and its history. Here Hall reaffirms the first, using the example of AIDS to argue for theory's "deadly seriousness," and recapitulates a personal version of the second.

While recognizing that cultural studies has many histories and legacies (he has particular difficulty with the "Britishness" of "British cultural studies"), Hall insists that, for him at least, the field emerges out of the 1950s disintegration of classical Marxism in its Eurocentrism and its thesis that the economic base has a determining effect on the cultural superstructure. (Hall does not mention the decline of class as an identity-forming category amongst the young in Britain at that time.) Hall acknowledges that cultural studies has been, and must be, formed in interruptions to its trajectories and perceived mission – notably, early on, by feminism and anti-racism. Nevertheless, he argues, what is stable in cultural studies is a Gramscian understanding of "conjunctural knowledge" – knowledge situated in, and applicable to, specific and immediate political or historical circumstances; as well as an awareness that the structure of representations which form culture's alphabet and grammar are instruments of social power, requiring critical and activist examination. It is this kind of examination that is at jeopardy in a professionalised cultural studies, Hall implies.

It is interesting to think about the relation of this essay to the work of cultural studies dissidents such as Tony Bennett, or to the work of openly philosophical theorists such as Judith Butler, or finally of US critics closer to Hall's understanding of radical intellectual practice but who write in a conjuncture he does not quite share, such as Lauren Berlant and Michael Warner (all collected in this volume).

Further reading: Bennett 1998; Dworkin 1997; Morley and Chen 1996; Morris 1990; Mouffe 1979.

My title suggests a look back to the past, to consult and think about the Now and the Future of cultural studies by way of a retrospective glance. It does seem necessary to do some genealogical and archaeological work on the archive. Now the question of the archives is extremely difficult for me because, where cultural studies is concerned, I sometimes feel like a *tableau vivant*, a spirit of the past resurrected, laying claim to the authority of an origin. After all, didn't cultural studies emerge somewhere at that moment when I first met Raymond Williams, or in the glance I exchanged with Richard Hoggart? In that moment, cultural studies was born; it emerged full-grown from the head! I do want to talk about the past, but definitely not in that way. I don't want to talk about British cultural studies (which is in any case a pretty awkward signifier for me) in a patriarchal way, as the keeper of the conscience of cultural studies, hoping to police you back into line with what it really was if only you knew. That is to say, I want to absolve myself of the many burdens of representation which people carry around – I carry around at least three: I'm expected to speak for the entire black race on all questions theoretical, critical, etc., and sometimes for British politics, as well as for cultural studies. This is what is known as the black person's burden, and I would like to absolve myself of it at this moment.

That means, paradoxically, speaking autobiographically. Autobiography is usually thought of as seizing the authority of authenticity. But in order not to be authoritative, I've got to speak autobiographically. I'm going to tell you about my own take on certain theoretical legacies and moments in cultural studies, not because it is the truth or the only way of telling the history. I myself have told it many other ways before; and I intend to tell it in a different way later. But just at this moment, for this conjuncture, I want to take a position in relation to the 'grand narrative' of cultural studies for the purposes of opening up some reflections on cultural studies as a practice, on our institutional position, and on its project. I want to do that by referring to some theoretical legacies or theoretical moments, but in a very particular way. This is not a commentary on the success or effectiveness of different theoretical positions in cultural studies (that is for some other occasion). It is an attempt to say something about what certain theoretical moments in cultural studies have been like for me, and from that position, to take some bearings about the general question of the politics of theory.

Cultural studies is a discursive formation, in Foucault's sense. It has no simple origins, though some of us were present at some point when it first named itself

in that way. Much of the work out of which it grew, in my own experience, was already present in the work of other people. Raymond Williams has made the same point, charting the roots of cultural studies in the early adult education movement in his essay on 'The future of cultural studies' (1989). 'The relation between a project and a formation is always decisive', he says, because they are 'different ways of materializing . . . then of describing a common disposition of energy and direction.' Cultural studies has multiple discourses; it has a number of different histories. It is a whole set of formations; it has its own different conjunctures and moments in the past. It included many different kinds of work. I want to insist on that! It always was a set of unstable formations. It was 'centres' only in quotation marks, in a particular kind of way which I want to define in a moment. It had many trajectories; many people had and have different trajectories through it; it was constructed by a number of different methodologies and theoretical positions, all of them in contention. Theoretical work in the Centre for Contemporary Cultural Studies was more appropriately called theoretical noise. It was accompanied by a great deal of bad feeling, argument, unstable anxieties, and angry silences.

Now, does it follow that cultural studies is not a policed disciplinary area? That it is whatever people do, if they choose to call or locate themselves within the project and practice of cultural studies? I am not happy with that formulation either. Although cultural studies as a project is open-ended, it can't be simply pluralist in that way. Yes, it refuses to be a master discourse or a meta-discourse of any kind. Yes, it is a project that is always open to that which it doesn't yet know, to that which it can't yet name. But it does have some will to connect; it does have some stake in the choices it makes. It does matter whether cultural studies is this or that. It can't be just any old thing which chooses to march under a particular banner. It is a serious enterprise, or project, and that is inscribed in what is sometimes called the 'political' aspect of cultural studies. Not that there's one politics already inscribed in it. But there is something *at stake* in cultural studies, in a way that I think, and hope, is not exactly true of many other very important intellectual and critical practices. Here one registers the tension between a refusal to close the field, to police it and, at the same time, a determination to stake out some positions within it and argue for them. That is the tension – the dialogic approach to theory – that I want to try to speak to in a number of different ways in the course of this paper. I don't believe knowledge is closed, but I do believe that politics is impossible without what I have called 'the arbitrary closure'; without what Homi Bhabha called social agency as an arbitrary closure. That is to say, I don't understand a practise which aims to make a difference in the world, which doesn't have some points of difference or distinction which it has to stake out, which really matter. It is a question of positionalities. Now, it is true that those positionalities are never final, they're never absolute. They can't be translated intact from one conjuncture to another; they cannot be depended on to remain in the same place. I want to go back to that moment of 'staking out a wager' in cultural studies, to those moments in which the positions began to matter.

This is a way of opening the questions of the 'wordliness' of cultural studies, to borrow a term from Edward Said. I am not dwelling on the secular connotations of the metaphor of worldliness here, but on the worldliness of cultural studies.

I'm dwelling on the 'dirtiness' of it: the dirtiness of the semiotic game, if I can put it that way. I'm trying to return the project of cultural studies from the clean air of meaning and textuality and theory to the something nasty down below. This involves the difficult exercise of examining some of the key theoretical turns or moments in cultural studies.

The first trace that I want to deconstruct has to do with a view of British cultural studies which often distinguishes it by the fact that, at a certain moment, it became a Marxist critical practice. What exactly does that assignation of cultural studies as a Marxist critical theory mean? How can we think cultural studies at that moment? What moment is it we are speaking of? What does that mean for the theoretical legacies, traces, and after-effects which Marxism continues to have in cultural studies? There are a number of ways of telling that history, and let me remind you that I'm not proposing this as the only story. But I do want to set it up in what I think may be a slightly surprising way to you.

I entered cultural studies from the New Left, and the New Left always regarded Marxism as a problem, as trouble, as danger, not as a solution. Why? It had nothing to do with theoretical questions as such or in isolation. It had to do with the fact that my own (and its own) political formation occurred in a moment historically very much like the one we are in now – which I am astonished that so few people have addressed – the moment of the disintegration of a certain kind of Marxism. In fact, the first British New Left emerged in 1956 at the moment of the disintegration of an entire historical/political project. In that sense I came into Marxism backwards: against the Soviet tanks in Budapest, as it were. What I mean by that is certainly not that I wasn't profoundly, and that cultural studies then wasn't from the beginning, proudly influenced by the questions that Marxism as a theoretical project put on the agenda: the power, the global reach and history-making capacities of capital; the question of class; the complex relationships between power, which is an easier term to establish in the discourses of culture than exploitation, and exploitation; the question of a general theory which could, in a critical way, connect together in a critical reflection different domains of life, politics and theory, theory and practice, economic, political, ideological questions and so on; the notion of critical knowledge itself and the production of critical knowledge as a practice. These important, central questions are what one meant by working within shouting distance of Marxism, working on Marxism, working against Marxism, working with it, working to try to develop Marxism.

There never was a prior moment when cultural studies and Marxism represented a perfect theoretical fit. From the beginning (to use this way of speaking for a moment) there was always-already the question of the great inadequacies, theoretically and politically, the resounding silences, the great evasions of Marxism – the things that Marx did not talk about or seem to understand which were our privileged object of study: culture, ideology, language, the symbolic. These were always-already, instead, the things which had imprisoned Marxism as a mode of thought, as an activity of critical practice – its orthodoxy, its doctrinal character, its determinism, its reductionism, its immutable law of history, its status as a meta-narrative. That is to say, the encounter between British cultural studies and Marxism has first to be understood as the engagement with a problem – not a theory, not even a problematic. It begins, and develops through the critique of

a certain reductionism and economism, which I think is not extrinsic but intrinsic to Marxism; a contestation with the model of base and superstructure, through which sophisticated and vulgar Marxism alike had tried to think the relationships between society, economy, and culture. It was located and sited in a necessary and prolonged and as yet unending contestation with the question of false consciousness. In my own case, it required a not-yet-completed contestation with the profound Eurocentrism of Marxist theory. I want to make this very precise. It is not just a matter of where Marx happened to be born, and of what he talked about, but of the model at the centre of the most developed parts of Marxist theory, which suggested that capitalism evolved organically from within its own transformations. Whereas I came from a society where the profound integument of capitalist society, economy, and culture had been imposed by conquest and colonization. This is a theoretical, not a vulgar critique. I don't blame Marx because of where he was born; I'm questioning the theory for the model around which it is articulated: its Eurocentrism.

I want to suggest a different metaphor for theoretical work: the metaphor of struggle, of wrestling with the angels. The only theory worth having is that which you have to fight off, not that which you speak with profound fluency. I mean to say something later about the astonishing theoretical fluency of cultural studies now. But my own experience of theory – and Marxism is certainly a case in point – is of wrestling with the angels – a metaphor you can take as literally as you like. I remember wrestling with Althusser. I remember looking at the idea of 'theoretical practice' in *Reading Capital* and thinking, 'I've gone as far in this book as it is proper to go'. I felt, I will not give an inch to this profound misreading, this superstructuralist mistranslation, of classical Marxism, unless he beats me down, unless he defeats me in spirit. He'll have to march over to me to convince me. I warred with him, to the death. A long, rambling piece I wrote on Marx's 1857 'Introduction' to *The Grundrisse*, in which I tried to stake out the difference between structuralism in Marx's epistemology and Althusser's, was only the tip of the iceberg of this long engagement. And that is not simply a personal question. In the Centre for Contemporary Cultural Studies, for five or six years, long after the anti-theoreticism or resistance to theory of cultural studies had been overcome, and we decided, in a very un-British way, we had to take the plunge into theory, we walked right around the entire circumference of European thought, in order not to be, in any simple capitulation to the *Zeitgeist*, Marxists. We read German idealism, we read Weber upside down, we read Hegelian idealism, we read idealistic art criticism.

So the notion that Marxism and cultural studies slipped into place, recognised an immediate affinity, joined hands in some teleological or Hegelian moment of synthesis, and there was the founding moment of cultural studies, is entirely mistaken. It couldn't have been more different from that. And when, eventually, in the 1970s, British cultural studies did advance – in many different ways, it must be said – within the problematic of Marxism, you should hear the term problematic in a genuine way, not just in a formalist-theoretical way: as a problem; as much about struggling against the constraints and limits of that model as about necessary questions it required us to address. And when, in the end, in my own work, I tried to learn from and work with the theoretical gains of Gramsci, it was

only because certain strategies of evasion had forced Gramsci's work, in a number of different ways, to respond to what I can only call (here's another metaphor for theoretical work) the conundrums of theory, the things which Marxist theory couldn't answer, the things about the modern world which Gramsci discovered remained unresolved within the theoretical framework of grand theory – Marxism – in which he continued to work. At a certain point, the questions I still wanted to address in short were inaccessible to me except via a detour through Gramsci. Not because Gramsci resolved them but because he at least addressed many of them. I don't want to go through what it is I personally think cultural studies in the British context, in a certain period, learned from Gramsci: immense amounts about the nature of culture itself, about the discipline of the conjunctural, about the importance of historical specificity, about the enormously productive metaphor of hegemony, about the way in which one can think questions of class relations only by using the displaced notion of ensemble and blocs. These are the particular gains of the 'detour' via Gramsci, but I'm not trying to talk about that. I want to say, in this context, about Gramsci, that while Gramsci belonged and belongs to the problematic of Marxism, his importance for this moment of British cultural studies is precisely the degree to which he radically *displaced* some of the inheritances of Marxism in cultural studies. The radical character of Gramsci's 'displacement' of Marxism has not yet been understood and probably won't ever be reckoned with, now we are entering the era of post-Marxism. Such is the nature of the movement of history and of intellectual fashion. But Gramsci also did something else for cultural studies, and I want to say a little bit about that because it refers to what I call the need to reflect on our institutional position, and our intellectual practice.

I tried on many occasions, and other people in British cultural studies and at the Centre especially have tried, to describe what it is we thought we were doing with the kind of intellectual work we set in place in the Centre. I have to confess that, though I've read many, more elaborated and sophisticated accounts, Gramsci's account still seems to me to come closest to expressing what it is I think we were trying to do. Admittedly, there's a problem with his phrase 'the production of organic intellectuals'. But there is no doubt in my mind that we were trying to find an institutional practice in cultural studies that might produce an organic intellectual. We didn't know previously what that would mean, in the context of Britain in the 1970s, and we weren't sure we would recognize him or her if we managed to produce it. The problem about the concept of an organic intellectual is that it appears to align intellectuals with an emerging historic movement and we couldn't tell then, and can hardly tell now, where that emerging historical movement was to be found. We were organic intellectuals without any organic point of reference; organic intellectuals with a nostalgia or will or hope (to use Gramsci's phrase from another context) that at some point we would be prepared in intellectual work for that kind of relationship, if such a conjuncture ever appeared. More truthfully, we were prepared to imagine or model or simulate such a relationship in its absence: 'pessimism of the intellect, optimism of the will'.

But I think it is very important that Gramsci's thinking around these questions certainly captures part of what we were about. Because a second aspect of Gramsci's

definition of intellectual work, which I think has always been lodged somewhere close to the notion of cultural studies as a project, has been his requirement that the 'organic intellectual' must work on two fronts at one and the same time. On the one hand, we had to be at the very forefront of intellectual theoretical work because, as Gramsci says, it is the job of the organic intellectual to know more than the traditional intellectuals do: really know, not just pretend to know, not just to have the facility of knowledge, but to know deeply and profoundly. So often knowledge for Marxism is pure recognition – the production again of what we have always known! If you are in the game of hegemony you have to be smarter than 'them'. Hence, there are no theoretical limits from which cultural studies can turn back. But the second aspect is just as crucial: that the organic intellectual cannot absolve himself or herself from the responsibility of transmitting those ideas, that knowledge, through the intellectual function, to those who do not belong, professionally, in the intellectual class. And unless those two fronts are operating at the same time, or at least unless those two ambitions are part of the project of cultural studies, you can get enormous theoretical advance without any engagement at the level of the political project.

I'm extremely anxious that you should not decode what I'm saying as an anti-theoretical discourse. It is not anti-theory, but it does have something to do with the conditions and problems of developing intellectual and theoretical work as a political practice. It is an extremely difficult road, not resolving the tensions between those two requirements, but living with them. Gramsci never asked us to resolve them, but he gave us a practical example of how to live with them. We never produced organic intellectuals (would that we had) at the Centre. We never connected with that rising historic movement; it was a metaphoric exercise. Nevertheless, metaphors are serious things. They affect one's practice. I'm trying to redescribe cultural studies as theoretical work which must go on and on living with that tension.

I want to look at two other theoretical moments in cultural studies which interrupted the already interrupted history of its formation. Some of these developments came as it were from outer space: they were not all generated from the inside, they were not part of an inner-unfolding general theory of culture. Again and again, the so-called unfolding of cultural studies was interrupted by a break, by real ruptures, by exterior forces; the interruption, as it were, of new ideas, which decentred what looked like the accumulating practice of the work. There's another metaphor for theoretical work: theoretical work as interruption.

There were at least two interruptions in the work of the Centre for Contemporary Cultural Studies: the first around feminism, and the second around questions of race. This is not an attempt to sum up the theoretical and political advances and consequences for British cultural studies of the feminist intervention; that is for another time, another place. But I don't want, either, to invoke that moment in an open-ended and casual way. For cultural studies (in addition to many other theoretical projects), the intervention of feminism was specific and decisive. It was ruptural. It reorganized the field in quite concrete ways. First, the opening of the question of the personal as political, and its consequences for changing the object of study in cultural studies, was completely revolutionary in a theoretical and practical way. Second, the radical expansion of the notion of

power, which had hitherto been very much developed within the framework of the notion of the public, the public domain, with the effect that we could not use the term power – so key to the earlier problematic of hegemony – in the same way. Third, the centrality of questions of gender and sexuality to the understanding of power itself. Fourth, the opening of many of the questions that we thought we had abolished around the dangerous area of the subjective and the subject, which lodged those questions at the centre of cultural studies as a theoretical practice. Fifth, 'the re-opening' of the closed frontier between social theory and the theory of the unconscious – psychoanalysis. It's hard to describe the import of the opening of that new continent in cultural studies, marked out by the relationship – or rather, what Jacqueline Rose has called the as yet 'unsettled relations' – between feminism, psychoanalysis and cultural studies, or indeed how it was accomplished.

We know it was, but it's not known generally how and where feminism first broke in. I use the metaphor deliberately: as the thief in the night, it broke in; interrupted, made an unseemly noise, seized the time, crapped on the table of cultural studies. The title of the volume in which this dawn-raid was first accomplished – *Women Take Issue* – is instructive: for they 'took issue' in both senses – took over that year's book and initiated a quarrel. But I want to tell you something else about it. Because of the growing importance of feminist work and the early beginnings of the feminist movement outside in the very early 1970s, many of us in the Centre – mainly, of course, men – thought it was time there was good feminist work in cultural studies. And we indeed tried to buy it in, to import it, to attract good feminist scholars. As you might expect, many of the women in cultural studies weren't terribly interested in this benign project. We were opening the door to feminist studies, being good, transformed men. And yet, when it broke in through the window, every single unsuspected resistance rose to the surface – fully installed patriarchal power, which believed it had disavowed itself. There are no leaders here, we used to say; we are all graduate students and members of staff together, learning how to practise cultural studies. You can decide whatever you want to decide, etc. And yet, when it came to the question of the reading list . . . Now that's where I really discovered about the gendered nature of power. Long, long after I was able to pronounce the words, I encountered the reality of Foucault's profound insight into the individual reciprocity of knowledge and power. Talking about giving up power is a radically different experience from being silenced. That is another way of thinking, and another metaphor for theory: the way feminism broke, and broke into, cultural studies.

Then there is the question of race in cultural studies. I've talked about the important 'extrinsic' sources of the formation of cultural studies – for example, in what I called the moment of the New Left, and its original quarrel with Marxism – out of which cultural studies grew. And yet, of course, that was a profoundly English or British moment. Actually getting cultural studies to put on its own agenda the critical questions of race, the politics of race, the resistance to racism, the critical questions of cultural politics, was itself a profound theoretical struggle, a struggle of which *Policing the Crisis* was, curiously, the first and very late example. It represented a decisive turn in my own theoretical and intellectual work, as well as in that of the Centre. Again, it was accomplished only as the result of a long,

and sometimes bitter – certainly bitterly contested – internal struggle against a resounding but unconscious silence. A struggle which continued in what has since come to be known, but only in the rewritten history, as one of the great seminal books of the Centre for Cultural Studies, *The Empire Strikes Back*. In actuality, Paul Gilroy and the group of people who produced the book found it extremely difficult to create the necessary theoretical and political space in the Centre in which to work on the project.

I want to hold to the notion, implicit in both these examples, that movements provoke theoretical moments. And historical conjunctures insist on theories: they are real moments in the evolution of theory. But here I have to stop and retrace my steps. Because I think you could hear, once again, in what I'm saying a kind of invocation of a simple-minded anti-theoretical populism, which does not respect and acknowledge the crucial importance, at each point in the moves I'm trying to renarrativize, of what I would call the necessary delay or detour through theory. I want to talk about that 'necessary detour' for a moment. What decentred and dislocated the settled path of the Centre for Contemporary Cultural Studies certainly, and British cultural studies to some extent in general, is what is sometimes called 'the linguistic turn': the discovery of discursivity, of textuality. There are casualties in the Centre around those names as well. They were wrestled with, in exactly the same way I've tried to describe earlier. But the gains which were made through an engagement with them are crucially important in understanding how theory came to be advanced in that work. And yet, in my view, such theoretical 'gains' can never be a self-sufficient moment.

Again, there is no space here to do more than begin to list the theoretical advances which were made by the encounters with structuralist, semiotic, and post-structuralist work: the crucial importance of language and of the linguistic metaphor to *any* study of culture; the expansion of the notion of text and textuality, both as a source of meaning, and as that which escapes and postpones meaning; the recognition of the heterogeneity, of the multiplicity, of meanings, of the struggle to close arbitrarily the infinite semiosis beyond meaning; the acknowledgment of textuality and cultural power, of representation itself, as a site of power and regulation; of the symbolic as a source of identity. These are enormous theoretical advances, though of course, it had always attended to questions of language (Raymond Williams's work, long before the semiotic revolution, is central there). Nevertheless, the refiguring of theory, made as a result of having to think questions of culture through the metaphors of language and textuality, represents a point beyond which cultural studies must now always necessarily locate itself. The metaphor of the discursive, of textuality, instantiates a necessary delay, a displacement, which I think is *always* implied in the concept of culture. If you work on culture, or if you've tried to work on some other really important things and you find yourself driven back to culture, if culture happens to be what seizes hold of your soul, you have to recognize that you will always be working in an area of displacement. There's always something decentred about the medium of culture, about language, textuality, and signification, which always escapes and evades the attempt to link it, directly and immediately, with other structures. And yet, at the same time, the shadow, the imprint, the trace, of those other formations, of the intertextuality of texts in their institutional positions, of texts as sources of

power, of textuality as a site of representation and resistance, all of those questions can never be erased from cultural studies.

The question is what happens when a field, which I've been trying to describe in a very punctuated, dispersed, and interrupted way, as constantly changing directions, and which is defined as a political project, tries to develop itself as some kind of coherent theoretical intervention? Or, to put the same question in reverse, what happens when an academic and theoretical enterprise tries to engage in pedagogies which enlist the active engagement of individuals and groups, tries to make a difference in the institutional world in which it is located? These are extremely difficult issues to resolve, because what is asked of us is to say 'yes' and 'no' at one and the same time. It asks us to assume that culture will always work through its textualities – and at the same time that textuality is never enough. But never enough of what? Never enough for what? That is an extremely difficult question to answer because, philosophically, it has always been impossible in the theoretical field of cultural studies – whether it is conceived either in terms of texts and contexts, of intertextuality, or of the historical formations in which cultural practices are lodged – to get anything like an adequate theoretical account of culture's relations and its effects. Nevertheless I want to insist that until and unless cultural studies learns to live with this tension, a tension that all textual practices must assume – a tension which Said describes as the study of the text in its affiliations with 'institutions, offices, agencies, classes, academies, corporations, groups, ideologically defined parties and professions, nations, races, and genders' – it will have renounced its 'worldly' vocation. That is to say, unless and until one respects the necessary displacement of culture, and yet is always irritated by its failure to reconcile itself with other questions that matter, with other questions that cannot and can never be fully covered by critical textuality in its elaborations, cultural studies as a project, an intervention, remains incomplete. If you lose hold of the tension, you can do extremely fine intellectual work, but you will have lost intellectual practice as a politics. I offer this to you, not because that's what cultural studies ought to be, or because that's what the Centre managed to do well, but simply because I think that, overall, is what defines cultural studies as a project. Both in the British and the American context, cultural studies has drawn the attention itself, not just because of its sometimes dazzling internal theoretical development but because it holds theoretical and political questions in an ever irresolvable but permanent tension. It constantly allows the one to irritate, bother and disturb the other, without insisting on some final theoretical closure.

I've been talking very much in terms of a previous history. But I have been reminded of this tension very forcefully in the discussions on AIDS. AIDS is one of the questions which urgently brings before us our marginality as critical intellectuals in making real effects in the world. And yet it has often been represented for us in contradictory ways. Against the urgency of people dying in the streets, what in God's name is the point of cultural studies? What is the point of the study of representations, if there is no response to the question of what you say to someone who wants to know if they should take a drug and if that means they'll die two days later or a few months earlier? At that point, I think anybody who is into cultural studies seriously as an intellectual practice, must feel, on their pulse, its ephemerality, its insubstantiality, how little it registers, how little we've been

able to change anything or get anybody to do anything. If you don't feel that as one tension in the work that you are doing, theory has let you off the hook. On the other hand, in the end, I don't agree with the way in which the dilemma is often posed for us, for it is indeed a more complex and displaced question than just people dying out there. The question of AIDS is an extremely important terrain of struggle and contestation. In addition to the people we know who are dying, or have died, or will, there are the many people dying who are never spoken of. How could we say that the question of AIDS is not also a question of who gets represented and who does not? AIDS is the site at which the advance of sexual politics is being rolled back. It's a site at which not only people will die, but desire and pleasure will also die if certain metaphors do not survive, or survive in the wrong way. Unless we operate in this tension, we don't know what cultural studies can do, can't, can never do; but also, what it has to do, what it alone has a privileged capacity to do. It has to analyse certain things about the constitutive and political nature of representation itself, about its complexities, about the effects of language, about textuality as a site of life and death. Those are the things cultural studies can address.

I've used that example, not because it's a perfect example, but because it's a specific example, because it has a concrete meaning, because it challenges us in its complexity, and in so doing has things to teach us about the future of serious theoretical work. It preserves the essential nature of intellectual work and critical reflection, the irreducibility of the insights which theory can bring to political practice, insights which cannot be arrived at in any other way. And at the same time, it rivets us to the necessary modesty of theory, the necessary modesty of cultural studies as an intellectual project.

I want to end in two ways. First I want to address the problem of the institutionalization of these two constructions: British cultural studies and American cultural studies. And then, drawing on the metaphors about theoretical work which I tried to launch (not I hope by claiming authority or authenticity but in what inevitably has to be a polemical, positional, political way), to say something about how the field of cultural studies has to be defined.

I don't know what to say about American cultural studies. I am completely dumbfounded by it. I think of the struggles to get cultural studies into the institution in the British context, to squeeze three or four jobs for anybody under some heavy disguise, compared with the rapid institutionalization which is going on in the United States. The comparison is not valid only for cultural studies. If you think of the important work which has been done in feminist history or theory in Britain and ask how many of those women have ever had full-time academic jobs in their lives or are likely to, you get a sense of what marginality is really about. So the enormous explosion of cultural studies in the United States, its rapid professionalization and institutionalization, is not a moment which any of us who tried to set up a marginalized Centre in a university like Birmingham could, in any simple way, regret. And yet I have to say, in the strongest sense, that it reminds me of the ways in which, in Britain, we are always aware of institutionalization as a moment of profound danger. Now, I've been saying that dangers are not places you run away from but places that you go towards. So I simply want you to know that my own feeling is that the explosion of cultural studies along

with other forms of critical theory in the academy represents a moment of extra-ordinarily profound danger. Why? Well, it would be excessively vulgar to talk about such things as how many jobs there are, how much money there is around, and how much pressure that puts on people to do what they think of as critical political work and intellectual work of a critical kind, while also looking over their shoulders at the promotions stakes and the publication stakes, and so on. Let me instead return to the point that I made before: my astonishment at what I called the theoretical fluency of cultural studies in the United States.

Now, the question of theoretical fluency is a difficult and provoking metaphor, and I want only to say one word about it. Some time ago, looking at what one can only call the deconstructive deluge (as opposed to deconstructive turn) which had overtaken American literary studies, in its formalist mode, I tried to distinguish the extremely important theoretical and intellectual work which it had made possible in cultural studies from a mere repetition, a sort of mimicry or deconstructive ventriloquism which sometimes passes as a serious intellectual exercise. My fear at that moment was that if cultural studies gained an equivalent institutionalization in the American context, it would, in rather the same way, formalize out of existence the critical questions of power, history, and politics. Paradoxically, what I mean by theoretical fluency is exactly the reverse. There is no moment now, in American cultural studies, where we are *not* able, extensively and without end, to theorize power – politics, race, class and gender, subjugation, domination, exclusion, marginality, Otherness, etc. There is hardly anything in cultural studies which isn't so theorized. And yet, there is the nagging doubt that this overwhelming textualization of cultural studies' own discourses somehow constitutes power and politics as exclusively matters of language and textuality itself. Now, this is not to say that I don't think that questions of power and the political have to be and are always lodged within representations, that they are always discursive questions. Nevertheless, there are ways of constituting power as an easy floating signifier which just leaves the crude exercise and connections of power and culture altogether emptied of any signification. That is what I take to be the moment of danger in the institutionalization of cultural studies in this highly rarified and enormously elaborated and well-funded professional world of American academic life. It has nothing whatever to do with cultural studies making itself more like British cultural studies, which is, I think, an entirely false and empty cause to try to propound. I have specifically tried not to speak of the past in an attempt to police the present and the future. But I do want to extract, finally, from the narrative I have constructed of the past some guidelines for my own work and perhaps for some of yours.

I come back to the deadly seriousness of intellectual work. It is a deadly serious matter. I come back to the critical distinctions between intellectual work and academic work: they overlap, they abut with one another, they feed off one another, the one provides you with the means to do the other. But they are not the same thing. I come back to the difficulty of instituting a genuine cultural and critical practice, which is intended to produce some kind of organic intellectual political work, which does not try to inscribe itself in the overarching meta-narrative of achieved knowledges, within the institutions. I come back to theory and politics, the politics of theory. Not theory as the will to truth, but theory as a set of

contested, localized, conjunctural knowledges, which have to be debated in a dialogical way. But also as a practice which always thinks about its intervention in a world in which it would make some difference, in which it would have some effect. Finally, a practice which understands the need for intellectual modesty. I do think there is all the difference in the world between understanding the politics of intellectual work and substituting intellectual work for politics.

Space and time

Edward Soja

HISTORY: GEOGRAPHY: MODERNITY

EDITOR'S INTRODUCTION

E DWARD SOJA PRESENTS a lucid defence of the demand for "geographical and spatial imagination" in theoretical work. He argues that academic study has, in the modern era, privileged time and history over space and geography. This has meant that modernity has been interpreted too quickly and simply as destroying and replacing traditions – whereas, Soja argues, it is more sensitively to be interpreted as a complex reorganization of temporal and spatial relations. For instance, a crucial feature of modernity is how change itself becomes increasingly globally synchronous, especially in the technological and economic spheres. Postmodern social transformations, in particular, involve a reordering of space: speed and accessibility triumph over distance, though the shrinking of the world can lead to strong barriers being placed between margins and centers from either side.

In this selection from a longer piece of work, Soja gives a brief account of Michel Foucault's demand for a "history of space" and of Marshall Berman's description of modernity's embrace of speed and simultaneity. Berman and Foucault, however, do not quite lead in the same direction. As the interview with Foucault in this collection makes clear, he is interested in making changes reversible by emphasizing the gaps between the intentions behind, and the effects of, the reorganization of space by planners, architects and so on; Berman, on the other hand, has a stronger sense of an increasingly impregnable global system moving in an irreversible direction.

Further reading: Berman 1982; Foucault 1986; Harvey 1989; Jameson 1990; Jameson and Miyoshi 1998; Kern 1983.

Did it start with Bergson or before? Space was treated as the dead, the fixed, the undialectical, the immobile. Time, on the contrary was richness, fecundity, life, dialectic.

(Foucault 1980b: 70)

The great obsession of the nineteenth century was, as we know, history: with its themes of development and of suspension, of crisis and cycle, themes of the ever-accumulating past, with its great preponderance of dead men and the menacing glaciation of the world . . . The present epoch will perhaps be above all the epoch of space. We are in the epoch of simultaneity: we are in the epoch of juxtaposition, the epoch of the near and far, of the side-by-side, of the dispersed. We are at a moment, I believe, when our experience of the world is less that of a long life developing through time than that of a network that connects points and intersects with its own skein. One could perhaps say that certain ideological conflicts animating present-day polemics oppose the pious descendants of time and the determined inhabitants of space.

(Foucault 1986: 22)

The nineteenth-century obsession with history, as Foucault described it, did not die in the *fin de siècle*. Nor has it been fully replaced by a spatialization of thought and experience. An essentially historical epistemology continues to pervade the critical consciousness of modern social theory. It still comprehends the world primarily through the dynamics arising from the emplacement of social being and becoming in the interpretive contexts of time: in what Kant called *nacheinander* and Marx defined so transfiguratively as the contingently constrained 'making of history'. This enduring epistemological presence has preserved a privileged place for the 'historical imagination' in defining the very nature of critical insight and interpretation.

So unbudgeably hegemonic has been this historicism of theoretical consciousness that it has tended to occlude a comparable critical sensibility to the spatiality of social life, a practical theoretical consciousness that sees the lifeworld of being creatively located not only in the making of history but also in the construction of human geographies, the social production of space and the restless formation and reformation of geographical landscapes: social being actively emplaced in space *and* time in an explicitly historical *and* geographical contextualization. Although others joined Foucault to urge a rebalancing of this prioritization of time over space, no hegemonic shift has yet occurred to allow the critical eye – or the critical I – to see spatiality with the same acute depth of vision that comes with a focus on *durée*. The critical hermeneutic is still enveloped in a temporal master-narrative, in a historical but not yet comparably geographical imagination. Foucault's revealing glance back over the past hundred years thus continues to apply today. Space still tends to be treated as fixed, dead, undialectical; time as richness, life, dialectic, the revealing context for critical social theorization.

As we move closer to the end of the twentieth century, however, Foucault's premonitory observations on the emergence of an 'epoch of space' assume a more

reasonable cast. The material and intellectual contexts of modern critical social theory have begun to shift dramatically. In the 1980s, the hoary traditions of a space-blinkered historicism are being challenged with unprecedented explicitness by convergent calls for a far-reaching spatialization of the critical imagination. A distinctively postmodern and critical human geography is taking shape, brashly reasserting the interpretive significance of space in the historically privileged confines of contemporary critical thought. Geography may not yet have displaced history at the heart of contemporary theory and criticism, but there is a new animating polemic on the theoretical and political agenda, one which rings with significantly different ways of seeing time and space together, the interplay of history and geography, the 'vertical' and 'horizontal' dimensions of being in the world freed from the imposition of inherent categorical privilege.

It remains all too easy for even the best of the 'pious descendants of time' to respond to these pesky postmodern intrusions with an antidisestablishmentarian wave of a still confident upper hand or with the presumptive yawns of a seen-it-all-before complacency. In response, the determined intruders often tend to overstate their case, creating the unproductive aura of an anti-history, inflexibly exaggerating the critical privilege of contemporary spatiality in isolation from an increasingly silenced embrace of time. But from these confrontational polemics is also arising something else, a more flexible and balanced critical theory that re-entwines the making of history with the social production of space, with the construction and configuration of human geographies. New possibilities are being generated from this creative commingling, possibilities for a simultaneously histori-cal and geographical materialism; a triple dialectic of space, time, and social being; a transformative re-theorization of the relations between history, geography, and modernity.

Locating the origins of postmodern geographies

The first insistent voices of postmodern critical human geography appeared in the late 1960s, but they were barely heard against the then prevailing temporal din. For more than a decade, the spatializing project remained strangely muted by the untroubled reaffirmation of the primacy of history over geography that enveloped both Western Marxism and liberal social science in a virtually sanctified vision of the ever-accumulating past. One of the most comprehensive and convincing pictures of this continuously historical contextualization was drawn by C. Wright Mills in his paradigmatic portrayal of the sociological imagination (Mills 1959). Mills's work provides a useful point of departure for spatializing the historical narrative and reinterpreting the course of critical social theory.

The silenced spatiality of historicism

Mills maps out a sociological imagination that is deeply rooted in a historical ration-ality – what Martin Jay (1984b) would call a 'longitudinal totalization' – that applies equally well to critical social science and to the critical traditions of Marxism.

> [The sociological imagination] is a quality of mind that will help [individuals] to use information and to develop reason in order to achieve lucid summations of what is going on in the world and of what may be happening within themselves.
>
> (Mills 1959: 11)

> The first fruit of this imagination – and the first lessons of the social science that embodies it – is the idea that the individual can understand his own experience and gauge his own fate only by locating himself within his period, that he can know his own chances in life only by becoming aware of those of all individuals in his circumstances . . . We have come to know that every individual lives, from one generation to the next, in some society; that he lives out a biography, and that he lives it out within some historical sequence. By the fact of his living he contributes, however minutely, to the shaping of this society and to the course of history, even as he is made by society and by its historical push and shove.
>
> (1959: 12)

He goes further:

> The sociological imagination enables us to grasp history and biography and the relations of the two within society. This is its task and its promise. To recognize this task and this promise is the mark of the classic social analyst . . . *No social study that does not come back to the problems of biography, of history, and of their intersections within society, has completed its intellectual journey.*
>
> (1959: 12, emphasis added)

I draw upon Mills's depiction of what is essentially a historical imagination to illustrate the alluring logic of historicism, the rational reduction of meaning and action to the temporal constitution and experience of social being. This connection between the historical imagination of historicism needs further elaboration. First, there is the easier question of why 'sociological' has been changed to 'historical'. As Mills himself notes, 'every cobbler thinks leather is the only thing', and as a trained sociologist Mills names his leather after his own disciplinary specialization and socialization. The nominal choice personally specifies what is a much more widely shared 'quality of mind' that Mills claims should pervade, indeed embody, all social theory and analysis, an emancipatory rationality grounded in the intersections of history, biography, and society.

To be sure, these 'life-stories' have a geography too; they have milieux, immediate locales, provocative emplacements which affect thought and action. The historical imagination is never completely spaceless and critical social historians have written, and continue to write, some of the best geographies of the past. But it is always time and history that provide the primary 'variable containers' in these geographies. This would be just as clear whether the critical orientation is described as sociological or political or anthropological – or for that matter phenomeno-

logical, existential, hermeneutic, or historical materialist. The particular emphases may differ, but the encompassing perspective is shared. An already made geography sets the stage, while the wilful making of history dictates the action and defines the story line.

It is important to stress that this historical imagination has been particularly central to critical social theory, to the search for practical understanding of the world as a means of emancipation versus maintenance of the status quo. Social theories which merely rationalize existing conditions and thereby serve to promote repetitive behaviour, the continuous reproduction of established social practices, do not fit the definition of critical theory. They may be no less accurate with respect to what they are describing, but their rationality (or irrationality, for that matter) is likely to be mechanical, normative, scientific, or instrumental rather than critical. It is precisely the critical and potentially emancipatory value of the historical imagination, of people 'making history' rather than taking it for granted, that has made it so compulsively appealing. The constant reaffirmation that the world can be changed by human action, by praxis, has always been the centrepiece of critical social theory whatever its particularized source and emphasis.

The development of critical social theory has revolved around the assertion of a mutable history against perspectives and practices that mystify the changeability of the world. The critical historical discourse thus sets itself against abstract and transhistorical universalizations (including notions of a general 'human nature' which explain everything and nothing at the same time); against naturalisms, empiricisms and positivisms which proclaim physical determinations of history apart from social origins; against religious and ideological fatalisms which project spiritual determinations and teleologies (even when carried forward in the cloak of human consciousness); against any and all conceptualizations of the world which freeze the frangibility of time, the possibility of 'breaking' and remaking history.

Both the attractive critical insight of the historical imagination and its continuing need to be forcefully defended against distracting mystifications have contributed to its exaggerated assertion as historicism. Historicism has been conventionally defined in several different ways. Raymond Williams's *Keywords* (1983), for example, presents three contemporary choices, which he describes as: first, 'neutral' – a method of study using facts from the past to trace the precedents of current events; second, 'deliberate' – an emphasis on variable historical conditions and contexts as a privileged framework for interpreting all specific events; and, third, 'hostile' – an attack on all interpretation and prediction which is based on notions of historical necessity or general laws of historical development.

I wish to give an additional twist to these options by defining historicism as an overdeveloped historical contextualization of social life and social theory that actively submerges and peripheralizes the geographical or spatial imagination. This definition does not deny the extraordinary power and importance of historiography as a mode of emancipatory insight, but identifies historicism with the creation of a critical silence, an implicit subordination of space to time that obscures geographical interpretations of the changeability of the social world and intrudes upon every level of theoretical discourse, from the most abstract ontological concepts of being to the most detailed explanations of empirical events.

This definition may appear rather odd when set against the long tradition of debate over historicism that has flourished for centuries. The failure of this debate to recognize the peculiar theoretical peripheralization of space that has accompanied even the most neutral forms of historicism is, however, precisely what began to be discovered in the late 1960s, in the ragged beginnings of what I have called a postmodern critical human geography. Even then, the main currents of critical social thought had become so spatially blinkered that the most forceful reassertions of space versus history, had little effect. The academic discipline of modern geography had, by that time, been rendered theoretically inert and contributed little to these first reassertions. And when some of the most influential social critics of the time took a bold spatial turn, not only was it usually seen by the unconverted as something else entirely, but the turners themselves often chose to muffle their critiques of historicism in order to be understood at all.

The ambivalent spatiality of Michel Foucault

The contributions of Foucault to the development of critical human geography must be drawn out archaeologically, for he buried his precursory spatial turn in brilliant whirls of historical insight. He would no doubt have resisted being called a postmodern geographer, but he was one, *malgré lui*, from *Madness and Civilization* (1965) to his last works on *The History of Sexuality* (1980a). His most explicit and revealing observations on the relative significance of space and time, however, appear not in his major published works but almost innocuously in his lectures and, after some coaxing interrogation, in two revealing interviews: 'Questions on geography' (Foucault 1980b) and 'Space, power and knowledge' (see Foucault below; see also Wright and Rabinow 1982).

The epochal observations which head this chapter, for example, were first made in a 1967 lecture entitled '*Des Espaces Autres*'. They remained virtually unseen and unheard for nearly twenty years, until their publication in the French journal *Architecture-Mouvement-Continuité* in 1984 and, translated by Jay Miskowiec as 'Of Other Spaces', in *Diacritics* (1986). In these lecture notes, Foucault outlined his notion of 'heterotopias' as the characteristic spaces of the modern world, superseding the hierarchic 'ensemble of places' of the Middle Ages and the enveloping 'space of emplacement' opened up by Galileo into an early modern, infinitely unfolding, 'space of extension' and measurement. Moving away from both the 'internal space' of Bachelard's brilliant poetics (1969) and the intentional regional descriptions of the phenomenologists, Foucault focused our attention on another spatiality of social life, an 'external space', the actually lived (and socially produced) space of sites and the relations between them:

> The space in which we live, which draws us out of ourselves, in which the erosion of our lives, our time and our history occurs, the space that claws and gnaws at us, is also, in itself, a heterogeneous space. In other words, we do not live in a kind of void, inside of which we could place individuals and things. We do not live inside a void that could be coloured with diverse shades of light, we live inside a set of relations that delineates sites which are irreducible to one another and absolutely not superimposable on one another.
>
> (1986: 23)

These heterogeneous spaces of sites and relations – Foucault's heterotopias – are constituted in every society but take quite varied forms and change over time, as 'history unfolds' in its adherent spatiality. He identifies many such sites: the cemetery and the church, the theatre and the garden, the museum and the library, the fairground and the 'vacation village', the barracks and the prison, the Moslem Hammam and the Scandinavian sauna, the brothel and the colony. Foucault contrasts these 'real places' with the 'fundamentally unreal spaces' of utopias which present society in either 'a perfected form' or else 'turned upside down':

> The heterotopia is capable of juxtaposing in a single real place several spaces, several sites that are in themselves incompatible . . . they have a function in relation to all the space that remains. This function unfolds between two extreme poles. Either their role is to create a space of illusion that exposes every real space, all the sites inside of which human life is partitioned, as still more illusory . . . Or else, on the contrary, their role is to create a space that is other, another real space, as perfect, as meticulous, as well arranged as ours is messy, ill constructed, and jumbled. The latter type would be the heterotopia, not of illusion, but of compensation, and I wonder if certain colonies have not functioned somewhat in this manner.
>
> (1986: 25, 27)

With these remarks Foucault exposed many of the compelling directions he would take in his lifework and indirectly raised a powerful argument against historicism – and against the prevailing treatments of space in the human sciences. Foucault's heterogeneous and relational space of heterotopias is neither a substanceless void to be filled by cognitive intuition nor a repository of physical forms to be phenomenologically described in all its resplendent variability. It is another space, what Lefebvre would describe as *l'espace vécu*, actually lived and socially created spatiality, concrete and abstract at the same time, the habitus of social practices. It is a space rarely seen for it has been obscured by a bifocal vision that traditionally views space as either a mental construct or a physical form.

To illustrate his innovative interpretation of space and time and to clarify some of the often confusing polemics which were arising around it, Foucault turned to the then current debates on structuralism, one of the twentieth century's most important avenues for the reassertion of space in critical social theory. Foucault vigorously insisted that he himself was not (just?) a structuralist, but he recognized in the development of structuralism a different and compelling vision of history and geography, a critical reorientation that was connecting space and time in new and revealing ways.

> Structuralism, or at least that which is grouped under this slightly too general name, is the effort to establish, between elements that could have been connected on a temporal axis, an ensemble of relations that makes them appear as juxtaposed, set off against one another, in short, as a sort of configuration. Actually structuralism does not entail a denial

of time; it does involve a certain manner of dealing with what we call
time and what we call history.

(1986: 22)

This synchronic 'configuration' is the spatialization of history, the making of history
entwined with the social production of space, the structuring of a historical geog-
raphy.

Foucault refused to project his spatialization as an anti-history but his history
was provocatively spatialized from the very start. This was not just a shift in
metaphorical preference, as it frequently seemed to be for Althusser and others
more comfortable with the structuralist label than Foucault. It was the opening
up of history to an interpretative geography. To emphasize the centrality of space
to the critical eye, especially regarding the contemporary moment, Foucault
becomes most explicit:

> In any case I believe that the anxiety of our era has to do fundamen-
> tally with space, no doubt a great deal more than with time. Time
> probably appears to us only as one of the various distributive opera-
> tions that are possible for the elements that are spread out in space.
>
> (1986: 23)

He would never be quite so explicit again. Foucault's spatialization took on a more
demonstrative rather than declarative stance, confident perhaps that at least the
French would understand the intent and significance of his strikingly spatialized
historiography.

In an interview conducted shortly before his death (see Foucault below),
Foucault reminisced on his exploration 'Of other spaces' and the enraged reac-
tions it engendered from those he once identified as the 'pious descendants of
time'. Asked whether space was central to the analysis of power, he answered:

> Yes. Space is fundamental in any form of communal life; space is funda-
> mental in any exercise of power. To make a parenthetical remark, I
> recall having been invited, in 1966, by a group of architects to do a
> study of space, of something that I called at that time 'heterotopias',
> those singular spaces to be found in some given social spaces whose
> functions are different or even the opposite of others. The architects
> worked on this, and at the end of the study someone spoke up – a
> Sartrean psychologist – who firebombed me, saying that *space* is reac-
> tionary and capitalist, but *history* and *becoming* are revolutionary. This
> absurd discourse was not at all unusual at the time. Today everyone
> would be convulsed with laughter at such a pronouncement, but
> not then.

Amidst today's laughter – still not as widespread and convulsive as Foucault
assumed it would be – one can look back and see that Foucault persistently explored
what he called the 'fatal intersection of time with space' from the first to the last
of his writings. And he did so, we are only now beginning to realize, infused with

the emerging perspective of a post-historicist and postmodern critical human geography.

Few could see Foucault's geography, however, for he never ceased to be a historian, never broke his allegiance to the master identity of modern critical thought. To be labelled a geographer was an intellectual curse, a demeaning association with an academic discipline so far removed from the grand houses of modern social theory and philosophy as to appear beyond the pale of critical relevance. Foucault had to be coaxed into recognizing his formative attachment to the geographer's spatial perspective, to admit that geography was always at the heart of his concerns. This retrospective admission appeared in an interview with the editors of the French journal of radical geography, *Herodote*, and was published in English as 'Questions on Geography', in *Power/Knowledge* (Foucault 1980b). In this interview, Foucault expanded upon the observations he made in 1967, but only after being pushed to do so by the interviewers.

At first, Foucault was surprised – and annoyed – at being asked by his interviewers why he had been so silent about the importance of geography and spatiality in his works despite the profuse use of geographical and spatial metaphors. The interviewers suggested to him:

> If geography is invisible or ungrasped in the area of your explorations and excavations, this may be due to the deliberately historical or archaeological approach which privileges the factor of time. Thus one finds in your work a rigorous concern with periodization that contrasts with the vagueness of your spatial demarcations.

Foucault responded immediately by diversion and inversion, throwing back the responsibility for geography to his interviewers (while remembering the critics who reproached him for his 'metaphorical obsession' with space). After further questioning, however, he admitted (again?) that space has been devalued for generations by philosophers and social critics, reasserted the inherent spatiality of power/knowledge and ended with a *volte face*:

> I have enjoyed this discussion with you because I've changed my mind since we started. I must admit that I thought you were demanding a place for geography like those teachers who protest when an education reform is proposed because the number of hours of natural sciences or music is being cut. . . . Now I can see that the problems you put to me about geography are crucial ones for me. Geography acted as the support, the condition of possibility for the passage between a series of factors I tried to relate. Where geography itself was concerned, I either left the question hanging or established a series of arbitrary connections. . . . Geography must indeed lie at the heart of my concerns.
>
> (Foucault 1980b: 77)

Foucault's argument here takes a new turn, from simply looking at 'other spaces' to questioning the origins of 'this devaluation of space that has prevailed

for generations'. It is at this point that he makes the comment cited earlier on the post-Bergsonian treatment of space as passive and lifeless, time as richness, fecundity, dialectic.

Here then are the inquisitive ingredients for a direct attack on historicism as the source of the devaluation of space, but Foucault had other things in mind. In a revealing aside, he takes an integrative rather than deconstructive path, holding on to his history but adding to it the crucial nexus that would flow through all his work: the linkage between space, knowledge, and power.

> For all those who confuse history with the old schemas of evolution, living continuity, organic development, the progress of consciousness or the project of existence, the use of spatial terms seems to have an air of an anti-history. If one started to talk in terms of space that meant one was hostile to time. It meant, as the fools say, that one 'denied history', that one was a 'technocrat'. They didn't understand that to trace the forms of implantation, delimitation and demarcation of objects, the modes of tabulation, the organisation of domains meant the throwing into relief of processes – historical ones, needless to say – of power. The spatializing description of discursive realities gives on to the analysis of related effects of power.
>
> (1980b: 77)

In 'The Eye of Power', published as a preface to Jeremy Bentham, *La Panoptique* (1977) and reprinted in *Power/Knowledge* (Foucault 1980b: 149), he restates his ecumenical project: 'A whole history remains to be written of *spaces* – which would at the same time be the history of *powers* [both of these terms in the plural] – from the great strategies of geopolitics to the little tactics of the habitat.' Foucault thus postpones a direct critique of historicism with an acute lateral glance, at once maintaining his spatializing project but preserving his historical stance. 'History will protect us from historicism,' he optimistically concludes.

The deconstruction and reconstitution of modernity

In *All that Is Solid Melts into Air: The Experience of Modernity* (1982), Marshall Berman explores the multiple reconfigurations of social life that have characterized the historical geography of capitalism over the past four hundred years. At the heart of his interpretive outlook is a revealing periodization of changing concepts of modernity from the formative sixteenth-century clash between the 'Ancients' and the 'Moderns' to the contemporary debates that herald still another conceptual and social reconfiguration, another reconsideration of what it means to be modern. In this concatenation of modernities is a history of historicism that can now begin to be written from a postmodern geographical perspective.

Berman broadly defines modernity as 'a mode of vital experience', a collective sharing of a particularized sense of 'the self and others', of 'life's possibilities and perils'. In this definition, there is a special place given to the ways we think about and experience time and space, history and geography, sequence and

simultaneity, event and locality, the immediate period and region in which we live. Modernity is thus comprised of both context and conjuncture. It can be understood as the specificity of being alive, in the world, at a particular time and place; a vital individual and collective sense of contemporaneity. As such, the experience of modernity captures a broad mesh of sensibilities that reflects the specific and changing meanings of the three most basic and formative dimensions of human existence: space, time, and being. Herein lies its particular usefulness as a means of resituating the debates on history and geography in critical social theory and for defining the context and conjuncture of postmodernity.

Just as space, time and matter delineate and encompass the essential qualities of the physical world, spatiality, temporality and social being can be seen as the abstract dimensions which together comprise all facets of human existence. More concretely specified, each of these abstract existential dimensions comes to life as a social construct which shapes empirical reality and is simultaneously shaped by it. Thus, the spatial order of human existence arises from the (social) production of space, the construction of human geographies that both reflect and configure being in the world. Similarly, the temporal order is concretised in the making of history, simultaneously constrained and constraining in an evolving dialectic that has been the ontological crux of Marxist thought for over a hundred years. To complete the necessary existential triad, the social order of being-in-the-world can be seen as revolving around the constitution of society, the production and reproduction of social relations, institutions, and practices. How this ontological nexus of space–time–being is conceptually specified and given particular meaning in the explanation of concrete events and occurrences is the generative source of all social theory, critical or otherwise. It provides an illuminating motif through which to view the interplay between history, geography, and modernity.

Sequences of modernity, modernization and modernism

In the experience of modernity, the ontological nexus of social theory becomes specifically and concretely composed in a changing 'culture of time and space', to borrow the felicitous phrase used by Stephen Kern (1983) to describe the profound reconfiguration of modernity that took place in the previous *fin de siècle*.

> From around 1880 to the outbreak of World War I a series of sweeping changes in technology and culture created distinctive new modes of thinking about and experiencing time and space. Technological innovations including the telephone, wireless telegraph, x-ray, cinema, bicycle, automobile and airplane established the material foundation for this reorientation; independent cultural developments such as the stream of consciousness novel, psychoanalysis, Cubism, and the theory of relativity shaped consciousness directly. The result was a transformation of the dimensions of life and thought.
>
> (1983: 1–2)

During this expanded *fin de siècle*, from the aftermath of the defeat of the Paris Commune to the events which would lead up to the Russian Revolution (to choose

somewhat different turning points), the world changed dramatically. Industrial capitalism survived its predicted demise through a radical social and spatial restructuring which both intensified (or deepened, as in the rise of corporate monopolies and mergers) and extensified (or widened, as in the global expansion of imperialism) its definitive production relations and divisions of labour. Accompanying the rise of this new political economy of capitalism was an altered culture of time and space, a restructured historical geography taking shape from the shattered remains of an older order and infused with ambitious new visions and designs for the future as the very nature and experience of modernity – what it meant to be modern – was significantly reconstituted. A similar reconstitution took place in the prevailing forms of social theorization, equally attuned to the changing nature of capitalist modernity. But before turning to this restructuring of social theory, there is more to be derived from Berman's conceptualization of modernity and the recognition of the parallelism between the past and present *fin de siècle*.

As so many have begun to see, both *fin de siècle* periods resonate with similarly transformative, but not necessarily revolutionary, socio-spatial processes. As occurred roughly a century ago, there is currently a complex and conflictful dialectic developing between urgent socio-economic modernization sparked by the system-wide crises affecting contemporary capitalist societies; and a responsive cultural and political modernism aimed at making sense of the material changes taking place in the world and gaining control over their future directions. Modernization and modernism interact under these conditions of intensified crisis and restructuring to create a shifting and conflictful social context in which everything seems to be 'pregnant with its contrary', in which all that was once assumed to be solid 'melts into air', a description Berman borrows from Marx and represents as an essential feature of the vital experience of modernity-in-transition.

Modernization can be directly linked to the many different 'objective' processes of structural change that have been associated with the ability of capitalism to develop and survive, to reproduce successfully its fundamental social relations of production and distinctive divisions of labour despite endogenous tendencies towards debilitating crisis. This defining association between modernization and the survival of capitalism is crucial, for all too often the analysts of modernity extract social change from its social origins in modes of production to 'stage' history in idealized evolutionary modellings. From these perspectives, change just seems to 'happen' in a lock-step march of modernity replacing tradition, a mechanical teleology of progress. Modernization is not entirely the product of some determinative inner logic of capitalism, but neither is it a rootless and ineluctable idealization of history.

Modernization, as I view it here, is a continuous process of societal restructuring that is periodically accelerated to produce a significant recomposition of space–time–being in their concrete forms, a change in the nature and experience of modernity that arises primarily from the historical and geographical dynamics of modes of production. For the past four hundred years, these dynamics have been predominantly capitalist, as has been the very nature and experience of modernity during that time. Modernization is, like all social processes, unevenly developed across time and space and thus inscribes quite different historical geographies across

different regional social formations. But on occasion, in the ever-accumulating past, it has become systematically synchronic, affecting all predominantly capitalist societies simultaneously. This synchronization has punctuated the historical geography of capitalism since at least the early nineteenth century with an increasingly recognizable macro-rhythm, a wave-like periodicity of societal crisis and restructuring that we are only now beginning to understand in all its ramifications.

Perhaps the earliest of these prolonged periods of 'global' crisis and restructuring stretched through what Hobsbawm termed the 'age of revolution' and peaked in the turbulent years between 1830 and 1848–51. The following decades were a time of explosive capitalist expansion in industrial production, urban growth, and international trade, the florescence of a classical, competitive, entrepreneurial regime of capital accumulation and social regulation. During the last three decades of the nineteenth century, however, boom turned largely into bust for the then most advanced capitalist countries as the Long Depression, as it was called, accentuated the need for another urgent restructuring and modernization, a new 'fix' for a capitalism forever addicted to crisis.

The same rollercoaster sequence of crisis-induced restructuring leading to an expansionary boom, and then to crisis and restructuring again, marked the first half of the twentieth century, with the Great Depression echoing the conflictful system-wide downturns of the past and initiating the transition from one distinctive regime of accumulation to another. And as it now seems increasingly clear, the last half of the twentieth century has followed a similar broad trajectory, with a prolonged expansionary period after the Second World War and a still ongoing, crisis-filled era of attempted modernization and restructuring taking us toward the next *fin de siècle*.

Michel de Certeau

WALKING IN THE CITY

EDITOR'S INTRODUCTION

I N THIS REMARKABLE ESSAY, carefully poised between poetry and semiotics, Michel de Certeau analyses an aspect of daily urban life. He presents a theory of the city, or rather an ideal for the city, against the theories and ideals of urban planners and managers, and to do so he does not look down at the city as if from a high-rise building – he walks in it.

Walking in the city turns out to have its own logic – or, as de Certeau puts it, its own "rhetoric." The walker individuates and makes ambiguous the "legible" order given to cities by planners, a little in the way that waking life is displaced and ambiguated by dreaming – to take one of de Certeau's several analogies.

This is a utopian essay: it conceives of the "everyday" as different from the official in the same way that poetry is other to a planning manual. And it grants twentieth-century urban experience, for which walking is a secondary form of loco-motion (usually a kind of drifting), the glamor that a writer such as Walter Benjamin found in the nineteenth-century leisured observer or *flâneur*. "Walking in the city" has been very influential in recent cultural studies just because of the way that it uses both imagination and technical semiotic analysis to show how everyday life has particular value when it takes place in the gaps of larger power structures.

Further reading: Ahearne 1995; de Certeau 1984; Harvey 1985; Lefebvre 1971; Morris 1990; Rigby 1991.

Seeing Manhattan from the 110th floor of the World Trade Center. Beneath the haze stirred up by the winds, the urban island, a sea in the middle of the sea, lifts up the skyscrapers over Wall Street, sinks down at Greenwich, then rises again to the crests of Midtown, quietly passes over Central Park and finally undulates off into the distance beyond Harlem. A wave of verticals. Its agitation is momentarily arrested by vision. The gigantic mass is immobilized before the eyes. It is transformed into a texturology in which extremes coincide – extremes of ambition and degradation, brutal oppositions of races and styles, contrasts between yesterday's buildings, already transformed into trash cans, and today's urban irruptions that block out its space. Unlike Rome, New York has never learned the art of growing old by playing on all its pasts. Its present invents itself, from hour to hour, in the act of throwing away its previous accomplishments and challenging the future. A city composed of paroxysmal places in monumental reliefs. The spectator can read in it a universe that is constantly exploding. In it are inscribed the architectural figures of the *coincidatio oppositorum* formerly drawn in miniatures and mystical textures. On this stage of concrete, steel and glass, cut out between two oceans (the Atlantic and the American) by a frigid body of water, the tallest letters in the world compose a gigantic rhetoric of excess in both expenditure and production.

Voyeurs or walkers

To what erotics of knowledge does the ecstasy of reading such a cosmos belong? Having taken a voluptuous pleasure in it, I wonder what is the source of this pleasure of 'seeing the whole', of looking down on, totalizing the most immoderate of human texts.

To be lifted to the summit of the World Trade Center is to be lifted out of the city's grasp. One's body is no longer clasped by the streets that turn and return it according to an anonymous law; nor is it possessed, whether as player or played, by the rumble of so many differences and by the nervousness of New York traffic. When one goes up there, he leaves behind the mass that carries off and mixes up in itself any identity of authors or spectators. An Icarus flying above these waters, he can ignore the devices of Daedalus in mobile and endless labyrinths far below. His elevation transfigures him into a voyeur. It puts him at a distance. It transforms the bewitching world by which one was 'possessed' into a text that lies before one's eyes. It allows one to read it, to be a solar Eye, looking down like a god. The exaltation of a scopic and gnostic drive: the fiction of knowledge is related to this lust to be a viewpoint and nothing more.

Must one finally fall back into the dark space where crowds move back and forth, crowds that, though visible from on high, are themselves unable to see down below? An Icarian fall. On the 110th floor, a poster, sphinx-like, addresses an enigmatic message to the pedestrian who is for an instant transformed into a visionary: *It's hard to be down when you're up.*

The desire to see the city preceded the means of satisfying it. Medieval or Renaissance painters represented the city as seen in a perspective that no eye had yet enjoyed. This fiction already made the medieval spectator into a celestial eye.

It created gods. Have things changed since technical procedures have organized an 'all-seeing power'? The totalizing eye imagined by the painters of earlier times lives on in our achievements. The same scopic drive haunts users of architectural productions by materializing today the utopia that yesterday was only painted. The 1370-foot-high tower that serves as a prow for Manhattan continues to construct the fiction that creates readers, makes the complexity of the city readable and immobilizes its opaque mobility in a transparent text.

Is the immense texturology spread out before one's eyes anything more than a representation, an optical artefact? It is the analogue of the facsimile produced, through a projection that is a way of keeping aloof, by the space planner urbanist, city planner or cartographer. The panorama-city is a 'theoretical' (that is, visual) simulacrum, in short a picture, whose condition of possibility is an oblivion and a misunderstanding of practices.

The ordinary practitioners of the city live 'down below', below the thresholds at which visibility begins. They walk – an elementary form of this experience of the city; they are walkers, *Wandersmänner*, whose bodies follow the thicks and thins of an urban 'text' they write without being able to read it. These practitioners make use of spaces that cannot be seen; their knowledge of them is as blind as that of lovers in each other's arms. The paths that correspond in this intertwining, unrecognized poems in which each body is an element signed by many others, elude legibility. It is as though the practices organizing a bustling city were characterized by their blindness. The networks of these moving, intersecting writings compose a manifold story that has neither author nor spectator, shaped out of fragments of trajectories and alterations of spaces: in relation to representations, it remains daily and indefinitely other.

Escaping the imaginary totalizations produced by the eye, the everyday has a certain strangeness that does not surface, or whose surface is only its upper limit, outlining itself against the visible. Within this ensemble, I shall try to locate the practices that are foreign to the 'geometrical' or 'geographical' space of visual, panoptic, or theoretical constructions. These practices of space refer to a specific form of *operations* ('ways of operating'), to 'another spatiality' (an 'anthropological', poetic and mythic experience of space), and to an *opaque and blind* mobility characteristic of the bustling city. A *migrational*, or metaphorical, city thus slips into the clear text of the planned and readable city.

From the concept of the city to urban practices

The World Trade Center is only the most monumental figure of Western urban development. The atopia–utopia of optical knowledge has long had the ambition of surmounting and articulating the contradictions arising from urban agglomeration. It is a question of managing a growth of human agglomeration or accumulation. 'The city is a huge monastery', said Erasmus. Perspective vision and prospective vision constitute the twofold projection of an opaque past and an uncertain future on to a surface that can be dealt with. They inaugurate (in the sixteenth century?) the transformation of the urban *fact* into the *concept* of a city. Long before the concept itself gives rise to a particular figure of history, it assumes that this fact

can be dealt with as a unity determined by an urbanistic *ratio*. Linking the city to the concept never makes them identical, but it plays on their progressive symbiosis: to plan a city is both to *think the very plurality* of the real and to make that way of thinking the plural *effective*; it is to know how to articulate it and be able to do it.

An operational concept?

The 'city' founded by utopian and urbanistic discourse is defined by the possibility of a threefold operation.

First, the production of its *own* space (*un espace propre*): rational organization must thus repress all the physical, mental and political pollutions that would compromise it;

Second, the substitution of a nowhen, or of a synchronic system, for the indeterminable and stubborn resistances offered by traditions; univocal scientific strategies, made possible by the flattening out of all the data in a plane projection, must replace the tactics of users who take advantage of 'opportunities' and who, through these trap-events, these lapses in visibility, reproduce the opacities of history everywhere;

Third and finally, the creation of a *universal* and anonymous *subject* which is the city itself: it gradually becomes possible to attribute to it, as to its political model, Hobbes's State, all the functions and predicates that were previously scattered and assigned to many different real subjects – groups, associations, or individuals. 'The city', like a proper name, thus provides a way of conceiving and constructing space on the basis of a finite number of stable, isolatable, and interconnected properties.

Administration is combined with a process of elimination in this place organized by 'speculative' and classificatory operations. On the one hand, there is a differentiation and redistribution of the parts and functions of the city, as a result of inversions, displacements, accumulations, etc.; on the other there is a rejection of everything that is not capable of being dealt with in this way and so constitutes the 'waste products' of a functionalist administration (abnormality, deviance, illness, death, etc.). To be sure, progress allows an increasing number of these waste products to be reintroduced into administrative circuits and transforms even deficiencies (in health, security etc.) into ways of making the networks of order denser. But in reality, it repeatedly produces effects contrary to those at which it aims: the profit system generates a loss which, in the multiple forms of wretchedness and poverty outside the system and of waste inside it, constantly turns production into 'expenditure'. Moreover, the rationalization of the city leads to its mythification in strategic discourses, which are calculations based on the hypothesis or the necessity of its destruction in order to arrive at a final decision. Finally, the functionalist organization, by privileging progress (i.e., time), causes the condition of its own possibility – space itself – to be forgotten; space thus becomes the blind spot in a scientific and political technology. This is the way in which the Concept-city functions; a place of transformations and appropriations, the object of various kinds of interference but also a subject that is constantly enriched by new attributes, it is simultaneously the machinery and the hero of modernity.

Today, whatever the avatars of this concept may have been, we have to acknowledge that if in discourse the city serves as a totalizing and almost mythical landmark for socio-economic and political strategies, urban life increasingly permits the re-emergence of the element that the urbanistic project excluded. The language of power is in itself 'urbanizing', but the city is left prey to contradictory movements that counterbalance and combine themselves outside the reach of panoptic power. The city becomes the dominant theme in political legends, but it is no longer a field of programmed and regulated operations. Beneath the discourses that ideologize the city, the ruses and combinations of powers that have no readable identity proliferate; without points where one can take hold of them, without rational transparency, they are impossible to administer.

The return of practices

The Concept-city is decaying. Does that mean that the illness afflicting both the rationality that founded it and its professionals afflicts the urban populations as well? Perhaps cities are deteriorating along with the procedures that organized them. But we must be careful here. The ministers of knowledge have always assumed that the whole universe was threatened by the very changes that affected their ideologies and their positions. They transmute the misfortune of their theories into theories of misfortune. When they transform their bewilderment into 'catastrophes', when they seek to enclose the people in the 'panic' of their discourses, are they once more necessarily right?

Rather than remaining within the field of a discourse that upholds its privilege by inverting its content (speaking of catastrophe and no longer of progress), one can try another path: one can analyse the microbe-like, singular and plural practices which an urbanistic system was supposed to administer or suppress, but which have outlived its decay; one can follow the swarming activity of these procedures that, far from being regulated or eliminated by panoptic administration, have reinforced themselves in a proliferating illegitimacy, developed and insinuated themselves into the networks of surveillance, and combined in accord with unreadable but stable tactics to the point of constituting everyday regulations and surreptitious creativities that are merely concealed by the frantic mechanisms and discourses of the observational organization.

This pathway could be inscribed as a consequence, but also as the reciprocal, of Foucault's analysis of the structures of power. He moved it in the direction of mechanisms and technical procedures, 'minor instrumentalities' capable, merely by their organization of 'details', of transforming a human multiplicity into a 'disciplinary' society and of managing, differentiating, classifying, and hierarchizing all deviances concerning apprenticeship, health, justice, the army or work. 'These often miniscule ruses of discipline', these 'minor but flawless' mechanisms, draw their efficacy from a relationship between procedures and the space that they redistribute in order to make an 'operator' out of it. But what *spatial practices* correspond, in the area where discipline is manipulated, to these apparatuses that produce a disciplinary space? In the present conjuncture, which is marked by a contradiction between the collective mode of administration and an individual mode of reappropriation, this question is no less important, if one admits that spatial practices

in fact secretly structure the determining conditions of social life. I would like to follow out a few of these multiform, resistant, tricky and stubborn procedures that elude discipline without being outside the field in which it is exercised, and which should lead us to a theory of everyday practices, of lived space, of the disquieting familiarity of the city.

The chorus of idle footsteps

> The goddess can be recognized by her step.
>
> Virgil, *Aeneid,* I, 405

Their story begins on ground level, with footsteps. They are myriad, but do not compose a series. They cannot be counted because each unit has a qualitative character: a style of tactile apprehension and kinesthetic appropriation. Their swarming mass is an innumerable collection of singularities. Their intertwined paths give their shape to spaces. They weave places together. In that respect, pedestrian movements form one of these 'real systems whose existence in fact makes up the city'. They are not localized; it is rather they that spatialize. They are no more inserted within a container than those Chinese characters speakers sketch out on their hands with their fingertips.

It is true that the operations of walking on can be traced on city maps in such a way as to transcribe their paths (here well-trodden, there very faint) and their trajectories (going this way and not that). But these thick or thin curves only refer, like words, to the absence of what has passed by. Surveys of routes miss what was: the act itself of passing by. The operation of walking, wandering, or 'window shopping', that is, the activity of passers-by, is transformed into points that draw a totalizing and reversible line on the map. They allow us to grasp only a relic set in the nowhen of a surface of projection. Itself visible, it has the effect of making invisible the operation that made it possible. These fixations constitute procedures for forgetting. The trace left behind is substituted for the practice. It exhibits the (voracious) property that the geographical system has of being able to transform action into legibility, but in doing so it causes a way of being in the world to be forgotten.

Walking rhetorics

The walking of passers-by offers a series of turns (*tours*) and detours that can be compared to 'turns of phrase' or 'stylistic figures'. There is a rhetoric of walking. The art of 'turning' phrases finds an equivalent in an art of composing a path (*tourner un parcours*). Like ordinary language, this art implies and combines styles and uses. *Style* specifies 'a linguistic structure that manifests on the symbolic level . . . an individual's fundamental way of being in the world'; it connotes a singular. Use defines the social phenomenon through which a system of communication manifests itself in actual fact; it refers to a norm. Style and use both have to do with a 'way of operating' (of speaking, walking, etc.), but style involves a peculiar processing of the symbolic, while use refers to elements of a code. They intersect to form a style of use, a way of being and a way of operating.

A friend who lives in the city of Sèvres drifts, when he is in Paris, toward the rue des Saints-*Pères* and the rue de *Sèvres*, even though he is going to see his mother in another part of town: these names articulate a sentence that his steps compose without his knowing it. Numbered streets and street numbers (112th St., or 9 rue Saint-Charles) orient the magnetic field of trajectories just as they can haunt dreams. Another friend unconsciously represses the streets which have names and, by this fact, transmit her – orders or identities in the same way as summonses and classifications; she goes instead along paths that have no name or signature. But her walking is thus still controlled negatively by proper names.

What is it then that they spell out? Disposed in constellations that hierarchize and semantically order the surface of the city, operating chronological arrangements and historical justifications, these words (*Borrégo, Botzaris, Bougainville* . . .) slowly lose, like worn coins, the value engraved on them, but their ability to signify outlives its first definition. *Saint-Pères, Corentin Celton, Red Square* . . . these names make themselves available to the diverse meanings given them by passers-by; they detach themselves from the places they were supposed to define and serve as imaginary meeting-points on itineraries which, as metaphors, they determine for reasons that are foreign to their original value but may be recognized or not by passers-by. A strange toponymy that is detached from actual places and flies high over the city like a foggy geography of 'meanings' held in suspension, directing the physical deambulations below: *Place de l'Étoile, Concorde, Poissonnière* . . . These constellations of names provide traffic patterns: they are stars directing itineraries. 'The Place de la Concorde does not exist,' Malaparte said, 'it is an idea.' It is much more than an 'idea'. A whole series of comparisons would be necessary to account for the magical powers proper names enjoy. They seem to be carried as emblems by the travellers they direct and simultaneously decorate.

Linking acts and footsteps, opening meanings and directions, these words operate in the name of an emptying-out and wearing-away of their primary role. They become liberated spaces that can be occupied. A rich indetermination gives them, by means of a semantic rarefaction, the function of articulating a second, poetic geography on top of the geography of the literal, forbidden or permitted meaning. They insinuate other routes into the functionalist and historical order of movement. Walking follows them: 'I fill this great empty space with a beautiful name.' People are put in motion by the remaining relics of meaning, and sometimes by their waste products, the inverted remainders of great ambitions. Things that amount to nothing, or almost nothing, symbolize and orient walkers' steps: names that have ceased precisely to be 'proper'.

Ultimately, since proper names are already 'local authorities' or 'superstitions', they are replaced by numbers: on the telephone, one no longer dials *Opera*, but 073. The same is true of the stories and legends that haunt urban space like superfluous or additional inhabitants. They are the object of a witch-hunt, by the very logic of the techno-structure. But their extermination (like the extermination of trees, forests, and hidden places in which such legends live) makes the city a 'suspended symbolic order'. The habitable city is thereby annulled. Thus, as a woman from Rouen put it, no, here 'there isn't any place special, except for my own home, that's all . . . There isn't anything.' Nothing 'special': nothing that is marked, opened up by a memory or a story, signed by something or someone

else. Only the cave of the home remains believable, still open for a certain time to legends, still full of shadows. Except for that, according to another city-dweller, there are only 'places in which one can no longer believe in anything'.

It is through the opportunity they offer to store up rich silences and wordless stories, or rather through their capacity to create cellars and garrets everywhere, that local legends (*legenda*: what is *to be read*, but also what *can be read*) permit exits, ways of going out and coming back in, and thus habitable spaces. Certainly walking about and travelling substitute for exits, for going away and coming back, which were formerly made available by a body of legends that places nowadays lack. Physical moving about has the itinerant function of yesterday's or today's 'superstitions'. Travel (like walking) is a substitute for the legends that used to open up space to something different. What does travel ultimately produce if it is not, by a sort of reversal, 'an exploration of the deserted places of my memory', the return to nearby exoticism by way of a detour through distant places, and the 'discovery' of relics and legends: 'fleeting visions of the French countryside', 'fragments of music and poetry', in short, something like an 'uprooting in one's origins' (Heidegger)? What this walking exile produces is precisely the body of legends that is currently lacking in one's own vicinity; it is a fiction, which moreover has the double characteristic, like dreams or pedestrian rhetoric, of being the effect of displacements and condensations. As a corollary, one can measure the importance of these signifying practices (to tell oneself legends) as practices that invent spaces.

From this point of view, their contents remain revelatory, and still more so is the principle that organizes them. Stories about places are makeshift things. They are composed with the world's debris. Even if the literary form and the actantial schema of 'superstitions' correspond to stable models whose structures and combinations have often been analysed over the past thirty years, the materials (all the rhetorical details of their 'manifestation') are furnished by the leftovers from nominations, taxonomies, heroic or comic predicates, etc., that is, by fragments of scattered semantic places. These heterogeneous and even contrary elements fill the homogeneous form of the story. Things *extra* and *other* (details and excesses coming from elsewhere) insert themselves into the accepted framework, the imposed order. One thus has the very relationship between spatial practices and the constructed order. The surface of this order is everywhere punched and torn open by ellipses, drifts, and leaks of meaning: it is a sieve-order.

Michel Foucault

SPACE, POWER AND KNOWLEDGE

EDITOR'S INTRODUCTION

THIS INTERVIEW, IN WHICH Michel Foucault talks to Paul Rabinow, makes its most general point last. Foucault argues that material changes cannot be used to explain changes in subjectivity. For instance, when, in the Middle Ages, chimneys were first walled and placed inside, rather than outside, houses, interpersonal relations were transformed. New interactions flourished around chimneys. But the building of chimneys is not enough to explain these changes – if, for instance, different discourses and values had been circulating at the time then chimneys would have produced different kinds of changes. Generalizing from this point, Foucault argues that abstract (and in the West highly valued) words like "liberty" and "rationality" refer neither simply to ideas nor to practices but to sets of complex exchanges between the two. None the less, it has been the "practices" of liberty and reason that have been neglected by intellectual and cultural historians.

This line of thought has an important consequence. It means that architects and other social managers cannot guarantee that their designs will secure liberty or rationality. What matters is the fit between the material reorganization of space, life-practices, values, and discourses: only if the fit is right will social managers be able to augment what Foucault calls "practices of liberty." In this light Foucault argues that intellectuals have a particular function when society is being modernized and rationalized by managers and experts: they are to remain critical of nostalgic, utopian and overly abstract thought.

Further reading: Burgin 1990; Dreyfus and Rabinow 1983; Foucault 1980b, 1988; T. Mitchell 1988 (a book which uses Foucault's work to describe the construction of colonial space).

Q. Do you see any particular architectural projects, either in the past or the present, as forces of liberation or resistance?

M.F. I do not think that it is possible to say that one thing is of the order of 'liberation' and another is of the order of 'oppression'. There are a certain number of things that one can say with some certainty about a concentration camp to the effect that it is not an instrument of liberation, but one should still take into account — and this is not generally acknowledged — that, aside from torture and execution, which preclude any resistance, no matter how terrifying a given system may be, there always remain the possibilities of resistance, disobedience, and oppositional groupings.

On the other hand, I do not think that there is anything that is functionally — by its very nature — absolutely liberating. Liberty is a *practice*. So there may, in fact, always be a certain number of projects whose aim is to modify some constraints, to loosen, or even to break them, but none of these projects can, simply by its nature, assure that people will have liberty automatically, that it will be established by the project itself. The liberty of men is never assured by the institutions and laws that are intended to guarantee them. This is why almost all of these laws and institutions are quite capable of being turned around. Not because they are ambiguous, but simply because 'liberty' is what must be exercised.

Q. Are there urban examples of this? Or examples where architects succeeded?

M.F. Well, up to a point there is Le Corbusier, who is described today — with a sort of cruelty that I find perfectly useless — as a sort of crypto-Stalinist. He was, I am sure, someone full of good intentions and what he did was in fact dedicated to liberating effects. Perhaps the means that he proposed were in the end less liberating than he thought, but, once again, I think that it can never be inherent in the structure of things to guarantee the exercise of freedom. The guarantee of freedom is freedom.

Q. So you do not think of Le Corbusier as an example of success. You are simply saying that his intention was liberating. Can you give us a successful example?

M.F. No. It *cannot* succeed. If one were to find a place, and perhaps there are some, where liberty is effectively exercised, one would find that this is not owing to the order of objects, but, once again, owing to the practice of liberty. Which is not to say that, after all, one may as well leave people in slums, thinking that they can simply exercise their rights there.

Q. Meaning that architecture in itself cannot resolve social problems?

M.F. I think that it can and does produce positive effects when the liberating intentions of the architect coincide with the real practice of people in the exercise of their freedom.

Q. But the same architecture can serve other ends?

M.F. Absolutely. Let me bring up another example: the *Familistère* of Jean-Baptiste Godin at Guise [1859]. The architecture of Godin was clearly intended for the freedom of people. Here was something that manifested the power of ordinary workers to participate in the exercise of their trade. It was a rather important sign and instrument of autonomy for a group of workers. Yet no one could enter or leave the place without being seen by everyone – an aspect of the architecture that could be totally oppressive. But it could only be oppressive if people were prepared to use their own presence in order to watch over others. Let's imagine a community of unlimited sexual practices that might be established there. It would once again become a place of freedom. I think it is somewhat arbitrary to dissociate the effective practice of freedom by people, the practice of social relations, and the spatial distributions in which they find themselves. If they are separated, they become impossible to understand. Each can only be understood through the other.

Q. Yet people have often attempted to find utopian schemes to liberate people, or to oppress them.

M.F. Men have dreamed of liberating machines. But there are no machines of freedom, by definition. This is not to say that the exercise of freedom is completely indifferent to spatial distribution, but it can only function when there is a certain convergence; in the case of divergence or distortion, it immediately becomes the opposite of that which had been intended. The panoptic qualities of Guise could perfectly well have allowed it to be used as a prison. Nothing could be simpler. It is clear that, in fact, the *Familistère* may well have served as an instrument for discipline and a rather unbearable group pressure.

Q. So, once again, the intention of the architect is not the fundamental determining factor.

M.F. Nothing is fundamental. That is what is interesting in the analysis of society. That is why nothing irritates me as much as these enquiries – which are by definition metaphysical – on the foundations of power in a society or the self-institution of a society, etc. These are not fundamental phenomena. There are only reciprocal relations, and the perpetual gaps between intentions in relation to one another.

Q. You have singled out doctors, prison wardens, priests, judges, and psychiatrists as key figures in the political configurations that involve domination. Would you put architects on this list?

M.F. You know, I was not really attempting to describe figures of domination when I referred to doctors and people like that, but rather to describe people through whom power passed or who are important in the fields of power relations. A patient in a mental institution is placed within a field of fairly complicated power relations, which Erving Goffman analysed very well. The pastor in a Christian or Catholic church (in Protestant churches it is somewhat different) is an important link in a set of power relations. The architect is not an individual of that sort.

After all, the architect has no power over me. If I want to tear down or change a house he built for me, put up new partitions, add a chimney, the architect has no control. So the architect should be placed in another category – which is not to say that he is not totally foreign to the organization, the implementation, and all the techniques of power that are exercised in a society. I would say that one must take *him* – his mentality, his attitude – into account as well as his projects, in order to understand a certain number of the techniques of power that are invested in architecture, but he is not comparable to a doctor, a priest, a psychiatrist, or a prison warden.

Q. 'Postmodernism' has received a great deal of attention recently in architectural circles. It is also being talked about in philosophy, notably by Jean-François Lyotard and Jürgen Habermas. Clearly, historical reference and language play an important role in the modern episteme. How do you see postmodernism, both as architecture and in terms of the historical and philosophical questions that are posed by it?

M.F. I think that there is a widespread and facile tendency, which one should combat, to designate that which has just occurred as the primary enemy, as if this were always the principal form of oppression from which one had to liberate oneself. Now this simple attitude entails a number of dangerous consequences: first, an inclination to seek out some cheap form of archaism or some imaginary past forms of happiness that people did not, in fact, have at all. For instance, in the areas that interest me, it is very amusing to see how contemporary sexuality is described as something absolutely terrible. To think that it is only possible now to make love after turning off the television! and in mass-produced beds! 'Not like that wonderful time when . . .' Well, what about those wonderful times when people worked eighteen hours a day and there were six people in a bed, if one was lucky enough to have a bed! There is in this hatred of the present or the immediate past a dangerous tendency to invoke a completely mythical past. Second, there is the problem raised by Habermas: if one abandons the work of Kant or Weber, for example, one runs the risk of lapsing into irrationality.

I am completely in agreement with this, but at the same time, our question is quite different: I think that the central issue of philosophy and critical thought since the eighteenth century has always been, still is, and will, I hope, remain the question: *What* is this Reason that we use? What are its historical effects? What are its limits, and what are its dangers? How can we exist as rational beings, fortunately committed to practising a rationality that is unfortunately crisscrossed by intrinsic dangers? One should remain as close to this question as possible, keeping in mind that it is both central and extremely difficult to resolve. In addition, if it is extremely dangerous to say that Reason is the enemy that should be eliminated, it is just as dangerous to say that any critical questioning of this rationality risks sending us into irrationality. One should not forget – and I'm saying this not in order to criticize rationality, but in order to show how ambiguous things are – it was on the basis of the flamboyant rationality of social Darwinism that racism was formulated, becoming one of the most enduring and powerful ingredients of Nazism. This was, of course, an irrationality, but an irrationality that was at the same time, after all, a certain form of rationality. . . .

This is the situation that we are in and that we must combat. If intellectuals in general are to have a function, if critical thought itself has a function, and, even more specifically, if philosophy has a function within critical thought, it is precisely to accept this sort of spiral, this sort of revolving door of rationality that refers us to its necessity, to its indispensability, and at the same time, to its intrinsic dangers.

Q. All that being said, it would be fair to say that you are much less afraid of historicism and the play of historical references than someone like Habermas is; also, that this issue has been posed in architecture as almost a crisis of civilization by the defenders of modernism, who contend that if we abandon modern architecture for a frivolous return to decoration and motifs, we are somehow abandoning civilization. On the other hand, some postmodernists have claimed that historical references per se are somehow meaningful and are going to protect us from the dangers of an overly rationalized world.

M.F. Although it may not answer your question, I would say this: one should totally and absolutely suspect anything that claims to be a return. One reason is a logical one; there is in fact no such thing as a return. History, and the meticulous interest applied to history, is certainly one of the best defences against this theme of the return. For me, the history of madness or the studies of the prison . . . were done in that precise manner because I knew full well – this is in fact what aggravated many people – that I was carrying out a historical analysis in such a manner that people *could* criticize the present, but it was impossible for them to say, 'Let's go back to the good old days when madmen in the eighteenth century . . .' or, 'Let's go back to the days when the prison was not one of the principal instruments . . .' No; I think that history preserves us from that sort of ideology of the return.

Q. Hence, the simple opposition between reason and history is rather silly . . . choosing sides between the two. . . .

M.F. Yes. Well, the problem for Habermas is, after all, to make a transcendental mode of thought spring forth against any historicism. I am, indeed, far more historicist and Nietzschean. I do not think that there is a proper usage of history or a proper usage of intrahistorical analysis – which is fairly lucid, by the way – that works precisely against this ideology of the return. A good study of peasant architecture in Europe, for example, would show the utter vanity of wanting to return to the little individual house with its thatched roof. History protects us from historicism – from a historicism that calls on the past to resolve the questions of the present.

Q. It also reminds us that there is always a history; that those modernists who wanted to suppress any reference to the past were making a mistake.

M.F. Of course.

Q. Your next two books deal with sexuality among the Greeks and the early Christians. Are there any particular architectural dimensions to the issues you discuss?

M.F. I didn't find any; absolutely none. But what is interesting is that in imperial Rome there were, in fact, brothels, pleasure quarters, criminal areas, etc., and there was also one sort of quasi-public place of pleasure: the baths, the *thermes*. The baths were a very important place of pleasure and encounter, which slowly disappeared in Europe. In the Middle Ages, the baths were still a place of encounter between men and women as well as of men with men and women with women, although that is rarely talked about. What were referred to and condemned, as well as practised, were the encounters between men and women, which disappeared over the course of the sixteenth and seventeenth centuries.

Q. In the Arab world it continues.

M.F. Yes; but in France it has largely ceased. It still existed in the nineteenth century. One sees it in *Les Enfants du Paradis*, and it is historically exact. One of the characters, Lacenaire, was – no one mentions it – a swine and a pimp who used young boys to attract older men and then blackmailed them; there is a scene that refers to this. It required all the *naïveté* and anti-homosexuality of the Surrealists to overlook that fact. So the baths continued to exist, as a place of sexual encounters. The bath was a sort of cathedral of pleasure at the heart of the city, where people could go as often as they want, where they walked about, picked each other up, met each other, took their pleasure, ate, drank, discussed. . . .

Q. So sex was not separated from the other pleasures. It was inscribed in the centre of the cities. It was public; it served a purpose. . . .

M.F. That's right. Sexuality was obviously considered a social pleasure for the Greeks and the Romans. What is interesting about male homosexuality today – this has apparently been the case of female homosexuals for some time – is that their sexual relations are immediately translated into social relations and the social relations are understood as sexual relations. For the Greeks and the Romans, in a different fashion, sexual relations were located within social relations in the widest sense of the term. The baths were a place of sociality that included sexual relations.

One can directly compare the bath and the brothel. The brothel is in fact a place, and an architecture, of pleasure. There is, in fact, a very interesting form of sociality that was studied by Alain Corbin in *Les Filles de Noces*. The men of the city met at the brothel; they were tied to one another by the fact that the same women passed through their hands, that the same diseases and infections were communicated to them. There was a sociality of the brothel, but the sociality of the baths as it existed among the ancients – a new version of which could perhaps exist again – was completely different from the sociality of the brothel.

Q. We now know a great deal about disciplinary architecture. What about confessional architecture – the kind of architecture that would be associated with a confessional technology?

M.F. You mean religious architecture? I think that it has been studied. There is the whole problem of a monastery as xenophobic. There one finds precise regulations concerning life in common; affecting sleeping, eating, prayer, the place of each individual in all of that, the cells. All of this was programmed from very early on.

Q. In a technology of power, of confession as opposed to discipline, space seems to play a central role as well.

M.F. Yes. Space is fundamental in any form of communcal life; space is fundamental in any exercise of power. To make a parenthetical remark, I recall having been invited, in 1966, by a group of architects to do a study of space, of something that I called at that time 'heterotopias', those singular spaces to be found in some given social spaces whose functions are different or even the opposite of others. The architects worked on this, and at the end of the study someone spoke up – a Sartrean psychologist – who firebombed me, saying that *space* is reactionary and capitalist, but *history* and *becoming* are revolutionary. This absurd discourse was not at all unusual at the time. Today everyone would be convulsed with laughter at such a pronouncement, but not then.

Q. Architects in particular, if they do choose to analyse an institutional building such as a hospital or a school in terms of its disciplinary function, would tend to focus primarily on the walls. After all, that is what they design. Your approach is perhaps more concerned with space, rather than architecture, in that the physical walls are only one aspect of the institution. How would you characterize the difference between these two approaches, between the building itself and space?

M.F. I think there is a difference in method and approach. It is true that for me, architecture, in the very vague analyses of it that I have been able to conduct, is only taken as an element of support, to ensure a certain allocation of people in space, a *canalization* of their circulation, as well as the coding of their reciprocal relations. So it is not only considered as an element in space, but is especially thought of as a plunge into a field of social relations in which it brings about some specific effects.

For example, I know that there is a historian who is carrying out some interesting studies of the archaeology of the Middle Ages, in which he takes up the problem of architecture, of houses in the Middle Ages, in terms of the problem of the chimney. I think that he is in the process of showing that beginning at a certain moment it was possible to build a chimney inside the house – a chimney with a hearth, not simply an open room or a chimney outside the house; that at that moment all sorts of things changed and relations between individuals became possible. All of this seems very interesting to me, but the conclusion that he presented in an article was that the history of ideas and thoughts is useless.

What is, in fact, interesting is that the two are rigorously indivisible. Why did people struggle to find the way to put a chimney inside a house? Or why did they put their techniques to this use? So often in the history of techniques it takes years or even centuries to implement them. It is certain, and of capital importance, that this technique was a formative influence on new human relations, but it is impossible to think that it would have been developed and adapted had there not been in the play and strategy of human relations something which tended in that direction. What is interesting is always interconnection, not the primacy of this over that, which never has any meaning.

Jean-François Lyotard

DEFINING THE POSTMODERN

EDITOR'S INTRODUCTION

T HE CLAIM THAT WE LIVE in the postmodern era has three separate grounds: first, that the ideas of progress, rationality, and scientific objectivity which legitimated Western modernity are no longer acceptable in large part because they take no account of cultural differences; second, that there is no confidence that "high" or avant-garde art and culture have more value than "low" or popular culture; and, third, that it is no longer possible securely to separate the "real" from the "copy," or the "natural" from the "artificial," in a historical situation where technologies (including technologies which produce and disseminate information and images) have so much control and reach.

Jean-François Lyotard, who has been responsible for influential critiques of modernist and universalist ideas of progress and rationality, as well as illuminating defences of the avant-garde, here argues against a historical reading of the "post" in "postmodernism." For him, the postmodern does not follow the modern in time: rather, modernity had always contained its "postmodern" moments.

Further reading: J. Collins 1989; Connor 1989; Docherty 1993; Harvey 1989; Hutcheon 1989; Jameson 1990; Lyotard 1986.

I should like to make only a small number of observations, in order to point to – and not at all to resolve – some problems surrounding the term 'postmodern'. My aim is not to close the debate, but to open it, to allow it to develop by avoiding certain confusions and ambiguities, as far as this is possible.

There are many debates implied by, and implicated in, the term 'postmodern'. I will distinguish three of them.

First, the opposition between postmodernism and modernism, or the Modern Movement (1910–45), in architectural theory. According to Paolo Portoghesi (*Dell'architectura moderna*), there is a rupture or break, and this break would be the abrogation of the hegemony of Euclidean geometry, which was sublimated in the plastic poetry of the movement known as De Stijl, for example. According to Victorio Grigotti, another Italian architect, the difference between the two periods is characterized by what is possibly a more interesting fissure. There is no longer any close linkage between the architectural project and socio-historical progress in the realization of human emancipation on the larger scale. Postmodern architecture is condemned to generate a multiplicity of small transformations in the space it inherits, and to give up the project of a last rebuilding of the whole space occupied by humanity. In this sense, a perspective is opened in the larger landscape.

In this account there is no longer a horizon of universalization, of general emancipation before the eyes of postmodern man, or in particular, of the postmodern architect. The disappearance of this idea of progress within rationality and freedom would explain a certain tone, style or modus which are specific to postmodern architecture. I would say a sort of *bricolage*: the high frequency of quotations of elements from previous styles or periods (classical or modern), giving up the consideration of environment, and so on.

Just a remark about this aspect. The 'post', in the term 'postmodernist' is in this case to be understood in the sense of a simple succession, of a diachrony of periods, each of them clearly identifiable. Something like a conversion, a new direction after the previous one. I should like to observe that this idea of chronology is totally modern. It belongs to Christianity, Cartesianism, Jacobinism. Since we are beginning something completely new, we have to re-set the hands of the clock at zero. The idea of modernity is closely bound up with this principle that it is possible and necessary to break with tradition and to begin a new way of living and thinking. Today we can presume that this 'breaking' is, rather, a manner of forgetting or repressing the past. That's to say of repeating it. Not overcoming it.

I would say that the quotation of elements of past architectures in the new ones seems to me to be the same procedure as the use of remains coming from past life in the dream-work as described by Freud, in the *Interpretation of Dreams*. This use of repetition or quotation, be it ironical or not, cynical or not, can be seen in the trends dominating contemporary painting, under the name of 'trans-avantgardism' (Achille Bonito Oliva) or under the name of neo-expressionism. I'll come back to this question in my third point.

The second point. A second connotation of the term 'postmodern', and I admit that I am at least partly responsible for the misunderstanding associated with this meaning.

The general idea is a trivial one. One can note a sort of decay in the confidence placed by the last two centuries in the idea of progress. This idea of progress

as possible, probable or necessary was rooted in the certainty that the development of the arts, technology, knowledge and liberty would be profitable to mankind as a whole. To be sure, the question of knowing which was the subject truly victimized by the lack of development – whether it was the poor, the worker, the illiterate – remained open during the nineteenth and twentieth centuries. There were disputes, even wars, between liberals, conservatives and leftists over the very name of the subject we are to help to become emancipated. Nevertheless, all the parties concurred in the same belief that enterprises, discoveries and institutions are legitimate only insofar as they contribute to the emancipation of mankind.

After two centuries, we are more sensitive to signs that signify the contrary. Neither economic nor political liberalism, nor the various Marxisms, emerge from the sanguinary last two centuries free from the suspicion of crimes against mankind. We can list a series of proper names (names of places, persons and dates) capable of illustrating and founding our suspicion. Following Theodor Adorno, I use the name of Auschwitz to point out the irrelevance of empirical matter, the stuff of recent past history, in terms of the modern claim to help mankind to emancipate itself. What kind of thought is able to sublate (*Aufheben*) Auschwitz in a general (either empirical or speculative) process towards a universal emancipation? So there is a sort of sorrow in the *Zeitgeist*. This can express itself by reactive or reactionary attitudes or by utopias, but never by a positive orientation offering a new perspective.

The development of techno-sciences has become a means of increasing disease, not of fighting it. We can no longer call this development by the old name of progress. This development seems to be taking place by itself, by an autonomous force or 'motricity'. It doesn't respond to a demand coming from human needs. On the contrary, human entities (individual or social) seem always to be destabilized by the results of this development. The intellectual results as much as the material ones. I would say that mankind is in the condition of running after the process of accumulating new objects of practice and thought. In my view it is a real and obscure question to determine the reason of this process of complexification. It's something like a destiny towards a more and more complex condition. Our demands for security, identity and happiness, coming from our condition as living beings and even social beings appear today irrelevant in the face of this sort of obligation to complexify, mediate, memorize and synthesize every object, and to change its scale. We are in this techno-scientific world like Gulliver: sometimes too big, sometimes too small, never at the right scale. Consequently, the claim for simplicity, in general, appears today that of a barbarian.

From this point, it would be necessary to consider the division of mankind into two parts: one part confronted with the challenge of complexity; the other with the terrible ancient task of survival. This is a major aspect of the failure of the modern project (which was, in principle, valid for mankind as a whole).

The third argument is more complex, and I shall present it as briefly as possible. The question of postmodernity is also the question of the expressions of thought: art, literature, philosophy, politics. You know that in the field of art for example, and more especially the plastic arts, the dominant idea is that the big movement of avant-gardism is over. There seems to be general agreement about laughing at the avant-gardes, considered as the expression of an obsolete modernity. I don't

like the term avant-garde any more than anyone else, because of its military connotations. Nevertheless I would like to observe that the very process of avant-gardism in painting was in reality a long, obstinate and highly responsible investigation of the presuppositions implied in modernity. The right approach, in order to understand the work of painters from, say, Manet to Duchamp or Barnett Newman is to compare their work with the anamnesis which takes place in psychoanalytical therapy. Just as the patient elaborates his present trouble by freely associating the more imaginary, immaterial, irrelevant bits with past situations, so discovering hidden meanings of his life, we can consider the work of Cézanne, Picasso, Delaunay, Kandinsky, Klee, Mondrian, Malevitch and finally Duchamp as a working through – what Freud called *Durcharbeitung* – operated by modernity on itself. If we give up this responsibility, it is certain that we are condemned to repeat, without any displacement, the modern neurosis, the Western schizophrenia, paranoia, and so on. This being granted, the 'post' of postmodernity does not mean a process of coming back or flashing back, feeding back, but of *ana*-lysing, *ana*-mnesing, of reflecting.

Ackbar Abbas

BUILDING ON DISAPPEARANCE
Hong Kong architecture and colonial space

EDITOR'S INTRODUCTION

ACKBAR ABBAS'S WONDERFUL ESSAY on Hong Kong architecture (or, really, its urbanism in general), extracted from his book *Hong Kong: Culture and the Politics of Disappearance*, combines a detailed grasp of the city's political economy with a flair for theory as developed by postmodernists like Paul Virilio.

Hong Kong is seen as a "para-site" – dependent on flows, in and out, of people, commodities, capital, marketing strategies, fashions, ideas . . . – a world-hub of what Arjun Appadurai in his essay collected here calls "scapes," but also possessed of a strengthening will for preservation and identity. Hong Kong is disappearing in three senses: its past is ceaselessly lost to it: erased, absorbed, and transformed by export market forces; its built environment is constantly being constructed, demolished, reconstructed again; and, at the time of writing, it was facing the 1997 handover from Britain to the People's Republic of China.

What Abbas does in this essay is use his analysis of Hong Kong as "disappearing" to account for how space and building is organized there. It's a piece that can profitably be read alongside Meaghan Morris's essay on Australian shopping centers in this volume. Hers is a less "top down" analysis, more interested in examining the relation between space and lived experience (especially of working-class women). What both texts share though is a belief that theory can help provide access to vernacular experience, and maybe more to the point, that history (or its disappearance) is lived through and in civic spatiality.

Further reading: Abbas 1997; Davis 1992; Hannertz 1996; Ivy 1995; Jameson 1990; Lefebvre 1991b; Sassen 1991; Vidler 1992; Virilio 1991a.

The remark that Hong Kong reinvents itself every few years becomes quite cred-ible when we look at the changing skyline of the Central District. This skyline may not yet rival that of New York or Chicago, but it is none the less highly impres-sive in its own way, with its growing number of signature buildings by international architects like Norman Foster, I. M. Pei, and Paul Rudolf. Such a skyline not only underlines the domination of the marketplace, with the architect's signature func-tioning as a brand name; it also takes to an extreme Sharon Zukin's argument that 'market' erodes 'place' (Zukin 1992). The combination of rising land prices, prop-erty speculation, and the presence of large corporations vying for prime space results in a constant rebuilding that makes the city subtly unrecognizable.

The most spectacular example of this might have been the Ritz Carlton Hotel, located in the heart of Central. When it was nearing completion in early 1993, the original owners sold it to a multinational consortium, who reportedly played quite seriously with the idea of razing the luxury hotel to the ground before a single guest was registered, and putting in an office building instead because of the potentially higher income that might be generated. Buildings in Hong Kong suffer the fate of any other commodity, an insight that Walter Benjamin arrived at more than half a century ago: 'In the convulsions of the commodity economy we begin to recognise the monuments of the bourgeoisie as ruins even before they have crumbled' (Benjamin 1978: 162), an insight that is finally coming into its own. Property speculation means that every building in Hong Kong, however new or monumental, faces imminent ruin, on the premise of here today, gone tomorrow – a logistics that, by contracting time, dispenses even with the pathos of decay. The political slogans of the day – 'Prosperity and stability' and 'Fifty years without change' – are thus belied by an urban landscape that mutates right under our noses, making the question of spatial identity particularly problematic.

Architecture, because it is always assumed to be *somewhere*, is the first visual evidence of a city's putative identity. In this regard, the symbolic landscape of Central exerts a particular fascination, not only for film-makers and photographers but also for the domestic workers from the Philippines who take it over on Sundays when it is closed to traffic. But can the architecture of Central, or even the whole of Hong Kong architecture, represent the city? As Diana Agrest has pointed out, it is one thing to look at the city from the point of view of architecture and quite something else to look at architecture from the point of view of the city. The city from the point of view of architecture may be associated with painterly modes of looking derived from classical tradition, but architecture from the point of view of the city can be associated only with film, 'the visual art that developed along-side the modern city', that is to say, the art that problematizes the visual as stable because it is film that gives us, in Jean-Luc Godard's words, truth twenty-four times a second.

In the case of Hong Kong, there is indeed an important relation between archi-tecture and cinema that goes beyond including shots of impressive buildings on film. Not only are they the two most developed cultural forms in Hong Kong, but they are also the most dependent on the market and the most pre-eminently visual. Nevertheless, there is a crucial difference, and it concerns their relation to the visual. The Hong Kong cinema, in the work of its more interesting practi-tioners, uses the visual to problematize visuality itself and in this way contributes

to a critical discourse on colonial space. The case of Hong Kong architecture, at least up to the present moment, is somewhat less sanguine. It constructs a visual space that to a large extent resists critical dismantling. In the cinema, the subject is surrounded by moving images, which requires even in its simpler forms a certain amount of critical attention to construe. By contrast, in the case of architecture, it is the subject itself that moves, around an image that is seen to be stationary (hence Agrest's point about the need to destabilize architecture through a cinematization of space). Architecture therefore has the dangerous potential of turning all of us, locals and visitors alike, into *tourists* gazing at a stable and monumental image.

Insofar as it encourages a process of unreflective visual consumption, architecture in Hong Kong is the main material support of a space that can still be called colonial, in spite of official avoidance of the term *colony*. Colonial space can be thought of as the projection of a colonial imaginary that maps out a symbolic order in whose grids the real appears and disappears for a colonial subject. This amounts to saying that the formulation of a spatial problematic is becoming increasingly necessary to an analysis of colonialism exactly because colonial space in Hong Kong is quite specifically a space of disappearance. In such an analysis, architecture has a crucial, if so far still negative, role to play. What this underlines, therefore, is the urgent need to develop a critical discourse on Hong Kong architecture and urban space, where the dominance of visuality is put into question, as in the case of the new Hong Kong cinema.

Let me elaborate on this notion of disappearance and the colonial gaze by referring to urban phenomena in Hong Kong that seem at first sight to stem from postcolonial sensibilities. The notion of disappearance I am alluding to does not connote vanishing without a trace. In fact, it can go together very well with a concern for presence and projects of preservation. In recent years, since the early 1980s in particular, there has been a growing interest in what is self-consciously being called Hong Kong culture, which many read as Hong Kong's acquiring a sense of identity. For example, there has been a continuing vogue for photographic exhibitions about old Hong Kong; an archive of old Hong Kong films is just being established, studies of Hong Kong customs, traditions, and folklore are gaining all the time in academic respectability. It is in this context of preserving a cultural identity through preservation of cultural and urban forms that the strong response to the demolition of the Kowloon Walled City, that inner city of inner cities, must be understood. Because of a historical anomaly, the Walled City was a no-man's-land that fell outside British jurisdiction and beyond the administrative reach of China. The result was that it became a haven for all sorts of illegal and clandestine activities, although it was also just 'home' to a number of ordinary people. When it was finally razed to the ground quite recently, an action made possible only through the approval of the Chinese authorities, there was a brief hue and cry, followed by the appearance of a glossy and expensive volume of essays and photographs commemorating it in all its seedy glory. What can we make of this example? If colonialism goes together with a devaluation of local culture and identity, then it would seem that this new interest in the local is the symptom of an emerging postcolonial awareness. However, the situation is much more ambivalent than this, if we remember what Frantz Fanon pointed out a long time ago:

'It is the colonialist who becomes defenders of the native style' (Fanon 1967a: 195). When the native style and culture are bracketed and separated out as a special category, they are effectively recontained and lose whatever potential they might have had to stir memory. Preservation, it should be noted, is not memory. Preservation is selective and tends to exclude the dirt and pain. Culture as preservation, which is what a lot that currently passes in Hong Kong for postcoloniality amounts to, can only be a form of kitsch.

The preservation of old buildings gives us history *in site*, but it also means keeping history *in sight*. A critique of preservation is therefore also a critique of visual ideology. Let me take this argument about colonialism as a politics of the gaze a little further with the help of three examples of architectural preservation. It should be noted that the argument is not directed so much against preservation per se, which has its legitimate uses, as against the use of preservation as history to bring about the disappearance of history.

The first example is the Hong Kong Cultural Center, built on the site of the old Hong Kong–Canton railway terminal. The design of the Cultural Center offered an opportunity to imagine a community, but, in the event, the opportunity was largely lost. The main structure that houses the auditoria is one of those modernist placeless structures that could be from anywhere, looking like nothing so much as a giant ski slope. As if to compensate for the neglect of the local, one significant design detail was introduced. The clock tower in red brick from the demolished railway station was saved and incorporated into the overall design. On one level, this 'quotation' from Hong Kong's architectural history is the expression of a sense of historical moment, giving to the Cultural Center a patina of local history. But on another level, this patina of history is no more than decorative, an *image* of history meant for visual consumption. In its relation to the overall design of the Cultural Center, the clock tower can be compared to that strange-looking, hard-to-construe, anamorphic object floating on the bottom of Hans Holbein's famous painting *The Ambassadors* (National Gallery, London), a painting that Jacques Lacan analyzed in his discussion of the gaze (Lacan 1977a). However, the difference between them is very significant and tells us something about how colonial space controls desire. Faced with *The Ambassadors*, the viewing subject caught in the gaze, that is, in the perspectival space that dominates most of the painting, cannot construe the anamorphic object as the representation of a skull. That is because the gaze is a channelling and socializing of desire, and it is such a desire that makes one space, the perspectival one, recognizable and turns the space of the anamorphic image into a hallucination. In the Hong Kong example, we have the opposite situation: the clock tower, unlike the skull, is seen *too easily* and is too quickly assimilated into the overall spatial ensemble (as an instance of 'Hong Kong history'). Space is homogenized in the colonial gaze, as 'old' and 'new' are placed together in contiguity and continuity. There is also a spatial programming and socializing of desire, but it consists of making us accept, without shock or protest, the most blatant discontinuities as continuities. Any image preserved from the past may serve as a sign of a communal history. Such spatial practices are not very different from the practices of Disney theme parks, which also specialize in providing images of history. We are beginning to find equivalents of such theme parks in Hong Kong, like the Sung Village in Kowloon and the more recently opened Middle

Kingdom — a re-creation in miniature of architectural monuments from China, which forms part of the Ocean Park complex. In these examples, as in the Cultural Center clock tower, an imaginary community takes the place of an imagined community. Culture as preservation leads not to the development of a critical sense of community but works to keep the colonial subject in place, occupied with gazing at images of identity.

The second example of preservation is Flagstaff House, an impressive colonial-style building constructed in the 1840s. First used as the headquarters of Jardine, Matheson, and Company and then as the headquarters of the British military, it was later converted into a residence for the commander of the British forces. More recently, with the withdrawal of the British military presence in Hong Kong, there was some debate on what to do with the building. Eventually, the government's Architectural Services Department decided to preserve it by turning it into a museum to house a magnificent collection of Chinese teaware. This was done in 1984, and in 1989 the building was declared a monument. In this way, a historically significant building is saved from the bulldozers and the general public gets an education in Chinese culture. All sides, it would seem, stand to benefit from such an arrangement, and there is some truth in this. However, there is a certain presumably unintended irony here, not only in the dates 1984 (the year of the Joint Declaration) and 1989 (the year of Tiananmen) but also in the historical associations that tea has with the Opium Wars and the British gunboat diplomacy that secured Hong Kong for Britain in the first place. This reincarnation of a British military establishment in the form of a museum of Chinese teaware skims over the monumental barbarisms of the nineteenth century by aestheticizing them out of existence. Flagstaff House could be read therefore as an example of the disappearance of history: not in the sense of history having come to an end, but in the sense of its *persistence along certain ideological guidelines*. Disappearance here implies the substitution of one thing for another, a displacement of attention from the sometimes conflictual colonial history of Hong Kong, to the harmonious accommodation of Chinese culture in colonial architecture.

The third example is the Repulse Bay Hotel. This example may seem a little different from the first two, as it comes from the private sector, but the implications of preservation we find here are largely comparable. The original Repulse Bay Hotel, built in 1920, was a grand colonial-style building that became a famous Hong Kong landmark. With its wide veranda overlooking the bay, it was a fashionable meeting place for Sunday afternoon tea. In early 1982, at the height of land speculation, the hotel was torn down to make way for the building of luxury apartment blocks. The timing could not have been poorer because later in the year came Margaret Thatcher's visit to China. The immediate effect on the property market was a catastrophic slump in property prices, and the construction of the apartment blocks was delayed. Enter a movie director, Ann Hui, who wanted a few background shots for a film. A quick replica was built on the original site. This may have given someone the idea that a full-scale replica was a viable business proposition. As market confidence returned to Hong Kong in 1985 (as it has always done so far, no matter what the catastrophe), construction of the Repulse Bay apartment complex was taken up again, and a replica of the old hotel was included as an integral part. The project was completed in 1989, and it won Hong

Kong's premium architectural award, the Hong Kong Institute of Architects' Silver Medal, partly for its successful integration of the 'old' and the 'new'. However, the relation between old and new is very much like what we find in the Cultural Center, with much the same implications, except that, in the case of the Repulse Bay apartment complex, the old is very clearly a remake, something that comes out of a movie set. The replica is not even, strictly speaking, an example of preservation, which is precisely what allows it to make more explicit what is only implicit in the two previous examples: how preservation is posited on the disappearance of the historical site.

These instances of preservation are significant, even though preservation is unlikely to be a major factor in Hong Kong's built space, because they exemplify the argument that the more abstract and ungraspable space becomes, the greater the importance of the image. Accordingly, in a space of disappearance, in the unprecedented historical situation that Hong Kong finds itself in of being caught between two colonialities (Britain's and China's), there is a desperate attempt to clutch at images of identity, however alien or clichéd these images are. There is a need to define a sense of place through buildings and other means, at the moment when such a sense of place (fragile to begin with) is being threatened with erasure by a more and more insistently globalizing space.

The complication, of course, is that 'place' and 'space' cannot be opposed in any simple way, nor can they be considered separately. It is clearly not possible to think of place merely in terms of definable physical characteristics and situatedness because the changing nature of space – that results from information technology, for example – inevitably entails a changing idea of place. Paul Virilio points out that the limits or boundaries of the city itself have come into question, largely because of new informational and communicational technologies that introduce a novel idea of space: space, in an important sense, as non-physical and dematerialized. He makes the point by asking how one now gains access to the contemporary city and answering: not through a city gate but rather through an electronic audience system: 'The sound of gates gives way to the clatter of data banks. . . . the urban wall has long been breached by an infinitude of openings and ruptured enclosures' (Virilio 1991a: 13). All major contemporary cities are thus 'overexposed' as the idea of *boundary* is gradually replaced by the idea of *interface*. In the case of Hong Kong, it would seem that it has been primed for overexposure since its inception in 1841 as a British colony and a free port, where accessibility is an overriding consideration – a consideration that produces its own aporias. The large number of illegal immigrants in the city shows how easily the border with China can be breached by land and sea. The difficulty of controlling smuggling (recently, of stolen luxury cars to the mainland) shows it is as easy physically to get out of the city as it is to get into it. Finally, the colony's by now definitive insertion into global networks of capital and information can therefore be seen as simply the latest episode in the relative devaluation of a physical idea of space *and* place.

On the other hand, even as place is being problematized by the new global space, it is nevertheless not the case that this space necessarily carries all before it. In this regard, Manuel Castels makes an essential point: 'New information technologies do have a fundamental impact on societies and therefore on cities and

regions, but their effects vary according to their interaction with the economic, social, political and cultural processes that shape the production and use of the new technological medium' (Castells 1989: 2). In other words, there is a whole range of spatial and historical mediations to be accounted for, and this leaves room for a politics of built space, even if it is a question of building on disappearance. This amounts to saying that architecture cannot be separated from the spatial or ideological context in which it is produced. Let me begin then by presenting some of the idiosyncrasies of Hong Kong's urban space, which is that peculiar kind of colonial space that I call a space of disappearance as a necessary preliminary to a discussion of its spatial politics.

Spatial histories

The theoretical implications of disappearance have been explored most thoroughly in the writings of Paul Virilio, where disappearance is a consequence of processes of speed and digitalization that deprive forms and figures – whether paintings and sculptures or monoliths and architectural constructions – of their material support and physical dimensions. 'Where once the aesthetics of the appearance of an analogical, stable image of static nature predominated, we now have the aesthetics of the disappearance of a numerical, unstable image of fleeting nature, whose persistence is exclusively retinal' (Virilio 1991a: 36). In relation to Hong Kong, however, a space of disappearance has specific local and historical references, which makes it possible to conceptualize it in several other ways as well.

In the first place, disappearance can be seen in relation to a recent cultural and political mood. There is something highly ambivalent about disappearance. It does not refer simply to the anxiety that the Hong Kong way of life will come to an end once Hong Kong is returned to China. It does not signify historical catastrophe *tout court* but is something more double-edged, the way an unprecedented and in many cases newfound interest in local culture and politics *appears* at the moment when catastrophe, real or imagined, threatens. The 'end of Hong Kong', to reiterate an important point, is therefore what inaugurates an intense interest in its historical and cultural specificity, a change from the hitherto almost exclusive fascination with its economic success. This is very precisely a culture of disappearance because it is a culture whose appearance is accompanied by a sense of the imminence of its disappearance, and the cause of its emergence – 1997 – may also be the cause of its demise. The affective state of disappearance can be compared to that deliberately created by a cigarette company when it displayed in a public space in Hong Kong a sign that read, 'No smoking. Not even Viceroy.' In both cases, a negative situation, or one perceived as such, functions to provoke a desire for the quick fix of a smoke or of an identity. Such a concern for 'Hong Kong culture' will indeed extend to an interest in its architecture and in the preservation of old buildings, but such an interest will have to be situated in turn within a space of disappearance.

A second sense of disappearance concerns representation. In disappearance there is a gap or *hysteresis* between the city and its representations, that is to say, between the city's erratic historical fortunes and the attempts to explain its

itinerary in terms of available models like modernization, dependency or devel-opment. The way the city has been made to appear in many representations in fact works to make it disappear. Let me offer two examples to illustrate this para-doxical relation between representation and disappearance, one positive and one negative.

Consider the representation of Hong Kong as an East–West city, mixing tradi-tion and modernity like memory and desire. We see this idea enshrined in one of the most durable images of Hong Kong, which shows a Chinese junk in Victoria Harbor against a backdrop of tall modernistic buildings. This image has gone beyond kitsch and stereotype, being promoted to, and promoted as, an urban archetype. We not only see it reproduced on countless postcards, but a stylized red junk is also the chosen logo of the Hong Kong Tourist Association. Whether the image 'misrepresents' Hong Kong or not (is Hong Kong really no more than the world's largest Chinatown?) is not the issue here. What is at issue is how an image of Hong Kong's architecture and urban space are used to support a narra-tive that implicitly attributes the colony's success to the smooth combination of British administration and Chinese entrepreneurship. Such a narrative also mobilizes ethnic and psychologistic assumptions that cannot bear scrutiny: the dogma that Hong Kong people are by nature hardworking, that they have a high tolerance for crowded living conditions by genetic design, that they will do anything for money. Peeping out from under this narrative is a master discourse that, seeing only its own mirror reflections, inscribes the primacy of the economic everywhere in the most literal-minded fashion. This is a discourse that elsewhere I have called decadent. This discourse manages to make a complex space disappear into a one-dimensional image, structured on a facile binarism. Such a binarism not only tends to domesticate differences and restabilize change; it also avoids the spatial issues, to give us only a copulation of clichés (Vladimir Nabokov's excellent definition of pornography).

Consider now a negative representation of Hong Kong, the obvious one of the city as a colony and dependent territory of Britain. It is true that the recent British decision to issue passports only to a relatively small number of Hong-Kong-British citizens giving them the right of abode in Britain clearly shows the small colonial mentality at work, but on the whole the effects of British colo-nization on Hong Kong would seem on the surface to have been relatively benign. However, to say this is not by any means to whitewash the history of British impe-rialism or to forget the Opium Wars. If the British could point with some justification to a record of non-exploitation in Hong Kong, it would be largely because there was to begin with little of substance to exploit, neither natural resources nor, until after 1949 when the city was swelled by refugees from China, human resources. In these respects, the Hong Kong case is very different from that of British India, a situation much easier to analyze in terms of dependency theory. As for Hong Kong, its very lack of resources or means of being indepen-dent was always curiously enough a factor in its favor: it meant that more could be gained all around by making the city work as a port city – by developing infra-structure, education, international networks. This was a position that both the colonizer and the colonized could agree on, a position of cute correspondence or collusion – hence the relative absence of political tensions or demands for

'democracy', until recently. Again and again in the history of Hong Kong, we see how lack and dependency were somehow advantages. For example, when the colony went into textile manufacturing, it was able to develop an international market ahead of Taiwan or Korea because, unlike these countries with their larger populations, Hong Kong lacked a significant domestic market. The way ahead was never toward independence, but always toward hyperdependency. To call Hong Kong a colony is hardly a misrepresentation, it merely leaves out how dependency has been turned into a fine art.

These examples do not define at what point Hong Kong moved ahead of its cultural representations, but at least they tell us that for some time it has been somewhere other than where it is represented to be. Other cities like Los Angeles or Tokyo were built on seismic fault lines or volcanic soil: Hong Kong seems to have been built on contingency, on geographic and historical accidents, shaped by times and circumstances beyond its control and by pragmatic accommodation to events. The harder we try to categorize it, the more the city mocks the available categories and remains, in spite of its overwhelming presence, a peculiar kind of 'invisible city' – it appears in the moment of disappearance (first sense), and it disappears in appearances or representations (second sense).

Yet cutting across the ambivalences of appearance/disappearance is always a specific historical situation – how can it be otherwise – and this suggests a third way in which a space of disappearance could be conceptualized: as a space that is historically produced. Yet to say this is not to imply that there is a historical narrative that, however it twists and turns, can nevertheless be definitive. A history of disappearance cannot but be inflected by the problematics of disappearance itself because, if a space of disappearance can elude familiar representations, it can also elude historical descriptions. Hence the need to say something about the complex relation between space and history in Hong Kong, that is, to speak of spatial histories, not least because such histories will tend to modify some common assumptions about the forms that both colonialism and postcolonialism would take. As I have tried to show, the new Hong Kong cinema's ability to link history, space, and affectivity is what accounts for its privileged position.

A space of disappearance challenges historical representation in a special way, in that it is difficult to describe precisely because it can adapt so easily to any description. It is a space that engenders images so quickly that it becomes *nondescript*. For example, even a text as programmatically antirealistic and nonhistorical as Alain Robbe-Grillet's *La Maison de rendezvous*, set tongue-in-cheek in Hong Kong, still captures *something* about the city's historical quality; it captures the way the nondescript heightens fantasy and gives rise to promiscuous images. We can think about a nondescript space as that strange thing: an ordinary, everyday space that has somehow lost some of its usual systems of interconnectedness, a deregulated space. Such a space defeats description not because it is illegible and none of the categories fit, but because it is hyperlegible and all the categories seem to fit, whether they are the categories of the social sciences, of cultural criticism or of fiction. Any description then that tries to capture the features of the city will have to be, to some extent at least, stretched between fact and fiction, somewhat like what we find in Jorge Luis Borges's short story *Emma Zunz*. If this is the case, then there can be no single-minded pursuit of signs that finishes with a systematic

reading of the city, only a compendium of *indices of disappearance* (like the non-descript) that takes into account the city's errancy and that addresses the city through its heterogeneity and parapraxias. A spatial history of disappearance will attempt to evoke the city rather than claim to represent it, in the sense of giving a definitive account of what it is 'really' like.

Histories of Hong Kong tell a story of successful development, depicting the colony's gradual gains in material substance with an appeal to statistics. Conversely, some recent histories that are more politically conscious emphasize the colony's relative absence of democratic institutions and right to self-determination. Such stories, valid though they may be on one level, require some qualification because they leave out the way the colony's fortunes follow not just a logic of development or a logic of 'oppression' but also a more paradoxical spatial logic where lack and dependency could somehow be advantageous. For example, statistics indeed show that at the last estimate Hong Kong is now the world's eighth-largest trading nation, an international city that has come a long way from the days when it was described in Palmerston's famous words as 'a barren island with hardly a house upon it'. But for all the discontinuities this new role implies, it has continued to be a *port* in the literal sense of the word: a door, a threshold, a conduit through which goods, currencies, and information flow; a kind of nodal point, an in-between state, therefore more of an inter-national city than an international one. It is true that the nature of the port or gateway has changed today: it connotes not just a good harbor but also an efficient communications system. The nature of the port may have changed, but Hong Kong has not changed as a port. In contrast to inter-national cities like New York, London or Tokyo, which are in relation to their respective regions central sites for the production of goods and culture, Hong Kong is primarily a space of facilitation. It is less a site than a *para-site*, in that its dominance in its region is due largely to its geographic proximity to China, together with its accessibility to the rest of the world. It is easy to see the economic opportunities that stem from being in such a unique geopolitical position. The para-site therefore connotes a position that in some strange way is both autonomous and dependent at the same time, a position in which autonomy is paradoxically a function of dependence.

In the inter-national city and the para-sitic city, something happens to the sense of time, of chronology. Consider once again how the space of Hong Kong has been formed: as a result not just of rapid changes but of an accelerated rate of change produced by historical events whose epicenters are elsewhere. Hong Kong by now has become so inured to change, to 'progress', that it can be taken as the perfect example of the situation that Gianni Vattimo describes as the experience of 'the end of history', a situation where 'progress becomes routine', which does not imply that 'progress' has been absorbed, much less understood (Vattimo 1988: 7). Nevertheless, one crucial effect of such routinization is a weakening of the sense of chronology, of historical sequentiality, so that 'old' and 'new' are easily contemporaneous with each other, and 'continuities' and 'discontinuities' can exist side by side, *without being integrated*. Perhaps the most powerful symbolization of this is in cinema, particularly in Stanley Kwan's figure of the ghost in *Rouge* that returns after fifty years to seek her lover, a revenant stepping out of freeze-frame. But other examples could be cited. For instance, it is not anomalous to see a high-

rise building, including Norman Foster's Hong Kong Shanghai Bank building with its space-age materials, surrounded by the traditional Chinese bamboo scaffolding during construction – a kind of spatial palimpsest. A palimpsest of another sort was the fantastic sum of HK$9.5 million paid recently by a property developer for the 'lucky' automobile licence number '2': lucky because 2 in Chinese is a homonym of the word 'easy' and because the number 2, shaped like a rooster (if we are willing to stretch our imaginations a bit), was purchased in the year of the rooster. On one level, we can see this as simply old-fashioned superstition, a case of 'numeracy' and a waste of money. But we could also see it, on another level, as money well spent in the purchase of what amounts almost to a company logo, a smart investment in the society of the spectacle. 'Premodern' and 'postmodern' join hands without having to acknowledge each other. Or take the example of built space. We have seen how high-investment buildings in Hong Kong are threatened by demolition, how what looks very permanent is in fact very temporary. But by the same logic, the temporary can also have a relative permanence. One example, by no means isolated, that comes to mind is a licensed food market in Western at the entrance of which is a sign that says 'Smithfield Road Temporary Market'. But the market has been there for as long as anyone can remember, and it seems to all intents and purposes very much like a permanent fixture of the neighborhood. What remains, it seems, are places that are as yet unmarketable. These examples suggest that the space of Hong Kong is a space of 'uneven development' in a specific sense: it is a space traversed by different times and speeds, where change has no clear direction but is experienced as a series of anticipations and residues that jostle each other for position. These are not examples of anachronisms, as anachronisms are perceived as chronology violated, rather, they are examples of what might be called *achronicities*, where past and present disappear in each other.

One main implication of the discussion so far is that disappearance pulls in different directions. It is heterogeneous and contradictory, not a seamless web. On the one hand, Hong Kong as a space of disappearance shows how the city dealt with dependency by developing a tendency towards timelessness (achronicity) and placelessness (the inter-national, the para-sitic), a tendency to live its own version of the 'floating world' without the need to establish stable identities. On the other hand, disappearance also alludes to the new cultural mood that registers, with a high degree of urgency, the need to have some kind of cultural identity in place before Hong Kong reenters the Chinese fold. This confrontation with history within a space of disappearance will have an effect on how we look at Hong Kong's urban space and on what we understand by a Hong Kong architecture.

Ways of seeing the city

Writing in the 1950s, the Situationists already noted that 'the visual aspect of cities counts only in relation to the psychological effects which it will be able to produce'. The remark itself can only have come out of a contemporary experience of the city. The movement away from the visual shows how problematic our visual experience of the city has become. Cities bombard us with a profusion

of signs in various states of motion that distract and confuse, from traffic to adver-
tisements to televisual media, all of which compete for attention with buildings.
Hong Kong is said to have the largest Marlboro Man sign in the world, the size
of a multistorey building. Bilingual, neon-lit advertisement signs are not only almost
everywhere; their often ingenious construction for maximum visibility deserves an
architectural monograph in itself. The result of all this insistence is a turning off
of the visual. As people in metropolitan centers tend to avoid eye contact with
one another, so they now tend also to avoid eye contact with the city. When the
visual becomes problematic because it is too complex, too conflicting, too un-
familiar, or too manipulative, then different ways of seeing the city – different
scopic regimes – have to be brought into play.

We can relate the different ways of seeing the city to a typology of urban
space recently proposed by Arata Isozaki and Akira Asada (Isozaki and Asada 1992:
16–17). In their typology, Isozaki and Asada distinguish between three kinds of
urban space, each defined according to an increasingly attenuated relationship to
its historical context. Thus *real* cities are those that have preserved their historical
contexts; *surreal* cities are metropolitan centers like Tokyo where urban elements
are mixed up and hybridized without regard for historical context; and *hyper-
real/simulated* cities are theme-park cities like Walt Disney, devoid of context and
based on fiction and artifice. We could now construct a typology of scopic regimes
that would roughly correspond to Isozaki and Asada's urban typology: 'real' cities
encourage a regime of the visible or seen, 'surreal' cities a regime of the sublim-
inal and uncanny or half-seen; 'hyperreal' cities a regime of the televisual or quickly
seen. Both typologies and the relation between them become useful if we bear in
mind that they give us only examples of 'ideal types'. Actual cities of a certain
magnitude and complexity – like Tokyo or Hong Kong – tend to be a mixture of
all three kinds outlined in Isozaki and Asada's typology: they are real, surreal and
hyperreal all at once and can be seen in different ways. This mixed nature of the
metropolis is important because it means that *there is always a choice of scopic regimes
available*, so that the choices that are actually made are historically significant. We
can see now how these remarks might apply in the case of Hong Kong.

For better or for worse, it is almost impossible to get any sense of Hong
Kong's urban space through the merely visible. Perhaps the only people who still
'see' the city are the tourists. But then what is visible to them are only landmarks
and monuments pointed out in guidebooks, while local history means only the
exotic. The more 'historical' a city, the more it falls prey to the tourist's gaze.
As Henri Lefebvre reminds us, a purely visual space 'has no social existence . . .
that which is merely seen (and merely visible) is hard to see – but it is spoken of
more and more eloquently and written of more and more copiously' (Lefebvre
1991b: 286). In this regard, it is interesting to note how a number of Hong Kong
films made recently, which concern themselves with the city's present historical
situation, attempt to identify the city by rendering it visible, particularly by
shooting what is most visible of all, its architecture. These films range from Evans
Chan's highly serious *To Liv(e)* to Tsui Hark's tongue-in-cheek *Wicked City*. But
because architecture is seen as a purely photogenic set of objects, we get the same
familiar shots of the same well-known buildings, taken from the same angles:
looking down towards the harbor from the Peak, looking up towards the Peak

from the harbor. It is as if it were necessary to hold on to the familiar for reassurance that the city is real. In any case, no identity emerges. Like a docile child, the city is seen but not heard.

Changing cities produce many sights that are unfamiliar. But rapidly changing cities, cities without brakes like Hong Kong, produce something else as well: *the unfamiliar in the familiar*, that is, the unfamiliar that is half-seen or seen subliminally behind the seen/scene of the familiar. This is the experience of the uncanny when the sense of 'I am here', of the familiar and the homely, shades into a sense of 'I have been here before', of the *Unheimlich*, when what is seen is mixed up with a feeling of the already seen, of *déjà vu*. It was Louis Aragon, the Surrealist poet, who captured the uncanny and subliminal nature of the rapidly changing city best, with its 'disquieting atmosphere of places . . . peopled with unrecognized sphinxes'. On the Paris arcades that were fast disappearing as a result of modern city planning, he wrote: 'It is only today, when the pickaxe menaces them, that they have at last become the true sanctuaries of a cult of the ephemeral . . . Places that were incomprehensible yesterday, and that tomorrow will never know.' The subliminal that Aragon evokes so well problematizes the visual, but it has not broken with it. That is why the subliminal is experienced in part visually, but also in part *allegorically*, that is, in terms of a spatio-temporal delay that prevents sign and meaning from coinciding. In allegory, signs are allowed their errancy; they become provocative: disquieting and sphinx-like, they provoke the making of narratives, including narratives of identity.

It would seem, therefore, that allegory is an appropriate mode for experiencing the peculiar realities of Hong Kong's urban space – except for one overriding consideration. As the city moves from manufacturing towards a greater concentration on service and finance, the regime of the televisual becomes increasingly dominant, introducing a new experience of space that Paul Virilio associates with what he calls the 'tele-conquest of appearance' (Virilio 1991a: 31). This televisual space is characterized by visual overload, the fusion and confusion of the fast and the slow, the absence of transition between the big and the small, the breakdown of the analogical in favor of the digital. The result is a 'tele-observation in which the observer has no immediate contact with the observed reality'. The effect of the televisual is that it destroys allegory as defined, by the same process in which the delays of time and space are canceled out by the speed of electronic media. But in this regime of insistent and quick visibility, the unfamiliar is no longer a provocative dimension of the familiar. The unfamiliar, through instant replays and 'real time' transmissions, itself becomes all too familiar, and the strange madness of the *déjà vu* turns into the ordinary madness of the *déjà disparu*, as the regime of the televisual threatens to supplant all other ways of looking at the city.

The question is how to see the city? Which scopic regime should we choose? The choice is a difficult, if not impossible, one as none of the ways of seeing the city seems appropriate to the situation of present-day Hong Kong. If the tourist's gaze gives us ready-made images of the city that have no social substance, and if the allegorical gaze is destroyed by the televisual, then we are left with the latter, which serves only to promote a sense of placelessness. At one time, in the shadowless days before the anxieties of 1997 and Tiananmen, a sense of placelessness –

which went together with an absence of strong local identities – was an asset, as it allowed Hong Kong to capitalize on its being a space-in-between. Now faced with the possibility of having an alien identity imposed on it from China – Hong Kong, British Dependent Territory may be as different from Xiang Gang China, as Paris, Texas is from Paris, France – there is immense pressure to develop an identity instantly. The danger, as I suggested earlier, is that in the representation of disappearance, even ersatz images may be found acceptable. It is at this juncture that the question what is Hong Kong architecture? becomes particularly relevant.

What is Hong Kong architecture?

If we take Hong Kong architecture at face value, we will see it merely as a sign of Hong Kong's growing prosperity. It is necessary to stress, when we pose the question of Hong Kong architecture, that built space bears more than one inscription, that built space is overinscribed. If there is a message, it is a jumbled one, not reducible to one meaning. The built space of the city not only evokes financial progress and the spatial appropriations of power but also gives us cultural residues, dreams of the future, as well as intimations of resistance. Built space therefore must not be understood as spatial forms but also as something that both produces and is produced by cultural practices. In the case of Hong Kong architecture, these will be the practices that relate to a culture of disappearance. We may begin by identifying three features.

The first concerns Hong Kong's receptivity to architectural styles. Architecture as buildings may always be situated in a place, but architecture as style and ideology is eminently transposable. In its architecture as in so much else, Hong Kong is an 'open city', exposed to all styles and influences: from the vernacular to the colonial, from modernism to postmodernism. This extreme receptivity is unusual and could be related as much to its 'floating' identity as to its growing affluence and accelerated development. In other words, space has as much to do with subjectivity as with economics. Many accounts of the city point out that Hong Kong does not look very different from other Asian cities, with its indiscriminate mix of drab and grandiose buildings. However, all we have to do is compare Hong Kong with a city like Taipei, which is quite as affluent, to see the difference. Taipei also displays a mixture of architectural styles, but the overall feeling is not quite the same. One of Taiwan's strongest claims to political legitimacy has always been to present itself as the true custodian of 'Chinese culture'. As a result, there is a kind of hesitancy in its employment of contemporary architectural forms, which stems from the implicit ideological interference of its image of Chinese identity. Hong Kong has neither a fixed identity nor the inhibitions that come from it. Hence the sharp contrast – to take one example – in the two cities' respective Cultural Centers. The Chiang Kai-shek cultural complex is a pastiche of Chinese architectural styles, while the Hong Kong Cultural Center is committed to contemporaneity.

Besides its receptivity to architectural styles, a second feature that is hard not to notice about Hong Kong is the constant building and rebuilding which might

remind us of that old joke about the colony: 'A nice city – once it is finished.' The building and rebuilding suggest that space is almost like a kind of very expensive magnetic tape that could be erased and reused. Here again, economic factors dovetail with subjective responses. What is erased are cultural memories; what is rebuilt are more profitable buildings. This applies to Hong Kong as a whole, but it is particularly true of Central, which is not only Hong Kong's business district today but also the area that historically was the first to be developed. There are almost no vestiges of this past history in Central, except for the old colonial-style Supreme Court building, which has been preserved from the bulldozers and is now used for Legislative Council meetings. In fact, one of the more paradoxical aspects of colonial space as a space of disappearance is the way in which 'preservation' itself, as I have suggested earlier, could be part of the process of this erasure of cultural memories.

But perhaps the most noticeable feature of all is the city's hyperdensity, estimated at more than forty thousand people per square mile. Even this high figure is only an overall average; there are indeed many areas like Mongkok and Shumshuipo that have considerably higher densities, or the recently demolished Walled City which, with an area of one-hundredth of a square mile, had a population of thirty-three thousand, giving it a density of more than three million per square mile, by far the highest in the world. Building expanded in two directions: horizontally, following the flat land along the coastline and areas reclaimed from the sea; vertically, in the form of high-rises that are like new kinds of walled cities. Finally, because high-density space has to serve a variety of purposes, form does not necessarily follow function, and there is in most districts no neat separation of commercial from residential use. I shall come back to this question of hyperdensity in a moment.

These features – heightened receptivity to stylistic influences, constant rebuilding, hyperdensity – do not in themselves define Hong Kong architecture for us. However, what the thematics of susceptibility to influence and the erasure of cultural memory suggest is that the question of Hong Kong architecture is intimately related to the question of Hong Kong's cultural self-definition, which in a space of disappearance can only be problematic. I propose, therefore, to approach Hong Kong architecture indirectly by considering different kinds of built space in the city and the urban issues they raise: issues about preservation and memory, about political allegory, about subjectivity.

A full survey of Hong Kong architecture will have to use many different categories and include the discussion of many different architectural examples. For the present purpose, however, we can divide Hong Kong's built space into three main types. Each type can claim to represent some aspect of Hong Kong, and in this sense to be regarded as 'local' – which merely serves to show how difficult it is to locate the local. On the one hand, there is what I will call the *merely local*, which consists of all those buildings largely belonging to another historical era, existing now, if they exist at all, mainly on the economic margins of the city. These include the indigenous architecture that has roots in the Qing dynasty; the buildings in the urban vernacular style resembling that in Guangzhou and Shanghai; and the colonial-style constructions found also in Malaysia and India, one gracious example of which is the Main Building of the University of Hong Kong. On the other hand,

we have the *placeless*, all those impressive multinational hotels and office buildings with no local memories, concentrated mainly in Central but now also moving eastwards toward the reclaimed land north of Gloucester Road on harborside Wanchai. These buildings could be found almost anywhere in the world, and they seem to have just *landed* on their sites out of nowhere. In between the *merely local* and the *placeless*, acting somewhat like a buffer zone, is the *anonymous*, all those nondescript commercial and residential blocks that seem to replicate themselves endlessly. These buildings may not inspire a second look, but they constitute the majority of built space in Hong Kong.

The *merely local* have a close link with Hong Kong's history and topography. Besides temples and shrines, they include those dwellings built on water that remind us that Hong Kong was once a fishing village. One example would be the sampan boats adapted as live work space still found in Aberdeen and Causeway Bay. However, the number of sampans is now dwindling, as more of the (literally) floating population is 'repatriated' to dry land to look for more conventional work and more conventional living space. Another example are the houses built on stilts near the sea, still found, for example, in the fishing village of Tai O to the northwest of Lantau Island. This once thriving village is now getting quite run-down, turned into a receiving center for smuggled goods; its main product, a preserved salted fish, is an ironic emblem of the village itself. In the New Territories can be found a number of villages of another kind, the indigenous Chinese-style walled village. One example is the Tsang Tai Uk in Shatin, still inhabited, and coexisting as in a time warp with and within sight of the government public housing blocks close by. The urban-vernacular-style buildings have largely gone except for a few scattered examples in Western, but a number of colonial-style structures can still be seen, like the previously discussed Flagstaff House and a much-gentrified Western Market, which has been turned into a kind of museum or mall on the model of Covent Garden and which now houses a number of Chinese restaurants and boutiques.

The *merely local* may have been structures rooted in a time and place, but it is a time and place that is no longer there. These structures may have interesting stories to tell, but they have no real voice in the present-day life of the city, which has moved elsewhere. However, they do raise an important and difficult issue about cultural memory and preservation, particularly about the difference between them. While one could certainly accept the rationale of preserving old buildings as a counterweight to the placelessness and anonymity of the rest of the city, there is in present-day Hong Kong another factor to consider: the way the impetus to preservation partly arises, as I suggested earlier, out of the ambivalences of a culture of disappearance. Even in more straightforward colonial situations like the ones analyzed by Anthony King, preservation is marked by ambiguity. For example, King describes what he calls 'the "preservation" syndrome': 'in the colonial context, this has a double irony. Not only does planning effort go into inculcating the colonized culture with similar values but the criteria of the colonial power are used to define and "preserve" "buildings of architectural and historic importance", while remnants of the indigenous culture are left to disappear' (King 1990: 56). In any case, preservation is not the same as memory: it is a memory without pain. In preserving what was there, there is

a danger of blotting out of memory *what was not there*, which is just as important. Preservation in its selectiveness is the disappearance of memory, and this disappearance, like the kinds of representation discussed earlier, can be very significant politically at this particular juncture of Hong Kong's history. It is surely not accidental that so many of the examples of preservation end up implicitly giving us history as decoration, as nostalgia. Nostalgia, we can say, is not the return of past memory: it is the return of memory to the past. Nostalgia is *déjà vu* without the uncanny.

In sharp contrast to the *merely local* are those *placeless* international buildings that usually get the most attention. They are buildings that are meant to be *read*, and according to Henri Lefebvre, such spaces made to be read are

> the most deceptive and tricked up imaginable . . . Monumentality, for instance, always embodies and imposes a clearly intelligible message . . . monumental buildings mask the will to power and the arbitrariness of power beneath signs and surfaces which claim to express collective will and collective thought. In the process, such signs and surfaces also manage to conjure away both possibility and time.
>
> (Lefebvre 1991b: 143)

More and more, monumental buildings are no longer only found in Central. The newest one, cheekily calling itself Central Plaza, is located in Wanchai and is now (but not for long) the tallest building in Asia. The *placeless* do not look local, but they are highly vocal. They do not so much tell a story as make a point, a rhetorical, usually phallocentric point: I am the tallest or the smartest or the most contemporary or the most expensive. Exchange Square, which houses the Hong Kong Stock Exchange and the offices of major international banks, used to be one of the smartest buildings around; nowadays, it is getting stiff competition from new arrivals like the Citibank Plaza in Central. The China Bank was Hong Kong's tallest building when it was built, now that title goes to Central Plaza, although the bank can still think of itself as being more elegant. The recently completed Number 9 Queen's Road was perhaps the first building in Hong Kong to pride itself on being 'postmodern' and hence very 'contemporary', because it played with architectural period styles. The most expensive and technologically advanced is still the Hong Kong Bank. And so it goes. All this architectural rhetoric seemed ripe for deconstruction. When Zaha Hadid took part in an international competition to build a luxury club in Hong Kong's Peak area, she produced a design that was quite anti-rhetorical. One chief feature of the design consisted of having four huge beams laid flat and driven into the hillside – an image of horizontally embedded skyscrapers to deconstruct the general rhetoric of verticality and phallocentrism.

The two most impressive buildings in Hong Kong are still the two banks, the Hong Kong Shanghai Bank built by the British architect Norman Foster and the Bank of China Tower by the overseas Chinese architect I. M. Pei. It is possible to see a political allegory emerging as we watch these two buildings stand in all their monumentalism close to each other in Central, locked in a relation of spatial and

political rivalry, even if it is an allegory of disappearance, as we shall see presently. The Foster building is reputed to be the world's most expensive piece of real estate. Constructed of space-age materials by a multinational team, its form is a brash celebration of high technology. By contrast, the more elegant Pei building is a kind of architectural ode to verticality and visuality. Its basic geometric form is that of the prism: from an arrangement of four prisms that form the solid lower sections it rises, twisting and becoming more ethereal, in successive arrangements of three, two and finally a single prism that forms its topmost stories, the whole structure surmounted by two poles pointing it still further upward: I like to think of it as the *Toblerone* building, after the distinctively shaped Swiss chocolate bar. To what extent, we might ask, do these two buildings connote 'China' and 'Britain' in Hong Kong, and, on that basis, solicit the loyalties of its citizenry? The interesting point to note is that however different the architectural rhetoric of these two buildings may be, both can be regarded as simply examples of contemporary architecture, two variations within a single system. That may be why in an attempt at 'localization' we see both buildings as incorporating design elements that have little to do with the formal logic of their structure. For example, the Hong Kong Shanghai Bank has retained as a kind of historical relic the two bronze lions that used to guard the entrance to the old bank building, two fierce lions of British imperialism. The problem, however, is that in the new building, there is no formal entrance as such, the ground floor now flowing into the roads on both sides, so that these two deterritorialized lions now look like harmless pussycats. In a similar effort at localization, the lower part of the otherwise unornamented glass-and-steel Pei building is decorated with black-and-white marble to give it a quasi-Chinese effect, while its twisting glass structure is often compared – with considerable contrivance – to bamboo. However, these efforts at differentiation only feebly disguise the fact that the spatial logic of these two buildings belongs to the same internationalist architectural system. This should force us to rethink the often repeated formula of 'one country, two systems' as the political model for Hong Kong after 1997, the view of a future Hong Kong as a special capitalist enclave within a socialist country. What the city's built forms themselves tell us is the very different story of 'one system' (that of international capital) at different stages of development. We find here a double set of disappearances, an allegory of disappearance, where the coziness implied by the phrase 'one country' disappears in the global economic system, and, by the same token, where the idea of ideologically differentiated socio-economic systems disappears as well.

In contrast to the architectural showpieces, the majority of the commercial and residential buildings in Hong Kong are not distinguished in any way. We find the same standardized forms replicating themselves whenever there is a site available. The huge residential estates, whether built by the government as public housing or by private enterprise, are like so many vertical walled villages. The result is that the present-day form of the urban vernacular presents us with a visual anonymity that spreads to most parts of the city and deprives it of architectural character. Yet for a number of reasons, the *anonymous* may be the most articulate and significant of all.

To begin with, there is a relation between architectural anonymity and the question of hyperdensity. It could be argued that the only solution to the problem

of hyperdensity was the instant high-rise and the enormous estate block. For example, the story is often told about Hong Kong's first housing estate at Shek Kip Mei, which was built very quickly in 1953 to house the thirty-three thousand people – mainly refugees from China – who were made homeless by a disastrous fire. Units in the estate – the Mark I model – were very basic, but it was at least an improvement on the shantytown-like conditions in which the inhabitants of Shek Kip Mei were living before. At present, 2.8 million people (about 50 per cent of the population) live in government-subsidized housing, and the authorities are building forty thousand new flats a year to meet the demand. For a city with a reputation for social ruthlessness, these are surprising and praiseworthy figures that present us with a conundrum – until we realize, as a number of critics have pointed out, that the government's motivation for building these resettlement estates did not come entirely out of a concern for social welfare. Resettlement was a means of acquiring valuable development land; cheap housing reduced upward pressure on wages, thus allowing for the reproduction of cheap labor power, and it pre-empted and defused squatters' resistance to clearance.

There is yet another (though related) side to the story. Hyperdensity is partly the result of limited space, but it is also a result of how this limited space could be exploited for economic gain. On the one hand, the colonial government deals with the problem of hyperdensity by constructing cheap housing estates. On the other hand, the government policy of releasing Crown land bit by bit at strategic moments and its prerogative, which it duly exercises, of designating land as rural (where strict building restrictions apply) or urban, ensure that building space remains scarce and property prices remain high. Complementing this is the banks' policy of giving preferential mortgage conditions to clients purchasing property less than ten years old and refusing to extend mortgages to property more than thirty years old, which means that developers are encouraged to build new properties, creating once more a demand for land. The anonymous high-rise block, both public and private, must therefore be seen not simply as a necessary solution to the problem of hyperdensity; it is also a way of turning the problem to the owner's advantage and exists as an index of the problem. As long as this is the case, the urban vernacular will retain its one-dimensional character.

In the face of the *placeless* landscape of power and the *anonymous* urban vernacular, we might ask where, then, are the erotic spaces of pleasure and encounter, the heterotopic spaces of contestation, the liminal spaces of transition and change? There are not many examples that come to mind, and even those that do are somewhat ambiguous. Take the area around Statue Square on Sundays. The square is a small and not particularly attractive concrete park in Central, opposite the Hong Kong Bank and adjacent to the world-class Mandarin Hotel. It is one of the few open spaces in an intensely built-up area. On weekdays, Central is Hong Kong's no-nonsense business district, but on Sundays the migrant domestic workers from the Philippines, almost entirely female, congregate around the square, taking it over and turning it into something like a festive space. There they chat, exchange news and information, share a meal or a hometown newspaper. Some small-scale entrepreneurial activities also take place: there are part-time beauticians and mani-curists, vendors of magazines in Tagalog, and so on. At one time, the authorities made some half-hearted attempts at discouraging these weekly meetings, but now

they have made the area into a traffic-free zone on weekends. Is Statue Square on Sundays an example then of the *détournement* or diversion of a space of power into a space of pleasure? This is unfortunately not entirely the case because the weekly congregations take place only by permission, and come Monday everything returns to 'normal'. No contestation has taken place. Perhaps the takeover of Central is more clearly an example of the fascination that the symbolic spaces of power exert on those excluded from them. The powerless are allowed to see Central – like looking at so many goods through a shop window – but not to touch it.

A somewhat different example is the area that takes its name after an old street in Central, Lan Kwei Fong. The area is situated in the hilly and less accessible part of Central, which therefore made it much less prestigious and desirable as commercial space. Not too long ago, Lan Kwei Fong was just an unremarkable and unfashionable bit of space on the commercial periphery, with its narrow streets, little shops and low-grade offices, local restaurants, flower stalls and street cobblers. It was just part of Hong Kong's anonymous urban vernacular. But as even this description already suggests, the area has its picturesque aspects that could be turned to advantage, it could be gentrified, as some business minds began to see. A string of smart restaurants began to appear, followed by European-style beer halls serving special brews, coffee bars, Hong Kong's only jazz club, art galleries, and generally stylish meeting places. The flower stalls and street cobblers are still there, next to high-tech chrome and Plexiglass shop fronts. The streets themselves have been repaved with cobblestones to give them a certain 'Ye Olde' look. The atmosphere is American (particularly Californian), European and local all at the same time. This cheekily mixed space makes the area instantly appealing to those who like to think of themselves as hip and arty; it certainly appeals to the young and affluent, the upwardly mobile who do not mind the hilly location and the steep prices. However, as a space of pleasure and encounter, which it clearly is, Lan Kwei Fong has one major drawback: the high cost of admission, although teenagers can and do stroll around its streets for free. Lan Kwei Fong may have some of the appearance of a liminal space, but it turns out to be just a variant of the dominant theme of capital. To use Sharon Zukin's terms, the plain 'vernacular' is appropriated by capital and transformed into desirable 'landscape' (Zukin 1992). But this process of transformation is entirely determined by commercialism and is ultimately indifferent to the urban vernacular at large, which remains untransformed by this example. In this regard, the space of Lan Kwei Fong can be compared to that of the more recently built mall-and-entertainment complex that calls itself Times Square, although the two look very different. Times Square, situated between Causeway Bay and Happy Valley on Russell Street, which was once a local market street, was designed as an autonomous inner-looking space, indifferent to its surroundings (like the 'postmodern' spaces Fredric Jameson has described). Thus visitors to the mall can ride up and down on its glass-cased elevators and, protected by the mall itself, look out with a certain pleasure straight into the interiors and rooftops of the run-down apartment houses just a few meters away on the other side of Russell Street. Lan Kwei Fong displays a comparable spatial indifference. It is a much appropriated vernacular space that has forgotten that it is vernacular.

The third example takes us back to the question of the vernacular response to the problem of hyperdensity. A team of Japanese architects who recently did

a study of Hong Kong's urban space focused precisely on this issue of hyper-density and came up with some surprising conclusions. They began by contrasting two ways of dealing with it. One way is suggested by modernist ideas of town planning derived from Le Corbusier's vision of the 'contemporary City for 3 million people', which put the stress on a separation of functions, a segregation of commercial and residential spaces. But would separation lead to the mutual enhancement of these spaces, or to the creation of a boring homogeneity? The other way is that of 'Hong Kong, the Alternative Metropolis', which consists of aggressively mixing up the functions, of not rigidly separating public and private, commercial and residential space. The result, it is argued, is heterogeneity, vitality, complexity. For example, Hong Kong may be one of the few cities in the world where one finds people in pyjamas strolling in shopping malls. Even when ideas are taken over from modernist town planning, they are changed in the process. Take the idea of the pedestrian walkway, whose rationale was to separate automobiles from people. We find a system of walkways in Central and in some of the new towns, but their function is changed. In Central, for example, walkways do not separate people from cars: they simply provide an additional or alternative path, while in the new towns themselves we often find walkways lined with shops and boutiques. The tendency then is not towards specialization and separation, but towards the multiplication and concentration of different functions in the same space. But perhaps the most characteristic way of all of dealing with hyperdensity is to transform the façades of anonymous apartment blocks by the construction of illegal and semi-legal structures: balconies, indoor gardens, additional storage space, and so on. It is as if the flat surface of these anonymous buildings were now covered in pleats or folds, multiplying in volume and interest and providing a zone of mediation between inside and outside.

In the argument of these Japanese architects, hyperdensity becomes positive, as anonymity is transformed into something that almost gives us the aesthetic pleasures of a baroque space, even if it is baroque by necessity rather than by design. Diversity, too, reappears, not in terms of a profusion of architectural styles but in the internal modification of standardized forms, comparable perhaps to the new Hong Kong cinema's use of genre. Such an argument, attractive and hopeful though it is in some respects, nevertheless contains one serious flaw. It largely ignores the politics and economics of hyperdensity discussed earlier and accepts the proliferation of anonymous high-rise blocks as the only solution. The question then understandably becomes how to deal with this anonymity, for which they came up with a very elegant answer: make the vernacular baroque. But the very attractiveness of such an analysis of Hong Kong's urban space would serve only to ensure that no more radical transformation of the vernacular need take place.

PART THREE

Nationalism, postcolonialism and globalization

Gayatri Chakravorty Spivak

SCATTERED SPECULATIONS ON THE QUESTION OF CULTURAL STUDIES

EDITOR'S INTRODUCTION

IN THIS DIFFICULT BUT REWARDING essay Spivak subtly asks two questions: what is it to be an American, and: what kind of cultural studies should exist in the US. These become closely related to one another once we accept, with Spivak, that Americanness is partly defined through what is taught about culture at school.

For Spivak, to be an American legally and politically is to enter into relation to that founding document, the Constitution, and therefore, more accurately, into changing and negotiable narratives about the Constitution. She argues that such narratives need to be globalized, to be connected to other national moments of origin, especially non-Western ones. This is a way of provincializing the West and of managing "sanctioned ignorance" — for instance (to use an example not given in the essay) the way in which it is acceptable to be ignorant of Indonesian massacres of the Chinese but not of German massacres of the Jews.

Likewise cultural studies — which for Spivak is a synonym for the general study of culture rather than a discipline in itself — needs to move out of its Eurocentrism, to become transnational and historical, while retaining a base in the society for which it is helping to educate citizens. Transnational cultural studies must remain focused on language (and the problems of translation) as well as on history, especially in two senses — history as used to legitimate the status quo, and history as a record in which the powerless or subaltern are only heard with difficulty. But cultural studies also needs to acknowledge the transformative power of capital, legal rights, and education upon the lives of the non-metropolitan unprivileged, a power that "development" models and practices merely use to bolster Western hegemony (as well as to denature the worlds of "developing" peoples — a theme that later Spivak essays take up).

Spivak obliquely inserts her essay into US debates over multiculturalism and the canon, exposing them to a subaltern and cosmopolitan perspective such as that explored, in different and various ways by Dipesh Chakrabarty, Bruce Robbins, and James Clifford, for instance. For those who wish to pursue further Spivak's understandings of her project as a radical intellectual, I recommend the interview in Osborne 1996.

Further reading: Chatterjee 1993; Cheah and Robbins 1998; Clifford 1997; Guillory 1993; C. Kaplan 1996; B. Robbins 1993b; Sangari 1987; Spivak 1988b, 1993.

It is through a critique of 'development' ideology that we can locate the migrant in the First World in a transnational frame shared by the obscure and oppressed rural subaltern. Otherwise, in our enthusiasm for migrant hybridity, Third World urban radicalism, First World marginality, and varieties of ethnographically retrieved ventriloquism, the subaltern is once again silent for us. It is here that we track the appropriation of ecology. I turn briefly to the work of Vandana Shiva, a powerful figure in feminist-subalternist-ecology, to attend to her cautions:

> 'Environmentalism' has finally become part of the dominant discourse. 'Development' has given way to 'sustainable development', and 'growth' has given way to 'green growth'. Yet the ruling paradigm about environmental issues continues to be biased in favor of the North, and the elites of the South.
>
> (Shiva 1991: 10)

It is the remoteness of the connections that allow the elite of the South to ignore their importance. Thus rural ecological problems, when noticed, are perceived as peripheral and precapitalist, and concern for their solution considered non-progressive in other quarters; as sentimental, or subjective. And, as Shiva points out, we see each cluster of issues, if we see them at all, as individual 'sets', 'anti-systemic movements', rather than operative moments in the functioning system of transnational capitalism determining itself through development, as in a prior dispensation through imperialism. As I have indicated, that other, largely urban or metropolitan, subaltern, the homeworker, remains invisible for comparable reasons. Both our support of culture and/or race identity *and* our distrust of general narratives stand in the way of this holistic perception. We will not understand that these movements, although local, are fully non-local in their impact, in order that transnational money-lending can be dissimulated as interest for the poor. Here the Derridean isolation of commercial capital as the object of criticism can perhaps be utilized; but even so the homeworker's relationship to women's waged and unwaged labor will skew our thought towards the surplus value of the human body, not only revenue and profit on the body of the earth. Be that as it may, if we dismiss general systemic critical perception as necessarily totalizing or central-izing, we merely prove once again that the subject of Capital can *in*habit its ostensible critique as well.

This expansion of the subjectship of Capital, as its post-Marxist, or feminist, or culturalist critique, is so pervasive that we might stop to think about it when-ever spurious binaries arise: Third World Issues Must Be Kept Separate from Multiculturalism (director of a Women's Studies Institute in the EED); the Study of Postcoloniality Is Not Feminist (white feminist professor in the US). There is interest, often unperceived by us, in not allowing transnational complicities to be perceived. There Capital is not the narrative of reference (Jameson) or subindi-vidual (Foucault). If anything, it can be compared to Foucault's imagining of the field of force: 'these then form a general line of force that traverses the local oppo-sitions and links them together; to be sure, they also bring about redistributions, realignments, homogenizations, serial arrangements and convergences of the false relations' (Foucault 1980a: 94). Shiva's call for 'lip-service' (from radical intel-lectuals) to make this thinking 'fashionable' shows us that careful cognitive mapping (Jameson) with the deconstructive awareness of complicity can have its uses for the internationalist activist, even if, in the intellectual's own circuit, it leads merely to self-perpetuating discourse at the mercy of the forces of reaction.

At best I can write as one such intellectual. In that spirit, writing these words in the offices of an Alternative Development Research Collective in Dhaka (Bangladesh), let me tell a few stories before we enter the next section. I will let the reader draw her own conclusions, knowing the risks on both sides.

In a series of videos made by Christian Aid, John Marshall, an activist priest working in Hackney, a poor multi-ethnic area of London, makes the point that although their absolute standard of living is higher, the rehabilitation of these disen-franchized migrants would help forge links with the bottom layers of society in postcolonial countries. As one who constantly shuttles on the cheap flights favored by migrants on visits home (rather unlike the sensationalism of migrant-woman thrillers), I would, with respect, differ. The trajectories of the Eurocentric migrant poor and the postcolonial rural poor are not only discontinuous but may be, through the chain-linkage that we are encouraged to ignore, opposed. This is not an accu-sation. The migrant poor are certainly victims of racism. But, in a non-Eurocentric frame, disavowal of their hope of insertion into a developed economy is of no use; although this hope is only a discolored, rejected, and broken fragment of the materials that build the edifice of development.

I came upon the video by chance in a rural health center in Bangladesh and watched it in the house of a resident woman doctor. In another context, and in a rather inaccessible interior village, I was chatting with another woman (an office holder in the government's program of Women's Development) about the Bangladeshis of London's East End and the white Londoner's racist contempt. My friend, speaking from the perspective of an educated provincial middle-class woman government worker, exclaimed, of these London Bangladeshis, 'But they're rich!' And indeed, the 'although their absolute standard of living is higher' of John Marshall shows once again a set perception, not a systemic one. On the other hand, the fact that these migrants might send money home is not their critique of development. With the lapse of time, even this connection becomes tenuous.

Both separations and false continuity are therefore part of the problem. In the name of transnationality, let us enter the United States.

1

I wrote the first part of this paper in response to a hundred-odd manuscript pages of Bruce Ackerman's book *Discovering the Constitution* [published in book form as *We the People*]. Fleshing it out, I have come to sense that the paper shares some of the occupational weaknesses of the new and somewhat beleaguered discipline of a transnational study of culture, especially if that study steps back from what is perceived as contemporary. Conceptual schemes and extent of scholarship cannot be made to balance. Once again, then, the following pages must be offered as possible directions for future work. I hope this will satisfy those friendly critics who have remarked that my point is that one needs to know nothing in order to do Culture Studies!

Here is a summary of my understanding of what I read in Ackerman's manuscript pages:

A dualist view of US political practice is true to American political philosophy and history. Legitimizing it in terms of foreign (read European) models is incorrect. The dualism is between normal everyday politics where We the People are not much involved. Contrasted to this are the great changes in political practice – constitutional politics – where We the People are mobilized and involved in the process of change through higher lawmaking. Professor Ackerman is aware that by thus naming the letter and the spirit of the law, so to speak, as *normal* and constitutional, he is taking the view that the role of We the People in the American polity is activated in 'exceptional' cases.

Ackerman's historical account discloses that these revolutions in the law are also managements of crisis. Although We the People were mobilized at the time of Reconstruction, it was the crisis of a possible impeachment of the President that brought the Constitutional amendments. Similarly, in spite of the electoral mobilization of We the People, it was the crisis of a possible court-packing that brought in the welfare state of the New Deal. Thus the changes from a federalist division of powers through a nationalist separation of powers to the consolidation of presidential power can be inserted into a continuation of *normal* political practice. Indeed, if I understand right, Ackerman comes close to suggesting that, in the modern context at least, the electoral mobilization of We the People provides an alibi for domestic crisis-management among the powers by allowing the party to claim 'A People's Mandate'.

We are, in other words, hearing the story of the gradual constitution (small *c*), normalization, and regularization of something called the People (capital *P*) as a collective subject (We) in the interest of crisis-management. Ackerman acknowledges that 'the Constitution presupposes a citizenry', and calls this process the 'popular cultivation of the arts of liberal citizenship'. And if you will forgive a slightly tendentious phrase, 'the ideological state apparatus' does work to this end.

Here, for trouble-free normal politics, is the making of a collective 'We the People' in the high school classroom:

> Mr. Bower's American Government class had been studying the US
> Constitution. He has designed a rich multiple-ability groupwork task
> to help his students understand the relationship among the three

branches of the federal government. To reach his objectives, he wants to challenge the students to think metaphorically and to produce insights that allow students to use their critical thinking skills. . . . The task will require many different abilities. Some students will have to be good conceptual thinkers; some will need to be good artists; at least one person will have to be able to quickly find the relevant passages in the Constitution; and someone will need to have strong presenta- tion skills . . . [This] example . . . demonstrate[s] the advantage of group work that may be gained with the proper preparation and structure necessary for success.

In fact, if not in intent, Mr Bower is preparing a General Will where the signifier 'People', seemingly remaining constant as a referent, is being charged with a more and more distanced and mediated signification, as actual agency passes from the popularly elected House of Commons model to today's electoral securing of the noun implicit in the adjective 'Popular' in 'Popular Mandate'. I do not ques- tion the astuteness of Ackerman's analysis or the efficiency of the gradual reconstitution of the signifying phrase 'We the People'. I do however question the conviction that this reading gives America back to the people in the American way. I dare to say this because such an unexamined view of the academic's social task (that would in fact be dormant and uncritical in everyday politics) is currently laying waste our own field of humanistic education – the proper field of the produc- tion of something called a 'People'.

If we move from the techniques of knowledge production to the techniques of the electoral securing of the Popular Mandate, this becomes even clearer. Editorials in all major newspapers have commented extensively on the fact that, under media management, candidates at all levels are becoming detached from local or popular constituencies. Jean Baudrillard has called this the electronic production of the 'hyper-real', which is simulated by agencies of power as the way things really are. 'Simulation' here means declaring the existence of some- thing that does not exist. Derrida has pointed at the ceaseless effort to construct the simulacrum of a committed and participatory public through talk show and poll, thus apparently (but only apparently) freezing the irregular daily pulse of democracy. Attention to the details of meaning-making might describe the mech- anisms of securing a higher law as a spectacular and seamless exercise in simulation.

I have taken a dualist, exceptionalist, and crisis-management reading of the Constitution as instrument of higher lawmaking through Popular Mandate to its logically rather unsettling consequences to highlight an obvious point: constitu- tional victory operates within a calculus that does not correspond to the possibility or even the guarantee of justice in the name of any personalized picture of a collec- tion of subjects called 'We the People'. In fact, as I will insist later in this paper, a constitution can operate only when the person has been coded into rational abstractions manipulable according to the principle of reason. The presupposed collective *constitutional* agent is apart from either the subject, or the universal-in- singular ethical agent.

Yet the narrative guarantee of justice in the name of a collection of subjects is perennially offered as legitimation to the people who will secure the 'Popular

Mandate'. And the authority behind this narrative legitimation – the Constitution as the expression of the general will to justice exercised in time of crisis – is itself secured with reference to an origin-story: the original documents left by the Founding Federalists, Reconstruction Republicans, New Deal Democrats.

It seems to me that an innovative and flexible text for use such as the US Constitution can only be given what Jean-François Lyotard has called a para-logical legitimation. In other words, it provides occasion for morphogenetic innovation – innovations leading to new forms.

Strictly speaking, *paral*ogical legitimation is not *teleo*logical. Yet the legitimizing debates at times of crisis impose closure by claiming faithfulness to original intent, even if only the intent to keep the document historically flexible, and thus restoring its origin by gaining its end. The more 'accurate' guarantee, not of justice as the expression of a general will of We the People but of a persistent critique of originary legitimations, by the very people who supply the Popular Mandate for the electoral machinery, can be precariously fabricated if the paralogical is kept in mind.

One of the counter-narratives that can help as a reminder of the paralogical is that of the contingency of origins. Let us consider an example.

Ackerman correctly states that the American origin was not simply 'an escape from old Feudalism', as de Tocqueville would have it, but a new start. Is it banal to remind ourselves that this new start or origin could be secured because the colonists encountered a sparsely populated, thoroughly precapitalist social formation that could be managed by pre-political manoeuvers? Robin Blackburn's recent compendious book *The Overthrow of Colonial Slavery* has argued that the manipulation of chattel slavery as an item of political economy was also effective in securing a seemingly uninscribed slate in a space effectively cleared of political significance in the indigenous population. No discussion of the historical development of the mode of operation of the Constitution can afford altogether to ignore this rusing at the origin:

> The key slogan in the struggle against the British had been 'no taxation without representation'. . . . The acceptance that slaves as wealth should entitle Southern voters to extra representation built an acknowledgment of slavery into the heart of the Constitution. . . . The text of the Constitution resorted to shamefaced circumlocution rather than use the dreaded words 'slave' and 'slavery': 'Representatives and direct Taxes shall be apportioned among the several states which may be included within this Union, according to their respective Numbers, which shall be determined by adding to the whole Number of free Persons, including those bound to Service for a Term of Years, and excluding Indians not taxed, three fifths of all other persons'.

Later in this essay I will present Derrida's discussion of the originary ruse that produces all signatories: the politics of the proper name. Here the origin of the 'Good People' of these colonies guaranteeing as they are guaranteed by the signatories is secured by staging the ruse in a theater of violence.

Since I am an Indian citizen, let me offer you a counter-narrative of what, in Ackerman's vocabulary, may be called a 'failed originary moment'. 'After much

hesitation . . . Elizabeth [I] . . . granted a charter of incorporation on December 31st 1600' to the East India Company. As is well known, there was increasing conflict between the British government and the Company until, by Pitt's India Act of 1784, 'the control of the Company was brought under the House of Commons'. Of course it is absurd to offer a fable as fact, or attempt to rewrite history counterfactually. But let us remember that Ackerman has the integrity to admit that he too is retelling a story. Let us also remember that, in the eighteenth century, economists such as Adam Smith, functionaries of the East India Company, as well as the British popular press, were exercised by the failed parallel between the American and Indian examples. Let me therefore ask you to imagine that, because the East India Company was incorporated, and because India was not a sparsely populated, thoroughly precapitalist social formation easily handled through pre-political manoeuver and the manipulation of chattel slavery, in other words because it was not possible for a group of British merchants to establish a settlement colony there, no apparent origin could be secured and no Founding Fathers could establish the United States of India, no 'Indian Revolution' against Britain could be organized by foreign settlers.

I admire the United States greatly, so much so that I have made it my second home, lived and worked here over half my life. Speaking as a not-quite-not-citizen, then, I would submit to you that Euramerican origins and foundations are secured *also* by the places where an 'origin' is violently instituted. In the current conjuncture, when so much of the identity of the American nation state is secured by global economic and political manipulation, and when the imminent prospect of large-scale fence-making beckons and recedes into a New World Order, it is not disrespectful of the energy of We the American People to insist that domestic accounts that emphasize America as a self-made giant illegally wrenching the origin of freedom from merely a moribund Europe has its own political agenda.

2

Constitutional talk is normally a tale of transactions between Europe and America. Transnational Culture Studies must put this transaction in an international frame. If, for example, the project of recovering or discovering the true structure of the national discourse from ideas of foreign manufacture is taken as a general principle of the study of the constitutions, the enterprise would become productively problematic as soon as we move outside Euramerica. One cannot substitute 'native' for 'national' in that undertaking. A transnational study of culture will not neutralize or disciplinarize the problem by defining it away as 'comparative' work, assimilate it by considering the last great wave of imperialism as basically a part of metropolitan history, or yet, however implicitly, bestow upon colonialism what Bernard Williams has called 'moral luck' in the context of ethical philosophy.

Turkey is a most interesting case in point. If we take the Conquest of Istanbul (1453) as a dividing line, we can see parallel but highly differentiated formations developing in Mediterranean and Western Europe on the one hand and the Ottoman Empire on the other. What characterizes the latter is the extraordinarily active and vastly heterogeneous diasporic activity that is constantly afoot on its terrain.

There is still an unfortunate tendency, in the 'comparativist' arena, to represent the Ottoman Empire as governed by the static laws of something like 'the Asiatic Mode of Production', with its change-inhibiting bureaucratic hierarchy and absence of private property in land. If, however, Western Europe is not taken as a necessary norm, the successes and vicissitudes of the Ottoman Empire can be seen as an extraordinary series of experiments to negotiate questions of ethnicity, religion and 'national' identity upon a model rather different from the story of the emergence of nationalism in the former space. How much of the events of the 1990s in Eastern Europe retain the lineaments of the non-teleological (tactical) nature of those ceaseless negotiations, suppressed for almost a century under the ferocious teleology of the Bolshevik experiment, and now emerging into a completely different field of strategy?

The staging of the fragments of Islam in that region is today under question once again. By citing an inter- or multinationality whose control was Islamic, I am of course not interested in legitimizing the Eurocentric model by endorsing an 'Islamic Revival', where an 'Islam' contained in diversified nation states, in postcoloniality and migrancy, is demonized or sacralised as a monolith. It has been argued by contemporary scholars that the economic formations of late eighteenth-century Western Europe began to shift the balance within the Ottoman Empire so that its Muslim component began increasingly to slip or remain contained in a precapitalist mode. Kemal Kerpat has argued that what was a curiosity about the West was gradually recoded as the necessity to imitate. Religious nationalism began to grow as 'the ideal of impartiality which insulated the bureaucracy' began to break down.

The Ottoman trade monopoly on the Black Sea came to an end in 1774. The Mediterranean trade had been dominated by the West. Now 'for the common good of the two Empires', Russia stepped into the Black Sea trade. In 1798 Napoleon invaded Egypt, threatening the British trade route to India. 'The Ottoman economy gradually entered a period of total submission to the industrial giants of Europe'. In this transforming society, religious difference gradually gets politically recoded as majorities and minorities, until, in a century's time, 'the Ottoman government [is] increasingly called "Turkish", and "Turkish" [now] means a dominant Muslim majority'.

This is not merely a demographic change imposed from without. It is a discursive shift making possible certain kinds of statements, ultimately making possible a Turkish nationalist who 'finds it "in vain to offer resistance" to European civilization', the 'visionary mimic man as father of the nation', Mustafa Kemal Ataturk.

We are speaking of the same period – 1774, 1798 – as in the cases of the US and India. But the narrative is different again. In the case of the United States, an originary claim is secured. In the case of India, colony and empire step forth as place-holders for a 'failed originary moment'. Here the question of origin is settled differently.

Let us consider secularism without the moralistic fervor with which we contemplate its 'organic development' in the West, just as we thought of 'nations' a moment ago without necessarily checking them against the story of the rise of nationalism in the West. In a practically multinational empire like the Ottoman, the separation of church and state was practically effective in the interest of the

overarching state. This secularism was not the name of the socializing of Western Christianity which has something like a relationship with the rise of industrial monopoly capitalist imperialism. It was rather a precapitalist practical (not philosophical) secularism which was given loose ideological support by a communitarianist universalism taken to be present in the Islamic *umma*. (Any suggestion that this can be suddenly injected into 'Islamic' politics today is to work in the 'naive conviction that the Muslim masses are still living in the religious atmosphere of the Middle Ages'.

The impact of a shift in world trade begins to reconstitute the *habitus* (Pierre Bourdieu's term) of the region into the Western European discursive formation at the end of the eighteenth century. In other words, things begin to 'make sense' in Western European terms. The Ottoman example is now a 'deviation'. And now, in a reconstituted Muslim-majority Turkish state, it is possible for Western Europe to *offer* an *originary* model. Turkey begins to constitute itself as a nation state. The Constitution of 1876 is its first inscription, the general 'balkanization' of the empire after the First World War its necessary military-political consolidation.

I have argued elsewhere that the peculiar play of contingency in the narrativization of history should not be construed as the Laws of Motion of History. My argument has been developed in the context of presenting a contrast between the circumstances contingent upon two great monotheisms – Christianity and Islam – in the possibility of their reinscription as secularism as such. Here I offer an example from recent Indian history.

The Khilafat movement (1918–25) in India, launched in the name of a multinational unitarian universalist Islam supporting the Ottoman Caliphate, was out of joint with the times. It was in fact an anti-imperialist nationalist attempt at the consolidation of the minority rights of Islam in India. Here too, the reconstitution of the Imperial Mughal State and the independent principalities of India through (more direct) contact with industrial monopoly capitalist imperialism had established a new habitus: majority–minority. In the sphere of decolonization it was European-style nationalism that was on the agenda. (In fact, that was the subtext of the Khilafat movement.) Thus, although the Khilafat movement lent support to the rise of Mustafa Kemal, the creator of 'modern Turkey', it was by Kemal's Constitution, in early 1924, that the actual Khilafat or Caliphate was abolished. For the Indians, after a negotiated Independence, in 1947, Western European codes and English Common Law offered models of origin. The constitution of the secular state of India was launched under the auspices of Lord Mountbatten, although the voice of Islam and a semitized Hinduism as alternatives to the European Enlightenment were still heard.

Let us look now at the question of origin in the Turkish case. A simulated alien origin or source, from which to draw 'modernization' and constitutionality appears, politically and philosophically cognizable, facing a terrain reterritorialized in response to the global release of industrial capital. The teleological vision of a Turkish 'nation' now effaces the incessantly negotiated multinationality that was the Ottoman Empire because that can no longer be recognized as multi-'nationality'. The gap can be measured by the distance between Midhat Pasha's Constitution of 1876 and Mustafa Kemal's Constitution of 1924.

> 1876: Art. 1. The Ottoman Empire comprises present countries and possessions and semi-dependent provinces. It forms an indivisible whole from which no portion can be detached under any pretext whatever . . . Art. 8. All subjects of the Empire are called Ottomans, without distinction, whatever faith they profess; the *status* of an Ottoman is acquired and lost, according to conditions specified by law.
>
> 1924: Art. 2. The Turkish State is republican, nationalist, populist, etatist, secular and reformist . . . Art. 68. Every Turk is born free, and free he lives.

Whatever the discrepancy, in the US or in Turkey, 'between constitutional norms and political realities', between empire and nation, by 1924 'the free Turk' is coded into constitutional rationality as a person, as opposed to the Ottoman. 'The free American', comparably coded, can disavow the contingent securing of his origin, and present his felicitous connection with world trade at the moment of origin (compounded by domestic simple commodity production with 'organic' links to industrial capitalism) as *only* a bold rupture. 'The free Turk' is obliged to a perennial acknowledgment of European debt.

I should like to look at the 'free Turk' in a sharper focus.

In the brief first section, entitled 'Declarations of Independence', of *Otobiographies*, Derrida points out that 'the good people of these Colonies' in whose name the representatives sign the American Declaration of Independence do not, strictly speaking, exist. As such they do not yet have the name and authority before the Declaration. At the same time, they are required to produce the authority for a Declaration which gives them being.

'This unheard-of thing [is] an everyday occurrence'. That fact does not, however, authorize us to ignore it as trivial.

> This undecidability between, let's say, a performative structure and a constative structure is *required* in order to produce the sought-after effect . . . The signature [on the Declaration] invents the signer [the name and authority of 'the good People'] . . . in a sort of fabulous retroactivity . . . [T]his fabulous event is only possible in truth thanks to [*par*] the inadequation to itself of a present. . . . The constitution . . . guarantee[s] . . . your passport . . . marriages . . . checks . . . [by] the signature of each American citizen [which] depends, in fact and by right, on this indispensable confusion . . . [The 'good People'] sign in the name of the laws of nature and in the name of God, creator of nature . . . and present performative utterances *as* constative utterances.
>
> (Derrida 1985: 10)

This confusion guarantees the identity of the national agent – passport, marriage, check. But this originary 'hypocrisy', entailing the involvement of the laws of nature, guarantees/produces the national agent *as such*, who is also the guarantor of the guarantee. The first is seen in the constative/performative in 'every Turk is *born* free' (1924). The second is seen in the guarantor/guaranteed

in the self-inadequate present of 'the system *is* based on the principle that the people personally and effectively *direct* their own destinies' (1921).

If the series of Turkish constitutions are read with Derrida's extraordinary attention to detail, we would, again and again, trace this disclosure or effacement of the trace, at the origin of the founding of modern constitutions. Undecidability secures the agent's ability to decide as a free national agent.

Why do we need to remember this? So that the possibility of agency is not taken to guarantee the self-proximity of the subject, and national or ethnic *identity* do not become fetishized. Nationalism in the context of metropolitan countries can then become the justification for the founding racist ideology of imperialism and neocolonialism, 'the end of history', declaring 'the triumph of the West', predicated upon being 'turned off by [the] nihilistic idea of what literature was all about [taught by] Roland Barthes and Jacques Derrida'. In the context of the Third World, if the undecidable and slippery founding of agency is seen to be the birth of a new man or woman, the act of the founding, celebrating *political* independence, comes to be seen as an end in itself. Some remain outside this constative/performative ruse. By contrast, the transplanting of nationalities in migrancy shows up the negotiability of the Constitutional subject.

Responding to the US reception of his *Islam and Capitalism*, so staunch a Marxist as Maxime Rodinson is obliged to renounce both economics as the last instance and access to scientific truth:

> I merely hold that the translation of the popular will into political deci-sions requires something else than free parliamentary elections, quite other arrangements differing according to the social condition of the population under consideration . . . My struggle [is] precisely against faith in the panacea of political independence. That does not mean that I scorn political independence, that I renounce my support of the struggle for decolonization . . . Just as it is important to perceive, behind the scenes in the representative institutions, the reality of the forces of economic pressure, so too is it necessary to understand that a world of independent political units, each with an equal voice at the U.N., even endowed with representative institutions, does not, in itself, make a 'free world'. That is undoubtedly obvious to the most naïve observer of the international political game, but the ideology that sacralizes political institutions impedes acknowledgment of all the conse-quences . . . The whole truth is no more accessible to man than full freedom or complete harmony of social relations.
>
> (Rodinson 1978: xxiii)

In the mid-1960s, writing for a French rather than a US audience, Rodinson had told his readers that 'there remain[ed] a very large area of the field of learning that can and must be explored with . . . philosophical presuppositions provisionally sus-pended . . . and the positivist procedure is the one to follow'. The American Preface, quoted above, shows the suspension of assurances of positivism as well. Activist thinkers of the third or any world, not merely anxious 'to shine in some salon, lecture-theatre or meeting-hall', repeatedly come up against the call to suspension when questions of originary justification for labels of identity confront them.

Having acknowledged that basing collective practice on the ground of identity begs the question in the very house of self-evidence, how do we reopen the distinction between the US and Turkish cases? It is in the area of the origin from which the new nation separates itself, an issue, as we have noticed in Ackerman's discussion, that is not without a certain importance: 'In this case, another state signature had to be effaced in "dissolving" the links of colonial paternity or maternity'. As the Declaration states: 'it becomes necessary for one people to dissolve the political bands which have connected them with another'. It is here that the laws of God and Nature provide the necessary last instance that can accommodate 'the hypocrisy indispensable to a politico-military-economic, etc. coup de force'. And stand behind the Constitution as pretext. The difference between this confident dissolution of origin and the cultural confusion and disavowal attendant upon migrancy is the difference between colonialism and migrancy. Here we are discussing a historical version of the precursor of modernization which will not fit the colonial discourse model too easily.

Like the US Declaration, what the Turkish Constitution separates itself from is its own past, or rather it secures a separation already inaugurated by the Ottoman Constitution of 1876. In terms of the access to agency, the earlier constitution had not yet fully coded a *coup* (blow) as a *coupure* (cut). The irreducible performative or constative confusion sustaining Art. 3 (1924) – 'sovereignty belongs *unconditionally* to the nation' – depends on the abolition of the Caliphate.

And this is not declared in the name of the Good People of Turkey; merely in the unwritten name of Europe. The 'national' is already catachrestic, 'wrested from its proper meaning'.

It might therefore be politically useful to consider whether Euro-American origins are also not catachrestic, secured by *other* places; to consider, in Derrida's words, 'the politics of the proper name used as the last instance'. God/Nature in the case of the United States, Europe in the case of Turkey. The two must be read side by side. Turkey is especially interesting because it is not a case of decolonization but rather an obligatory self-de-imperialization. For a transnational study of culture, the 'comparative' gesture cannot be docketed in a comfortable academic subdivision of labor; but rather, the inexhaustible taxonomy of catachreses – *how* a constitution begs the question of origin – must at least be invoked at every step. Culture studies must therefore constantly risk (though not flaunt) a loss of specialism.

3

It is perhaps unrealistic to expect transnational literacy in the high school classroom. Indeed, I have argued elsewhere that even the undergraduate classroom might be too early to broach true transnational literacy. It was, however, interesting to find that, although 'Constitutional Convention', 'constitutional monarchy', and 'Constitution of the United States' were three items listed under 'What literate Americans know' in E. D. Hirsch's provocative book *Cultural Literacy*, the Constitution was not an index entry. In other words, constitutional matters did not form part of Hirsch's own thinking in the making of his argument.

There is nothing in his index between 'Conservatism' and 'Constructive Hypothesis'. In sections 1 and 2 above, I have tried to build towards the argument that, if one is going to speak for or plan for that complicated thing, an 'American', one must think of his or her relationship to the Constitution.

If the high school social sciences class gives America to the people in the American way, and if the American way is divided into the *normal* and the constitutional, and the high school humanities class is restructuring itself by way of books such as *Cultural Literacy*, humanities teachers on the tertiary level ought perhaps to ask what the cultural politics of the production of the 'American Way' might be.

Like E. D. Hirsch, Jr, I am a teacher of English. I must take into account that English is in the world, not just in Britain and the United States. Yet, English is the medium and the message through which, in education, Americans are most intimately made. And, first, the history of higher lawmaking, the reality of normal politics, and changes in electoral mechanics show us that the connection between 'We the People' and a General Will is constantly negotiable; second, a making of Americans that would be faithful to American origins is not just a transaction with Europe; third, as teachers in the humanities, and as teachers of English, our role in training citizens should not ignore this.

I entered a department of English as a junior in 1957 in another world, in Presidency College at the University of Calcutta. Yet, such is the power of epochs or eras that I did not come to the slow thinking of *other* worlds choreographing the march of English until about the mid-1970s, when I had already been teaching in the United States for about a decade. Thus here too my perspective is of the not-quite-not-citizen, an economic migrant with a toehold in postcoloniality.

As such, I must speak from within the debate over the teaching of the canon.

There can be no general theory of canons. Canons are the condition of institutions and the effect of institutions. Canons secure institutions as institutions secure canons. The canon as such – those books of the Bible accepted as authentic by the church – provides a clear-cut example. It is within this constraint, then, that some of us in the profession are trying to expand the canon.

Since it is indubitably the case that there is no expansion without contraction, we *must* remove the single-author courses from the English major curriculum. We must make room for the co-ordinated teaching of the new entries into the canon. When I bring this up, I hear stories of how undergraduates have told their teachers that a whole semester of Shakespeare, or Milton, or Chaucer, changed their lives. I do not doubt these stories, but we have to do a quality/quantity shift if we are going to canonize the new entries. I have given something like a general rationale for this expansion in the first part of my paper. And, to be consistent with this resolve, even the feminist approaches to Shakespeare, the Marxist approaches to Milton, and the anti-imperialist approaches to Chaucer (are there those?) will have to relinquish the full semester allowed on the coat-tails of the Old Masters of the Canon. The undergraduates will have their lives changed perhaps by a sense of the diversity of the new canon and the unacknowledged power-play involved in securing the old. The world has changed too much. The least we can do to accept it is to make the small move to push the single-author courses up into the terminal MA.

The matter of the literary canon is in fact a political matter: securing authority. In order to secure authority we sometimes have to engage in some scrupulous

versions of 'doctrinaire gesture politics'. But, in the double-take that the daily administering of that authority entails comes the sense

> that there can be no 'knowledge' in political practice . . . Political practice involves the calculation of effect, of the possibilities and results of political action, and that calculation rests on political relations [in this case within the institutional network of United States tertiary education] which condition the degrees of certainty of calculation and the range of the calculable.
>
> (Hindess and Hirst 1987: 58)

A well-known paragraph in Capital, III, stages this double-take impressively. First the tremendous gestures toward the Realm of Freedom and the Realm of Necessity, the entire span of the human being in Nature and in social action; finally, the brief concluding sentence of the range of the calculable: 'The reduction of the working day is the founding condition'. A model for emulation: a lot of gesture politics, talk of other worlds. But the reduction of the space and time spent on the old canon is the founding condition.

What comes to fill the released space and time? Even the most cursory look at the publishers' catalogues that cross our desks, and the ever proliferating journals concerned with the matter of the counter-canon, convinces us that there is no shortage of material. What I will say will seem to leave out many subtleties of approach. But please bear with me, for that is the hazard of all overviews. Let me then tabulate the 'others', at least keeping in mind that the lines cross, under and over one item to another: women; women of color; gays, lesbians; Afro-America; immigrant literature; literature of ethnicity; working-class literature; working-class women; non-Western literature; and, in peculiar companionship, something called 'theory'.

I am not the only feminist who thinks that the situation of women's literature as such is rather particular here. Some women had made it into the general canon. 'A gentleman's library', wrote H. P. Marquand, a thoroughly sexist genteel American novelist writing in 1958 in his particularly sexist novel Women and Thomas Harrow, 'as the [small-town, New England, nineteenth-century] Judge very well understood, comprised the British poets, the works of Bulwer Lytton, the Waverley Novels, Dickens and Thackeray, Austen and the Brontë sisters and Trollope'. We can update this list by at least Virginia Woolf, Toni Morrison and perhaps Edith Wharton.

With regard to these writers, even more than with the old masters, it is a question of restoration to a feminist perspective. But outside of this sphere, there were all the certainly-as-good-as-the-men women writers who did not get into the canon because the larger grid of social production would not let them in.

In this broad sweep, and speaking only from the angle of bursting into the canon, how can the institution be obliged to calculate the literature of gender-differentiated homosexuality? Only with the assumption that, since sexuality-and-sexual-difference is one of the main themes and motors of literary production, this literature, in its historical determinations, continues to complicate and supplement that network, not only by giving us the diverse scoring of 'the uses of

pleasure' but also by showing us how, by the divisive logic of normalizing the production of reproductive heterosexuality, we work at the continued securing of even the enlarged canon.

Two such different scholars and critics as bell hooks and Hazel Carby have shown that the moment the color black is injected into these calculations, the structures of exclusion that have to be encountered appear much less accessible, much more durable. We need an approach here that is more than an awareness of the contemporary culture of white supremacy, of the fetishization of the black body, of the histories of black heroism in the nineteenth century that complete the list. The work on slave narratives done by women like Mary Helen Washington and others begins to give us a sense of what has been called '*the reverse side*' of the mere 'trac[ing] back from images to . . . structure', a tracing that constituted the self-representation of the American literary canon since its inception. By comparison, the restoration and insertion of the white-majority feminist canon is a matter of correcting and altering the established image-structure line of representation as if it restrained the garment of the body politic. With the able editorship of Henry Louis Gates, Jr, and others, explosive quantities of material for study are being made available. Gates's own work, tracing figurations of Africa, takes us out of the strictly English canon into the area of culture studies.

This literature, the literature of slavery, struggle, freedom, social production is different from the narratives of migrant ethnicity inscribed on the body of something called 'America'. There cannot be a general concept of the other that can produce and secure both. In the interest of solidarity and gesture politics, we must forget these differences. For the painstaking task of training students and teachers within the institutional obligation to certify a canon, however, we must remember them.

It seems right that the literature of the working class should form a part of disciplinary preparation. Yet in this parade of abstract figures on the grid of canonical calculation – woman, gay, lesbian, black, ethnic – the class-subject is aggressively more abstract as a concept. And on that level of abstraction, there may be a contradiction between embattled class consciousness and the American Dream. Perhaps in Britain the situation is different; both because of its *earlier* entry into the organised left and its *later* entry into something resembling the American Dream, through Thatcher's brilliant maneuvers. One cannot not commend the study of the writing of the exploited in struggle. Yet is there something particularly disqualifying about 'working-class' becoming a canonical descriptive rather than an oppositional transformative? Certainly the basic argument of Jonathan Rée's *Proletarian Philosophers* would seem to suggest so.

This could in fact be the problem with all noncanonical teaching in the humanities, an implicit confusion between *descriptive* canonical practices within an institution and *transformative* practices to some 'real ' world. It is this area of confusion that can be depolemicized and made productive, through deconstructive strategies of teaching. With this in mind, I will soon touch upon the need for deconstructive, power/knowledge-based, generally post-structuralist, preparation for our *faculty*. My cautions about the *undergraduate* teaching of post-structuralism relate to the breeding of recuperative analogies or preprogrammed hostility toward post-structuralism within the institutional calculus.

Let us, for the moment, avoid this problem and go back to our English major, strung tight with the excitement of learning to read the diversity of the new canon: a bit of the old masters in new perspectives, women's literature, black women's literature, a glimpse of Afro-America, the literature of gendered homosexuality, of migrant ethnicity, of the exploited in struggle.

We are taking good teaching for granted, a teaching that can make the student grasp that this *is* a canon, that this *is* the proper object of study of the new English major. Teaching is a different matter from our list of ingredients. The proof of the pudding is in the classroom. And, as I will say again, pedagogy talk is different from conference talk. Let us then return to our well-taught undergraduate and look at the last two items on our list: theory, and the literature of the rest of the world.

Theory in the United States institution of the profession of English is often shorthand for the general critique of humanism undertaken in France in the wake of the Second World War and then, in a double-take, further radicalized in the mid-1960s in the work of the so-called post-structuralists. I believe this material has no claim to a *separate* enclave in our undergraduate major.

The critique of humanism in France was related to the perceived failure of the European ethical subject after the War. The second wave in the mid-1960s, coming in the wake of the Algerian revolution, sharpened this in terms of disciplinary practice in the humanities and social sciences because, as historians, philosophers, sociologists and psychologists, the participants felt that their practice was not merely a disinterested pursuit of knowledge, but productive in the making of human beings. It was because of this that they did not accept unexamined human experience as the source of meaning and the making of meaning as an unproblematic thing. And each one of them offered a method that would challenge the outlines of a discipline: archaeology, genealogy, power/knowledge reading, schizo-analysis, rhizo-analysis, non-subjective psychoanalysis, affirmative deconstruction, paralogic legitimation. At the end of the Second World War, the self-representation of the United States, on the other hand, was that of a savior, both militarily and, as the architect of the Marshall Plan, in the economic and therefore socio-cultural sphere. In fact, given the nature of United States society, the phrase 'failure of the ethical subject felt by humanist intellectuals' has almost no meaning. And, given the ego-based pragmatism in the fields of history, philosophy, sociology, psychology and, indeed, literary criticism in the United States, the majority of United States teachers in the humanities saw and see the relevant French intellectuals as merely being *anti*humanists who believe that there is no human subject and no truth. As Pierre Bourdieu makes clear in his *Homo Academicus*, this group of intellectuals did not have an impact on the protocols of institutional pedagogy in France either. I think therefore it is absurd to expect our undergraduate majors to clue into this package called 'theory' as part of the canon. There is often a required history of criticism course for them. I suppose the impact of 'theory' in literary criticism can find a corner there. If they can understand Plato against the poets, or Coleridge on the imagination, and Freud on Hoffman, they can understand Barbara Johnson on Poe. And the critique of the subject that they *can* learn from the counter-canonical new material is that the old canon conspired, only sometimes unwittingly, to make the straight white Christian man of property the ethical universal.

Because the use of what is called 'theory' is in 'educating the educators', it is the doctoral student – the future teacher – who can be carefully inserted into it. And although I see no harm in introductory courses in theory on this level, I feel its real arena is an elected sequence, where interested students are prepared to resonate with something so much outside their own thoroughly pragmatic national tradition. By 'preparation' I do not mean just chunks of Marx, Nietzsche, Freud, Heidegger. I mean practice in analyzing critical prose. I have limited experience in long-term teaching at elite institutions. In my experience doctoral students in English are generally encouraged to judge without preparation. This is lethal in the critique of the canon, and doubly so in the study of so-called 'theory', for the practitioners there are writers of historical, sociological, philosophical, psychological prose who rely on rhetoric to help them. These students must also take seriously their foreign language requirement, which is generally a scandal. The intellectual-historical difference between Western Europe and the Anglo-United States in the postwar and Cold War years and indeed the difference in the fate of liberal humanism in these spaces is such that the most conscientious translators have often destroyed and trivialized the delicacy as well as the power of the critique, not knowing what to preserve.

These students must learn that it is possible to be 'wrong' on a certain restrictive level and take that as an incentive for further inquiry. I know the bumper sticker says 'Kids need praise every day', but doctoral students, who are going to reproduce cognitive authority soon, might be encouraged to recognize that acknowledgment of error before texts from another tradition need not be disabling or paralyzing. I emphasize this because here we are attempting not merely to enlarge the canon with a counter-canon but to dethrone canonical *method*: not only in literary criticism but in social production; the axiom that something called concrete experience is the last instance. The canon is, after all, not merely the authentic books of the Bible, it is also, the *OED* tell us, 'a fundamental principle . . . or axiom governing the systematic or scientific treatment of a subject'. Why is it necessary to gut the canon in this way? But I also hope that those students in the doctoral stream who choose to follow this counter-intuitive route will acquire some notion of its usefulness.

I have kept the rest of the world till the end. I think a general acquaintance with the landmarks of world literature outside of Euramerica should be part of the general undergraduate requirement. On the level of the English major, especially if we keep the single-author courses, a survey course is an insult to world literature. I would propose a one-semester senior seminar, shared with the terminal MA, utilising the resources of the Asian, Latin American, Pacific, and African studies, in conjunction with the creative writing programs, where the student is made to share the difficulties and triumphs of translation. There is nothing that would fill out an English major better than a sense of the limits of this exquisite and supple language.

The division between substantive expansion of the canon and a critique of canonical method is most rigorously to be kept in mind in world literature studies on the graduate level: colonial and postcolonial discourse, studies in a critique of imperialism. As long as this line of work is critical of the canon it can remain conscientiously researched straight English: Laura Brown's work with Swift

and Gauri Viswanathan's on T. S. Eliot come to mind. One can think of the role of the navy in Jane Austen's *Mansfield Park*, or of Christianity in *Othello*, and so on. But as soon as it becomes a substantive insertion *into* the canon, we should call a halt.

There has been a recent spate of jobs opening up in the anglophone literature of the Third World. This is to be applauded. But the doctoral study of colonial and postcolonial discourse and the critique of imperialism as a substantive undertaking cannot be contained fully within English, although the first initiative might well come from there. In my thinking, this study should yoke itself with other disciplines, including the social sciences, so that we have degrees in English *and* History, English *and* Asian Studies, English *and* Anthropology, English *and* African Studies, where the English half of it will allow the student to read critically the production of knowledge in the other discipline, as well as her own all-too-easy conclusions. *Mutatis mutandis*, metropolitan national literature departments can also serve as bases.

I think this speciality should carry a rigorous language requirement in at least one colonized vernacular. What I am describing is the core of a transnational study of culture, a revision of the old vision of Comparative Literature. Otherwise:

Colonial and postcolonial discourse studies can, at worst, allow the indigenous elite from other countries to claim marginality without *any developed* doctoral-level sense of the problematic of decolonized space and without any method of proper verification within the discipline.

If this study is forever contained within English (or other metropolitan literatures), without expansion into fully developed transnational culture studies, colonial and postcolonial discourse studies can also construct a canon of 'Third World Literature (in translation)' that may lead to a 'new orientalism'. It can fix Eurocentric paradigms, taking 'magical realism' to be the trademark of Third World literary production, for example. It can begin to define 'the rest of the world' simply by checking out if it is feeling sufficiently 'marginal' with regard to the West or not.

We cannot fight imperialism by perpetrating a 'new orientalism'. My argument is not a guilt and shame trip. It is a warning. Indeed, the institutional imperatives for breaching the very *imperium* of English, even with its revised canon, cannot be fully developed from within English departments, for in its highly sophisticated vocabulary for cultural descriptions, the knowledge of English can sometimes sanction a kind of global ignorance.

4

Arrived here, it seems to me that institutes and curricula for a historically sophisticated transnational study of culture have become an item on the agenda. They can help us undo disciplinary boundaries and clear a space for study in a constructive way. They can provide the field for the new approach.

The point is to negotiate between the national, the global, and the historical as well as the contemporary diasporic. We must both anthropologize the West and study the various cultural systems of Africa, Asia, Asia Pacific and the Americas

as if peopled by historical agents. Only then can we begin to put together the story of the development of a cosmopolitanism that is global, gendered, and dynamic. In our telematic or micro-electronic world, such work can get quite technical: consideration of the broader strategies of information control, productive of satisfactory and efficient cultural explanations; consideration of the systems of representation for the generated explanations; mapping out the techniques of their validation and deployment. This can disclose an inexhaustible field of connections. A discipline must constrain the inexhaustible. Yet the awareness of the potential inexhaustibility works against the conviction of cultural supremacy, a poor starting point for new research and teaching.

This last paragraph is grant proposal talk. How does this type of prose translate to teaching talk? Let us move from high tech to humanism. Let us learn and teach how to distinguish between '*internal* colonization' – the patterns of exploitation and domination of disenfranchised groups *within* the United States – and the various different heritages or operations of colonization in the rest of the world. The United States is certainly a multiracial culture, but its parochial multicultural debates, however animated, are not a picture of globality. Thus we must negotiate between nationalism (uni- or multicultural) and globality.

Let us take seriously the idea that systems of representation come to hand when we secure our own culture – our own cultural explanations. Think upon the following set:

First, the making of an American must be defined by at least a desire to enter the 'We the People' of the Constitution. There is no way that the 'radical' or the 'ethnicist' can take a position against civil rights, the Equal Rights Amendment or great transformative opinions such as *Roe* v. *Wade*. One way or another, we cannot not want to inhabit this great rational abstraction.

Second, traditionally, this desire for the abstract American 'we' has been recoded by the fabrication of ethnic enclaves, artificial and affectively supportive subsocieties that, claiming to preserve the ethnos or culture of origin, move further and further away from the vicissitudes and transformations of the nation or group of origin. If a constitution establishes at least the legal possibility of an abstract collectivity, these enclaves provide a counter-collectivity that seems reassuringly 'concrete'.

Third, *our* inclination to obliterate the difference between United States internal colonization and the dynamics of decolonized space makes use of this already established American ethno-cultural agenda. At worst, it secures the 'they' of development or aggression against the constitutional 'we'. At best, it suits our institutional convenience and brings the rest of the world home. A certain double standard, a certain sanctioned ignorance, can now begin to operate in the areas of the study of central and so-called marginal cultures.

There is a lot of name-calling on both sides of the West-and-the-rest debate in the United States. In my estimation, although the politics of the only-the-West supporters is generally worth questioning, in effect the two sides legitimize each other. In a Foucauldian language, one could call them an opposition within the same discursive formation. The new culture studies must displace this opposition by keeping nation and globe distinct as it studies their relationship, and by taking a moratorium on cultural supremacy as an unquestioned springboard.

I am not speaking against the tendency to conflate ethnos of origin and the historical space left behind with the astonishing construction of a multicultural and multiracial identity for the United States. What I am suggesting is that if, as academics in the humanities, we take this as the founding principle for a study of globality, then we are off base. In the most practical terms, we are allowing a parochial decanonization debate to stand in for a study of the world.

A slightly different point needs to be made here. I am not arguing for an unexamined nativism as an alibi for culture studies. To keep the rest of the world obliged to remain confined within a mere ethnic pride and an acting out of a basically static ethnicity is to confuse political gestures with an awareness of history. That confinement was rather astutely practiced by the traditionally defined disciplinary subdivision of labor within history, anthropology, and comparative literature. Cultural studies must set up an active give-and-take with them so that it gains in substance what it provides in method. And, the educators must educate themselves in effective interdisciplinary (postdisciplinary?) teaching. As a practical academic, one must be thinking about released time for faculty and curricular development in the newly instituted programs. These endeavors must ask: How can models of reasoning be taken as culture-free? How can help and explanation be both culture-specific and 'objective'? If there are answers to these questions, how can they remain relevant across disciplines?

Homi K. Bhabha

THE POSTCOLONIAL AND THE POSTMODERN
The question of agency

EDITOR'S INTRODUCTION

H OMI BHABHA'S WORK BELONGS more to cultural and literary
theory than to cultural studies as narrowly understood. History and everyday
life appear in his writing not so much as objects on their own account but as
examples inside a mode of dense, semiotically orientated philosophical analysis –
which, however, has been very influential in cultural, and especially in postcolonial,
studies.

In this essay Bhabha explores congruences between the postmodern and the
postcolonial by way of a post-structuralist theory of language. The classical struc-
turalist distinction between *langue* (language as a system) and *parole* (individual
speech acts) is interpreted as a temporal lag between thought and expression,
between daydreaming and writing, between the intention to express meaning and
the verbal performance in which meaning is articulated. Bhabha argues that each
of the second moments in this series is a revision of the first – a revision in which
exists the possibility for openness and contingency; the possibility, in short, of a
certain freedom. For victims of colonialism, culture means strategies of survival
as much as heritage, so that the gap between inherited or official meaning (ideology)
and its individual performance provides room for resistance and individuation.
Drawing upon Ranajit Guha's researches, the concrete example Bhabha points to
is the hybrid, improvised "rebel consciousness" in the Bengali struggle against
British imperialism.

Bhabha also suggests that his account of semiotics provides a theoretical basis
for a radically multicultural society able to incorporate cultural "incommensura-
bility" (that is, internal cultures which share no values or projects). This is also,
he contends, what a postmodern society is.

Bhabha's theory is finally both anti-racist and counter-historical: the kind of cultural temporality he endorses eludes the determining pressures of ethnicity and race as well as the weight of tradition, indeed of history itself. That is what the "contingency" and "incommensurability" of his subaltern or postmodern cultural acts of signification imply. But, however valuable, this move also involves, or at any rate risks, a blanding out of differences – like those between poor rural workers in South Asia and London multicultural artists and theorists, for instance. It is because it carries this risk that "postcolonialism" as a general concept has been questioned by critics such as Anne McClintock – and why the work of a post-colonial theorist like Gayatri Spivak (including her essay in this volume) can be read as negotiating the huge (incommensurable?) distance between the lifeways of the subaltern and the privileged theorist.

Further reading: Bhabha 1994; Dirlik 1994; During 1998; Fanon 1967a, 1967b; Gilroy 1994; McClintock 1994; Young 1995; Zizek 1986.

The survival of culture

Postcolonial criticism bears witness to the unequal and uneven forces of cultural representation involved in the contest for political and social authority within the modern world order. Postcolonial perspectives emerge from the colonial testimony of Third World countries and the discourses of 'minorities' within the geopolitical divisions of East and West, North and South. They intervene in those ideological discourses of modernity that attempt to give a hegemonic 'normality' to the uneven development and the differential, often disadvantaged, histories of nations, races, communities, peoples. They formulate their critical revisions around issues of cultural difference, social authority and political discrimination in order to reveal the antagonistic and ambivalent moments within the 'rationalizations' of modernity. To bend Jürgen Habermas to our purposes, we could argue also that the postcolonial project, at the most general theoretical level, seeks to explore those social pathologies – 'loss of meaning, conditions of anomie' – that no longer simply 'cluster around class antagonism, [but] break up into widely scattered historical contingencies' (Habermas 1987: 348).

A range of contemporary critical theories suggest that it is from those who have suffered the sentence of history – subjugation, domination, diaspora, displacement – that we learn our most enduring lessons for living and thinking. There is even a growing conviction that the affective experience of social marginality – as it emerges in non-canonical cultural forms – transforms our critical strategies. It forces us to confront the concept of culture outside *objets d'art* or beyond the canonization of the 'idea' of aesthetics, to engage with culture as an uneven, incomplete production of meaning and value, often composed of incommensurable demands and practices, produced in the act of social survival. Culture reaches out to create a symbolic textuality to give the alienating everyday an aura of selfhood, a promise of pleasure. The transmission of *cultures of survival* does not occur in the ordered *musée imaginaire* of national cultures with their claims to the continuity of

an authentic 'past' and a living 'present' – whether this scale of value is preserved in the organicist 'national' traditions of romanticism or with the more universal proportions of classicism.

Culture as a strategy of survival is both transnational and translational. It is transnational because contemporary postcolonial discourses are rooted in specific histories of cultural displacement, whether they are the 'middle passage' of slavery and indenture, the 'voyage out' of the civilizing mission, the fraught accommodation of Third World migration to the West after the Second World War, or the traffic of economic and political refugees within and outside the Third World. Culture is translational because such spatial histories of displacement – now accompanied by the territorial ambitions of 'global' media technologies – make the question of how culture signifies, or what is signified by *culture*, a rather complex issue.

It becomes crucial to distinguish between the semblance and similitude of the symbols across diverse cultural experiences – literature, art, music, ritual, life, death – and the social specificity of each of these productions of meanings as they circulate as signs within specific contextual locations and social systems of value. The transnational dimension of cultural tranformation – migration, diaspora, displacement, relocation – makes the process of cultural translation a complex form of signification. The natural(ized), unifying discourse of 'nation', 'peoples', or authentic 'folk' tradition, those embedded myths of culture's particularity, cannot be readily referenced. The great, though unsettling, advantage of this position is that it makes you increasingly aware of the construction of culture and the invention of tradition.

The postcolonial perspective departs from the traditions of the sociology of underdevelopment or 'dependency' theory. As a mode of analysis, it attempts to revise those nationalist or 'nativist' pedagogies that set up the relation of Third World and First World in a binary structure of opposition. The postcolonial perspective resists the attempt at holistic forms of social explanation. It forces a recognition of the more complex cultural and political boundaries that exist on the cusp of these often opposed political spheres.

It is from this hybrid location of cultural value – the transnational as the translational – that the postcolonial intellectual attempts to elaborate a historical and literary project. My growing conviction has been that the encounters and negotiations of differential meanings and values within 'colonial' textuality, its governmental discourses and cultural practices, have anticipated, *avant la lettre*, many of the problematics of signification and judgement that have become current in contemporary theory – aporia, ambivalence, indeterminacy, the question of discursive closure, the threat to agency, the status of intentionality, the challenge to 'totalizing' concepts, to name but a few.

In general terms, there is a colonial contramodernity at work in the eighteenth- and nineteenth-century matrices of Western modernity that, if acknowledged, would question the historicism that analogically links, in a linear narrative, late capitalism and the fragmentary, simulacral, pastiche symptoms of postmodernity. This linking does not account for the historical traditions of cultural contingency and textual indeterminacy (as forces of social discourse) generated in the attempt to produce an 'enlightened' colonial or postcolonial subject, and it transforms, in

the process, our understanding of the narrative of modernity and the 'values' of progress.

Postcolonial critical discourses require forms of dialectical thinking that do not disavow or sublate the otherness (alterity) that constitutes the symbolic domain of psychic and social identifications. The incommensurability of cultural values and priorities that the postcolonial critic represents cannot be accommodated within theories of cultural relativism or pluralism. The cultural potential of such differential histories has led Fredric Jameson to recognize the 'internationalization of the national situations' in the postcolonial criticism of Roberto Retamar. This is not an absorption of the particular in the general, for the very act of articulating cultural differences 'calls us into question fully as much as it acknowledges the Other . . . neither reduc[ing] the Third World to some homogeneous Other of the West, not . . . vacuously celebrat[ing] the astonishing pluralism of human cultures' (Jameson 1989: xi–xii).

The historical grounds of such an intellectual tradition are to be found in the revisionary impulse that informs many postcolonial thinkers. C. L. R. James once remarked, in a public lecture, that the postcolonial prerogative consisted in re-interpreting and rewriting the forms and effects of an 'older' colonial consciousness from the later experience of the cultural displacement that marks the more recent, postwar histories of the Western metropolis. A similar process of cultural translation, and transvaluation, is evident in Edward Said's assessment of the response from disparate postcolonial regions as a 'tremendously energetic attempt to engage with the metropolitan world in a common effort at re-inscribing, re-interpreting and expanding the sites of intensity and the terrain contested with Europe' (Said 1990: 49).

How does the deconstruction of the 'sign', the emphasis on indeterminism in cultural and political judgement, transform our sense of the 'subject' of culture and the historical agent of change? If we contest the 'grand narratives', then what alternative temporalities do we create to articulate the differential (Jameson), contrapuntal (Said), interruptive (Spivak) historicities of race, gender, class, nation within a growing transnational culture? Do we need to rethink the terms in which we conceive of community, citizenship, nationality and the ethics of social affiliation?

Jameson's justly famous reading of Conrad's *Lord Jim* in *The Political Unconscious* provides a suitable example of a kind of reading against the grain that a postcolonial interpretation demands, when faced with attempts to sublate the specific 'interruption', or the interstices, through which the colonial text utters its interrogations, its contrapuntal critique. Reading Conrad's narrative and ideological contradictions 'as a canceled realism . . . like Hegelian *Aufhebung*', Jameson represents the fundamental ambivalences of the ethical (honour/guilt) and the aesthetic (premodern/postmodern) as the allegorical restitution of the socially concrete subtext of late nineteenth-century rationalization and reification (Jameson 1981: 266). What his brilliant allegory of late capitalism fails to represent sufficiently, in *Lord Jim* for instance, is the specifically colonial address of the narrative aporia contained in the ambivalent, obsessive repetition of the phrase 'He was one of us' as the major trope of social and psychic identification throughout the text. The repetition of 'He was one of us' reveals the fragile margins of the concepts of

Western civility and cultural community put under colonial stress; Jim is reclaimed at the moment when he is in danger of being cast out or made outcast, manifestly 'not one of us'. Such a discursive ambivalence at the very heart of the issue of honour and duty in the colonial service represents the liminality, if not the end, of the masculinist, heroic ideal (and ideology) of a healthy imperial Englishness – those pink bits on the map that Conrad believed were genuinely salvaged by being the preserve of English colonization, which served the larger idea, and ideal, of Western civil society.

Such problematic issues are activated within the terms and traditions of post-colonial critique as it reinscribes the cultural relations between spheres of social antagonism. Current debates in postmodernism question the cunning of modernity – its historical ironies, its disjunctive temporalities, its paradoxes of progress, its representational aporia. It would profoundly change the values, and judgements, of such interrogations, if they were open to the argument that metropolitan histories of civitas cannot be conceived without evoking the savage colonial antecedents of the ideals of civility. It also suggests, by implication, that the language of rights and obligations, so central to the modern myth of a people, must be questioned on the basis of the anomalous and discriminatory legal and cultural status assigned to migrant, diasporic and refugee populations. Inevitably, they find themselves on the frontiers between cultures and nations, often on the other side of the law.

The postcolonial perspective forces us to rethink the profound limitations of a consensual and collusive 'liberal' sense of cultural community. It insists that cultural and political identity are constructed through a process of alterity. Questions of race and cultural difference overlay issues of sexuality and gender and overdetermine the social alliances of class and democratic socialism. The time for 'assimilating' minorities to holistic and organic notions of cultural value has dramatically passed. The very language of cultural community needs to be rethought from a postcolonial perspective, in a move similar to the profound shift in the language of sexuality, the self and cultural community, effected by feminists in the 1970s and the gay community in the 1980s.

Culture becomes as much an uncomfortable, disturbing practice of survival and supplementarity – between art and politics, past and present, the public and the private – as its resplendent being is a moment of pleasure, enlightenment or liberation. It is from such narrative positions that the postcolonial prerogative seeks to affirm and extend a new collaborative dimension, both within the margins of the nation-space and across boundaries between nations and peoples. My use of poststructuralist theory emerges from this postcolonial contramodernity. I attempt to represent a certain defeat, or even an impossibility, of the 'West' in its authorization of the 'idea' of colonization. Driven by the subaltern history of the margins of modernity – rather than by the failures of logocentrism – I have tried, in some small measure, to revise the known, to rename the postmodern from the position of the postcolonial.

New times

The enunciative position of contemporary cultural studies is both complex and problematic. It attempts to institutionalize a range of transgressive discourses whose strategies are elaborated around non-equivalent sites of representation where a history of discrimination and misrepresentation is common among, say, women, blacks, homosexuals and Third World migrants. However, the 'signs' that construct such histories and identities – gender, race, homophobia, postwar diaspora, refugees, the international division of labour, and so on – not only differ in content but often produce incompatible systems of signification and engage distinct forms of social subjectivity. To provide a social imaginary that is based on the articulation of differential, even disjunctive, moments of history and culture, contemporary critics resort to the peculiar temporality of the language metaphor. It is as if the arbitrariness of the sign, the indeterminacy of writing, the splitting of the subject of enunciation, these theoretical concepts, produce the most useful descriptions of the formation of 'postmodern' cultural subjects.

Cornel West enacts 'a measure of *synechdochical* thinking' (my emphasis) as he attempts to talk of the problems of address in the context of a black, radical, 'practicalist' culture:

> A tremendous articulateness is syncopated with the African drumbeat
> . . . into an American postmodernist product: there is no subject
> expressing originary anguish here but a fragmented subject, pulling from
> past and present, innovatively producing a heterogeneous product . . .
> [I]t is part and parcel of the subversive energies of black underclass
> youth, energies that are forced to take a cultural mode of articulation.
>
> (West 1988: 280–1)

Stuart Hall, writing from the perspective of the fragmented, marginalized, racially discriminated-against members of a post-Thatcherite underclass, questions the sententiousness of left orthodoxy where 'we go on thinking a unilinear and irreversible political logic, driven by some abstract entity that we call the economic or capital unfolding to its pre-ordained end' (Hall 1988: 273). Earlier in his book, he uses the linguistic sign as a metaphor for a more differential and contingent logic of ideology:

> [T]he ideological sign is always multi-accentual, and Janus-faced – that
> is, it can be discursively rearticulated to construct new meanings,
> connect with different social practices, and position social subjects
> differently . . . Like other symbolic or discursive formations, [ideology]
> is connective across different positions, between apparently dissimilar,
> sometimes contradictory, ideas. Its 'unity' is always in quotation marks
> and always complex, a suturing together of elements which have no
> necessary or eternal 'belongingness'. It is always, in that sense, organ-
> ized around arbitrary and not natural closures.
>
> (Hall 1988: 9–10)

The 'language' metaphor raises the question of cultural difference and incommensurability, not the consensual, ethnocentric notion of the pluralistic existence of cultural diversity. It represents the temporality of cultural meaning as 'multi-accentual', 'discursively rearticulated'. It is a time of the cultural sign that unsettles the liberal ethic of tolerance and the pluralist framework of multiculturalism. Increasingly, the issue of cultural difference emerges at points of social crises, and the questions of identity that it raises are agonistic; identity is claimed either from a position of marginality or in an attempt at gaining the centre: in both senses, ex-centric.

The authority of customary, traditional practices – culture's relation to the historic past – is not dehistoricized in Hall's language metaphor. Those anchoring moments are revalued as a form of anteriority whose causality is effective because it returns to displace the present, to make it disjunctive. This kind of disjunctive temporality is of the utmost importance for the politics of cultural difference. It creates a signifying time for the inscription of cultural incommensurability where differences cannot be sublated or totalized because 'they somehow occupy the same space'. It is this liminal form of cultural identification that is relevant to Charles Taylor's proposal for a 'minimal rationality' as the basis for non-ethnocentric, transcultural judgements. The effect of cultural incommensurability is that it 'takes us beyond merely *formal criteria of rationality*, and points us toward the human *activity of articulation* which gives the value of rationality its sense' (C. Taylor 1985: 145).

Minimal rationality, as the activity of articulation embodied in the language metaphor, alters the subject of culture from an epistemological function to an enunciative practice. If culture as epistemology focuses on function and intention, then culture as enunciation focuses on signification and institutionalization; if the epistemological tends towards a *reflection* of its empirical referent or object, the enunciative attempts repeatedly to reinscribe and relocate the political claim to cultural priority and hierarchy (high/low, ours/theirs) in the social institution of the signifying activity. The epistemological is locked into the hermeneutic circle, in the description of cultural elements as they tend towards a totality. The enunciative is a more dialogic process that attempts to track displacements and realignments that are the effects of cultural antagonisms and articulations – subverting the rationale of the hegemonic moment and relocating alternative, hybrid sites of cultural negotiation.

My shift from the cultural as an epistemological object to culture as an enactive, enunciatory site opens up possibilities for other 'times' of cultural meaning (retroactive, prefigurative) and other narrative spaces (fantasmic, metaphorical). My purpose in specifying the enunciative present in the articulation of culture is to provide a process by which objectified others may be turned into subjects of their history and experience. My theoretical argument has a descriptive history in recent work in literary and cultural studies by African American and black British writers. Hortense Spillers, for instance, evokes the field of 'enunciative possibility' to reconstitute the narrative of slavery:

> [A]s many times as we re-open slavery's closure we are hurtled rapidly
> forward into the dizzying motions of a symbolic enterprise, and it

becomes increasingly clear that the cultural synthesis we call 'slavery' was never homogenous in its practices and conceptions, nor unitary in the faces it has yielded.

(Spillers 1989: 29)

Paul Gilroy writes of the dialogic, performative 'community' of black music – rap, dub, scratching – as a way of constituting an open sense of black collectivity in the shifting, changing beat of the present. More recently, Houston A. Baker, Jr. has made a spirited argument against 'high cultural' sententiousness and for the 'very, very sound game of rap (music)', which comes through vibrantly in the title of his essay, *Hybridity, the Rap Race, and the Pedagogy of the 1990s*. In his perceptive introduction to an anthology of black feminist criticism, Henry Louis Gates, Jr, describes the contestations and negotiations of black feminists as empowering cultural and textual strategies precisely because the critical position they occupy is free of the 'inverted' polarities of a 'counter-politics of exclusion': 'They have never been obsessed with arriving at any singular self-image; or legislating who may or may not speak on the subject; or policing boundaries between "us" and "them"' (Gates 1990: 8).

What is striking about the theoretical focus on the enunciatory present as a liberatory discursive strategy is its proposal that emergent cultural identifications are articulated at the liminal edge of identity – in that arbitrary closure, that 'unity' . . . in quotation marks' (Hall) that the language metaphor so clearly enacts. Postcolonial and black critiques propose forms of contestatory subjectivities that are empowered in the act of erasing the politics of binary opposition – the inverted polarities of a counter-politics (Gates). There is an attempt to construct a theory of the social imaginary that requires no subject expressing originary anguish (West), no singular self-image (Gates), no necessary or eternal belongingness (Hall). The contingent and the liminal become the times and the spaces for the historical representation of the subjects of cultural difference in a postcolonial criticism.

It is the ambivalence enacted in the enunciative present – disjunctive and multiaccentual – that produces the objective of political desire, what Hall calls 'arbitrary closure', *like the signifier*. But this arbitrary closure is also the cultural space for opening up new forms of identification that may confuse the continuity of historical temporalities, confound the ordering of cultural symbols, traumatize tradition. The African drumbeat syncopating heterogeneous black American postmodernism, the arbitrary but strategic logic of politics – these moments contest the sententious 'conclusion' of the discipline of cultural history.

We cannot understand what is being proposed as 'new times' within postmodernism – politics at the site of cultural enunciation, cultural signs spoken at the margins of social identity and antagonism – if we do not briefly explore the paradoxes of the language metaphor. In each of the illustrations I've provided, the language metaphor opens up a space where a theoretical disclosure is used to move beyond theory. A form of cultural experience and identity is envisaged in a theoretical description that does not set up a theory–practice polarity, nor does theory become 'prior' to the contingency of social experience. This 'beyond theory' is itself a liminal form of signification that creates a space for the contingent, indeterminate articulation of social 'experience' that is particularly important for

envisaging emergent cultural identities. But it is a representation of 'experience' without the transparent reality of empiricism and outside the intentional mastery of the 'author'. Nevertheless, it is a representation of social experience as the contingency of history – the indeterminacy that makes subversion and revision possible – that is profoundly concerned with questions of cultural 'authorization'.

To evoke this 'beyond theory', I turn to Roland Barthes's exploration of the cultural space 'outside the sentence'. In *The Pleasure of the Text* I find a subtle suggestion that beyond theory you do not simply encounter its opposition, theory/practice, but an 'outside' that places the articulation of the two – theory and practice, language and politics – in a productive relation similar to Derrida's notion of supplementarity:

> a non-dialectical middle, a structure of jointed predication, which cannot itself be comprehended by the predicates it distributes . . . Not that this ability . . . shows a lack of power; rather this inability is constitutive of the very possibility of the logic of identity.

Outside the sentence

Half-asleep on his banquette in a bar, of which Tangiers is the exemplary site, Barthes attempts to 'enumerate the stereophony of languages within earshot': music, conversations, chairs, glasses, Arabic, French. Suddenly the inner speech of the writer turns into the exorbitant space of the Moroccan souk:

> [T]hrough me passed words, syntagms, bits of formulae and no sentence formed, as though that were the law of such a language. This speech at once very cultural and very savage, was above all lexical, sporadic; it set up in me, through its apparent flow, a definitive discontinuity: this non-sentence was in no way something that could not have acceded to the sentence, that might have been before the sentence; it was: what is . . . *outside the sentence*.
>
> (Barthes 1975: 49)

At this point, Barthes writes, all linguistics that gives an exorbitant dignity to predicative syntax fell away. In its wake it becomes possible to subvert the 'power of completion which defines sentence mastery and marks, as with a supreme, dearly won, conquered *savoir faire*, the agents of the sentence'. The hierarchy and the subordinations of the sentence are replaced by the definitive discontinuity of the text, and what emerges is a form of writing that Barthes describes as 'writing aloud': 'a text of pulsional incidents, the language lined with flesh, a text where we can hear the grain of the throat . . . a whole carnal stereophony: the articulation of the tongue, not the meaning of language'(Barthes 1975: 66–7).

Why return to the semiotician's daydream? Why begin with 'theory' as story, as narrative and anecdote, rather than with the history or method? Beginning with the semiotic project – enumerating all the languages within earshot – evokes memories of the seminal influence of semiotics within our contemporary critical discourse.

To that end, this *petit récit* rehearses some of the major themes of contemporary theory prefigured in the practice of semiotics – the author as an enunciative space; the formation of textuality after the fall of linguistics; the agonism between the sentence of predicative syntax and the discontinuous subject of discourse; the disjunction between the lexical and the grammatical dramatized in the liberty (perhaps libertinism) of the signifier.

To encounter Barthes's daydream is to acknowledge the formative contribution of semiotics to those influential concepts – sign, text, limit text, idiolect, *écriture* – that have become all the more important since they have passed into the unconscious of our critical trade. When Barthes attempts to produce, with his suggestive, erratic brilliance, a space for the pleasure of the text somewhere between 'the political policeman and the psychoanalytical policeman' – that is, between 'futility and/or guilt, pleasure is either idle or vain, a class notion or an illusion' – he evokes memories of the attempts, in the late 1970s and mid-1980s, to hold fast the political line while the poetic line struggled to free itself from its post-Althusserian arrest. What guilt, what pleasure.

To thematize theory is, for the moment, beside the point. To reduce this weird and wonderful daydream of the semiotic pedagogue, somewhat in his cups, to just another repetition of the theoretical litany of the death of the author would be reductive in the extreme. For the daydream takes semiotics by surprise; it turns pedagogy into the exploration of its own limits. If you seek simply the sententious or the exegetical, you will not grasp the hybrid moment outside the sentence – not quite experience, not yet concept; part dream, part analysis; neither signifier nor signified. This intermediate space between theory and practice disrupts the disciplinary semiological demand to enumerate all the languages within earshot.

Barthes's daydream is supplementary, not alternative, to acting in the real world; Freud reminds us that the structure of fantasy narrates the subject of daydream as the articulation of incommensurable temporalities, disavowed wishes, and discontinuous scenarios. The meaning of fantasy does not emerge in the predicative or propositional value we might attach to being outside the sentence. Rather, the performative structure of the text reveals a temporality of discourse that I believe is significant. It opens up a narrative strategy for the emergence and negotiation of those agencies of the marginal, minority, subaltern, or diasporic that incite us to think through – and beyond – theory.

What is caught anecdotally 'outside the sentence', in Barthes's concept, is that problematic space – performative rather than experiential, non-sententious but no less theoretical – of which post-structuralist theory speaks in its many varied voices. In spite of the fall of a predictable, predicative linguistics, the space of the non-sentence is not a negative ontology: not *before* the sentence but something that *could have* acceded to the sentence and yet was *outside it*. This discourse is indeed one of indeterminism, unexpectability, one that is neither 'pure' contingency or negativity nor endless deferral. 'Outside the sentence' is not to be opposed to the inner voice; the non-sentence does not relate to the sentence as a polarity. The timeless capture that stages such epistemological 'confrontations', in Richard Rorty's term, is now interrupted and interrogated in the doubleness of writing – 'at once very cultural and very savage', 'as though that were the law of such a

language'. This disturbs what Derrida calls the occidental stereotomy, the onto-logical, circumscribing space between subject and object, inside and outside. It is the question of agency, as it emerges in relation to the indeterminate and the contingent, that I want to explore 'outside the sentence'. However, I want to preserve, at all times, that menacing sense in which the non-sentence is contiguous with the sentence, near but different, not simply its anarchic disruption.

Tangiers or Casablanca?

What we encounter outside the sentence, beyond the occidental stereotomy, is what I shall call the 'temporality' of Tangiers. It is a structure of temporality that will emerge only slowly and indirectly, as time goes by, as they say in Moroccan bars, whether in Tangiers or Casablanca. There is, however, an instruc-tive difference between Casablanca and Tangiers. In Casablanca the passage of time preserves the identity of language; the possibility of naming over time is fixed in the repetition:

> You must remember this
> a kiss is still a kiss
> a sigh is but a sigh
> the fundamental things apply
> As time goes by.
> (*Casablanca*)

'Play it again, Sam', which is perhaps the Western world's most celebrated demand for repetition, is still an invocation to similitude, a return to the eternal verities.

In Tangiers, as time goes by, it produces an iterative temporality that erases the occidental spaces of language – inside/outside, past/present, those founda-tionalist epistemological positions of Western empiricism and historicism. Tangiers opens up disjunctive, incommensurable relations of spacing and temporality *within* the sign – an 'internal difference of the so-called ultimate element (*stoikheion*, trait, letter, seminal mark)'. The non-sentence is not before (either as the past or a priori) or inside (either as depth or presence) but outside (both spatially and tempo-rally ex-centric, interruptive, in-between, on the borderlines, turning inside outside). In each of these inscriptions there is a doubling and a splitting of the temporal and spatial dimensions in the very act of signification. What emerges in this agonistic, ambivalent form of speech – 'at once very cultural and very savage' – is a question abut the subject of discourse and the agency of the letter: can there be a social subject of the 'non-sentence'? Is it possible to conceive of historical agency in that disjunctive, indeterminate moment of discourse outside the sentence? Is the whole thing no more than a theoretical fantasy that reduces any form of political critique to a daydream?

These apprehensions about the agency of the aporetic and the ambivalent become more acute when political claims are made for their strategic action. This is precisely Terry Eagleton's position, in his critique of the libertarian pessimism of poststructuralism:

> [It is] libertarian because something of the old model of expression/
> repression lingers on in the dream of an entirely free-floating signifier,
> an infinite textual productivity, an existence blessedly free from the
> shackles of truth, meaning and sociality. Pessimistic, because whatever
> blocks such creativity – law, meaning, power, closure – is acknowl-
> edged to be built into it, in a sceptical recognition of the imbrication
> of authority and desire.
>
> (Eagleton 1991: 38)

The agency implicit in this discourse is objectified in a structure of the nego-
tiation of meaning that is not a free-floating time lack but a *time-lag* – a contingent
moment – in the signification of closure. Tangiers, the 'sign' of the 'non-sentence'
turns retroactively, at the end of Barthes's essay, into a form of discourse that he
names 'writing aloud'. The time-lag between the event of the sign (Tangiers) and
its discursive eventuality (writing aloud) exemplifies a process where intentionality
is negotiated retrospectively. The sign finds its closure retroactively in a discourse
that it anticipates in the semiotic fantasy: there is a contiguity, a coextensivity,
between Tangiers (as sign) and writing aloud (discursive formation), in that writing
aloud is the mode of inscription of which Tangiers is a sign. There is no strict
causality between Tangiers as the beginning of predication and writing aloud as
the end or closure; but there is no free-floating signifier or an infinity of textual
productivity. There is the more complex possibility of negotiating meaning and
agency through the time-lag in-between the sign (Tangiers) and its initiation of a
disclosure or narrative, where the relation of theory to practice is part of what
Rodolphe Gasché termed 'jointed predication'. In this sense, closure comes to be
effected in the contingent moment of repetition, 'an overlap without equivalence:
fort:da'.

The temporality of Tangiers is a lesson in reading the agency of the social text
as ambivalent and catachrestic. Gayatri Spivak has usefully described the 'negoti-
ation' of the postcolonial position 'in terms of reversing, displacing and seizing the
apparatus of value-coding', constituting a catachrestic space: words or concepts
wrested from their proper meaning, 'a concept-metaphor without an adequate
referent' that perverts its embedded context. Spivak continues, 'Claiming
catachresis from a space that one cannot not want to inhabit [the sentence, senten-
tious], yet must criticize [from outside the sentence] is then, the deconstructive
predicament of the postcolonial.'

This Derridean position is close to the conceptual predicament outside the
sentence. I have attempted to provide the discursive temporality, or time-lag,
which is crucial to the process by which this turning around – of tropes, ideolo-
gies, concept metaphors – comes to be textualized and specified in postcolonial
agency: the moment when the 'bar' of the occidental stereotomy is turned into
the coextensive, contingent boundaries of relocation and reinscription: the catachr-
estic gesture. The insistent issue in any such move is the nature of the negotiatory
agent realized through the time-lag. How does agency come to be specified and
individuated, outside the discourses of individualism? How does the time-lag signify
individuation as a position that is an effect of the 'intersubjective': contiguous with
the social and yet contingent, indeterminate, in relation to it?

Writing aloud, for Barthes, is neither the 'expressive' function of language as authorial intention or generic determination nor meaning personified. It is similar to the *actio* repressed by classical rhetoric, and it is the 'corporeal exteriorization of discourse'. It is the art of guiding one's body into discourse, in such a way that the subject's accession to, and erasure in, the signifier as individuated is paradoxically accompanied by its remainder, an afterbirth, a double. Its noise – 'crackle, grate, cut' – makes vocal and visible, across the flow of the sentence's communicative code, the struggle involved in the insertion of agency – wound and bow, death and life – into discourse.

In Lacanian terms, which are appropriate here, this 'noise' is the 'leftover' after the *capitonnage*, or positioning, of the signifier for the subject. The Lacanian 'voice' that speaks outside the sentence is itself the voice of an interrogative, calculative agency: '*Che vuoi?* You are telling me that, but what do you want with it, what are you aiming at?' (For a clear explanation of this process, see Zizek, *The Sublime Object of Ideology* [1986].) What speaks in the place of this question, Jacques Lacan writes, is a 'third locus which is neither my speech nor my interlocutor' (Lacan 1977b: 173).

The time-lag opens up this negotiatory space between putting the question to the subject and the subject's repetition 'around' the neither/nor of the third locus. This constitutes the return of the subject agent, as the interrogative agency in the catachrestic position. Such a disjunctive space of temporality is the locus of symbolic identification that structures the intersubjective realm – the realm of otherness and the social – where 'we identify ourselves with the other precisely at a point at which he is inimitable, at the point which eludes resemblance'. My contention, elaborated in my writings on postcolonial discourse in terms of mimicry, hybridity, sly civility, is that this liminal moment of identification – eluding resemblance – produces a subversive strategy of subaltern agency that negotiates its own authority through a process of iterative 'unpicking' and incommensurable, insurgent relinking. It singularizes the 'totality' of authority by suggesting that agency requires a grounding, but it does not require a totalization of those grounds; it requires movement and manoeuvre, but it does not require a temporality of continuity or accumulation; it requires direction and contingent closure but no teleology and holism.

The individuation of the agent occurs in a moment of displacement. It is a pulsional incident, the split-second movement when the process of the subject's designation – its fixity – opens up beside it, uncannily *abseits*, a supplementary space of contingency. In this 'return' of the subject, thrown back across the distance of the signified, outside the sentence, the agent emerges as a form of retroactivity. It is not agency as itself (transcendent, transparent) or in itself (unitary, organic, autonomous). As a result of its own splitting in the time-lag of signification, the moment of the subject's individuation emerges as an effect of the intersubjective – as the return of the subject as agent. This means that those elements of social 'consciousness' imperative for agency – deliberative, individuated action and specificity in analysis – can now be thought outside that epistemology that insists on the subject as always prior to the social or on the knowledge of the social as necessarily subsuming or sublating the particular 'difference' in the transcendent homogeneity of the general. The iterative and contingent

that marks this intersubjective relation can never be libertarian or free-floating, as Eagleton claims, because the agent, constituted in the subject's return, is in the dialogic position of calculation, negotiation, interrogation: *Che vuoi?*

Agent without a cause?

Something of this genealogy of postcolonial agency has already been encountered in my expositions of the ambivalent and the multivalent in the language metaphor at work in West's 'synechdochical thinking' about black American cultural hybridity and Hall's notion of 'politics like a language'. The implications of this line of thinking were productively realized in the work of Spillers, Baker, Gates and Gilroy, all of whom emphasize the importance of the creative heterogeneity of the enunciatory 'present' that liberates the discourse of emancipation from binary closures. I want to give contingency another turn – through the Barthesian fantasy – by throwing the last line of the text, its conclusion, together with an earlier moment when Barthes speaks suggestively of closure as agency. Once again, we have an overlap without equivalence. For the notion of a non-teleological and a non-dialectical form of closure has often been considered the most problematic issue for the postmodern agent without a cause:

> [Writing aloud] succeed[s] in shifting the signified a great distance and in throwing, so to speak, the anonymous body of the actor into my ear. . . . And this body of bliss is also *my historical subject*; for it is at the *conclusion* of a very complex process of biographical, historical, sociological, neurotic elements . . . that I control the contradictory interplay of [cultural] pleasure and [non-cultural] bliss that I write myself as a subject at present out of place.
>
> (Barthes 1975: 62, 67)

The contingency of the subject as agent is articulated in a double dimension, a dramatic action. The signified is distanced; the resulting time-lag opens up the space between the lexical and the grammatical, between enunciation and enounced, in-between the anchoring of signifiers. Then, suddenly, this in-between spatial dimension, this distancing, converts itself into the temporality of the 'throw' that iteratively (re)turns the subject as a moment of conclusion and control: a histori-cally or contextually specific subject. How are we to think the control or conclusion in the context of contingency?

We need, not surprisingly, to invoke both meanings of *contingency* and then to repeat the difference of the one in the other. Recall my suggestion that to inter-rupt the occidental stereotomy – inside/outside, space/time – one needs to think, outside the sentence, at once very cultural and very savage. The contingent is contiguity, metonymy, the touching of spatial boundaries at a tangent, and, at the same time, the contingent is the temporality of the indeterminate and the unde-cidable. It is the kinetic tension that holds this double determination together and apart within disclosure. They represent the repetition of the one in or as the other, in a structure of 'abyssal overlapping' (a Derridean term) which enables us to

conceive of strategic closure and control for the agent. Representing social contradiction or antagonism in this doubling discourse of contingency – where the spatial
dimension of contiguity is reiterated in the temporality of the indeterminate –
cannot be dismissed as the arcane practice of the undecidable or aporetic.

The importance of the problematic of contingency for historical discourse is
evident in Ranajit Guha's attempt to represent the specificity of rebel consciousness. Guha's argument reveals the need for such a double and disjunctive sense of
the contingent, although his own reading of the concept, in terms of the 'universal-
contingent' couple, is more Hegelian in its elaboration. Rebel consciousness is
inscribed in two major narratives. In bourgeois-nationalist historiography, it is seen
as 'pure spontaneity pitted against the will of the State as embodied in the Raj'.
The will of the rebels is either denied or subsumed in the individualized capacity
of their leaders, who frequently belong to the elite gentry. Radical historiography
failed to specify rebel consciousness because its continuist narrative ranged 'peasant
revolts as a succession of events ranged along a direct line of descent . . . as a
heritage'. In assimilating all moments of rebel consciousness to the 'highest moment
of the series – indeed to an Ideal Consciousness' – these historians 'are ill-equipped
to cope with contradictions which are indeed the stuff history is made of' (Guha
1983: 39).

Guha's elaborations of rebel contradiction as consciousness are strongly
suggestive of agency as the activity of the contingent. What I have described as
the return of the subject is present in his account of rebel consciousness as self-
alienated. My suggestion that the problematic of contingency strategically allows
for a spatial contiguity – solidarity, collectivite action – to be (re)articulated in
the moment of indeterminacy is, reading between the lines, very close to his
sense of the strategic alliances at work in the contradictory and hybrid sites, and
symbols, of peasant revolt. What historiography fails to grasp is indeed agency at
the point of the 'combination of sectarianism and militancy . . . [specifically] the
ambiguity of such phenomena'; causality as the 'time' of indeterminate articulation:
'the *swift* transformation of class struggle into communal strife and vice versa
in our countryside'; and ambivalence at the point of 'individuation' as an inter-
subjective affect:

> Blinded by the glare of a perfect and immaculate consciousness the
> historian sees nothing . . . but solidarity in rebel behaviour and fails
> to notice its Other, namely, betrayal . . . He underestimates the
> brakes put on [insurgency as a *generalized* movement] by localism and
> territoriality.
>
> (Guha 1983: 40)

Finally, as if to provide an emblem for my notion of agency in the apparatus of
contingency – its hybrid figuring of space and time – Guha, quoting Sunil Sen's
Agrarian Struggle in Bengal, beautifully describes the 'ambiguity of such phenomena'
as the hybridized signs and sites during the Tebhaga movement in Dinajpur:

> Muslim peasants [came] to the Kisan Sabha 'sometimes inscribing a
> hammer and a sickle on the Muslim League flag' and young maulavis

'[recited] melodious verses from the Koran' at village meetings 'as they condemned the jotedari system and the practice of charging high interest rates'.

(Guha 1983: 39)

The social text: Bakhtin and Arendt

The contingent conditions of agency also take us to the heart of Mikhail M. Bakhtin's important attempt, in speech genres, to designate the enunciative subject of heteroglossia and dialogism. As with Guha, my reading will be catechrestic: reading between the lines, taking neither him at his word nor me fully at mine. In focusing on how the chain of speech communication comes to be constituted, I deal with Bakhtin's attempt to individuate social agency as an after-effect of the intersubjective. My cross-hatched matrix of contingency – as spatial difference and temporal distance, to turn the terms somewhat – enables us to see how Bakhtin provides a knowledge of the transformation of social discourse while displacing the originating subject and the causal and continuist progress of discourse: 'The object, as it were, has already been articulated, disputed, elucidated and evaluated in various ways . . . The speaker is not the biblical Adam . . . as simplistic ideas about communication as a logical-psychological basis for the sentence suggest' (Bakhtin 1986: 93).

Bakhtin's use of the metaphor of the chain of communication picks up the sense of contingency as contiguity, while the question of the 'link' immediately raises the issue of contingency as the indeterminate. Bakhtin's displacement of the author as agent results from his acknowledgment of the 'complex, multiplanar' structure of the speech genre that exists in that kinetic tension in-between the two forces of contingency. The spatial boundaries of the object of utterance are contiguous in the assimilation of the other's speech; but the allusion to another's utterance produces a dialogical turn, a moment of indeterminacy in the act of 'addressivity' (Bakhtin's concept) that gives rise within the chain of speech communion to 'unmediated responsive reactions and dialogic reverberations'.

Although Bakhtin acknowledges this double movement in the chain of the utterance, there is a sense in which he disavows its effectivity at the point of the enunciation of discursive agency. He displaces this conceptual problem that concerns the performativity of the speech act – its enunciative modalities of time and space – to an empiricist acknowledgment of the 'area of human activity and everyday life to which the given utterance is related'. It is not that the social context does not localize the utterance; it is simply that the process of specification and individuation still needs to be elaborated within Bakhtin's theory, as the modality through which the speech genre comes to recognize the specific as a signifying limit, a discursive boundary.

There are moments when Bakhtin obliquely touches on the tense doubling of the contingent that I have described. When he talks of the 'dialogic overtones' that permeate the agency of utterance – 'many half-concealed or completely concealed words of others with varying degrees of foreignness' – his metaphors hint at the iterative intersubjective temporality in which the agency is realized 'outside' the author:

> [T]he utterance appears to be furrowed with distant and barely audible echoes of changes of speech subjects and dialogic overtones, greatly weakened utterance boundaries that are completely permeable to the author's expression. The utterance proves to be a very complex and multiplanar phenomenon if considered not in isolation and with respect to its author . . . but as a link in the chain of speech communication and with respect to other related utterances.
>
> (Bakhtin 1986: 93)

Through this landscape of echoes and ambivalent boundaries, framed in passing, furrowed horizons, the agent who is 'not Adam' but is, indeed, time-lagged, emerges into the social realm of discourse.

 Agency, as the return of the subject, as 'not Adam', has a more directly political history in Hannah Arendt's portrayal of the troubled narrative of social causality. According to Arendt the notorious uncertainty of all political matters arises from the fact that the disclosure of *who* – the agent as individuation – is contiguous with the *what* of the intersubjective realm. This contiguous relation between *who* and *what* cannot be transcended but must be accepted as a form of indeterminism and doubling. The *who* of agency bears no mimetic immediacy or adequacy of representation. It can be signified only outside the sentence in that sporadic, ambivalent temporality that inhabits the notorious unreliability of ancient oracles who 'neither reveal nor hide in words but give manifest signs'. The unreliability of signs introduces a perplexity in the social text:

> The perplexity is that in any series of events that together form a story with a unique meaning we can at best isolate the agent who set the whole process into motion; and although this agent frequently remains the subject, the 'hero' of the story, we can never point unequivocally to him as the author of its outcome.
>
> (Arendt 1958: 185)

 This is the structure of the intersubjective space between agents, what Arendt terms human 'inter-est'. It is this public sphere of language and action that must become at once the theatre and the screen for the manifestation of the capacities of human agency. Tangiers-like, the event and its eventuality are separated; the narrative time-lag makes the *who* and the *what* contingent, splitting them, so that the agent remains the subject, in suspension, outside the sentence. The agent who 'causes' the narrative becomes part of the interest, only because we cannot point unequivocally to that agent at the point of outcome. It is the contingency that constitutes individuation – in the return of the subject as agent – that protects the interest of the intersubjective realm.

 The contingency of closure socializes the agent as a collective 'effect' through the distancing of the author. Between the cause and its intentionality falls the shadow. Can we then unquestionably propose that a story has a unique meaning in the first place? To what end does the series of events tend if the author of the outcome is not unequivocally the author of the cause? Does it not suggest that agency arises in the return of the subject, from the interruption of the series

of events as a kind of interrogation and reinscription of before and after? Where the two touch is there not that kinetic tension between the contingent as the contiguous and the indeterminate? Is it not from there that agency speaks and acts: *Che vuoi?*

These questions are provoked by Arendt's brilliant suggestiveness, for her writing symptomatically performs the perplexities she evokes. Having brought close together the unique meaning and the causal agent, she says that the 'invisible actor' is an 'invention arising from a mental perplexity' corresponding to no real experience. It is this distancing of the signified, this anxious fantasm or simulacrum – in the place of the author – that, according to Arendt, indicates most clearly the political nature of history. The sign of the political is, moreover, not invested in 'the character of the story itself but only [in] the *mode* in which it came into existence'. So it is the realm of representation and the process of signification that constitutes the space of the political. What is temporal in the mode of existence of the political? Here Arendt resorts to a form of repetition to resolve the ambivalence of her argument. The 'reification' of the agent can only occur, she writes, through 'a kind of repetition, the imitation of mimesis, which according to Aristotle prevails in all arts but is actually appropriate to the drama'.

This repetition of the agent, reified in the liberal vision of togetherness, is quite different from my sense of the contingent agency for our postcolonial age. The reasons for this are not difficult to find. Arendt's belief in the revelatory qualities of Aristotelian mimesis are grounded in a notion of community, or the public sphere, that is largely consensual: 'where people are *with* others, and neither for nor against them – that is sheer human togetherness'. When people are passionately for or against one another, then human togetherness is lost as they deny the fullness of Aristotelian mimetic time. Arendt's form of social mimesis does not deal with social marginality as a product of the liberal state, which can, if articulated, reveal the limitations of its common sense (inter-est) of society from the perspective of minorities or the marginalized. Social violence is, for Arendt, the denial of the disclosure of agency, the point at which 'speech becomes "mere talk", simply one more means towards the end'.

My concern is with other articulations of human togetherness, as they are related to cultural difference and discrimination. For instance, human togetherness may come to represent the forces of hegemonic authority; or a solidarity founded in victimization and suffering may, implacably, sometimes violently, become bound against oppression; or a subaltern or minority agency may attempt to interrogate and rearticulate the 'inter-est' of society that marginalizes its interests. These discourses of cultural dissent and social antagonism cannot find their agents in Arendt's Aristotelian mimesis. In the process I've described as the return of the subject, there is an agency that seeks revision and reinscription: the attempt to renegotiate the third locus, the intersubjective realm. The repetition of the iterative, the activity of the time-lag, is not so much arbitrary as interruptive, a closure that is not conclusion but a liminal interrogation outside the sentence.

Revisions

The concept of reinscription and negotiation that I am elaborating must not be confused with the powers of 'redescription' that have become the hallmark of the liberal ironist or neo-pragmatist. I do not offer a critique of this influential non-foundationalist position here except to point to the obvious differences of approach. Rorty's conception of the representation of difference in social discourse is the consensual overlapping of 'final vocabularies' that allow imaginative identification with the other so long as certain words – 'kindness, decency, dignity' – are held in common. However, as he says, the liberal ironist can never elaborate an empowering strategy. Just how disempowering his views are for the non-Western other, how steeped in a Western ethnocentricism, is seen, appropriately for a non-foundationalist, in a footnote.

Rorty suggests that

> liberal society already contains the institutions for its own improvement [and that] Western social and political thought may have had the last conceptual revolution it needs in J. S. Mill's suggestion that governments should optimize the balance between leaving people's private lives alone and preventing suffering.
>
> (Rorty 1989: 92)

Appended to this is the footnote where liberal ironists suddenly lose their powers of redescription:

> This is not to say that the world has had the last political revolution it needs. It is hard to imagine the diminution of cruelty in countries like South Africa, Paraguay, and Albania without violent revolution . . . But in such countries raw courage (like that of the leaders of COSATU or the signers of Charta 77) is the relevant virtue, not the sort of reflective acumen which makes contributions to social theory.
>
> (Rorty 1989: 63)

This is where Rorty's conversation stops, but we must force the dialogue to acknowledge postcolonial perspective: 'Bourgeois culture hits its historical limit in colonialism', writes Guha sententiously, and, almost as if to speak 'outside the sentence', Veena Das reinscribes Guha's thought into the affective language of a metaphor and the body: 'Subaltern rebellions can only provide a night-time of love . . . Yet perhaps in capturing this defiance the historian has given us a means of constructing the objects of such power as *subjects.*'

In her excellent essay 'Subaltern as perspective', Das demands a historiography of the subaltern that displaces the paradigm of social action as defined primarily by rational action. She seeks a form of discourse where affective and iterative writing develops its own language. History as a writing that constructs the moment of defiance emerges in the 'magma of significations', for the 'representational closure which presents itself when we encounter thought in objectified forms is now ripped open. Instead we see this order interrogated'. In an argument that

demands an enunciative temporality remarkably close to my notion of the time-lag that circulates at the point of the sign's seizure or caesura of symbolic synchronicity, Das locates the moment of transgression in the splitting of the discursive present: a greater attention is required to locate transgressive agency in 'the splitting of the various types of speech produced into statements of referential truth in the indicative present' (Das 1989: 316).

This emphasis on the disjunctive present of utterance enables the historian to get away from defining subaltern consciousness as binary, as having positive or negative dimensions. It allows the articulation of subaltern agency to emerge as relocation and reinscription. In the seizure of the sign, as I've argued, there is neither dialectical sublation nor the empty signifier: there is a contestation of the given symbols of authority that shift the terrains of antagonism. The synchronicity in the social ordering of symbols is challenged within its own terms, but the grounds of engagement have been displaced in a supplementary movement that exceeds those terms. This is the historical movement of hybridity as camouflage, as a contesting, antagonistic agency functioning in the time-lag of sign or symbol, which is a space in-between the rules of engagement. It is this theoretical form of political agency I've attempted to develop that Das beautifully fleshes out in a historical argument:

> It is the nature of the conflict within which a caste or tribe is locked which may provide the characteristics of the historical moment; to assume that we may know a priori the mentalities of castes or communities is to take an essentialist perspective which the evidence produced in the very columns of *Subaltern Studies* would not support.
>
> (Das 1989: 320)

Is the contingent structure of agency not similar to what Frantz Fanon describes as the knowledge of the practice of action? Fanon argues that the primitive Manichaeanism of the settler – black and white, Arab and Christian – breaks down in the present of struggle for independence. Polarities come to be replaced with truths that are only partial, limited and unstable. Each 'local ebb of the tide reviews the political question from the standpoint of all political networks'. The leaders should stand firmly against those within the movement who tend to think that 'shades of meaning constitute dangers and drive wedges into the solid block of popular opinion.' What Das and Fanon both describe is the potentiality of agency constituted through the strategic use of historical contingency.

David Forgacs

NATIONAL-POPULAR
Genealogy of a concept

EDITOR'S INTRODUCTION

THIS ESSAY DESCRIBES SOME IDEAS first formulated by Antonio Gramsci, the Italian Marxist, when he was imprisoned by Mussolini's fascist government. Unlike most other essays in this collection, it is mainly intended to offer an interpretation of an important past theorist. But it is an appropriate essay for a cultural studies reader because Gramsci has been the thinker that the Birmingham school, in its immediate post-Hoggart/Williams phase, turned to most often. As David Forgacs notes, his ideas remain important because they help us think about the emergence of a popular new right. The reason for this is not that the new right is an equivalent to fascism but that alternatives to the new right are as dispersed and fragmented as they were to fascism. In this situation, "educative alliances" which call upon minority and "subaltern" (but *not* "unpopular") cultural values and discourses rather than monocultural and scientific/expert values and skills have real potential. It is these alliances which constitute the "national popular."

Gramsci, unlike Louis Althusser, thought about culture and power more than ideology and science. David Forgacs describes the conditions in Italy that made this possible – in particular the absence of a national culture and language. Again these historical conditions are especially worth recalling because they anticipate the multicultural condition in which most post-industrial nation states now exist.

Further reading: Bhabha 1990; Gramsci 1971, 1978; D. Harris 1992; Holub 1992; Laclau 1977; Laclau and Mouffe 1985.

1

The term 'national-popular' is a relatively new addition to the conceptual luggage of the British left and, of concepts originating in the work of Gramsci, it has been one of the slowest to arrive here. Its presence in the late 1970s and 1980s can be partly explained, I believe, by the toughening of the political climate which has taken place in this period and by the weakening of the grip of Althusserian Marxism upon certain sectors of the new left. In the mid-1970s, the Gramsci being discussed was mediated through the filter of Althusser, whose writings became widely known in English during the same period (the early 1970s) and who had drawn on the Italian communist's work in several important respects. Yet the figure that emerged through this 'French connection' was one that was sanitized by Althusserian scientism. One paid this Gramsci due homage for having brought ideology from heaven to earth by incarnating it in material institutions and social practices and for having developed a non-economistic model for analysing conjunctures as asymmetrical relations of forces not reducible to a single all-englobing contradiction. But his 'absolute historicism', his collapsing together of philosophy, politics, religion and ideology, and his conception of Marxism as involving an intellectual and moral reformation were considered too embarrassingly primitive to be given serious attention by rigorous Marxist theoreticians. For as long as Althusserianism retained its cultural prestige as a kind of orthodoxy, the distinguishing wedge that Althusser and Poulantzas had driven between Gramsci's positive work of political analysis and his historicist Marxism remained operative and effectively served to suppress parts of his writings. The turn-about that is now taking place, by which these suppressed parts are coming to the fore, involves a reaction against the political impasse towards which Althusser's later formulations on ideology, science and the subject tend. For Althusser's radical anti-historicism and anti-humanism make problematical the moment of acquisition of mass revolutionary consciousness by implicitly polarizing on the one hand a mass of subjects-in-ideology and on the other the bearers of science, the intellectuals working in the van of the party. The moment of a liberatory mass action against oppression is thus radically deferred, taken off the agenda. Yet, at a time when the tough and flexible ideological resources of Thatcherism have proved capable of mobilizing a large popular base, the dangers of this kind of impasse become clear. Moreover, the late 1970s and early 1980s in Britain have seen a renewed spate of militancy among groups and social elements without a strict party or uniform class collocation – the women's movement, black people, lesbians and gay men, unemployed youth, students, nuclear disarmament, community pressure groups and so on – which the traditional left has been uncertain of how to relate to itself or to channel, and which have tended to jostle together in a relatively loose and uncoordinated way beneath or alongside the ideological umbrella of the Labour Party. It is these two things arrayed against one another – the new state formation and the heterogeneous oppositional forces – which produce the need for a concept like the national-popular.

2

In Italy, where published extracts of Gramsci's prison writings began circulating immediately after the end of the Second World War, the national-popular was treated largely as a *cultural* concept and associated with progressive realist forms in literature, cinema and the other arts, which the Italian Communist Party (PCI) began to back in the 1940s and 1950s. 'National-popular' became a sort of slogan for forms of art that were rooted both in the national tradition and in popular life, and as such it became identified with an artistic style or styles. In this form, the term was to become the symbolic target of stringent criticism in the 1960s from the Italian new left, who interpreted it as the cornerstone of a 'typically idealist operation' by which Gramsci had allegedly cast the intellectuals and their collective incarnation, the PCI, in the role of inheritors of nineteenth-century radical bourgeois culture. 'Gramsci's national-popular', a critic wrote, 'ends up . . . being the cage within which all attempts at renewal turn out to be constrained by the iron laws of tradition and the Italian social "status quo"'. The concept was seen as involving a double terminological slide – *national* replaced *international* and *popular* replaced *proletarian*. This in turn was symptomatic of a political elision of revolution into reformism, the parliamentary road and a form of political democracy based on broad class alliances: in short, the strategy of the PCI since the end of the war.

In Britain, the national-popular has been received and used as a *political* concept and identified with the notion of popular-democratic struggles without a specific class character which can be articulated in relation to the struggle of labour against capital. In this form, the concept has been involved in discussions of whether certain ideologies have a necessary class-belonging or whether an economistic perspective can be transcended and a broad ideological front theorized in its stead. It has also been involved in debate about how various forms of oppression are related to each other and to the class struggle, about whether the state in capitalist society is an instrument of bourgeois class rule or a site of class compromises with space for expansive democratization, and about how statist models of socialist struggle might be overcome by a broader theorization of struggle on several fronts in civil society and the state.

These two applications or interpretations of the national-popular concept make curious bedfellows. Although in each case practices of class alliance are involved, there is a substantial difference of emphasis: the first is cultural, the second political. How did this come about? And how is it that, in its cultural form, it was accused of being a conservative notion, inhibiting cultural change? I suggest that Gramsci's concept is in fact an integral one, whose cultural and political faces overlap and fuse; that not to understand this is to make only a partial reading and therefore to lay oneself open to a misreading of it (as the early, culturalist, reading was); and that the only way to reappropriate the concept in full is to make an excursus through Gramsci's writings, to see how the term emerges and the meanings it assumes within them. The present article is intended to do no more than provide the spade-work of textual reconstruction that will make this reappropriation possible.

3

It was in response to the conjuncture of ascendant fascism in Italy and the ebb-tide of revolution in the West that Gramsci began to elaborate the concept of the national-popular. The period was between 1924 and 1926. Within these two years leading up to his arrest, he returned from Moscow and Vienna, took over the leadership of the PCI from Amadeo Bordiga, and imposed a new strategic line on the party. This involved an implicit self-criticism of his own earlier 'work-erism', his concentration, in the period 1919–21, on the factory councils in northern industry as organs of workers' control and as political units of socialist democracy.

Gramsci identified in Italy a highly advanced, but very small, industrial prole-tariat concentrated in the north-west of the peninsula; a large but often ideologically backward peasantry, much of it located in the south and islands; a large stratum of petty-bourgeois intellectuals who exercised a degree of ideological control over the proletariat and peasantry and who, although themselves traditionally hegemo-nized by the bourgeoisie, tended to waver in the way they identified their class interest. By the time Gramsci launched his turn against Bordiga's leadership, fascism had installed itself in power by a class alliance between the northern industrial bourgeoisie and the large landowners with the crucial support of the petty bour-geoisie. Although it had not yet outlawed the PCI and other opposition parties, it had been conducting systematic repression of Communist activities and arresting Communist personnel. On Gramsci's reckoning, a political strategy based exclusively on the proletariat led by a vanguard party in isolation from other social forces was quite inadequate as a strategy to defeat fascism. It was necessary, rather, to construct a class alliance between three principal groups – the northern proletariat, the southern peasantry and the petty-bourgeois intelligentsia – under the hegemony of the proletariat, in order not only to provide a mass base for political action but also to prise open the interstices of the north–south industrial–landowner alliance.

For Gramsci, an immediate transition from fascism to socialism was improb-able, not least because 'the existing armed forces, given their composition, cannot at once be won over' (Gramsci 1978: 406). An interlude was therefore necessary in which the liberal-democratic political structures were restored to power. It is thus in a context of a disarticulation and ideological disintegration of consent for fascism, a context in which, nevertheless, direct seizure of power is ruled out because 'the state apparatus is far more resistant than is often possible to believe' (Gramsci 1978: 409), that Gramsci puts forward the concept of the national-popular in an embryonic, tactical form:

> For all the capitalist countries a fundamental problem is posed – the problem of the transition from the united front tactic, understood in a general sense, to a specific tactic which confronts the concrete prob-lems of national life and operates on the basis of the popular forces as they are historically determined.
>
> (Gramsci 1978: 410)

In the prison notebooks, written between 1929 and 1935, the national-popular concept is closely bound up with that of Jacobinism, which in Gramsci means a form of political domination based on the ability to overcome a narrow economic-corporate conception of a class or class-fraction and form *expansive*, *universalizing* alliances with other classes and class-fractions whose interests can be made to be seen as coinciding with those of the hegemonic class. Hegemony, in turn, differs from Lenin's conception of proletarian dictatorship because it involves ideological and not just political domination – in other words a coming to conscious-ness of a coincidence of interests. Only by breaking with an economistic correlation between ideology and class was Gramsci able to think this expansion of the concept of hegemony. Only one of the two fundamental classes – bourgeoisie and proletariat – can, however, be hegemonic. In the French Revolution, the radical bourgeoisie became hegemonic in the phase of Jacobin domination by universalizing and expanding its class interests to incorporate those of the urban artisans and the peasantry. The same process must be repeated in Italy, for Gramsci, by the proletariat in a socialist revolution. The class must secure hege-mony over the peasants and the other intermediate social strata by making them conscious of a shared interest. Hegemony is thus a process of radiating out from the Communist Party and the working class a *collective will* which is national-popular:

> Any formation of a national-popular collective will is impossible, unless the great mass of peasant farmers bursts *simultaneously* into political life. That was Machiavelli's intention through the reform of the militia, and it was achieved by the Jacobins in the French Revolution . . . All history from 1815 onwards shows the efforts of the traditional classes to prevent the formation of a collective will of this kind, and to main-tain 'economic-corporate' power in an international system of passive equilibrium.
>
> (Gramsci 1971: 132)

In his notes on the Risorgimento, Gramsci observed how the democratic repub-lican leaders around Mazzini and the Action Party failed to generalize their struggle beyond the radical bourgeoisie and win the support of the peasantry. They were thus subsumed and defeated by the Moderates under Cavour, who were able to construct a hegemonic alliance of the bourgeoisie with the southern landowners, an alliance whose continuation was secured in the state through transformism (*ad hoc* ministerial coalitions) and by the economic subjection of the South to the North in a colonial relationship offset for the big landowners by protectionist poli-cies. This 'chapter of past history' bears on the concrete relations of force in the 1920s and 1930s because of its historical parallel with the PCI at the time of the rise to power of fascism. This party too had failed to become hegemonic because of its inability to carry out the Jacobin task of linking countryside to city – peasantry to proletariat, south to north – to form a national-popular collective will. In its place, the Fascist Party had carried out a reform-revolution or passive revolution, based on the defensive, transformist alliance of the industrial bourgeoisie, big landowners and petty bourgeoisie, which involved no fundamental reorganization

of the economic structure – only its technical modernization along rational 'Fordist' lines – coupled with an increase in state coercion and the securing of mass popular consent in civil society.

At a political level, then, there are four points to be noted about the national-popular concept. It was elaborated in response to fascism, a conservative social bloc made up of heterogeneous economic groups with a permanently mobilized mass base, possessing organizational reserves (military, ideological) which rule out a frontal attack (war of manoeuvre) and favour a construction of hegemony (war of position) as the correct strategy to defeat it. It was dependent on the relative numerical weakness of the Italian proletariat. It involved the formation of a collective will through the building of a mass party, where a number of social classes and class-fractions are successfully hegemonized by the party and the proletariat. It was conceived of as a transitional stage leading to the dictatorship of the proletariat, to socialist democracy (soviets) as opposed to bourgeois democracy (parliament). These concepts underwent no substantial modification at a political level, as a strategic perspective, between the period in which they were first formulated (1924–6) and the time of Gramsci's death in 1937. They were, however, qualitatively deepened by being developed in cultural and ideological terms.

4

The entry in the prison notebooks headed 'Concept of national-popular' has no overtly political content. It discusses, instead, the problem of why Italian literature did not, with a few exceptions, have a wide popular readership in Italy and why Italian newspapers, which since the late nineteenth century had adopted the practice of serializing fiction to increase circulation, were publishing predominantly French and not Italian authors. Gramsci's answer is that in Italy

> neither a popular artistic literature nor a local production of 'popular' literature exists because 'writers' and 'people' do not have the same conception of the world. In other words the feelings of the people are not lived by the writers as their own, nor do the writers have a 'national educative' function: they have not and do not set themselves the problem of elaborating popular feelings after having relived them and made them their own.
>
> (Gramsci 1985: 206–7)

Italian readers therefore turn to French writers, who had this national function, because in France there existed a 'close and dependent relationship between people-nation and intellectuals' which Italian readers feel.

In several notes containing the phrase 'national-popular' (or 'popular-national', 'people-nation', 'nation-people') one finds this theme of the separation between intellectuals and the people in Italy (which is often, as here, contrasted with France). This separation was traditional both in that it went back a long way into Italian history and in that it had been traditionally remarked upon, notably in the Risorgimento where it had become a leitmotif among democratic intellectuals

(Mazzini, De Sanctis and so forth) who had seen the Renaissance as producing a cleavage between culture and the people, between knowledge and popular life. In fact, much of what Gramsci writes about the national-popular is a materialist recasting of these abstract and idealist formulations by a re-reading of Italian cultural history.

In a long discussion of the Renaissance in notebook 5, he traces the dualism back to a separation, occurring in the fourteenth and fifteenth centuries, of a literary and philosophical elite from the commercial, manufacturing and financial bourgeoisie. The latter had acquired political domination in the period of the Communes (from the twelfth to the fourteenth century) but had been unable to consolidate it because it had failed to go beyond its economic-corporate limits and become hegemonic as a class. The return at a cultural level to classicism – humanism – was therefore a restoration which

> like every restoration . . . assimilated and developed, better than the revolutionary class it had politically suffocated, the ideological principles of the defeated class, which had not been able to go beyond its corporate limits and create the superstructures of an integral society. Except that this development was 'abstract', it remained the patrimony of an intellectual caste and had no contact with the people-nation.
>
> (Gramsci 1985: 234)

Humanism and the Renaissance in Italy were thus 'the phenomenon of an aristocracy removed from the people-nation'. Whereas in the other European countries the exported Renaissance produced a progressive scientific intelligentsia which played a crucial role in the formation of the modern national states, in Italy itself it led to the involutionary Counter-Reformation and the ideological triumph of the Catholic intellectual hierarchy. This outcome was itself linked to two factors to which Gramsci's analysis assigns great importance. The first was the fact that Italy had been the centre of the Roman Empire and then, by 'translation', of the Catholic church, both of which exercised their power through cosmopolitan (international) intellectual castes. The second was the failure of a common national vernacular to develop in the peninsula, where instead two culturally prestigious written cosmopolitan languages (first Latin and then, after the sixteenth century, literary Tuscan) had dominated over a large number of less prestigious spoken dialects. The political disunity of Italy, of which Machiavelli complained in *The Prince*, was compounded by these factors. In the sixteenth century, the Papacy blocked the Protestant Reformation and with it the possibility of forming a modern national state. In the nineteenth century, it again constituted a major obstacle to national unification by its anti-liberalism and by jealously guarding its temporal power over central Italy. At the same time, the regional and cultural heterogeneity of the peninsula could be read off from the multiplicity of dialects, which acted as a practical obstacle to the diffusion of any national culture. The Italian nation had thus been more a rhetorical or legal entity than a felt cultural reality, existing at most for the intellectual and ruling elites but not for the masses. 'Nation' and 'people' did not coincide in Italian history:

One should note that in many languages 'national' and 'popular' are either synonymous or nearly so (they are in Russian, in German, where *völkisch* has an even more intimate meaning of race, and in the Slavonic languages in general; in France the meaning of 'national' already includes a more politically elaborated notion of 'popular' because it is related to the concept of 'sovereignty': national sovereignty and popular sovereignty have, or had, the same value). In Italy, the term 'national' has an ideologically very restricted meaning, and does not in any case coincide with 'popular' because in Italy the intellectuals are distant from the people, i.e. from the 'nation'. They are tied instead to a caste tradition that has never been broken by a strong popular or national political movement from below.

(Gramsci 1985: 208)

What is the aim of these meanderings through Italian history and culture, meanderings that make up a substantial proportion of the prison notes as a whole? The answer is that they flow into Gramsci's *political* project. They are readings of Italian cultural history undertaken in order to understand the structural reasons for the lack of any organic national-popular movement in the past and thus in order to work out the preconditions for such a movement in the present. 'Culture' in Gramsci is the sphere in which ideologies are diffused and organized, in which hegemony is constructed and can be broken and reconstructed. An essential part of the process by which the party builds the apparatuses of its social power is the molecular diffusion of a new humanism, an intellectual and moral reformation – in other words a new ideology, a new common sense based on historical materialism. A popular reformation of this kind is what has been lacking in Italian history, and Gramsci's notes on the national-popular reveal the extent to which the cosmopolitan traditions of the Italian intellectuals had impeded the molecular ideological activity by which such a reformation could be brought about:

> The lay forces have failed in their historical task as educators and elaborators of the intellect and the moral awareness of the people-nation. They have been incapable of satisfying the intellectual needs of the people precisely because they have failed to represent a lay culture, because they have not known how to elaborate a modern 'humanism' able to reach right to the simplest and most uneducated classes, as was necessary from the national point of view, and because they have been tied to an antiquated world, narrow, abstract, too individualistic or caste-like.
>
> (Gramsci 1985: 211)

When the prison notebooks were first published in Italy between 1948 and 1951, there was much talk on the left there about a 'national-popular culture' and the need for the intellectuals to contribute to the production of such a culture. As I have mentioned, this culture was identified with realism, and thus the national-popular slogan was neatly inserted into the discussions on socialist realism and progressive or critical bourgeois realism that were common currency among left

literary circles around that period. Yet, though Gramsci's prison notes on litera-
ture certainly reveal that his own personal tastes ran to progressive realism, such
as the nineteenth-century Russian novel, and that he tended to see modernist
writing as intellectualistic, coterie art, it was a fundamental misappropriation of
the national-popular concept to identify it with a particular type of art in this way.
When Gramsci wrote that the model of national-popular literature was constituted
by the Greek tragedians, Shakespeare and the great Russian novelists, he did not
mean that an Italian national-popular literature would have to resemble those kinds
of text. 'National-popular' designates not a cultural content but, as we have seen,
the possibility of an alliance of interests and feelings between different social agents
which varies according to the structure of each national society. A future Italian
national-popular literature, which will result from a socialist transformation
of society in which the working class creates it own organic intellectuals, cannot
therefore resemble the national-popular literature that developed in the era of
bourgeois revolutions elsewhere in Europe. It has clearly been one of the hardest
points for Gramsci's interpreters to grasp that he cannot specify the content of a
national-popular culture that has not yet formed, but only the social preconditions
of its formation. It is, as he points out, an idealist error to think that a national-
popular culture will resemble any hitherto existing cultural style, because those
past styles have all been the product of social formations in which culture has been
stratified into high and low and dominated by specialist intellectuals without organic
links with the broad popular masses. 'Popular culture' has thus been constructed
as the culture of the dominated classes in antithesis to 'artistic culture', a division
that is perpetuated and reproduced daily by capitalist control of the organs of
both high and popular culture. The theoretical break Gramsci made with his
contemporaries in Marxist cultural theory was to think of a whole culture formation
or cultural space as a unity in which to intervene. As he points out, discussing the
question of how to create a new literature:

> The most common prejudice is this: that the new literature should be
> identified with an artistic school of intellectual origins, as was the case
> with Futurism. The premiss of the new literature cannot but be histori-
> cal, political and popular: it must work towards the elaboration of
> what already exists, whether polemically or in other ways does not
> matter. What matters is that it sink its roots in the humus of popular
> culture as it is, with its tastes and tendencies and with its moral and
> intellectual world, even if it is backward and conventional.
>
> (Gramsci 1985: 102)

The formation of a national-popular culture in Italy would mean confronting
and overcoming the same obstacles (dialects, folklore, local particularisms) as the
formation of a national language. Because of this, what Gramsci says about language
gives us the clearest example of how he conceptualized cultural change as a whole.
In the prison notebooks, parallels are implicitly established between a series of
dominant–subordinate couplings: language–dialects, philosophy–common sense
(or folklore), high culture–popular culture, intellectuals–people, party–masses.
The point in each case is not to impose the former on the latter but to construct

an educative alliance between them ('Every relationship of "hegemony" is necessarily an educational relationship') so that one establishes an 'organic unity between theory and practice, between intellectual strata and popular masses, between rulers and ruled' which constitutes democratic centralism. The spreading of a national language is the paradigm for all these other relationships:

> Since the process of formation, spread and development of a unified national language occurs through a whole complex of molecular processes, it helps to be aware of the entire process as a whole in order to be able to intervene actively in it with the best possible results. One need not consider this intervention as 'decisive' and imagine that the ends proposed will all be reached in detail, i.e. that one will obtain a *specific* unified language. One will obtain *a unified language*, if it is a necessity, and the organized intervention will speed up the already existing processes. What this language will be, one cannot foresee or establish: in any case, if the intervention is 'rational', it will be organically tied to tradition, and this is of no small importance in the economy of culture.
>
> (Gramsci 1971: 350)

As well as being a paradigm for the other hegemonic relationships, language is also their social medium. Thus what Gramsci is talking about here is a process of constructing ideological hegemony among a wide range of social strata. Just as, at present, 'the national-popular mass is excluded from learning the educated language, since the highest level of the ruling class, which traditionally speaks standard Italian passes it on from generation to generation', so the popular masses are excluded from high culture and '"official" conceptions of the world' and possess instead the unelaborated and unsystematic conceptions of folklore and common sense. Hence in order to be hegemonized, these strata must be addressed through a medium adapted to their different cultural positions. There will not, for instance, be a single party newspaper but a whole party press whose various organs can adapt their tone and content to different readerships.

5

With these cultural dimensions, then, the national-popular concept clearly developed beyond the immediate conjunctural considerations from which it had originated in 1924–6, where it was linked to the Comintern tactic of the united front with the socialists (1921–6), and beyond the political expedient of inter-class and inter-party alliances as a temporary anti-fascist strategy – the Popular Front line of 1935, to which it has often been reductively and polemically assimilated. It became a *historical* strategy, dependent both on the historic absence in Italy of a revolution from below, on a specifically Italian economic and social structure with special disequilibria (combining advanced and third world characteristics, for example) and also on the development of capitalist societies in the West generally, as Gramsci witnessed them being transformed by American forms of social and economic management and elaborating extensive ideological resistances.

Nor is it hard to see why, at a general level, the concept retains its validity. It recognizes the specificity of national conditions and traditions. It valorizes civil society as a key site of struggle. It emphasizes the role of ideological reorganization and struggle. It identifies struggles common to more than one social class, fraction or group which can be strategically linked together. It recognizes that different social elements can, and do, act in terms not only of economic or ideological self-interest but also in terms of shared interests. Yet it also leaves a number of problematical questions very much open. By what means does one initially win the consent of other forces and movements? How can what Gramsci called the economic-corporate interests of a class or social group then be transcended in a higher collective will? How can this will, once established, be secured and prevented from disintegrating back into competing sectoral interests? For Gramsci these problems were, after 1926, posed largely in theory, and they tended to be resolved in the notebooks within the formula of party centralism and the belief in the transitional nature of any form of interclassist alliance: in other words within a still essentially Leninist perspective of the single party and the replacement of parliament by soviets.

The crucial practical problem of the national-popular lies in this: that there is often a narrow distinction between class alliances that are effectively hegemonic for the working class, class alliances that are merely federative groupings around particular issues or at particular times (for instance elections), and class alliances that can be tipped the other way and reorganized under the hegemony of the bourgeoisie. The PCI in the 1944–8 period, after Gramsci's death (1937), not only conceded too much to its alliance partners in terms of the restoration of the old economic and political infrastructures and the maintenance of fascist personnel, notably in the police and militia. It also failed to radiate a collective will of a genuinely oppositional type into the rank and file at a time when the relations of forces were regrouping to the right, and it thus ended up excluded from the executive in 1947 and defeated at the polls in 1948.

That these practices were not simple realizations of Gramsci's theories but political choices overdetermined by all sorts of strategic choices need not be spelt out. Gramsci had not only stressed, as we saw, the essentially transitional nature of the constituent assembly under proletarian leadership but he had also emphasized that the assembly was to have been a site of struggle against 'all projects of peaceful reform, demonstrating to the Italian working class how the only possible solution in Italy resides in the proletarian revolution'. Nevertheless, the questions of when a class alliance contains or does not contain a collective will and of when it lays itself open to reorganization under bourgeois hegemony were posed starkly by the Italian Communists' practical development of Gramsci's theories. And they remain of great actuality in the West today.

Arjun Appadurai

DISJUNCTURE AND DIFFERENCE IN THE GLOBAL CULTURAL ECONOMY

EDITOR'S INTRODUCTION

DOES GLOBALIZATION MEAN THAT local cultures are becoming more homogeneous? Firmly answering "no" to the "homogenization thesis," Arjun Appadurai goes on to make a series of path-breaking and exhilarating suggestions which have reconfigured theories of postcolonialism, postmodernism, and globalization.

He argues that we need to let go the old oppositions like "global/local," "North/South," "metropolitan/non-metropolitan" which divided the world in two. We need to think rather of distinct flows or "scapes" which ceaselessly sweep through the globe carrying capital, information, images, people, ideas, technologies.

The content of these flows constantly mutates; their relation to one another is increasingly distant and antagonistic. As they pass through national boundaries, in each country they intensify the division between the nation (the country's cultural identity and unity) and the state (the country's public, governmental institutions).

Reading between the lines of this essay, I would suggest that for Appadurai this globe of scapes contains much more possibility than the old world of colonies and centers, and of nations firmly bound to states. His is a celebratory globalism.

The question is: how utopic is it? Who is losing out in this mobile new world of mutating, disjunct flows? Gayatri Spivak's essay in this volume is one place to look for an answer; Hamid Naficy also provides a case study which brings the new globalism closer to everyday life.

Further reading: During 1997; Ginsburg 1991; Jameson and Miyoshi 1998; Morley and Robins 1995; Virilio 1991a, 1991b.

The central problem of today's global interactions is the tension between cultural homogenization and cultural heterogenization. A vast array of empirical facts could be brought to bear on the side of the 'homogenization' argument, and much of it has come from the left end of the spectrum of media studies. Most often, the homogenization argument subspeciates into either an argument about Americanization or an argument about 'commoditization', and very often the two arguments are closely linked. What these arguments fail to consider is that at least as rapidly as forces from various metropolises are brought into new societies they tend to become indigenized in one or other way: this is true of music and housing styles as much as it is true of science and terrorism, spectacles and constitutions. The dynamics of such indigenization have just begun to be explored in a sophisticated manner, and much more needs to be done. But it is worth noticing that for the people of Irian Jaya, Indonesianization may be more worrisome than Americanization, as Japanization may be for Koreans, Indianization for Sri Lankans, Vietnamization for the Cambodians, Russianization for the people of Soviet Armenia and the Baltic Republics. Such a list of alternative fears to Americanization could be greatly expanded, but it is not a shapeless inventory: for polities of smaller scale, there is always a fear of cultural absorption by polities of larger scale, especially those that are nearby. One man's imagined community (Anderson 1991) is another man's political prison.

This scalar dynamic, which has widespread global manifestations, is also tied to the relationship between nations and states, to which I shall return later in this essay. For the moment let us note that the simplification of these many forces (and fears) of homogenization can also be exploited by nation states in relation to their own minorities, by posing global commoditization (or capitalism, or some other such external enemy) as more 'real' than the threat of its own hegemonic strategies.

The new global cultural economy has to be understood as a complex, overlapping, disjunctive order, which cannot any longer be understood in terms of existing centre–periphery models (even those that might account for multiple centers and peripheries). Nor is it susceptible to simple models of push and pull (in terms of migration theory) or of surpluses and deficits (as in traditional models of balance of trade), or of consumers and producers (as in most neo-Marxist theories of development). Even the most complex and flexible theories of global development which have come out of the Marxist tradition (Mandel 1978; Wallerstein 1974; Wolf 1982) are inadequately quirky, and they have not come to terms with what Lash and Urry (1987) have recently called 'disorganized capitalism'. The complexity of the current global economy has to do with certain fundamental disjunctures between economy, culture and politics which we have barely begun to theorize.

I propose that an elementary framework of exploring such disjunctures is to look at the relationship between five dimensions of global cultural flow which can be termed: first, ethnoscapes; second, mediascapes; third, technoscapes; fourth, finanscapes; and fifth, ideoscapes. I use terms with the common suffix scape to indicate first of all that these are not objectively given relations which look the same from every angle of vision, but rather that they are deeply perspectival constructs, inflected very much by the historical, linguistic and political

situatedness of different sorts of actors: nation states, multinationals, diasporic communities, as well as sub-national groupings and movements (whether religious, political or economic), and even intimate face-to-face groups, such as villages, neighborhoods and families. Indeed, the individual actor is the last locus of this perspectival set of landscapes, for these landscapes are eventually navigated by agents who both experience and constitute larger formations, in part by their own sense of what these landscapes offer. These landscapes thus, are the building blocks of what, extending Benedict Anderson, I would like to call 'imagined worlds', that is, the multiple worlds which are constituted by the historically situated imaginations of persons and groups spread around the globe. An important fact of the world we live in today is that many persons on the globe live in such imagined 'worlds' and not just in imagined communities, and thus are able to contest and sometimes even subvert the 'imagined worlds' of the official mind and of the entrepreneurial mentality that surround them. The suffix scape also allows us to point to the fluid, irregular shapes of these landscapes, shapes which characterize international capital as deeply as they do international clothing styles.

By 'ethnoscape', I mean the landscape of persons who constitute the shifting world in which we live: tourists, immigrants, refugees, exiles, guestworkers and other moving groups and persons constitute an essential feature of the world, and appear to affect the politics of and between nations to a hitherto unprecedented degree. This is not to say that there are not anywhere relatively stable communities and networks, of kinship, of friendship, of work and of leisure, as well as of birth, residence and other filiative forms. But it is to say that the warp of these stabilities is everywhere shot through with the woof of human motion, as more persons and groups deal with the realities of having to move, or the fantasies of wanting to move. What is more, both these realities as well as these fantasies now function on larger scales, as men and women from villages in India think not just of moving to Poona or Madras, but of moving to Dubai and Houston, and refugees from Sri Lanka find themselves in South India as well as in Canada, just as the Hmong are driven to London as well as to Philadelphia. And as international capital shifts its needs, as production and technology generate different needs, as nation states shift their policies on refugee populations, these moving groups can never afford to let their imagination rest too long, even if they wished to.

By 'technoscape', I mean the global configuration, also ever fluid, of technology, and of the fact that technology, both high and low, both mechanical and informational, now moves at high speeds across various kinds of previously impervious boundaries. Many countries now are the roots of multinational enterprise: a huge steel complex in Libya may involve interests from India, China, Russia and Japan, providing different components of new technological configurations. The odd distribution of technologies, and thus the peculiarities of these technoscapes, are increasingly driven not by any obvious economies of scale, of political control, or of market rationality, but of increasingly complex relationships between money flows, political possibilities and the availability of both low- and highly skilled labor. So, while India exports waiters and chauffeurs to Dubai and Sharjah, it also exports software engineers to the United States (indentured briefly to Tata-Burroughs or the World Bank), then laundered through the State Department to become wealthy 'resident aliens', who are in turn objects of

seductive messages to invest their money and know-how in federal and state projects in India. The global economy can still be described in terms of traditional 'indicators' (as the World Bank continues to do) and studied in terms of traditional comparisons (as in Project Link at the University of Pennsylvania), but the complicated technoscapes (and the shifting ethnoscapes), which underlie these 'indicators' and 'comparisions' are further out of the reach of the 'queen of the social sciences' than ever before. How is one to make a meaningful comparison of wages in Japan and the United States, or of real estate costs in New York and Tokyo, without taking sophisticated account of the very complex fiscal and investment flows that link the two economies through a global grid of currency speculation and capital transfer?

Thus it is useful to speak as well of 'finanscapes', since the disposition of global capital is now a more mysterious, rapid and difficult landscape to follow than ever before, as currency markets, national stock exchanges, and commodity speculations move mega-money through national turnstiles at blinding speed, with vast absolute implications for small differences in percentage points and time units. But the critical point is that the global relationship between ethnoscapes, technoscapes and finanscapes is deeply disjunctive and profoundly unpredictable, since each of these landscapes is subject to its own constraints and incentives (some political, some informational and some techno-environmental), at the same time as each acts as a constraint and a parameter for movements in the other. Thus, even an elementary model of global political economy must take into account the shifting relationship between perspectives on human movement, technological flow and financial transfers, which can accommodate their deeply disjunctive relationships with one another.

Built upon these disjunctives (which hardly form a simple, mechanical global 'infrastructure' in any case) are what I have called 'mediascapes' and 'ideoscapes', though the latter two are closely related landscapes of images. 'Mediascapes' refer both to the distribution of the electronic capabilities to produce and disseminate information (newspapers, magazines, television stations, film production studios, etc.), which are now available to a growing number of private and public interests throughout the world; and to the images of the world created by these media. These images of the world involve many complicated inflections, depending on their mode (documentary or entertainment), their hardware (electronic or pre-electronic), their audiences (local, national or transnational) and the interests of those who own and control them. What is most important about these mediascapes is that they provide (especially in their television, film and cassette forms) large and complex repertoires of images, narratives and 'ethnoscapes' to viewers throughout the world, in which the world of commodities and the world of 'news' and politics are profoundly mixed. What this means is that many audiences throughout the world experience the media themselves as a complicated and interconnected repertoire of print, celluloid, electronic screens and billboards. The lines between the 'realistic' and the fictional landscapes they see are blurred, so that the further away these audiences are from the direct experiences of metropolitan life, the more likely they are to construct 'imagined worlds' which are chimerical, aesthetic, even fantastic objects, particularly if assessed by the criteria of some other perspective, some other 'imagined world'.

'Mediascapes', whether produced by private or state interests, tend to be image-centered, narrative-based accounts of strips of reality, and what they offer to those who experience and transform them is a series of elements (such as characters, plots and textual forms) out of which scripts can be formed of imagined lives, their own as well as those of others living in other places. These scripts can and do get disaggregated into complex sets of metaphors by which people live as they help to constitute narratives of the 'other' and proto-narratives of possible lives, fantasies which could become prologemena to the desire for acquisition and movement.

'Ideoscapes' are also concatenations of images, but they are often directly political and frequently have to do with the ideologies of states and the counter-ideologies of movements explicitly oriented to capturing state power or a piece of it. These ideoscapes are composed of elements of the Enlightenment world-view, which consists of a concatenation of ideas, terms and images, including 'freedom', 'welfare', 'rights', 'sovereignty', 'representation' and the master-term 'democracy'. The master-narrative of the Enlightenment (and its many variants in England, France and the United States) was constructed with a certain internal logic and presupposed a certain relationship between reading, representation and the public sphere (for the dynamics of this process in the early history of the United States, see Warner 1990). But their diaspora across the world, especially since the nineteenth century, has loosened the internal coherence which held these terms and images together in a Euro-American master-narrative, and provided instead a loosely structured synopticon of politics, in which different nation states, as part of their evolution, have organized their political cultures around different 'keywords'.

As a result of the differential diaspora of these keywords, the political narratives that govern communication between elites and followings in different parts of the world involve problems of both a semantic and a pragmatic nature: semantic to the extent that words (and their lexical equivalents) require careful translation from context to context in their global movements; and pragmatic to the extent that the use of these words by political actors and their audiences may be subject to very different sets of contextual conventions that mediate their translation into public politics. Such conventions are not only matters of the nature of political rhetoric (viz. what does the aging Chinese leadership mean when it refers to the dangers of hooliganism? What does the South Korean leadership mean when it speaks of 'discipline' as the key to democratic industrial growth?).

These conventions also involve the far more subtle question of what sets of communicative genres are valued in what way (newspapers versus cinema for example) and what sorts of pragmatic genre conventions govern the collective 'readings' of different kinds of text. So, while an Indian audience may be attentive to the resonances of a political speech in terms of some key words and phrases reminiscent of Hindi cinema, a Korean audience may respond to the subtle codings of Buddhist or neo-Confucian rhetorical strategy encoded in a political document. The very relationship of reading to hearing and seeing may vary in important ways that determine the morphology of these different 'ideoscapes' as they shape themselves in different national and transnational contexts. This globally variable synaesthesia has hardly even been noted, but it demands urgent analysis. Thus

'democracy' has clearly become a master-term, with powerful echoes from Haiti and Poland to the Soviet Union and China, but it sits at the center of a variety of ideoscapes (composed of distinctive pragmatic configurations of rough 'translations' of other central terms from the vocabulary of the Enlightenment). This creates ever new terminological kaleidoscopes, as states (and the groups that seek to capture them) seek to pacify populations whose own ethnoscapes are in motion, and whose mediascapes may create severe problems for the ideoscapes with which they are presented. The fluidity of ideoscapes is complicated in particular by the growing diasporas (both voluntary and involuntary) of intellectuals who continuously inject new meaning-streams into the discourse of democracy in different parts of the world.

This extended terminological discussion of the five terms I have coined sets the basis for a tentative formulation about the conditions under which current global flows occur: *they occur in and through the growing disjunctures between ethnoscapes, technoscapes, finanscapes, mediascapes and ideoscapes*. This formulation, the core of my model of global cultural flow, needs some explanation. First, people, machinery, money, images, and ideas now follow increasingly non-isomorphic paths: of course, at all periods in human history, there have been some disjunctures between the flows of these things, but the sheer speed, scale and volume of each of these flows is now so great that the disjunctures have become central to the politics of global culture. The Japanese are notoriously hospitable to ideas and are stereotyped as inclined to export (all) and import (some) goods, but they are also notoriously closed to immigration, like the Swiss, the Swedes and the Saudis. Yet the Swiss and Saudis accept populations of guestworkers, thus creating labor diasporas of Turks, Italians and other circum-Mediterranean groups. Some such guestworker groups maintain continuous contact with their home nations, like the Turks, but others, like high-level South Asian migrants, tend to desire lives in their new homes, raising anew the problem of reproduction in a deterritorialized context.

Deterritorialization, in general, is one of the central forces of the modern world, since it brings laboring populations into the lower-class sectors and spaces of relatively wealthy societies, while sometimes creating exaggerated and intensified senses of criticism or attachment to politics in the home state. Deterritorialization, whether of Hindus, Sikhs, Palestinians or Ukranians, is now at the core of a variety of global fundamentalisms, including Islamic and Hindu fundamentalism. In the Hindu case for example, it is clear that the overseas move-ment of Indians has been exploited by a variety of interests both within and outside India to create a complicated network of finances and religious identifications, in which the problems of cultural reproduction for Hindus abroad has become tied to the politics of Hindu fundamentalism at home.

At the same time, deterritorialization creates new markets for film compa-nies, art impresarios and travel agencies, who thrive on the need of the deterritorialized population for contact with its homeland. Naturally, these invented homelands, which constitute the mediascapes of deterritorialized groups, can often become sufficiently fantastic and one-sided that they provide the material for new ideoscapes in which ethnic conflicts can begin to erupt. The creation of 'Khalistan', an invented homeland of the deterritorialized Sikh population of England, Canada and the United States, is one example of the bloody potential in such mediascapes,

as they interact with the 'internal colonialisms' (Hechter 1974) of the nation state. The West Bank, Namibia and Eritrea are other theaters for the enactment of the bloody negotiation between existing nation states and various deterritorialized groupings.

The idea of deterritorialization may also be applied to money and finance, as money managers seek the best markets for their investments, independent of national boundaries. In turn, these movements of money are the basis of new kinds of conflict, as Los Angelenos worry about the Japanese buying up their city, and people in Bombay worry about the rich Arabs from the Gulf States who have not only transformed the prices of mangoes in Bombay, but have also substantially altered the profile of hotels, restaurants and other services in the eyes of the local population, just as they continue to do in London. Yet, most residents of Bombay are ambivalent about the Arab presence there, for the flip side of their presence is the absence of friends and kinsmen earning big money in the Middle East and bringing back both money and luxury commodities to Bombay and other cities in India. Such commodities transform consumer taste in these cities, and also often end up smuggled through air and sea ports and peddled in the gray markets of Bombay's streets. In these gray markets, some members of Bombay's middle classes and of its lumpenproletariat can buy some of these goods, ranging from cartons of Marlboro cigarettes to Old Spice shaving cream and tapes of Madonna. Similarly gray routes, often subsidized by the moonlighting activities of sailors, diplomats, and airline stewardesses who get to move in and out of the country regularly, keep the gray markets of Bombay, Madras and Calcutta filled with goods not only from the West but also from the Middle East, Hong Kong and Singapore.

It is this fertile ground of deterritorialization, in which money, commodities and persons are involved in ceaselessly chasing each other around the world, that the mediascapes and ideoscapes of the modern world find their fractured and fragmented counterpart. For the ideas and images produced by mass media often are only partial guides to the goods and experiences that deterritorialized populations transfer to one another. In Mira Nair's brilliant film, *India Cabaret*, we see the multiple loops of this fractured deterritorialization as young women, barely competent in Bombay's metropolitan glitz, come to seek their fortunes as cabaret dancers and prostitutes in Bombay, entertaining men in clubs with dance formats derived wholly from the prurient dance sequences of Hindi films. These scenes cater in turn to ideas about Western and foreign women and their 'looseness', while they provide tawdry career alibis for these women. Some of these women come from Kerala, where cabaret clubs and the pornographic film industry have blossomed, partly in response to the purses and tastes of Keralites returned from the Middle East, where their diasporic lives away from women distort their very sense of what the relations between men and women might be. These tragedies of displacement could certainly be replayed in a more detailed analysis of the relations between the Japanese and German sex tours to Thailand and the tragedies of the sex trade in Bangkok, and in other similar loops which tie together fantasies about the other, the conveniences and seductions of travel, the economics of global trade and the brutal mobility fantasies that dominate gender politics in many parts of Asia and the world at large.

While far more could be said about the cultural politics of deterritorialization and the larger sociology of displacement that it expresses, it is appropriate at this juncture to bring in the role of the nation state in the disjunctive global economy of culture today. The relationship between states and nations is everywhere an embattled one. It is possible to say that in many societies, the nation and the state have become one another's projects. That is, while nations (or more properly groups with ideas about nationhood) seek to capture or co-opt states and state power, states simultaneously seek to capture and monopolize ideas about nationhood. In general, separatist, transnational movements, including those which have included terror in their methods, exemplify nations in search of states: Sikhs, Tamil Sri Lankans, Basques, Moros, Québécois, each of these represent imagined communities which seek to create states of their own or carve pieces out of existing states. States, on the other hand, are everywhere seeking to monopolize the moral resources of community, either by flatly claiming perfect coevality between nation and state or by systematically museumizing and representing all the groups within them in a variety of heritage politics that seems remarkably uniform throughout the world. Here, national and international mediascapes are exploited by nation states to pacify separatists or even the potential fissiparousness of all ideas of difference. Typically, contemporary nation states do this by exercising taxonomical control over difference; by creating various kinds of international spectacle to domesticate difference; and by seducing small groups with the fantasy of self-display on some sort of global or cosmopolitan stage. One important new feature of global cultural politics, tied to the disjunctive relationships between the various landscapes discussed earlier, is that state and nation are at each other's throats, and the hyphen that links them is now less an icon of conjuncture than an index of disjuncture. This disjunctive relationship between nation and state has two levels: at the level of any given nation state, it means that there is a battle of the imagination, with state and nation seeking to cannibalize one another. Here is the seedbed of brutal separatisms, majoritarianisms that seem to have appeared from nowhere, and micro-identities that have become political projects within the nation state. At another level, this disjunctive relationship is deeply entangled with the global disjunctures discussed throughout this essay: ideas of nationhood appear to be steadily increasing in scale and regularly crossing existing state boundaries: sometimes, as with the Kurds, because previous identities stretched across vast national spaces, or, as with the Tamils in Sri Lanka, the dormant threads of a transnational diaspora have been activated to ignite the micro-politics of a nation state.

In discussing the cultural politics that have subverted the hyphen that links the nation to the state, it is especially important not to forget its mooring in the irregularities that now characterize 'disorganized capital' (Lash and Urry 1987). It is because labor, finance and technology are now so widely separated that the volatilities that underlie movements for nationhood (as large as transnational Islam on the one hand, or as small as the movement of the Gurkhas for a separate state in the north-east of India) grind against the vulnerabilities which characterize the relationships between states. States find themselves pressed to stay 'open' by the forces of media, technology, and travel which had fueled consumerism throughout the world and have increased the craving, even in the non-Western world, for new commodities and spectacles. On the other hand, these very cravings can become

caught up in new ethnoscapes, mediascapes, and eventually, ideoscapes, such as 'democracy' in China, that the state cannot tolerate as threats to its own control over ideas of nationhood and 'peoplehood'. States throughout the world are under siege, especially where contests over the ideoscapes of democracy are fierce and fundamental, and where there are radical disjunctures between ideoscapes and technoscapes (as in the case of very small countries that lack contemporary technologies of production and information); or between ideoscapes and finanscapes (as in countries, such as Mexico or Brazil, where international lending influences national politics to a very large degree); or between ideoscapes and ethnoscapes (as in Beirut, where diasporic, local and translocal filiations are suicidally at battle); or between ideoscapes and mediascapes (as in many countries in the Middle East and Asia) where the lifestyles represented on both national and international television and cinema completely overwhelm and undermine the rhetoric of national politics: in the Indian case, the myth of the law-breaking hero has emerged to mediate this naked struggle between the pieties and the realities of Indian politics, which has grown increasingly brutalized and corrupt.

The transnational movement of the martial arts, particularly through Asia, as mediated by the Hollywood and Hong Kong film industries, is a rich illustration of the ways in which longstanding martial arts traditions, reformulated to meet the fantasies of contemporary (sometimes lumpen) youth populations, create new cultures of masculinity and violence, which are in turn the fuel for increased violence in national and international politics. Such violence is in turn the spur to an increasingly rapid and amoral arms trade which penetrates the entire world. The worldwide spread of the AK-47 and the Uzi, in films, in corporate and state security, in terror, and in police and military activity, is a reminder that apparently simple technical uniformities often conceal an increasingly complex set of loops, linking images of violence to aspirations for community in some 'imagined world'.

Returning then to the 'ethnoscapes' with which I began, the central paradox of ethnic politics in today's world is that primordia (whether of language or skin color or neighborhood or kinship) have become globalized. That is, sentiments whose greatest force is in their ability to ignite intimacy into a political sentiment and turn locality into a staging ground for identity, have become spread over vast and irregular spaces, as groups move, yet stay linked to one another through sophisticated media capabilities. This is not to deny that such primordia are often the product of invented traditions (Hobsbawm and Ranger 1983) or retrospective affiliations but to emphasize that because of the disjunctive and unstable interplay of commerce, media, national politics and consumer fantasies, ethnicity, once a genie contained in the bottle of some sort of locality (however large) has now become a global force, forever slipping in and through the cracks between states and borders.

But the relationship between the cultural and economic levels of this new set of global disjunctures is not a simple one-way street in which the terms of global cultural politics are set wholly by, or confined wholly within, the vicissitudes of international flows of technology, labor and finance, demanding only a modest modification of existing neo-Marxist models of uneven development and state-formation. There is a deeper change, itself driven by the disjunctures between all

the landscapes I have discussed, and constituted by their continuously fluid and uncertain interplay, which concerns the relationship between production and consumption in today's global economy. Here I begin with Marx's famous (and often mined) view of the fetishism of the commodity, and suggest that this fetishism has been replaced in the world at large (now seeing the world as one, large, interactive system, composed of many complex subsystems) by two mutually supportive descendants, the first of which I call production fetishism, and the second of which I call the fetishism of the consumer.

By production fetishism I mean an illusion created by contemporary transnational production loci, which masks translocal capital, transnational earning-flows, global management and often faraway workers (engaged in various kinds of high-tech putting out operations) in the idiom and spectacle of local (sometimes even worker) control, national productivity and territorial sovereignty. To the extent that various kinds of free trade zone have become the models for production at large, especially of high-tech commodities, production has itself become a fetish, masking not social relations as such but the relations of production, which are increasingly transnational. The locality (both in the sense of the local factory or site of production and in the extended sense of the nation state) becomes a fetish which disguises the globally dispersed forces that actually drive the production process. This generates alienation (in Marx's sense) twice intensified, for its social sense is now compounded by a complicated spatial dynamic which is increasingly global.

As for the fetishism of the consumer, I mean to indicate here that the consumer has been transformed, through commodity flows (and the mediascapes, especially of advertising, that accompany them) into a sign, both in Baudrillard's sense of a simulacrum which only asymptotically approaches the form of a real social agent; and in the sense of a mask for the real seat of agency, which is not the consumer but the producer and the many forces that constitute production. Global advertising is the key technology for the worldwide dissemination of a plethora of creative, and culturally well-chosen, ideas of consumer agency. These images of agency are increasingly distortions of a world of merchandising so subtle that the consumer is consistently helped to believe that he or she is an actor, where in fact he or she is at best a chooser.

The globalization of culture is not the same as its homogenization, but globalization involves the use of a variety of instruments of homogenization (armaments, advertising techniques, language hegemonies, clothing styles and the like), which are absorbed into local political and cultural economies, only to be repatriated as heterogeneous dialogues of national sovereignty, free enterprise, fundamentalism etc. in which the state plays an increasingly delicate role: too much openness to global flows and the nation state is threatened by revolt – the China syndrome; too little, and the state exits the international stage, as Burma, Albania and North Korea in various ways have done. In general, the state has become the arbiter of this *repatriation of difference* (in the form of goods, signs, slogans, styles etc.) But this repatriation or export of the designs and commodities of difference continuously exacerbates the 'internal' politics of majoritarianism and homogenization, which is most frequently played out in debates over heritage.

Thus the central feature of global culture today is the politics of the mutual effect of sameness and difference to cannibalize one another and thus to proclaim

their successful hijacking of the twin Enlightenment ideas of the triumphantly universal and the resiliently particular. This mutual cannibalization shows its ugly face in riots, in refugee flows, in state-sponsored torture and in ethnocide (with or without state support). Its brighter side is in the expansion of many individual horizons of hope and fantasy, in the global spread of oral rehydration therapy and other low-tech instruments of well-being, in the susceptibility even of South Africa to the force of global opinion, in the inability of the Polish state to repress its own working classes, and in the growth of a wide range of progressive, transnational alliances. Examples of both sorts could be multiplied. The critical point is that both sides of the coin of global cultural process today are products of the infinitely varied mutual contest of sameness and difference on a stage characterized by radical disjunctures between different sorts of global flows and the uncertain landscapes created in and through these disjunctures.

Ethnicity and multiculturalism

bell hooks

A REVOLUTION OF VALUES
The promise of multicultural change

EDITOR'S INTRODUCTION

IN THIS ESSAY, WHICH BEGINS as reminiscence of her schooldays during the 1960s' black liberation struggles, bell hooks moves effortlessly from her experiences as a young woman dealing each day with the affronts of patriarchy and racism (affronts which white liberals are unable effectively to combat) to her current situation as a teacher and writer working on behalf of a cultural diversity which recognizes not just equality and difference – in a word, not just pluralism – but the continuing presence of exploitation and conflict.

It's an essay which explicitly draws sustenance from Martin Luther King's teachings. What makes it very relevant to contemporary cultural studies is that it provides not simply a confessional and self-analytical perspective which bears witness to experiences but also a practical will for change that cultural theory often assumes and, in assuming, obscures.

Further reading: Chambers 1994; Gilroy 1994; Goldberg 1994; Moraga and Anzaldúa 1981; P. Williams 1991.

Two summers ago I attended my twentieth high school reunion. It was a last-minute decision. I had just finished a new book. Whenever I finish a work, I always feel lost, as though a steady anchor has been taken away and there is no sure ground under my feet. During the time between ending one project and beginning another, I always have a crisis of meaning. I begin to wonder what my life is all about and what I have been put on this earth to do. It is as though immersed in a project I lose all sense of myself and must then, when the work is

done, rediscover who I am and where I am going. When I heard that the reunion was happening, it seemed just the experience to bring me back to myself, to help in the process of rediscovery. Never having attended any of the past reunions, I did not know what to expect. I did know that this one would be different. For the first time we were about to have a racially integrated reunion. In past years, reunions had always been segregated. White folks had their reunion on their side of town and black folks had a separate reunion.

None of us was sure what an integrated reunion would be like. Those periods in our adolescent lives of racial desegregation had been full of hostility, rage, conflict, and loss. We black kids had been angry that we had to leave our beloved all-black high school, Crispus Attucks, and be bussed halfway cross town to integrate white schools. We had to make the journey and thus bear the responsibility of making desegregation a reality. We had to give up the familiar and enter a world that seemed cold and strange, not our world, not our school. We were certainly on the margin, no longer at the center, and it hurt. It was such an unhappy time. I still remember my rage that we had to awaken an hour early so that we could be bussed to school before the white students arrived. We were made to sit in the gymnasium and wait. It was believed that this practice would prevent outbreaks of conflict and hostility since it removed the possibility of social contact before classes began. Yet, once again, the burden of this transition was placed on us. The white school was desegregated, but in the classroom, in the cafeteria and in most social spaces racial apartheid prevailed. Black and white students who considered ourselves progressive rebelled against the unspoken racial taboos meant to sustain white supremacy and racial apartheid even in the face of desegregation. The white folks never seemed to understand that our parents were no more eager for us to socialize with them than they were to socialize with us. Those of us who wanted to make racial equality a reality in every area of our life were threats to the social order. We were proud of ourselves, proud of our willingness to transgress the rules, proud to be courageous.

Part of a small integrated clique of smart kids who considered ourselves 'artists', we believed we were destined to create outlaw culture where we would live as Bohemians forever free; we were certain of our radicalness. Days before the reunion, I was overwhelmed by memories and shocked to discover that our gestures of defiance had been nowhere near as daring as they had seemed at the time. Mostly, they were acts of resistance that did not truly challenge the status quo. One of my best buddies during that time was white and male. He had an old gray Volvo that I loved to ride in. Every now and then he would give me a ride home from school if I missed the bus – an action which angered and disturbed those who saw us. Friendship across racial lines was bad enough, but across gender it was unheard of and dangerous. (One day, we found out just how dangerous when grown white men in a car tried to run us off the road.) Ken's parents were religious. Their faith compelled them to live out a belief in racial justice. They were among the first white folks in our community to invite black folks to come to their house, to eat at their table, to worship together with them. As one of Ken's best buddies, I was welcome in their house. After hours of discussion and debate about possible dangers, my parents agreed that I could go there for a meal. It was my first time eating together with white people. I was sixteen years old.

I felt then as though we were making history, that we were living the dream of democracy, creating a culture where equality, love, justice, and peace would shape America's destiny.

After graduation, I lost touch with Ken even though he always had a warm place in my memory. I thought of him when meeting and interacting with liberal white folks who believed that having a black friend meant that they were not racist, who sincerely believed that they were doing us a favor by extending offers of friendly contact for which they felt they should be rewarded. I thought of him during years of watching white folks play at unlearning racism but walking away when they encountered obstacles, rejection, conflict, pain. Our high school friendship had been forged not because we were black and white but because we shared a similar take on reality. Racial difference meant that we had to struggle to claim the integrity of that bonding. We had no illusions. We knew there would be obstacles, conflict, and pain. In white supremacist capitalist patriarchy – words we never used then – we knew we would have to pay a price for this friendship, that we would need to possess the courage to stand up for our belief in democracy, in racial justice, in the transformative power of love. We valued the bond between us enough to meet the challenge.

Days before the reunion, remembering the sweetness of that friendship, I felt humbled by the knowledge of what we give up when we are young, believing that we will find something just as good or better some day, only to discover that not to be so. I wondered just how it could be that Ken and I had ever lost contact with one another. Along the way I had not found white folks who understood the depth and complexity of racial injustice, and who were as willing to practice the art of living a non-racist life, as folks were then. In my adult life I have seen few white folks who are really willing to go the distance to create a world of racial equality – white folks willing to take risks, to be courageous, to live against the grain. I went to the reunion hoping that I would have a change to see Ken face-to-face, to tell him how much I cherished all that we had shared, to tell him – in words which I never dared to say to any white person back then – simply that I loved him.

Remembering this past, I am most struck by our passionate commitment to a vision of social transformation rooted in the fundamental belief in a radically democratic idea of freedom and justice for all. Our notions of social change were not fancy. There was no elaborate postmodern political theory shaping our actions. We were simply trying to change the way we went about our everyday lives so that our values and habits of being would reflect our commitment to freedom. Our major concern then was ending racism. Today, as I witness the rise in white supremacy, the growing social and economic apartheid that separates white and black, the haves and the have-nots, men and women, I have placed alongside the struggle to end racism a commitment to ending sexism and sexist oppression, to eradicating systems of class exploitation. Aware that we are living in a culture of domination, I ask myself now, as I did more than twenty years ago, what values and habits of being reflect my/our commitment to freedom?

In retrospect, I see that in the last twenty years I have encountered many folks who say they are committed to freedom and justice for all even though the way they live, the values and habits of being they institutionalize daily, in public and

private rituals, help maintain the culture of domination, help create an unfree world. In the book *Where Do We Go From Here? Chaos or Community*, Martin Luther King, Jr told the citizens of this nation, with prophetic insight, that we would be unable to go forward if we did not experience a 'true revolution of values'. He assured us that

> the stability of the large world house which is ours will involve a revolution of values to accompany the scientific and freedom revolutions engulfing the earth. We must rapidly begin the shift from a 'thing'-oriented society to a 'person'-oriented society. When machines and computers, profit motives and property rights are considered more important than people, the giant triplets of racism, materialism and militarism are incapable of being conquered. A civilization can flounder as readily in the face of moral and spiritual bankruptcy as it can through financial bankruptcy.

Today, we live in the midst of that floundering. We live in chaos, uncertain about the possibility of building and sustaining community. The public figures who speak the most to us about a return to old-fashioned values embody the evils King describes. They are most committed to maintaining systems of domination – racism, sexism, class exploitation and imperialism. They promote a perverse vision of freedom that makes it synonymous with materialism. They teach us to believe that domination is 'natural', that it is right for the strong to rule over the weak, the powerful over the powerless. What amazes me is that so many people claim not to embrace these values and yet our collective rejection of them cannot be complete since they prevail in our daily lives.

These days, I am compelled to consider what forces keep us from moving forward, from having that revolution of values that would enable us to live differently. King taught us to understand that if 'we are to have peace on earth' that 'our loyalties must transcend our race, our tribe, our class, and our nation'. Long before the word 'multiculturalism' became fashionable, he encouraged us to 'develop a world perspective'. Yet, what we are witnessing today in our everyday life is not an eagerness on the part of neighbors and strangers to develop a world perspective but a return to narrow nationalism, isolationisms and xenophobia. These shifts are usually explained in New Right and neoconservative terms as attempts to bring order to the chaos, to return to an (idealized) past. The notion of family evoked in these discussions is one in which sexist roles are upheld as stabilizing traditions. Not surprisingly, this vision of family life is coupled with a notion of security that suggests we are always most safe with people of our same group, race, class, religion, and so on. No matter how many statistics on domestic violence, homicide, rape and child abuse indicate that, in fact, the idealized patriarchal family is not a 'safe' space, that those of us who experience any form of assault are more likely to be victimized by those who are like us rather than by some mysterious strange outsiders, these conservative myths persist. It is apparent that one of the primary reasons we have not experienced a revolution of values is that a culture of domination necessarily promotes addiction to lying and denial.

That lying takes the presumably innocent form of many white people (and even some black folks) suggesting that racism does not exist any more, and that conditions of social equality are solidly in place that would enable any black person who works hard to achieve economic self-sufficiency. Forget about the fact that capitalism requires the existence of a mass underclass of surplus labor. Lying takes the form of mass media creating the myth that the feminist movement has completely transformed society, so much so that the politics of patriarchal power have been inverted and that men, particularly white men, just like emasculated black men, have become the victims of dominating women. So, it goes, all men (especially black men) must pull together (as in the Clarence Thomas hearings)[1] to support and reaffirm patriarchal domination. Add to this the widely held assumptions that blacks, other minorities and white women are taking jobs from white men, and that people are poor and unemployed because they want to be, and it becomes most evident that part of our contemporary crisis is created by a lack of meaningful access to truth. That is to say, individuals are not just presented untruths but are told them in a manner that enables most effective communication. When this collective cultural consumption of and attachment to misinformation is coupled with the layers of lying individuals do in their personal lives, our capacity to face reality is severely diminished as is our will to intervene and change unjust circumstances.

If we examine critically the traditional role of the university in the pursuit of truth and the sharing of knowledge and information, it is painfully clear that biases that uphold and maintain white supremacy, imperialism, sexism, and racism have distorted education so that it is no longer about the practice of freedom. The call for a recognition of cultural diversity, a rethinking of ways of knowing, a deconstruction of old epistemologies, and the concomitant demand that there be a transformation in our classrooms, in how we teach and what we teach, has been a necessary revolution – one that seeks to restore life to a corrupt and dying academy.

When everyone first began to speak about cultural diversity, it was exciting. For those of us on the margins (people of color, folks from working-class backgrounds, gays, and lesbians and so on) who had always felt ambivalent about our presence in institutions where knowledge was shared in ways that reinscribed colonialism and domination, it was thrilling to think that the vision of justice and democracy that was at the very heart of the civil rights movement would be realized in the academy. At last, there was the possibility of a learning community, a place where difference could be acknowledged, where we would finally all understand, accept and affirm that our ways of knowing are forged in history and relations of power. Finally, we were all going to break through collective academic denial and acknowledge that the education most of us had received and were giving was not and is never politically neutral. Though it was evident that change would not be immediate, there was tremendous hope that this process we had set in motion would lead to a fulfillment of the dream of education as the practice of freedom.

Many of our colleagues were initially reluctant participants in this change. Many folks found that as they tried to respect 'cultural diversity' they had to confront the limitations of their training and knowledge, as well as a possible loss of 'authority'. Indeed, exposing certain truths and biases in the classroom often

created chaos and confusion. The idea that the classroom should always be a 'safe', harmonious place was challenged. It was hard for individuals to grasp fully the idea that recognition of difference might also require of us a willingness to see the classroom change, to allow for shifts in relations between students. A lot of people panicked. What they saw happening was not the comforting 'melting pot' idea of cultural diversity, the rainbow coalition where we would all be grouped together in our difference, but everyone wearing the same have-a-nice-day smile. This was the stuff of colonizing fantasy, a perversion of the progressive vision of cultural diversity. Critiquing this longing in a recent interview, 'Critical multi-culturalism and democratic schooling' (in the *International Journal of Educational Reform*), Peter McLaren asserted:

> Diversity that somehow constitutes itself as a harmonious ensemble of benign cultural spheres is a conservative and liberal model of multi-culturalism that, in my mind, deserves to be jettisoned because, when we try to make culture an undisturbed space of harmony and agree-ment where social relations exist within cultural forms of uninterrupted accords we subscribe to a form of social amnesia in which we forget that all knowledge is forged in histories that are played out in the field of social antagonisms.

Many professors lacked strategies to deal with antagonisms in the classroom. When this fear joined with the refusal to change that characterized the stance of an old (predominantly white male) guard it created a space for disempowered collective backlash.

All of a sudden, professors who had taken issues of multiculturalism and cultural diversity seriously were backtracking, expressing doubts, casting votes in direc-tions that would restore biased traditions or prohibit changes in faculty and curricula that were to bring diversity of representation and perspective. Joining forces with the old guard, previously open professors condoned tactics (ostracization, belittle-ment and so on) used by senior colleagues to dissuade junior faculty members from making paradigm shifts that would lead to change. In one of my Toni Morrison seminars, as we went around our circle voicing critical reflections on Morrison's language, a sort of classically white, blondish, J. Crew coed shared that one of her other English professors, an older white man (whose name none of us wanted her to mention), confided that he was so pleased to find a student still interested in reading literature – words – the language of texts and 'not that race and gender stuff'. Somewhat amused by the assumption he had made about her, she was disturbed by his conviction that conventional ways of critically approaching a novel could not coexist in classrooms that also offered new perspectives.

I then shared with the class my experience of being at a Hallowe'en party. A new white male colleague, with whom I was chatting for the first time, went on a tirade at the mere mention of my Toni Morrison seminar, emphasizing that *Song of Solomon* was a weak rewrite of Hemingway's *For Whom the Bell Tolls*. Passionately full of disgust for Morrison he, being a Hemingway scholar, seemed to be sharing the often-heard concern that black women writers or thinkers are just poor imita-tions of 'great' white men. Not wanting at that moment to launch into Unlearning

Colonialism, Divesting of Racism and Sexism 101, I opted for the strategy taught to me by that in-denial-of-institutionalized-patriarchy, self-help book *Women Who Love Too Much*. I just said, 'Oh!' Later, I assured him that I would read *For Whom the Bell Tolls* again to see if I would make the same connection. Both these seemingly trivial incidents reveal how deep-seated is the fear that any de-centering of Western civilizations, of the white male canon, is really an act of cultural genocide.

Some folks think that everyone who supports cultural diversity wants to replace one dictatorship of knowing with another, changing one set way of thinking for another. This is perhaps the gravest misperception of cultural diversity. Even though there are those overly zealous among us who hope to replace one set of absolutes with another, simply changing content, this perspective does not accurately represent progressive visions of the way commitment to cultural diversity can constructively transform the academy. In all cultural revolutions there are periods of chaos and confusion, times when grave mistakes are made. If we fear mistakes, doing things wrongly, constantly evaluating ourselves, we will never make the academy a culturally diverse place where scholars and the curricula address every dimension of that difference.

As backlash swells, as budgets are cut, as jobs become even more scarce, many of the few progressive interventions that were made to change the academy, to create an open climate for cultural diversity are in danger of being undermined or eliminated. These threats should not be ignored. Nor should our collective commitment to cultural diversity change because we have not yet devised and implemented perfect strategies for them. To create a culturally diverse academy we must commit ourselves fully. Learning from other movements for social change, from civil rights and feminist liberation efforts, we must accept the protracted nature of our struggle and be willing to remain both patient and vigilant. To commit ourselves to the work of transforming the academy so that it will be a place where cultural diversity informs every aspect of our learning, we must embrace struggle and sacrifice. We cannot be easily discouraged. We cannot despair when there is conflict. Our solidarity must be affirmed by shared belief in a spirit of intellectual openness that celebrates diversity, welcomes dissent, and rejoices in collective dedication to truth.

Drawing strength from the life and work of Martin Luther King, Jr, I am often reminded of his profound inner struggle when he felt called by his religious beliefs to oppose the war in Vietnam. Fearful of alienating conservative bourgeois supporters, and of alienating the black church, King meditated on a passage from Romans, chapter 12, verse 2, which reminded him of the necessity of dissent, challenge and change: 'Be not conformed to this world but be ye transformed by the renewal of your minds'. All of us in the academy and in the culture as a whole are called to renew our minds if we are to transform educational institutions – and society – so that the way we live, teach, and work can reflect our joy in cultural diversity, our passion for justice, and our love of freedom.

Note

1 Clarence Thomas was nominated by Ronald Reagan as a Supreme Court judge and, during the US Senate's ratification of the nomination, he was examined in relation to sexual harassment charges made against him by Anita Hill. Reagan's nomination was upheld.

Eric Lott

RACIAL CROSS-DRESSING AND THE CONSTRUCTION OF AMERICAN WHITENESS

EDITOR'S INTRODUCTION

E RIC LOTT'S ESSAY IS A contribution to white studies, which is the study of whiteness as a historically constructed ethnic or cultural identity. The field was first defined in left-wing US labor history (e.g. Roediger 1991), for it was in the difficult past of white working-class Americans that the contingencies and strategies involved in establishing oneself as white became impossible for American academics to ignore. In conventional historiography and social theory, whiteness had been a universal rather than an identity. Being white, having white values and status, was the standard of humanness in general, to which others aspired and in relation to which they were judged.

For Lott, though, whiteness is a constructed and imagined identity which, especially in the US, requires continual effort to sustain. The effort is made by whites performing whiteness in all kinds of ways – performances which are addressed, not necessarily explicitly, to blacks. The construction and performance of whiteness is best unpicked through an analysis of white impersonations of blackness, so-called "blackface," a term which Lott extends beyond the familiar theatrical genre to a quite widely dispersed white desire to be black, or at least to simulate blackness.

Lott argues further that the invention of whiteness cannot be disentangled from questions of sexuality and gender. The white will to blackness is usually a performance of masculine mastery, but not just that. Pulling off a black mask may glorify the whiteness beneath, but putting on the mask may be a means of expressing repressed forms of homosocial or homosexual desires, as his analysis of Howard Griffin's *Black Like Me* shows. And the whiteness of the white in black-face is always shadowed and made fragile by its inverse: the blackness of the black in whiteface.

Lott's essay suggests a number of important questions. One obvious one is: if white men have to negotiate their masculinity in relation to black masculinity, what about women? Is there a tradition of female blackface/whiteface? And if less so, why? Into what imbrications of sexuality, gender and race does this question lead?

Further reading: Dyer 1997; Frankenberg 1993; Hall 1996a; McClintock 1995; Roediger 1991; Ross 1989.

At the start of a journey into the 'night side of American life', which would furnish the material for his *Black Like Me* (1961), John Howard Griffin strikes up a relationship with a black shoe-shine boy (Griffin 1961: 14). Griffin, a white investigative journalist turned black by medical treatments, sunlamp sessions and black stain, asks for lessons in the ways of Negro life. The shine man, Sterling Williams, 'promised perfect discretion and enthusiastically began coaching me'. '"You just watch me and listen how I talk"', says Williams. '"You'll catch on"' (p. 27). Apparently he does catch on, for Williams soon certifies Griffin's racial transmutation. 'Within a short time [Williams] lapsed into familiarity,' Griffin writes, 'forgetting I was once white. He began to use the "we" form and to discuss "our situation". The illusion of my "Negro-ness" took over so completely that I fell into the same pattern of talking and thinking. It was my first intimate glimpse. We were Negroes and our concern was the white man and how to get along with him' (p. 28).

Griffin's narrative is only one relatively recent example of a blackface tradition that is fundamentally concerned with a forbidden 'lapse into familiarity' between black and white men. No disembodied affair, the ventriloquizing or indeed purloining of black and other cultures has in many instances taken the form of a homosocial dance of white men and black. Whether blackface performers' fascination with slave singers and dancers, Carl Van Vechten's mimicking and brokering of Harlem Renaissance writers or white-Negro Norman Mailer's pursuit of Muhammad Ali and others, white men's intercourse with black men has been fraught with masculinist rivalry as well as 'compromising' desire. These instances have injected potent fantasies of the black male body into the white Imaginary – and thence into the culture industry. In thus giving shape to the white racial unconscious, such homosocial scenarios found the color line even as they witness that latter's continual transgression. Griffin's 'We were Negroes' is the perfect summation of this dynamic: renegades together on the 'night side', Griffin and Williams enact a racial encounter that is both age-old and implicitly affirming of the Berlin Wall they have momentarily agreed to scale.

For me, this instance raises the question of why and under what circumstances a blackface tradition emerged and continues intermittently to re-emerge, if only briefly and in more or less ironized form. My assumption is that blackface is a charged signifier with no coincidental relationship to the racial politics of culture in which it is embedded. Why, we might ask, this literal inhabiting of black bodies as a way of interracial male bonding? There are, after all, alternatives to such a practice; as Griffin's civil-rights-era contemporary Leslie Fiedler argued in *Love and*

Death in the American Novel (1960), our white male writers have been stubbornly preoccupied with white male/dark male dyads (Ishmael and Queequeg, Huck and Jim) which apparently fulfill a white need to be 'Negroes' together. The historical fact of white men literally assuming a 'black' self, the eternal and predictable return of the racial signified of blackface, is another matter entirely; and I would argue that it began and continues to occur when the lines of 'race' appear both intractable and obstructive, when there emerges a collective desire (conscious or not) to bridge a gulf that is, however, perceived to separate the races absolutely. Griffin's *Black Like Me* and blackface minstrelsy both exemplify this structure of feeling, the former in its earnest anti-segregationist politics, the latter in its derisive but transparently obsessive attempts to try on the accents of 'blackness'. Blackface acknowledges a racial relationship which to whites seems neither satisfactory nor surmountable; this acknowledgment owes in turn to perceptions of 'race' and its signifiers that we would now term 'essentialist'. To 'black up' is to express a belief in the complete suturing together of the markers of 'blackness' and the black culture, apparently sundered from the dominant one, to which they refer. John Szwed observes of the withering-away of blackface: 'The fact that, say, a Mick Jagger can today perform in the [blackface] tradition without blackface simply marks the detachment of culture from race and the almost full absorption of a black tradition into white culture (Szwed 1975: 27). Blackface, then, reifies and at the same time trespasses on the boundaries of 'race'. I see this doubleness as highly indicative of the shape of American whiteness.

Indeed, in the largest terms this racial trope obliges us to confront the process of 'racial' construction itself, the historical formation of whites no less than of blacks. Our typical focus on the way 'blackness' in the popular imagination has been produced out of white cultural expropriation and travesty misses how necessary this process is to the making of white American manhood. The latter simply could not exist without a racial other against which it defines itself and which to a very great extent it takes up into itself as one of its own constituent elements. By way of several rather underhistoricized instances in the history of blackface miming and of imaginary racial transformation, I want to look at some American constructions of whiteness – in particular this curious dependence upon and necessary internalization of the cultural practices of the dispossessed. My title implies that Griffin's *Black Like Me* is precisely misnamed, that what Griffin uncovers in his trip through the black South are the contours of straight Caucasian maleness. But to engage this and other post-World-War-II texts of racial cross-dressing we must acknowledge the American racial histories and cultural products that implicitly structure them. By this of course I mean nineteenth-century blackface performance and other similar texts; but I mean also US imperialism and its material and cultural transactions and results. Encounters with the other both at home and abroad easily become intertwined; as Griffin puts it early on, 'the South's racial situation was a blot on the whole country, and especially reflected against us overseas' (p. 8). In examining the racial unconscious of American imperial whiteness, I assume (absent the space adequately to demonstrate it) that the connection between internal and international is intimate. If national esteem in racial matters is related to international prestige – the ability to wield power among foreign races – it is also (or therefore) the case that representations of national racial

difference often provide displaced maps for international ones. Not to put too fine a point on it, the domination of international others has depended on mastering the other at home – and in oneself: an internal colonization whose achievement is fragile at best and which is often exceeded or threatened by the gender and racial arrangements on which it depends.

'Brothers for the time being'

The minstrel show's great popularity with northern white urban audiences in the middle decades of the nineteenth century has been read as a fairly pat instance of financial and cultural manipulation. With its comic darkies, 'plantation melodies', challenge dances, malapropistic wizardry, and general racial revanchism, minstrelsy long cried out for the revisionist critique to which it was only truly subjected in the 1960s and after. In one of the most thoroughgoing and persuasive of such critiques, Alexander Saxton surveys the social origins of certain major minstrel figures, among them T. D. Rice, Dan Emmett, E. P. Christy and Stephen Foster. Many of the major innovators were northerners of urban origin (none from New England) who were raised in families with intimations of upward mobility. All of them rejected the Protestant ethic and escaped into the latitudes of the entertainment world. In the course of such escape they came into contact with – and stole – the music and dance of slaves and free blacks and first tasted theatrical success in blackface performances. While these 'professionals' were sometimes class mutineers, passing up opportunities at a clerkship or better to immerse themselves in the underground world of blackface theater, they nevertheless shared with their families certain political ties to the elite of the Democratic party, the party of Andrew Jackson, antimonopoly, expansionism – and white supremacy. Henry Wood of Christy and Wood's Minstrels was the brother of Fernando Wood, Southern-sympathizing mayor of New York; another brother served three terms as a Democratic Congressman from Buffalo and one term as a state senator. Stephen Foster belonged to a family of ardent Democrats related by marriage to President Buchanan's brother, and Foster himself helped to organize a local Buchanan-for-President club.

Yet it seems to me that one unfortunate effect of this necessary critique has been to reify and even reinforce the cultural domination taking place in the minstrel show. And evidence from performers themselves points to a more complex dynamic, in which such dominative tendencies coexisted with or indeed depended upon a self-conscious attraction to the black men it was the job of these performers to mimic. Billy Whitlock, banjo player of Dan Emmett's Virginia Minstrels, said that when on tour in the South he would, as the *New York Clipper* put it, 'quietly steal off to some negro hut to hear the darkeys sing and see them dance, taking with him a jug of whiskey to make them all the merrier' (13 April 1878). More revealingly, performer Ben Cotton claimed that he would sit with and study blacks on Mississippi riverboats:

> I used to sit with them in front of their cabins, and we would start the banjo twanging, and their voices would ring out in the quiet night air

in their weird melodies. They did not quite understand me. I was the
first white man they had seen who sang as they did; but we were
brothers for the time being and were perfectly happy.

Self-serving as this is, it none the less indicates that a major strain of American
bohemia has its origins in blackface performers and enthusiasts. So much the worse
for bohemia, perhaps; but in addition to the minor disasters bohemia has perpe-
trated from Walt Whitman to Carl Van Vechten to Jack Kerouac, there is in its
activities an implicit tribute to, or at the very least a self-marginalizing mimicry
of, black culture's male representatives. This hardly addresses the social *results* of
such activities, which may be more or less harmful than the exoticism that gener-
ated them. But with antebellum blackface performers a set of racial attitudes and
cultural styles that in America goes by the name of bohemianism first emerged,
and in this clumsy courtship of black men the contours of masculine whiteness as
we know it began to take a definitive and recognizable form.

Most minstrel performers were minor, apolitical theatrical men of the northern
artisanate who pursued a newly available bourgeois dream of freedom and play by
paradoxically coding themselves as 'black'. Indeed if, for men, sexuality is where
freedom and play meet, 'blackness' was for antebellum bohemians its virtual condi-
tion – a fascinating imaginary space of fun and license seemingly outside but in
fact structured by Victorian bourgeois norms. This space seems to have arisen
largely from encounters with black men – slave or dancer or vendor – to whom
blackface minstrels had much access. For instance, according to legend – the closest
we are going to get in the matter – T. D. Rice used an old black stableman's song
and dance in his first 'Jim Crow' act. Dan Emmett had left his Mount Vernon,
Ohio, home by the age of eighteen (in 1834) and joined the military, where he
learned to play the infantry drum from a man nicknamed 'Juba' – a black name,
if not a black man, perhaps earned for the style of drum he played. Appearing as
a banjo player in various circuses, Emmett was very soon teamed up with dancer
Frank Brower, who had learned his dances directly from black men. Stephen Foster
no doubt had contact with black wharf workers and boatmen in his hometown of
Pittsburgh, but according to his brother he experienced black church singing first-
hand through a family servant, Olivia Pise, 'member of a church of shouting colored
people'. Ralph Keeler ran away from his Buffalo home at the age of eleven and
wrote that as a dancer with Johnny Booker's minstrels in the 1850s he 'wandered
all over the Western country', keeping continual company with that troupe's Negro
baggage handler, Ephraim. E. P. Christy reportedly drew material in the late 1830s
from One-legged Harrison, a black church singer in Buffalo; Christy said the two
had often traded 'down home talk'. Within the institution of minstrelsy itself, the
renowned black dancer Juba (William Henry Lane) provided a link between the
cultures, figuring centrally in many challenge-dance contests between black and
white dancers. The tableau reiterated in many of these scenes – a white man and
a black man becoming, as Ben Cotton put it, 'brothers for the time being' – shows
up often enough to be a defining interest of these white Negroes, and we might
pause over its role in the construction of American whiteness.

For what appear in fact to have been negotiated in blackface performance were
certain kinds of masculinity. To put on the cultural forms of 'blackness' was to

engage in a complex affair of manly mimicry. Examples of this dynamic since the heyday of minstrelsy are ready enough at hand, but in the early nineteenth century it had yet to be given an available public form. To wear or even enjoy blackface was literally, for a time, to become black, to inherit the cool, virility, humility, abandon, or *gaité de coeur* that were the prime components of white ideologies of black manhood. T. D. Rice, said that his friend F. C. Wemyss, in the event of a bad draw, fell into a kind of black homespun when dealing with theater managers, as though indeed into a black-white dyad that reproduced his own felicitous exchanges with black men: '"Lookye here, my master, this has been a bad job – I don't think you ought to suffer to this tune; live and let live is a good motto – hand over – and I will give you a receipt in full, and wish you better luck another time."' How interesting that Rice should assume this humbled sense of masculinity precisely at the guilty moment of payment for expropriated goods, in the process authenticating his claim on the material; how fitting, too, that this disturbing moment of conventional masculinity in the public sphere – the hard bargain, the deal – could with a ventriloquial shift be evaded or at least better managed.

It is worth remarking the way minstrelsy traded on racialized images of masculinity if only because they have become so familiar, indeed ritualized. In *North Toward Home* (1967), white Mississippian Willie Morris remembers 'a stage, when we were about thirteen, in which we "went Negro". We tried to broaden our accents to sound like Negroes, as if there were not enough similarity already. We consciously walked like young Negroes, mocking their swinging gait, moving our arms the way they did, cracking our knuckles and whistling between our teeth.' I would maintain that this dynamic, persisting into adulthood, is so much a part of most American white men's equipment for living that they remain entirely unaware of their participation in it. The special achievement of minstrel performers was to have intuited and formalized the white male fascination with the turn to black (manhood), which Leslie Fiedler puts this way: 'Born theoretically white, we are permitted to pass our childhood as imaginary Indians, our adolescence as imaginary Negroes, and only then are expected to settle down to being what we really are: white once more.' These common white associations of black maleness with the onset of pubescent sexuality indicate that the assumption of dominant codes of masculinity in the United States is partly negotiated through an imaginary black interlocutor. If this suggests that minstrelsy's popularity depended in part on the momentary return of its partisans to a state of arrested adolescence – largely the condition to which dominant codes of masculinity aspire – one must also conclude that white male fantasies of black men undergird the subject positions white men grow up to occupy.

And this is no foregone conclusion – it is full of the fiercest anxieties and potential disturbances. There is evidence, for example, that performers and audiences also found in blackface something closer to a homoerotic charge. Eve Sedgwick has argued that nineteenth-century bohemia was a space not of infinite heterosexual appetite but of ambiguous sexual definition, through which young bourgeois men passed on their way to the 'repressive, self-ignorant, and apparently consolidated status of the mature bourgeois *paterfamilias*' (Sedgwick 1990). Something of this situation applied in the case of minstrel men, certain of whose female impersonations appear, in the context of rough-and-tumble Jacksonian

manliness, to have grown out of a sense of sexual ambiguity. Actress Olive Logan wrote that 'some of the men who undertake this ["wench"] business are marvellously well fitted by nature for it, having well-defined soprano voices, plump shoulders, beardless faces, and tiny hands and feet. Many dress most elegantly as women.' While she is referring here to post-Civil-War female impersonation – which as an American showbusiness tradition probably got its start in minstrelsy – there is no reason to believe that the wide renown of antebellum 'wenches' (George Christy, Barney Williams) owed any less to their aptitude for or predisposition to such roles. And while it is inaccurate simply to read off homosexuality from effeminacy or indeed transvestism, same-sex desire does seem to have been registered by these performers. 'Heaps of boys in my locality don't believe yet it's a man in spite of my saying it was', said a Rochester critic of Francis Leon, the most famous postwar female impersonator. Leon was authentic enough as a female, this writer remarked, 'to make a fool of a man if he wasn't sure'.

Other performers evinced homosexual attractions more obliquely. 'A minstrel show came to town and I thought of nothing else for weeks', said Ben Cotton – this from the man who recalled the brotherhood of black and white singers. George Thatcher, well known later in the century, said of his first encounter with blackface performance in Baltimore: 'I found myself dreaming of minstrels; I would awake with an imaginary tambourine in my hand, and rub my face with my hands to see if I was blacked up . . . The dream of my life was to see or speak to a performer.' We might speculate a little as to the referent of the imaginary tambourine; the fantasy of racial conversion enacted in blackface seems to gesture at least toward sexual envy of black men (tambourine as penis), if not desire for them (tambourine as hymen). The fantasy may indeed direct us to a process in which homosexual desire is deflected by *identifying with* potent male heterosexuality. Perhaps the fantasy indicates only the usefulness of blackface in mediating white men's desire for other white men. In any case it did nothing to redirect myths of black masculinity, to say nothing of white men's attitudes toward women; and it only confirmed black men's status as bearers of black culture, objects of exchange. But it does bring to the surface a more submerged motive for racial intercourse, and it was (and is) probably one moment of most white men's enjoyment of black caricature.

These examples suggest that blackface performance reproduced or instantiated a structured *relationship* between the races, racial difference itself, as much as black cultural forms. They suggest moreover that this difference was as internal as it was external. To assume the mantle of whiteness, these examples seem to say, is not only to 'befriend' a racial other but to introject or internalize its imagined special capacities and attributes. The other is of course 'already in us', a part of one's (white) self, filled out according to the ideological shapes one has met in one's entry into the culture. The black male and fantasies about him supply the content of the white male Imaginary, they make up its repertoire. This (racial) splitting of the subject actually makes possible one whole area of white desire – but it also insures that the color line thus erected is constantly open to transgression or disruption.

Several theorists have termed this predicament 'abjection'. Julia Kristeva writes of the abject that '"unconscious" contents remain . . . *excluded* but in strange

fashion', clearly enough 'for a defensive *position* to be established' yet 'not radically enough to allow for a secure differentiation between subject and object' (Kristeva 1980: 7). This glosses very nicely the combined vigilance and absorptive cross-racial fascination of North American whiteness. Deviser of boundaries, 'raced' signs and practices by way of an engagement with the other, the blackface performer or white-Negro heir, in Kristeva's words, 'never stops demarcating his universe whose fluid confines . . . constantly question his solidity and impel him to start afresh'(p. 8). The abjection so redolent of pre-Oedipal archaism is reactivated amid the guilty pleasure we have witnessed in blackface performance, but it is masked with a racial logic. In rationalized Western societies, becoming 'white' and male seems to depend upon the remanding of enjoyment, the body, an aptitude for pleasure. It is the other who is always putatively 'excessive' in this respect, whether through exotic food, strange and noisy music, outlandish bodily exhibitions, or unremitting sexual appetite. Whites in fact organize their own enjoyment through the other, Slavoj Zizek has written, and access pleasure precisely by fantasizing about the other's 'special' pleasure. Hatred of the other arises from the necessary hatred of one's own excess; ascribing this excess to the 'degraded' other *and indulging* it – by imagining, incorporating or impersonating the other – one conveniently and surreptitiously takes and disavows pleasure at one and the same time (Zizek 1990: 57). This is the mixed erotic economy, what Homi Bhabha terms the 'ambivalence' of American whiteness.

In practice, this structure has meant, for one thing, that the dispossessed become bearers of the dominant classes' 'folk' culture, its repository of joy and revivification. And it is here that the agenda of pleasure meets that of domination, white male meets imperial subject. Whether it precedes or follows the dominative logic of imperialism, pleasure in the other is in fact its necessary twin. In the case of blackface these two agendas consorted in extremely complex ways, performance legitimating and sometimes subverting the politics of white supremacy, politics giving rise to an obsessive entertainment of racial difference. This double bind is the bedrock reality of racial cross-dressing, whatever its local habitation and name.

Elvis as metaphor

Norman Mailer's 'The white negro' (1959), a text whose mythologies are as telling as its analysis, is of course the post-Second-World-War reinvention of this structure of feeling. As none other than Norman Podhoretz observed in 1958 of the white-Negro discourse of which Mailer's essay was the centerpiece: 'I doubt if a more idyllic picture of Negro life has been painted since certain Southern ideologues tried to convince the world that things were just fine as fine could be for the slaves on the old plantation'. Not a postdating or mere continuation of antebellum racial cross-dressing but its genealogical legacy, this postwar discourse – the Beat writers, Elvis Presley's early career, John Howard Griffin's *Black Like Me* and others – did (despite its racial 'modernity') reproduce the obsessions of certain nineteenth-century *Northern* ideologues. To the extent that these obsessions weren't wholly continuous with the dominant culture in the ensuing years of protest, they

returned as farce in the late 1960s: Elvis's 1968 comeback television special, Grace Halsell's *Soul Sister* (1969) (a second-generation simulacrum, for it imitates Griffin's *Black Like Me*), and, in a crowning blow (to which I will return), Melvin Van Peebles's *Watermelon Man* (1970) – in which Godfrey Cambridge in whiteface plays a suburban racist who wakes up one morning to find himself black (too much time under the sunlamp). The almost 'classical' resurgence of this trope and of white Negroism generally in the late 1980s and early 1990s – the movie *Soul Man* (1986); black-folk-filled music videos by Sting, Madonna, Steve Winwood and many others; Lee Atwater's blues Republicanism (R.I.P.); Vanilla Ice; *True Identity* (1991); Michelle Shocked's *Arkansas Traveler* (1992) – is as troubling in its ubiquity as it is bewildering in its ideological variousness, but I think these texts too confirm some of the remarks with which I began.

Mailer's piece codifies the renegade ethic of male sexuality conceived out of and projected on to black men – and always 'compromised' by white men's evident attraction to them – that informs the more than metaphorical racial romance underlying the construction of American whiteness:

> Knowing in the cells of his existence that life was war, nothing but war, the Negro (all exceptions admitted) could rarely afford the sophisticated inhibitions of civilization, and so he kept for his survival the art of the primitive, he lived in the enormous present, he subsisted for his Saturday night kicks, relinquishing the pleasures of the mind for the more obligatory pleasures of the body, and in his music he gave voice to the character and quality of his existence, to his rage and the infinite variations of joy, lust, languor, growl, cramp, pinch, scream and despair of his orgasm.
>
> (Mailer 1959: 314)

Mailer and other white Negroes inherited a structure of feeling whose self-valorizing marginality and distinction require a virtual impersonation of black manhood. It is revealing that while the specific preoccupations of Mailer's existential errand are far from either Griffin's *Black Like Me* or Elvis Presley, the shape of this white mythology looks pretty much the same in all cases.

Its resonance is, for instance, succinctly articulated in white guitarist Scotty Moore's remark to Presley at one of the mid-1950s recording sessions in which Elvis first found his voice: '*Damn*, nigger!' As Nelson George has observed, Elvis was the historical referent Mailer missed in limning the 'white Negro'. Bringing to the stage the sort of 'symbolic fornication' that for whites denotes 'blackness', his hair pomaded in imitation of blacks' putative imitation of whites, Elvis illustrates the curious dependence of white working-class manhood on imitations of fantasized black male sexuality. It is true that in Elvis's case we must be clear about the precise nature of the indebtedness; nobody who thinks with their ears can dismiss Presley as merely a case of racial rip-off. I agree with Greil Marcus that Elvis's working-class origins placed him as close to Bobby Bland as to Perry Como – that in creating what was after all a distinctive rather than derivative sound he didn't so much steal the blues as live up to them. Yet fantasies of 'blackness' were unquestionably crucial in shaping a persona capable of such a task.

One image in particular stands out for its greater sublimation of this racial narrative. Much has been made of Presley's 1968 Christmas special, when after several years of silly movies and lifeless singing he roared back in black leather on network television. Marcus rightly identifies the central drama of the show as Elvis's attempt to win back his audience, and he demonstrates the way in which Elvis pulled all the stops out to do so. We might, however, also pause over the curious form of the show, in which Broadway productions of Elvis numbers (Elvis had not yet entered his Vegas period) alternate with an 'unplugged' circle of Elvis and fellow musicians getting raw. In these latter scenes the black leather of his outfit defines the ambience; it refuses to slip from the viewer's mind; Presley himself remarks upon how hot it is. Both Elvis's look and the doubled structure of the show seem to me to call up the racial themes I have been developing. Particularly in a show dedicated to proving how fore-ordained and irrelevant is all the music since Elvis's early triumphs (stage patter at one point has Elvis damning with faint praise 'the Beatles, the Beards, and the whoever'), its 'blues' portions appear to mediate (against all odds and despite the artist's intentions) what had been going on in the streets by the time it aired in late 1968. That is to say, the split show structure suggests the meaning of the suit and the 'blacker' performances: they are the 'unconscious' of the production numbers – white as the whale – that surround them. In the leather-suited takes, and in songs such as the following year's 'In the Ghetto', Elvis reveals his reliance even for resurrection upon 'blackness'. And his ever-increasing stature as *the* icon of white American culture, a fulfillment of the dubious potential augured by the comeback special's production numbers, only clinches my sense of the necessary *centrality and suppression* of 'blackness' in the making of American whiteness.

Black Like Me turns this structure into social criticism. While Griffin has 'blacked up' to beat his forebears, his text is not a story of passing. In fact he has only spotty interest in what blacks think of him; his concern is with whites and how they will treat him in his adopted state. Whiteness is his standard: ' "Do you suppose they'll treat me as John Howard Griffin, regardless of my color – or will they treat me as some nameless Negro, even though I am still the same man?" ' Griffin asks some friends, among whom, incidentally, are three FBI agents (p.10). It is the position of 'nameless Negro', not member of any community one might care to name, that interests Griffin. He passes less into a black world than into a 'black' part of himself, the remissible pleasures of abjection, triggered or made possible by white distaste and aversion. (Some of this is his own – he speaks of the idea of turning black as having 'haunted' him 'for years' before undertaking his effort [p. 7].) What he goes on to uncover are the contours of blackness *for whites*: contours he has externalized and thus indulges in his very disguise.

This racial logic underlies Griffin's whole enterprise. In revealing ways, *Black Like Me* is complicitous with the racial designs it sets out to expose. Griffin seems only dimly aware, for instance, that his disguise *is* an externalization, and yet there is evidence that his imagination of 'blackness' colors him before his blackface does. Early on, pondering the dangers of his experiment, Griffin is gratified to find his wife ready, while he is gone, 'to lead, with our three children, the unsatisfactory family life of a household deprived of husband and father' (p. 9). That this is an unconscious reference to the much-bruited female-headed black family that would

soon be mythologized in Daniel Patrick Moynihan's 'The Negro family: the case for national action' (1965) is indicated by Griffin's other mentions of the sadly depaternalized black family – as in: '[The black man's] wife usually earns more than he. He is thwarted in his need to be father-of-the-household' (p. 90; see also p. 42). Even when Griffin is white, that is, he is 'black' inside; it is this part of his 'make-up' that he explores in *Black Like Me*.

One need not look far for the sources of this concern in Griffin's text. Early in his days of blackness, Griffin, for reasons that appear as unclear to him as they do to us, walks down his hotel hallway in the early hours of the morning (he can't sleep) to the men's room. There he encounters two black men, one in the shower and the other naked on the floor awaiting his turn. Griffin writes that the waiting man 'leaned back against the wall with his legs stretched out in front of him. Despite his state of undress, he had an air of dignity' (p. 19). This rather anxious (and certainly clichéd) assurance to the reader has its counterpart in Griffin's remark to the man: '"You must be freezing on that bare floor, with no clothes on"' (p.20). As if things weren't bare enough all around, the waiting man 'flick[s] back the wet canvas shower curtain' and implores the bather to let Griffin wash his hands in the shower. (A nearby sink has been discovered to have no drain pipe.) Griffin hastily interjects:

> 'That's all right, I can wait,' I said.
> 'Go ahead,' he nodded.
> 'Sure – come on,' the man in the shower said. He turned the water down to a dribble. In the shower's obscurity, all I could see was a black shadow and gleaming white teeth. I stepped over the other's outstretched legs and washed quickly, using the soap the man in the shower thrust into my hands. When I had finished, I thanked him.
> (1961: 20)

Clearly the driving force here is the simultaneously fascinating and threatening proximity of black male bodies, beckoning, stretching, thrusting. If the accident of the scene's having occurred is not revealing, Griffin's retrospective mapping of it surely is. Moments like this put Griffin in the position of racial voyeur, allow him to confront the 'shadows' of the white Imaginary. Paradoxically, as with his tutorials with the shine man, Sterling Williams, their result is to help Griffin identify with black men; 'I fell into the same pattern of talking and thinking', he says of Williams (p. 28). Whether or not as a defense against interracial homoerotic desire, Griffin in any case mentally assumes and impersonates – one might almost say he 'masters' – the position and shape of black maleness. Poised in his disguise between white subject and black object, Griffin enters 'blackness' according to the dictates of white desire.

This indeed emerges from the many pages that are taken up with conversations that a hitchhiking Griffin has with white men who pummel him with questions about his sex life. 'There's plenty white women would like to have a good buck Negro', says one (p. 86); another man, with an 'educated flair' (p. 86), opines that blacks 'don't get so damned many *conflicts*': 'I understand you make more of an art – or maybe *hobby* out of your sex than we do' (p. 87). Griffin's disgust

at this predictable turn of events disguises the homosocial nature of the dialogues. For in these conversations, white men's interest in black male sexuality is mediated by but also identifies them with the white women black men are supposed to crave. In other words, the voyeuristic urge to expose the black man's body in congress with a white women is quite cognate with fantasies of the forbidden coupling of black and white *men* – a coupling, after all, that Griffin has in effect been engaged in. These car scenes, of course, merely reiterate the shower scene, and implicitly place Griffin in the white male driver's seat as well as in that of the black passenger. Griffin's conscious distaste permits him both to distance himself from the debased discourse of which he is structurally the victim (the walking black penis that forms the object of white male desire) *and* to engage in that obsessive discourse through the pleasures of impersonation.

Leaving to one side *Black Like Me*'s stated intent of showing for the first time what it was like to be black in the segregated South – as though plenty of black-authored books had not investigated that predicament already – Griffin's text can be read as a story of what happens when this sexualized racial unconscious of American whiteness is not, as in the foregoing instances, kept suppressed or partitioned. It is all very well to fetishize black male bodies, as Griffin does above and also when he remembers seeing black dockworkers in Mobile, 'stripped to the waist, their bodies glistening with sweat under their loads' (p. 99). But it is quite another thing, Griffin finds, to inhabit a black body. In a scene before the mirror that reveals his blackness to him for the first time, Griffin experiences total self-negation:

> Turning off all the lights, I went into the bathroom and closed the door. I stood in the darkness before the mirror, my hand on the light switch. I forced myself to flick it on.
> In the flood of light against white tile, the face and shoulders of a stranger – a fierce, bald, very dark Negro – glared at me from the glass. He in no way resembled me.
>
> (1961: 15)

The transformation, Griffin says, 'was total and shocking'; he feels 'imprisoned in the flesh of an utter stranger'; all traces of the John Griffin I had been were wiped from existence' (p. 15). 'White skin', to play on Frantz Fanon, is here obliterated by 'black mask' – a possibility available only to someone who imagines skin color in the way Griffin apparently does, as completely constitutive of identity and entirely divisive of the races. He fears he has gone too far: 'the black man is wholly a Negro, regardless of what he once may have been' (p. 16). Any sense of double perspective that chances to emerge – for instance, Griffin remarks that he 'became two men, the observing one and the one who panicked' – melts away under the feeling of being 'Negroid even into the depths of his entrails' (p. 16). Fantasy here returns as frightening fact. Confronted with a 'black' self-image, Griffin simply empties out the self. In what is perhaps an allusion to Ralph Ellison, Griffin writes that 'The Griffin that was had become invisible' (p. 16).

We ought, at this moment of crisis, to look at *Watermelon Man*, which, nine years after *Black Like Me*, alludes in turn to Griffin's travails. *Watermelon Man*'s

white protagonist, Jeff Gerber, awakes in the middle of the night, stumbles to the bathroom, looks in the mirror, and experiences precisely Griffin's sense of self-negation upon learning that he has become black. In the first part of the film Gerber (Godfrey Cambridge) is a jocular though devoted racist whose compulsive engagement with 'blackness' undergirds or buttresses his whiteness. He exercises while singing blackface tunes ('Jimmy crack corn') and stages imaginary boxing bouts with Muhammad Ali ('you're a credit to your race', he says to an imaginary Ali). The film gives body to this fascination by way of Gerber's ongoing sarcastic banter with three black men: a bus driver, an elevator operator and a lunch-counter waiter (played, in a stroke of casting genius, by an aged Mantan Moreland – the perennially frightened sidekick from the Charlie Chan movies). Disdainful of the black urban insurrections on television that comprise the film's soundtrack, yet everywhere dropping into 'black' dialect and other 'black' affectations, Gerber reveals that white supremacy has as one of its constituent (if unconscious) elements an imaginary closeness to black culture.

His sudden turn to black is thus both a logical and a scarifying one. Transfixed before the mirror, Gerber is at first frightened; he then hysterically acts out his subject/object split. He shadowboxes in the mirror the imaginary Ali he has now become; chants 'how now brown cow'; robs his mirror image at gunpoint; drinks some milk; gets an idea and looks down his pants (but: 'that's an old wives tale', he says); soaps himself; and 'proves' by his bridgework that the man in the mirror is really himself. The frenzied shifts in subject-position, from white to black to white again, point up what Van Peebles is ultimately after in the film – a state-of-the-race address on black self-hatred. Posed against *Black Like Me*, it offers, in other words, a perspective on the status of black masculinity apart from white male fantasy.

No simple affirmations are forthcoming, though. Much of the impact of *Watermelon Man* stems from its implication that the identities of both white and black men owe a heavy debt to a sort of displaced minstrelsy. Lamenting his new color, Gerber cries that his kids won't love him anymore, won't understand: 'wait till I get down on my knee and I sing "Mammy"!' The inevitable Jolson joke is actually a rather complex figure in this context. Surely it suggests a Gerber in blackface, referring once again to the obsession with blackness. But it also puts a *black* Gerber in blackface, lays a burden of white-filtered black images on his shoulders. As in Fanon, Gerber undergoes the self-othering attendant upon blacks in the West and devalues and ridicules his race accordingly. Soon Gerber is tracking down all the skin lighteners, hair straighteners, facial molds, and milk baths he can find. If as a white man he had wanted to be black, and dedicated many hours under the sunlamp to attain it, as a black man he wants just the opposite. No wonder Negroes riot, he says – the facial creams don't work.

Ultimately a simple attention to the facts of everyday life forces him to sympathize with the black militants and then become one. In fantastical form, then, Gerber experiences the transmogrification into 'blackness' that the film perceives blacks generally to have experienced in the 1960s. Meanwhile Gerber's blackness comes between him and his wife, Althea (Estelle Parsons); she leaves and takes the kids to her mother's home in Indiana. The primal scene of the interracial marriage bed is crucial as well to the climax of Griffin's *Black Like Me* – but in

light of *Watermelon Man* it carries a very different meaning. For Melvin Van Peebles's *Watermelon Man*, the way out of black racial mimicry or minstrelsy is into a militant blackness; its consequence is a refusal of desire for the white woman's body. (Jeff Gerber's chief moment of black self-understanding, a foretaste of the problematic gender politics of Van Peebles's *Sweet Sweetback's Baadasssss Song* [1971], occurs as he stares into the mirror of a black bar; a topless black female dancer is visible above his head in the mirror; two white detectives conduct a vice raid in the corner.) Conversely, for John Howard Griffin, the way out of the threatening sexual return of black manhood (his own included) is into a despairing liberal whiteness; its consequence is a retreat to the politics of minstrelsy.

At a pivotal moment, under a great deal of stress, beset by racist harassers and black self-haters, Griffin finds himself alone in a Hattiesburg rooming-house contemplating his family. He spots some old film negatives on the floor; they are 'blank'. Griffin imagines a prior occupant having had them developed only to find them wasted. This negating of the negative is of course meant to be a kind of self-portrait of Griffin in extremis. The image does echo a remark Griffin earlier makes about 'the world of the Negro' appearing to him as 'a blank' (p. 12); the lexical similarity of 'blank' and 'black' and their unfortunate metaphorical association in Griffin's mind (from negatives to Negroes) help Griffin to articulate his experience of self-cancellation. This glossing of the situation is, however, at odds with what happens next. Immediately after he spots the blank negatives, he tries to write to his wife: 'No words would come. She had nothing to do with this life, nothing to do with the room in Hattiesburg or with its Negro inhabitant . . . My conditioning as a Negro, and the immense sexual implications with which the racists in our culture bombard us, cut me off, even in my most intimate self, from any connection with my wife' (p. 68). The page before him remains 'blank' (p. 68). Griffin means this as self-conscious, anti-racist lament; the image he uses to describe himself under the reign of 'blackness' – blankness – accords with the uncitizenly debasement he has wanted to experience. Yet I would suggest that he is himself actively suppressing the definite shape of (his) black manhood. For, here and elsewhere, Griffin perceives the 'immensity' of black men to be anything but blank. Indeed the 'blank' page seems to loom for Griffin as a terrifying plenitude that must be sabotaged; its intimation of interracial sex, we note, 'cut [him] off'. Intoxicating if imagined, the fantasized black interlocutor is far too threatening as he rises up between white husband and wife. Griffin, haunted by a return of the racial repressed, in effect plumps for reifying or policing the color line. One suspects that the reason his family constantly feels so distant, why there is an absolute separation of self and other in the mirror, is because the transgressive racial pleasure Griffin everywhere imagines, and which he attempts to inhabit in his crossing of the line, must finally remain unbidden or refused. The rather flat film version of *Black Like Me* (1964) employs as one of its central cutting devices a highway's broken center line in motion, no doubt emblematic of Griffin's travels and transgressions. It appears that to cross the line is to encounter one's imagined other head-on, throwing whiteness into jeopardy.

Or into self-mimicry. One result of all this is that whiteness itself ultimately becomes an impersonation. The subterranean components of whiteness that so often threaten it require an edgy, constant patrolling. If *Watermelon Man* too easily

leaves Jeff Gerber in a black, deminstrelized zone, his selfhood no longer routed through white fantasies of blacks, *Black Like Me* throws John Griffin back into a whiteness that has been decisively disrupted and must be shored up. At the end of Griffin's book, the citizens of his home town try to run him out: 'But I felt I must remain a while longer . . . I could not allow them to say they had "chased" me out' (p. 155). This final imitation of white manhood, Griffin's righteous 'last stand' – conceptually indistinguishable, as Richard Slotkin has shown, from notions of hegemonic whiteness and symmetrically opposed to the ending of *Watermelon Man* – is the goal towards which his text has tended (Slotkin 1985). 'White like me' precisely names the internal division, the white self impersonating itself, that is the consequence of white men's fantasized proximity to black men. If Fanon's work and *Watermelon Man* give anti-imperialist force to the racist adage that 'good' blacks are 'white inside', the texts I've examined suggest that whiteness harbors some secrets of its own.

Cornel West

THE NEW CULTURAL POLITICS
OF DIFFERENCE

EDITOR'S INTRODUCTION

CORNEL WEST'S ESSAY CAN BE READ as a manifesto for intel-
lectuals who work on behalf of the "culture of difference." It is aimed at
helping us to avoid the reductive ways of thinking that endanger such work – that
is, it helps us to avoid those "one-factor analyses" which "lose touch" with the
complexities of thought and action in the world, and which, in their simplifica-
tions, provide props for racism, sexism, and monoculturalism. To escape such
simplifications and to begin to provide an ethics for cultural workers, West turns
to history. He presents a brief "genealogy" of the decline of Eurocentrism and
white suprematism – "genealogy" being a word he borrows from Michel Foucault
to refer to a history that supports current political practice. He argues that the
task of "demystification" (or ideology-critique) can only be carried out by those
whose confidence and sense of the contemporary cultural-political structures is
supported by a knowledge of Eurocentrism's history. Here cultural studies and
history become indivisible.

Since this essay first appeared, "black cultural studies" has developed further
to produce a number of debates concerning questions of identity, sexuality and
gender. It would be especially rewarding to read West's essay in relation to so-
called black British cultural studies, for instance as articulated (in importantly
different ways) by Paul Gilroy and Kobena Mercer, or in relation to feminist work
such as bell hooks's in her essay in this volume.

Further reading: Baker, Diawara and Lindeborg 1997; CCCS 1982; Gates 1986,
1987; Gilroy 1994; Gordon and Newfield 1996; Mercer 1994.

In the last few years of the twentieth century, there is emerging a significant shift in the sensibilities and outlooks of critics and artists. In fact, I would go so far as to claim that a new kind of cultural worker is in the making, associated with a new politics of difference. These new forms of intellectual consciousness advance new conceptions of the vocation of critic and artist, attempting to undermine the prevailing disciplinary divisions of labour in the academy, museum, mass media, and gallery networks while preserving modes of critique within the ubiquitous commodification of culture in the global village. Distinctive features of the new cultural politics of difference are to trash the monolithic and homogeneous in the name of diversity, multiplicity, and heterogeneity; to reject the abstract, general, and universal in light of the concrete, specific, and particular; and to historicize, contextualize, and pluralize by highlighting the contingent, provisional, variable, tentative, shifting, and changing. Needless to say, these gestures are not new in the history of criticism or art, yet what makes them novel – along with the cultural politics they produce – is how and what constitutes difference, the weight and gravity it is given in representation, and the way in which highlighting issues like exterminism, empire, class, race, gender, sexual orientation, age, nation, nature, and region at this historical moment acknowledges some discontinuity and disruption from previous forms of cultural critique. To put it bluntly, the new cultural politics of difference consists of creative responses to the precise circumstances of our present moment – especially those of marginalized First World agents who shun degraded self-representations, articulating instead their sense of the flow of history in light of the contemporary terrors, anxieties, and fears of highly commercialized North Atlantic capitalist cultures (with their escalating xenophobias against people of colour, Jews, women, gays, lesbians, and the elderly). The thawing, yet still rigid Second World ex-communist cultures (with increasing nationalist revolts against the legacy of hegemonic party henchmen), and the diverse cultures of the majority of inhabitants on the globe smothered by international communication cartels and repressive postcolonial elites (sometimes in the name of communism, as in Ethiopia), or starved by austere World Bank and IMF policies that subordinate them to the North (as in free-market capitalism in Chile), also locate vital areas of analysis in this new cultural terrain.

The new cultural politics of difference are neither simply oppositional in contesting the mainstream (or *male*stream) for inclusion, nor transgressive in the avant-gardist sense of shocking conventional bourgeois audiences. Rather, they are distinct articulations of talented (and usually privileged) contributors to culture who desire to align themselves with demoralized, demobilized, depoliticized, and disorganized people in order to empower and enable social action and, if possible, to enlist collective insurgency for the expansion of freedom, democracy, and individuality. This perspective impels these cultural critics and artists to reveal, as an integral component of their production, the very operations of power within their immediate work contexts (i.e., academy, museum, gallery, mass media). This strategy, however, also puts them in an inescapable double bind – while linking their activities to the fundamental, structural overhaul of these institutions, they often remain financially dependent on them. (So much for 'independent' creation.) For these critics of culture, theirs is a gesture that is simultaneously progressive *and* co-opted. Yet, without social movement or political pressure from outside

these institutions (extra-parliamentary and extra-curricular actions like the social movements of the recent past), transformation degenerates into mere accommodation or sheer stagnation, and the role of the 'co-opted progressive' – no matter how fervent one's subversive rhetoric – is rendered more difficult. In this sense there can be no artistic breakthrough or social progress without some form of crisis in civilization – a crisis usually generated by organizations or collectivities that convince ordinary people to put their bodies and lives on the line. There is, of course, no guarantee that such pressure will yield the result one wants, but there is a guarantee that the status quo will remain or regress if no pressure is applied at all.

The new cultural politics of difference faces three basic challenges – intellectual, existential, and political. The intellectual challenge – usually cast as a methodological debate in these days in which academicist forms of expression have a monopoly on intellectual life – is how to think about representational practices in terms of history, culture, and society. How does one understand, analyse, and enact such practices today? An adequate answer to this question can be attempted only after one comes to terms with the insights and blindness of earlier attempts to grapple with the question in light of the evolving crisis in different histories, cultures, and societies. I shall sketch a brief genealogy – a history that highlights the contingent origins and often ignoble outcomes – of exemplary critical responses to the question.

The intellectual challenge

An appropriate starting point is the ambiguous legacy of the Age of Europe. Between 1492 and 1945, European breakthroughs in oceanic transportation, agricultural production, state consolidation, bureaucratization, industrialization, urbanization, and imperial dominion shaped the makings of the modern world. Precious ideals like the dignity of persons (individuality) or the popular accountability of institutions (democracy) were unleashed around the world. Powerful critiques of illegitimate authorities – of the Protestant Reformation against the Roman Catholic Church, the Enlightenment against state churches, liberal movements against absolutist states and feudal guild constraints, workers against managerial subordination, people of colour and Jews against white and gentile supremacist decrees, gays and lesbians against homophobic sanctions – were fanned and fuelled by these precious ideals refined within the crucible of the Age of Europe. Yet, the discrepancy between sterling rhetoric and lived reality, glowing principles and actual practices, loomed large.

By the last European century – the last epoch in which European domination of most of the globe was uncontested and unchallenged in a substantive way – a new world seemed to be stirring. At the height of England's reign as the major imperial European power, its exemplary cultural critic, Matthew Arnold, painfully observed in his 'Stanzas from the Grand Chartreuse' that he felt some sense of 'wandering between two worlds, one dead / the other powerless to be born'. Following his Burkean sensibilities of cautious reform and fear of anarchy, Arnold acknowledged that the old glue – religion – that had tenuously and often

unsuccessfully held together the ailing European regimes could not do so in the mid-nineteenth century. Like Alexis de Tocqueville in France, Arnold saw that the democratic temper was the wave of the future. So he proposed a new conception of culture – a secular, humanistic one – that could play an integrative role in cementing and stabilizing an emerging bourgeois civil society and imperial state. His famous castigation of the immobilizing materialism of the declining aristocracy, the vulgar philistinism of the emerging middle classes, and the latent explosiveness of the working-class majority was motivated by a desire to create new forms of cultural legitimacy, authority, and order in a rapidly changing moment in nineteenth-century Europe.

The second historical coordinate of my genealogy is the emergence of the United States as *the* world power (in the words of André Malraux, the first nation to do so without trying to do so). The United States was unprepared for world power status. However, with the recovery of Stalin's Russia (after losing twenty million lives), the United States felt compelled to make its presence felt around the globe. Then, with the Marshall Plan to strengthen Europe, it seemed clear that there was no escape from world power obligations.

The first significant blow was dealt when assimilated Jewish Americans entered the higher echelons of the cultural apparatuses (academy, museums, galleries, mass media). Lionel Trilling is an emblematic figure. This Jewish entrée into the anti-semitic and patriarchal critical discourse of the exlusivistic institutions of American culture initiated the slow but sure undoing of the male WASP cultural hegemony and homogeneity. Trilling's project was to appropriate Matthew Arnold's for his own political and cultural purposes – thereby unravelling the old male WASP consensus while erecting a new post-Second-World-War liberal academic consensus around cold war, anti-communist renditions of the values of complexity, difficulty, variousness, and modulation. This suspicion of the academicization of knowledge is expressed in Trilling's well-known essay, 'On the teaching of modern literature'.

Trilling laments the fact that university instruction often quiets and domesticates radical and subversive works of art, turning them into objects 'of merely habitual regard'. This process of 'the socialization of the anti-social, or the acculturation of the anti-cultural, or the legitimization of the subversive' leads Trilling to 'question whether in our culture the study of literature is any longer a suitable means for developing and refining the intelligence'. He asks this question not in the spirit of denigrating and devaluing the academy but rather in the spirit of highlighting the possible failure of an Arnoldian conception of culture to contain what he perceives as the philistine and anarchic alternatives becoming more and more available to students of the 1960s – namely, mass culture and radical politics.

This threat is partly associated with the third historical co-ordinate of my genealogy – the decolonization of the Third World. It is crucial to recognize the importance of this world-historical process if one wants to grasp the significance of the end of the Age of Europe and the emergence of the United States as a world power. With the first defeat of a Western nation by a non-Western nation – in Japan's victory over Russia (1905); revolutions in Persia (1905), Turkey (1908), Mexico (1911–12), China (1912); and much later the independence of India (1947), China (1948); and the triumph of Ghana (1957) – the actuality of a decolonized globe loomed large. Born of violent struggle, consciousness-raising,

and the reconstruction of identities, decolonization simultaneously brings with it new perspectives on that long festering underside of the Age of Europe (of which colonial domination represents the *costs* of 'progress', 'order', and 'culture'), as well as requiring new readings of the economic boom in the United States (wherein the Black, Brown, Yellow, Red, White, female, gay, lesbian, and elderly working class live the same *costs* as cheap labour at home as well as in US-dominated Latin American and Pacific rim markets).

The impetuous ferocity and moral outrage that motors the decolonization process is best captured by Frantz Fanon in *The Wretched of the Earth*:

> Decolonization, which sets out to change the order of the world, is obviously a program of complete disorder . . . Decolonization is the meeting of two forces, opposed to each other by their very nature, which in fact owe their originality to that sort of substantification which results from and is nourished by the situation in the colonies. Their first encounter was marked by violence and their existence together – that is to say the exploitation of the native by the settler – was carried on by dint of a great array of bayonets and cannons.
>
> (Fanon 1967a)

Fanon's strong words describe the feelings and thoughts between the occupying British army and the colonized Irish in Northern Ireland, the occupying Israeli army and the subjugated Palestinians on the West Bank and Gaza Strip, the South African army and the oppressed Black South Africans in the townships, the Japanese police and the Koreans living in Japan, the Russian army and subordinated Armenians, and others in southern and eastern Russia. His words also partly invoke the sense many Black Americans have towards police departments in urban centres. In other words, Fanon is articulating century-long, heartfelt, human responses to being degraded and despised, hated and hunted, oppressed and exploited, and marginalized and dehumanized at the hands of powerful, xenophobic European, American, Russian and Japanese imperial countries.

During the late 1950s, 1960s and early 1970s in the United States, these decolonized sensibilities fanned and fuelled the Civil Rights and Black Power movements, as well as the student anti-war, feminist, grey, brown, gay, and lesbian movements. In this period we witnessed the shattering of male WASP cultural homogeneity and the collapse of the short-lived liberal consensus. The inclusion of African Americans, Latino/a Americans, Asian Americans, Native Americans, and American women in the culture of critical discourse yielded intense intellectual polemics and inescapable ideological polarization that focused principally on the exclusions, silences, and blindnesses of male WASP cultural homogeneity and its concomitant Arnoldian notions of the canon.

In addition, these critiques promoted three crucial processes that affected intellectual life in the country. First is the appropriation of the theories of postwar Europe – especially the work of the Frankfurt School (Marcuse, Adorno, Horkheimer), French/Italian Marxisms (Sartre, Althusser, Lefebvre, Gramsci), structuralisms (Lévi-Strauss, Todorov), and post-structuralisms (Deleuze, Derrida, Foucault). These diverse and disparate theories – all preoccupied with keeping

alive radical projects after the end of the Age of Europe – tend to fuse versions of transgressive European modernisms with Marxist or post-Marxist left politics, and unanimously shun the term 'postmodernism'. Second, there is the recovery and revisioning of American history in light of the struggles of White male workers, African Americans, Native Americans, Latino/a Americans, gays and lesbians. Third is the impact of forms of popular culture such as television, film, music videos, and even sports on highbrow, literate culture. The Black-based hip-hop culture of youth around the world is one grand example.

After 1973, with the crisis in the international world economy, America's slump in productivity, the challenge of OPEC nations to the North Atlantic monopoly of oil production, the increasing competition in hi-tech sectors of the economy from Japan and West Germany, and the growing fragility of the international debt structure, the United States entered a period of waning self-confidence (compounded by Watergate), and a nearly contracted economy. As the standards of living for the middle classes declined – owing to runaway inflation and escalating unemployment, underemployment, and crime – the quality of living fell for most everyone, and religious and secular neoconservatism emerged with power and potency. This fusion of fervent neonationalism, traditional cultural values, and 'free market' policies served as the groundwork for the Reagan–Bush era.

The ambiguous legacies of the European Age, American pre-eminence, and decolonization continue to haunt our postmodern moment as we come to terms with both the European, American, Japanese, Soviet, and Third World *crimes against* and *contributions to* humanity. The plight of Africans in the New World can be instructive in this regard.

By 1914, European maritime empires had dominion over more than half of the land and a third of the peoples in the world – almost 72 million square kilometres of territory and more than 560 million people under colonial rule. Needless to say, this European control included brutal enslavement, institutional terrorism, and cultural degradation of Black diaspora people. The death of roughly 75 million Africans during the centuries-long transatlantic slave trade is but one reminder, among others, of the assault on Black humanity. The Black diaspora condition of New World servitude – in which they were viewed as mere commodities with production value, who had no proper legal status, social standing, or public worth – can be characterized as, following Orlando Patterson, natal alienation. This state of perpetual and inheritable domination that diaspora Africans had at birth produced the *modern Black diaspora problematic of invisibility and namelessness*. White supremacist practices – enacted under the auspices of the prestigious cultural authorities of the churches, print media, and scientific academics – promoted Black inferiority and constituted the European background against which Black diaspora struggles for identity, dignity (self-confidence, self-respect, self-esteem), and material resources took place.

The modern Black diaspora problematic of invisibility and namelessness can be understood as the condition of *relative lack of Black power to present themselves to themselves and others as complex human beings, and thereby to contest the bombardment of negative, degrading stereotypes put forward by White supremacist ideologies*. The initial Black response to being caught in this whirlwind of Europeanization was to resist the misrepresentation and caricature of the terms set by uncontested

non-Black norms and models, and fight for self-recognition. Every modern Black person, especially cultural disseminators, encounters this problematic of invisibility and namelessness. The initial Black diaspora response was a mode of resistance that was *moralistic in content* and *communal in character*. That is, the fight for representation and recognition highlighted moral judgements regarding Black 'positive' images over and against White supremacist stereotypes. These images 'represented' monolithic and homogeneous Black communities in a way that could displace past misrepresentations of these communities. Stuart Hall has discussed these responses as attempts to change the 'relations of representation'.

These courageous yet limited Black efforts to combat racist cultural practices uncritically accepted non-Black conventions and standards in two ways. First, they proceeded in an *assimilationist manner* that set out to show that Black people were really like White people – thereby eliding differences (in history and culture) between Whites and Blacks. Black specificity and particularity was thus banished in order to gain White acceptance and approval. Second, these Black responses rested upon a *homogenizing impulse* that assumed that all Black people were really alike – hence obliterating differences (class, gender, region, sexual orientation) between Black peoples. I submit that there are elements of truth in both claims, yet the conclusions are unwarranted owing to the basic fact that non-Black paradigms set the terms of the replies.

The insight in the first claim is that Blacks and Whites are in some important sense alike – i.e., in their positive capacities for human sympathy, moral sacrifice, service to others, intelligence, and beauty; or negatively, in their capacity for cruelty. Yet, the common humanity they share is jettisoned when the claim is cast in an assimilationist manner that subordinates Black particularity to a false universalism, i.e., non-Black rubrics and prototypes. Similarly, the insight in the second claim is that all Blacks are in some significant sense 'in the same boat' – that is, subject to White supremacist abuse. Yet, this common condition is stretched too far when viewed in a *homogenizing* way that overlooks how racist treatment vastly differs owing to class, gender, sexual orientation, nation, region, hue, and age.

The moralistic and communal aspects of the initial Black diaspora responses to social and psychic erasure were not simply cast into simplistic binary oppositions of positive/negative, good/bad images that privileged the first term in light of a White norm so that Black efforts remained inscribed within the very logic that dehumanized them. They were further complicated by the fact that these responses were also advanced principally by anxiety-ridden, middle-class Black intellectuals (predominantly male and heterosexual) grappling with their sense of double-consciousness – namely their own crisis of identity, agency, audience – caught between a quest for White approval and acceptance and an endeavour to overcome the internalized association of Blackness with inferiority. And I suggest that these complex anxieties of modern Black diaspora intellectuals partly motivate the two major arguments that ground the assimilationist moralism and homogeneous communalism just outlined.

Kobena Mercer has talked about these two arguments as the *reflectionist* and the *social engineering* arguments. The reflectionist argument holds that the fight for Black representation and recognition – against White racist stereotypes – must

reflect or mirror the real Black community, not simply the negative and depressing representations of it. The social engineering argument claims that since any form of representation is constructed – i.e., selective in light of broader aims – Black representation (especially given the difficulty of Blacks gaining access to positions of power to produce any Black imagery) should offer positive images, thereby countering racist stereotypes. The hidden assumption of both arguments is that we have unmediated access to what the 'real Black community' is and what 'positive images' are. In short, these arguments presuppose the very phenomena to be interrogated, and thereby foreclose the very issues that should serve as the subject matter to be investigated.

Any notions of 'the real Black community' and 'positive images' are value-laden, socially loaded, and ideologically charged. To pursue this discussion is to call into question the possibility of such an uncontested consensus regarding them. Hall has rightly called this encounter 'the end of innocence or the end of the innocent notions of the essential Black subject . . . the recognition that "Black" is essentially a politically and culturally *constructed* category'. This recognition – more and more pervasive among the postmodern Black diaspora intelligentsia – is facilitated in part by the slow but sure dissolution of the European Age's maritime empires, and the unleashing of new political possibilities and cultural articulations among ex-colonized peoples across the globe.

One crucial lesson of this decolonization process remains the manner in which most Third World authoritarian bureaucratic elites deploy essentialist rhetorics about 'homogeneous national communities' and 'positive images' in order to repress and regiment their diverse and heterogeneous populations. Yet in the diaspora, especially among First World countries, this critique has emerged not so much from the Black male component of the left, but rather from the Black women's movement. The decisive push of postmodern Black intellectuals toward a new cultural politics of difference has been made by the powerful critiques and constructive explorations of Black diaspora women (e.g., Toni Morrison). The coffin used to bury the innocent notion of the essential Black subject was nailed shut with the termination of the Black male monopoly on the construction of the Black subject. In this regard, the Black diaspora womanist critique has had a greater impact than the critiques that highlight exclusively class, empire, age, sexual orientation, or nature.

This decisive push toward the end of Black innocence – though prefigured in various degrees in the best moments of James Baldwin, Amiri Baraka, Anna Cooper, W. E. B. DuBois, Frantz Fanon, C. L. R. James, Claudia Jones, the later Malcolm X, and others – forces Black diaspora cultural workers to encounter what Hall has called the 'politics of representation'. The main aim now is not simply access to representation in order to produce positive images of homogeneous communities – though broader access remains a practical and political problem. Nor is the primary goal here that of contesting stereotypes – though contestation remains a significant though limited venture. Following the model of the Black diaspora traditions of music, athletics, and rhetoric, Black cultural workers must constitute and sustain discursive and institutional networks that deconstruct earlier modern Black strategies for identity formation, demystify power relations that incorporate class, patriarchal, and homophobic biases, and construct more multivalent and

multidimensional responses that articulate the complexity and diversity of Black practices in the modern and postmodern world.

Furthermore, Black cultural workers must investigate and interrogate the other of Blackness/Whiteness. One cannot deconstruct the binary oppositional logic of images of Blackness without extending it to the contrary condition of Blackness/Whiteness itself. However, a mere dismantling will not do – for the very notion of a deconstructive social theory is oxymoronic. Yet, social theory is what is needed to examine and *explain* the historically specific ways in which 'Whiteness' is a politically constructed parasitic on 'Blackness', and thereby to conceive of the profoundly hybrid character of what we mean by 'race', 'ethnicity', and 'nationality'. Needless to say, these enquiries must traverse those of 'male/female', 'colonizer/colonized', 'heterosexual/homosexual' *et al.*, as well.

Demystification is the most illuminating mode of theoretical enquiry for those who promote the new cultural politics of difference. Social structural analyses of empire, exterminism, class, race, gender, nature, age, sexual orientation, nation, and region are the springboards – though not landing grounds – for the most desirable forms of critical practice that take history (and herstory) seriously. Demystification tries to keep track of the complex dynamics of institutional and other related power structures in order to disclose options and alternatives for transformative praxis; it also attempts to grasp the way in which representational strategies are creative responses to novel circumstances and conditions. In this way, the central role of human agency (always enacted under circumstances not of one's choosing) – be it in the critic, artist, or constituency, and audience – is accented.

I call demystificatory criticism 'prophetic criticism' – the approach appropriate for the new cultural politics of difference – because while it begins with social structural analyses it also makes explicit its moral and political aims. It is partisan, partial, engaged, and crisis-centred, yet always keeps open a sceptical eye to avoid dogmatic traps, premature closures, formulaic formulations, or rigid conclusions. In addition to social structural analyses, moral and political judgements, and sheer critical consciousness, there indeed is evaluation. Yet the aim of this evaluation is neither to pit art-objects against one another like racehorses nor to create eternal canons that dull, discourage, or even dwarf contemporary achievements. We listen to Laurie Anderson, Kathleen Battle, Ludwig Beethoven, Charlie Parker, Luciano Pavarotti, Sarah Vaughan, or Stevie Wonder; read Anton Chekhov, Ralph Ellison, Gabriel García Márquez, Doris Lessing, Toni Morrison, Thomas Pynchon, William Shakespeare; or see the works of Ingmar Bergman, Le Corbusier, Frank Gehry, Barbara Kruger, Spike Lee, Martin Puryear, Pablo Picasso, or Howardena Pindell – not in order to undergird bureaucratic assents or enliven cocktail party conversations, but rather to be summoned by the styles they deploy for their profound insights, pleasures, and challenges. Yet, all evaluation – including a delight in Eliot's poetry despite his reactionary politics, or a love of Zora Neale Hurston's novels despite her Republican party affiliations – is inseparable, though not identical or reducible to social structural analyses, moral and political judgements, and the workings of a curious critical consciousness.

The deadly traps of demystification – and any form of prophetic criticism – are those of reductionism, be it of the sociological, psychological, or historical sort. By reductionism I mean either one-factor analyses (i.e., crude Marxisms,

feminisms, racialisms, etc.) that yield a one-dimensional functionalism or a hyper-subtle analytical perspective that loses touch with the specificity of an art work's form and the context of its reception. Few cultural workers of whatever stripe can walk the tightrope between the Scylla of reductionism and the Charybdis of aestheticism – yet, demystificatory (or prophetic) critics must. Of course, since so many art practices these days also purport to be criticism, this also holds true for artists.

The existential challenge

The existential challenge to the new cultural politics of difference can be stated simply: how does one acquire the resources to survive and the cultural capital to thrive as a critic or artist? By cultural capital (Pierre Bourdieu's term), I mean not only the high-quality skills required to engage in critical practices, but more impor-tant, the self-confidence, discipline, and perseverance necessary for success without an undue reliance on the mainstream for approval and acceptance. This challenge holds for all prophetic critics, yet it is especially difficult for those of colour. The widespread modern European denial of the intelligence, ability, beauty, and char-acter of people of colour puts a tremendous burden on critics and artists of colour to 'prove' themselves in light of norms and models set by White elites whose own heritage devalued and dehumanized them. In short, in the court of criticism and art – or any matters regarding the life of the mind – people of colour are guilty (i.e., not expected to meet standards of intellectual achievement) until 'proven' innocent (i.e., acceptable to 'us').

This is more a structural dilemma than a matter of personal attitudes. The profoundly racist and sexist heritage of the European Age has bequeathed to us a set of deeply ingrained perceptions about people of colour including, of course, the self-perceptions that people of colour bring. It is not surprising that most intel-lectuals of colour in the past exerted much of their energies and efforts to gain acceptance and approval by 'White normative gazes'. The new cultural politics of difference advises critics and artists of colour to put aside this mode of mental bondage, thereby freeing themselves both to interrogate the ways in which they are bound by certain conventions and to learn from and build on these very norms and models. One hallmark of wisdom in the context of any struggle is to avoid knee-jerk rejection and uncritical acceptance.

There are four basic options for people of colour interested in representation – if they are to survive and thrive as serious practitioners of their craft. First, there is the Booker T. Temptation, namely the individual preoccupation with the main-stream and its legitimizing power. Most critics and artists of colour try to bite this bait. It is nearly unavoidable, yet few succeed in a substantive manner. It is no accident that the most creative and profound among them – especially those with staying power beyond mere flashes in the pan to satisfy faddish tokenism – are usually marginal to the mainstream. Even the pervasive professionalization of cultural practitioners of colour in the past few decades has not produced towering figures who reside within the established White patronage system that bestows the rewards and prestige for chosen contributions to American society.

It certainly helps to have some trustworthy allies within this system, yet most of those who enter and remain tend to lose much of their creativity, diffuse their prophetic energy, and dilute their critiques. Still, it is unrealistic for creative people of colour to think they can sidestep the White patronage system. And though there are indeed some White allies conscious of the tremendous need to rethink identity politics, it is naive to think that being comfortably nested within this very same system – even if one can be a patron to others – does not affect one's work, one's outlook, and, most important, one's soul.

The second option is the Talented Tenth Seduction, namely, a move toward arrogant group insularity. This alternative has a limited function – to preserve one's sanity and sense of self as one copes with the mainstream. Yet, it is, at best, a transitional and transient activity. If it becomes a permanent option it is self-defeating in that it usually reinforces the very inferiority complexes promoted by the subtly racist mainstream. Hence it tends to revel in a parochialism and encourage a narrow racialist and chauvinistic outlook.

The third strategy is the Go-It-Alone option. This is an extreme rejectionist perspective that shuns the mainstream and group insularity. Almost every critic and artist of colour contemplates or enacts this option at some time in his or her pilgrimage. It is healthy in that it reflects the presence of independent, critical, and sceptical sensibilities toward perceived constraints on one's creativity. Yet, it is, in the end, difficult if not impossible to sustain if one is to grow, develop and mature intellectually, as some semblance of dialogue with a community is necessary for almost any creative practice.

The most desirable option for people of colour who promote the new cultural politics of difference is to be a Critical Organic Catalyst. By this I mean a person who stays attuned to the best of what the mainstream has to offer – its paradigms, viewpoints, and methods – yet maintains a grounding in affirming and enabling subcultures of criticism. Prophetic critics and artists of colour should be exemplars of what it means to be intellectual freedom fighters, that is, cultural workers who simultaneously position themselves within (or alongside) the mainstream while clearly aligned with groups who vow to keep alive potent traditions of critique and resistance. In this regard, one can take clues from the great musicians or preachers of colour who are open to the best of what other traditions offer, yet are rooted in nourishing subcultures that build on the grand achievements of a vital heritage. Openness to others – including the mainstream – does not entail wholesale co-operation, and group autonomy is not group insularity. Louis Armstrong, Ella Baker, W. E. B. DuBois, Martin Luther King, Jr, Jose Carlos Mariatequi, Wynton Marsalis, M. M. Thomas, and Ronald Takaki have understood this well.

The new cultural politics of difference can thrive only if there are communities, groups, organizations, institutions, subcultures, and networks of people of colour who cultivate critical sensibilities and personal accountability – without inhibiting individual expressions, curiosities, and idiosyncrasies. This is especially needed given the escalating racial hostility, violence, and polarization in the United States. Yet, this critical coming-together must not be a narrow closing of ranks. Rather, it is a strengthening and nurturing endeavour that can forge more solid alliances and coalitions. In this way, prophetic criticism – with its stress on

historical specificity and artistic complexity – directly addresses the intellectual challenge. The cultural capital of people of colour – with its emphasis on self-confidence, discipline, perseverance, and subcultures of criticism – also tries to meet the existential requirement. Both are mutually reinforcing. Both are motivated by a deep commitment to individuality and democracy – the moral and political ideals that guide the creative response to the political challenge.

The political challenge

Adequate rejoinders to intellectual and existential challenges equip the practitioners of the new cultural politics of difference to meet the political ones. This challenge principally consists of forging solid and reliable alliances of people of colour and White progressives guided by a moral and political vision of greater democracy and individual freedom in communities, states, and transnational enterprises – i.e., corporations, and information and communications conglomerates. Jesse Jackson's Rainbow coalition is a gallant, yet flawed effort in this regard – gallant due to the tremendous energy, vision, and courage of its leader and followers; flawed because of its failure to take seriously critical and democratic sensibilities within its own operations.

The time has come for critics and artists of the new cultural politics of difference to cast their nets widely, flex their muscles broadly, and thereby refuse to limit their visions, analyses, and praxis to their particular terrains. The aim is to dare to recast, redefine, and revise the very notions of 'modernity', 'mainstream', 'margins', 'difference', 'otherness'. We have now reached a new stage in the perennial struggle for freedom and dignity. And while much of the First World intelligentsia adopts retrospective and conservative outlooks that defend the crisis-ridden present, we promote a prospective and prophetic vision with a sense of possibility and potential, especially for those who bear the social costs of the present. We look to the past for strength, not solace; we look at the present and see people perishing, not profits mounting; we look toward the future and vow to make it different and better.

Science and cyberculture

Donna Haraway

A CYBORG MANIFESTO

EDITOR'S INTRODUCTION

I S THIS REALLY A manifesto? For whom? Whatever the answer, it's an amazing "blasphemous" call for a profound change of consciousness in everyone living and working in high-tech culture. Donna Haraway's manifesto sits dead-center within cultural studies in its radical, pleasure-seeking affirmation of an often maligned and feared feature of the contemporary world – technologization. And it also mediates in particular on women's relation to technoscience.

The essay is usefully read as an exercise in feminist post-structuralism, prefiguring both queer theory and later conceptualizations of the post-human, as well as shadowing the French philosophers Deleuze and Guattari's experimental prescriptions for contemporary thought and living.

In particular, Haraway targets: first, nature fetishism which finds value in what is natural, where nature is interpreted as the opposite of artifice and technology; second, organicism which analyses society and culture in terms of organic unities, and where it does not find them, bitterly complains; third, sexualism for which sex is best as reproduction, and social bonds which are grounded in sex ("blood" ties, filiative associations) are primary; and, fourth, identity thinking for which selves are discrete wholes with specific identities. It's a cliché: but once you have read and taken in this essay, you won't think the same way about things again.

Further reading: Bukatman 1993; Deleuze and Guattari 1977, 1988; Fox-Keller 1984; Gray 1997; Penley 1997; Penley and Ross 1991; Robertson *et al.* 1996; Treichler, Cartwright and Penley 1998.

This essay is an effort to build an ironic political myth faithful to feminism, socialism, and materialism. Perhaps more faithful as blasphemy is faithful, than as reverent worship and identification. Blasphemy has always seemed to require taking things very seriously. I know no better stance to adopt from within the secular-religious, evangelical traditions of United States politics, including the politics of socialist feminism. Blasphemy protects one from the moral majority within, while still insisting on the need for community. Blasphemy is not apostasy. Irony is about contradictions that do not resolve into larger wholes, even dialectically, about the tension of holding incompatible things together because both or all are necessary and true. Irony is about humour and serious play. It is also a rhetorical strategy and a political method, one I would like to see more honoured within socialist-feminism. At the centre of my ironic faith, my blasphemy, is the image of the cyborg.

A cyborg is a cybernetic organism, a hybrid of machine and organism, a creature of social reality as well as a creature of fiction. Social reality is lived social relations, our most important political construction, a world-changing fiction. The international women's movements have constructed 'women's experience', as well as uncovered or discovered this crucial collective object. This experience is a fiction and fact of the most crucial, political kind. Liberation rests on the construction of the consciousness, the imaginative apprehension, of oppression, and so of possibility. The cyborg is a matter of fiction and lived experience that changes what counts as women's experience in the late twentieth century. This is a struggle over life and death, but the boundary between science fiction and social reality is an optical illusion.

Contemporary science fiction is full of cyborgs – creatures simultaneously animal and machine, who populate worlds ambiguously natural and crafted. Modern medicine is also full of cyborgs, of couplings between organism and machine, each conceived as coded devices, in an intimacy and with a power that was not generated in the history of sexuality. Cyborg 'sex' restores some of the lovely replicative baroque of ferns and invertebrates (such nice organic prophylactics against hetero-sexism). Cyborg replication is uncoupled from organic reproduction. Modern production seems like a dream of cyborg colonization work, a dream that makes the nightmare of Taylorism seem idyllic. And modern war is a cyborg orgy, coded by C^3I, command-control-communication-intelligence, an $84 billion item in 1984's US defence budget. I am making an argument for the cyborg as a fiction mapping our social and bodily reality and as an imaginative resource suggesting some very fruitful couplings. Michel Foucault's biopolitics is a flaccid premonition of cyborg politics, a very open field.

By the late twentieth century, our time, a mythic time, we are all chimeras, theorized and fabricated hybrids of machine and organism; in short, we are cyborgs. The cyborg is our ontology; it gives us our politics. The cyborg is a condensed image of both imagination and material reality, the two joined centres structuring any possibility of historical transformation. In the traditions of 'Western' science and politics – the tradition of racist, male-dominant capitalism; the tradition of progress; the tradition of the appropriation of nature as resource for the productions of culture; the tradition of reproduction of the self from the reflections of the other – the relation between organism and machine has been a border war.

The stakes in the border war have been the territories of production, reproduction, and imagination. This essay is an argument for *pleasure* in the confusion of boundaries and for *responsibility* in their construction. It is also an effort to contribute to socialist-feminist culture and theory in a postmodernist, non-naturalist mode and in the utopian tradition of imagining a world without gender, which is perhaps a world without genesis, but maybe also a world without end. The cyborg incarnation is outside salvation history. Nor does it mark time on an oedipal calendar, attempting to heal the terrible cleavages of gender in an oral symbiotic utopia or post-oedipal apocalypse.

The cyborg is a creature in a post-gender world; it has no truck with bisexuality, pre-oedipal symbiosis, unalienated labour, or other seductions to organic wholeness through a final appropriation of all the powers of the parts into a higher unity. In a sense, the cyborg has no origin story in the Western sense – a 'final' irony since the cyborg is also the awful apocalyptic *telos* of the 'West's' escalating dominations of abstract individuation, an ultimate self untied at last from all dependency, a man in space. An origin story in the 'Western', humanist sense depends on the myth of original unity, fullness, bliss and terror, represented by the phallic mother from whom all humans must separate, the task of individual development and of history, the twin potent myths inscribed most powerfully for us in psychoanalysis and Marxism. Hilary Klein has argued that both Marxism and psychoanalysis, in their concepts of labour and of individuation and gender formation, depend on the plot of original unity out of which difference must be produced and enlisted in a drama of escalating domination of woman/nature. The cyborg skips the step of original unity, of identification with nature in the Western sense. This is its illegitimate promise that might lead to subversion of its teleology as star wars.

The cyborg is resolutely committed to partiality, irony, intimacy, and perversity. It is oppositional, utopian, and completely without innocence. No longer structured by the polarity of public and private, the cyborg defines a technological polis based partly on a revolution of social relations in the *oikos*, the household. Nature and culture are reworked; the one can no longer be the resource for appropriation or incorporation by the other. The relationships for forming wholes from parts, including those of polarity and hierarchical domination, are at issue in the cyborg world. Unlike the hopes of Frankenstein's monster, the cyborg does not expect its father to save it through a restoration of the garden; that is, through the fabrication of a heterosexual mate, through its completion in a finished whole, a city and cosmos. The cyborg does not dream of community on the model of the organic family, this time without the oedipal project. The cyborg would not recognize the Garden of Eden; it is not made of mud and cannot dream of returning to dust. Perhaps that is why I want to see if cyborgs can subvert the apocalypse of returning to nuclear dust in the manic compulsion to name the Enemy. Cyborgs are not reverent; they do not re-member the cosmos. They are wary of holism, but needy for connection – they seem to have a natural feel for united front politics, but without the vanguard party. The main trouble with cyborgs, of course, is that they are the illegitimate offspring of militarism and patriarchal capitalism, not to mention state socialism. But illegitimate offspring are often exceedingly unfaithful to their origins. Their fathers, after all, are inessential.

I will return to the science fiction of cyborgs at the end of this essay, but now I want to signal three crucial boundary breakdowns that make the following political-fictional (political-scientific) analysis possible. By the late twentieth century in United States scientific culture, the boundary between human and animal is thoroughly breached. The last beachheads of uniqueness have been polluted if not turned into amusement parks – language, tool use, social behaviour, mental events, nothing really convincingly settles the separation of human and animal. And many people no longer feel the need for such a separation; indeed, many branches of feminist culture affirm the pleasure of connection of human and other living creatures. Movements for animal rights are not irrational denials of human uniqueness; they are a clear-sighted recognition of connection across the discredited breach of nature and culture. Biology and evolutionary theory over the last two centuries have simultaneously produced modern organisms as objects of knowledge and reduced the line between humans and animals to a faint trace re-etched in ideological struggle or professional disputes between life and social science. Within this framework, teaching modern Christian creationism should be fought as a form of child abuse.

Biological-determinist ideology is only one position opened up in scientific culture for arguing the meanings of human animality. There is much room for radical political people to contest the meanings of the breached boundary. The cyborg appears in myth precisely where the boundary between human and animal is transgressed. Far from signalling a walling off of people from other living beings, cyborgs signal disturbingly and pleasurably tight coupling. Bestiality has a new status in this cycle of marriage exchange.

The second leaky distinction is between animal-human (organism) and machine. Pre-cybernetic machines could be haunted; there was always the spectre of the ghost in the machine. This dualism structured the dialogue between materialism and idealism that was settled by a dialectical progeny, called spirit or history, according to taste. But basically machines were not self-moving, self-designing, autonomous. They could not achieve man's dream, only mock it. They were not man, an author to himself, but only a caricature of that masculinist reproductive dream. To think they were otherwise was paranoid. Now we are not so sure. Late twentieth-century machines have made thoroughly ambiguous the difference between natural and artificial, mind and body, self-developing and externally designed, and many other distinctions that used to apply to organisms and machines. Our machines are disturbingly lively, and we ourselves frighteningly inert.

Technological determination is only one ideological space opened up by the reconceptions of machine and organism as coded texts through which we engage in the play of writing and reading the world. 'Textualization' of everything in post-structuralist, postmodernist theory has been damned by Marxists and socialist feminists for its utopian disregard for the lived relations of domination that ground the 'play' of arbitrary reading. It is certainly true that postmodernist strategies, like my cyborg myth, subvert myriad organic wholes (for example, the poem, the primitive culture, the biological organism). In short, the certainty of what counts as nature – a source of insight and promise of innocence – is undermined, probably fatally. The transcendent authorization of interpretation is lost, and with it the ontology grounding 'Western' epistemology. But the alternative

is not cynicism or faithlessness, that is, some version of abstract existence, like the accounts of technological determinism destroying 'man' by the 'machine' or 'meaningful political action' by the 'text'. Who cyborgs will be is a radical question; the answers are a matter of survival.

The third distinction is a subset of the second: the boundary between physical and non-physical is very imprecise for us. Pop physics books on the consequences of quantum theory and the indeterminacy principle are a kind of popular scientific equivalent to Harlequin romances as a marker of radical change in American white heterosexuality: they get it wrong, but they are on the right subject. Modern machines are quintessentially microelectronic devices: they are everywhere and they are invisible. Modern machinery is an irreverent upstart god, mocking the Father's ubiquity and spirituality. The silicon chip is a surface for writing; it is etched in molecular scales disturbed only by atomic noise, the ultimate interference for nuclear scores. Writing, power, and technology are old partners in Western stories of the origin of civilization, but miniaturization has changed our experience of mechanism. Miniaturization has turned out to be about power; small is not so much beautiful as pre-eminently dangerous, as in cruise missiles. Contrast the television sets of the 1950s or the news cameras of the 1970s with the television wrist bands or hand-sized video cameras now advertised. Our best machines are made of sunshine; they are all light and clean because they are nothing but signals, electromagnetic waves, a section of a spectrum, and these machines are eminently portable, mobile – a matter of immense human pain in Detroit and Singapore. People are nowhere near so fluid, being both material and opaque. Cyborgs are ether, quintessence.

The ubiquity and invisibility of cyborgs is precisely why these sunshine-belt machines are so deadly. They are as hard to see politically as materially. They are about consciousness – or its simulation. They are floating signifiers moving in pickup trucks across Europe, blocked more effectively by the witch-weavings of the displaced and so unnatural Greenham women, who read the cyborg webs of power so very well, than by the militant labour of older masculinist politics, whose natural constituency needs defence jobs. Ultimately the 'hardest' science is about the realm of greatest boundary confusion, the realm of pure number, pure spirit, C^3I, cryptography, and the preservation of potent secrets. The new machines are so clean and light. Their engineers are sun-worshippers mediating a new scientific revolution associated with the night dream of post-industrial society. The diseases evoked by these clean machines are 'no more' than the minuscule coding changes of an antigen in the immune system, 'no more' than the experience of stress. The nimble fingers of 'Oriental' women, the old fascination of little Anglo-Saxon Victorian girls with doll's houses, women's enforced attention to the small take on quite new dimensions in this world. There might be a cyborg Alice taking account of these new dimensions.

So my cyborg myth is about transgressed boundaries, potent fusions, and dangerous possibilities which progressive people might explore as one part of needed political work. One of my premises is that most American socialists and feminists see deepened dualisms of mind and body, animal and machine, idealism and materialism in the social practices, symbolic formulations, and physical artefacts associated with 'high technology' and scientific culture. From *One-Dimensional*

Man (Marcuse 1964) to *The Death of Nature* (Merchant 1980), the analytic resources developed by progressives have insisted on the necessary domination of technics and recalled us to an imagined organic body to integrate our resistance. Another of my premises is that the need for unity of people trying to resist worldwide intensification of domination has never been more acute. But a slightly perverse shift of perspective might better enable us to contest for meanings, as well as for other forms of power and pleasure in technologically mediated societies.

From one perspective, a cyborg world is about the final imposition of a grid of control on the planet, about the final abstraction embodied in a Star Wars apocalypse waged in the name of defence, about the final appropriation of women's bodies in a masculinst orgy of war. From another perspective, a cyborg world might be about lived social and bodily realities in which people are not afraid of their joint kinship with animals and machines, not afraid of permanently partial identities and contradictory standpoints. The political struggle is to see from both perspectives at once because each reveals both dominations and possibilities unimaginable from the other vantage point. Single vision produces worse illusions than double vision or many-headed monsters. Cyborg unities are monstrous and illegitimate; in our present political circumstances, we could hardly hope for more potent myths for resistance and recoupling. I like to imagine LAG, the Livermore Action Group, as a kind of cyborg society, dedicated to realistically converting the laboratories that most fiercely embody and spew out the tools of technological apocalypse, and committed to building a political form that actually manages to hold together witches, engineers, elders, perverts, Christians, mothers, and Leninists long enough to disarm the state. Fission Impossible is the name of the affinity group in my town. (Affinity: related not by blood but by choice, the appeal of one chemical nuclear group for another, avidity.)

Fractured identities

It has become difficult to name one's feminism by a single adjective — or even to insist in every circumstance upon the noun. Consciousness of exclusion through naming is acute. Identities seem contradictory, partial, and strategic. With the hard-won recognition of their social and historical constitution, gender, race, and class cannot provide the basis for belief in 'essential' unity. There is nothing about being 'female' that naturally binds women. There is not even such a state as 'being' female, itself a highly complex category constructed in contested sexual scientific discourses and other social practices. Gender, race, or class consciousness is an achievement forced on us by the terrible historical experience of the contradictory social realities of patriarchy, colonialism, and capitalism. And who counts as 'us' in my own rhetoric? Which identities are available to ground such a potent political myth called 'us', and what could motivate enlistment in this collectivity? Painful fragmentation among feminists (not to mention among women) along every possible fault line has made the concept of *woman* elusive, an excuse for the matrix of women's dominations of each other. For me — and for many who share a similar historical location in white, professional middle-class, female, radical, North American, mid-adult bodies — the sources of a crisis in political identity are legion.

The recent history for much of the US left and US feminism has been a response to this kind of crisis by endless splitting and searches for a new essential unity. But there has also been a growing recognition of another response through coalition – affinity, not identity.

Chela Sandoval, from a consideration of specific historical moments in the formation of the new political voice called women of color, has theorized a hopeful model of political identity called 'oppositional consciousness', born of the skills for reading webs of power by those refused stable membership in the social categories of race, sex, or class. 'Women of color', a name contested at its origins by those whom it would incorporate, as well as a historical consciousness marking systematic breakdown of all the signs of Man in 'Western' traditions, constructs a kind of postmodernist identity out of otherness, difference, and specificity. This postmodernist identity is fully political, whatever might be said about other possible postmodernisms. Sandoval's oppositional consciousness is about contradictory locations and heterochronic calendars, not about relativisms and pluralisms.

Sandoval emphasizes the lack of any essential criterion for identifying who is a woman of color. She notes that the definition of the group has been by conscious appropriation of negation. For example, a Chicana or US black woman has not been able to speak as a woman or as a black person or as a Chicano. Thus, she was at the bottom of a cascade of negative identities, left out of even the privileged oppressed authorial categories called 'women and blacks', who claimed to make the important revolutions. The category 'woman' negated all non-white women; 'black' negated all non-black people, as well as all black women. But there was also no 'she', no singularity, but a sea of differences among US women who have affirmed their historical identity as US women of color. This identity marks out a self-consciously constructed space that cannot affirm the capacity to act on the basis of natural identification, but only on the basis of conscious coalition, of affinity, of political kinship. Unlike the 'woman' of some streams of the white women's movement in the United States, there is no naturalization of the matrix, or at least this is what Sandoval argues is uniquely available through the power of oppositional consciousness.

Sandoval's argument has to be seen as one potent formulation for feminists out of the worldwide development of anti-colonialist discourse; that is to say, discourse dissolving the 'West' and its highest product – the one who is not animal, barbarian, or woman; man, that is, the author of a cosmos called history. As orientalism is deconstructed politically and semiotically, the identities of the occident destabilize, including those of feminists. Sandoval argues that 'women of color' have a chance to build an effective unity that does not replicate the imperializing, totalizing revolutionary subjects of previous Marxisms and feminisms which had not faced the consequences of the disorderly polyphony emerging from decolonization.

Katie King has emphasized the limits of identification and the political/poetic mechanics of identification built into reading 'the poem', that generative core of cultural feminism. King criticizes the persistent tendency among contemporary feminists from different 'moments' or 'conversations' in feminist practice to taxonomize the women's movement to make one's own political tendencies appear to be the *telos* of the whole. These taxonomies tend to remake feminist history so that it appears to be an ideological struggle among coherent types persisting over

time, especially those typical units called radical, liberal, and socialist feminism. Literally, all other feminisms are either incorporated or marginalized, usually by building an explicit ontology and epistemology. Taxonomies of feminism produce epistemologies to police deviation from official women's experience. And of course, 'women's culture', like women of colour, is consciously created by mechanisms inducing affinity. The rituals of poetry, music, and certain forms of academic practice have been pre-eminent. The politics of race and culture in the US women's movements are intimately interwoven. The common achievement of King and Sandoval is learning how to craft a poetic/political unity without relying on a logic of appropriation, incorporation, and taxonomic identification.

The theoretical and practical struggle against unity-through-domination or unity-through-incorporation ironically not only undermines the justifications for patriarchy, colonialism, humanism, positivism, essentialism, scientism, and other unlamented -isms, but *all* claims for an organic or natural standpoint. I think that radical and socialist/Marxist feminisms have also undermined their/our own epistemological strategies and that this is a crucially valuable step in imagining possible unities. It remains to be seen whether all 'epistemologies' as Western political people have known them fail us in the task to build effective affinities.

It is important to note that the effort to construct revolutionary standpoints, epistemologies as achievements of people committed to changing the world, has been part of the process showing the limits of identification. The acid tools of postmodernist theory and the constructive tools of ontological discourse about revolutionary subjects might be seen as ironic allies in dissolving Western selves in the interests of survival. We are excruciatingly conscious of what it means to have a historically constituted body. But with the loss of innocence in our origin, there is no expulsion from the Garden either. Our politics lose the indulgence of guilt with the *naïveté* of innocence. But what would another political myth for socialist feminism look like? What kind of politics could embrace partial, contradictory, permanently unclosed constructions of personal and collective selves and still be faithful, effective – and, ironically, socialist feminist?

I do not know of any other time in history when there was greater need for political unity to confront effectively the dominations of 'race', 'gender', 'sexuality', and 'class'. I also do not know of any other time when the kind of unity we might help build could have been possible. None of 'us' have any longer the symbolic or material capability of dictating the shape of reality to any of 'them'. Or at least 'we' cannot claim innocence from practising such dominations. White women, including socialist feminists, discovered (that is, were forced kicking and screaming to notice) the non-innocence of the category 'woman'. That consciousness changes the geography of all previous categories; it denatures them as heat denatures a fragile protein. Cyborg feminists have to argue that 'we' do not want any more natural matrix of unity and that no construction is whole. Innocence, and the corollary insistence on victimhood as the only ground for insight, has done enough damage. But the constructed revolutionary subject must give late-twentieth-century people pause as well. In the fraying of identities and in the reflexive strategies for constructing them, the possibility opens up for weaving something other than a shroud for the day after the apocalypse that so prophetically ends salvation history.

Both Marxist/socialist feminisms and radical feminisms have simultaneously naturalized and denatured the category 'woman' and consciousness of the social lives of 'women'. Perhaps a schematic caricature can highlight both kinds of moves. Marxian socialism is rooted in an analysis of wage labour which reveals class structure. The consequence of the wage relationship is systematic alienation, as the worker is dissociated from his (*sic*) product. Abstraction and illusion rule in knowledge, domination rules in practice. Labour is the pre-eminently privileged category enabling the Marxist to overcome illusion and find that point of view which is necessary for changing the world. Labour is the humanizing activity that makes man; labour is an ontological category permitting the knowledge of a subject, and so the knowledge of subjugation and alienation.

In faithful filiation, socialist feminism advanced by allying itself with the basic analytic strategies of Marxism. The main achievement of both Marxist feminists and socialist feminists was to expand the category of labour to accommodate what (some) women did, even when the wage relation was subordinated to a more comprehensive view of labour under capitalist patriarchy. In particular, women's labour in the household and women's activity as mothers generally (that is, reproduction in the socialist feminist sense), entered theory on the authority of analogy to the Marxian concept of labour. The unity of women here rests on an epistemology based on the ontological structure of 'labour'. Marxist/socialist feminism does not 'naturalize' unity; it is a possible achievement based on a possible standpoint rooted in social relations. The essentializing move is in the ontological structure of labour or of its analogue, women's activity. The inheritance of Marxian humanism, with its pre-eminently Western self, is the difficulty for me. The contribution from these formulations has been the emphasis on the daily responsibility of real women to build unities, rather than to naturalize them.

Catherine MacKinnon's version of radical feminism is itself a caricature of the appropriating, incorporating, totalizing tendencies of Western theories of identity grounding action. It is factually and politically wrong to assimilate all of the diverse 'moments' or 'conversations' in recent women's politics named radical feminism to MacKinnon's version. But the teleological logic of her theory shows how an epistemology and ontology – including their negations – erase or police difference. Only one of the effects of MacKinnon's theory is the rewriting of the history of the polymorphous field called radical feminism. The major effect is the production of a theory of experience, of women's identity, that is a kind of apocalypse for all revolutionary standpoints. That is, the totalization built into this tale of radical feminism achieves its end – the unity of women – by enforcing the experience of and testimony to radical non-being. As for the Marxist/socialist feminist, consciousness is an achievement, not a natural fact. And MacKinnon's theory eliminates some of the difficulties built into humanist revolutionary subjects, but at the cost of radical reductionism.

MacKinnon argues that feminism necessarily adopted a different analytical strategy from Marxism, looking first not at the structure of class but at the structure of sex or gender and its generative relationship, men's constitution and appropriation of women sexually. Ironically, MacKinnon's 'ontology' constructs a non-subject, a non-being. Another's desire, not the self's labour, is

the origin of 'woman'. She therefore develops a theory of consciousness that enforces what can count as 'women's' experience – anything that names sexual violation, indeed, sex itself as far as 'women' can be concerned. Feminist practice is the construction of this form of consciousness; that is, the self-knowledge of a self-who-is-not.

Perversely, sexual appropriation in this feminism still has the epistemological status of labour; that is to say, the point from which an analysis able to contribute to changing the world must flow. But sexual objectification, not alienation, is the consequence of the structure of sex or gender. In the realm of knowledge, the result of sexual objectification is illusion and abstraction. However, a woman is not simply alienated from her product, but in a deep sense does not exist as a subject, or even potential subject, since she owes her existence as a woman to sexual appropriation. To be constituted by another's desire is not the same thing as to be alienated in the violent separation of the labourer from his product.

MacKinnon's radical theory of experience is totalizing in the extreme; it does not so much marginalize as obliterate the authority of any other women's political speech and action. It is a totalization producing what Western patriarchy itself never succeeded in doing – feminists' consciousness of the non-existence of women, except as products of men's desire. I think MacKinnon correctly argues that no Marxian version of identity can firmly ground women's unity. But in solving the problem of the contradictions of any Western revolutionary subject for feminist purposes, she develops an even more authoritarian doctrine of experience. If my complaint about socialist/Marxian standpoints is their unintended erasure of polyvocal, unassimilable, radical difference made visible in anticolonial discourse and practice, MacKinnon's intentional erasure of all difference through the device of the 'essential' non-existence of women is not reassuring.

In my taxonomy, which like any other taxonomy is a re-inscription of history, radical feminism can accommodate all the activities of women named by socialist feminists as forms of labour only if the activity can somehow be sexualized. Reproduction had different tones of meanings for the two tendencies, one rooted in labour, one in sex, both calling the consequences of domination and ignorance of social and personal reality 'false consciousness'.

Beyond either the difficulties or the contributions in the argument of any one author, neither Marxist nor radical feminist points of view have tended to embrace the status of a partial explanation; both were regularly constituted as totalities. Western explanation has demanded as much; how else could the 'Western' author incorporate its others? Each tried to annex other forms of domination by expanding its basic categories through analogy, simple listing, or addition. Embarrassed silence about race among white radical and socialist feminists was one major, devastating political consequence. History and polyvocality disappear into political taxonomies that try to establish genealogies. There was no structural room for race (or for much else) in theory claiming to reveal the construction of the category woman and social group women as a unified or totalizable whole. The structure of my caricature looks like this:

socialist feminism – structure of class // wage labour // alienation
labour, by analogy reproduction, by extension sex, by addition race

 radical feminism – structure of gender // sexual appropriation // objecti-
 fication
 sex, by analogy labour, by extension reproduction, by addition race

In another context, the French theorist, Julia Kristeva, claimed that women appeared as a historical group after the Second World War, along with groups like youth. Her dates are doubtful; but we are now accustomed to remembering that as objects of knowledge and as historical actors, 'race' did not always exist, 'class' has a histori-cal genesis, and 'homosexuals' are quite junior. It is no accident that the symbolic system of the family of man – and so the essence of woman – breaks up at the same moment that networks of connection among people on the planet are unprecedent-edly multiple, pregnant and complex. 'Advanced capitalism' is inadequate to con-vey the structure of this historical moment. In the 'Western' sense, the end of man is at stake. It is no accident that woman disintegrates into women in our time. Perhaps socialist feminists were not substantially guilty of producing essentialist theory that suppressed women's particularity and contradictory interests. I think we have been, at least through unreflective participation in the logics, languages, and practices of white humanism and through searching for a single ground of domina-tion to secure our revolutionary voice. Now we have less excuse. But in the consciousness of our failures, we risk lapsing into boundless difference and giving up on the confusing task of making partial, real connection. Some differences are playful; some are poles of world historical systems of domination. 'Epistemology' is about knowing the difference.

The informatics of domination

In this attempt at an epistemological and political position, I would like to sketch a picture of possible unity, a picture indebted to socialist and feminist principles of design. The frame for my sketch is set by the extent and importance of rearrange-ments in worldwide social relations tied to science and technology. I argue for a politics rooted in claims about fundamental changes in the nature of class, race, and gender in an emerging system of world order analogous in its novelty and scope to that created by industrial capitalism; we are living through a movement from an organic, industrial society to a polymorphous, information system – from all work to all play, a deadly game. Simultaneously material and ideological, the dichotomies may be expressed in the following chart of transitions from the comfortable old hierarchical dominations to the scary new networks I have called the informatics of domination:

Representation	Simulation
Bourgeois novel, realism	Science fiction, postmodernism
Organism	Biotic component
Depth, integrity	Surface, boundary
Heat	Noise
Biology as clinical practice	Biology as inscription
Physiology	Communications engineering

Small group	Subsystem
Perfection	Optimization
Eugenics	Population Control
Decadence, *Magic Mountain*	Obsolescence, *Future Shock*
Hygiene	Stress Management
Microbiology, tuberculosis	Immunology, AIDS
Organic division of labour	Ergonomics/cybernetics of labour
Functional specialization	Modular construction
Reproduction	Replication
Organic sex role specialization	Optimal genetic strategies
Biological determinism	Evolutionary inertia, constraints
Community ecology	Ecosystem
Racial chain of being	Neo-imperialism, United Nations humanism
Scientific management in home/factory	Global factory/electronic cottage
Family/market/factory	Women in the Integrated Circuit
Family wage	Comparable worth
Public/private	Cyborg citizenship
Nature/culture	Fields of difference
Co-operation	Communications enhancement
Freud	Lacan
Sex	Genetic engineering
Labour	Robotics
Mind	Artificial Intelligence
Second World War	Star Wars
White capitalist patriarchy	Informatics of domination

This list suggests several interesting things. First, the objects on the right-hand side cannot be coded as 'natural', a realization that subverts naturalistic coding for the left-hand side as well. We cannot go back ideologically or materially. It's not just that 'god' is dead; so is the 'goddess'. Or both are revivified in the worlds charged with microelectronic and biotechnological politics. In relation to objects like biotic components, one must think not in terms of essential properties, but in terms of design, boundary constraints, rates of flows, systems logics, costs of lowering constraints. Sexual reproduction is one kind of reproductive strategy among many, with costs and benefits as a function of the system environment. Ideologies of sexual reproduction can no longer reasonably call on notions of sex and sex role as organic aspects in natural objects like organisms and families. Such reasoning will be unmasked as irrational, and ironically corporate executives reading *Playboy* and anti-porn radical feminists will make strange bedfellows in jointly unmasking the irrationalism.

Likewise for race, ideologies about human diversity have to be formulated in terms of frequencies of parameters, like blood groups or intelligence scores. It is 'irrational' to invoke concepts like primitive and civilized. For liberals and radicals, the search for integrated social systems gives way to a new practice called 'experimental ethnography' in which an organic object dissipates in attention to

the play of writing. At the level of ideology, we see translations of racism and colonialism into languages of development and under-development, rates and constraints of modernization. Any objects or persons can be reasonably thought of in terms of disassembly and reassembly; no 'natural' architectures constrain system design. The financial districts in all the world's cities, as well as the export-processing and free-trade zones, proclaim this elementary fact of 'late capitalism'. The entire universe of objects that can be known scientifically must be formulated as problems in communications engineering (for the managers) or theories of the text (for those who would resist). Both are cyborg semiologies.

One should expect control strategies to concentrate on boundary conditions and interfaces, on rates of flow across boundaries – and not on the integrity of natural objects. 'Integrity' or 'sincerity' of the Western self gives way to decision procedures and expert systems. For example, control strategies applied to women's capacities to give birth to new human beings will be developed in the languages of population control and maximization of goal achievement for individual decision-makers. Control strategies will be formulated in terms of rates, costs of constraints, degrees of freedom. Human beings, like any other component or subsystem, must be localized in a system architecture whose basic modes of operation are probabilistic, statistical. No objects, spaces, or bodies are sacred in themselves; any component can be interfaced with any other if the proper standard, the proper code, can be constructed for processing signals in a common language. Exchange in this world transcends the universal translation effected by capitalist markets that Marx analysed so well. The privileged pathology affecting all kinds of components in this universe is stress – communications breakdown. The cyborg is not subject to Foucault's biopolitics; the cyborg simulates politics, a much more potent field of operations.

This kind of analysis of scientific and cultural objects of knowledge which have appeared historically since the Second World War prepares us to notice some important inadequacies in feminist analysis which has proceeded as if the organic, hierarchical dualisms ordering discourse in 'the West' since Aristotle still ruled. They have been cannibalized. The dichotomies between mind and body, animal and human, organism and machine, public and private, nature and culture, men and women, primitive and civilized are all in question ideologically. The actual situation of women is their integration or exploitation into a world system of production/reproduction and communication called the informatics of domination. The home, workplace, market, public arena, the body itself – all can be dispersed and interfaced in nearly infinite, polymorphous ways, with large consequences for women and others – consequences that themselves are very different for different people and which make potent oppositional international movements difficult to imagine and essential for survival. One important route for reconstructing socialist-feminist politics is through theory and practice addressed to the social relations of science and technology, including crucially the systems of myth and meanings structuring our imaginations. The cyborg is a kind of disassembled and reassembled, postmodern collective and personal self. This is the self feminists must code.

Communications technologies and biotechnologies are the crucial tools recrafting our bodies. These tools embody and enforce new social relations for women

worldwide. Technologies and scientific discourses can be partially understood as formalizations, i.e., as frozen moments, of the fluid social interactions constituting them, but they should also be viewed as instruments for enforcing meanings. The boundary is permeable between tool and myth, instrument and concept, historical systems of social relations and historical anatomies of possible bodies, including objects of knowledge. Indeed, myth and tool mutually constitute each other.

Furthermore, communications sciences and modern biologies are constructed by a common move – *the translation of the world into a problem of coding*, a search for a common language in which all resistance to instrumental control disappears and all heterogeneity can be submitted to disassembly, reassembly, investment, and exchange.

In communications sciences, the translation of the world into a problem in coding can be illustrated by looking at cybernetic (feedback-controlled) systems theories applied to telephone technology, computer design, weapons deployment, or data base construction and maintenance. In each case, solution to the key questions rests on a theory of language and control; the key operation is determining the rates, directions, and probabilities of flow of a quantity called information. The world is subdivided by boundaries differentially permeable to information. Information is just that kind of quantifiable element (unit, basis of unity) which allows universal translation, and so unhindered instrumental power (called effective communication). The biggest threat to such power is interruption of communication. Any system breakdown is a function of stress. The fundamentals of this technology can be condensed into the metaphor C^3I, command-control-communication-intelligence, the military's symbol for its operations theory.

In modern biologies, the translation of the world into a problem in coding can be illustrated by molecular genetics, ecology, sociobiological evolutionary theory, and immunobiology. The organism has been translated into problems of genetic coding and read-out. Biotechnology, a writing technology, informs research broadly. In a sense, organisms have ceased to exist as objects of knowledge, giving way to biotic components, i.e., special kinds of information-processing devices. The analogous moves in ecology could be examined by probing the history and utility of the concept of the ecosystem. Immunobiology and associated medical practices are rich exemplars of the privilege of coding and recognition systems as objects of knowledge, as constructions of bodily reality for us. Biology here is a kind of cryptography. Research is necessarily a kind of intelligence activity. Ironies abound. A stressed system goes awry; its communication processes break down; it fails to recognize the difference between self and other. Human babies with baboon hearts evoke national ethical perplexity – for animal rights activists at least as much as for the guardians of human purity. In the US gay men and intravenous drug users are the 'privileged' victims of an awful immune system disease that marks (inscribes on the body) confusion of boundaries and moral pollution.

But these excursions into communications sciences and biology have been at a rarefied level; there is a mundane, largely economic reality to support my claim that these sciences and technologies indicate fundamental transformations in the structure of the world for us. Communications technologies depend on electronics. Modern states, multinational corporations, military power, welfare state

apparatuses, satellite systems, political processes, fabrication of our imaginations, labour-control systems, medical constructions of our bodies, commercial pornography, the international division of labour, and religious evangelism depend intimately upon electronics. Microelectronics is the technical basis of simulacra; that is, of copies without originals.

Microelectronics mediates the translations of labour into robotics and word processing, sex into genetic engineering and reproductive technologies, and mind into artificial intelligence and decision procedures. The new biotechnologies concern more than human reproduction. Biology as a powerful engineering science for redesigning materials and processes has revolutionary implications for industry, perhaps most obvious today in areas of fermentation, agriculture, and energy. Communications sciences and biology are constructions of natural-technical objects of knowledge in which the difference between machine and organism is thoroughly blurred; mind, body, and tool are on very intimate terms. The 'multinational' material organization of the production and reproduction of daily life and the symbolic organization of the production and reproduction of culture and imagination seem equally implicated. The boundary-maintaining images of base and superstructure, public and private, or material and ideal never seemed more feeble.

I have used Rachael Grossman's image of women in the integrated circuit to name the situation of women in a world so intimately restructured through the social relations of science and technology. I used the odd circumlocution, 'the social relations of science and technology', to indicate that we are not dealing with a technological determinism, but with a historical system depending upon structured relations among people. But the phrase should also indicate that science and technology provide fresh sources of power, that we need fresh sources of analysis and political action. Some of the rearrangements of race, sex, and class rooted in high-tech-facilitated social relations can make socialist feminism more relevant to effective progressive politics.

The 'homework economy' outside 'the home'

The 'New Industrial Revolution' is producing a new worldwide working class, as well as new sexualities and ethnicities. The extreme mobility of capital and the emerging international division of labour are intertwined with the emergence of new collectivities, and the weakening of familiar groupings. These developments are neither gender- nor race-neutral. White men in advanced industrial societies have become newly vulnerable to permanent job loss, and women are not disappearing from the job rolls at the same rates as men. It is not simply that women in Third World countries are the preferred labour force for the science-based multinationals in the export-processing sectors, particularly in electronics. The picture is more systematic and involves reproduction, sexuality, culture, consumption, and production. In the prototypical Silicon Valley, many women's lives have been structured around employment in electronics-dependent jobs, and their intimate realities include serial heterosexual monogamy, negotiating childcare, distance from extended kin or most other forms of traditional community, a high

likelihood of loneliness and extreme economic vulnerability as they age. The ethnic and racial diversity of women in Silicon Valley structures a microcosm of conflicting differences in culture, family, religion, education, and language.

Richard Gordon has called this new situation the 'homework economy'. Although he includes the phenomenon of literal homework emerging in connection with electronics assembly, Gordon intends 'homework economy' to name a restructuring of work that broadly has the characteristics formerly ascribed to female jobs, jobs literally done only by women. Work is being redefined as both literally female and feminized, when performed by men or women. To be feminized means to be made extremely vulnerable; able to be disassembled, reassembled, exploited as a reserve labour force; seen less as workers than as servers; subjected to time arrangements on and off the paid job that make a mockery of a limited work day; leading an existence that always borders on being obscene, out of place, and reducible to sex. Deskilling is an old strategy newly applicable to formerly privileged workers. However, the homework economy does not refer only to large-scale deskilling, nor does it deny that new areas of high skill are emerging, even for women and men previously excluded from skilled employment. Rather, the concept indicates that factory, home and market are integrated on a new scale and that the places of women are crucial – and need to be analysed for differences among women and for meanings for relations between men and women in various situations.

The homework economy as a world capitalist organizational structure is made possible by (not caused by) the new technologies. The success of the attack on relatively privileged, mostly white, men's unionized jobs is tied to the power of the new communications technologies to integrate and control labour despite extensive dispersion and decentralizaton. The consequences of the new technologies are felt by women both in the loss of the family (male) wage (if they ever had access to this white privilege) and in the character of their own jobs, which are becoming capital-intensive; for example, office work and nursing.

The new economic and technological arrangements are also related to the collapsing welfare state and the ensuing intensification of demands on women to sustain daily life for themselves as well as for men, children, and old people. The feminization of poverty – generated by dismantling the welfare state, by the homework economy where stable jobs become the exception, and sustained by the expectation that women's wages will not be matched by a male income for the support of children – has become an urgent focus. The causes of various women-headed households are a function of race, class, or sexuality; but their increasing generality is a ground for coalitions of women on many issues. That women regularly sustain daily life partly as a function of their enforced status as mothers is hardly new; the kind of integration with the overall capitalist and progressively war-based economy is new. The particular pressure, for example, on US black women, who have achieved an escape from (barely) paid domestic service and who now hold clerical and similar jobs in large numbers, has large implications for continued enforced black poverty *with* employment. Teenage women in industrializing areas of the Third World increasingly find themselves the sole or major source of a cash wage for their families, while access to land is ever more problematic. These developments must have major consequences in the psychodynamics and politics of gender and race.

Within the framework of three major stages of capitalism (commercial or early industrial, monopoly, multinational) – tied to nationalism, imperialism, and multi-nationalism, and related to Jameson's three dominant aesthetic periods of realism, modernism, and postmodernism – I would argue that specific forms of families dialectically relate to forms of capital and to its political and cultural concomitants. Although lived problematically and unequally, ideal forms of these families might be schematized as, first, the patriarchal nuclear family, structured by the dichotomy between public and private and accompanied by the white bourgeois ideology of sep-arate spheres and nineteenth-century Anglo-American bourgeois feminism; second, the modern family mediated (or enforced) by the welfare state and institutions like the family wage, with a flowering of afeminist heterosexual ideologies, including their radical versions represented in Greenwich Village around the First World War; and, third, the 'family' of the homework economy with its oxymoronic structure of women-headed households and its explosion of feminisms and the paradoxical inten-sification and erosion of gender itself. This is the context in which the projections for worldwide structural unemployment stemming from the new technologies are part of the picture of the homework economy. As robotics and related technologies put men out of work in 'developed' countries and exacerbate failure to generate male jobs in Third World 'development', and as the automated office becomes the rule even in labour-surplus countries, the feminization of work intensifies. Black women in the United States have long known what it looks like to face the struc-tural underemployment ('feminization') of black men, as well as their own highly vulnerable position in the wage economy. It is no longer a secret that sexuality, reproduction, family, and community life are interwoven with this economic struc-ture in myriad ways which have also differentiated the situations of white and black women. Many more women and men will contend with similar situations, which will make cross-gender and cross-race alliances on issues of basic life support (with or without jobs) necessary, not just nice.

The new technologies also have a profound effect on hunger and on food production for subsistence worldwide. Rae Lessor Blumberg estimates that women produce about 50 per cent of the world's subsistence food. Women are excluded generally from benefiting from the increased high-tech commodification of food and energy crops, their days are made more arduous because their responsibilities to provide food do not diminish, and their reproductive situations are made more complex. Green Revolution technologies interact with other high-tech industrial production to alter gender divisions of labour and differential gender migration patterns.

The new technologies seem deeply involved in the forms of 'privatization' that Ros Petchesky has analysed, in which militarization, right-wing family ideologies and policies, and intensified definitions of corporate (and state) property as private synergistically interact. The new communications technologies are fundamental to the eradication of 'public life' for everyone. This facilitates the mushrooming of a permanent high-tech military establishment at the cultural and economic expense of most people, but especially of women. Technologies like video games and highly miniaturized televisions seem crucial to production of modern forms of 'private life'. The culture of video games is heavily orientated to individual competition and extraterrestrial warfare. High-tech, gendered imaginations are produced here,

imaginations that can contemplate destruction of the planet and a sci-fi escape from its consequences. More than our imaginations is militarized; and the other realities of electronic and nuclear warfare are inescapable. These are the technologies that promise ultimate mobility and perfect exchange – and incidentally enable tourism, that perfect practice of mobility and exchange, to emerge as one of the world's largest single industries.

The new technologies affect the social relations of both sexuality and of reproduction, and not always in the same ways. The close ties of sexuality and instrumentality, of views of the body as a kind of private satisfaction – and utility-maximizing machine, are described nicely in sociobiological origin stories that stress a genetic calculus and explain the inevitable dialectic of domination of male and female gender roles. These sociobiological stories depend on a high-tech view of the body as a biotic component or cybernetic communications system. Among the many transformations of reproductive situations is the medical one, where women's bodies have boundaries newly permeable to both 'visualization' and 'intervention'. Of course, who controls the interpretation of bodily boundaries in medical hermeneutics is a major feminist issue. The speculum served as an icon of women's claiming their bodies in the 1970s; that handcraft tool is inadequate to express our needed body politics in the negotiation of reality in the practices of cyborg reproduction. Self-help is not enough. The technologies of visualization recall the important cultural practice of hunting with the camera and the deeply predatory nature of a photographic consciousness. Sex, sexuality, and reproduction are central actors in high-tech myth systems structuring our imaginations of personal and social possibility.

Another critical aspect of the social relations of the new technologies is the reformulation of expectations, culture, work, and reproduction for the large scientific and technical workforce. A major social and political danger is the formation of a strongly bimodal social structure, with the masses of women and men of all ethnic groups, but especially people of colour, confined to a homework economy, illiteracy of several varieties, and general redundancy and impotence, controlled by high-tech repressive apparatuses ranging from entertainment to surveillance and disappearance. An adequate socialist feminist politics should address women in the privileged occupational categories, and particularly in the production of science and technology that constructs scientific-technical discourses, processes, and objects.

This issue is only one aspect of enquiry into the possibility of a feminist science, but it is important. What kind of constitutive role in the production of knowledge, imagination, and practice can new groups doing science have? How can these groups be allied with progressive social and political movements? What kind of political accountability can be constructed to tie women together across the scientific-technical hierarchies separating us? Might there be ways of developing feminist science/technology politics in alliance with anti-military science facility conversion action groups? Many scientific and technical workers in Silicon Valley, the high-tech cowboys included, do not want to work on military science. Can these personal preferences and cultural tendencies be welded into progressive politics among this professional middle class in which women, including women of colour, are coming to be fairly numerous?

Women in the integrated circuit

Let me summarize the picture of women's historical locations in advanced industrial societies, as these positions have been restructured partly through the social relations of science and technology. If it was ever possible ideologically to characterize women's lives by the distinction of public and private domains – suggested by images of the division of working-class life into factory and home, of bourgeois life into market and home, and of gender existence into personal and political realms – it is now a totally misleading ideology, even to show how both terms of these dichotomies construct each other in practice and in theory. I prefer a network ideological image, suggesting the profusion of spaces and identities and the permeability of boundaries in the personal body and in the body politic. 'Networking' is both a feminist practice and a multinational corporate strategy – weaving is for oppositional cyborgs.

So let me return to the earlier image of the informatics of domination and trace one vision of women's 'place' in the integrated circuit, touching only a few idealized social locations seen primarily from the point of view of advanced capitalist societies: Home, Market, Paid Work Place, State, School, Clinic-Hospital, and Church. Each of these idealized spaces is logically and practically implied in every other locus, perhaps analogous to a holographic photograph. I want to suggest the impact of the social relations mediated and enforced by the new technologies in order to help formulate needed analysis and practical work. However, there is no 'place' for women in these networks, only geometrics of difference and contradiction crucial to women's cyborg identities. If we learn how to read these webs of power and social life, we might learn new couplings, new coalitions. There is no way to read the following list from a standpoint of 'identification', of a unitary self. The issue is dispersion. The task is to survive in the diaspora.

Home. Women-headed households, serial monogamy, flight of men, old women alone, technology of domestic work, paid homework, re-emergence of home sweatshops, home-based businesses and telecommuting, electronic cottage, urban homelessness, migration, module architecture, reinforced (simulated) nuclear family, intense domestic violence.

Market. Women's continuing consumption work, newly targeted to buy the profusion of new production from the new technologies (especially as the competitive race among industrialized and industrializing nations to avoid dangerous mass unemployment necessitates finding ever bigger new markets for ever less clearly needed commodities); bimodal buying power, coupled with advertising targeting of the numerous affluent groups and neglect of the previous mass markets; growing importance of informal markets in labour and commodities parallel to high-tech, affluent market structures; surveillance systems through electronic funds transfer; intensified market abstraction (commodification) of experience, resulting in ineffective utopian or equivalent cynical theories of community; extreme mobility (abstraction) of marketing or financing systems; interpenetration of sexual and labour markets; intensified sexualization of abstracted and alienated consumption.

Paid Work Place. Continued intense sexual and racial division of labour, but considerable growth of membership in privileged occupational categories for many white women and people of colour; impact of new technologies on women's work

in clerical, service, manufacturing (especially textiles), agriculture, electronics; international restructuring of the working classes; development of new time arrangements to facilitate the homework economy (flexi time, part time, over time, no time); homework and out work; increased pressures for two-tiered wage structures; significant numbers of people in cash-dependent populations worldwide with no experience or no further hope of stable employment; most labour 'marginal' or 'feminized'.

State. Continued erosion of the welfare state; decentralizations with increased surveillance and control; citizenship by telematics; imperialism and political power broadly in the form of information-rich/information-poor differentiation; increased high-tech militarization increasingly opposed by many social groups; reduction of civil service jobs as a result of the growing capital intensification of office work, with implications for occupational mobility for women of colour; growing privatization of material and ideological life and culture; close integration of privatization and militarization, the high-tech forms of bourgeois capitalist personal and public life; invisibility of different social groups to each other, linked to psychological mechanisms of belief in abstract enemies.

School. Deepening coupling of high-tech capital needs and public education at all levels, differentiated by race, class, and gender; managerial classes involved in educational reform and refunding at the cost of remaining progressive educational democratic structures for children and teachers; education for mass ignorance and repression in technocratic and militarized culture; growing anti-science mystery cults in dissenting and radical political movements; continued relative scientific illiteracy among white women and people of colour; growing industrial direction of education (especially higher education) by science-based multinationals (particularly in electronics-dependent and biotechnology-dependent companies); highly educated, numerous elites in a progressively bimodal society.

Clinic-hospital. Intensified machine–body relations; renegotiations of public metaphors which channel personal experience of the body, particularly in relation to reproduction, immune system functions, and 'stress' phenomena; intensification of reproductive politics in response to world historical implications of women's unrealized, potential control of their relation to reproduction; emergence of new, historically specific diseases; struggles over meanings and means of health in environments pervaded by high technology products and processes; continuing feminization of health work; intensified struggle over state responsibility for health; continued ideological role of popular health movements as a major form of American politics.

Church. Electronic fundamentalist 'super-saver' preachers solemnizing the union of electronic capital and automated fetish gods; intensified importance of churches in resisting the militarized state; central struggle over women's meanings and authority in religion; continued relevance of spirituality, intertwined with sex and health, in political struggle.

The only way to characterize the informatics of domination is as a massive intensification of insecurity and cultural impoverishment, with common failure of subsistence networks for the most vulnerable. Since much of this picture interweaves with the social relations of science and technology, the urgency of a socialist feminist politics addressed to science and technology is plain. There is much now

being done, and the grounds for political work are rich. For example, the efforts to develop forms of collective struggle for women in paid work should be a high priority for all of us. These efforts are profoundly tied to technical restructuring of labour processes and reformations of working classes. These efforts also are providing understanding of a more comprehensive kind of labour organization, involving community, sexuality, and family issues never privileged in the largely white male industrial unions.

The structural rearrangements related to the social relations of science and technology evoke strong ambivalence. But it is not necessary to be ultimately depressed by the implications of late twentieth-century women's relation to all aspects of work, culture, production of knowledge, sexuality, and reproduction. For excellent reasons, most Marxisms see domination best and have trouble under-standing what can only look like false consciousness and people's complicity in their own domination in late capitalism. It is crucial to remember that what is lost, perhaps especially from women's points of view, is often virulent forms of oppression, nostalgically naturalized in the face of current violation. Ambivalence towards the disrupted unities mediated by high-tech culture requires not sorting consciousness into categories of 'clear-sighted critique grounding a solid political epistemology' versus 'manipulated false consciousness', but subtle understanding of emerging pleasures, experiences, and powers with serious potential for changing the rules of the game.

There are grounds for hope in the emerging bases for new kinds of unity across race, gender, and class, as these elementary units of socialist feminist analysis them-selves suffer protean transformations. Intensifications of hardship experienced worldwide in connection with the social relations of science and technology are severe. But what people are experiencing is not transparently clear, and we lack suf-ficiently subtle connections for collectively building effective theories of experience. Present efforts – Marxist, psychoanalytic, feminist, anthropological – to clarify even 'our' experience are rudimentary.

I am conscious of the odd perspective provided by my historical position – a PhD in biology for an Irish Catholic girl was made possible by Sputnik's impact on US national science-education policy. I have a body and mind as much constructed by the post-Second-World-War arms race and Cold War as by the women's movements. There are more grounds for hope in focusing on the contra-dictory effects of politics designed to produce loyal American technocrats, which also produced large numbers of dissidents, than in focusing on the present defeats.

The permanent partiality of feminist points of view has consequences for our expectations of forms of political organization and participation. We do not need a totality in order to work well. The feminist dream of a common language, like all dreams for a perfectly true language, or perfectly faithful naming of experi-ence, is a totalizing and imperialist one. In that sense, dialectics too is a dream language, longing to resolve contradiction. Perhaps, ironically, we can learn from our fusions with animals and machines how not to be Man, the embodiment of Western *logos*. From the point of view of pleasure in these potent and taboo fusions, made inevitable by the social relations of science and technology, there might indeed be a feminist science.

Andrew Ross

THE CHALLENGE OF SCIENCE

EDITOR'S INTRODUCTION

I N THIS ESSAY, Andrew Ross asks two questions. The first is very general: "Who is qualified to critique science?", and the second rather more specific: "What has cultural studies to say about science?" These questions derive their energy by breaking out from the usual hands-off-science mentality which, Ross suggests, has its origins in the sociologist Max Weber's positing of a value-free humanities in his famous 1918 address, "Science as a vocation," largely as a riposte to German antisemitism of the time. In fact a great deal of Ross's essay is devoted to explaining *why* science needs critique.

For Ross, working in the United States, technoscience is the ultimate horizon of most post-Second-World-War academic work, even in the humanities. That is where the money comes from. The implications of this have not sufficiently filtered through into cultural studies, which too often still assumes a hard culture/science division, and accepts scientific resistance to non-scientists' examining the social and cultural grounds and effects of their work. That resistance has only been increased by the various attacks on cultural studies' supposed incompetence in the field, of which the most influential have been by Gross and Levitt (1994) and Alan Sokal (Sokal and Bricmont 1997) – Sokal becoming notorious after the scandal which followed his hoodwinking the editors of *Social Text* by palming off a parodic essay on to their journal.

Ross's sensible and modest essay is a riposte to claims that cultural studies is a pseudo-discipline, lacking the conceptual rigor to deal with issues like the effect of science on society and culture. He argues that because science permeates and shapes modern culture so powerfully and divisively, it would be irresponsible not to analyze it and its effects from the outside, and ask of it: what are you doing to create a fairer, less risky society?

Further reading: Franklin 1995; Haraway 1991, 1997; Harding 1995; Ross 1991, 1994, 1996.

1

When future historians, as the cliché goes, survey the modern versions of the division of knowledge, what will seem most anachronistic? One of the likely contenders will be the strong pact by which the empirical pursuit of reason, at one end of the field, was guaranteed immunity from socio-political scrutiny at the same time as the ethical realm of values, at the other end, was relieved of any obligation to respond to advances in scientific knowledge. This entente proved to be the source of the dominant traditions of inquiry in the natural sciences and the humanities for most of the twentieth century. Science would undertake to provide neutral, public knowledge in a value-free setting so that humanists could grapple with the corrosive, contradictory life of social, cultural, and political issues in a milieu barred to technical experts; and vice versa.

For different reasons, this entente worked to the advantage of both traditions, reaffirming core elements of their respective professional ethics. Arguably, the greatest value has accrued to managerial elites, whether in the academy, in business, or in politics, who have benefited from the separation of the realm of facts from that of values: administrative control can be established with ease once employees or subjects have acknowledged the principle of 'that's not my department'. But the mutual pact also meant different things at different times. Robert Proctor has described, for example, how the social sciences initially sought the value-free imprimatur of science – Weber's *Wertfreiheit* – in order to build a protective neutrality zone against political coercion, primarily from the right, since sociology was perceived first as a socialist, and then, by the Nazis, as a Jewish discipline. The value-free neutrality of this paradigm had an especial appeal to the American academy in the 'end of ideology' period of the Cold War. For its critics, the ascendancy of the principle of *Wertfreiheit* over the course of the next two decades came to signify political quietism in the social sciences, and selling one's skills to the highest bidders in the natural sciences. In the humanities, a cognate set of 'self-evident' principles of taste – crystallized in the concept of the literary 'canon' – encouraged a formalist dogma whose death throes engendered the bitter spectacle of the Culture Wars in political life at the end of the 1980s. The powerful Cold War consensus that had ruled out of court any attention to the institutional arrangement or social conditions of knowledge did not end with a whimper.

So when C. P. Snow issued his famous mid-century complaint about the increasing divergence of the 'two cultures', he was describing a condition that was not so much tendential as contractual. And since science had long since become the dominant civil authority in society, there was no real symmetry in this arrangement. While humanists preferred to think of the field of knowledge as an even spectrum, running from hard sciences to the fine arts, logical positivists of the Vienna circle reflected the much greater cultural power of abstract reason in their

topographical choice of a hierarchy, with physics at the very top. Accordingly, for Snow, and those who swallowed his story about the two cultures, the burden of education fell not upon scientists but upon humanists whose alleged technophobia had made them anachronistic legatees of a Romantic past, ill-equipped to face the challenge, technocratic or otherwise, of the future. For too long, Snow's fellow British intellectuals had followed William Blake's thunder, and paid too little heed to what Harold Wilson would shortly come to call the 'white heat of the technological revolution'. While Snow's polite thesis almost immediately became part of the folklore of intellectual life, there was little evidence that science was taken any more seriously as a cultural force. Speaking from the heart of the radical science movement in the early 1970s, Hilary Rose and Steven Rose lamented that there had been virtually no discussion of science's *cultural* role in central New Left history surveys like Raymond Williams's *The Long Revolution* or Perry Anderson's *The Components of the National Culture* (Rose and Rose 1976: 13). In the more pragmatic US, things were little better. Scan the writings of the New York Intellectuals, or the more academic tracts of postmodernism and multiculturalism in the 1970s and 1980s, and sustained engagement with the institutions of science is thin on the ground, despite feminism's sweeping indictment, during the same period, of the long history of biological and medical disciplining of women.

In recent years, however, it is not the education of humanists but the education of scientists that has been questioned. Fears about 'scientific illiteracy' are now more often applied, as Sandra Harding puts it, to the 'Eurocentrism and androcentrism of many scientists, policymakers and highly educated citizens' with an outcome that 'severely limits public understanding of science as a fully social process'. Such influential people, she argues, need 'a kind of scientific education' – rooted in social experience – 'that has not been available to them' (Harding 1995: 1). Indeed, the cloistered scientist, shielded from self-critical knowledge about the social origins and conditions of his or her instruments, empirical methods, and research applications, has emerged as a much greater danger to our social and environmental survival than the cloistered humanist. In view of the restructuring of our business civilization around the future of technoscience and biomedicine, the narrow, technical education of a small number of Western scientists has far-reaching consequences for everyone else. The long history of science serving as the handmaiden of militarism and capital accumulation may only be a prelude to the role being cast by today's corporations for their own technoscientific workforce and their subcontracted hands in the academy. Indeed, the social education of scientists is increasingly seen as one of the more important pedagogical tasks of the day.

Does cultural studies have some part to play in this education? The knowledge that science is not only socially determined but also culturally specific has modern scholarly lineage that dates back at least to the famous paper given by Soviet historian of science Boris Hessen at a London conference in 1931, in which he demonstrated how Newton's *Principia* responded to the emergent needs of British mercantile capitalism: particularly in the areas of transportation, communications and military production. This knowledge was subsequently drawn out in the work of J. D. Bernal, J. B. S. Haldane, and Joseph Needham. The externalism of these British Marxists was displaced and depoliticized in the Mertonian school

of the sociology of science and in Kuhn's influential volume on scientific revolutions, and then revived in a more empirical form in the 1970s movement known as SSK (sociology of scientific knowledge), with its many factional variants (Edinburgh, Bath, Paris, York, Tremont) and recent offshoots. The radical science movement that grew out of the anti-war movement in the late 1960s established 'science for the people' as a rallying cry, while the US academic field of STS came to maturity with its less radical, vocational agenda of democratizing technoscience. Today's burgeoning field of science studies is driven by assumptions and principles that are consonant with cultural studies, and includes prominent practitioners, mostly feminists, who are quite comfortable working under, or adjacent to, the rubric of cultural studies. Indeed, the watchword of 'science as culture' (also the name of the splendid journal that succeeded the *Radical Science Journal*) has come to be an eclectic rubric, including not only ethnographic attention to the minutiae of scientific culture, and the analyses of the role of science and scientific authority in the culture at large, but also interventions in matters of science policy and ideology. This is the point at which the broad tradition of cultural studies meets up with developments in science studies – when a continuum of power is established between the interests of the state and the expressive, daily realm of rituals.

The most consistent origin story for cultural studies describes it as the adulterated offspring of an insurgent sociology in revolt against Parsonian functionalism, and a 'left-Leavisite' cultural criticism (minus the high cultural elitism), pledged against what F. R. Leavis had called 'technologico-Benthamite civilization' and its rule of utilitarian reason. In this account, cultural studies has always been in flight from particular forms of instrumental reason, although not from rationality as such. None the less, the cause it has primarily pursued – that of cultural politics – has often been trivialized, on the hard left, as a displacement of 'real' politics, and, ultimately, as a dangerous immersion in the destructive element of unreason – the stuff of nationalism, fascism, imperialism, and capitalist commodification. According to this view, which has deep roots in the doctrine of 'scientific socialism', the path of progressive politics is an insuperably rational development, whose objective processes are contaminated by attention to the 'subjective' factors posed by cultural issues. In the wake of the Culture Wars, which have propelled cultural issues and values to the forefront of the New Right's political agenda, this position, often described as 'unreconstructed', seems especially untenable. Consequently, cultural politics has emerged as legitimate, unavoidable, and indispensable. At least one outcome of the face-off between mono- and multi-culturalists is the recognition that people feel their right to cultural respect and civility as strongly as they feel their right to the benefits of a social wage. Consequently, full citizenship has come to be seen as a cultural, as well as a socio-economic, achievement.

What does this account of citizenship have to learn from cultural studies of science? Adherence to scientific reason is a constituent element of cultural belief in advanced industrial societies, even in countries like the US where a vast portion of the population also believes that the world was created in six days. The authority of science is thus a central vehicle of consent in a technocratic democracy. This authority is exercised largely through appeal to expertise, from the dismal science of the economists at the commanding heights of the corporate state to the routines

followed by technological dead labor in the workplace. Where scientific reason is the dominant cognitive authority, its cultural and economic role in maintaining a social system of inequalities must be open to analysis and to reform in ways that go far beyond internalist adjustments and purifications. While the value-free neutrality of the scientific method is the legitimating basis for empowered forms of technical expertise, scientists themselves rarely feel personally or professionally responsible for any of the social or political uses of the name of science. The division of labor that accompanies value-free ideology – 'that's not my department' – means that scientists have been able to disavow knowledge about the social origins or applications of their research. The model for this division of labor, of course, was the archetypal example of the 'abuse' of science – the Manhattan Project, where the specialized allocation of research tasks pre-empted any knowledge on the part of individual participants about the overmanagers' mission.

The state's utilitarian endorsement of the ideology of 'value-free science' has long been a source of criticism and activism, and most egregiously in a period when so many of the world's scientists have been involved in military research or its spin-off industries. Yet many scientists charge that the criticism of scientific research and its results is often uninformed or non-specific. In the 1970s, this complaint met with an empirical response in the 'descriptive turn' of the SSK school, represented in the work of Barry Barnes, David Bloor, Steve Shapin, Michael Mulkay, and Harry Collins, and followed by Nigel Gilbert, Joan Fujimura, Ian Hacking, Eric Livingston, Trevor Pinch, Sal Restivo, Nancy Cartwright, David Gooding, and others. Rather than study the products of science, or scientists' own representations of science, the strong program of SSK endorsed the rigorously sociological study of science in practice, through first-hand observation. This empirical approach generated research in three main genres: studies of scientific controversies; historical studies; and ethnographic accounts of laboratory procedures, such as Bruno Latour and Steve Woolgar's *Laboratory Life* (1979), Karen Knorr Cetina's *The Manufacture of Knowledge* (1981), Michael Lynch's *Art and Artifact in Laboratory Science* (1985) and Sharon Traweek's *Beamtimes and Lifetimes* (1988). Such studies, identifying the role played by social interests in every aspect of research, demonstrated that scientific knowledge is not given by the natural world but is produced or constructed through social interactions between/among scientists and their instruments, and that these interactions are mediated by the conceptual apparatuses created in order to frame and interpret the results. The knowledge produced is often so local and context-specific that it makes sense only in relation to the laboratory instruments, modes of analysis, and specialized textual practices engineered within a specific field.

The result of this kind of attention has been a more systematic description of 'science in action', better equipped to demystify scientists' perception that their research laboratories and working communities are value-free zones. Each zone, in turn, came to be seen as an intersection of various belief systems, patched together to form a seemingly coherent whole. But the relativism inherent in the descriptive turn was much criticized as a theory that ultimately declared the sociological equivalence of all beliefs, whether true or false according to internal or external criteria. It did little, as Steve Fuller has argued, to dislodge the elitist perception that only scientists can do science, and it shied away from all norma-

tive or evaluative analysis that might produce change in scientific institutions (Fuller 1992: 390–428). In opting for a program of social realism that eschewed value-laden or moralistic critique, SSK's passive 'explanation' of science's social and cultural construction was open to charges of quietism. Contrary to the positivist view of science which stressed the universality of scientific knowledge, SSK demonstrated that there was little distinctive to differentiate science from other social activities. But this evidence could not in itself lead to alternative ways of doing science. Nor would it suggest alternative criteria (i.e. other than those framed by the needs of the military, capital, or the state) to judge the successes and failures of science. Only normative critiques could change the status quo.

It could be argued that a similar set of concerns accompanied the ethnographic turn in cultural studies, coming, as it did, at a point where excessively abstract theorizing about 'spectators' and 'readers' had devolved attention away from the contexts in which people actually utilized culture. Turning its back on the long history, within cultural theory, of moralizing assumptions about the behavior and beliefs of 'the masses', cultural studies tried to relinquish patronizing value-judgements, sought to renounce recruitism, and vowed to find out instead what real people said, thought and did in their lived environments. The powerless and disenfranchised turned out to be creative, diverse, and, yes, resistant in response to the media flow in which they had been immersed. Intellectuals found a way to salve their separation from the popular classes, and in doing so, found a refuge from the pressures of bourgeois taste. And a much greater understanding of the processes of cultural consumption emerged. As in the case of SSK, criticism of this ethnographic turn appeals to the need to recommend and exhort alternatives to the status quo. Eschewing value-judgements (suspending opinions about whether cultural texts were good or bad) meant that critics also gave up the authority to demand change, a dereliction, in some respects, of the tradition of the 'responsibility of intellectuals' (see Brunsdon 1990). Since normative judgements of taste were hardly absent from the realm of popular opinion itself, the cultural studies classroom, as Simon Frith recently pointed out, became virtually the only place where the act of passing value-judgements was more or less prohibited (Frith 1996). By contrast, conservative intellectuals picked up the baton, and have been running away with the 'values' contest. Accordingly, this critique of the ethnographic phase of cultural studies has been largely responsible for the emergence of the new cadre of 'public intellectuals', pursuing the limited access available in the public, non-academic media to left-wing intellectuals.

In accord with similar developments in science studies, that part of cultural studies that has concerned itself with state policy (primarily in Australia, and, to a much lesser extent, in the UK) finds itself inevitably compromised not only by bureaucratic calculation but also by accommodation to the 'direction' of the corporate state. Attempts to redirect science policy or cultural policy towards the public interest or the service of social relevance have been obliged to abandon or dumb down their critiques and oppositional strategies. On the other hand, the route of institutional empowerment provides opportunities for reform of policies and structures rarely open to the fiercely independent dissident.

Clearly, the mutually exclusive attractions of administrative influence and prophetic opposition pull both ways for both fields. In addition, cultural studies

and science studies share the position of bridge disciplines, the former crossing humanities and the social sciences, the latter crossing social sciences and the natural sciences. So much is shared between the two fields that conservatives active in the recent Science Wars have been able to group together, in a spurious 'anti-science movement', as their common antagonists, social constructionists and postmodernists in both cultural studies and science studies. (The eclectic mix of arraigned 'irrationalists' also includes astrologists, eco-feminists, Afrocentrists, New Agers, and Christian fundamentalists.) Of course, there are many significant distinctions between these intellectual tendencies, but the immediate outcome of the Science Wars, as I shall discuss below, has been not only to encourage unity and alliances among these tendencies but to highlight more clearly the ideas, assumptions, and principles that lie at the core of scientific conservatism.

2

Every time I fly these days, I remind myself that I am sitting in a slightly modified bomber. After all, that is what civilian aircraft are. Sometimes, I even imagine that I am on a combat mission, in cynical sympathy perhaps, with my fellow flyers, many of whom (on weekdays, when I mostly travel to give lectures) are invariably business people, psyching themselves up for some hardball meeting with their regional peers. Most recently, I've had to think about the following, infamous statement made by Richard Dawkins in a September 1994 issue of the *Times Higher Education Supplement*: 'If it gives you satisfaction to say that the theory of aerodynamics is a social construct that is your privilege, but why do you entrust your air travel plans to a Boeing rather than a magic carpet . . . Show me a cultural relativist at 20,000 feet and I will show you a hypocrite.' As Sarah Franklin has retorted, 'Show me a person who denies that airplane design is a highly organized human social activity, and I'll show you an unreconstructed objectivist' (Franklin 1995). Philosophers like Wittgenstein used the desk or table as the favoured example of their ontological proofs and refutations. Currently, the airplane is a likely candidate as the object of choice in disputes within science studies. On the one hand, objectivists can invoke the irrefutability of the law of gravity, on the other, their antagonists can show how the history of entire sciences like the 'pure' mathematics of aerodynamics have been determined by military needs in ballistics research and technologies. We needn't even get into the history of how Newton came to apply the metaphor of *gravitas*, originally a human attribute, to the principle of mutual attraction between bodies. The metaphor eventually died off into literalness.

But the choice of the airplane would also be emotionally magnified, I suspect, by the complex set of fears and anxieties associated with the experience of civilian air flight, including a response to the rituals and institutions pioneered by military usage and preserved to this day in the culture of air transport. The massive surveillance at airports, the inflight physical experience of involuntary confinement and submission to centralized commands, and the rituals of national identification that accompany border crossing, are more evocative of military service than most routine civilian events. That terrorism is associated with air travel has as much to

do with its continuity with the militarized cultural environment as with the fact that passengers are particularly vulnerable in mid-air.

The risks and fears associated with airplanes could be characterized as techno-phobia in the fullest sense of the term; no longer a knee-jerk reaction to the unknown world of machines but a complex and informed response to objects and ideas within a daily environment pervaded by the sway of technoscience. This kind of technophobia has become part of our routine response to modernity, perhaps even an intrinsic feature of modernity itself. No less complex, these days, is its manifestation in the field of knowledge. If I had to say what it is that terrorizes my students most today it would be the task of engaging with technoscientific rationality and all of its imposing institutional fortifications, a task that they none the less feel more responsive to than have previous generations of cultural critics. Why do they feel more responsive to meeting the critical challenges of science?

Some cynical commentators might say that it is all part of the colonizing will of cultural studies to penetrate every corner of the field of knowledge in an expan-sionist movement that masquerades as postdisciplinarity. Whatever truth there might be to this ambition, it would still pale beside the reductionist aspirations of science's Holy Grail of a unified theory of the natural world. When Francis Bacon announced, 'I have taken all knowledge to be my province', Eurocentric science was acquiring a colonizing voice that sought universality for its particular views. Conservatives in science get nearer the mark when they see the knowledge claims of cultural studies – local, specific, and social – as contaminants, and likely to weaken and infect the core, universalist beliefs of the natural sciences in the same way as its contagion has swept through the humanities and social sciences. The viral metaphors are not mine; I cite them because they are typical of the epidemi-ological rhetoric utilized by science purists.

My own impression is that these students are probably not acquiescent agents of either intellectual contagion or disciplinary colonialism. To my mind, they are responding, in a much more informed way, to conditions largely created in the last two decades in which technoscience has played a conclusive role in reshaping the economic and cultural composition of most people's productive lives, espe-cially those involving intellectual and knowledge workers. Most of these students are Internet-savvy, and are therefore proficient in the cyberculture that is emerging as the international language of the professional-managerial class, and arguably, the first *lingua franca* of business, government, and academic elites to be inaccessible to most of the population since preliterate, preindustrial times. They also know that the utopian trappings of that cybermedium may very soon be remembered only as a brief golden age before Disney, Murdoch, Microsoft, AT&T, and Time Warner monopolized the real estate, in accord with the privatizing rage of capital-intensive technoscience. Whatever opportunities remain for the academy and the Internet's spectrum of independents to develop a halfway-decent public sphere are more compromised by the day, and in the scarcity climate favoured by national and global managers, resources will only dwindle. Our students, acutely aware of their tenuous future in the shrinking educational sector, are highly conscious of the factors driving the scarcity revolution.

As little as twenty-five years ago, it was naive, but still tenable, to ignore the pivotal contribution of universities to emergent forms of post-industrialism – in

retrospect, a socio-economic revolution driven by the commercial potential of scientific R&D, managed by technocratic cadres churned out by higher education, maintained by Third World labor pools and resources, and facilitated by global economic restructuring. Indeed, the student movements of the 1960s were, in part, prompted by a generational aversion to the prospect of being apprenticed en masse to occupy semi-professional niches in the technostructure of the corporate state and the burgeoning transnational metastate. The anti-war movements on campuses were directed at the widespread use of university facilities and resources for military research and applications – a public relations debacle for the vaunted ideology of science's disinterested ethos.

Today, your head has to be buried very deep in the sand to ignore the pervasive presence of technoscience in all of the institutional environments that house our intellectual work. I am referring not simply to the computerization of the workplace and of the professional culture of intellectual work in general. The demand for productivity at reduced wages, the erosion of benefits and job stability, the geographical dislocation of economic life, the maintenance of a swollen, reserve army of highly educated labor, widespread technological disemployment and downsizing, the privatization of public work environments and the routinization of concessions and other sacrifices at the budgetary altar of pro-scarcity politics – all of these conditions characteristic of the postindustrial economy as a whole have taken a sizeable toll upon the workplaces of higher education. While the ever-eccentric rituals and traditions of academic life serve to distribute the full impact of technological change unevenly across our campuses, most of our research universities resemble commercial laboratories more than they do ivory towers these days.

This state of affairs is a consequence of the contractual agreements forged during the 1980s that bound academic science to the industrial marketplace, and redefined universities as public institutions doing private business, patenting genetic material today, for example, like any pharmaceutical company, or else handing the patents over to the corporate sponsors of academic research as contractually required. In the Reagan–Bush years, at the height of the Pentagon's cashflow volume, basic science was forced onto the international marketplace in the name of competitiveness in war and in trade. Economic restructuring around science and technology has meant that industrial sponsorship of the academic scientific community is now a primary basis for corporate competitiveness where access to basic science is the driving force (Dickson 1988). Under these circumstances, it is all the more necessary for boosters to prop up the old distinction between science and technology – the idea that science is the disinterested pursuit of public knowledge made internationally available at no cost and that technology alone applies to the sector of commercial product development. But in today's marketplace, it is the corporate bottom line, expressed, for example, in the golden rule of patent protection, that decides when public sharing of scientific information ends and when product development and monopoly control over profits takes over – very quickly, in most instances. The Human Genome Project has been the exemplary modern instance of this rule; even as it proceeds under the benign rubric of public enlightenment, only a dunce would bet that, in the current economic climate, it will not lead to the private ownership of life processes. Universities and corporations already hold private patents on all sorts of genetic material. The

section on Trade-related Intellectual Property Rights in the GATT agreement has, most recently, guaranteed a future of biopiracy for the gene hunters of the North unmatched since the heyday of botanical imperialism.

To cut a long story short, we live and work now in conditions and environments that demand a critique of technoscience as a matter of course, as part of a commonplace response to daily life. Our students have absorbed this critical temper, not because of their proximity to campus research environments but because it has become a normalized feature of life in an advanced industrial society. Scepticism about the artifactual power harbored within the laboratories and hi-tech factories is a minimal exercise of citizenship. It forms the basis for massive public anxiety about the safety of everything from the processed food we consume to a biologically engineered future often described, in popular shorthand, as 'tampering with nature'. Knowledge about the risks surrounding us is unevenly shared, as a result of class and education, but it is a part of everyone's daily experience of modernity.

One of the touchstones of cultural studies is Raymond Williams's maxim that 'culture is ordinary' – an everyday creative activity that everyone does. So, too, we might say that the critique of science is ordinary, exercised in a hundred little ways on a daily basis; from suspicion of the latest nutritionist advice to distrust of the first and second medical opinions; from doubts about the safety of the nearest chemical storage facility to apprehension about the latest biogenetic laboratory animal. These are routine responses, often made without prolonged reflection, but that does not make them mindless. They are invariably based upon a complex process of risk perception and risk assessment. In his influential book, *Risk Society*, Ulrich Beck has described a society increasingly characterized by the overproduction of risks, and socially organized around the power that comes from achieving and possessing a risk-free environment (Beck 1992). In such a society, popular technoscepticism has come to replace the older semi-rational fears once associated with the term technophobia. Demonizing technology is by now a campy part of retro culture, reminiscent of a B-Grade science-fiction movie. By contrast, today's anxieties are thoroughly domestic, and so much under the skin they can no more easily be projected onto discrete objects than can boundaries be strictly maintained between the ecosphere and the technosphere. They have become part of the birthright of modernity, an offshoot of the Enlightenment rationality that fostered modern science itself.

If the critique of technoscience has come to be normalized, the same cannot be said of science itself. Science is not recognized as an ordinary activity because it is practiced by highly specialized and highly credentialed experts. So too, a consideration of who is qualified to critique science leads to no ordinary conclusion. At the very least, it requires some recognition of the priestly order that obtains within scientific institutions (wielding a power that is further concentrated and sanctified as scientific and technical knowledge attains more and more importance in society), and, on the other hand, the lay status automatically accorded to all non-professionals who are not involved directly in the networks of prestige that determine decision-making within science communities. This is a status as readily accepted by most of us, through science envy as much as anything, as it is exploited by those seeking the name of science for their political purposes. Let me give you

a succinct example of how both of these outcomes reinforce each other. In Stephen Jay Gould's review of *The Bell Curve* in the *New Yorker*, he noted that reviewer after reviewer in the public media confessed that he or she was not a scientist or an expert in any of the empirical fields represented in Murray and Herrnstein's book, and that they therefore did not feel qualified to judge fully the worth of the book's arguments. Gould concludes that *The Bell Curve*, though only 'a rhetorical masterpiece of scientism', succeeds largely because 'it benefits from the particular kind of fear that numbers impose on nonprofessional commentators'. He then proceeds to tear apart the numbers in his own incisive way. Bestowing the status of a masterpiece, even of scientism, is a little overgenerous, but Gould's observation allows us to see how a smelly piece of racist welfare-bashing can succeed in cowing ordinarily feisty opinion-makers into silence simply by wheeling in some heavy statistical artillery and festooning its pages with references to science scholarship that has been fully discredited for decades. Of course, *The Bell Curve* was not written to generate debate among experts. It was designed to feed intravenously into public policy, and so few people were prepared to take a stand over its scientific validity. In the current climate, however, when the social institutions targeted by Murray are being undermined daily, it is only a matter of time before we see more concerted efforts at scientific racism, at which point critics of these ideas will be tarred with the science-bashing brush that has been so broadly applied by conservatives in the Science Wars.

3

While science boosters have seldom missed an opportunity to scare up anti-science folk devils in order to reinforce access to resources, funding, and other privileges, the origin of the current backlash can be traced to the publication of Paul Gross and Norman Levitt's book *Higher Superstition: The Academic Left and its Quarrels with Science* in the spring of 1994. Drawing directly upon the lessons of the Culture Wars, Gross and Levitt cut a swathe through the usual PC suspects, caricaturing multiculturalists, postmodernists, and constructionists alike. The book escalated the low-level friction between conservative scientists and the science studies community. Soon after, the National Association of Scholars took up the cause, launching and coordinating a well-funded campaign to promote the backlash. In October 1994, the NAS convened its second annual conference, 'Objectivity and Truth in the Natural Sciences, the Social Sciences, and the Humanities', in order to combat what it presented as the growing 'denigration of science'. In the words of the advertisement for the conference, this denigration, hitherto confined to 'quarters outside the academy', increasingly now 'comes from within' and has to be stopped because it 'undermines public confidence . . . alters directions of research . . . affects funding [and] subverts the standards of reason and truth.' Another large conference, 'The Flight from Reason and Truth', was convened at the New York Academy of Sciences in June 1995, and by July the press campaign had worked its way up the media food chain from the glossy weeklies to the op-ed pages of the quality dailies. By this time, proponents of critical science studies were being grouped alongside astrologists, New Age cultists, Creationists, Lysenkoists, and Nazi Aryan

scientists. In the meantime, Gross and Levitt (nicknamed Love-it or Leave-it by the science studies community) and their colleagues had begun what amounted to a holy war at the risk of exhibiting all the symptoms associated with the popular stereotype of the bad scientist: arrogant, insular, self-interested, and aggressively resistant to external inquiry and public accountability.

Many factors have been cited for the sudden advent of this backlash, but most commentators agreed that the decline in funding of science, and the erosion of its popular authority combined to service the need for public scapegoats (Ross 1996). On the other hand, it was clearly triggered by, and targeted at, the influence of cultural studies within science studies. SSK, STS, History of Science, Sociology of Science, Anthropology of Science and other disciplinary undertakings had ruffled feathers over the years. But it was the offending combination of attention to gender, race, ethnocentrism and elite culturalism – the same potent mixture that had fuelled the Culture Wars – that raised the temperature to the boiling point. Critiques of defense funding and corporate sponsorship could always be answered by the 'abuse of science' argument, i.e., humans kill, not guns. So, too, SSK critiques drew the kind of response that promised to reconstruct science from within by rendering it more objective yet in its pursuit of better knowledge through less impure procedures. At bottom, it could still be maintained in both instances that the 'scientific method' was sound. This was less the case with the 'science as culture' critiques, directed, as they were, at more fundamental flaws, and suggesting changes in the very epistemology of the scientific method. If everything from the socialization of scientists to the corporate structuring of research institutions has a recognizable effect upon the shaping of science, how can the purified method of experimental objectivity be declared off-limits to social inquiry and reformation? When there are so many different versions of doing science, even within the domains of Western science (the world's dominant paradigm of rational inquiry), who would dream of reserving an uncontested status for the truth claims of a unitary, abstract method? Consequently, there has been a wholesale challenge to the assumption that objectivity in science is best served by methods pursued at a distance from the social contexts in which science is applied and from the communities most affected by science. In a society so organized hierarchically by class, race, and sexuality, there is no prospect of real objectivity.

Thus Harding argues that objectivity in science would be better ensured if anti-sexist, anti-racist, and pro-democratic principles were adopted as the governing assumptions of research. Only if such moral and political programs were embraced could the prevailing anti-democratic prejudices in science be expunged (Harding 1991). Against science's God's-eye view of nature, comprehensive and yet located nowhere in particular, Donna Haraway argues for 'situated knowledge' on behalf of 'embodied' perspectives of the natural world (Haraway 1988).

Other than reiterating the bromide that science serves truth and not society, interpretations of objectivity that challenge the exclusivity of the empirical method have mostly been answered in the Science Wars by caricature and red-baiting. The more academic response – based on the charge of technical ignorance – has been selected by Gross and Levitt as the ultimate Science Wars put-down: if you haven't solved a 'first order linear differential equation', then you have no business recording your opinion on any of the pressing business that science does in society.

Given the arcane authority of credentialism in a technocracy, such an argument will suffice to silence many. On the contrary, it should be seen as the kind of argument that exposes the way in which technical elites protect their privileges in a society where the most valued forms of knowledge are well nigh inaccessible to most of the population. Indeed, the use of technical expertise as a criterion to intimidate, exclude and disenfranchise is a primary exercise of power in the knowledge society we now inhabit. If you are a non-professional, of course you will never know enough to satisfy your scientist interlocutors. (To do so, you have to be head of a lab, with a fistful of funding, and with a good deal of clout in other places.) But how much do you need to know about nuclear fission to know that nuclear reactors are an insane idea?

On the other hand, we live in times when corporations have their eyes fixed on the patent prize. Consequently, much more is at stake in these Science Wars than the self-interested status of scientists. Given the potential rewards, critique from the non-professional public or from non-credentialed professionals is a costly risk. And so the principle of the disinterested autonomy of scientific inquiry, voiced in the past as a protection against state interference, is more often a serviceable smoke screen today, at a time when scientific knowledge is systematically whisked out of the orbit of education and converted into private capital. The question raised earlier here – Who is qualified to critique science? – already carries set answers in a culture of expertise. One of our jobs is to turn this question around. How can science qualify *us* to sustain a critical view of society?

Sexuality and gender

Teresa de Lauretis

UPPING THE ANTI (*SIC*) IN FEMINIST THEORY

EDITOR'S INTRODUCTION

DE LAURETIS'S ESSAY contributes to the feminist debate over "essen-
tialism." The debate arises because, for structuralist and post-structuralist
thought, identity is always articulated within a system of differences and is there-
fore never fixed. To take a concrete example: a signifier like "women" which is
important to forming identities (in statements such as "I am a woman") does not,
for instance, refer transparently to a particular kind of body – as if that kind of
body were the essence of "being-woman." After all, individuals who do not have
a woman's body can still possess a woman's identity, and structuralists argue that
this is possible just because "woman" means something, not in relation to any
essential quality of womanhood, but in distinction to other categories like, most
obviously, "maleness".

The debate between essentialists and (post)structuralists had been productively
elaborated during the 1970s, but, in this essay, de Lauretis proposed a new move.
She turns towards what she calls feminism's "essential differences." This phrase
brings both sides of the debate together, not in the spirit of synthesis but to point
to the structure of differences in which feminism carries out its work. Feminism's
"essential difference" is to be found in its "historical specificity" and in the sites,
bodies, discourses in and through which women live differently both from men and
from each other. De Lauretis further suggests that analysis of feminism's histori-
cal specificity has to begin its work not with a category as unnuanced as "woman"
but with the more subtle one of the "female-embodied social subject."

By suggesting that we might return to the history and cultural formations in
which "women" are constructed, de Lauretis is not so much depriving cultural
studies of feminist theory as using cultural studies to make theory less routine.

In a later essay (de Lauretis 1991), which drew upon the theory outlined here to move beyond feminism, de Lauretis coined the phrase "queer theory" in order to point out the "difference" – the specificity and disruptiveness – of identities embodied in sexual (and racial) minorities. Though de Lauretis herself abandoned the term "queer," as it became mainstreamed, this essay can be read as establishing a basis, within feminism, for queer theory itself.

Further reading: Butler 1991, 1993; De Lauretis 1991, 1994; Fuss 1989, 1995; Gallop 1982; Jardine 1985; Mohanty 1984; Probyn 1993.

Essentialism and anti-essentialism

Nowadays, the term *essentialism* covers a range of metacritical meanings and strategic uses that go the very short distance from convenient label to buzzword. Many who, like myself, have been involved with feminist critical theory for some time, and who did use the term, initially, as a serious critical concept, have grown impatient with this word – essentialism – time and again repeated with its reductive ring, its self-righteous tone of superiority, its contempt for 'them' – those guilty of it. Yet, few would deny that feminist theory is all about an essential difference, an irreducible difference, though not a difference between woman and man, nor a difference inherent in 'woman's nature' (in woman as nature), but a difference in the feminist conception of woman, women, and the world.

Let us say, then, that there is an essential difference between a feminist and a non-feminist understanding of the subject and its relation to institutions; between feminist and non-feminist knowledges, discourses, and practices of cultural forms, social relations, and subjective processes; between a feminist and a non-feminist historical consciousness. That difference is essential in that it is constitutive of feminist thinking and thus of feminism: it is what makes the thinking feminist, and what constitutes certain ways of thinking, certain practices of writing, reading, imaging, relating, acting, etc., into the historically diverse and culturally heterogeneous social movement which, qualifiers and distinctions notwithstanding, we continue with good reasons to call feminism. Another way to say this is that the essential difference of feminism lies in its historical specificity – the particular conditions of its emergence and development, which have shaped its object and field of analysis, its assumptions and forms of address; the constraints that have attended its conceptual and methodological struggles; the erotic component of its political self-awareness; the absolute novelty of its radical challenge to social life itself.

But even as the specific, essential difference of feminism may not be disputed, the question of the nature of its specificity or what is of the essence in feminist thought and self-representation has been an object of contention, an issue over which divisions, debates, and polarizations have occurred consistently, and without resolution, since the beginning of that self-conscious critical reflection that constitutes the theory of feminism. The currency of the term 'essentialism' may be based

on nothing more than its capacity to circumvent this very question – the nature of the specific difference of feminism – and thus to polarize feminist thought on what amounts to a red herring. I suggest that the current enterprise of 'anti-essentialist' theorists engaged in typologizing, defining and branding various 'feminisms' along an ascending scale of theoretico-political sophistication where 'essentialism' weighs heavy at the lower end, may be seen in this perspective.

This is not to say that there should be no critique of feminist positions or no contest for the practical as well as the theoretical meanings of feminism, or even no appeal for hegemony by participants in a social movement which, after all, potentially involves all women. My polemical point here is that either too much or too little is made of the 'essentialism' imputed to most feminist positions (notably those labelled cultural, separatist or radical, but others as well, whether labelled or not), so that the term serves less the purposes of effective criticism in the ongoing elaboration of feminist theory than those of convenience, conceptual simplification or academic legitimation. Taking a more discerning look at the *essence* that is in question in both *essentialism* and *essential difference*, therefore, seems like a very good idea.

Among the several acceptations of 'essence' (from which 'essentialism' is apparently derived) in the *OED*, the most pertinent to the context of use that is in question here are the following:

1. Absolute being, substance in the metaphysical sense; the reality underlying phenomena.
2. That which constitutes the being of a thing; that 'by which it is what it is'. In two different applications (distinguished by Locke as *nominal essence* and *real essence* respectively):
 a. of a conceptual entity: The totality of the properties, constituent elements, etc., without which it would cease to be the same thing; the indispensable and necessary attributes of a thing as opposed to those which it may have or not . . .
 b. of a real entity: Objective character, intrinsic nature as a 'thing-in-itself'; 'that internal constitution, on which all the sensible properties depend'.

Examples of (*a*), dated from 1600 to 1870, include Locke's statement in the *Essay on Human Understanding*: 'The Essence of a Triangle, lies in a very little compass . . . three Lines meeting at three Angles, make up that Essence'; and all the examples given for (*b*), from 1667 to 1856, are to the effect that the essence of a real entity, the 'thing-in-itself', is either unknown or unknowable.

Which of these 'essences' are imputed to feminist 'essentialists' by their critics? If most feminists, however one may classify trends and positions – cultural, radical, liberal, socialist, post-structuralist and so forth – agree that women are made, not born, that gender is not an innate feature (as sex may be) but a socio-cultural construction (and precisely for that reason it is oppressive to women), that patriarchy is historical (especially so when it is believed to have superseded a previous matriarchal realm), then the 'essence' of woman that is described in the writings of many so-called essentialists is not the *real essence*, in Locke's terms, but more

likely a *nominal* one. It is a totality of qualities, properties, and attributes that such feminists define, envisage, or enact for themselves (and some in fact attempt to live out in 'separatist' communities), and possibly also wish for other women. This is more a project, then, than a description of existent reality; it is an admittedly feminist project of 're-vision', where the specifications *feminist* and *revision* already signal its historical location, even as the (re)vision projects itself outward geographically and temporally (universally) to recover the past and to claim the future. This may be utopian, idealist, perhaps misguided or wishful thinking, it may be a project one does not want to be a part of, but it is not essentialist as is the belief in a God-given or otherwise immutable nature of woman.

In other words, barring the case in which woman's 'essence' is taken as absolute being or substance in the traditional metaphysical sense (and this may actually be the case for a few, truly fundamentalist thinkers to whom the term essentialist would properly apply), for the great majority of feminists the 'essence' of woman is more like the essence of the triangle than the essence of the thing-in-itself: it is the specific properties (e.g., a female-sexed body), qualities (a disposition to nurturance, a certain relation to the body, etc.), or necessary attributes (e.g., the experience of femaleness, of living in the world as female) that women have developed or have been bound to historically, in their differently patriarchal sociocultural contexts, which make them women, and not men. One may prefer one triangle, one definition of women and/or feminism, to another and, within her particular conditions and possibilities of existence, struggle to define the triangle she wants or wants to be – feminists do want differently. And in these very struggles, I suggest, consist the historical development and the specific difference of feminist theory, the essence of the triangle.

It would be difficult to explain, otherwise, why thinkers or writers with political and personal histories, projects, needs, and desires as different as those of white women and women of colour, of lesbians and heterosexuals, of differently abled women, and of successive generations of women, would all claim feminism as a major – if not the only – ground of difference; why they would address both their critiques or accusations and their demands for recognition to other women, feminists in particular; why the emotional and political stakes in feminist theorizing should be so high, dialogue so charged, and confrontation so impassioned; why, indeed, the proliferation of typologies and the wide currency of 'essentialism' on one hand, countered by the equally wide currency of the term 'male theory' on the other. It is one of the projects of this paper to up the *anti* in feminist theoretical debates, to shift the focus of the controversy from 'feminist essentialism', as a category by which to classify feminists or feminisms, to the historical specificity, the essential difference of feminist theory itself. To this end I first turn to two essays which prompted my reflection on the uses of 'essentialism' in current Anglo-American feminist critical writing, Chris Weedon's *Feminist Practice and Poststructuralist Theory*, published in London in 1987, and Linda Alcoff's 'Cultural feminism versus post-structuralism: the identity crisis in feminist theory', published in the spring 1988 issue of *Signs*. Then I will go on to argue that the essential difference of feminist theory must be looked for in the form as well as the contents of its political, personal, critical, and textual practices, in the diverse oppositional stances feminism has taken *vis-à-vis* social and cultural formations, and in the

resulting divisions, self-conscious reflection, and conceptual elaboration that consti-
tute the effective history of feminism. And thus a division such as the one over
the issue of 'essentialism' only *seems* to be a purely 'internal', intra-feminist one,
a conflict within feminism. In fact, it is not.

The notion of an 'essential womanhood, common to all women, suppressed or
repressed by patriarchy' recurs in Weedon's book as the mark of 'radical-feminist
theory', whose cited representatives are Mary Daly, Susan Griffin, and Adrienne
Rich. 'Radical feminist theory' is initially listed together with 'socialist feminist
and psychoanalytic feminist theories' as 'various attempts to systematize individual
insights about the oppression of women into relatively coherent theories of patri-
archy', in spite of the author's statement, on the same page, that radical feminist
writers are hostile to theory because they see it as a form of male dominance
which co-opts women and suppresses the feminine (Weedon 1987: 6). As one
reads on, however, socialist feminism drops out altogether while psychoanalytic
feminism is integrated into a new and more 'politically' sophisticated discourse
called 'feminist poststructuralism'. Thus, three-fourths of the way through the
book, one finds this summary statement:

> For poststructuralist feminism, neither the liberal-feminist attempt to
> redefine the truth of women's nature within the terms of existing social
> relations and to establish women's full equality with men, nor the
> radical-feminist emphasis on fixed difference, realized in a separatist
> context, is politically adequate. Poststructuralist feminism requires
> attention to historical specificity in the production, for women, of
> subject positions and modes of femininity and their place in the overall
> network of social power relations. In this the meaning of biological
> sexual difference is never finally fixed . . . An understanding of how
> discourses of biological sexual difference are mobilized, in a particular
> society, at a particular moment, is the first stage in intervening in order
> to initiate change.
>
> (1987: 135)

There is more than simple irony in the claim that this late-comer, post-structuralist
feminism, dark horse and winner of the feminist theory contest, is the 'first stage'
of feminist intervention. How can Weedon, at one and the same time, so strongly
insist on attention to historical specificity and social – not merely individual –
change, and yet disregard the actual historical changes in Western culture brought
about in part, at least, by the women's movement and at least in some measure
by feminist critical writing over the past twenty years?

 One could surmise that Weedon does not like the changes that have taken place
(even as they allow the very writing and publication of her book), or does not
consider them sufficient, though that would hardly be reason enough to disregard
them so blatantly. A more subtle answer may lie in the apologetic and militant pro-
ject of her book, a defence of post-structuralism *vis-à-vis* both the academic estab-
lishment and the general educated reader, but with an eye to the women's studies
corner of the publishing market; whence, one must infer, the lead position in the

title of the other term of the couple, feminist practice. For, as the Preface states, 'the aim of this book is to make poststructuralist theory accessible to readers to whom it is unfamiliar, to argue its political usefulness to feminism and to consider its implications for feminist critical practice' (p. vii). Somehow, however, in the course of the book, the Preface's modest claim 'to point to a possible direction for future feminist cultural criticism' (p. vii) is escalated into a peroration for the new and much improved feminist theory called feminist post-structuralism or, indifferently, post-structural feminism.

In the concluding chapter on 'Feminist critical practice' (strangely in the singular, as if among so many feminisms and feminist theories, only one practice could properly be called both feminist and critical), the academic contenders are narrowed down to two. The first is the post-structural criticism produced by British feminists (two are mentioned, E. Ann Kaplan and Rosalind Coward) looking 'at the mechanisms through which meaning is constructed' mainly in popular culture and visual representation; the second is 'the other influential branch of feminist criticism [that] looks to fiction as an expression of an already constituted gendered experience' (p. 152). Reappearing here, the word 'experience', identified earlier on as the basis for radical feminist politics ('many feminists assume that women's experience, unmediated by further theory, is the source of true knowledge', p. 8), links this second branch of feminist (literary) criticism to radical feminist ideology. Its standard-bearers are Americans, Showalter's gynocritics and the 'woman-centred criticism' of Gilbert and Gubar, whose reliance on the concept of authorship as a key to meaning and truth also links them with 'liberal-humanist criticism' (pp. 154–5).

A particular subset of this – by now radical liberal – feminist criticism 'dedicated to constructing traditions' (p. 156) is the one concerned with 'black and lesbian female experience'; here the problems and ideological traps appear most clearly, in Weedon's eyes, and are 'most extreme in the case of lesbian writing and the construction of a lesbian aesthetic' (p. 158). The reference works for her analysis, rather surprisingly in view of the abundance of Black and lesbian feminist writings in the 1980s, are a couple of rather dated essays by Barbara Smith and Bonnie Zimmerman reprinted in a collection edited by Elaine Showalter and, in fact, misnamed *The* New *Feminist Criticism*. But even more surprisingly – or not at all so, depending on one's degree of optimism – it is again post-structuralist criticism that, with the help of Derridean deconstruction, can set all of these writers straight, as it were, as to the real, socially constructed and discursively produced nature of gender, race, class, and sexuality – as well as authorship and experience! Too bad for us that no exemplary post-structuralist feminist works or critics are discussed in this context (Cixous, Kristeva, and Irigaray figure prominently, but as psychoanalytic feminists earlier in the book).

Now, I should like to make it clear that I have no quarrel with post-structuralism as such, or with the fundamental importance for all critical thinking, feminist theory included, or many of the concepts admirably summarized by Weedon in passages such as the following:

> For a theoretical perspective to be politically useful to feminism, it
> should be able to recognize the importance of the *subjective* in consti-

tuting the meaning of women's lived reality. It should not deny subjec-
tive experience, since the ways in which people make sense of their
lives is a necessary starting point for understanding how power rela-
tions structure society. Theory must be able to address women's
experience by showing where it comes from and how it relates to
material social practices and the power relations which structure them
. . . In this process subjectivity becomes available, offering the indi-
vidual both a perspective and a choice, and opening up the possibility
of political change.

(1987: 8–9)

But while I am in complete agreement that experience is a difficult, ambiguous,
and often oversimplified term, and that feminist theory needs to elaborate further
'the relationship between experience, social power and resistance' (p. 8), I would
insist that the notion of experience in relation both to social-material practices and
to the formation and processes of subjectivity is a feminist concept, not a post-
structuralist one (this is an instance of that essential difference of feminism which
I want to reclaim from Weedon's all-encompassing 'poststructuralism'), and would
be still unthinkable were it not for specifically feminist practices, political, criti-
cal, and textual: consciousness raising, the rereading and revision of the canon,
the critique of scientific discourses, and the imaging of new social spaces and forms
of community. In short, the very practices of those feminist critics Weedon allo-
cates to the 'essentialist' camp. I would also add that 'a theory of the relationship
between experience, social power and resistance' is precisely one possible defini-
tion of feminist, not of post-structuralist, theory, as Weedon would have it, since
the latter does not countenance the notion of experience within its conceptual
horizon or philosophical presuppositions; and that, moreover, these issues have
been posed and argued by several non-denominational feminist theories in the
United States for quite some time: for example, in the works of Biddy Martin,
Nancy K. Miller, Tania Modleski, Mary Russo, Kaja Silverman as well as myself,
and even more forcefully in the works of feminist theorists and writers of colour
such as Gloria Anzaldúa, Audre Lorde, Chandra Mohanty, Cherríe Moraga, and
Barbara Smith.

 So my quarrel with Weedon's book is about its reductive opposition – all the
more remarkable coming from a proponent of deconstruction – of a *lumpen* femi-
nist essentialism (radical-liberal-separatist and American) to a phantom feminist
post-structuralism (critical-socialist-psychoanalytic and Franco-British), and with
the by-products of such a *parti-pris*: the canonization of a few (in)famous feminists
as signposts of the convenient categories set up by the typology, the agonistic
narrative structure of its account of 'feminist theories', and finally its failure to
contribute to the elaboration of feminist critical thought, however useful the book
may be to its other intended readers, who can thus rest easy in the fantasy that
post-structuralism is the theory and feminism is just a practice.

The title of Alcoff's essay, 'Cultural feminism versus post-structuralism: the iden-
tity crisis in feminist theory', bespeaks some of the same problems: a manner of
thinking by mutually oppositional categories, an agonistic frame of argumentation,

and a focus on division, a 'crisis in feminist theory' that may be read not only as a crisis *over* identity, a metacritical doubt and a dispute among feminists as to the notion of identity, but also as a crisis *of* identity, of self-definition, implying a theoretical impasse for feminism as a whole. The essay, however, is more discerning, goes much further than its title suggests, and even contradicts it in the end, as the notion of identity, far from fixing the point of an impasse, becomes an active shifter in the feminist discourse of woman.

Taking as its starting point 'the concept of woman', or rather, its redefinition in feminist theory ('the dilemma facing feminist theorists today is that our very self-definition is grounded in a concept that we must deconstruct and de-essentialize in all of its aspects'), Alcoff finds two major categories of responses to the dilemma, or what I would call the paradox of woman (Alcoff 1988: 406). Cultural feminists, she claims, 'have not challenged the defining of woman but only that definition given by men' (p. 407), and have replaced it with what they believe a more accurate description and appraisal, 'the concept of the essential female' (p. 408). On the other hand, the post-structuralist response has been to reject the possibility of defining woman altogether and to replace 'the politics of gender or sexual difference . . . with a plurality of difference where gender loses its position of significance' (p. 407). A third category is suggested, but only indirectly, in Alcoff's unwillingness to include among cultural feminists certain writers of colour such as Moraga and Lorde in spite of their emphasis on cultural identity, for in her view 'their work has consistently rejected essentialist conceptions of gender' (p. 412). Why an emphasis on racial, ethnic, and/or sexual identity need not be seen as essentialist is discussed more fully later in the essay with regard to identity politics and in conjunction with a third trend in feminist theory which Alcoff sees as a new course for feminism, 'a theory of the gendered subject that does not slide into essentialism' (p. 422).

Whereas the narrative structure underlying Weedon's account of feminist theories is that of a contest where one actor successively engages and defeats or conquers several rivals, Alcoff's develops as a dialectic. Both the culturalist and post-structuralist positions display internal contradictions: for example, not all cultural feminists 'give explicitly essentialist formulations of what it means to be a woman' (p. 411), and their emphasis on the affirmation of women's strength and positive cultural roles and attributes has done much to counter images of woman as victim or of woman as male when in a business suit; but insofar as it reinforces the essentialist explanations of those attributes that are part and parcel of the traditional notion of womanhood, cultural feminism may, and for some women does, foster another form of sexist oppression. Conversely, if the post-structuralist critique of the unified, authentic subject of humanism is more than compatible with the feminist project to 'deconstruct and de-essentialize' woman (as Alcoff puts it, in clearly post-structuralist terms), its absolute rejection of gender and its negation of biological determinism in favour of a cultural-discursive determinism result, as concerns women, in a form of nominalism. If 'woman' is a fiction, a locus of pure difference and resistance to logocentric power, and if there are no women as such, then the very issue of women's oppression would appear to be obsolete and feminism itself would have no reason to exist (which, it may be noted, is a corollary of post-structuralism and the stated position of those who call themselves 'post-feminists'). 'What can we demand in the name of women,' Alcoff asks, 'if "women"

do not exist and demands in their name simply reinforce the myth that they do?' (p. 420).

The way out – let me say, the sublation – of the contradictions in which are caught these two mainstream feminist views lies in 'a theory of the subject that avoids both essentialism and nominalism' (p. 421), and Alcoff points to it in the work of a few theorists, 'a few brave souls', whom she rejoins in developing her notion of 'woman as positionality': 'woman is a position from which a feminist politics can emerge rather than a set of attributes that are "objectively identifi-able"' (pp. 434–5). In becoming feminist, for instance, women take up a position, a point of perspective, from which to interpret or (re)construct values and mean-ings. That position is also a politically assumed identity, and one relative to their socio-historical location, whereas essentialist definitions would have woman's iden-tity or attributes independent of her external situation; however, the positions available to women in any socio-historical location are neither arbitrary nor unde-cidable. Thus, Alcoff concludes,

> If we combine the concept of identity politics with a conception of the subject as positionality, we can conceive of the subject as nonessen-tialized and emergent from a historical experience and yet retain our political ability to take gender as an important point of departure. Thus we can say at one and the same time that gender is not natural, biologi-cal, universal, ahistorical, or essential and yet still claim that gender is relevant because we are taking gender as a position from which to act politically.
>
> (1988: 433)

I am, of course, in agreement with her emphases on issues and arguments that have been central in my work, such as the necessity to theorize experience in rela-tion to practices, the understanding of gendered subjectivity as 'an emergent property of a historicized experience' (p. 431), and the notion that identity is an active construction and a discursively mediated political interpretation of one's history. What I must ask, and less as a criticism of Alcoff's essay than for the purposes of my argument here, is: why is it still necessary to set up two opposing categories, cultural feminism and post-structuralism, or essentialism and anti-essentialism, thesis and antithesis, when one has already achieved the vantage point of a theoretical position that overtakes them or sublates them?

Doesn't the insistence on the 'essentialism' of cultural feminists reproduce and keep in the foreground an image of 'dominant' feminism that is at least reductive, at best tautological or superseded, and at worst not in our interests? Doesn't it feed the pernicious opposition of low versus high theory, a low-grade type of criti-cal thinking (feminism) that is contrasted with the high-test theoretical grade of a post-structuralism from which some feminists would have been smart enough to learn? As one feminist theorist who's been concurrently involved with feminism, women's studies, psychoanalytic theory, structuralism, and film theory from the beginning of my critical activity, I know that learning to be a feminist has grounded, or embodied, all of my learning and so engendered thinking and knowing itself. That engendered thinking and that embodied, situated knowledge (in Donna

Haraway's phrase) are the stuff of feminist theory, whether by 'feminist theory' is meant one of a growing number of feminist critical discourses – on culture, science, subjectivity, writing, visual representation, social institutions, etc. – or, more particularly, the critical elaboration of feminist thought itself and the ongoing (re)definition of its specific difference. In either case, feminist theory is not of a lower grade than that which some call 'male theory', but different in kind; and it is its essential difference, the essence of that triangle, that concerns me here as a theorist of feminism.

Why then, I ask again, continue to constrain it in the terms of essentialism and anti-essentialism even as they no longer serve (but did they ever?) to formulate our questions? For example, in her discussion of cultural feminism, Alcoff accepts another critic's characterization despite some doubt that the latter 'makes it appear too homogeneous and . . . the charge of essentialism is on shaky ground' (p. 411). Then she adds:

> In the absence of a clearly stated position on the ultimate source of gender difference, Echols *infers* from their emphasis on building a feminist free-space and woman-centred culture that cultural feminists hold some version of essentialism. I share Echols's *suspicion*. Certainly, *it is difficult to render the views of Richard Daly into a coherent whole without supplying a missing premise* that there is an innate female essence.
>
> (1988: 412; emphasis added)

But why do it at all? What is the purpose, or the gain, of supplying a missing premise (innate female essence) in order to construct a coherent image of feminism which thus becomes available to charges (essentialism) based on the very premise that had to be supplied? What motivates such a project, the suspicion, and the inferences?

Theorizing beyond reconciliation

For a theorist of feminism, the answer to these questions should be looked for in the particular history of feminism, the debates, internal divisions, and polarizations that have resulted from its engagement with the various institutions, discourses, and practices that constitute the social, and from its self-conscious reflection on that engagement; that is to say, the divisions that have marked feminism as a result of the divisions (of gender, sex, race, class, ethnicity, sexuality, etc.) in the social itself, and the discursive boundaries and subjective limits that feminism has defined and redefined for itself contingently, historically, in the process of its engagement with social and cultural formations. The answer should be looked for, in other words, in the form as well as the contents that are specific to feminist political practices and conceptual elaboration, in the paradoxes and contradictions that constitute the effective history, the essential difference, of feminist thought.

In one account that can be given of that history, feminist theory has developed a series of oppositional stances not only *vis-à-vis* the wider, 'external' context (the social constraints, legislation, ideological apparati, dominant discourses and

representations against which feminism has pitched its critique and its political strategies in particular historical locations), but also, concurrently and inter-relatedly, in its own 'internal', self-critical processes. For instance, in the 1970s, the debates on academic feminism versus activism in the United States defined an opposition between theory and practice which led, on the one hand, to a polar-ization of positions either *for* theory or *against* theory in nearly all cultural practices and, on the other, to a consistent, if never fully successful, effort to overcome the opposition itself. Subsequently, the internal division of the movement over the issue of separatism or 'mainstreaming', both in the academy and in other institu-tional contexts, recast the practice/theory opposition in terms of lesbian versus heterosexual identification, and of women's studies versus feminist cultural theory, among others. Here, too, the opposition led to both polarization (e.g., feminist criticism versus feminist theory in literary studies) and efforts to overcome it by an expanded, extremely flexible, and ultimately unsatisfactory redefinition of the notion of 'feminist theory' itself.

Another major division and the resulting crucial shift in feminist thought were prompted, at the turn of the decade into the 1980s, by the wider dissemination of the writings of women of colour and their critique of racism in the women's movement. The division over the issue of race versus gender, and of the relative importance of each in defining the modes of women's oppression, resistance, and agency, also produced an opposition between a 'white' or 'Western feminism' and a 'US Third World feminism' articulated in several racial and ethnic hyphenations, or called by an altogether different name (e.g., black 'womanism'). Because the oppositional stance of women of colour was markedly, if not exclusively, addressed to white women in the context of feminism – that is to say, their critique addressed more directly white feminists than it did (white) patriarchal power struc-tures, men of colour or even white women in general – once again that division on the issue of race versus gender led to polarization as well as to concerted efforts to overcome it, at least internally to feminist theoretical and cultural practices. And once again those efforts met with mostly unsatisfactory or inadequate results, so that no actual resolution, no dialectic sublation has been achieved in this oppo-sition either, as in the others. For even as the polarization may be muted or displaced by other issues that come to the fore, each of those oppositions remains present and active in feminist consciousness and, I want to argue, must so remain in a feminist theory of the female-sexed or female-embodied social subject that is based on its specific and emergent history.

Since the mid-1980s, the so-called feminist sex wars (Ruby Rich) have pitched 'pro-sex' feminists versus the anti-pornography movement in a conflict over representation that recast the sex/gender distinction into the form of a para-doxical opposition: sex and gender are either collapsed together, and rendered both analytically and politically indistinguishable (MacKinnon, Hartsock) or they are severed from each other and seen as endlessly recombinable in such figures of boundary crossing as transsexualism, transvestism, bisexualism, drag and imper-sonation (Butler), cyborgs (Haraway), etc. This last issue is especially central to the lesbian debate on sadomasochism (*Coming to Power*, *Against Sadomasochism*), which recasts the earlier divisions of lesbians between the women's liberation movement, with its more or less overt homophobia (Bearchell, Clark), and the gay liberation

movement, with its more or less overt sexism (Frye), into the current opposition of radical S/M lesbianism to mainstream-cultural lesbian feminism (Rubin, Califia), an opposition whose mechanical binarism is tersely expressed by the recent magazine title *On Our Backs* punning on the long-established feminist periodical *Off Our Backs*. And here may be also mentioned the opposition pro and against psychoanalysis (e.g., Rose and Wilson) which, ironically, has been almost completely disregarded in these sexuality debates, even as it determined the conceptual elaboration of sexual difference in the 1970s and has since been fundamental to the feminist critique of representation in the media and the arts.

This account of the history of feminism in relation to both 'external' and 'internal' events, discourses, and practices suggests that two concurrent drives, impulses or mechanisms, are at work in the production of its self-representation: *an erotic, narcissistic drive* that enhances images of feminism as difference, rebellion, daring, excess, subversion, disloyalty, agency, empowerment, pleasure and danger, and rejects all images of powerlessness, victimization, subjection, acquiescence, passivity, conformism, femininity; and *an ethical drive* that works towards community, accountability, entrustment, sisterhood, bonding, belonging to a common world of women or sharing what Adrienne Rich has poignantly called 'the dream of a common language'. Together, often in mutual contradiction, the erotic and ethical drives have fuelled not only the various polarizations and the construction of oppositions but also the invention or conceptual imaging of a 'continuum' of experience, a global feminism, a 'house of difference', or a separate space where 'safe words' can be trusted and 'consent' be given uncoerced. And an erotic and an ethical drive may be seen to underlie and sustain at once the possibility of, and the difficulties involved in, the project of articulating a female symbolic. Are these two drives together, most often in mutual contradiction, what particularly distinguishes lesbian feminism, where the erotic is as necessary a condition as the ethical, if not more?

That the two drives often clash or bring about political stalemates and conceptual impasses is not surprising, for they have contradictory objects and aims, and are forced into open conflict in a culture where women are not supposed to be, know, or see themselves as subjects. And for this very reason perhaps, the two drives characterize the movement of feminism, and more emphatically lesbian feminism, its historically intrinsic, essential condition of contradiction, and the processes constitutive of feminist thought in its specificity. As I have written elsewhere, 'the tension of a twofold pull in contrary directions – the critical negativity of its theory, and the affirmative positivity of its politics – is both the historical condition of existence of feminism and its theoretical condition of possibility'. That tension, as the condition of possibility and effective elaboration of feminist theory, is most productive in the kind of critical thinking that refuses to be pulled to either side of an opposition and seeks instead to deconstruct it, or better, to disengage it from the fixity of polarization in an 'internal' feminist debate and to reconnect it to the 'external' discursive and social context from which it finally cannot be severed except at the cost of repeatedly reducing a historical process, a movement, to an ideological stalemate. This may be the approach of those writers whom Alcoff would call 'brave souls . . . attempting to map out a new course' (1988: 407). But that course, I would argue, does not proceed in the manner of

a dialectic, by resolving or reconciling the given terms of an opposition – say, essentialism/anti-essentialism or pro-sex/anti-pornography – whether the resolution is achieved discursively (for example, alleging a larger, tactical or political perspective on the issue) or by pointing to their actual sublation in existing material conditions (for example, adducing sociological data or statistical arguments). It proceeds, in my view, by what I call upping the 'anti': by analysing the undecidability, conceptual as well as pragmatic, of the alternative *as given*, such critical works release its terms from the fixity of meaning into which polarization has locked them, and reintroduce them into a larger contextual and conceptual frame of reference; the tension of positivity and negativity that marks feminist discourse in its engagement with the social can then displace the impasse of mere 'internal' opposition to a more complex level of analysis.

Seen in this larger, historical frame of reference, feminist theory is not merely a theory of gender oppression in culture, as both MacKinnon and Rubin maintain, from the respective poles of the sex/gender and pro-sex/anti-pornography debates, and as is too often reiterated in women's studies textbooks; nor is it the essentialist theory of women's nature which Weedon opposes to an anti-essentialist, post-structuralist theory of culture. It is instead a developing theory of the female-sexed or female-embodied social subject, whose constitution and whose modes of social and subjective existence include most obviously sex and gender, but also race, class, and any other significant socio-cultural divisions and representations; a developing theory of the female-embodied social subject that is based on its specific, emergent, and conflictual history.

Note

Another version of this essay was published in *Differences: A Journal of Feminist Cultural Studies* 1 (2) (fall 1989) with the title 'The essence of the triangle or, taking the risk of essentialism seriously: feminist theory in Italy, the US, and Britain'. The essay was initially written for the issue of *Differences* devoted to 'The Essential Difference: Another Look at Essentialism', but then rethought in the context of the project of a book addressing the problem of 'conflicts in feminism'. The two versions have in common the arguments set out in Part I, but then, in Parts II and III, present two quite distinct accounts of what I call the effective history of feminist theory and its specific, essential difference as a developing theory of the female-sexed or female-embodied social subject: there, an account, one possible history of feminist theory in Italy, here one account of feminist theory in North America.

Eve Kosofsky Sedgwick

AXIOMATIC

EDITOR'S INTRODUCTION

IN THIS SUBTLE PIECE of methodological ground-clearing (or mine-sweeping), part of the introduction to her book *Epistemology of the Closet*, Eve Sedgwick elaborates some deceptively simple axioms from which gay and lesbian studies might proceed. Of particular interest is her discussion of the Foucauldian claim that "homosexuality" begins around 1870. What this means, of course, is that individuals who preferred sex with people of their own gender were then for the first time defined or identified as (fundamentally pathological) "homosexuals." But, as Sedgwick argues, even as we try to dismantle the category "homosexual" we are playing a game in which one large model is being replaced with another large model. In this situation it is important to take the banality "We are all different people" (Axiom 1) very seriously.

This banal proposition contains a pun: we're all different from each other, and we're not always the same ourselves. It is because the first is true that "allo-identification" (identification with the other) should take place, however rarely it does; and it is because the second is true that the first *can* take place: we cannot simply "auto-identify" once and for all. Thus same-gender sex, like different-gender sex, involves a mixture of both kinds of identification. At a more general level, for Sedgwick, auto-identification requires narratives which try to account for *how* we came to be what we are and, more than that, to establish *what* we are – though, of course, this can never be finally determined. Such narratives can also trigger further identifications by and with others. More particularly, Sedgwick implies, lesbian and gay studies need a particular mix of auto- and allo-identification if they are to remain different from, but not radically other to, each other.

Further reading: Butler 1991; Edelman 1994; Foucault 1980a; Fuss 1991; Halperin 1995; Heath 1982; Rubin 1975, 1984; Sedgwick 1987, 1990; Weeks 1985.

Epistemology of the Closet proposes that many of the major nodes of thought and knowledge in twentieth-century Western culture as a whole are structured – indeed, fractured – by a chronic, now endemic crisis of homo/heterosexual definition, indicatively male, dating from the end of the nineteenth century. The book will argue that an understanding of virtually any aspect of modern Western culture must be, not merely incomplete, but damaged in its central substance to the degree that it does not incorporate a critical analysis of modern homo/heterosexual definition; and it will assume that the appropriate place for that critical analysis to begin is from the relatively decentred perspective of modern gay and antihomophobic theory.

The passage of time, the bestowal of thought and necessary political struggle since the turn of the century have only spread and deepened the long crisis of modern sexual definition, dramatizing, often violently, the internal incoherence and mutual contradiction of each of the forms of discursive and institutional 'common sense' on this subject inherited from the architects of our present culture. The contradictions I will be discussing are not in the first place those between pro-homosexual and anti-homosexual people or ideologies, although the book's strongest motivation is indeed the gay-affirmative one. Rather, the contradictions that seem most active are the ones internal to all the important twentieth-century understandings of homo/heterosexual definition, both heterosexist and antihomophobic. Their outlines and something of their history are sketched in Chapter 1. Briefly, they are two. The first is the contradiction between seeing homo/heterosexual definition on the one hand as an issue of active importance primarily for a small, distinct, relatively fixed homosexual minority (what I refer to as a minoritizing view), and seeing it on the other hand as an issue of continuing, determinative importance in the lives of people across the spectrum of sexualities (what I refer to as a universalizing view). The second is the contradiction between seeing same-sex object choice on the one hand as a matter of liminality or transitivity between genders, and seeing it on the other hand as reflecting an impulse of separatism – though by no means necessarily political separatism – within each gender. The purpose of this book is not to adjudicate between the two poles of either of these contradictions, for, if its argument is right, no epistemological grounding now exists from which to do so. Instead, I am trying to make the strongest possible introductory case for a hypothesis about the centrality of this nominally marginal, conceptually intractable set of definitional issues to the important knowledges and understandings of twentieth-century Western culture as a whole.

The word 'homosexual' entered Euro-American discourse during the last third of the nineteenth century – its popularization preceding, as it happens, even that of the word 'heterosexual'. It seems clear that the sexual behaviours, and even for some people the conscious identities, denoted by the new term 'homosexual' and its contemporary variants already had a long, rich history. So, indeed,

did a wide range of other sexual behaviors and behavioral clusters. What *was* new from the turn of the century was the world-mapping by which every given person, just as he or she was necessarily assignable to a male or a female gender, was not considered necessarily assignable as well to a homo- or a hetero-sexuality, a binarized identity that was full of implications, however confusing, for even the ostensibly least sexual aspects of personal existence. It was this new development that left no space in the culture exempt from the potent incoherences of homo/heterosexual definition.

New, institutionalized taxonomic discourses – medical, legal, literary, psychological – centring on homo/heterosexual definition proliferated and crystallized with exceptional rapidity in the decades around the turn of the century, decades in which so many of the other critical nodes of the culture were being, if less suddenly and newly, nonetheless also definitively reshaped. Both the power relations between the genders and the relations of nationalism and imperialism, for instance, were in highly visible crisis. For this reason, and because the structuring of same-sex bonds can't, in any historical situation marked by inequality and contest *between* genders, fail to be a site of intensive regulation that intersects virtually every issue of power and gender, lines can never be drawn to circumscribe within some proper domain of sexuality (whatever that might be) the consequences of a shift in sexual discourse. Furthermore, in accord with Foucault's demonstration, whose results I will take to be axiomatic, that modern Western culture has placed what it calls sexuality in a more and more distinctively privileged relation to our most prized constructs of individual identity, truth, and knowledge, it becomes truer and truer that the language of sexuality not only intersects with but transforms the other languages and relations by which we know.

An assumption underlying the book is that the relations of the closet – the relations of the known and the unknown, the explicit and the inexplicit around homo/heterosexual definition – have the potential for being peculiarly revealing, in fact, about speech acts more generally. But, in the vicinity of the closet, even what *counts* as a speech act is problematized on a perfectly routine basis. As Foucault says: 'there is no binary division to be made between what one says and what one does not say; we must try to determine the different ways of not saying such things. . . . There is not one but many silences, and they are an integral part of the strategies that underlie and permeate discourses' (Foucault 1980a: 27). 'Closetedness' itself is a performance initiated as such by the speech act of a silence – not a particular silence, but a silence that accrues particularity by fits and starts, in relation to the discourse that surrounds and differentially constitutes it. The speech acts that coming out, in turn, can comprise are as strangely specific. And they may have nothing to do with the acquisition of new information. I think of a man and a woman I know, best friends, who for years canvassed freely the emotional complications of each other's erotic lives – the man's eroticism happening to focus exclusively on men. But it was only after one particular conversational moment, fully a decade into this relationship, that it seemed to either of these friends that permission had been given to the woman to refer to the man, in their conversation together, as *a gay man*. Discussing it much later, both agreed they had felt at the time that this one moment had constituted a clear-cut act of coming out, even in the context of years and years beforehand of exchange predicated on

the man's *being* gay. What was said to make this difference? Not a version of 'I am gay', which could only have been bathetic between them. What constituted coming out for this man, in this situation, was to use about himself the phrase 'coming out' – to mention, as if casually, having come out to someone else. (Similarly, a T-shirt that ACT UP sells in New York bearing the text 'I am out, therefore I am', is meant to do for the wearer not the constative work of reporting that s/he *is* out, but the performative work of coming out in the first place.) And the fact that silence is rendered as pointed and performative as speech, in relations around the closet, depends on and highlights more broadly the fact that ignorance is as potent and as multiple a thing there as is knowledge.

Anyone working in gay and lesbian studies, in a culture where same-sex desire is still structured by its distinctive public/private status, at once marginal and central, as *the* open secret, discovers that the line between straining at truths that prove to be imbecilically self-evident, on the one hand, and on the other hand tossing off commonplaces that turn out to retain their power to galvanize and divide, is weirdly unpredictable. In dealing with an open-secret structure, it's only by being shameless about risking the obvious that we happen into the vicinity of the transformative. I have methodically to sweep into one little heap some of the otherwise unarticulated assumptions and conclusions from a long-term project of anti-homophobic analysis. These nails, these scraps of wiring: will they bore or will they shock?

Under the rule that most privileges the most obvious:

Axiom 1: People are different from each other

It is astonishing how few respectable conceptual tools we have for dealing with this self-evident fact. A tiny number of inconceivably coarse axes of categorization have been painstakingly inscribed in current critical and political thought: gender, race, class, nationality, sexual orientation are pretty much the available distinctions. They, with the associated demonstrations of the mechanisms by which they are constructed and reproduced, are indispensable, and they may indeed override all or some other forms of difference and similarity. But the sister or brother, the best friend, the classmate, the parent, the child, the lover, the ex-: our families, loves, and enmities alike, not to mention the strange relations of our work, play, and activism, prove that even people who share all or most of our own positionings along these crude axes may still be different enough from us, and from each other, to seem like all but different species.

Everybody has learned this, I assume, and probably everybody who survives at all has reasonably rich, unsystematic resources of nonce taxonomy for mapping out the possibilities, dangers, and stimulations of their human social landscape. It is probably people with the experience of oppression or subordination who have most *need* to know it; and I take the precious, devalued arts of gossip, immemorially associated in European thought with servants, with effeminate and gay men, with all women, to have to do not even so much with the transmission of necessary news as with the refinement of necessary skills for making, testing, and using unrationalized and provisional hypotheses about what *kinds of people* there are to

be found in one's world. The writing of a Proust or a James would be exemplary here: projects precisely of *nonce* taxonomy, of the making and unmaking and remaking and redissolution of hundreds of old and new categorical imaginings concerning all the kinds it may take to make up a world.

I don't assume that all gay men or all women are very skilled at the nonce-taxonomic work represented by gossip, but it does make sense to suppose that our distinctive needs are peculiarly disserved by its devaluation. For some people, the sustained, foregrounded pressure of loss in the AIDS years may be making such needs clearer: as one anticipates or tries to deal with the absence of people one loves, it seems absurdly impoverishing to surrender to theoretical trivialization or to 'the sentimental' one's descriptive requirements that the piercing bouquet of a given friend's particularity be done some justice. What is more dramatic is that – in spite of every promise to the contrary – every single theoretically or politically interesting project of postwar thought has finally had the effect of delegitimating our space for asking or thinking in detail about the multiple, unstable ways in which people may be like or different from each other. This project is not rendered otiose by any demonstration of how fully people may differ also from themselves. Deconstruction, founded as a very science of *differ(e/a)nce*, has both so fetishized the idea of difference and so vaporized its possible embodiments that its most thoroughgoing practitioners are the last people to whom one would now look for help in thinking about particular differen*ces*. The same thing seems likely to prove true of theorists of postmodernism. Psychoanalytic theory, if only through the almost astrologically lush plurality of its overlapping taxonomies of physical zones, developmental stages, representational mechanisms, and levels of consciousness, seemed to promise to introduce a certain becoming amplitude into discussions of what different people are like – only to turn, in its streamlined trajectory across so many institutional boundaries, into the sveltest of metatheoretical disciplines, sleeked down to such elegant operational entities as *the* mother, *the* father, *the* pre-oedipal, *the* oedipal, *the* other or Other. Within the less theorized institutional confines of intra-psychoanalytic discourse, meanwhile, a narrowly and severely normative, difference-eradicating ethical programme has long sheltered under developmental narratives and a metaphorics of health and pathology. In more familiar ways, Marxist, feminist, postcolonial, and other engagé critical projects have deepened understandings of a few crucial axes of difference, perhaps necessarily at the expense of more ephemeral or less global impulses of differential grouping. In each of these enquiries, so much has been gained by the different ways we have learned to deconstruct the category of *the individual* that it is easy for us now to read, say, Proust, as the most expert operator of our modern technologies for dismantling taxonomies of the person. For the emergence and persistence of the vitalizing worldly taxonomic energies on which Proust also depends, however, we have no theoretical support to offer. And these defalcations in our indispensable anti-humanist discourses have apparently ceded the potentially forceful ground of profound, complex variation to humanist liberal 'tolerance' or repressively trivializing celebration at best, to reactionary suppression at worst.

In the particular area of sexuality, for instance, I assume that most of us know the following things that can differentiate even people of identical gender, race, nationality, class, and 'sexual orientation' – each one of which, however, if taken

seriously as pure *difference*, retains the unaccounted-for potential to disrupt many forms of the available thinking about sexuality.

- Even identical genital acts mean very different things to different people.
- To some people, the nimbus of 'the sexual' seems scarcely to extend beyond the boundaries of discrete genital acts; to others, it enfolds them loosely or floats virtually free of them.
- Sexuality makes up a large share of the self-perceived identity of some people, a small share of others'.
- Some people spend a lot of time thinking about sex, others little.
- Some people like to have a lot of sex, others little or none.
- Many people have their richest mental or emotional involvement with sexual acts that they don't do, or even don't *want* to do.
- For some people, it is important that sex be embedded in contexts resonant with meaning, narrative, and connectedness with other aspects of their life; for other people, it is important that they not be; to others it doesn't occur that they might be.
- For some people, the preference for a certain sexual object, act, role, zone, or scenario is so immemorial and durable that it can only be experienced as innate; for others, it appears to come late or to feel aleatory or discretionary.
- For some people, the possibility of bad sex is aversive enough that their lives are strongly marked by its avoidance; for others, it isn't.
- For some people, sexuality provides a needed space of heightened discovery and cognitive hyperstimulation. For others, sexuality provides a needed space of routinized habituation and cognitive hiatus.
- Some people like spontaneous sexual scenes, others like highly scripted ones, others like spontaneous-sounding ones that are nonetheless totally predictable.
- Some people's sexual orientation is intensely marked by autoerotic pleasures and histories – sometimes more so than by any aspect of alloerotic object choice. For others the autoerotic possibility seems secondary or fragile, if it exists at all.
- Some people, homo-, hetero-, and bisexual, experience their sexuality as deeply embedded in a matrix of gender meanings and gender differentials. Others of each sexuality do not.

Axiom 2: The study of sexuality is not coextensive with the study of gender; correspondingly, anti-homophobic enquiry is not coextensive with feminist enquiry. But we can't know in advance how they will be different

Sex, gender, sexuality: three terms whose usage relations and analytical relations are almost irremediably slippery. The charting of a space between something called 'sex' and something called 'gender' has been one of the most influential and successful undertakings of feminist thought. For the purposes of that undertaking, 'sex' has had the meaning of a certain group of irreducible, biological differentiations between members of the species *Homo sapiens* who have XX and those who have XY chromosomes. These include (or are ordinarily thought to include) more

or less marked dimorphisms of genital formation, hair growth (in populations that have body hair), fat distribution, hormonal function, and reproductive capacity. 'Sex' in this sense – what I'll demarcate as 'chromosomal sex' – is seen as the relatively minimal raw material on which is then based the social construction of *gender*. Gender, then, is the far more elaborated, more fully and rigidly dichotomized social production and reproduction of male and female identities and behaviours – of male and female *persons* – in a cultural system for which 'male/female' functions as a primary and perhaps model binarism affecting the structure and meaning of many, many other binarisms whose apparent connection to chromosomal sex will often be exiguous or non-existent. Compared to chromosomal sex, which is seen (by these definitions) as tending to be immutable, immanent in the individual, and biologically based, the meaning of gender is seen as culturally mutable and variable, highly relational (in the sense that each of the binarized genders is defined primarily by its relation to the other), and inextricable from a history of power differentials between genders. This feminist charting of what Gayle Rubin refers to as a 'sex/gender system', the system by which chromosomal sex is turned into, and processed as, cultural gender, has tended to minimize the attribution of people's various behaviours and identities to chromosomal sex and to maximize their attribution to socialized gender constructs. The purpose of that strategy has been to gain analytic and critical leverage on the female-disadvantaging social arrangements that prevail at a given time in a given society, by throwing into question their legitimative ideological grounding in biologically based narratives of the 'natural'.

'Sex' is, however, a term that extends indefinitely beyond chromosomal sex. That its history of usage often overlaps with what might, now, more properly be called 'gender' is only one problem. ('I can only love someone of my own sex.' Shouldn't 'sex' be 'gender' in such a sentence? 'M. saw that the person who approached was of the opposite sex.' Genders – insofar as there are two and they are defined in contradistinction to one another – may be said to be opposite; but in what sense is XX the opposite of XY?) Beyond chromosomes, however, the association of 'sex', precisely through the physical body, with reproduction and with genital activity and sensation keeps offering new challenges to the conceptual clarity or even possibility of sex/gender differentiation. There is a powerful argument to be made that a primary (or *the* primary) issue in gender differentiation and gender struggle is the question of who is to have control of women's (biologically) distinctive reproductive capability. Indeed, the intimacy of the association between several of the most signal forms of gender oppression and 'the facts' of women's bodies and women's reproductive activity has led some radical feminists to question, more or less explicitly, the usefulness of insisting on a sex/gender distinction. For these reasons, even usages involving the 'sex/gender system' within feminist theory are able to use 'sex/gender' only to delineate a problematical *space* rather than a crisp distinction. My own loose usage in this book will be to denominate that problematized space of the sex/gender system, the whole package of physical and cultural distinctions between women and men, more simply under the rubric 'gender'. I do this in order to reduce the likelihood of confusion between 'sex' in the sense of 'the space of differences between male and female' (what I'll be grouping under 'gender') and 'sex' in the sense of sexuality.

Table 1 Some mappings of sex, gender, and sexuality

Biological	Cultural
Essential	Constructed
Individually immanent	Relational

Constructivist Feminist Analysis

chromosomal sex ————————————————— gender

gender inequality

Radical Feminist Analysis

chromosomal sex

reproductive relations ————————————— reproductive relations

sexual inequality sexual inequality

Foucault-influenced Analysis

chromosomal sex ————— reproduction ————— sexuality

For meanwhile the whole realm of what modern culture refers to as 'sexuality' and *also* calls 'sex' – the array of acts, expectations, narratives, pleasures, identity-formations, and knowledges, in both women and men, that tends to cluster most densely around certain genital sensations but is not adequately defined by them – that realm is virtually impossible to situate on a map delimited by the feminist-defined sex/gender distinction. To the degree that it has a centre or starting point in certain physical sites, acts, and rhythms associated (however contingently) with procreation or the potential for it, 'sexuality' in this sense may seem to be of a piece with 'chromosomal sex': biologically necessary to species survival, tending toward the individually immanent, the socially immutable, the given. But to the extent that, as Freud argued and Foucault assumed, the distinctively sexual nature of human sexuality has to do precisely with its excess over or potential difference from the bare choreographies of procreation, 'sexuality' might be the very opposite of what we originally referred to as (chromosomal-based) sex: it could occupy, instead, even more than 'gender' the polar position of the relational, the social/symbolic, the constructed, the variable, the representational (see Table 1). To note that, according to these different findings, *something* legitimately called sex or sexuality is all over the experiential and conceptual map is to record a problem less resolvable than a necessary choice of analytic paradigms or a determinate slippage of semantic meaning; it is rather, I would say, true to quite a range of contemporary worldviews and intuitions to find that sex/sexuality *does* tend to represent the full spectrum of positions between the most intimate and the most social, the most predetermined and the most aleatory, the most physically rooted and the most symbolically infused, the most innate and the most learned, the most autonomous and the most relational traits of being.

If all this is true of the definitional nexus between sex and sexuality, how much less simple, even, must be that between sexuality and gender. It will be an assumption of this study that there is always at least the potential for an analytic distance between gender and sexuality, even if particular manifestations or features of particular sexualities are among the things that plunge women and men

most ineluctably into the discursive, institutional, and bodily enmeshments of gender definition, gender relation, and gender inequality. This book will hypothesize that the question of gender and the question of sexuality, inextricable from one another though they are in that each can be expressed only in terms of the other, are none the less not the same question, that in twentieth-century Western culture gender and sexuality represent two analytic axes that may productively be imagined as being as distinct from one another as, say, gender and class, or class and race. Distinct, that is to say, no more than minimally, but none the less usefully.

It would be a natural corollary to Axiom 2 to hypothesize, then, that gay/lesbian and anti-homophobic enquiry still has a lot to learn from asking questions that feminist enquiry has learned to ask – but only so long as we don't demand to receive the same answers in both interlocutions. In a comparison of feminist and gay theory as they currently stand, the newness and consequent relative underdevelopment of gay theory are seen most clearly in two manifestations. First, we are by now very used to asking as feminists what we aren't yet used to asking as anti-homophobic readers: how a variety of forms of oppression intertwine systematically with each other; and especially how the person who is disabled through one set of oppressions may *by the same positioning* be enabled through others. For instance, the understated demeanour of educated women in our society tends to mark both their deference to educated men and their expectation of deference from women and men of lower class. Again, a woman's use of a married name makes graphic at the same time her subordination as a woman and her privilege as a presumptive heterosexual. Or, again, the distinctive vulnerability to rape of women of all races has become in this country a powerful tool for the racist enforcement by which white people, including women, are privileged at the expense of Black people of both genders. That one is *either* oppressed *or* an oppressor, or that, if one happens to be both, the two are not likely to have much to do with each other, still seems to be a common assumption, however, in at any rate male gay writing and activism, as it hasn't for a long time been in careful feminist work.

Indeed, it was the long, painful realization, *not* that all oppressions are congruent, but that they are *differently* structured and so must intersect in complex embodiments that was the first great heuristic breakthrough of socialist-feminist thought and of the thought of women of colour. This realization has as its corollary that the comparison of different axes of oppression is a crucial task, not for any purpose of ranking oppressions but to the contrary because each oppression is likely to be in a uniquely indicative relation to certain distinctive nodes of cultural organization. The *special* centrality of homophobic oppression in the twentieth century, I will be arguing, has resulted from its inextricability from the question of knowledge and the processes of knowing in modern Western culture at large.

The second and perhaps even greater heuristic leap of feminism has been the recognition that categories of gender and, hence, oppressions of gender can have a structuring force for nodes of thought, for axes of cultural discrimination, whose thematic subject isn't explicitly gendered at all. Through a series of developments structured by the deconstructive understandings and procedures sketched above, we have now learned as feminist readers that dichotomies in a given text of culture

as opposed to nature, public as opposed to private, mind as opposed to body, activity as opposed to passivity, etc. etc., are, under particular pressures of culture and history, likely places to look for implicit allegories of the relations of men to women; more, that to fail to analyse such nominally ungendered constructs in gender terms can itself be a gravely tendentious move in the gender politics of reading. This has given us ways to ask the question of gender about texts even where the culturally 'marked' gender (female) is not present as either author or thematic.

Axiom 3: There can't be an a priori decision about how far it will make sense to conceptualize lesbian and gay male identities together. Or separately

The lesbian interpretative framework most readily available at the time this project began was the separatist-feminist one that emerged from the 1970s. According to that framework, there were essentially no valid grounds of commonality between gay male and lesbian experience and identity; to the contrary, women-loving women and men-loving men must be at precisely opposite ends of the gender spectrum. The assumptions at work here were indeed radical ones: most important, the stunningly efficacious re-visioning, in female terms, of same-sex desire as being at the very definitional centre of each gender, rather than as occupying a cross-gender or liminal position between them. Thus, women who loved women were seen as *more* female, men who loved men as quite possibly more male, than those whose desire crossed boundaries of gender. The axis of sexuality, in this view, was not only exactly coextensive with the axis of gender but expressive of its most heightened essence: 'Feminism is the theory, lesbianism is the practice.' By analogy, male homosexuality could be, and often was, seen as the practice for which male supremacy was the theory. A particular reading of modern gender history was, of course, implicit in and in turn propelled by this gender-separatist framework. In accord with, for instance, Adrienne Rich's understanding of many aspects of women's bonds as constituting a 'lesbian continuum', this history, found in its purest form in the work of Lilian Faderman, deemphasized the definitional discontinuities and perturbations between more and less sexualized, more and less prohibited, and more and less gender-identity-bound forms of female same-sex bonding. Insofar as lesbian object-choice was viewed as epitomizing a specificity of female experience and resistance, insofar as a symmetrically opposite understanding of gay male object-choice also obtained, and insofar also as feminism necessarily posited male and female experiences and interests as different and opposed, the implication was that an understanding of male homo/heterosexual definition could offer little or no affordance or interest for any lesbian theoretical project. Indeed, the powerful impetus of a gender-polarized feminist ethical schema made it possible for a profoundly anti-homophobic reading of lesbian desire (as a quintessence of the female) to fuel a correspondingly homophobic reading of gay male desire (as a quintessence of the male).

Since the late 1970s, however, there have emerged a variety of challenges to this understanding of how lesbian and gay male desires and identities might be mapped against each other. Each challenge has led to a refreshed sense that lesbians

and gay men may share important though contested aspects of one another's histo-
ries, cultures, identities, politics, and destinies. These challenges have emerged
from the 'sex wars' within feminism over pornography and S/M, which seemed
to many pro-sex feminists to expose a devastating continuity between a certain,
theretofore privileged feminist understanding of a resistant female identity, on the
one hand, and on the other the most repressive nineteenth-century bourgeois
constructions of a sphere of pure femininity. Such challenges emerged as well from
the reclamation and relegitimation of a courageous history of lesbian transgender
role-playing and identification. Along with this new historical making-visible of
self-defined mannish lesbians came a new salience of the many ways in which male
and female homosexual identities had in fact been constructed through and in rela-
tion to each other over the last century – by the variously homophobic discourses
of professional expertise, but also and just as actively by many lesbians and gay
men. The irrepressible, relatively class-non-specific popular culture in which James
Dean has been as numinous an icon for lesbians as Garbo or Dietrich has for gay
men seems resistant to a purely feminist theorization. It is in these contexts that
calls for a theorized axis of sexuality as distinct from gender have developed. And
after the anti-S/M, anti-pornography liberal feminist move toward labelling and
stigmatizing particular sexualities joined its energies with those of the much longer-
established conservative sanctions against all forms of sexual 'deviance', it remained
only for the terrible accident of the HIV epidemic and the terrifyingly genocidal
overdeterminations of AIDS discourse to reconstruct a category of the pervert
capacious enough to admit homosexuals of any gender. The newly virulent homo-
phobia of the 1980s, directed alike against women and men even though its medical
pretext ought, if anything, logically to give a relative exemptive privilege to
lesbians, reminds ungently that it is more to friends than to enemies that gay
women and gay men are perceptible as distinct groups. Equally, however, the
internal perspective of the gay movements shows women and men increasingly,
though far from uncontestingly and far from equally, working together on mutu-
ally anti-homophobic agendas. The contributions of lesbians to current gay and
AIDS activism are weighty, not despite, but because of the intervening lessons of
feminism. Feminist perspectives on medicine and health-care issues, on civil disobe-
dience, and on the politics of class and race as well as of sexuality have been
centrally enabling for the recent waves of AIDS activism. What this activism returns
to the lesbians involved in it may include a more richly pluralized range of imag-
inings of lines of gender and sexual identification.

Thus, it can no longer make sense, if it ever did, simply to assume that a
male-centred analysis of homo-heterosexual definition will have no lesbian
relevance or interest. At the same time, there are no algorithms for assuming a
priori what its lesbian relevance could be or how far its lesbian interest might
extend.

Axiom 4: The immemorial, seemingly ritualized debates on nature versus nurture take place against a very unstable background of tacit assumptions and fantasies about both nurture and nature

If there is one compulsory setpiece for the Introduction to any gay-oriented book written in the late 1980s, it must be the meditation on and attempted adjudication of constructivist versus essentialist views of homosexuality. My demurral has two grounds. The first is that any such adjudication is impossible to the degree that a conceptual deadlock between the two opposing views has by now been built into the very structure of every theoretical tool we have for undertaking it. The second one is already implicit in a terminological choice I have been making: to refer to 'minoritizing' versus 'universalizing' rather than to essentialist versus constructivist understandings of homosexuality. I prefer the former terminology because it seems to record and respond to the question, 'In whose lives is homo/heterosexual definition an issue of continuing centrality and difficulty?' rather than either of the questions that seem to have got conflated in the constructivist/essentialist debate: on the one hand what one might call the question of phylogeny, 'How fully are the meaning and experience of sexual activity and identity contingent on their mutual structuring with other, historically and culturally variable aspects of a given society?'; and on the other what one might call that of ontogeny, 'What is the cause of homo- [or of hetero-] sexuality in the individual?' I am specifically offering minoritizing/universalizing as an *alternative* (though not an equivalent) to essentialist/constructivist, in the sense that I think it can do some of the same analytic work as the latter binarism, and rather more tellingly. I think it may isolate the areas where the questions of ontogeny and phylogeny most consequentially overlap. I also think, as I suggested in Axiom 1, that it is more respectful of the varied proprioception of many authoritative individuals. But I am additionally eager to promote the obsolescence of 'essentialist/constructivist' because I am very dubious about the ability of even the most scrupulously gay-affirmative thinkers to divorce these terms, especially as they relate to the question of ontogeny, from the essentially gay-genocidal nexuses of thought through which they have developed. And beyond that: even where we may think we know the conceptual landscape of their history well enough to do the delicate, always dangerous work of prying them loose from their historical backing to attach to them newly enabling meanings, I fear that the special volatility of postmodern bodily and technological relations may make such an attempt peculiarly liable to tragic misfire. Thus, it would seem to me that gay-affirmative work does well when it aims to minimize its reliance on any particular account of the origin of sexual preference and identity in individuals.

In particular, my fear is that there currently exists no framework in which to ask about the origins or development of individual gay identity that is not already structured by an implicit, trans-individual Western project or fantasy of eradicating that identity. It seems ominously symptomatic that, under the dire homophobic pressures of the last few years, and in the name of Christianity, the subtle constructivist argument that sexual aim is, at least for many people, not a hard-wired biological given but, rather, a social fact deeply embedded in the cultural and linguistic forms of many, many decades is being degraded to the blithe ukase that

people are 'free at any moment to' (i.e., must immediately) 'choose' to adhere to a particular sexual identity (say, at a random hazard, the heterosexual) rather than to its other. (Here we see the disastrously unmarked crossing of phylogenetic with ontogenetic narratives.) To the degree – and it is significantly large – that the gay essentialist/constructivist debate takes its form and premises from, and insistently refers to, a whole history of other nature/nurture or nature/culture debates, it partakes of a tradition of viewing culture as malleable relative to nature: that is, culture, unlike nature, is assumed to be the thing that can be changed; the thing in which 'humanity' has, furthermore, a right or even an obligation to intervene. This has certainly been the grounding of, for instance, the feminist formulation of the sex/gender system described above, whose implication is that the more fully gender inequality can be shown to inhere in human culture rather than in biological nature, the more amenable it must be to alteration and reform. I remember the buoyant enthusiasm with which feminist scholars used to greet the finding that one or other brutal form of oppression was not biological but 'only' cultural! I have often wondered what the basis was for our optimism about the malleability of culture by any one group or programme. At any rate, never so far as I know has there been a sufficiently powerful place from which to argue that such manipulations, however triumphal the ethical imperative behind them, were not a right that belonged to anyone who might have the power to perform them.

The number of persons or institutions by whom the existence of gay people – never mind the existence of *more gay people* – is treated as a precious desideratum, a needed condition of life, is small, even compared to those who may wish for the dignified treatment of any gay people who happen already to exist. Advice on how to make sure your kids turn out gay, not to mention your students, your parishioners, your therapy clients, or your military subordinates, is less ubiquitous than you might think. By contrast, the scope of institutions whose programmatic undertaking is to prevent the development of gay people is unimaginably large. No major institutionalized discourse offers a firm resistance to that undertaking; in the United States, at any rate, most sites of the state, the military, education, law, penal institutions, the church, medicine, mass culture, and the mental health industries enforce it all but unquestioningly, and with little hesitation even at recourse to invasive violence. So for gay and gay-loving people, even though the space of cultural malleability is the only conceivable theatre for our effective politics, every step of this constructivist nature/culture argument holds danger: it is so difficult to intervene in the seemingly natural trajectory that begins by identifying a place of cultural malleability; continues by inventing an ethical or therapeutic mandate for cultural manipulation; and ends in the overarching, hygienic Western fantasy of a world without any more homosexuals in it.

That's one set of dangers, and it is against them, I think, that essentialist understandings of sexual identity accrue a certain gravity. The resistance that seems to be offered by conceptualizing an unalterably *homosexual body*, to the social engineering momentum apparently built into every one of the human sciences of the West, can reassure profoundly. Furthermore, it reaches deeply and, in a sense, protectively into a fraught space of life-or-death struggle that has been more or less abandoned by constructivist gay theory: that is, the experience and identity

of gay or proto-gay children. The ability of anyone in the culture to support and honour gay kids may depend on an ability to name them as such, notwithstanding that many gay adults may never have been gay kids and some gay kids may not turn into gay adults. It seems plausible that a lot of the emotional energy behind essentialist historical work has to do not even in the first place with reclaiming the place and eros of Homeric heroes, Renaissance painters, and medieval gay monks, so much as with the far less permissible, vastly more necessary project of recognizing and validating the creativity and heroism of the effeminate boy or tommish girl of the 1950s (or 1960s or 1970s or 1980s) whose sense of constituting precisely a *gap* in the discursive fabric of the given has not been done justice, so far, by constructivist work.

At the same time, however, just as it comes to seem questionable to assume that cultural constructs are peculiarly malleable ones, it is also becoming increasingly problematical to assume that grounding an identity in biology or 'essential nature' is a stable way of insulating it from societal interference. If anything, the gestalt of assumptions that undergird nature/nurture debates may be in the process of direct reversal. Increasingly it is the conjecture that a particular trait is genetically or biologically based, *not* that it is 'only cultural', that seems to trigger an oestrus of manipulative fantasy in the technological institutions of the culture. A relative depressiveness about the efficacy of social engineering techniques, a high mania about biological control: the Cartesian bipolar psychosis that always underlay the nature/nurture debates has switched its polar assignments without surrendering a bit of its hold over the collective life. And in this unstable context, the dependence on a specified *homosexual body* to offer resistance to any gay-eradicating momentum is tremblingly vulnerable. AIDS, though it is used to proffer every single day to the news-consuming public the crystallized vision of a world after the homosexual, could never by itself bring about such a world. What whets these fantasies more dangerously, because more blandly, is the presentation, often in ostensibly or authentically gay-affirmative contexts, of biologically based 'explanations' for deviant behaviour that are absolutely invariably couched in terms of 'excess', 'deficiency', or 'imbalance' – whether in the hormones, in the genetic material, or, as is currently fashionable, in the fetal endocrine environment. If I had ever, in any medium, seen any researcher or popularizer refer even once to any supposed gay-producing circumstance as the *proper* hormone balance, or the *conducive* endocrine environment, for gay generation, I would be less chilled by the breezes of all this technological confidence. As things are, a medicalized dream of the prevention of gay bodies seems to be the less visible, far more respectable underside of the AIDS-fuelled public dream of their extirpation. In this unstable balance of assumptions between nature and culture, at any rate, under the overarching, relatively unchallenged aegis of a culture's desire that gay people *not be*, there is no unthreatened, unthreatening conceptual home for a concept of gay origins. We have all the more reason, then, to keep our understanding of gay origin, of gay cultural and material reproduction, plural, multi-capillaried, argus-eyed, respectful, and endlessly cherished.

Axiom 5: The historical search for a Great Paradigm Shift may obscure the present conditions of sexual identity

Since 1976, when Michel Foucault, in an act of polemical bravado, offered 1870 as the date of birth of modern homosexuality, the most sophisticated historically oriented work in gay studies has been offering ever more precise datings, ever more nuanced narratives of the development of homosexuality 'as we know it today'. The great value of this scholarly movement has been to subtract from that 'as we know it today' the twin positivist assumptions, first, that there must be some *transhistorical* essence of 'homosexuality' available to modern knowledge, and, second, that the history of understandings of same-sex relations has been a history of increasingly direct, true knowledge or comprehension of that essence. To the contrary, the recent historicizing work has assumed, first, that the differences between the homosexuality 'we know today' and previous arrangements of same-sex relations may be so profound and so integrally rooted in other cultural differences that there may be no continuous, defining essence of 'homosexuality' to *be* known; and, second, that modern 'sexuality' and hence modern homosexuality are so intimately entangled with the historically distinctive contexts and structures that now count as *knowledge* that such 'knowledge' can scarcely be a transparent window onto a separate realm of sexuality but, rather, itself constitutes that sexuality.

These developments have promised to be exciting and productive in the way that the most important work of history or, for that matter, of anthropology may be: in radically defamiliarizing and denaturalizing not only the past and the distant, but the present. One way, however, in which such an analysis is still incomplete – in which, indeed, it seems to me that it has tended inadvertently to *re*familiarize, *re*naturalize, damagingly reify an entity that it could be doing much more to subject to analysis – is in counterposing against the alterity of the past a relatively unified homosexuality that 'we' *do* 'know today'. It seems that the *topos* of 'homosexuality as we know it today', or even, to incorporate more fully the anti-positivist finding of the Foucauldian shift, 'homosexuality as we *conceive of it* today', has provided a rhetorically necessary fulcrum point for the denaturalizing work on the past done by many historians. But an unfortunate side effect of this move has been implicitly to underwrite the notion that 'homosexuality as we conceive of it today' itself comprises a coherent definitional field rather than a space of overlapping, contradictory, and conflictual definitional forces. Unfortunately, this presents more than a problem of oversimplification. To the degree that power relations involving modern homo/heterosexual definition have been structured by the very tacitness of the double-binding force fields of conflicting definition – to that degree these historical projects, for all their immense care, value, and potential, still risk reinforcing a dangerous consensus of knowingness about the genuinely *un*known, more than vestigially contradictory structurings of contemporary experience.

As an example of this contradiction effect, let me juxtapose two programmatic statements of what seem to be intended as parallel and congruent projects. In the foundational Foucault passage to which I alluded above, the modern category of 'homosexuality' that dates from 1870 is said to be

characterized . . . less by a type of sexual relations than by a certain
quality of sexual sensibility, a certain way of inverting the masculine
and feminine in oneself. Homosexuality appeared as one of the forms
of sexuality when it was transposed from the practice of sodomy onto
a kind of interior androgyny, a hermaphrodism of the soul. The
sodomite had been a temporary aberration; the homosexual was now
a species.

In Foucault's account, the unidirectional emergence in the late nineteenth century
of 'the homosexual' as 'a species', of homosexuality as a minoritizing identity, is
seen as tied to an also unidirectional, and continuing, emergent understanding of
homosexuality in terms of gender inversion and gender transitivity. This under-
standing appears, indeed, according to Foucault, to underlie and constitute the
common sense of the homosexuality 'we know today'. A more recent account by
David M. Halperin, on the other hand, explicitly in the spirit and under the influ-
ence of Foucault but building, as well, on some intervening research by George
Chauncey and others, constructs a rather different narrative – but constructs it,
in a sense, *as if it were the same one*:

> Homosexuality and heterosexuality, as we currently understand them,
> are modern, Western, bourgeois productions. Nothing resembling them
> can be found in classical antiquity. . . . In London and Paris, in the
> seventeenth and eighteenth centuries, there appear . . . social gathering-
> places for persons of the same sex with the same socially deviant
> attitudes to sex and gender who wish to socialize and to have sex with
> one another. . . . This phenomenon contributes to the formation of the
> great nineteenth-century experience of 'sexual inversion', or sex-role
> reversal, in which some forms of sexual deviance are interpreted as,
> or conflated with, gender deviance. The emergence of homosexuality
> out of inversion, the formation of a sexual orientation independent of
> relative degrees of masculinity and femininity, takes place during the
> latter part of the nineteenth century and comes into its own only in
> the twentieth. Its highest expression is the 'straight-acting and
> -appearing gay male', a man distinct from other men in absolutely no
> other respect besides that of his 'sexuality'.
>
> (Halperin 1989: 8–9)

Halperin offers some discussion of why and how he has been led to differ from
Foucault in discussing 'inversion' as a stage that in effect preceded 'homosex-
uality'. What he does not discuss is that his reading of 'homosexuality' as 'we
currently understand' it – his presumption of the reader's common sense, present-
tense conceptualization of homosexuality, the point from which all the thought
experiments of differentiation must proceed – is virtually the opposite of Foucault's.
For Halperin, what is presumed to define modern homosexuality 'as we under-
stand' it, in the form of the straight-acting and -appearing gay male, is gender
intransitivity; for Foucault, it is, in the form of the feminized man or virilized
woman, gender transitivity.

What obscures this difference between two historians, I believe, is the underlying structural congruence of the two histories: each is a unidirectional narrative of supersession. Each one makes an overarching point about the complete conceptual alterity of earlier models of same-sex relations. In each history one model of same-sex relations is superseded by another, which may again be superseded by another. In each case the superseded model then drops out of the frame of analysis. For Halperin, the power and interest of a post-inversion notion of 'sexual orientation independent of relative degrees of masculinity and femininity' seem to indicate that that notion must necessarily be seen as superseding the inversion model; he then seems to assume that any elements of the inversion model still to be found in contemporary understandings of homosexuality may be viewed as mere historical remnants whose process of withering away, however protracted, merits no analytic attention. The end point of Halperin's narrative differs from that of Foucault, but his proceeding does not: just as Halperin, having discovered an important *intervening* model, assumes that it must be a *supervening* one as well, so Foucault had already assumed that the nineteenth-century intervention of a minoritizing discourse of sexual identity in a previously extant, universalizing discourse of 'sodomitic' sexual acts must mean, for all intents and purposes, the eclipse of the latter.

This assumption is significant only if – as I will be arguing – the most potent effects of modern homo/heterosexual definition tend to spring precisely from the inexplicitness or denial of the gaps *between* long-coexisting minoritizing and universalizing, or gender-transitive and gender-intransitive, understandings of same-sex relations. If that argument is true, however, then the enactment performed by these historical narratives has some troubling entailments. For someone who lives, for instance, as I do, in a state where certain acts called 'sodomy' are criminal regardless of the gender, never mind the homo/heterosexual 'identity', of the persons who perform them, the threat of the juxtaposition *on* that prohibition against *acts* of an additional, unrationalized set of sanctions attaching to *identity* can only be exacerbated by the insistence of gay theory that the discourse of acts can represent nothing but an anachronistic vestige. The project of the present book will be to show how issues of modern homo/heterosexual definition are structured, not by the supersession of one model and the consequent withering away of another, but instead by the relations made possible by the unrationalized coexistence of different models during the times they do coexist. This project does not involve the construction of historical narratives alternative to those that have emerged from Foucault and his followers. Rather, it requires a reassignment of attention and emphasis within those valuable narratives – attempting, perhaps, to denarrativize them somewhat by focusing on a performative space of contradiction that they both delineate and, themselves performative, pass over in silence. I have tended, therefore, in these chapters not to stress the alterity of disappeared or now-supposed-alien understandings of same-sex relations but instead to invest attention in those unexpectedly plural, varied, and contradictory historical understandings whose residual – indeed, whose renewed – force seems most palpable today. My first aim is to denaturalize the present, rather than the past – in effect, to render less destructively presumable 'homosexuality as we know it today'.

Axiom 6: The paths of allo-identification are likely to be strange and recalcitrant. So are the paths of auto-identification

What would make a good answer to implicit questions about someone's group-identification across politically charged boundaries, whether of gender, of class, of race, of sexuality, of nation? It could never be a version of 'But everyone *should* be able to make this identification.' Perhaps everyone should, but everyone does not, and almost no one makes more than a small number of very narrowly channelled ones. (A currently plausible academic ideology, for instance, is that everyone in a position of class privilege *should* group-identify across lines of class; but who hasn't noticed that of the very few US scholars under fifty who have been capable of doing so productively, and over the long haul, most also 'happen to have been' red diaper babies?) If the ethical prescription is explanatory at all – and I have doubts about that – it is anything but a full explanation. It often seems to me, to the contrary, that what these implicit questions really ask for is narrative, and of a directly personal sort. When I have experimented with offering such narrative, in relation to this ongoing project, it has been with several aims in mind. I wanted to disarm the categorical imperative that seems to do so much to promote cant and mystification about motives in the world of politically correct academia. I wanted to try opening channels of visibility – towards the speaker, in this case – that might countervail somewhat against the terrible one-directionality of the culture's spectacularizing of gay men, to which it seems almost impossible, in any powerful gay-related project, not also to contribute. I meant, in a sense, to give hostages, though the possible thud of them on the tarmac of some future conflict is not something I can contemplate. I also wanted to offer (though on my own terms) whatever tools I could with which a reader who needed to might begin unknotting certain overdetermined impactions that inevitably structure these arguments. Finally, I have come up with such narrative because I desired and needed to, because its construction has greatly interested me, and what I learned from it has often surprised me.

A note appended to one of these accounts suggested an additional reason: 'Part of the motivation behind my work on it', I wrote there, 'has been a fantasy that readers or hearers would be variously – in anger, identification, pleasure, envy, "permission", exclusion – stimulated to write accounts "like" this one (whatever that means) of their own, and share those' (Sedgwick 1987: 137). My impression, indeed, is that some readers of that essay have done so. An implication of that wishful note was that it is not only identifications *across* definitional lines that can evoke or support or even require complex and particular narrative explanation; rather, the same is equally true of any person's identification with her or his 'own' gender, class, race, sexuality, nation. I think, for instance, of a graduate class I taught a few years ago in gay and lesbian literature. Half the students in the class were men, half women. Throughout the semester all the women, including me, intensely uncomfortable with the dynamics of the class and hyperconscious of the problems of articulating lesbian with gay male perspectives, attributed our discomfort to some obliquity in the classroom relations between ourselves and the men. But by the end of the semester it seemed clear that we were in the grip of some much more intimate dissonance. It seemed that it was among the group of women,

all feminists, largely homogeneous in visible respects, that some nerve of individually internal difference had been set painfully, contagiously atremble. Through a process that began, but *only* began, with the perception of some differences among our most inexplicit, often somewhat uncrystallized sexual self-definitions, it appeared that each woman in the class possessed (or might, rather, feel we were possessed by) an ability to make one or more of the other women radically and excruciatingly doubt the authority of her own self-definition as a woman; as a feminist; and as the positional subject of a particular sexuality.

I think it probable that most people, especially those involved with any form of politics that touches on issues of identity – race, for instance, as well as sexuality and gender – have observed or been part of many such circuits of intimate denegation, as well as many circuits of its opposite. The political or pedagogical utility or destructiveness of those dissonant dynamics is scarcely a given, though perhaps it must always be aversive to experience them. Such dynamics – the denegating ones along with the consolidating ones – are not epiphenomenal to identity politics, but constitute it. After all, to identify *as* must always include multiple processes of identification *with*. It also involves identification *as against*; but even did it not, the relations implicit in *identifying with* are, as psychoanalysis suggests, in themselves quite sufficiently fraught with intensitities of incorporation, diminishment, inflation, threat, loss, reparation, and disavowal. For a politics like feminism, furthermore, effective moral authority has seemed to depend on its capacity for conscientious and non-perfunctory enfoldment of women alienated from one another in virtually every other relation of life. Given this, there are strong political motives for obscuring any possibility of differentiating between one's identification *as* (a woman) and one's identification *with* (women very differently situated – for bourgeois feminists, this means radically less privileged ones). At least for relatively privileged feminists of my generation, it has been an article of faith, and a deeply educative one, that to conceive of oneself as a woman at all must mean trying to conceive oneself, over and over, as if incarnated in ever more palpably vulnerable situations and embodiments. The costs of this pressure toward mystification – the constant reconflation, as one monolithic act, of *identification with/as* – are, I believe, high for feminism, though its rewards have also been considerable. (Its political efficacy in actually broadening the bases of feminism is still, it seems to me, very much a matter of debate.) *Identification with/as* has a distinctive resonance for women in the oppressively tidy dovetailing between old ideologies of women's traditional 'selflessness' and a new one of feminist commitment that seems to begin with a self but is legitimated only by wilfully obscuring most of its boundaries.

For better and for worse, mainstream, male-centred gay politics has tended not to be structured as strongly as feminism has by that particular ethical pressure. Yet, there is a whole different set of reasons why a problematics of *identification with/as* seems to be distinctively resonant with issues of male homo/heterosexual definition. *Between Men* tried to demonstrate that modern, homophobic constructions of male heterosexuality have a conceptual dependence on a distinction between men's *identification* (with men) and their *desire* (for women), a distinction whose factitiousness is latent where not patent. The (relatively new) emphasis on the 'homo-', on the dimension of sameness, built into

modern understandings of relations of sexual desire within a given gender, has had a sustained and active power to expose that factitiousness, to show how close may be the slippage or even the melding between identification and desire. Thus, an entire social region of the vicarious becomes peculiarly charged in association with homo-heterosexual definition. I will argue that processes of homosexual attribution and identification have had a distinctive centrality, in this century, for many stigmatized but extremely potent sets of relations involving projective chains of vicarious investment: sentimentality, kitsch, camp, the knowing, the prurient, the arch, the morbid.

There may, then, be a rich and conflictual salience of the vicarious embedded within gay definition. I don't point out to offer an excuse for the different, openly vicariating cathexis from outside that motivates this study; it either needs or, perhaps, can have none. But this in turn may suggest some ways in which the particular obliquities of my approach to the subject may bias what I find there. I can say generally that the vicarious investments most visible to me have had to do with my experiences as a woman; as a fat woman; as a non-procreative adult; as someone who is, under several different discursive regimes, a sexual pervert; and, under some, a Jew. To give an example: I've wondered about my ability to keep generating ideas about 'the closet', compared to a relative inability, so far, to have new ideas about the substantive differences made by post-Stonewall imperatives to rupture or vacate that space (this, obviously, despite every inducement to thought provided by the immeasurable value of 'out' liberatory gay politics in the lives around me and my own). May it not be influenced by the fact that my own relation, as a woman, to gay male discourse and gay men echoes most with the pre-Stonewall gay self-definition of (say) the 1950s? – something, that is, whose names, where they exist at all, are still so exotically coarse and demeaning as to challenge recognition, never mind acknowledgement; leaving, in the stigma-impregnated space of refused recognition, sometimes also a stimulating ether of the unnamed, the lived experiment.

Judith Butler

SUBJECTS OF SEX/GENDER/DESIRE

EDITOR'S INTRODUCTION

JUDITH BUTLER'S WORK belongs to philosophy or feminist theory; it's a long way, for instance, from the media-studies side of cultural studies. Here she develops her arguments by way of commentary on two key French feminist philosophers – Simone de Beauvoir (an existentialist, writing in the 1940s and 1950s, often thought of as the first modern feminist thinker) and Luce Irigaray (a post-structuralist, writing mainly in the 1970s). Yet this essay contributes to cultural studies because, like de Lauretis and Sedgwick, as well as (in different areas) Bhabha, Spivak and Fraser, Butler provides an abstract conceptual framework (or should that be a "working through" of abstract concepts?) which is of real use to the case-based, descriptive analyses more characteristic of cultural studies.

Butler's basic ideas in this piece are similar to Sedgwick's in her essay collected here. We can summarize them like this: not all women are feminists; gender is not to be equated with sex; women are not covered and defined by "womenness" (that is, women are not just women); gender roles are maintained by being continually performed; heterosexuality is not normal by right or nature, rather it is promoted within hetero-normative social regimes. She comes to these premises by joining what she has learnt from Foucault to a certain psychoanalysis via a searching deconstructionist method.

Butler is Foucauldian in arguing that the social and legal regulations which seem to limit freedom actually provide the conditions for the identities in which freedom becomes meaningful and desirable.

She is Freudian in that, for her, desires, drives, and identities are not simply social constructions. They belong to the body which is not quite the creature of

ideological or familial structures. Same-sex desire, for instance, is not to be derived either from individual life histories (stories of failed socialization or triumphant dissidence) or from the negative codings that such desire is given culturally and legally. Same-sex desire belongs to the body, wherever else it may gain definition and force.

Butler is a deconstructionist most of all in that she does not organize her thoughts in binary oppositions. This essay is a critique of the notion that people necessarily have one of two genders; it is also a critique of the idea that we must choose between "nature" and "nurture." She's indebted to deconstruction too in being very alive to the ways in which "performative speech acts" can be passed off as descriptions: for instance, to give the case of most interest to her here, we often describe ourselves as having identities as if those identities exist in the real world whereas, in fact, the phrases which refer to those identities create them. Identity talk is a performance in which its objects are conjured up as much as it is analysis of things that exist out there – and it's just one of the performances in which gender identities are maintained.

Further reading: Butler 1991, 1993, 1997; de Beauvoir 1973; Foucault 1980a; Fuss 1989; Irigaray 1985; Riviere 1986.

One is not born a woman, but rather becomes one.

Simone de Beauvoir

Strictly speaking, 'women' cannot be said to exist.

Julia Kristeva

Woman does not have a sex.

Luce Irigaray

The deployment of sexuality . . . established this notion of sex.

Michel Foucault

The category of sex is the political category that founds society as heterosexual.

Monique Wittig

'Women' as the subject of feminism

For the most part, feminist theory has assumed that there is some existing identity, understood through the category of women, which not only initiates feminist interests and goals within discourse but constitutes the subject for whom political representation is pursued. But *politics* and *representation* are controversial terms. On the one hand, *representation* serves as the operative term within a political process that seeks to extend visibility and legitimacy to women as political subjects; on the other hand, representation is the normative function of a language which is said either to reveal or to distort what is assumed to be true about the category of women. For

feminist theory, the development of a language that fully or adequately represents women has seemed necessary to foster the political visibility of women. This has seemed obviously important considering the pervasive cultural condition in which women's lives were either misrepresented or not represented at all.

Recently, this prevailing conception of the relation between feminist theory and politics has come under challenge from within feminist discourse. The very subject of women is no longer understood in stable or abiding terms. There is a great deal of material that not only questions the viability of 'the subject' as the ultimate candidate for representation or, indeed, liberation, but there is very little agreement after all on what it is that constitutes, or ought to constitute, the category of women. The domains of political and linguistic 'representation' set out in advance the criterion by which subjects themselves are formed, with the result that representation is extended only to what can be acknowledged as a subject. In other words, the qualifications for being a subject must first be met before representation can be extended.

Foucault points out that juridical systems of power *produce* the subjects they subsequently come to represent. Juridical notions of power appear to regulate political life in purely negative terms – that is, through the limitation, prohibition, regulation, control and even 'protection' of individuals related to that political structure through the contingent and retractable operation of choice. But the subjects regulated by such structures are, by virtue of being subjected to them, formed, defined, and reproduced in accordance with the requirements of those structures. If this analysis is right, then the juridical formation of language and politics that represents women as 'the subject' of feminism is itself a discursive formation and effect of a given version of representational politics. And the feminist subject turns out to be discursively constituted by the very political system that is supposed to facilitate its emancipation. This becomes politically problematic if that system can be shown to produce gendered subjects along a differential axis of domination or to produce subjects who are presumed to be masculine. In such cases, an uncritical appeal to such a system for the emancipation of 'women' will be clearly self-defeating.

The question of 'the subject' is crucial for politics, and for feminist politics in particular, because juridical subjects are invariably produced through certain exclusionary practices that do not 'show' once the juridical structure of politics has been established. In other words, the political construction of the subject proceeds with certain legitimating and exclusionary aims, and these political operations are effectively concealed and naturalized by a political analysis that takes juridical structures as their foundation. Juridical power inevitably 'produces' what it claims merely to represent; hence, politics must be concerned with this dual function of power: the juridical and the productive. In effect, the law produces and then conceals the notion of 'a subject before the law' in order to invoke that discursive formation as a naturalized foundational premise that subsequently legitimates that law's own regulatory hegemony. It is not enough to inquire into how women might become more fully represented in language and politics. Feminist critique ought also to understand how the category of 'women', the subject of feminism, is produced and restrained by the very structures of power through which emancipation is sought.

Indeed, the question of women as the subject of feminism raises the possibility that there may not be a subject who stands 'before' the law, awaiting representation in or by the law. Perhaps the subject, as well as the invocation of a temporal 'before' is constituted by the law as the fictive foundation of its own claim to legitimacy. The prevailing assumption of the ontological integrity of the subject before the law might be understood as the contemporary trace of the state of nature hypothesis, that foundationalist fable constitutive of the juridical structures of classical liberalism. The performative invocation of a non-historical 'before' becomes the foundational premise that guarantees a presocial ontology of persons who freely consent to be governed and, thereby, constitute the legitimacy of the social contract.

Apart from the foundationalist fictions that support the notion of the subject, however, there is the political problem that feminism encounters in the assumption that the term *women* denotes a common identity. Rather than a stable signifier that commands the assent of those whom it purports to describe and represent, *women*, even in the plural, has become a troublesome term, a site of contest, a cause for anxiety. As Denise Riley's title suggests, *Am I That Name?* is a question produced by the very possibility of the name's multiple significations. If one 'is' a woman, that is surely not all one is; the term fails to be exhaustive, not because a pre-gendered 'person' transcends the specific paraphernalia of its gender, but because gender is not always constituted coherently or consistently in different historical contexts, and because gender intersects with racial, class, ethnic, sexual, and regional modalities of discursively constituted identities. As a result, it becomes impossible to separate out 'gender' from the political and cultural intersections in which it is invariably produced and maintained.

The political assumption that there must be a universal basis for feminism, one which must be found in an identity assumed to exist cross-culturally, often accompanies the notion that the oppression of women has some singular form discernible in the universal or hegemonic structure of patriarchy or masculine domination. The notion of a universal patriarchy has been widely criticized in recent years for its failure to account for the workings of gender oppression in the concrete cultural contexts in which it exists. Where those various contexts have been consulted within such theories, it has been to find 'examples' or 'illustrations' of a universal principle that is assumed from the start. That form of feminist theorizing has come under criticism for its efforts to colonize and appropriate non-Western cultures to support highly Western notions of oppression, but because they tend as well to construct a 'Third World' or even an 'Orient' in which gender oppression is subtly explained as symptomatic of an essential, non-Western barbarism. The urgency of feminism to establish a universal status for patriarchy in order to strengthen the appearance of feminism's own claims to be representative has occasionally motivated the shortcut to a categorial or fictive universality of the structure of domination, held to produce women's common subjugated experience.

Although the claim of universal patriarchy no longer enjoys the kind of credibility it once did, the notion of a generally shared conception of 'women', the corollary to that framework, has been much more difficult to displace. Certainly, there have been plenty of debates: Is there some commonality among 'women'

that pre-exists their oppression, or do 'women' have a bond by virtue of their oppression alone? Is there a specificity to women's cultures that is independent of their subordination by hegemonic, masculinist cultures? Are the specificity and integrity of women's cultural or linguistic practices always specified against and, hence, within the terms of some more dominant cultural formation? If there is a region of the 'specifically feminine', one that is both differentiated from the masculine as such and recognizable in its difference by an unmarked and, hence, presumed universality of 'women'? The masculine/feminine binary constitutes not only the exclusive framework in which that specificity can be recognized, but in every other way the 'specificity' of the feminine is once again fully decontextualized and separated off analytically and politically from the constitution of class, race, ethnicity and other axes of power relations that both constitute 'identity' and make the singular notion of identity a misnomer.

My suggestion is that the presumed universality and unity of the subject of feminism is effectively undermined by the constraints of the representational discourse in which it functions. Indeed, the premature insistence on a stable subject of feminism, understood as a seamless category of women, inevitably generates multiple refusals to accept the category. These domains of exclusion reveal the coercive and regulatory consequences of that construction, even when the construction has been elaborated for emancipatory purposes. Indeed, the fragmentation within feminism and the paradoxical opposition to feminism from 'women' whom feminism claims to represent suggest the necessary limits of identity politics. The suggestion that feminism can seek wider representation for a subject that it itself constructs has the ironic consequence that feminist goals risk failure by refusing to take account of the constitutive powers of their own representational claims. This problem is not ameliorated through an appeal to the category of women for merely 'strategic' purposes, for strategies always have meanings that exceed the purposes for which they are intended. In this case, exclusion itself might qualify as such an unintended yet consequential meaning. By conforming to a requirement of representational politics that feminism articulate a stable subject, feminism thus opens itself to charges of gross misrepresentation.

Obviously, the political task is not to refuse representational politics – as if we could. The juridical structures of language and politics constitute the contemporary field of power; hence, there is no position outside this field, but only a critical genealogy of its own legitimating practices. As such, the critical point of departure is *the historical present*, as Marx put it. And the task is to formulate within this constituted frame a critique of the categories of identity that contemporary juridical structures engender, naturalize and immobilize.

Perhaps there is an opportunity at this juncture of cultural politics, a period that some would call 'postfeminist', to reflect from within a feminist perspective on the injunction to construct a subject of feminism. Within feminist political practice, a radical rethinking of the ontological constructions of identity appears to be necessary in order to formulate a representational politics that might revive feminism on other grounds. On the other hand, it may be time to entertain a radical critique that seeks to free feminist theory from the necessity of having to construct a single or abiding ground which is invariably contested by those identity positions or anti-identity positions that it invariably excludes. Do the exclusionary practices

that ground feminist theory in a notion of 'women' as subject paradoxically undercut feminist goals to extend its claims to 'representation'?

Perhaps the problem is even more serious. Is the construction of the category of women as a coherent and stable subject an unwitting regulation and reification of gender relations? And is not such a reification precisely contrary to feminist aims? To what extent does the category of women achieve stability and coherence only in the context of the heterosexual matrix? If a stable notion of gender no longer proves to be the foundational premise of feminist politics, perhaps a new sort of feminist politics is now desirable to contest the very reifications of gender and identity, one that will take the variable construction of identity as both a methodological and normative prerequisite, if not a political goal.

To trace the political operations that produce and conceal what qualifies as the juridical subject of feminism is precisely the task of a *feminist genealogy* of the category of women. In the course of this effort to question 'women' as the subject of feminism, the unproblematic invocation of that category may prove to *preclude* the possibility of feminism as a representational politics. What sense does it make to extend representation to subjects who are constructed through the exclusion of those who fail to conform to unspoken normative requirements of the subject? What relations of domination and exclusion are inadvertently sustained when representation becomes the sole focus of politics? The identity of the feminist subject ought not to be the foundation of feminist politics, if the formation of the subject takes place within a field of power regularly buried through the assertion of that foundation. Perhaps, paradoxically, 'representation' will be shown to make sense for feminism only when the subject of 'women' is nowhere presumed.

The compulsory order of sex/gender/desire

Although the unproblematic unity of 'women' is often invoked to construct a solidarity of identity, a split is introduced in the feminist subject by the distinction between sex and gender. Originally intended to dispute the biology-is-destiny formulation, the distinction between sex and gender serves the argument that whatever biological intractability sex appears to have, gender is culturally constructed: hence, gender is neither the causal result of sex nor as seemingly fixed as sex. The unity of the subject is thus already potentially contested by the distinction that permits of gender as a multiple interpretation of sex.

If gender is the cultural meanings that the sexed body assumes, then a gender cannot be said to follow from a sex in any one way. Taken to its logical limit, the sex/gender distinction suggests a radical discontinuity between sexed bodies and culturally constructed genders. Assuming for the moment the stability of binary sex, it does not follow that the construction of 'men' will accrue exclusively to the bodies of males or that 'women' will interpret only female bodies. Further, even if the sexes appear to be unproblematically binary in their morphology and constitution (which will become a question), there is no reason to assume that genders ought also to remain as two. The presumption of a binary gender system implicitly retains the belief in a mimetic relation of gender to sex whereby gender mirrors sex or is otherwise restricted by it. When the constructed status of

gender is theorized as radically independent of sex, gender itself becomes a free-floating artifice, with the consequence that *man* and *masculine* might just as easily signify a female body as a male one, and *woman* and *feminine* a male body as easily as a female one.

This radical splitting of the gendered subject poses yet another set of problems. Can we refer to a 'given' sex or a 'given' gender without first inquiring into how sex and/or gender is given, through what means? And what is 'sex' anyway? Is it natural, anatomical, chromosomal, or hormonal, and how is a feminist critic to assess the scientific discourses which purport to establish such 'facts' for us? Does sex have a history? Does each sex have a different history, or histories? Is there a history of how the duality of sex was established, a genealogy that might expose the binary options as a variable construction? Are the ostensibly natural facts of sex discursively produced by various scientific discourses in the service of other political and social interests? If the immutable character of sex is contested, perhaps this construct called 'sex' is as culturally constructed as gender; indeed, perhaps it was always already gender, with the consequence that the distinction between sex and gender turns out to be no distinction at all.

It would make no sense, then, to define gender as the cultural interpretation of sex, if sex itself is a gendered category. Gender ought not to be conceived merely as the cultural inscription of meaning on a pregiven sex (a juridical conception); gender must also designate the very apparatus of production whereby the sexes themselves are established. As a result, gender is not to culture as sex is to nature; gender is also the discursive/cultural means by which 'sexed nature' or 'a natural sex' is produced and established as 'prediscursive', prior to culture, a politically neutral surface *on which* culture acts. At this juncture it is already clear that one way the internal stability and binary frame for sex is effectively secured is by casting the duality of sex in a prediscursive domain. This production of sex *as* the prediscursive ought to be understood as the effect of the apparatus of cultural construction designated by *gender*. How, then, does gender need to be reformulated to encompass the power relations that produce the effect of a prediscursive sex and so conceal that very operation of discursive production?

Gender: the circular ruins of contemporary debate

Is there 'a' gender which persons are said *to have*, or is it an essential attribute that a person is said *to be*, as implied in the question 'What gender are you?'? When feminist theorists claim that gender is the cultural interpretation of sex or that gender is culturally constructed, what is the manner or mechanism of this construction? If gender is constructed, could it be constructed differently, or does its constructedness imply some form of social determinism, foreclosing the possibility of agency and transformation? Does 'construction' suggest that certain laws generate gender differences along universal axes of sexual difference? How and where does the construction of gender take place? What sense can we make of a construction that cannot assume a human constructor prior to that construction? On some accounts, the notion that gender is constructed suggests a certain determinism of gender meanings inscribed on anatomically differentiated bodies, where

those bodies are understood as passive recipients of an inexorable cultural law. When the relevant 'culture' that 'constructs' gender is understood in terms of such a law or set of laws, then it seems that gender is as determined and fixed as it was under the biology-is-destiny formulation. In such a case, not biology, but culture, becomes destiny.

On the other hand, Simone de Beauvoir suggests in *The Second Sex* that 'one is not born a woman, but, rather, becomes one'. For de Beauvoir, gender is 'constructed', but implied in her formulation is an agent, a *cogito*, who somehow takes on or appropriates that gender and could, in principle, take on some other gender. Is gender as variable and volitional as de Beauvoir's account seems to suggest? Can 'construction' in such a case be reduced to a form of choice? De Beauvoir is clear that one 'becomes' a woman, but always under a cultural compulsion to become one. And clearly, the compulsion does not come from 'sex'. There is nothing in her account that guarantees that the 'one' who becomes a woman is necessarily female. If 'the body is a situation', as she claims, there is no recourse to a body that has not always already been interpreted by cultural meanings; hence, sex could not qualify as a prediscursive anatomical facticity. Indeed, sex, by definition, will be shown to have been gender all along.

The controversy over the meaning of *construction* appears to founder on the conventional philosophical polarity between free will and determinism. As a consequence, one might reasonably suspect that some common linguistic restriction on thought both forms and limits the terms of the debate. Within those terms, 'the body' appears as a passive medium on which cultural meanings are inscribed or as the instrument through which an appropriative and interpretive will determines a cultural meaning for itself. In either case, the body is figured as a mere *instrument* or *medium* for which a set of cultural meanings are only externally related. But 'the body' is itself a construction, as are the myriad 'bodies' that constitute the domain of gendered subjects. Bodies cannot be said to have a signifiable existence prior to the mark of their gender; the question then emerges: To what extent does the body *come into being* in and through the mark(s) of gender? How do we reconceive the body no longer as a passive medium or instrument awaiting the enlivening capacity of a distinctly immaterial will?

Whether gender or sex is fixed or free is a function of a discourse which, it will be suggested, seeks to set certain limits to analysis or to safeguard certain tenets of humanism as presuppositional to any analysis of gender. The locus of intractability, whether in 'sex' or 'gender' or in the very meaning of 'construction', provides a clue to what cultural possibilities can and cannot become mobilized through any further analysis. The limits of the discursive analysis of gender presuppose and pre-empt the possibilities of imaginable and realizable gender configurations within culture. This is not to say that any and all gendered possibilities are open, but that the boundaries of analysis suggest the limits of a discursively conditioned experience. These limits are always set within the terms of a hegemonic cultural discourse predicated on binary structures that appear as the language of universal rationality. Constraint is thus built into what that language constitutes as the imaginable domain of gender.

Although social scientists refer to gender as a 'factor' or a 'dimension' of an analysis, it is also applied to embodied persons as 'a mark' of biological, linguistic, and/or cultural difference. In these latter cases, gender can be understood as a signification that an (already) sexually differentiated body assumes, but even then that signification exists only *in relation* to another, opposing signification. Some feminist theorists claim that gender is 'a relation', indeed, a set of relations, and not an individual attribute. Others, following de Beauvoir, would argue that only the feminine gender is marked, that the universal person and the masculine gender are conflated, thereby defining women in terms of their sex and extolling men as the bearers of a body-transcendent universal personhood.

In a move that complicates the discussion further, Luce Irigaray argues that women constitute a paradox, if not a contradiction, within the discourse of identity itself. Women are the 'sex' which is not 'one'. Within a language pervasively masculinist, a phallogocentric language, women constitute the *unrepresentable*. In other words, women represent the sex that cannot be thought, a linguistic absence and opacity. Within a language that rests on univocal signification, the female sex constitutes the unconstrainable and undesignatable. In this sense, women are the sex which is not 'one', but multiple. In opposition to de Beauvoir, for whom women are designated as the Other, Irigaray argues that both the subject and the Other are masculine mainstays of a closed phallogocentric signifying economy that achieves its totalizing goal through the exclusion of the feminine altogether. For de Beauvoir, women are the negative of men, the lack against which masculine identity differentiates itself; for Irigaray, that particular dialectic constitutes a system that excludes an entirely different economy of signification. Women are not only represented falsely within the Sartrian frame of signifying-subject and signified-Other, but the falsity of the signification points out the entire structure of representation as inadequate. The sex which is not one, then, provides a point of departure for a criticism of hegemonic Western representation and of the metaphysics of substance that structures the very notion of the subject.

What is the metaphysics of substance, and how does it inform thinking about the categories of sex? In the first instance, humanist conceptions of the subject tend to assume a substantive person who is the bearer of various essential and nonessential attributes. A humanist feminist position might understand gender as an *attribute* of a person who is characterized essentially as a pregendered substance or 'core', called the person, denoting a universal capacity for reason, moral deliberation, or language. The universal conception of the person, however, is displaced as a point of departure for a social theory of gender by those historical and anthropological positions that understand gender as a *relation* among socially constituted subjects in specifiable contexts. This relational or contextual point of view suggests that what the person 'is', and, indeed, what gender 'is', is always relative to the constructed relations in which it is determined. As a shifting and contextual phenomenon, gender does not denote a substantive being but a relative point of convergence among culturally and historically specific sets of relations.

Irigaray would maintain, however, that the feminine 'sex' is a point of linguistic *absence*, the impossibility of a grammatically denoted substance, and, hence, the point of view that exposes that substance as an abiding and foundational illusion of a masculinist discourse. This absence is not marked as such within the mascu-

line signifying economy — a contention that reverses de Beauvoir's argument that the female sex *is* marked, while the male sex is not. For Irigaray, the female sex is not a 'lack' or an 'Other' that immanently and negatively defines the subject in its masculinity. On the contrary, the female sex eludes the very requirements of representation, for she is neither 'Other' nor the 'lack', those categories remaining relative to the Sartrian subject, immanent to that phallogocentric scheme. Hence, for Irigaray, the feminine could never be the *mark of a subject*, as de Beauvoir would suggest. Further, the feminine could not be theorized in terms of a determinate *relation* between the masculine and the feminine within any given discourse, for discourse is not a relevant notion here. Even in their variety, discourses constitute so many modalities of phallogocentric language. The female sex is thus also *the subject* that is not one. The relation between masculine and feminine cannot be represented in a signifying economy in which the masculine constitutes the closed circle of signifier and signified. Paradoxically enough, de Beauvoir prefigured this impossibility in *The Second Sex* when she argued that men could not settle the question of women because they would then be acting as both judge and party to the case.

The distinctions among the above positions are far from discrete; each of them can be understood to problematize the locality and meaning of both the 'subject' and 'gender' within the context of socially instituted gender asymmetry. The interpretive possibilities of gender are in no sense exhausted by the alternatives suggested above. The problematic circularity of a feminist inquiry into gender is underscored by the presence of positions which, on the one hand, presume that gender is a secondary characteristic of persons and those which, on the other hand, argue that the very notion of the person, positioned within language as a 'subject', is a masculinist construction and prerogative which effectively excludes the structural and semantic possibility of a feminine gender. The consequence of such sharp disagreements about the meaning of gender (indeed, whether *gender* is the term to be argued about at all, or whether the discursive construction of *sex* is, indeed, more fundamental, or perhaps *women* or *woman* and/or *men* and *man*) establishes the need for a radical rethinking of the categories of identity within the context of relations of radical gender asymmetry.

For de Beauvoir, the 'subject' within the existential analytic of misogyny is always already masculine, conflated with the universal, differentiating itself from a feminine 'Other' outside the universalizing norms of personhood, hopelessly 'particular', embodied, condemned to immanence. Although de Beauvoir is often understood to be calling for the right of women, in effect, to become existential subjects and, hence, for inclusion within the terms of an abstract universality, her position also implies a fundamental critique of the very disembodiment of the abstract masculine epistemological subject. That subject is abstract to the extent that it disavows its socially marked embodiment and, further, projects that disavowed and disparaged embodiment on to the feminine sphere, effectively renaming the body as female. This association of the body with the female works along magical relations of reciprocity whereby the female sex becomes restricted to its body, and the male body, fully disavowed, becomes, paradoxically, the incorporeal instrument of an ostensibly radical freedom. De Beauvoir's analysis implicitly poses the question: Through what act of negation and disavowal does the masculine

pose as a disembodied universality and the feminine get constructed as a disavowed corporeality? The dialectic of master–slave, here fully reformulated within the nonreciprocal terms of gender asymmetry, prefigures what Irigaray will later describe as the masculine signifying economy that includes both the existential subject and its Other.

De Beauvoir proposes that the female body ought to be the situation and instrumentality of women's freedom, not a defining and limiting essence. The theory of embodiment informing her analysis is clearly limited by the uncritical reproduction of the Cartesian distinction between freedom and the body. Despite my own previous efforts to argue the contrary, it appears that de Beauvoir maintains the mind/body dualism, even as she proposes a synthesis of those terms. The preservation of that very distinction can be read as symptomatic of the very phallogocentrism that de Beauvoir underestimates. In the philosophical tradition that begins with Plato and continues through Descartes, Husserl, and Sartre, the ontological distinction between soul (consciousness, mind) and body invariably supports relations of political and psychic subordination and hierarchy. The mind not only subjugates the body but occasionally entertains the fantasy of fleeing its embodiment altogether. The cultural associations of mind with masculinity and body with femininity are well documented within the field of philosophy and feminism. As a result, any uncritical reproduction of the mind/body distinction ought to be rethought for the implicit gender hierarchy that the distinction has conventionally produced, maintained, and rationalized.

The discursive construction of 'the body' and its separation from 'freedom' in de Beauvoir fails to mark along the axis of gender the very mind-body distinction that is supposed to illuminate the persistence of gender asymmetry. Officially, de Beauvoir contends that the female body is marked within masculinist discourse, whereas the masculine body, in its conflation with the universal, remains unmarked. Irigaray clearly suggests that both marker and marked are maintained within a masculinist mode of signification in which the female body is 'marked off', as it were, from the domain of the signifiable. In post-Hegelian terms, she is 'cancelled', but not preserved. On Irigaray's reading, de Beauvoir's claim that woman 'is sex' is reversed to mean that she is not the sex she is designated to be but, rather, the masculine sex *encore* (and *en corps*) parading in the mode of otherness. For Irigaray, that phallogocentric mode of signifying the female sex perpetually reproduces phantasms of its own self-amplifying desire. Instead of a self-limiting linguistic gesture that grants alterity or difference to women, phallogocentrism offers a name to eclipse the feminine and take its place.

Theorizing the binary, the unitary and beyond

De Beauvoir and Irigaray clearly differ over the fundamental structures by which gender asymmetry is reproduced; de Beauvoir turns to the failed reciprocity of an asymmetrical dialectic, while Irigaray suggests that the dialectic itself is the monologic elaboration of a masculinist signifying economy. Although Irigaray clearly broadens the scope of feminist critique by exposing the epistemological, ontological, and logical structures of a masculinist signifying economy, the power of her analysis

is undercut precisely by its globalizing reach. Is it possible to identify a monolithic as well as a monologic masculinist economy that traverses the array of cultural and historical contexts in which sexual difference takes place? Is the failure to acknowledge the specific cultural operations of gender oppression itself a kind of epistemological imperialism, one which is not ameliorated by the simple elaboration of cultural differences as 'examples' of the selfsame phallogocentrism? The effort to *include* 'Other' cultures as variegated amplifications of a global phallogocentrism constitutes an appropriative act that risk a repetition of the self-aggrandizing gesture of phallogocentrism, colonizing under the sign of the same those differences that might otherwise call that totalizing concept into question.

Feminist critique ought to explore the totalizing claims of a masculinist signifying economy, but also remain self-critical with respect to the totalizing gestures of feminism. The effort to identify the enemy as singular in form is a reverse-discourse that uncritically mimics the strategy of the oppressor instead of offering a different set of terms. That the tactic can operate in feminist and antifeminist contexts alike suggests that the colonizing gesture is not primarily or irreducibly masculinist. It can operate to effect other relations of racial, class, and heterosexist subordination, to name but a few. And clearly, listing the varieties of oppression, as I began to do, assumes their discrete, sequential coexistence along a horizontal axis that does not describe their convergences within the social field. A vertical model is similarly insufficient; oppressions cannot be summarily ranked, causally related, distributed among planes of 'originality' and 'derivativeness'. Indeed, the field of power structured in part by the imperializing gesture of dialectical appropriation exceeds and encompasses the axis of sexual difference, offering a mapping of intersecting differentials which cannot be summarily hierarchized either within the terms of phallogocentrism or any other candidate for the position of 'primary condition of oppression'. Rather than an exclusive tactic of masculinist signifying economies, dialectical appropriation and suppression of the Other is one tactic among many, deployed centrally but not exclusively in the service of expanding and rationalizing the masculinist domain.

The contemporary feminist debates over essentialism raise the question of the universality of female identity and masculinist oppression in other ways. Universalistic claims are based on a common or shared epistemological standpoint, understood as the articulated consciousness or shared structures of oppression or in the ostensibly transcultural structures of femininity, maternity, sexuality, and/or *écriture féminine*. The opening discussion in this chapter argued that this globalizing gesture has spawned a number of criticisms from women who claim that the category of 'women' is normative and exclusionary and is invoked with the unmarked dimensions of class and racial privilege intact. In other words, the insistence upon the coherence and unity of the category of women has effectively refused the multiplicity of cultural, social, and political intersections in which the concrete array of 'women' is constructed.

Some efforts have been made to formulate coalitional politics which do not assume in advance what the content of 'women' will be. They propose instead a set of dialogic encounters by which variously positioned women articulate separate identities within the framework of an emergent coalition. Clearly, the value of coalitional politics is not to be underestimated, but the very form of coalition,

of an emerging and unpredictable assemblage of positions, cannot be figured in advance. Despite the clearly democratizing impulse that motivates coalition building, the coalitional theorist can inadvertently reinsert herself as sovereign of the process by trying to assert an ideal form for coalitional structures *in advance*, one that will effectively guarantee unity as the outcome. Related efforts to determine what is and is not the true shape of a dialogue, what constitutes a subject-position, and, most importantly, when 'unity' has been reached, can impede the shelf-shaping and self-limiting dynamics of coalition.

The insistence in advance on coalitional 'unity' as a goal assumes that solidarity, whatever its price, is a prerequisite for political action. But what sort of politics demands that kind of advance purchase on unity? Perhaps a coalition needs to acknowledge its contradictions and take action with those contradictions intact. Perhaps also part of what dialogic understanding entails is the acceptance of divergence, breakage, splinter, and fragmentation as part of the often tortuous process of democratization. The very notion of 'dialogue' is culturally specific and historically bound, and while one speaker may feel secure that a conversation is happening, another may be sure it is not. The power relations that condition and limit dialogic possibilities need first to be interrogated. Otherwise, the model of dialogue risks relapsing into a liberal model that assumes that speaking agents occupy equal positions of power and speak with the same presuppositions about what constitutes 'agreement' and 'unity' and, indeed, that those are the goals to be sought. It would be wrong to assume in advance that there is a category of 'women' that simply needs to be filled in with various components of race, class, age, ethnicity and sexuality in order to become complete. The assumption of its essential incompleteness permits that category to serve as a permanently available site of contested meanings. The definitional incompleteness of the category might then serve as a normative ideal relieved of coercive force.

Is 'unity' necessary for effective political action? Is the premature insistence on the goal of unity precisely the cause of an ever more bitter fragmentation among the ranks? Certain forms of acknowledged fragmentation might facilitate coalitional action precisely because the 'unity' of the category of women is neither presupposed nor desired. Does 'unity' set up an exclusionary norm of solidarity at the level of identity that rules out the possibility of a set of actions which disrupt the very borders of identity concepts, or which seek to accomplish precisely that disruption as an explicit political aim? Without the presupposition or goal of 'unity', which is, in either case, always instituted at a conceptual level, provisional unities might emerge in the context of concrete actions that have purposes other than the articulation of identity. Without the compulsory expectation that feminist actions must be instituted from some stable, unified, and agreed-upon identity, those actions might well get a quicker start and seem more congenial to a number of 'women' for whom the meaning of the category is permanently moot.

The antifoundationalist approach to coalitional politics assumes neither that 'identity' is a premise nor that the shape or meaning of a coalitional assemblage can be known prior to its achievement. Because the articulation of an identity within available cultural terms instates a definition that forecloses in advance the emergence of new identity concepts in and through politically engaged actions, the foundationalist tactic cannot take the transformation or expansion of existing

identity concepts as a normative goal. Moreover, when agreed-upon identities or agreed-upon dialogic structures, through which already established identities are communicated, no longer constitute the theme or subject of politics, then identities can come into being and dissolve depending on the concrete practices that constitute them. Certain political practices institute identities on a contingent basis in order to accomplish whatever aims are in view. Coalitional politics requires neither an expanded category of 'women' nor an internally multiplicitous self that offers its complexity at once.

Gender is a complexity whose totality is permanently deferred, never fully what it is at any given juncture in time. An open coalition, then, will affirm identities that are alternately instituted and relinquished according to the purposes at hand; it will be an open assemblage that permits of multiple convergences and divergences without obedience to a normative *telos* of definitional closure.

Lauren Berlant and Michael Warner

SEX IN PUBLIC

EDITOR'S INTRODUCTION

FOR ALL THEIR DIFFERENCES, Berlant and Warner's essay is profitably to be read alongside Nancy Fraser's in this volume. Both derive from Jürgen Habermas's work. Whereas Fraser, writing as a social theorist, outlines possibilities for a society constituted by many public spheres, including oppositional ones, Berlant and Warner, writing in queer cultural studies, consider the relation between the public and the personal.

Nothing divides the personal from the public more than the idea that the personal is where intimacy happens, with sex being the most intimate area of all. Berlant and Warner note that 1990s conservatism, in its pursuit of family values and public order, is policing the personal/public division with renewed vigor – at no time more fiercely than when "sex in public" is at stake.

For Berlant and Warner, it's because sex and intimacy are used to regulate the personal/public opposition so routinely that sex and intimacy might be used to shift and unsettle that opposition. Thus the essay appeals for "non-standard intimacies" and welcomes occasions where such intimacies occur in some kind of public space.

Cultural studies has recently addressed two different but related questions to those addressed here, but about which Berlant and Warner have things to say by implication at least. The first concerns the instability of the public/private opposition, especially the way in which private life is actually lived as if it were open to wider – more public – inspection and assessment, as a kind of open secret (see Sedgwick 1990). The second concerns the way in which gossip (public circulation of private matters) has become a staple of popular media – which has, on the one hand, broken down the classical association of public life with affairs of state and

civic responsibility, and, on the other, undermined the strict ascription of what is supposedly nobody else's business (everyday pleasures, traumas, scandals, relationship breakdowns etc.) to private life (see Mellencamp 1992).

Further reading: Abelove *et al.* 1993; Berlant 1997; Califia 1994; Hansen 1993; Kipnis 1996; Martin 1994; Negt and Kluge 1993; Rubin 1984; Warner 1993.

There is nothing more public than privacy

A paper titled 'Sex in public' teases with the obscurity of its object and the twisted aim of its narrative. In this paper we will be talking not about the sex people already have clarity about, nor identities and acts, nor a wildness in need of derepression; but rather about sex as it is mediated by publics. Some of these publics have an obvious relation to sex: pornographic cinema, phone sex, 'adult' markets for print, lap dancing. Others are organized around sex, but not necessarily sex *acts* in the usual sense: queer zones and other worlds estranged from heterosexual culture, but also more tacit scenes of sexuality like official national culture, which depends on a notion of privacy to cloak its sexualization of national membership.

The aim of this paper is to describe what we want to promote as the radical aspirations of queer culture building: not just a safe zone for queer sex but the changed possibilities of identity, intelligibility, publics, culture, and sex that appear when the heterosexual couple is no longer the referent or the privileged example of sexual culture. Queer social practices like sex and theory try to unsettle the garbled but powerful norms supporting that privilege – including the project of normalization that has made heterosexuality hegemonic – as well as those material practices that, though not explicitly sexual, are implicated in the hierarchies of property and propriety that we will describe as heteronormative.

By heteronormativity we mean the institutions, structures of understanding, and practical orientations that make heterosexuality seem not only coherent – that is, organised as a sexuality – but also privileged. Its coherence is always provisional, and its privilege can take several (sometimes contradictory) forms: unmarked, as the basic idiom of the personal and the social; or marked as a natural state; or projected as an ideal or moral accomplishment. It consists less of norms that could be summarized as a body of doctrine than of a sense of rightness produced in contradictory manifestations – often unconscious, immanent to practice or to institutions. Contexts that have little visible relation to sex practice, such as life narrative and generational identity, can be heteronormative in this sense, while in other contexts forms of sex between men and women might *not* be heteronormative. Heteronormativity is thus a concept distinct from heterosexuality. One of the most conspicuous differences is that it has no parallel, unlike heterosexuality, which organizes homosexuality as its opposite. Because homosexuality can never have the invisible, tacit, society-founding rightness that heterosexuality has, it would not be possible to speak of 'homonormativity' in the same sense.

We open with two scenes of sex in public.

Scene 1

In 1993 *Time* magazine published a special issue about immigration called 'The new face of America'. The cover girl of this issue was morphed via computer from head shots representing a range of US immigrant groups: an amalgam of 'Middle Eastern', 'Italian', 'African', 'Vietnamese', 'Anglo-Saxon', 'Chinese', and 'Hispanic' faces. The new face of America is supposed to represent what the model citizen will look like when, in the year 2004, it is projected, there is no longer a white statistical majority in the United States. Naked, smiling, and just off-white, *Time*'s divine Frankenstein aims to organize hegemonic optimism about citizenship and the national future. *Time*'s theory is that by the twenty-first century interracial reproductive sex will have taken place in the United States on such a mass scale that racial difference itself will be finally replaced by a kind of family feeling based on blood relations. In the twenty-first century, *Time* imagines, hundreds of millions of hybrid faces will erase American racism altogether: the nation will become a happy racial monoculture made up of 'one (mixed) blood'.

The publication of this special issue caused a brief flurry of interest but had no important effects; its very banality calls us to understand the technologies that produce its ordinariness. The fantasy banalized by the image is one that reverberates in the law and in the most intimate crevices of everyday life. Its explicit aim is to help its public process the threat to 'normal' or 'core' national culture that is currently phrased as 'the problem of immigration'. But this crisis image of immigrants is also a *racial mirage* generated by a white-dominated society, supplying a specific phobia to organize its public so that a more substantial discussion of exploitation in the United States can be avoided and then remaindered to the part of collective memory sanctified not by nostalgia but by mass aversion. Let's call this the amnesia archive. The motto above the door is Memory Is the Amnesia You Like.

But more than exploitation and racism are forgotten in this whirl of projection and suppression. Central to the transfiguration of the immigrant into a nostalgic image to shore up core national culture and allay white fears of minoritization is something that cannot speak its name, though its signature is everywhere: national heterosexuality. National heterosexuality is the mechanism by which a core national culture can be imagined as a sanitized space of sentimental feeling and immaculate behavior, a space of pure citizenship. A familial model of society displaces the recognition of structural racism and other systemic inequalities. This is not entirely new: the family form has functioned as a mediator and metaphor of national existence in the United States since the eighteenth century. We are arguing that its contemporary deployment increasingly supports the governmentality of the welfare state by separating the aspirations of national belonging from the critical culture of the public sphere and from political citizenship (see Habermas 1989). Immigration crises have also previously produced feminine icons that function as prostheses for the state – most famously, the Statue of Liberty, which symbolized seamless immigrant assimilation to the metaculture of the United States. In *Time*'s face it is not symbolic femininity but practical heterosexuality that guarantees the monocultural nation.

The nostalgic family values covenant of contemporary American politics stipulates a privatization of citizenship and sex in a number of ways. In law and political

ideology, for example, the fetus and the child have been spectacularly elevated to the place of sanctified nationality. The state now sponsors stings and legislation to purify the internet on behalf of children. New welfare and tax 'reforms' passed under the co-operation between the Contract with America and Clintonian familialism seek to increase the legal and economic privileges of married couples and parents. Vouchers and privatization rezone education as the domain of parents rather than citizens. Meanwhile, senators such as Ted Kennedy and Jesse Helms support amendments that refuse federal funds to organizations that 'promote, disseminate, or produce materials that are obscene or that depict or describe, in a patently offensive way, sexual or excretory activities or organs, including but not limited to obscene depictions of sadomasochism, homo-eroticism, the sexual exploitation of children, or individuals engaged in sexual intercourse'. These developments, though distinct, are linked in the way they organize a hegemonic national public around sex. But because this sex public officially claims to act only in order to protect the zone of heterosexual privacy, the institutions of economic privilege and social reproduction informing its practices and organizing its ideal world are protected by the spectacular demonization of any represented sex.

Scene 2

In October 1995, the New York City Council passed a new zoning law by a forty-one to nine vote. The Zoning Text Amendment covers adult book and video stores, eating and drinking establishments, theaters, and other businesses. It allows these businesses only in certain areas zoned as non-residential, most of which turn out to be on the waterfront. Within the new reserved districts, adult businesses are disallowed within five hundred feet of another adult establishment or within five hundred feet of a house of worship, school, or day-care center. They are limited to one per lot and in size to ten thousand square feet. Signs are limited in size, placement, and illumination. All other adult businesses are required to close within a year. Of the estimated 177 adult businesses in the city, all but 28 may have to close under this law. Enforcement of the bill is entrusted to building inspectors.

A court challenge against the bill was brought by a coalition that also fought it in the political process, formed by anti-censorship groups such as the New York Civil Liberties Union (NYCLU), Feminists for Free Expression, People for the American Way, and the National Coalition Against Censorship as well as gay and lesbian organizations such as the Lambda Legal Defense Fund, the Empire State Pride Agenda, and the AIDS Prevention Action League. These latter groups joined the anti-censorship groups for a simple reason: the impact of rezoning on businesses catering to queers, especially to gay men, will be devastating. All five of the adult businesses on Christopher Street will be shut down, along with the principal venues where men meet men for sex. None of these businesses has been a target of local complaints. Gay men have come to take for granted the availability of explicit sexual materials, theaters, and clubs. That is how they have learned to find each other; to map a commonly accessible world; to construct the architecture of queer space in a homophobic environment; and, for the last fifteen years, to cultivate a collective ethos of safer sex. All of that is about to change. Now, gay men who want sexual materials or who want to meet other men for sex will

have two choices: they can cathect the privatized virtual public of phone sex and the internet; or they can travel to small, inaccessible, little-trafficked, badly lit areas, remote from public transportation and from any residences, mostly on the waterfront, where heterosexual porn users will also be relocated and where the risk of violence will consequently be higher. In either case, the result will be a sense of isolation and diminished expectations for queer life, as well as an attenuated capacity for political community. The nascent lesbian sexual culture, including the Clit Club and the only video rental club catering to lesbians, will also disappear. The impact of the sexual purification of New York will fall unequally on those who already have fewest publicly accessible resources.

Normativity and sexual culture

Heterosexuality is not a thing. We speak of heterosexual culture rather than heterosexuality because that culture never has more than a provisional unity. It is neither a single Symbolic nor a single ideology nor a unified set of shared beliefs. The conflicts between these strands are seldom more than dimly perceived in practice, where the givenness of male–female sexual relations is part of the ordinary rightness of the world, its fragility masked in shows of solemn rectitude. Such conflicts have also gone unrecognized in theory, partly because of the meta-cultural work of the very category of heterosexuality, which consolidates as *a sexuality* widely differing practices, norms, and institutions; and partly because the sciences of social knowledge are themselves so deeply anchored in the process of normalization to which Foucault attributes so much of modern sexuality. Thus when we say that the contemporary United States is saturated by the project of constructing national heterosexuality, we do not mean that national hetero-sexuality is anything like a simple monoculture. Hegemonies are nothing if not elastic alliances, involving dispersed and contradictory strategies for self-maintenance and reproduction.

Heterosexual culture achieves much of its metacultural intelligibility through the ideologies and institutions of intimacy. We want to argue here that although the intimate relations of private personhood appear to be the realm of sexuality itself, allowing 'sex in public' to appear like matter out of place, intimacy is itself publicly mediated, in several senses. First, its conventional spaces presuppose a structural differentiation of 'personal life' from work, politics, and the public sphere. Second, the normativity of heterosexual culture links intimacy only to the institutions of personal life, making them the privileged institutions of social repro-duction, the accumulation and transfer of capital, and self-development. Third, by making sex seem irrelevant or merely personal, heteronormative conventions of intimacy block the building of non-normative or explicit public sexual cultures. Finally, those conventions conjure a mirage: a home base of prepolitical humanity from which citizens are thought to come into political discourse and to which they are expected to return in the (always imaginary) future after political conflict. Intimate life is the endlessly cited *elsewhere* of political public discourse, a promised haven that distracts citizens from the unequal conditions of their political and economic lives, consoles them for the damaged humanity of mass society, and

shames them for any divergence between their lives and the intimate sphere that is alleged to be simple personhood.

Ideologies and institutions of intimacy are increasingly offered as a vision of the good life for the destabilized and struggling citizenry of the United States, the only (fantasy) zone in which a future might be thought and willed, the only (imaginary) place where good citizens might be produced away from the confusing and unsettling distractions and contradictions of capitalism and politics. Indeed, one of the unforeseen paradoxes of national-capitalist privatization has been that citizens have been led through heterosexual culture to identify both themselves *and their politics* with privacy. In the official public, this involves making sex private; reintensifying blood as a psychic base for identification; replacing state mandates for social justice with a privatized ethics of responsibility, charity, atonement, and 'values'; and enforcing boundaries between moral persons and economic ones.

A complex cluster of sexual practices gets confused, in heterosexual culture, with the love plot of intimacy and familialism that signifies belonging to society in a deep and normal way. Community is imagined through scenes of intimacy, coupling, and kinship; a historical relation to futurity is restricted to generational narrative and reproduction. A whole field of social relations becomes intelligible as heterosexuality, and this privatized sexual culture bestows on its sexual practices a tacit sense of rightness and normalcy. This sense of rightness – embedded in things and not just in sex – is what we call heteronormativity. Heteronormativity is more than ideology, or prejudice, or phobia against gays and lesbians; it is produced in almost every aspect of the forms and arrangements of social life: nationality, the state, and the law; commerce; medicine; and education; as well as in the conventions and affects of narrativity, romance, and other protected spaces of culture. It is hard to see these fields as heteronormative because the sexual culture straight people inhabit is so diffuse, a mix of languages they are just developing with premodern notions of sexuality so ancient that their material conditions feel hard-wired into personhood.

But intimacy has not always had the meaning it has for contemporary heteronormative culture. Along with Foucault and other historians, the classicist David Halperin, for example, has shown that in ancient Athens sex was a transitive act rather than a fundamental dimension of personhood or an expression of intimacy. The verb for having sex appears on a late antique list of things that are not done in regard to or through others: 'namely, speaking, singing, dancing, fist-fighting, competing, hanging oneself, dying, being crucified, diving, finding a treasure, having sex, vomiting, moving one's bowels, sleeping, laughing, crying, talking to the gods, and the like'. Halperin points out that the inclusion of fucking on this list shows that sex is not here 'knit up in a web of mutuality'. In contrast, modern heterosexuality is supposed to refer to relations of intimacy and identification with other persons, and sex acts are supposed to be the most intimate communication of them all. The sex act shielded by the zone of privacy is the affectional nimbus that heterosexual culture protects and from which it abstracts its model of ethics, but this utopia of social belonging is also supported and extended by acts less commonly recognized as part of sexual culture: paying taxes, being disgusted, philandering, bequeathing, celebrating a holiday, investing for the

future, teaching, disposing of a corpse, carrying wallet photos, buying economy size, being nepotistic, running for president, divorcing, or owning anything 'His' and 'Hers'.

The elaboration of this list is a project for further study. Meanwhile, to make it and to laugh at it is not immediately to label any practice as oppressive, uncool, or definitive. We are describing a constellation of practices that everywhere disperses heterosexual privilege as a tacit but central organizing index of social membership. Exposing it inevitably produces what we have elsewhere called a 'wrenching sense of recontextualization', as its subjects, even its gay and lesbian subjects, begin to piece together how it is that social and economic discourses, institutions, and practices that don't feel especially sexual or familial collaborate to produce as a social norm and ideal an extremely narrow context for living (Berlant and Warner 1995: 345). Heterosexual culture cannot recognize, validate, sustain, incorporate or remember much of what people know and experience about the cruelty of normal culture even to the people who identify with it.

But that cruelty does not go unregistered. Intimacy, for example, has a whole public environment of therapeutic genres dedicated to witnessing the constant failure of heterosexual ideologies and institutions. Every day, in many countries now, people testify to their failure to sustain or be sustained by institutions of privacy on talk shows, in scandal journalism, even in the ordinary course of main-stream journalism addressed to middle-brow culture. We can learn a lot from these stories of love plots that have gone astray: about the ways quotidian violence is linked to complex pressures from money, racism, histories of sexual violence, cross-generational tensions. We can learn a lot from listening to the increasing demands on love to deliver the good life it promises. And we can learn from the extremely punitive responses that tend to emerge when people seem not to suffer enough for their transgressions and failures.

Maybe we would learn too much. Recently, the proliferation of evidence for heterosexuality's failings has produced a backlash against talk-show therapy. It has even brought William Bennett to the podium; but rather than confessing his trans-gressions or making a complaint about someone else's, we find him calling for boycotts and for the suppression of heterosexual therapy culture altogether. Recognition of heterosexuality's daily failures agitates him as much as queerness. 'We've forgotten that civilization depends on keeping some of this stuff under wraps', he said. 'This is a tropism toward the toilet.'

But does civilization need to cover its ass? Or does heterosexual culture actu-ally secure itself through banalizing intimacy? Does belief that normal life is actually possible *require* amnesia and the ludicrous stereotyping of a bottom-feeding culture apparently inadequate to intimacy? On these shows no one ever blames the ideology and institutions of heterosexuality. Every day, even the talk-show hosts are newly astonished to find that people who are committed to hetero intimacy are never-theless unhappy. After all is said and done, the prospects and promises of heterosexual culture still represent the optimism for optimism, a hope to which people apparently have already pledged their consent – at least in public.

Recently, Biddy Martin has written that some queer social theorists have produced a reductive and pseudoradical antinormativity by actively repudiating the institutions of heterosexuality that have come to oversaturate the social

imaginary. She shows that the kinds of arguments that crop up in the writings of people like Andrew Sullivan are not just right-wing fantasies. 'In some queer work,' she writes,

> the very fact of attachment has been cast as only punitive and constraining because already socially constructed . . . Radical anti-normativity throws out a lot of babies with a lot of bathwater . . . An enormous fear of ordinariness or normalcy results in superficial accounts of the complex imbrication of sexuality with other aspects of social and psychic life, and in far too little attention to the dilemmas of the average people that we also are.

We think our friend Biddy might be referring to us, although in this segment she cites no one in particular. We would like to clarify the argument. To be against heteronormativity is not to be against norms. To be against the processes of normalization is not to be afraid of ordinariness. Nor is it to advocate the 'existence without limit' she sees as produced by bad Foucauldians. Nor is it to decide that sentimental identifications with family and children are waste or garbage, or make people into waste or garbage. Nor is to say that any sex called 'lovemaking' isn't lovemaking; whatever the ideological or historical burdens of sexuality have been, they have not excluded, and indeed may have entailed, the ability of sex to count as intimacy and care. What we have been arguing here is that the space of sexual culture has become obnoxiously cramped from doing the work of maintaining a normal metaculture. When Biddy Martin calls us to recognize ourselves as 'average people', to relax from an artificially stimulated 'fear of normalcy', the image of average personhood appears to be simply descriptive. But its averageness is also normative, in exactly the sense that Foucault meant by 'normalization': not the imposition of an alien will but a distribution around a statistically imagined norm. This deceptive appeal of the average remains heteronormative, measuring deviance from the mass. It can also be consoling, an expression of a utopian desire for unconflicted personhood. But this desire cannot be satisfied in the current conditions of privacy. People feel that the price they must pay for social membership and a relation to the future is identification with the heterosexual life narrative; that they are individually responsible for the rages, instabilities, ambivalences, and failures they experience in their intimate lives, while the fractures of the contemporary United States shame and sabotage them everywhere. Heterosexuality involves so many practices that are not sex that a world in which this hegemonic cluster would not be dominant is, at this point, unimaginable. We are trying to bring that world into being.

Queer counter-publics

By queer culture we mean a world-making project, where 'world', like 'public', differs from community or group because it necessarily includes more people than can be identified, more spaces than can be mapped beyond a few reference points, modes of feeling that can be learned rather than experienced as a birthright. The

queer world is a space of entrances, exits, unsystematized lines of acquaintance, projected horizons, typifying examples, alternate routes, blockages, incommensurate geographies. World-making, as much in the mode of dirty talk as of print-mediated representation, is dispersed through incommensurate registers, by definition *unrealizable* as community or identity. Every cultural form, be it a novel or an after-hours club or an academic lecture, indexes a virtual social world, in ways that range from a repertoire of styles and speech genres to referential metaculture. A novel like Andrew Holleran's *Dancer from the Dance* relies much more heavily on referential metaculture than does an after-hours club that survives on word of mouth and may be a major scene because it is only barely coherent *as* a scene. Yet for all their differences, both allow for the concretization of a queer counter-public. We are trying to promote this world-making project, and a first step in doing so is to recognize that queer culture constitutes itself in many ways other than through the official publics of opinion culture and the state, or through the privatized forms normally associated with sexuality. Queer and other insurgents have long striven, often dangerously or scandalously, to cultivate what good folks used to call criminal intimacies. We have developed relations and narratives that are only recognized as intimate in queer culture: girlfriends, gal pals, fuck buddies, tricks. Queer culture has learned not only how to sexualize these and other relations, but also to use them as a context for witnessing intense and personal affect while elaborating a public world of belonging and transformation. Making a queer world has required the development of kinds of intimacy that bear no necessary relation to domestic space, to kinship, to the couple form, to property, or to the nation. These intimacies *do* bear a necessary relation to a counter-public – an indefinitely accessible world conscious of its subordinate relation. They are typical both of the inventiveness of queer world-making and of the queer world's fragility.

Non-standard intimacies would seem less criminal and less fleeting if, as used to be the case, normal intimacies included everything from consorts to courtiers, friends, amours, associates, and co-conspirators. Along with the sex it legitimates, intimacy has been privatized; the discourse contexts that narrate true personhood have been segregated from those that represent citizens, workers, or professionals.

This transformation in the cultural forms of intimacy is related both to the history of the modern public sphere and to the modern discourse of sexuality as a fundamental human capacity. In *The Structural Transformation of the Public Sphere*, Habermas shows that the institutions and forms of domestic intimacy made private people private, members of the public sphere of private society rather than the market or the state. Intimacy grounded abstract, disembodied citizens in a sense of universal humanity. In *The History of Sexuality*, Foucault describes the personalization of sex from the other direction: the confessional and expert discourses of civil society continually posit an inner personal essence, equating this true personhood with sex and surrounding that sex with dramas of secrecy and disclosure. There is an instructive convergence here in two thinkers who otherwise seem to be describing different planets. Habermas overlooks the administrative and normalizing dimensions of privatized sex in sciences of social knowledge because he is interested in the norm of a critical relation between state and civil society. Foucault overlooks the critical culture that might make transformation of sex and other

private relations; he wants to show that modern epistemologies of sexual person-
hood, far from bringing sexual publics into being, are techniques of isolation; they
identify persons as normal or perverse, for the purpose of medicalizing or other-
wise administering them as individuals. Yet both Habermas and Foucault point to
the way a hegemonic public has founded itself by a privatization of sex and the
sexualization of private personhood. Both identify the conditions in which sexu-
ality seems like a property of subjectivity rather than a publicly or counterpublicly
accessible culture.

Like most ideologies, that of normal intimacy may never have been an accu-
rate description of how people actually live. It was from the beginning mediated
not only by a structural separation of economic and domestic space but also by
opinion culture, correspondence, novels, and romances; Rousseau's *Confessions* is
typical both of the ideology and of its reliance on mediation by print and by new,
hybrid forms of life narrative. Habermas notes that 'subjectivity, as the innermost
core of the private, was always oriented to an audience' (Habermas 1991: 49),
adding that the structure of this intimacy includes a fundamentally contradictory
relation to the economy:

> To the autonomy of property owners in the market corresponded a
> self-presentation of human beings in the family. The latter's intimacy,
> apparently set free from the constraint of society, was the seal on the
> truth of a private autonomy exercised in competition. Thus it was a
> private autonomy denying its economic origins . . . that provided the
> bourgeois family with its consciousness of itself.
>
> (1991: 49)

This structural relation is no less normative for being imperfect in practice. Its
force is to prevent the recognition, memory, elaboration, or institutionalization of
all the nonstandard intimacies that people have in everyday life. Affective life slops
over onto work and political life; people have key self-constitutive relations with
strangers and acquaintances; and they have eroticism, if not sex, outside of the
couple form. These border intimacies give people tremendous pleasure. But when
that pleasure is called sexuality, the spillage of eroticism into everyday social life
seems transgressive in a way that provokes normal aversion, a hygienic recoil even
as contemporary consumer and media cultures increasingly trope toiletward, splat-
tering the matter of intimate life at the highest levels of national culture.

In gay male culture, the principal scenes of criminal intimacy have been
tearooms, streets, sex clubs, and parks – a tropism toward the public toilet.
Promiscuity is so heavily stigmatized as non-intimate that it is often called anony-
mous, whether names are used or not. One of the most commonly forgotten
lessons of AIDS is that this promiscuous intimacy turned out to be a life-saving
public resource. Unbidden by experts, gay people invented safer sex; and, as
Douglas Crimp wrote in 1987

> we were able to invent safe sex because we have always known that
> sex is not, in an epidemic or not, limited to penetrative sex. Our
> promiscuity taught us many things, not only about the pleasures of sex,

but about the great multiplicity of those pleasures. It is that psychic preparation, that experimentation, that conscious work on our own sexualities that has allowed many of us to change our sexual behaviors – something that brutal 'behavioral therapies' tried unsuccessfully for over a century to force us to do – very quickly and very dramatically . . . All those who contend that gay male promiscuity is merely sexual *compulsion* resulting from fear of intimacy are now faced with very strong evidence against their prejudices . . . Gay male promiscuity should be seen instead as a positive model of how sexual pleasures might be pursued by and granted to everyone if those pleasures were not confined within the narrow limits of institutionalized sexuality.

(Crimp 1987: 253)

AIDS is a special case, and this model of sexual culture has been typically male. But sexual practice is only one kind of counterintimacy. More important is the critical practical knowledge that allows such relations to count as intimate, to be not empty release or transgression but a common language of self-cultivation, shared knowledge, and the exchange of inwardness.

Queer culture has found it necessary to develop this knowledge in mobile sites of drag, youth culture, music, dance, parades, flaunting, and cruising – sites whose mobility makes them possible but also renders them hard to recognize as world-making because they are so fragile and ephemeral. They are paradigmatically trivialized as 'lifestyle'. But to understand them only as self-expression or as a demand for recognition would be to misrecognize the fundamentally unequal material conditions whereby the institutions of social reproduction are coupled to the forms of hetero culture. Contexts of queer world-making depend on parasitic and fugitive elaboration through gossip, dance clubs, softball leagues, and the phone-sex ads that increasingly are the commercial support for print-mediated left culture in general. Queer is difficult to entextualize *as* culture.

This is particularly true of intimate culture. Heteronormative forms of intimacy are supported, as we have argued, not only by overt referential discourse such as love plots and sentimentality but materially, in marriage and family law, in the architecture of the domestic, in the zoning of work and politics. Queer culture, by contrast, has almost no institutional matrix for its counter-intimacies. In the absence of marriage and the rituals that organize life around matrimony, improvization is always necessary for the speech act of pledging, or the narrative practice of dating, or for such apparently noneconomic economies as joint checking. The heteronormativity in such practices may seem weak and indirect. After all, same-sex couples have sometimes been able to invent versions of such practices. But they have done so only by betrothing themselves to the couple form and its language of personal significance, leaving untransformed the material and ideological conditions that divide intimacy from history, politics, and publics. The queer project we imagine is not just to destigmatize those average intimacies, not just to give access to the sentimentality of the couple for persons of the same sex, and definitely not to certify as properly private the personal lives of gays and lesbians. Rather, it is to support forms of affective, erotic, and personal living that are public in the sense of accessible, available to memory, and sustained through collective activity.

Because the heteronormative culture of intimacy leaves queer culture especially dependent on ephemeral elaborations in urban space and print culture, queer publics are also peculiarly vulnerable to initiatives such as Mayor Rudolph Giuliani's new zoning law. The law aims to restrict any counter-public sexual culture by regulating its economic conditions; its effects will reach far beyond the adult businesses it explicitly controls. The gay bars on Christopher Street draw customers from people who come there because of its sex trade. The street is cruisier because of the sex shops. The boutiques that sell freedom rings and 'Don't Panic' T-shirts do more business for the same reasons. Not all of the thousands who migrate or make pilgrimages to Christopher Street use the porn shops, but all benefit from the fact that some do. After a certain point, a quantitative change is a qualitative change. A critical mass develops. The street becomes queer. It develops a dense, publicly accessible sexual culture. It therefore becomes a base for non-porn businesses, like the Oscar Wilde Bookshop. And it becomes a political base from which to pressure politicians with a gay voting bloc.

No group is more dependent on this kind of pattern in urban space than queers. If we could not concentrate a publicly accessible culture somewhere, we would always be outnumbered and overwhelmed. And because what brings us together is sexual culture, there are very few places in the world that have assembled much of a queer population without a base in sex commerce, and even those that do exist, such as the lesbian culture in Northampton, Massachusetts, are stronger because of their ties to places like the West Village, Dupont Circle, West Hollywood and the Castro. Respectable gays like to think that they owe nothing to the sexual subculture they think of as sleazy. But their success, their way of living, their political rights, and their very identities would never have been possible but for the existence of the public sexual culture they now despise. Extinguish it, and almost all *out* gay or queer culture will wither on the vine. No one knows this connection better than the right. Conservatives would not so flagrantly contradict their stated belief in a market free from government interference if they did not see this kind of hyper-regulation as an important victory.

The point here is not that queer politics needs more free-market ideology, but that heteronormative forms, so central to the accumulation and reproduction of capital, also depend on heavy interventions in the regulation of capital. One of the most disturbing fantasies in the zoning scheme, for example, is the idea that an urban locale is a community of shared interest based on residence and property. The ideology of the neighborhood is politically unchallengeable in the current debate, which is dominated by a fantasy that sexual subjects only reside, that the space relevant to sexual politics is the neighborhood. But a district like Christopher Street is not just a neighborhood affair. The local character of the neighborhood depends on the daily presence of thousands of non-residents. Those who actually live in the West Village should not forget their debt to these mostly queer pilgrims. And we should not make the mistake of confusing the class of citizens with the class of property owners. Many of those who hang out on Christopher Street – typically young, queer, and African American – couldn't possibly afford to live there. Urban space is always a host space. The right to the city extends to those who use the city. It is not limited to property owners. It is not because of a fluke in the politics of zoning that urban space is so deeply misrecognized; normal

sexuality requires such misrecognitions, including their economic and legal enforcement, in order to sustain its illusion of humanity.

Tweaking and thwacking

Queer social theory is committed to sexuality as an inescapable category of analysis, agitation, and refunctioning. Like class relations, which in this moment are mainly visible in the polarized embodiments of identity forms, heteronormativity is a fundamental motor of social organization in the United States, a founding condition of unequal and exploitative relations throughout even straight society. Any social theory that miscomprehends this participates in their reproduction.

The project of thinking about sex in public does not only engage sex when it is disavowed or suppressed. Even if sex practice is not the object domain of queer studies, sex is everywhere present. But where is the tweaking, thwacking, thumping, sliming, and rubbing you might have expected – or dreaded – in a paper on sex? We close with two scenes that might have happened on the same day in our wanderings around the city. One afternoon, we were riding with a young straight couple we know, in their station wagon. Gingerly, after much circumlocution, they brought the conversation around to vibrators. These are people whose reproductivity governs their lives, their aspirations, and their relations to money and entailment, mediating their relations to everyone and everything else. But the woman in this couple had recently read an article in a women's magazine about sex toys and other forms of non-reproductive eroticism. She and her husband did some mail-order shopping and have become increasingly involved in what from most points of view would count as queer sex practices; their bodies have become disorganized and exciting to them. They said to us: you're the only people we can talk to about this; to all of our straight friends this would make us perverts. In order not to feel like perverts, they had to make *us* into a kind of sex public.

Later, the question of aversion and pervasion came up again. This time we were in a bar that on most nights is a garden-variety leather bar, but that, on Wednesday nights, hosts a sex performance event called 'Pork'. Shows typically include spanking, flagellation, shaving, branding, laceration, bondage, humiliation, wrestling – you know, the usual: amateur, everyday practitioners strutting for everyone else's gratification, not unlike an academic conference. This night, word was circulating that the performance was to be erotic vomiting. This sounded like an appetite spoiler, and the thought of leaving early occurred to us but was overcome by a simple curiosity: what would the foreplay be like? Let's stay until it gets messy. Then we can leave.

A boy, twentyish, very skateboard, comes on the low stage at one end of the bar, wearing lycra shorts and a dog collar. He sits loosely in a restraining chair. His partner comes out and tilts the bottom's head up to the ceiling, stretching out his throat. Behind them is an array of foods. The top begins pouring milk down the boy's throat, then food, then more milk. It spills over, down his chest and on to the floor. A dynamic is established between them in which they carefully keep at the threshold of gagging. The bottom struggles to keep taking in more than he

really can. The top is careful to give him just enough to stretch his capacities. From time to time a baby bottle is offered as a respite, but soon the rhythm intensifies. The boy's stomach is beginning to rise and pulse, almost convulsively.

It is at this point that we realize we cannot leave, cannot even look away. No one can. The crowd is transfixed by the scene of intimacy and display, control and abandon, ferocity and abjection. People are moaning softly with admiration, then whistling, stomping, screaming encouragements. They have pressed forward in a compact and intimate group. Finally, as the top inserts two, then three fingers in the bottom's throat, insistently offering his own stomach for the repeated climaxes, we realize that we have never seen such a display of trust and violation. We are breathless. But, good academics that we are, we also have some questions to ask. Word has gone around that the boy is straight. We want to know: What does that mean in this context? How did you discover that this is what you want to do? How did you find a male top to do it with? How did you come to do it in a leather bar? Where else do you do this? How do you feel about your new partners, this audience?

We did not get to ask these questions, but we have others that we can pose now, about these scenes where sex appears more sublime than narration itself, neither redemptive nor transgressive, moral nor immoral, hetero nor homo, nor sutured to any axis of social legitimation. We have been arguing that sex opens a wedge to the transformation of those social norms that require only its static intelligibility or its deadness as a source of meaning. In these cases, though, paths through publicity led to the production of nonheteronormative bodily contexts. They intended non-heteronormative worlds because they refused to pretend that privacy was their ground; because they were forms of sociability that unlinked money and family from the scene of the good life; because they made sex the consequence of public mediations and collective self-activity in a way that made for unpredicted pleasures; because, in turn, they attempted to make a context of support for their practices; because their pleasures were not purchased by a redemptive pastoralism of sex, nor by mandatory amnesia about failure, shame and aversion.

We are used to thinking about sexuality as a form of intimacy and subjectivity, and we have just demonstrated how limited that representation is. But the heteronormativity of US culture is not something that can be easily rezoned or disavowed by individual acts of will, by a subversiveness imagined only as personal rather than as the basis of public-formation, nor even by the lyric moments that interrupt the hostile cultural narrative that we have been staging here. Remembering the utopian wish behind normal intimate life, we also want to remember that we aren't married to it.

Carnival and utopia

Richard Dyer

ENTERTAINMENT AND UTOPIA

EDITOR'S INTRODUCTION

R ICHARD DYER'S SHORT article has been very influential in cultural
studies. Originally published in the magazine *Movie* in 1977, it was one of
the first attempts to move out of the mix of semiotic/Althusserian and Gramscian
thinking dominant at the time.

Dyer's article begins as a theoretical meditation on the Hollywood musical.
The musical differs from most other Hollywood genres in its presentation of non-
narrative moments. From that starting point, Dyer argues that the entertainment
industry, being "relatively autonomous," does not simply reproduce patriarchal
capitalism. Developing this familiar proposition in a new direction, he goes on to
note that, indeed, the industry expresses its audiences' real needs – in particular
their needs for a different and better social order. How does show biz fulfill utopian
desires? Not by literally representing a perfect society (like Sir Thomas More's
Utopia) but, first, by "non-representational means" – through music, color, move-
ment and so on – and, second, by picturing relations between people more simply
and directly than they exist in actuality. Here the "escapism" and "one-dimen-
sionality" of the culture industry are (within limits) positively affirmed.

Dyer's recuperation of entertainment shares something with Bakhtin's notion
of the carnival, as it does with the theories of Ernst Bloch, Adorno's German
Marxist contemporary. Within current cultural studies, it has helped pave the way
for the cultural populism now so important a force in the discipline.

Further reading: Bloch 1988; Chambers 1986; Dyer 1979; Fiske 1987b, 1989;
McGuigan 1992; Storey 1998; Walkerdine 1986.

This article is about musicals as entertainment. I don't necessarily want to disagree with those who would claim that musicals are also 'something else' (e.g., 'Art') or argue that entertainment itself is only a product of 'something more important' (e.g., political or economic manipulation, psychological forces), but I want to put the emphasis here on entertainment as entertainment. Musicals were predominantly conceived of, by producers and audiences alike, as 'pure entertainment' – the *idea* of entertainment was a prime determinant on them. Yet because entertainment is a commonsense, 'obvious' idea, what is really meant and implied by this never gets discussed.

Musicals are one of a whole string of forms – music hall, variety, television spectaculars, pantomime, cabaret etc. – that are usually summed up by the term 'show biz'. The idea of entertainment I want to examine here is most centrally embodied by these forms, although I believe that it can also be seen at work, *mutatis mutandis,* in other forms and I suggest below, informally, how this might be so. However, it is probably true to say that 'show biz' is the most thoroughly entertainment-oriented of all types of performance, and that notions of myth, art, instruction, dream and ritual may be equally important, even at the conscious level with regard to, say, Westerns, the news, soap opera, or rock music.

It is important, I think, to stress the cultural and historical specificity of entertainment. The kinds of performance produced by professional entertainment are different in audience, performers and above all intention from the kinds of performance produced in tribal, feudal or socialist societies. It is not possible here to provide the detailed historical and anthropological argument to back this up, but I hope the differences will suggest themselves when I say that entertainment is a type of performance produced for profit, performed before a generalized audience (the 'public') by a trained, paid group who do nothing else but produce performances which have the sole (conscious) aim of providing pleasure.

Because entertainment is produced by professional entertainers, it is also largely defined by them. That is to say, although entertainment is part of the coinage of everyday thought, none the less how it is defined, what it is assumed to be, is basically decided by those people responsible (paid) for providing it in concrete form. Professional entertainment is the dominant agency for defining what entertainment is. This does not mean, however, that it *simply* reproduces and expresses patriarchal capitalism. There is the usual struggle between capital (the backers) and labour (the performers) over the control of the product, and professional entertainment is unusual in that, first, it is in the business of producing forms, not things, and, second, the workforce (the performers themselves) is in a better position to determine the form of its product than are, say, secretaries or car workers. The fact that professional entertainment has been by and large conservative in the twentieth century should not blind us to the implicit struggle within it, and looking beyond class to divisions of sex and race, we should note the important role of structurally subordinate groups in society – women, blacks, gays – in the development and definition of entertainment. In other words, show business's relationship to the demands of patriarchal capitalism is a complex one. Just as it does not simply 'give the people what they want' (since it actually defines those wants), so, as a relatively autonomous mode of cultural production, it does not

simply reproduce unproblematically patriarchal capitalist ideology. Indeed, it is precisely on seeming to achieve both these often opposed functions simultaneously that its survival largely depends.

Two of the taken-for-granted descriptions of entertainment, as 'escape' and as 'wish-fulfilment', point to its central thrust, namely, utopianism. Entertainment offers the image of 'something better' to escape into, or something we want deeply that our day-to-day lives don't provide. Alternatives, hopes, wishes – these are the stuff of utopia, the sense that things could be better, that something other than what is can be imagined and maybe realized.

Entertainment does not, however, present models of utopian worlds, as in the classic utopias of Sir Thomas More, William Morris, *et al*. Rather the utopianism is contained in the feelings it embodies. It presents, head-on as it were, what utopia would feel like rather than how it would be organized. It thus works at the level of sensibility, by which I mean an effective code that is characteristic of, and largely specific to, a given mode of cultural production.

This code uses both representational and, importantly, non-representational signs. There is a tendency to concentrate on the former, and clearly it would be wrong to overlook them – stars are nicer than we are, characters more straightforward than people we know, situations more soluble than those we encounter. All this we recognize through representational signs. But we also recognize qualities in non-representational signs – colour, texture, movement, rhythm, melody, camerawork – although we are much less used to talking about them. The nature of non-representational signs is not however so different from that of representational. Both are, in C. S. Peirce's terminology, largely iconic; but whereas the relationship between signifier and signified in a representational icon is one of resemblance between their appearance, their look, the relationship in the case of the non-representational icon is one of resemblance at the level of basic structuration.

This concept has been developed (among other places) in the work of Suzanne K. Langer, particularly in relation to music. We feel music (arguably more than any other performance medium), yet it has the least obvious reference to 'reality' – the intensity of our response to music can only be accounted for by the way music, abstract, formal though it is, still embodies feeling. Langer puts it thus in *Feeling and Form*:

> The tonal structures we call 'music' bear a close logical similarity to the forms of human feeling – forms of growth and of attenuation, flowing and slowing, conflict and resolution, speed, arrest, terrific excitement, calm or subtle activation or dreamy lapses – not joy and sorrow perhaps, but the poignancy of both – the greatness and brevity and eternal passing of everything vitally felt. Such is the pattern, or logical form, of sentience; and the pattern of music is that same form worked out in pure measures, sound and silence. Music is a tonal analogue of emotive life.
>
> Such formal analogy, or congruence of logical structures, is the prime requisite for the relation between a symbol and whatever it is to mean.

> The symbol and the object symbolized must have some common logical form.

Langer realizes that recognition of a common logical form between a performance sign and what it signifies is not always easy or natural: 'The congruence of two given perceptible forms is not always evident upon simple inspection. The common *logical* form they both exhibit may become apparent only when you know the principle whereby to relate them.' This implies that responding to a performance is not spontaneous – you have to learn what emotion is embodied before you can respond to it. A problem with this as Langer develops it is the implication that the emotion itself is not coded, is simply 'human feeling'. I would be inclined, however, to see almost as much coding in the emotions as in the signs for them. Thus, just as writers such as E. H. Gombrich and Umberto Eco stress that different modes of representation (in history and culture) correspond to different modes of perception, so it is important to grasp that modes of experiential art and entertainment correspond to different culturally and historically determined sensibilities.

This becomes clear when one examines how entertainment forms come to have the emotional signification they do: that is, by acquiring their signification in relation to the complex of meanings in the social-cultural situation in which they are produced. Take the extremely complex history of tap dance – in black culture, tap dance has had an improvisatory, self-expressive function similar to that in jazz; in minstrelsy, it took on an aspect of jolly mindlessness, inane good humour, in accord with minstrelsy's image of the Negro; in vaudeville, elements of mechanical skill, tap dance as a feat, were stressed as part of vaudeville's celebration of the machine and the brilliant performer. Clearly there are connections between these different significations, and there are residues of all of them in tap as used in films, television and contemporary theatre shows. This has little to do however with the intrinsic meanings of hard, short, percussive, syncopated sounds arranged in patterns and produced by the movement of feet, and everything to do with the significance such sounds acquire from their place within the network of signs in a given culture at a given point of time. Nevertheless, the signification is essentially apprehended through the coded non-representational form (although the representational elements usually present in a performance sign – a dancer is always 'a person dancing' – may help to anchor the necessarily more fluid signification of the non-representational elements; for example, a black man, a white man in blackface, a troupe, or a white woman tap-dancing may suggest different ways of reading the taps, because each relates to a slightly different movement in the evolution of the non-representational form, tap dance).

I have laboured this point at greater length than may seem warranted partly with polemic intent. First, it seems to me that the reading of non-representational signs in the cinema is particularly undeveloped. On the one hand, the *mise-en-scène* approach (at least as classically developed in *Movie*) tends to treat the non-representational as a function of the representational, simply a way of bringing out, emphasizing, aspects of plot, character, situation, without signification in their own right. On the other hand, semiotics has been concerned with the codification of the representational. Second, I feel that film analysis remains notoriously non-

historical, except in rather lumbering, simplistic ways. My adaptation of Langer seeks to emphasize not the connection between signs and historical events, personages or forces, but rather the history of signs themselves as they are produced in culture and history. Nowhere here has it been possible to reproduce the detail of any sign's history (and I admit to speculation in some instances), but most of the assertions are based on more thorough research, and even where they are not, they should be.

The categories of entertainment's utopian sensibility are sketched in the accompanying table together with examples of them. The three films used will be discussed below; the examples from Westerns and television news are just to suggest how the categories may have wider application; the sources referred to are the cultural, historical situation of the code's production.

The categories are, I hope, clear enough, but a little more needs to be said about 'intensity'. It is hard to find a word that quite gets what I mean. What I have in mind is the capacity of entertainment to present either complex or unpleasant feelings (e.g., involvement in personal or political events, jealousy, loss of love, defeat) in a way that makes them seem uncomplicated, direct and vivid, not 'qualified' or 'ambiguous' as day-to-day life makes them, and without those intimations of self-deception and pretence. (Both intensity and transparency can be related to wider themes in the culture, as 'authenticity' and 'sincerity' respectively; see Lionel Trilling's *Sincerity and Authenticity*.)

The obvious problem raised by this breakdown of the utopian sensibility is where these categories come from. One answer, at a very broad level, might be that they are a continuation of the utopian tradition in Western thought. George Kateb, in his survey of utopian thought, *Utopia and Its Enemies*, describes what he takes to be the dominant motifs in this tradition, and they do broadly overlap with those outlined above. Thus: 'when a man [sic] thinks of perfection . . . he thinks of a world permanently without strife, poverty, constraint, stultifying labour, irrational authority, sensual deprivation . . . peace, abundance, leisure, equality, consonance of men and their environment'.

We may agree that notions in this broad conceptual area are common throughout Western thought, giving it, and its history, its characteristic dynamic, its sense of moving beyond what is to what ought to be or what we want to be. However, the very broadness, and looseness, of this common ground does not get us very far — we need to examine the specificity of entertainment's utopia.

One way of doing so is to see the categories of the sensibility as temporary answers to the inadequacies of the society which is being escaped from through entertainment. This is proposed by Hans Magnus Enzensberger in his article, 'Constituents of a theory of the media' (in *Sociology of Mass Communication* edited by Dennis McQuail). Enzensberger takes issue with the traditional left-wing use of concepts of 'manipulation' and 'false needs' in relation to the mass media:

> The electronic media do not owe their irresistible power to any sleight-of-hand but to the elemental power of deep social needs which come through even in the present depraved form of these media . . .

Consumption as spectacle contains the promise that want will disappear. The deceptive, brutal and obscene features of this festival derive from the fact that there can be no question of a real fulfilment of its promise. But so long as scarcity holds sway, use-value remains a decisive category which can only be abolished by trickery. Yet trickery on such a scale is only conceivable if it is based on mass need. This need – it is a utopian one – is there. It is the desire for a new ecology, for a breaking-down of environmental barriers, for an aesthetic which is not limited to the sphere of the 'artistic'. These desires are not – or are not primarily – internalized rules of the games as played by the capitalist system. They have physiological roots and can no longer be suppressed. Consumption as spectacle is – in parody form – the anticipation of a utopian situation.

This does, I think, express well the complexity of the situation. However Enzensberger's appeal to 'elemental' and 'physiological' demands, although we do not need to be too frightened by them, is lacking in both historical and anthropological perspectives. I would rather suggest, a little over-schematically, that the categories of the utopian sensibility are related to specific inadequacies in society as follows:

Social tension / Inadequacy / Absence	Utopian solution
Scarcity (actual poverty in the society; poverty observable in the surrounding societies, e.g., Third World); unequal distribution of wealth	Abundance (elimination of poverty for self and others; equal distribution of wealth)
Exhaustion (work as a grind, alienated labour, pressures of urban life)	Energy (work and play synonymous), city-dominated (On the Town) or pastoral return (The Sound of Music)
Dreariness (monotony, predictability, instrumentality of the daily round)	Intensity (excitement, drama, affectivity of living)
Manipulation (advertising, bourgeois democracy, sex roles)	Transparency (open, spontaneous, honest communications and relationships)
Fragmentation (job mobility, rehousing and development, high-rise flats, legislation against collective action)	Community (all together in one place, communal interests, collective activity)

The advantage of this analysis is that it does offer some explanation of why entertainment *works*. It is not just left-overs from history, it is not *just* what show business, or 'they', force on the rest of us, it is not simply the expression of eternal needs – it responds to real needs *created by society*. The weakness of the analysis (and this holds true for Enzensberger too) is in the give-away absences from the left-hand column – no mention of class, race or patriarchy. That is, while

entertainment is responding to needs that are real, at the same time it is also defining and delimiting what constitutes the legitimate needs of people in this society.

I am not trying to recoup here the false needs argument – we are talking about real needs created by real inadequacies, but they are not the only needs and inadequacies of the society. Yet entertainment, by so orienting itself to them, effectively denies the legitimacy of other needs and inadequacies, and especially of class, patriarchal and sexual struggles. (Though once again we have to admit the complexity and contradictions of the situation – that, for instance, entertainment is not the only agency which defines legitimate needs, and that the actual role of women, gay men and blacks in the creation of show business leaves its mark in such central oppositional icons as, respectively, the strong woman type, e.g., Ethel Merman, Judy Garland, Elsie Tanner, camp humour and sensuous taste in dress and decor, and almost all aspects of dance and music. Class, it will be noted, is still nowhere.)

Class, race and sexual caste are denied validity as problems by the dominant (bourgeois, white, male) ideology of society. We should not expect show business to be markedly different. However, there is one further turn of the screw, and that is that, with the exception perhaps of community (the most directly working class in source), the ideals of entertainment imply wants that capitalism itself promises to meet. Thus abundance becomes consumerism, energy and intensity personal freedom and individualism, and transparency freedom of speech. In other (Marcuse's) words, it is a partially 'one-dimensional' situation. The categories of the sensibility point to gaps or inadequacies in capitalism, but only those gaps or inadequacies that capitalism proposes itself to deal with. At our worst sense of it, entertainment provides alternatives *to* capitalism which will be provided *by* capitalism.

However, this one-dimensionality is seldom so hermetic, because of the deeply contradictory nature of entertainment forms. In variety, the essential contradiction is between comedy and music turns; in musicals, it is between the narrative and the numbers. Both these contradictions can be rendered as one between the heavily representational and verisimilitudinous (pointing to the way the world is, drawing on the audience's concrete experience of the world) and the heavily non-representational and 'unreal' (pointing to how things could be better). In musicals, contradiction is also to be found at two other levels – within numbers, between the representational and the non-representational, and within the non-representational, owing to the differing sources of production inscribed in the signs.

To be effective, the utopian sensibility has to take off from the real experiences of the audience. Yet to do this, to draw attention to the gap between what is and what could be, is, ideologically speaking, playing with fire. What musicals have to do, then (not through any conspiratorial intent, but because it is always easier to take the line of least resistance, i.e., to fit in with prevailing norms), is to work through these contradictions at all levels in such a way as to 'manage' them, to make them seem to disappear. They don't always succeed.

I have chosen three musicals which seem to me to illustrate the three broad tendencies of musicals – those that keep narrative and number clearly separated (most typically, the backstage musical); those that retain the division between

narrative as problems and numbers as escape, but try to 'integrate' the numbers by a whole set of papering-over-the-cracks devices (e.g., the well-known 'cue for a song'); and musicals which try to dissolve the distinction between narrative and numbers, thus implying that the world of the narrative is also (already) utopian.

The clear separation of numbers and narrative in *Golddiggers of 1933* (1933) is broadly in line with a 'realist' aesthetic: the numbers occur in the film in the same way as they occur in life, that is, on stages and in cabarets. This 'realism' is of course reinforced by the social-realist orientation of the narrative, settings and characterization, with their emphasis on the Depression, poverty, the quest for capital, 'gold-digging' (and prostitution). However, the numbers are not wholly contained by this realist aesthetic – the way in which they are opened out, in scale and in cinematic treatment (overhead shots, etc.), represents a quite marked shift from the real to the non-real, and from the largely representational to the largely non-representational (sometimes to the point of almost complete abstraction). The thrust of the narrative is towards seeing the show as a 'solution' to the personal, Depression-induced problems of the characters; yet the non-realist presentation of the numbers makes it very hard to take this solution seriously. It is 'just' escape, 'merely' utopian.

If the numbers embody (capitalist) palliatives to the problems of the narrative – chiefly, abundance (spectacle) in place of poverty, and (non-efficacious) energy (chorines in self-enclosed patterns) in place of dispiritedness – then the actual mode of presentation undercuts this by denying it the validity of 'realism'.

However, if one then looks at the contradiction between the representational and non-representational within the numbers, this becomes less clear-cut. Here much of the representational level reprises the lessons of the narrative – above all, that women's only capital is their bodies as objects. The abundant scale of the numbers is an abundance of piles of women; the sensuous materialism is the texture of femaleness; the energy of the dancing (when it occurs) is the energy of the choreographic imagination, to which the dancers are subservient. Thus, while the non-representational certainly suggests an alternative to the narrative, the representational merely reinforces the narrative (women as sexual coinage, women – and men – as expressions of the male producer).

Finally, if one then looks at the non-representational alone, contradictions once again become apparent – e.g., spectacle as materialism and metaphysics (that is, on the one hand, the sets, costumes, etc. are tactile, sensuous, physically exhilarating, but, on the other hand, are associated with fairy-land, magic, the by-definition immaterial), dance as human creative energy and sub-human mindlessness.

In *Funny Face* (1956), the central contradiction is between art and entertainment, and this is further worked through in the antagonism between the central couple, Audrey Hepburn (art) and Fred Astaire (entertainment). The numbers are escapes from the problems, and discomforts, of the contradiction – either by asserting the unanswerably more pleasurable qualities of entertainment (e.g., 'Clap yo' hands' following the dirge-like Juliette-Greco-type song in the 'empathicalist', i.e. existentialist, *soirée*), or in the transparency of love in the Hepburn–Astaire numbers.

But it is not always that neat. In the empathicalist cellar club, Hepburn escapes Astaire in a number with some of the other beats in the club. This reverses the escape direction of the rest of the film (i.e., it is an escape from entertainment/Astaire into art). Yet within the number, the contradiction repeats itself. Before Hepburn joins the group, they are dancing in a style deriving from Modern Dance, angular, oppositional shapes redolent in musical convention of neurosis and pretentiousness (cf. Danny Kaye's number, 'Choreography', in *White Christmas* [1954]). As the number proceeds, however, more show-biz elements are introduced – use of syncopated clapping, forming in a vaudeville line-up, and American Theatre Ballet shapes. Here an 'art' form is taken over and infused with the values of entertainment. This is a contradiction between the representational (the dreary night club) and the non-representational (the oomph of music and movement) but also, within the non-representational, between different dance forms. The contradiction between art and entertainment is thus repeated at each level.

In the love numbers, too, contradictions appear, partly by the continuation in them of troubling representational elements. In *Funny Face,* photographs of Hepburn as seen by Astaire, the fashion photographer, are projected on the wall as background to his wooing her and her giving in. Again, their final dance of reconciliation to ''S wonderful' takes place in the grounds of a chateau, beneath the trees, with doves fluttering around them. Earlier, this setting was used as the finish for their fashion photography sequence. In other words, in both cases, she is reconciled to him only by capitulating to his definition of her. In itself, there is nothing contradictory in this – it is what Ginger Rogers always had to do. But here the mode of reconciliation is transparency and yet we can see the strings of the number being pulled. Thus the representational elements, which bespeak manipulation of romance, contradict the non-representational, which bespeaks its transparency.

The two tendencies just discussed are far more common than the third, which has to suggest that utopia is implicit in the world of the narrative as well as in the world of the numbers.

The commonest procedure for doing this is removal of the whole film in time and space – to turn-of-the-century America (*Meet Me in St Louis* [1944], *Hello Dolly!* [1969]), Europe (*The Merry Widow* [1925], *Gigi* [1958], *Song of Norway* [1970]), cockney London (*My Fair Lady* [1964], *Oliver!* [1968], *Scrooge* [1970]), black communities (*Hallelujah!* [1929], *Cabin in the Sky* [1943], *Porgy and Bess* [1958]), etc. – to places, that is, where it can be believed (by white urban Americans) that song and dance are 'in the air', built into the peasant/black culture and blood, or part of a more free-and-easy stage in American development. In these films, the introduction of any real narrative concerns is usually considerably delayed and comes chiefly as a temporary threat to utopia – thus reversing the other two patterns, where the narrative predominates and numbers function as temporary escapes from it. Not much happens, plot-wise, in *Meet Me in St Louis* until we have had 'Meet me in St Louis', 'The boy next door', 'The trolley song' and 'Skip to my Lou' – only then does father come along with his proposal to dismantle this utopia by his job mobility.

Most of the contradictions developed in these films are overridingly bought off by the nostalgia or primitivism which provides them with the point of departure.

Far from pointing forwards, they point back, to a golden age — a reversal of utopi-
anism that is only marginally offset by the narrative motive of recovery of utopia.
What makes *On the Town* (1949) interesting is that its utopia is a well-known
modern city. The film starts as an escape — from the confines of Navy life into
the freedom of New York, and also from the weariness of work, embodied in the
docker's refrain, 'I feel like I'm not out of bed yet', into the energy of leisure,
as the sailors leap into the city for their day off. This energy runs through the
whole film, *including the narrative*. In most musicals, the narrative represents things
as they are, to be escaped from. But most of the narrative of *On the Town* is about
the transformation of New York into utopia. The sailors release the *social* frustra-
tions of the women — a tired taxi driver just coming off shift, a hard-up dancer
reduced to belly-dancing to pay for ballet lessons, a woman with a sexual appetite
that is deemed improper — not so much through love and sex as through energy.
This sense of the sailors as a transforming energy is heightened by the sense of
pressure on the narrative movement suggested by the device of a time-check flashed
on the screen intermittently.

This gives a historical dimension to a musical, that is, it shows people making
utopia rather than just showing them from time to time finding themselves in it.
But the people are men — it is still men making history, not men and women
together. (And the Lucy Schmeeler role is unforgivably male chauvinist.) In this
context, the 'Prehistoric Man' number is particularly interesting. It centres on Ann
Miller, and she leads the others in the take-over of the museum. For a moment,
then, a woman 'makes history'. But the whole number is riddled with contradic-
tions, which revolve round the very problem of having an image of a woman acting
historically. If we take the number and her part in it to pieces, we can see that
it plays on an opposition between self-willed and mindless modes of being; and
this play is between representational (R) and non-representational (NR) at all
aesthetic levels.

Self-willed	*Mindless*
Miller as star (R)	Miller's image ('magnificent animal') (R)
Miller character — decision-maker in narrative (R)	Number set in anthropology museum — associations with primitivism (R)
Tap as self-expressive form (NR)	Tap as mindless repetitions (NR)
Improvisatory routine (R/NR)	

The idea of a historical utopianism in narrativity derives from the work of
Ernest Bloch. According to Fredric Jameson in *Marxism and Form,* Bloch

> has essentially two different languages or terminological systems at his
> disposition to describe the formal nature of Utopian fulfilment: the
> movement of the world in time towards the future's ultimate moment,
> and the more spatial notion of that adequation of object to subject
> which must characterise that moment's content . . . [these] correspond
> to dramatic and lyrical modes of the presentation of not-yet-being.

Musicals (and variety) represent an extraordinary mix of these two modes – the historicity of narrative and the lyricism of numbers. They have not often taken advantage of it, but the point is that they could, and that this possibility is always latent in them. They are a form we still need to look at if films are, in Brecht's words on the theatre, to 'organise the enjoyment of changing reality'.

Peter Stallybrass and Allon White

BOURGEOIS HYSTERIA AND
THE CARNIVALESQUE

EDITOR'S INTRODUCTION

THIS EDITED CHAPTER FROM Stallybrass and White's *The Politics and Poetics of Transgression* develops an account of carnival first put forward by the Russian theorist Mikhail Bakhtin, who wrote while Stalin was in power. Bakhtin tacitly opposed Stalinism's strictly modernizing program and rhetoric by arguing that carnivals and other "survivals" of the premodern period expressed energies suppressed in modernized everyday life and also an alternative politics. For Bakhtin, carnival contained a utopian urge: it displaced, even inverted, the normal social hierarchies. Carnival was also a time which encouraged bodily needs and pleasures different from those called upon by the ordinary rhythm of labor and leisure.

Stallybrass and White here argue that in the modern era, carnival was "sublimated." On the one hand (as by Freud), the opposition between order and carnival was transposed into models of the psyche; on the other, carnival becomes spectacularized, the object of a large audience's remote and sentimental gaze. Theirs is a thesis which helps make sense of a number of seemingly disparate cultural formations, though it is important not to forget that, just as the carnivalesque does not die out in modernity, rigid social hierarchies and controls predate modernization and industrialization, and may be found, in some form or other, wherever carnival exists. If that is not recognized, the Bakhtinian thesis developed by Stallybrass and White settles back into nostalgia.

Further reading: Bakhtin 1981, 1987; Fiske 1987b; Hartley 1996; Stallybrass and White 1986.

> While she was being massaged she told me only that the children's governess had brought her an ethnological atlas and that some of the pictures in it of American Indians dressed up as animals had given her a great shock. 'Only think, if they came to life' (she shuddered). I instructed her not to be frightened of the pictures of the Red Indians but to laugh heartily at them. And this did in fact happen after she had woken up: she looked at the book, asked whether I had seen it, opened it at the page and laughed at the grotesque figures, without a trace of fear and without any strain in her features.
>
> 'Studies on hysteria', Frau Emmy von N. (Freud 1974: 109–10)

Carnival debris spills out of the mouths of those terrified Viennese women in Freud's 'Studies on hysteria'. 'Don't you hear the horses stamping in the circus?' Frau Emmy von N. implores Freud at a moment of particularly abject horror. It is striking how the broken fragments of carnival, terrifying and disconnected, glide through the discourse of the hysteric. Occasionally, as in the extract quoted above, it appears that Freud's therapeutic project was simply the reinflexion of this grotesque material into comic form. When Frau Emmy can at last look at the 'grotesque figures' and 'laugh without a trace of fear', it is as if Freud had managed a singular restitution, salvaging torn shreds of carnival from their phobic alienation in the bourgeois unconscious by making them once more the object of cathartic laughter.

It is of course significant that the carnivalesque practice which produced the phobic symptom in Frau Emmy is that of an alien, non-European culture. Not the least significant element in the middle-class rejection of the indigenous carnival tradition in the late nineteenth century in Europe was a compensatory plundering of ethnographic material – masks, rituals, symbols – from colonized cultures. In this respect Joseph Conrad was doing no more than Frau Emmy in placing 'savage rites' at the heart of European darkness in the 1890s.

As we know, within a very few years Freud was to abandon the cathartic approach which he used with his early hysterical patients and to lose interest in the attempt to precipitate the abreactive rituals which might reinflect the grotesque and the disgusting into a *comic* form. There is some contention that this was not necessarily a positive move (Scheff 1979), but in any event it is a notable feature of the early case histories that it is *the patients themselves* who, in their pastiche appropriations of festive, carnival, religious and pantomimic gestures, suggest kinds of alleviation to their own suffering. Anna O. is credited by Ernest Jones as being the real discoverer of the cathartic method and Breuer developed and formalized her practical notions in his own method (Scheff 1979: 28). Freud's gradual move away from abreactive ritual of a cathartic kind towards associative methods of self-consciousness is entirely consonant with his desire to produce a professional, *scientific* psychology. This is because science, particularly in the late nineteenth century, was deeply hostile to ritual. It even saw itself, on occasion, as self-consciously improving upon those areas of social life which, once governed by 'irrational' rituals, could now be brought under scientific control.

Indeed science only emerged as an autonomous set of discursive values after a prolonged struggle against ritual, and it marked out its own identity by the

distance which it established from 'mere superstition' – science's label for, among other things, a large body of social practices of a therapeutic kind. Scheff has suggested that there is a strongly cognitive bias against ritual and catharsis in much recent work in psychology and anthropology. A re-reading of hysteria case studies (not only Freud's) in relation to the ritualistic and symbolic material of carnival suggests new ways of interpreting the hostility, the felt incompatibility, of rational knowledge to ritual behaviour.

In the 'Studies on hysteria' many of the images and symbols which were once the focus of various pleasures in European carnival have become transformed into the morbid symptoms of private terror. Again and again these patients suffer acute attacks of disgust, literally vomiting out horrors and obsessions which look surprisingly like the rotted residue of traditional carnival practices. At the same time the patients seem to be reaching out, in their highly stylized gestures and discourses, towards a repertoire of carnival material as both expression and support. They attempt to mediate their terrors by enacting private, made-up carnivals. In the absence of social forms they attempt to produce their own by pastiche and parody in an effort to embody semiotically their distress. Once noticed, it becomes apparent that there is a second narrative fragmented and marginalized, lodged within the emergent psychoanalytic discourse. It witnesses a complex interconnection between hints and scraps of parodic festive form and the body of the hysteric. In his general remarks on hysterical attacks (Freud 1963), Freud himself even makes this 'other narrative' part of his definition of hysteria, without, however, making anything of it: 'When one psychoanalyses a patient subject to hysterical attacks one soon gains the conviction that these attacks are nothing but phantasies projected and translated into motor activity and *represented in pantomime*' (Freud 1963: 153, our italics).

Freud goes on to talk about the distortion which 'the pantomimic representation of phantasy' undergoes as a result of censorship. Yet the semiotic encoding of the hysterical symptom in pantomime mimicry is given as the very form of representation of fantasy: Freud's definition of hysteria makes pantomime the *symptomatic* locus of the Imaginary, that second-order signifying system which 'translates' and 'represents' the anterior language of the unconscious. Thus when Julia Kristeva attempted to synthesize the Bakhtinian opposition between the classical and grotesque with the Lacanian terms of the symbolic and the Imaginary, there was warrant for the connection not only at the theoretical level but in this 'other narrative' of the hysteric (Kristeva 1974). Yet such is the low status of popular ritual and dramatic representation that Freud never 'sees' his own reference to pantomime as anything other than metaphorical. Towards the end of a letter to Fliess written in 1896, Freud remarks on what Charcot had dubbed the 'clownism' phase of hysterical attacks. He writes of: 'the "clownism" in boys' hysteria, the imitation of animals and circus scenes . . . a compulsion to repeat dating from their youth [in which they] seek their satisfaction to the accompaniment of the craziest capers, somersaults and grimaces' (Freud 1954: 182).

Even though Charcot's typology of hysterical styles is unreliable and contrived, especially for the photographic representations, the 'clownism' was frequently attested to as a symptomatic aspect of hysteria. Freud, in the explanation which he offers to Fliess in the letter, refers to the 'perversion of the seducers' (the

patients themselves) who, he says, 'connect up nursery games and sexual scenes'. This is something we explored in the preceding chapter in relation to the nurse-maid: here, offered as an explanation of the clownism, it does not take sufficient account of the whole range of festive material scattered through various studies on hysteria and which together create a subtext irreducible to nursery games. There are indeed deep connections between childhood rituals, games and carni-valesque practices (White 1983), but here Freud's insistence upon a purely sexual aetiology obscures a fundamental socio-historical matrix of the symptom.

The carnival material of the case studies witnesses an historical repression and return. The repression includes the gradual, relentless attack on the 'grotesque body' of carnival by the emergent middle and professional classes from the Renaissance onwards. Interestingly, scholars of European popular culture have occasionally wanted to connect up, backwards as it were, Renaissance festive form to Freud's ideas. Thus C. L. Barber claims that 'A saturnalian attitude, assumed by a clear-cut gesture toward liberty, brings mirth, an accession of wanton vitality. In terms of Freud's analysis of wit, the energy normally occupied in maintaining inhibition is freed for celebration' (Barber 1959: 7). But Barber's reference to Freud seems like a reaching after validation which confuses the histori-cally complex relation of the discourse of psychoanalysis to festive practices. The demonization and the exclusion of the carnivalesque has to be related to the victorious emergence of specifically bourgeois practices and languages which rein-flected and incorporated this material within a negative, individualist framework. In one way or another Freud's patients can be seen as enacting desperate ritual fragments salvaged from a festive tradition, *the self-exclusion from which* had been one of the identifying features of their social class. The language of bourgeois neurosis both disavows and appropriates the domain of calendrical festive prac-tices. Thus the 'highly gifted lady' of the case studies celebrated a whole series of what she called 'festivals of remembrance', annually re-enacting the various scenes of her affliction.

It might at first seem plausible to view the discourses of neurosis as the *psychic* irruption of *social* practices which had been suppressed. Certainly, in the long-term history from the seventeenth to the twentieth century, as we have seen above, there were literally thousands of acts of legislation introduced which attempted to eliminate carnival and popular festivity from European life. In different areas of Europe the pace varied, depending upon religious, class and economic factors. But everywhere, against the periodic revival of local festivity and occasional reversals, a fundamental ritual order of Western culture came under attack – its feasting, violence, drinking, processions, fairs, wakes, rowdy spectacle and outrageous clamour were subject to surveillance and repressive control. We can briefly list some particular instances of this general process. In 1855 the Great Donnybrook Fair of Dublin was abolished in the very same year that Bartholomew Fair in London finally succumbed to the determined attack of the London City Missions Society. In the decade following the Fairs Act of 1871 over seven hundred fairs, mops and wakes were abolished in England. By the 1880s the Paris carnival was rapidly being transformed into a trade show cum civic/military parade (Faure 1978), and although the '*cortège du boeuf gras*' processed round the streets until 1914, 'little by little it was suppressed and restricted because it was said to cause

a traffic problem' (Pillement 1972: 383). In 1873 the famous Nice carnival was taken over by a *comité des Fêtes*, brought under bureaucratic bourgeois control and reorganized quite self-consciously as a tourist attraction for the increasing numbers who spent time on the Riviera and who were finding neighbouring San Remo's new casino a bigger draw (Sidro 1979: 57–62). As Wolfgang Hartmann has shown (1976), in Germany in the aftermath of the Franco-Prussian war traditional processions and festivities were rapidly militarized and incorporated into the symbolism and 'classical body' of the state. This dramatic transformation of the ritual calendar had implications not only for each stratum of the social formation, particularly for those which were disengaging *themselves* from ongoing practices, but for the basic structures of symbolic activity in Europe: carnival was now everywhere and nowhere.

Many social historians treat the attack on carnival as a victory over popular culture, first by the Absolutist state and then by the middle classes, a process which is viewed as the more or less complete destruction of popular festivity: the end of carnival. In this vision of the complete elimination of the ritual calendar there is the implicit assumption that, in so far as it was the culture of a rural population which was disappearing, the modernization of Europe led inevitably to the supersession of traditional festivity – it was simply one of the many casualties in the movement towards an urban, industrial society. On the other hand recent literary criticism, following Bakhtin, has found elements of the carnivalesque everywhere it has looked in *modern* as well as traditional literature. Critics now discover the forms, symbols, rituals and structures of carnival to be among the fundamental elements in the aesthetics of modernism (White 1982).

By and large literary critics have not connected with the work of social historians to ask how or why this carnivalesque material should persistently inform modern art because, busy with the task of textual analysis, they move too easily from social practice to textual composition. Yet the social historians who have charted the transformations of carnival as a social practice have not registered its *displacements* into bourgeois discourses like art and psychoanalysis: adopting a naïvely empirical view they have outlined a simple disappearance, the elimination of the carnivalesque.

But, as we have shown, carnival did not simply disappear. At least four different processes were involved in its ostensible break-up: fragmentation; marginalization; sublimation; repression.

Carnival had always been a loose amalgam of procession, feasting, competition, games and spectacle, combining diverse elements from a large repertoire and varying from place to place. Even the great carnivals of Venice, Naples, Nice, Paris and Nuremberg were fluid and changeable in their combination of practices. During the long and uneven process of suppression (we often find that a carnival is banned over and over again, only to re-emerge each time in a slightly altered fashion), there was a tendency for the basic mixture to break down, certain elements becoming separated from others. Feasting became separated from performances, spectacle from procession: the grotesque body was fragmented. At the same time it began to be marginalized both in terms of social class and geographical location. It is important to note that even as late as the nineteenth century, in some places, carnival remained a ritual involving most classes and sections of a

community – the disengaging of the middle class from it was a slow and uneven matter. Part of that process was, as we have seen, the 'disowning' of carnival and its symbolic resources, a gradual reconstruction of the idea of carnival as the culture of the Other. This act of disavowal on the part of the emergent bourgeoisie, with its sentimentalism and its disgust, *made* carnival into the festival of the Other. It encoded all that which the proper bourgeois must strive *not to be* in order to preserve a stable and 'correct' sense of self.

William Addison (1953) charts many of these geographical marginalizations in the English context in the seventeenth and eighteenth centuries. Within a town the fair, mop, wake or carnival, which had once taken over the whole of the town and permitted neither outside nor outsider to its rule, was confined to certain areas and gradually driven out from the well-to-do neighbourhoods. In the last years of the Bury St Edmunds Fair it was 'banished from the aristocratic quarter of Angel Hill and confined to St Mary's and St James's squares' (Addison 1953: 163). In and around London:

> Both regular and irregular fairs were being steadily pushed from the centre outwards as London grew and the open spaces were built over. Greenwich and Stepney were the most popular at one time. Others – Croydon's for example – came to the fore later when railways extended the range of pleasure as well as the range of boredom, until towards the end of the nineteenth century London was encircled by these country fairs, some of which were, in fact, ancient charter fairs made popular by easier transport. . . . Most of them were regarded by the magistrates as nuisances, and sooner or later most of those without charters were suppressed. Yet such was the popularity of these country fairs round London that to suppress them in one place led inevitably to an outbreak elsewhere, and often where control was more difficult. As the legal adviser to the City Corporation had said in the 1730's, 'It is at all times difficult by law to put down the ancient customs and practices of the multitude.'
>
> (Addison 1953: 100)

In England the sites of 'carnival' moved more and more to the coastal periphery, to the seaside. The development of Scarborough, Brighton, Blackpool, Clacton, Margate and other seaside resorts reflects a process of liminality which, in different ways, was taking place across Europe as a whole. The seaside was partially legitimated as a carnivalesque site of pleasure on the grounds of health, since it combined the (largely mythical) medicinal virtues of the spa resorts with tourism and the fairground. It can be argued that this marginalization is a *result* of other, anterior processes of bourgeois displacement and even repression. But even so, this historical process of marginalization must be seen as an historical tendency distinct from the actual elimination of carnival.

Bakhtin is right to suggest that post-romantic culture is, to a considerable extent, subjectivized and interiorized and on this account frequently related to private terrors, isolation and insanity rather than to robust kinds of social celebration and critique. Bakhtin however does not give us a convincing explanation

of this *sublimation* of carnival. The social historians, on the other hand, tend not to consider processes of sublimation at all: for them carnival came to an end and that was that. They tend not to believe in the return of the repressed.

But a convincing map of the transformation of carnival involves tracing migrations, concealment, metamorphoses, fragmentations, internalization and neurotic sublimations. The *disjecta membra* of the grotesque body of carnival found curious lodgement throughout the whole social order of late nineteenth- and early twentieth-century Europe. These dispersed carnivalesque elements represent more than the insignificant nomadic residues of the ritual tradition. In the long process of disowning carnival and rejecting its periodical inversions of the body and the social hierarchy, bourgeois society problematized its own relation to the power of the 'low', enclosing itself, indeed often defining itself, by its suppression of the 'base' languages of carnival.

As important as this was the fact that carnival was being marginalized *temporally* as well as spatially. The carnival calendar of oscillation between production and consumption which had once structured the whole year was displaced by the imposition of the working week under the pressure of capitalist industrial work regimes. The semiotic polarities, the symbolic clusters of classical and grotesque, were no longer *temporally* pinned into a calendrical or seasonal cycle, and this involved a degree of unpredictability in moment and surface of emergence. The 'carnivalesque' might erupt from the literary text, as in so much surrealist art, or from the advertisement hoarding, or from a pop festival or a jazz concert.

Carnival was too disgusting for bourgeois life to endure except as sentimental spectacle. Even then its specular identifications could only be momentary, fleeting and partial – voyeuristic glimpses of a promiscuous loss of status and decorum which the bourgeoisie had had to deny as abhorrent in order to emerge as a distinct and 'proper' class.

Consumption and the market

Meaghan Morris

THINGS TO DO WITH
SHOPPING CENTRES

EDITOR'S INTRODUCTION

MEAGHAN MORRIS'S ESSAY is an exemplary instance of contemporary cultural studies. It carefully considers the conditions of its own production and reception – reminding us that its author is a shopper herself. Thus it is written from a position for which both the "grammar" of shopping centres (the way their elements are put together) and their workability are part of everyday life. But it is also written from a feminist, theoretical position where such practical considerations are not all that matter. Hence, it is not written for "ordinary women" (who, as Morris notes, exist as such only in the social imaginary) as much as for intellectuals, students, academics. This does not mean, however, that it can either condescend to shoppers who are not also theorists or assume that its readers are exceptional.

This sense that theory can never either remain within the sites of everyday life or cut itself loose from them has another aspect. For Morris recognizes that those who design, manage and market shopping centres are theorists too. Certainly they know a great deal about the women who constitute so much of their custom. This cannot be simply dismissed or deplored, for shopping centres are not just useful; they may also be, for Morris, "lovable."

Because so much information about, and theory of, shopping centers circulates; because, finally, they exist as architectural outcomes of information technologies which track and manage consumption, Morris cannot write a piece which limits "shopping in a shopping centre" to individual pleasure and consciousness in the manner of de Certeau's "walking in the city." Instead she turns to a history of particular shopping-centre sites she knows.

Yet, although Morris does not delocalize shopping in the way de Certeau delocalizes urban walking, certain questions remain, most obviously: how much

money do you have to have to "love" a shopping centre? Is shopping in a shopping centre the same for an unemployed as an employed person – assuming that the first have access to them to begin with? These are old, but not tired, questions which the essay certainly does not pre-empt – and they allow us to think about the relation between this kind of work on consumption and earlier, more obviously "left," cultural studies themes.

Further reading: N. Harris 1990; Kowinski 1985; D. Miller 1998; Morris 1988a, 1988b; Nava 1987; Williamson 1986.

The first thing I want to do is to cite a definition of modernity. It comes not from recent debates in feminist theory or aesthetics or cultural studies, but from a paper called 'Development in the retail scene' given in Perth in 1981 by John Lennen of Myer Shopping Centres. To begin his talk (to a seminar organized by the Australian Institute of Urban Studies), Lennen told this fable: 'As Adam and Eve were leaving the Garden of Eden, Adam turned to Eve and said, "Do not be distressed, my dear, we live in times of change."' After quoting Adam, Lennen went on to say, 'Cities live in times of change. We must not be discouraged by change, but rather we must learn to manage change.' He meant that the role of shopping centres was changing from what it had been in the 1970s, and that retailers left struggling with the consequences (planning restrictions, post-boom economic conditions, new forms of competition) should not be discouraged, but should change their practices accordingly.

I want to discuss some issues for feminist criticism that emerge from a study I'm doing of the management of change in certain sites of 'cultural production' involving practices regularly, if by no means exclusively, carried out by women – shopping, driving, the organization of leisure, holiday and/or unemployment activities. By 'sites', I mean shopping centres, cars, highways, 'homes' and motels. It's a large project, and this essay is a kind of preface to one or two of its problems. The essay has a framing theme, however – the 'Edenic' allegories of consumerism in general, and of shopping centres in particular, that one can find elaborated in a number of different discourses (and cultural 'sites'). It also has an argument, which will take the form of a rambling response to three questions that I've often been asked by women with whom I've discussed the project.

One of these is very general: 'what's feminist about it?' I can't answer that in any direct or immediate way, since obviously 'feminism' is not a set of approved concerns and methods, a kind of planning code, against which one can measure one's own interests and aspirations. To be frank, it's a question that I find almost unintelligible. While I do understand the polemical, and sometimes theoretical, value of arguing that something is *not* feminist, to demand a definition of positive feminist identity seems to me to require so many final decisions to be taken, and to assume so much about shared and settled values, that it makes the very concept of a 'project' – undecided and unsettled – impossible. So I shall take this question here as an invitation to make up answers as I go, and the essay will be the response. (That's a way of saying that for me, the answer to 'what's feminist about it?' should be 'I don't know yet'.)

The other two questions are more specific, and relate particularly to shopping centres.

The first question is asked almost invariably by women with whom I've discussed the topic of shopping. They say: 'Yes, you do semiotics . . . are you looking at how shopping centres are all the same everywhere? – laid out systematically, everyone can read them?' They don't ask about shopping centres and change, or about a semiotics of the management of change.

In fact, my emphasis is rather the opposite. It's true that at one level of analysis (and of our 'practice' of shopping centres), layout and design principles ensure that all centres are minimally readable to anyone literate in their use – that is, to almost if not quite everybody in the Western suburban culture I'm concerned with here. This 'readability' may be minimal indeed: many centres operate a strategy of alternating surprise and confusion with familiarity and harmony; and in different parts of any one centre, clarity and opacity will occur in different degrees of intensity for different 'users'. To a newcomer, for example, the major supermarket in an unfamiliar centre is usually more difficult to read than the spatial relations between the speciality food shops and the boutiques. Nevertheless, there are always some basic rules of contiguity and association at work to assist you to make a selection (of shops, as well as products).

However, I am more interested in a study that differentiates particular shopping centres. Differentiating shopping centres means, among other things, looking at how particular centres produce and maintain what the architectural writer Neville Quarry calls (in an appreciation of one particular effort) 'a unique sense of place' – in other terms, a myth of identity. I see this as a 'feminist' project because it requires the predication of a more complex and localized affective relation to shopping spaces (and to the links between those spaces and other sites of domestic and familial labour) than does the scenario of the cruising grammarian reading similarity from place to place. In one way, all shoppers may be cruising grammarians. I do not need to deny this, however, in order to choose to concentrate instead on the ways that particular centres strive to become 'special', for better or for worse, in the everyday lives of women in local communities. Men, of course, may have this relation to a shopping centre, too. So my 'feminism' at this stage is defined in non-polemical and non-exclusive (that is, non-self-identical) terms.

Obviously, shopping centres produce a sense of place for economic, 'come-hither' reasons, and sometimes because the architects and planners involved may be committed, these days, to an aesthetics or even a politics of the local. But we cannot derive commentary on their function, people's responses to them, or their own cultural production of 'place' in and around them, from this economic rationale. Besides, shopping-centre identities aren't fixed, consistent or permanent. Shopping centres do get facelifts, and change their image – increasingly so as the great classic structures in any region begin to age, fade and date.

But the cost of renovating them (especially the larger ones) means that the identity effect produced by any one centre's spatial play in time is not only complex, highly nuanced and variable in detail, but also simple, massive and relatively enduring overall, and over time, in space. At every possible 'level' of analysis – and there are very many indeed with such a complex, continuous social event

– shopping centres are overwhelmingly and constitutively paradoxical. This is one of the things that makes it very hard to differentiate them. On the one hand, they seem so monolithically present – solid, monumental, rigidly and indisputably on the landscape, and in our lives. On the other hand, when you try to dispute with them, they dissolve at any one point into a fluidity and indeterminacy that might suit any philosopher's delirium of an abstract femininity – partly because the shopping centre 'experience' at any one point includes the experience of crowds of people (or of their relative absence), and so of all the varied responses and uses that the centre provokes and contains.

To complicate matters, this *dual* quality is very much a part of shopping-centre strategies of appeal, their 'seductiveness', and also of their management of change. The stirring tension between the massive stability of the structure, and the continually shifting, ceaseless spectacle within and around the 'centre', is one of the things that people who like shopping centres really love about shopping centres. At the same time, shopping-centre management methods (and contracts) are very much directed towards organizing and unifying – at the level of administrative control, if not of achieved aesthetic effect – as much of this spectacle as possible by regulating tenant mix, signing and advertising styles, common space decor, festivities, and so on. This does not mean, however, that they succeed in 'managing' either the total spectacle (which includes what people do with what they provide) or the responses it provokes (and may include).

So the task of analysing shopping centres partly involves on the one hand exploring common sensations, perceptions and emotional states aroused by them (which can be negative, of course, as well as delirious), and on the other hand, battling against those perceptions and states in order to make a place from which to speak other than that of the fascinated describer – either standing 'outside' the spectacle qua ethnographer, or (in a pose which seems to me to amount to much the same thing) ostentatiously absorbed in her own absorption in it, qua celebrant of 'popular culture'.

If the former mode of description may be found in much sociology of consumerism, or 'leisure', the latter mode is the more common today in cultural studies – and it has its persuasive defenders. Iain Chambers, for example, has argued strongly that to appreciate the democratic 'potential' of the way that people live through (not 'alongside') culture – appropriating and transforming everyday life – we must first pursue the 'wide-eyed presentation of actualities' that Adorno disapproved of in some of Benjamin's work on Baudelaire. It's difficult to disagree with this as a general orientation, and I don't. But if we look more closely at the terms of Adorno's objection (and leave aside here the vexed question of its pertinence to Benjamin's work), it's possible to read in them now a description of shopping-centre mystique: 'your study is located at the crossroads of magic and positivism. That spot is bewitched.' With a confidence that feminist philosophers have taught us to question, Adorno continues that 'Only theory could break the spell . . .' (although in context, he means Benjamin's own theoretical practice, not a force of theory-in-general).

In my view, neither a strategy of 'wide-eyed presentation' nor a faith in theory as the exorcist is adequate to dealing with the critical problems posed by feminism in the analysis of 'everyday life'. If we locate our own study at that 'crossroads

of magic and positivism' to be found in the grand central court of any large regional mall, then social experiences more complex than wide-eyed bewitchment are certain to occur – and to elicit, for a feminist, a more critical response than 'presentation' requires. If it is today fairly easy to reject the rationalist and gyno-phobic prejudice implied by Adorno's scenario (theory breaking the witch's spell), and if it is also easy to refuse the old critiques of 'consumption' as false conscious-ness (bewitchment by the mall), then it is perhaps not so easy at the moment *also* to question the 'wide-eyed' pose of critical amazement at the performance of the everyday.

There's a great deal to be said about that, but my one point here must be that at the very least, a feminist analysis of shopping centres will insist initially upon ambivalence about its objects rather than a simple astonishment 'before' them. Ambivalence allows a thinking of relations between contradictory states: it is also a 'pose', no doubt, but one that is probably more appropriate to an everyday practice of using the same shopping centres often, for different reasons (rather than visiting several occasionally, just in order to see the sights). Above all, it does not eliminate the moment of everyday discontent – of anger, frustration, sorrow, irritation, hatred, boredom, fatigue. Feminism is minimally a movement of discon-tent with 'the everyday' and with wide-eyed definitions of the everyday as 'the way things are'. While feminism too may proceed by 'staring hard at the realities of the contemporary world we all inhabit', as Chambers puts it, feminism also allows the possibility of rejecting what we see and refusing to take it as 'given'. Like effective shopping, feminist criticism includes moments of sharpened focus, narrowed gaze – of sceptical, if not paranoid, assessment. (This is a more polemi-cal sense in which I shall consider this project to be 'feminist' in the context of cultural studies.)

Recent feminist theory in a number of academic domains has provided a great many tools for any critical study of myths of identity and difference, and the rhetoric of 'place' in everyday life. But in using them in shopping centres, I strike another difficulty: a rhetorical one this time, with resonances of interdisciplinary conflict. It's the difficulty of what can seem to be a lack, or lapse, of appropri-ateness between my discourse as feminist intellectual and my objects of study.

To put it bluntly: isn't there something really 'off' about mobilizing the weapons (and I use that violent metaphor deliberately) of an elite, possibly still fashionable but definitively *un*popular theoretical discourse against a major element in the lived culture of 'ordinary women' to whom that discourse might be as irrel-evant as a stray copy of a book by Roland Barthes chosen to decorate a simulated yuppie apartment on display at Canberra's Freedom furniture showroom? And wouldn't using that discourse, and its weapons, be 'off' in a way that it isn't off to use them to re-read Gertrude Stein, or other women modernists, or indeed to rewrite devalued and non-modernist writings by women so that they may be used to revise existing concepts of the literary canon?

Of course, these are not questions that any academic, even feminist, is obliged to ask or to answer. One can simply define one's 'object' strategically, in the limited way most appropriate to a determined disciplinary, and institutional, context. They are also questions that it's impossible to answer without challenging

their terms – by pointing out, for example, that a politics of 'relevance', and appropriateness (in so far as it can be calculated at all) depends as much on the 'from where' and the 'to whom' of any discourse as it does on its relations to an 'about'. For example, the reason that I referred to 'interdisciplinary conflict' above is that during my research, I have found the pertinence or even the 'good taste' of using a theoretical vocabulary derived from semiotics to discuss 'ordinary women's lives' questioned more severely by sociologists or historians (for whom the question becomes more urgent, perhaps, as so-called 'theory' becomes more respectable) than by non-academic (I do not say 'ordinary') women – who have been variously curious, indifferent or amused.

Nevertheless, these are questions that feminist intellectuals do ask each other; and we will no doubt continue to do so as long as we retain some sense of a wider social (as well as 'interdisciplinary') context and political import for our work. So I want to suggest the beginnings of an answer, one 'appropriate' to a cross-disciplinary gathering of feminist intellectuals, by questioning the function of the 'ordinary woman' as a figure in our polemics. As a feminist, I cannot and do not wish the image, or the reality, of other women away. As a semiotician, however, I must notice that 'images' of other women, even those which I've just constructed in mentioning 'them' as problem ('sociologists and historians' for me, rather than 'ordinary women') are, in fact, images.

My difficulty in the shopping-centre project will thus be not simply my relation as intellectual to the culture I'm speaking 'about', but to whom I will imagine that I will be speaking. So if, in a first instance, the task of differentiating shopping centres involves a struggle with fascinated description – consuming and consumerist list-making, attempts to freeze and fix a spectacular reality – my second problem will be to produce a mode of address that will 'evade' the fascinated or mirroring relationship to both the institutional discourses 'about' women that I'm contesting, and the imaginary figure of Everywoman that those discourses – along with many feminist arguments – keep on throwing up.

However in making that argument, I also evaded the problem of 'other' (rather than 'ordinary') women. I slid from restating the now conventional case that an image of a woman shopping is not a 'real' (or really representative) woman shopping to talking as though that difference absolved me from thinking about other women's ideas about their experience in shopping centres, as 'users' and as workers there. This is a problem of method, to which I'd like to return. First, I want to make a detour to consider the second enquiry I've had from 'other' women: 'What's the point of differentiating shopping centres? So what if they're *not* all the same?'

Here I want to make two points, about method. The first is that if this project on 'Things to do with shopping centres' could have a subtitle, it would be *'Pedestrian notes on modernity'*. I agree with Alice Jardine's argument in her book *Gynesis* that feminist criticism has much to gain from studying recent debates about 'modernity' in thought (that is, 'modernity' in the general European sense of life after industrialization – a sense which includes but is broader than the American aesthetic term 'postmodernity').

Studying shopping centres should be (like studying women modernists) one way to contest the idea that you can find, for example, at moments in the work

of Julia Kristeva, that the cultural production of 'actual women' has historically fallen short of a modernity understood as, or in terms derived from, the critical construction of modernism. In this project, I prefer to study instead the everyday, the so-called banal, the supposedly un- or non-experimental, asking not, 'why does it fall short of modernism?' but 'how do classical theories of modernism fall short of women's modernity?'

Second, the figure of the pedestrian gives me a way of imaging a critical method for analysing shopping centres that doesn't succumb unequivocally to the lure of using the classical images of the Imaginary, in the psychoanalytic sense, as a mirror to the shopping-town spectacle. Such images are very common now in the literature about shopping centres: especially about big, enclosed, enveloping, 'spectacular' centres like one of those I'm studying, Indooroopilly Shoppingtown. Like department stores before them (and which they now usually contain), they are described as palaces of dreams, halls of mirrors, galleries of illusion . . . and the fascinated analyst becomes identified as a theatre critic, reviewing the spectacle, herself in the spectacle, and the spectacle in herself. This rhetoric is closely related, of course, to the vision of shoppingtown as Eden, or paradise: the shopping centre is figured as, if not exactly utopian, then a mirror to utopian desire, the desire of fallen creatures nostalgic for the primal garden, yet aware that their paradise is now an illusion.

The pedestrian, or the woman walker, doesn't escape this dreamy ambivalence. Indeed, sociological studies suggest that women who don't come in cars to shopping centres spend much more time in them than those that do. The slow, evaluative, appreciatively critical relation is not enjoyed to the same extent by women who hit the car park, grab the goods, and head on out as fast as possible. Obviously, different women do both at different times. But if walking around for a long time in one centre creates engagement with and absorption in the spectacle, then one sure way at least to begin from a sharply defined sense of critical estrangement is to arrive at a drive-in centre on foot – and have to find a way to walk in. (Most women non-drivers, of course, don't arrive on foot – especially with children – but by public transport: which can, in Australia, produce an acutely estranging effect.)

I have to insert a qualification here about the danger of constructing exemplary allegorical figures (even that of the 'woman walker') if they're taken to refer to some model of the 'empirical social user' of shopping centres. It's a fairly futile exercise to try to make generalizations, beyond statistical averaging, about the users of shopping centres at any particular time – even in terms of class, race, age or gender. It's true that where you find a centre in a socially homogenized area (very common in some suburban regions of most Australian cities), you do find a high incidence of regular use by specific social groups (which may contribute strongly to the centre's identity effect). At a lot of centres, nevertheless, that's not the case. And even where it is, such generalizations remain abstractions, for concrete reasons: cars, public transport, visiting and tourist practices (since shopping centres can be used for sightseeing), and day-out patterns of movement, all mean that centres do not automatically 'reflect' the composition of their immediate social environment. Also, there are different practices of use in one centre on any one day: some people may be there for the one and only time in their

lives; there are occasional users choosing that centre rather than this on that day for particular, or quite arbitrary, reasons; people may shop at one centre and go to another to socialize or hang around. The use of centres as meeting places (and sometimes for free warmth and shelter) by young people, pensioners, the unemployed and the homeless is a familiar part of their social function – often planned for, now, by centre management (distribution of benches, video games, security guards). And many of a centre's habitual users may not always live in its vicinity.

Shopping centres illustrate very well, I think, the argument that you can't treat a public at a cultural event as directly expressive of social groups and classes, or their supposed sensibility. Publics aren't stable, homogeneous entities – and polemical claims assuming that they are tell us little beyond the display of political position and identification being made by the speaker. These displays may be interesting in themselves, but they don't necessarily say much about the wider social realities such polemics often invoke.

Shopping-centre designers know this very well, in fact – and some recent retailing theory talks quite explicitly about the marketing need to break down the old standardized predication of a 'vast monolithic middle-class market' for shopping-centre product that characterized the strategy of the 1970s. The prevailing marketing philosophy for the 1980s (especially in the United States, but visible also in parts of Australia) has been rather to develop spectacles of 'diversity and market segmentation'. That is, to produce images of class, ethnic, age and gender *differentiation* in particular centres – not because a Vietnamized centre, for example, would better 'express' the target culture and better serve Vietnamese (though it may well do so, particularly since retail theorists seem to have pinched the idea partly from the forms of community politics), but because the display of difference will today increase a centre's 'tourist' appeal to everyone else from elsewhere.

This is a response, of course, to the disintegration of the postwar 'middle class', and the ever-growing disparity in the developed nations between rich and poor. This change is quite menacing to the suburban shopping centres, however structurally complicit the companies that profit from them may have been in bringing the change about; and what's interesting is the attempt to 'manage' the change in terms of a differential thematization of 'shoppers' – and thus of the centres to serve them. Three years ago, one theorist imagined the future thus: 'Centres will be designed specifically to meet demands of the *economic* shopper, the *recreational* shopper, or the *pragmatic* shopper, and so on.' His scenario is already being realized, although once again this does not mean that as 'shoppers' we do in fact conform to, let alone become, the proffered image of our 'demands'.

That said, I want to make one more point about pedestrian leisureliness and critical time. One thing that it's important to do with particular centres is to write them a (differential) history. This can be surprisingly difficult and time-consuming. The shopping centre 'form' itself – a form often described as 'one of the few new building types created in our time' – certainly has had its histories written, mostly in heroic and expansive terms. But I've found empirically that while some local residents are able to tell stories of a particular development and its effects on their lives, the people who manage centres in Australia are often disconcerted at the suggestion that *their* centre could have a history. There are several obvious reasons for that – short-term employment patterns, employee and even managerial

indifference to the workplace, ideologies about what counts as proper history, the consecration of shopping centres to the perpetual present of consumption ('nowness'), suspicion of 'media enquiries' (that is, of me) in centres hostile to publicity they don't control, and also the feeling that in many cases, the history is best forgotten. For example, the building of Indooroopilly Shoppingtown required the blitzing of a huge chunk of old residential Indooroopilly.

But there's a parallel avoidance of local shopping-centre histories in much of the critical writing on centres – except for those which (like Southdale Mall or Faneuil Hall Marketplace in the United States, and Roselands in Australia) figure as pioneers in the history of development. Leaving aside for the moment the material produced by commercial interests (which tends to be dominated, as one might expect, by complex economic and futuristic speculation developed, in relation to particular centres, along interventionist lines), I'd argue that an odd gap usually appears between, on the one hand, critical writing where the shopping place becomes the metaphorical site for a practice of personal reminiscence (autobiography, the production of a written self), and, on the other, the purely formal description of existing structures found in architectural criticism. Walter Benjamin's *A Berlin Chronicle* (for older market forms) and Donald Horne's memoir of the site of Miranda Fair in *Money Made Us* are examples of the first practice, and the article by Neville Quarry that I've mentioned an example of the second.

The gap between these two genres (reminiscence and formal description) may in turn correspond to one produced by so-called 'Man-Environment' studies. For example, Amos Rapoport's influential book *The Meaning of the Built Environment* depends entirely on the humanist distinction between 'users' meanings' (the personal) and 'designers' meanings' (the professional). I think that a feminist study of shopping centres should *occupy* this user/designer, memory/aesthetics gap, not, of course, to 'close' or to 'bridge' it, but to dislocate the relationship between the poles that create it, and so dissolve their imaginary autonomy. Of course, any vaguely anti-humanist critique would want to say as much. What is of particular interest to me as a feminist is to make relations between on the one hand those competing practices of 'place' (which Michel de Certeau calls 'spatial stories') that by investing sites with meaning make them sites of social conflict, and on the other, women's discourses of memory and local history.

A shopping centre is a 'place' combining an extreme project of general 'planning' competence (efforts at total unification, total management) with an intense degree of aberrance and diversity in local performance. It is also a 'place' consecrated to timelessness and stasis (no clocks, perfect weather . . .) yet lived and celebrated, lived and loathed, in intimately historic terms: for some, as ruptural event (catastrophic or Edenic) in the social experience of a community, for others, as the enduring scene (as the cinema once was, and the home still may be) of all the changes, fluctuations and repetitions of the passing of everyday life. For both of these reasons, a shopping centre seems to me to be a good place to begin to consider women's 'cultural production' of modernity.

This is also why I suggested that it can be important to write a history of particular shopping centres. It is one way in which the clash of conflicting programmes for the management of change, and for resisting, refusing or evading 'management', can better be understood.

Such a history can be useful in other ways. It helps to denaturalize the myths of spectacular identity-in-place that centres produce in order to compete with each other, by analysing how these myths, those spectacles, are constructed for particular spaces over time. The qualification 'particular' is crucial, I think, because like many critics now I have my doubts that polemical demonstrations of the fact that such 'myth-making' takes place have much to offer a contemporary cultural politics. Like revelations of essentialism or, indeed, 'naturalism' in other people's arguments, simple demythologization all too often retrieves, at the end of the process, its own untransformed basic premises now masked as surprising conclusions. I also think that the project itself is anachronistic: commercial culture today proclaims and advertises, rather than 'naturalizes', its powers of artifice, myth invention, simulation. In researching the history of myth-making in a particular place, however, one is obliged to consider how it works in concrete social circumstances that inflect, in turn, its workings – and one is obliged to learn from that place, make discoveries, change the drift of one's analysis, rather than use it as a site of theoretical self-justification.

Second such a history must assume that centres and their myths are actively transformed by their 'users' (although in very ambiguous ways) and that the history itself would count as one such transformation by a user. In my study this will mean, in practice, that I'm going to analyse only shopping centres that I know personally.

I'm not going to use them to tell my life story, but I am going to refuse the discursive position of externalized visitor/observer, or ethnographer/celebrant, by setting up as my objects only those centres where I have, or have had, some practice other than that of analyst – places I've lived near or used as consumer, window-shopper, tourist, or as escapee from a passing mood (since refuge, or R&R, is one of the social functions of shopping centres, though women who just hate them may find that hard to accept). As the sociologist John Carroll reports with the cheerfulness of the true conservative, 'The Promotions Manager of one of the Shopping World chains in Australia has speculated that these centres may replace Valium.' Carroll doesn't add anything about their role in creating needs for Valium, or in selling it, but only if you combine all three functions do you get a sense, I think, of Shopping World's lived ambiguity.

And here I return to the question of 'other women' and my relation to their relation to these shopping centres. I've argued quite clearly, I hope, my objections in the present context to procedures of sampling 'representative' shoppers, framing exemplary figures, targeting empirical 'user groups', and so on. That doesn't mean that I think there's anything 'wrong' with those methods, that I wouldn't use them in another context or borrow, in this context, from studies which have used them. Nor does it mean that I think there's no way to produce knowledge of shopping centres except from 'personal experience' (which would preclude me, for example, from considering what it's like to work in one for years).

However I'm interested in something a little more fugitive – or pedestrian – than either a professionally based informatics, or a narcissistically enclosed reverie, can give me. I'm interested in impromptu shopping-centre encounters: chit-chat, with women I meet in and around and because of these centres that I know personally (ranging from close family friends at some to total strangers at others).

Collecting chit-chat in situ is, of course, a pedestrian professional practice ('journalism'). But I also want to analyse it in terms of the theoretical concerns I've outlined (rather than as 'evidence' of how others really feel) as a means of doubting and revising, rather than confirming, my own 'planning' programme.

In order to pass on to a few comments about one shopping centre 'history', I'd like first to describe the set of three to which it belongs in my project. I chose this set initially for quite personal reasons: three favourite shopping centres, one of which my family used, and two of which I had often used as a tourist; two of which I loved, and one of which I hated. But I discovered subsequently that this 'set' also conforms to a system of formal distinctions conventionally used by the people who build and manage shopping centres. These are planners' terms, 'designers' meanings' . But most of us are familiar in practice with these distinctions, and some whole cities (like Canberra) are built around them.

Until recently, there has been a more or less universally accepted classification system based on three main types of centre: the 'neighbourhood' centre, the 'community' centre, and the 'regional' centre. Some writers add extra categories, like the 'super-regional', a huge and now mostly uneconomic dinosaur (rare in Australia, but common in more populous countries) with four to six full-line department stores. With the ageing of the classic suburban form and the burgeoning of rival retail formats better adapted to current economic conditions (discount chains, hypermarkets, neo-arcades, ethnic and other 'theme' environments, history-zones, speciality malls, multi-use centres and urban megastructures), the basic schema is losing some of its reality-productive power. But it remains operative (and, in Australia, dominant) for those classic and still active structures of suburban life that I'm discussing.

The basic triad – neighbourhood/community/regional – is defined not in terms of catchment-area size, or type of public attracted, or acreage occupied. It depends instead on the type of major store that a centre offers to 'anchor' its speciality shops. (As an anchor, it is usually placed at the end of the central strip.) Neighbourhood stores have only a supermarket, while community centres have a supermarket and either a discount house or a chain store (Big W, Target). Regional centres have both of these, plus at least one full department store. The anchor store is also called the magnet: it is considered to regulate the flows of attraction, circulation and expulsion of people, commodities and cars.

For example, lndooroopilly Shoppingtown in Brisbane is a canonical example of the classical postwar regional shopping centre. It's also an aristocrat – a 'Westfield'. As Australia's leading shopping-centre developer, now achieving the ultimate goal of operating in the United States and buying into the movie business, Westfield celebrates its own norm-setting status in an art corridor at Sydney's Miranda Fair, where you can visit glorious full-colour photographs of all the other major Westfields in Australia, including Indooroopilly. Indooroopilly Shoppingtown itself is a place with a postcard – a site unto itself from which people can state their whereabouts in writing. It's an instance of the model form celebrated in the general histories I mentioned above. These are expansionist histories of postwar centrifugal movements of cars and people away from old city centres – because of urban congestion in American and Australian cases, and congestion or war damage or both in European towns and cities.

Ideally these centres, according to the histories, are so-called 'greenfield' developments on the edge of or outside towns – on that ever-receding transformation zone where the country becomes the city as suburbia. Of course, they have often in fact been the product of suburb-blitzing, not suburb-creating processes – though the blitzing of one may help to create another on the city's periphery. So strong has been the force of the centrifugal imaginary, however, that in the case of the Brisbane *Courier-Mail*'s coverage of the building of Indooroopilly Shoppingtown, the houses being moved to make way for it were represented as flying off happily like pioneers out to the far frontiers of the city. The postwar regional centre, then, is traditionally represented as the 'revolutionary', explosive suburban form.

At the opposite end of the spectrum, Fortitude Valley Plaza, again in Brisbane, is an example of a neighbourhood centre. The term 'neighbourhood' may conjure up cosy, friendly images of intimacy, but this centre is actually at a major urban transit point, over a railway station, in a high density area and on one of the most polluted roads in Australia. It's also an early example neither of greenfield nor blitzing development, but of the recently very popular practice of 'infill' (or 'twilight zone') development. 'Infill' has been filling in the central shopping districts of many country towns and old suburbs over the past few years. It means that bits of shopping centre and arcade snake around to swallow the gaps between existing structures. This practice has been important in the downtown revivals that succeeded (along with the energy crisis) the heroic age of the regional shopping centre.

Again, the *Courier-Mail*'s coverage was metaphorically apt. Because there had been an old open railway line on the site, the Valley Plaza was seen to be resourcefully filling in the 'previous useless airspace' wasted by the earlier structure. It was promoted as a thrifty, perhaps even ecologically sound, solution to a problem of resources. The Valley Plaza is also an example of a centre that has undergone an identity change. When I first studied it in 1983, it was a bit dank and dated – vintage pop futurist in style, with plenty of original but pollution-blackened 1960s orange and once-zappy geometrical trimmings. Now it's light green, and Chinatownified (with Chinese characters replacing the op-art effects), to blend in with the ethnic repackaging of Fortitude Valley as a whole.

Finally, Green Hills is an example of the mediating category, a 'community' centre in East Maitland, a town near the industrial city of Newcastle in New South Wales. It's a Woolworths centre, with a supermarket and a Big W Discount House. Unlike the other two it is a mostly open mall. It's badly signed and bordered, and in fact it's mostly hidden from view in relation to the major highway (the New England) that runs right alongside. Whatever the original considerations and/or accidents behind this design, its effect now is in fact a very appropriate paranoid country town, insiders-only identity. Like much country town cultural production, you have to know where it is to find it.

Yet it was, for many years, very successful. Generically a community centre, it has none the less had a regional function – with its Big W Discount magnet pulling in people from all over the Hunter Valley who might once have gone on through to Newcastle. People didn't just come to Maitland – they went to Green Hills. So if, in this particular triad, Indooroopilly is explosive and the Valley Plaza is thrifty in the local rhetorics of space, Green Hills was represented in terms

of a go-ahead conservatism – extending and renewing the old town of Maitland, while acting to help maintain the town's traditional economic and cultural independence.

I want to examine the representation of Green Hills in more detail, and one reason for looking at the triad of formal distinctions has been to provide a context for doing so. In the short history of Green Hills that I've been able to construct, it's clear that allusions to the other shopping-centre forms, and especially to the suburban-explosive model, played a very complex role first in Woolworths' strategic presentation of the project to build Green Hills, and second, once it was built, in the promotional rhetoric used to specify an ideal public to whom the centre would appeal (something like 'the loyal citizens' of Maitland).

In presenting a couple of elements of that history now, I must make two strong qualifications about what sort of history it is (in the context of this paper), and why. First, it is primarily derived from coverage in the local newspaper, the *Maitland Mercury*. Other sources generate other stories. This version is specifically concerned with the rhetorical collusion between the local media and the interests of Woolworths; and also with the ways that this relationship cut across two pre-existing but at this point contradictory collusions of interest between the media and the council on the one hand, and the media and local small business interests on the other. (Small business, of course, was understandably most alarmed about the prospect of the Green Hills development.) Close relations between these parties – council, media, small business – are very common in nearly all country news-papers now, which tend to define the town's interests very much in terms of the doings of civic fathers on the one hand, and those of local enterprise on the other. Sport and the cycle of family life are two major sites on which those doings are played out. In that sense, country newspapers are unashamedly one long adverto-rial. But in the building of Green Hills, civic fathers and local business were opposed in a conflict that took the form of a debate about the meaning of 'local commu-nity'. To describe this conflict briefly, I shall give it the form of an over-coherent, paranoid story.

Second, as my choice of sources suggests, this version could be criticized as lopsidedly restricted to 'designers' meanings', planners' programmes. I don't mind too much about that, for two reasons. One is that, as a long-term if irregular 'user' of Green Hills, I was more interested in pursuing what I didn't already know about it, or hadn't noticed when it was happening. This 'place' had simply appeared where once there had been a border-zone that in the 1960s had signi-fied the joys of driving out of town and the ambivalence of returning, and was, in earlier decades, the field of the illicit outside town (the forbidden picnic-ground).

The other reason is that I actually have no clear idea of what follows from the espousal of an emphasis on 'users' meanings' (or as anti-humanists might say, 'practices of consumption') – except, perhaps, for more celebrant sociology, and/or a reinvigorated local history.

Part of the problem, perhaps, is the common substitution between 'users' meanings' and 'practices of consumption'. It's an easy slide: from user to consumer to consumption, from persons to structures and processes. A whole essay could be written about what's wrong with making this and the parallel slide from notions

of individual and group 'creativity' to cultural 'production' to political 'resistance' – which can lead to the kind of criticism that a friend once parodied as 'the discovery that washing your car on Sunday is a revolutionary event'.

All I want to say here is that if the production/consumption opposition is not just a 'designer/user' relation writ large (because relations of production cannot be trivialized to 'people planning things'), then it doesn't follow that representations of a shopping-centre design project circulated by local media and consumed (creatively or otherwise) by some of its readership can be slotted away as production history. Indeed, I'm not sure that media practices can usefully be 'placed' on either 'side' of such a dichotomy. I think that the dichotomy itself needs to be re-examined, especially since it now floats free of its old anchorage in theories of social totality; and the assumption that production and consumption can be read somehow as parallel or diverging realities depends on another assumption (becoming more dubious with every chip of change in technology) that we know enough now about production and can move to the other side. As though production, somehow, stays put.

The story of Green Hills is in a way an allegory about a politics of staying put, and it begins, paranoiacally, not with the first obvious appearance of a sign staking out a site, but behind the scenes – with an article in the NSW State Planning Authority journal *SPAN* in January 1969 and a report about it published in the *Newcastle Morning Herald* (24 January 1969). The *Herald*'s story had the provocative title 'Will Maitland retain its entity or become a Newcastle suburb?'

Several general problems were facing Maitland, and many other country towns in Eastern Australia, at this time: population drift, shrinking local employment prospects, declining or anachronistic community facilities, the 'nothing to do' syndrome. Maitland also had regional problems as a former rural service centre and coalfields capital en route to becoming a dormitory suburb, menaced by residential creep towards Newcastle – then about twenty miles away and getting closer. Maitland in particular suffered as well from physical fragmentation after ruinous floods in 1949 and 1955. The 1955 flood devastated the old commercial centre and the inner residential area: houses were shifted out and away in response to a 'natural' blitzing.

So the threat of suburbanization and annexation uttered by the *Herald* produced an outraged response in that afternoon's *Maitland Mercury* from the Maitland mayor who, in spurning these 'dismal prophecies', mentioned the 'hope' that Woolworths would soon name the day for a development at East Maitland. From this moment on, and during all the conflicts that followed, Woolworths never figured in the council discourse as a national chain just setting up a store in a likely spot, but as a gallant and caring saviour come to make Maitland whole again – to stop the gap, to restore definition, to contain the creeping and seeping and to save Our Town's 'Entity'. In actual fact, of course, and following a well-known law of development, Green Hills was built on the town fringe nearest Newcastle, and the ensuing growth around it took the town kilometres closer to Newcastle and helped to fragment further the old city centre.

Four months after the *SPAN* and *Herald* incidents, the *Mercury* published a photo of an anonymous man staring at a mystery sign behind wire in the bush, saying

'This site has been selected for another all Australian development by Woolworths' (*Maitland Mercury,* 16 May 1969). The site was at that time still a ragged border wasteland, across the hill from a notorious old 'slum' called Eastville. The *Mercury* photo initiated a long-running mystery story about the conversion of the indefinite bush-border into a 'site', the site into a place, the place into a suburb, in a process of territorialization that I'll call the fabrication of a place-name.

To summarize the episodes briefly: first, the mystery sign turned out to be not just a bait to initiate interest but a legal loophole that allowed Woolworths to claim, when challenged by local business firms, that it had fulfilled the terms of a 1965 agreement to develop the site by a certain date *(Maitland Mercury,* 25 June 1969). The sign itself could count as a developmental structure, and it had appeared just in time. Second, the first sign was replaced by another: a board at first adorned only by the letter 'G'. Maitland 'citizens' were to participate in a guessing competition to find the name of the place, and a new letter was added each week until the full place-name, and the name of a lucky winner, emerged. This happened on 22 October 1969; and on the following Remembrance Day, 11 November, the city council abolished the name of the slum across the highway, Eastville. Eastville's name was to be forgotten, said the *Mercury,* in order to 'unify the area with East Maitland' ('Eastville to go west', *Maitland Mercury*, 12 November 1969).

The basic Green Hills complex – at this stage a neighbourhood centre with a supermarket only – was opened in February 1972. The ceremony included ritual displays of crowd hysteria, with frenzied women fainting and making off with five thousand pairs of 8-cent pantyhose in the first five minutes *(Maitland Mercury,* 10 February 1972). This rite of baptism, or of public consent to the place-name, was repeated even more fervently in November 1977 when the Big W Discount House was added to make Green Hills a community centre. This time, women came wearing signs of Green Hills identity: said the *Mercury,* 'A sea of green mums flooded in. . . . The mums dressed in sea green, celery green, grass green, olive green, green florals – every green imaginable – to take advantage of a 2NX offer of free dinner tickets for women dressed in that colour' *(Maitland Mercury,* 14 November 1977).

That wasn't the end of it. The process now known as 'metro-nucleation' had begun. In 1972, a company associated with Woolworths began a hundred-home subdivision behind the centre. The area then acquired more parking, a pub, a motel, light industry, an old people's home, more speciality shops at the centre itself in 1980, and then, in 1983, a community health centre. This centre, said the *Mercury* – forgetting that the forgetting of Eastville had been to unify East Maitland – would serve 'to service people living in the Berefield, Maitland, Bolwarra, East Maitland *and* Green Hills areas' *(Maitland Mercury,* 14 November 1983). Maitland's 'entity' at this stage was still a dubious mess, but Green Hills' identity was established, its status as a place-name secure. Presented rhetorically as a gesture of community unification, it had been, in effect, suburban-explosive in function.

The story continues, of course: I shan't follow it further, except to note that after this decade of expansion (a decade of acute economic distress for Maitland, and the Hunter Valley coal towns in general) Green Hills went into a certain

decline. Woolworths got into trouble nationally and their Big W discount stores failed to keep pace with newer retail styles. Green Hills in particular faced stiff competition when a few blocks of the old city centre were torn down for a Coles-Myer Super-K semi-hypermarket, and when rapid infill development brought the twilight zone to town. Even residents hostile to these changes transferred their interest to them: one said, 'It's awesome how many places they think we can use just to buy our few pounds of mince.'

I want to conclude with a few general points about things to do with this story. First, there are obviously a number of standardized elements in it that would appear in any such story set anywhere. For example, oceanic and hysterical crowd behaviour, in which the crowd itself becomes a decorative feature of the shopping centre's performance, is a traditional motif (and the *Mercury* in the late 1960s ran news features on how people behaved at shopping centres in Sydney and the United States). More generally, the process of development itself was impeccably normal.

Yet in looking at local instances of these general models, the well-known things that shopping centres do, one is also studying the practical inflections, or rewritings, of those models that can account for, and found, a regional politics. In the Green Hills case, I think that the Woolworths success story was written by the media very much in terms of a specific response to pre-existing discourses about Maitland's 'very own' problems of identity and unity. In this sense, Woolworth's 'success' was precisely to efface the similarity between what was happening in Maitland and what was going on elsewhere. That's the kind of problem I'd like to consider further: the ways in which the exploitation of the sense of 'difference' in contemporary culture can be quite as complex as, and necessarily related to, the construction and deconstruction of imaginary identities.

Second, I'd like to use the Green Hills study to question some recent accounts in cultural studies of so-called 'commodity semiosis' – the processes whereby commodities become signs, and signs become commodities – and the tendency to feminize (for example, through a theme of seduction) the terms in which that semiosis is discussed.

In an interesting critique of the work of Jean Baudrillard, Andrew Wernick writes: 'The sales aim of commodity semiosis is to differentiate the product as a valid, or at least resonant, social totem, and this would be impossible without being able to appeal to taken-for-granted systems of cultural reference' (Wernick 1987: 31).

While it is inappropriate (if consonant with marketspeak) simply to equate a whole shopping centre with 'the product' in Wernick's sense, I could say that, in the Green Hills case, Woolworths' strategy in selling the centre to the town was to appeal to that taken-for-granted cultural reference system of 'booster' discourse deployed by ideologues of Australian country towns – towns which have long been losing their old reasons for being, and so their sense of the meaning and aim of their 'history'. Donald Horne has defined the elements of 'booster' discourse in Australia as, first, getting bigger and, second, making it last – aims which we might rephrase in combination here as 'keeping it up'.

I can say practically nothing here about the inner workings of Green Hills: but one thing that a feminist critique of commodity semiosis might notice there

is that among the taken-for-granted cultural reference systems appealed to by suburban shopping centres is a garden furniture aesthetic that not only makes all centres seem the same, but, through a play of echoing spatial analogy, makes shopping centres seem like a range of other sites consecrated to the performance of family life, to women's work in leisure: shopping-town, beer garden, picnic spot, used-car yard (with bunting), scenic lookout, town garden, public park, suburban backyard.

The brightly coloured benches of Green Hills – along with coloured rubbish cones, rustic borders, foliage, planters, mulch and well-spaced saplings – are all direct descendants of what in 1960 Robin Boy called, in *The Australian Ugliness*, the 'desperately picturesque accoutrements' then just bursting out brightly as 'features' at Australian beauty-spots. There's nothing desperate about their picturesqueness now, although they may mean desperation to some of their users (as well as cheer and comfort to others, especially those who remember the unforgiving discomforts of seatless, as well as featureless, Australian country town streets). Today, I think, they work to produce a sense of 'setting' that defines an imaginary coherence of public space in Australia – or more precisely, of a 'lifestyle' space declaring the dissolution of boundaries between public and private space, between public domains of work and private spheres of leisure.

Janet Woolf has argued that the emergence of the distinction between public and private spheres in the nineteenth century made impossible a female *flâneur* – a female strolling heroine 'botanizing on the asphalt' as Walter Benjamin put it in his study of Baudelaire (Woolf 1988). I want to argue that it is precisely the proclaimed dissolution of public and private on the botanized asphalt of shopping-town today that makes possible not a *flâneuse*, since that term becomes anachronistic, but a practice of modernity by women for which it is most important not to begin by identifying heroines and victims (even of conflicts with male paranoia), but a profound ambivalence about shifting roles.

Yet here again, I want to differentiate. At places 'like' Green Hills, the given function of hallucinatory spatial resemblance and recall is not, as it might be in an urban road-romance, a thinning out of significance through space so that one place ends up like any other in its drab indifference. Nor is it, as it might be in a big city, a move in a competitive game where one space says of its nearby rivals, 'We Do All the Same Things Better'. Green Hills appeals instead to a dream of plenitude and of a paradoxically absolute yet expansive self-sufficiency: a country town (if not 'male') paranoia seeking reassurance that nothing is lacking in this one spot. It's the motherland dream of staying home, staying put: and as an uncle said to me on a stray visit to Green Hills, made simply to be sociable, waving round at the mulch and the benches and the glass façade of Big W – 'Why go elsewhere when you've got it all here?' The centre itself, in his imagination, was not a fallen land of fragmented modernity, but the Garden of Eden itself. (Two years later, however, he sent me by myself to buy him cut-price T-shirts from Super-K in town – now the place where everyone wants to shop but no one cares to visit.)

Having arrived at last at the irresistible Big W magnet, I'd like to conclude with a comment on a text which seems to me to be a 'radical' culture-criticism equivalent of the Garden of Eden fable by Myer's John Lennen with which I began.

It's a passage from Terry Eagleton's book *Walter Benjamin, or Towards a Revolutionary Criticism*; and it is also, although obliquely, a parable of modernity that depends on figuring consumption as a seductively fallen state. Paraphrasing and developing Benjamin's study of the *flâneur*, Eagleton writes:

> the commodity disports itself with all comers without its halo slipping, promises permanent possession to everyone in the market without abandoning its secretive isolation. Serializing its consumers, it nevertheless makes intimate *ad hominem* address to each.
>
> (Eagleton 1981: 27)

Now if this is not, as in Lennen's paper, a figure of Adam comforting Eve with a note on the postmodern condition, it's certainly Adam comforting himself with a certain ambivalent fantasy about Eve. It's a luscious, self-seducingly *risqué* fantasy that Adam has, a commodity thought, rather like the exquisite bottle of perfume or the pure wool jumper in the import shop, nestling deep in an upmarket neo-arcade, its ambience aglow with *Miami Vice* pastels or (since that's now been a little overdone) cooled by marbloid Italianate tiling.

But its pertinence to retailing, commodity semiosis, and shopping practices today is questionable not least because the development of forms like the neo-arcade (or the fantastically revamped prewar elegance of certain city department stores) is a response to the shopping-centre forms I've been discussing: a response which works by offering signs of old-fashioned commodity fetishism precisely because suburban shopping centres don't do so. Part of my argument has been that in suburban shopping practices it isn't necessarily or always the objects consumed that count in the act of consumption, but rather that unique sense of place. Beyond that, however, I think that the Benjamin–Eagleton style of boudoir-talk about commodities can be doubly misleading.

First, one might ask, what is the sound of an intimate *ad hominem* address from a raincoat at Big W? Where is the secretive isolation of the thongs in a pile at Super-K? The commodities in a discount house boast no halo, no aura. On the contrary, they promote a lived aesthetic of the serial, the machinic, the mass-reproduced: as one pair of thongs wears out, it is replaced by an identical pair, the same sweatshirt is bought in four different colours, or two different and two the same; a macramé planter defies all middle-class whole-earth naturalness connotations in its dyes of lurid chemical mustard and killer neon pink. Second, commodity boudoir-talk gathers up into the single and class-specific image of the elite courtesan a number of different relations women and men may invent both to actual commodities, the activity of combining them and, above all, to the changing discursive frames (like shopping centres) that invest the practices of buying, trafficking with and using commodities with their variable local meanings.

So one of the things I'd like to do with shopping centres is to make it more difficult for 'radical' culture critics to fall back quite so comfortably on the classic image of European bourgeois luxury to articulate theories of sexual and economic exchange. If I were, for the sake of argument, to make up a fable of Adam and Eve and the fall into modernity, I wouldn't have my image of Eve taking comfort from modernist explanation (as she does from Lennen's Adam), and I wouldn't

have her flattering him as she does for Eagleton's 'comers'. I'd have an image of her as a pedestrian, laughing at both of them, walking on past saying, 'Boys, you sound just like the snake.'

But of course, that's not good enough. It's the Eden story that's the problem, the fable of the management of change that's wrong – with its images of the garden, the snake, the couple, the Fall, and the terms that the story imposes, no matter how or by whom it's rewritten. To deny that shopping centres, and consumption, provide allegories of modernity as a fallen state is to claim that for feminism, some stories may be beyond salvage.

A film about these matters (and about elite courtesans) shown at the Feminist Criticism and Cultural Production Conference – *Seduction – The Cruel Woman* by Elfi Mikesch and Monika Treut – interested me in its luxuriant difference from an imaginary text I've often wanted to write about country town familial sado-masochism, called 'Maitland S&M'.

This text is about the orchestration of modes of domestic repetition, the going back again and again over the same stories, the same terrains, the same sore spots, which I think a centre like Green Hills has successfully incorporated and mobilized in its fabrication of a myth of staying put at home. In case this sounds like feminist paranoia about, once again, planners, designers and producers, I should stress that one of the things that is fascinating about Big W aesthetics is the way that the store provides little more than a set of managerial props for the perform-ance of inventive scenarios in a drama that circulates endlessly between home and the pub and the car park and Green Hills and back again to home. One can emerge for a good session of ritualized pain and sorrow (as well as, of course, more pedestrian experiences) dressed in nothing more ferocious or costly than a fluffy pink top and a sweet floral skirt.

My main point, however, is that in so far as I have myself used the story of Green Hills as an allegory, it has been to argue that while it's clearly crucial, and fun, for feminist criticism to keep on rewriting the given stories of culture, to keep on revising and transforming their meanings, we must also remember that with some stories in some places, we do become cruelly bound by repetition, confined by the reiteration of the terms we're contesting. Otherwise, in an act of voluntary if painful servitude, feminist criticism ties its own hands and finds itself, again and again, at Green Hills, bound back home – to the same old story.

Raymond Williams

ADVERTISING
The magic system

EDITOR'S INTRODUCTION

RAYMOND WILLIAMS'S ESSAY was originally written as a chapter in his 1961 book *The Long Revolution*, but was published only later and as an essay. It belongs to an older form of British-orientated cultural studies than the other essays collected here, but one that it is important not to forget.

It stands apart in two main ways: first, for Williams, cultural studies moves unproblematically back into cultural history. For him, telling the story of advertising's development allows one to grasp the forces which condition it now, and also, thus, to begin to be able to conceive of a different contemporary function for advertising. Second, Williams writes as a committed socialist; for him private-sector capitalism cannot fulfill the needs of society as a whole.

Today it is, perhaps, harder to promote state socialism than to insist that cultural studies requires historical narratives. But it is not as though these two strands of Williams's essay are quite separate. For him, the history of advertising shows a minor mode of communication becoming a major one – a vital component in the organization and reproduction of capital. In a metaphor which goes back to Marx's belief that capitalism makes commodities "fetishes," for Williams advertising is "magic" because it transforms commodities into glamorous signifiers (turning a car into a sign of masculinity, for instance) and these signifiers present an imaginary, in the sense of unreal, world. Most of all, capitalism makes us forget how much work and suffering went into the production of commodities. Williams's history aims to dis-enchant capitalism: to show us what it really is. It might be objected, of course, that advertising's magic (like many magics) actually works: that, today, the use-value of many commodities is their signifying-function.

But that objection (and others) which may occur to readers does not spoil the essay's power to defamiliarize the current advertising industry through erudite narrative history.

Further reading: Ewen 1976; Jhally 1987; Lears 1983; Marchand 1985; Pope 1977; R. Williams 1965; Williamson 1978.

History

It is customary to begin even the shortest account of the history of advertising by recalling the three-thousand-year-old papyrus from Thebes, offering a reward for a runaway slave, and to go on to such recollections as the crier in the streets of Athens, the paintings of gladiators, with sentences urging attendance at their combats, in ruined Pompeii, and the fly-bills on the pillars of the Forum in Rome. This pleasant little ritual can be quickly performed, and as quickly forgotten: it is, of course, altogether too modest. If by advertising we mean what was meant by Shakespeare and the translators of the Authorized Version – the processes of taking or giving notice of something – it is as old as human society, and some pleasant recollections from the Stone Age could be quite easily devised.

The real business of the historian of advertising is more difficult: to trace the development from processes of specific attention and information to an institutionalized system of commercial information and persuasion; to relate this to changes in society and in the economy: and to trace changes in method in the context of changing organizations and intentions.

The spreading of information, by the crier or by handwritten and printed broadsheets, is known from all periods of English society. The first signs of anything more organized come in the seventeenth century, with the development of newsbooks, mercuries and newspapers. Already certain places, such as St Paul's in London, were recognized as centres for the posting of specific bills, and the extension of such posting to the new printed publications was a natural development. The material of such advertisements ranged from offers and wants in personal service, notices of the publication of books, and details of runaway servants, apprentices, horses and dogs, to announcements of new commodities available at particular shops, enthusiastic announcements of remedies and specifics, and notices of the public showing of monsters, prodigies and freaks. While the majority were the simple, basically factual and specific notices we now call 'classified', there were also direct recommendations, as here, from 1658:

> That Excellent, and by all Physicians, approved China drink, called by the Chineans Tcha, by other nations *Tay* alias *Tee*, is sold at the Sultaness Head Cophee-House in Sweeting's Rents, by the Royal Exchange, London.

Mention of the physicians begins that process of extension from the conventional recommendations of books as 'excellent' or 'admirable' and the conventional

adjectives which soon become part of the noun, in a given context (as in my native village, every dance is a Grand Dance). The most extravagant early extensions were in the field of medicines, and it was noted in 1652, of the writers of copy in newsbooks:

> There is never a mountebank who, either by professing of chymistry or any other art drains money from the people of the nation but these arch-cheats have a share in the booty – because the fellow cannot lye sufficiently himself he gets one of these to do't for him.

Looking up, in the 1950s, from the British Dental Association's complaints of misleading television advertising of toothpastes, we can recognize the advertisement, in 1660, of a 'most Excellent and Approved DENTIFRICE', which not only makes the teeth 'white as Ivory', but

> being constantly used, the Parties using it are never troubled with the Tooth-ache. It fastens the Teeth, sweetens the Breath, and preserves the Gums and Mouth from Cankers and Imposthumes.

Moreover

> the right are onely to be had at Thomas Rookes, Stationer, at the Holy Lamb at the east end of St Paul's Church, near the School, in sealed papers at 12d the paper.

In the year of the Plague, London was full of 'SOVEREIGN Cordials against the Corruption of the Air'. These did not exactly succeed, but a long and profitable trade, and certain means of promoting it, were now firmly established.

With the major growth of newspapers, from the 1690s, the volume of advertisements notably increased. The great majority of them were still of the specific 'classified' kind, and were grouped in regular sections of the paper or magazine. Ordinary household goods were rarely advertised; people knew where to get these. But, apart from the wants and the runaways, new things, from the latest book or play to new kinds of luxury or 'cosmatick' made their way through these columns. By and large, it was still only in the pseudo-medical and toilet advertisements that persuasion methods were evident. The announcements were conventionally printed, and there was hardly any illustration. Devices of emphasis – the hand, the asterisk, the NB – can be found, and sailing announcements had small woodcuts of a ship, runaway notices similar cuts of a man looking back over his shoulder. But, in the early eighteenth century, these conventional figures became too numerous, and most newspapers banned them. The manufacturer of a 'Spring Truss' who illustrated his device, had few early imitators.

A more general tendency was noted by Johnson in 1758:

> Advertisements are now so numerous that they are very negligently perused, and it is therefore become necessary to gain attention by magnificence of promises and by eloquence sometimes sublime and

sometimes pathetick. Promise, large promise, is the soul of an adver-
tisement. I remember a washball that had a quality truly wonderful –
it gave *an exquisite edge to the razor*! The trade of advertising is now so
near to perfection that it is not easy to propose any improvement.

This is one of the earliest of 'gone about as far as they can go' conclusions on
advertisers, but Johnson, after all, was sane. Within the situation he knew, of
newspapers directed to a small public largely centred on the coffee-houses, the
natural range was from private notices (of service wanted and offered, of things
lost, found, offered and needed) through shopkeepers' information (of actual goods
in their establishments) to puffs for occasional and marginal products. In this last
kind, and within the techniques open to them, the puffmen had indeed used, inten-
sively, all the traditional forms of persuasion, and of cheating and lying. The
mountebank and the huckster had got into print, and, while the majority of adver-
tisements remained straightforward, the influence of this particular group was on
its way to giving 'advertising' a more specialized meaning.

Development

There is no doubt that the Industrial Revolution, and the associated revolution in
communications, fundamentally changed the nature of advertising. But the change
was not simple, and must be understood in specific relation to particular devel-
opments. It is not true, for example, that with the coming of factory production
large-scale advertising became economically necessary. By the 1850s, a century
after Johnson's comment, and with Britain already an industrial nation, the adver-
tising pages of the newspapers, whether *The Times* or the *News of the World*, were
still basically similar to those in eighteenth-century journals, except that there were
more of them, that they were more closely printed, and that there were certain
exclusions (lists of whores, for example, were no longer advertised in the *Morning
Post*).
 The general increase was mainly due to the general growth in trade, but was
aided by the reduction and then abolition of a long-standing Advertisement Tax.
First imposed in 1712, at one shilling an announcement, this had been a means,
with the Stamp Duty, of hampering the growth of newspapers, which successive
Governments had good reason to fear. By the time of the worst repression, after
the Napoleonic Wars, Stamp Duty was at 4*d* a sheet, and Advertisement Tax at
3*s* 6*d*. In 1833, Stamp Duty was reduced to 1*d*, and Advertisement Tax to 1*s* 6*d*.
A comparison of figures for 1830 and 1838 shows the effect of this reduction: the
number of advertisements in papers on the British mainland in the former year
was 877,972; by the later date it stood at 1,491,911. Then in 1853 the Advertise-
ment Tax was abolished, and in 1855 the Stamp Duty. The rise in the circulation
of newspapers, and in the number of advertisements, was then rapid.
 Yet, still in the 1850s advertising was mainly of a classified kind, in specified
parts of the publication. It was still widely felt, in many kinds of trade, that (as a
local newspaper summarised the argument in 1859) 'it is not *respectable*. Advertising
is resorted to for the purposes of introducing inferior articles into the market.'

Rejecting this argument, the newspaper (*The Eastbourne Gazette and Fashionable Intelligencer*) continued:

> Competition is the soul of business, and what fairer or more legitimate means of competition can be adopted than the availing oneself of a channel to recommend goods to public notice which is open to all? Advertising is an open, fair, legitimate and respectable means of competition; bearing upon its face the impress of free-trade, and of as much advantage to the consumer as the producer.

The interesting thing is not so much the nature of this argument but that, in 1859, it still had to be put in quite this way. Of course the article concluded by drawing attention to the paper's own advertising rates, but even then, to get the feel of the whole situation, we have to look at the actual advertisements flanking the article. Not only are they all from local tradesmen, but their tone is still eighteenth-century, as for example:

> To all who pay cash and can appreciate
> GOOD AND FINE TEAS
> CHARLES LEA
>
> Begs most respectfully to solicit a trial of his present stock which has been selected with the greatest care, and paid for before being cleared from the Bonded warehouses in London . . .

In all papers, this was still the usual tone, but, as in the eighteenth century, one class of product attracted different methods. Probably the first nationally advertised product was Warren's Shoe Blacking, closely followed by Rowland's Macassar Oil (which produced the counter-offensive of the antimacassar), Spencer's Chinese Liquid Hair Dye and Morison's Universal Pill. In this familiar field, as in the eighteenth century, the new advertising was effectively shaped, while for selling cheap books the practice of including puffs in announcements was widely extended. Warren's Shoe Blacking had a drawing of a cat spitting at its own reflection, and hack verses were widely used:

> The goose that on our Ock's green shore
> Thrives to the size of Albatross
> Is twice the goose it was before
> When washed with Neighbour Goodman's sauce.

Commercial purple was another writing style, especially for pills:

> The spring and fall of the leaf has been always remarked as the periods when disease, if it be lurking in the system, is sure to show itself.
>
> (Parr's Life Pills, 1843)

The manner runs back to that of the eighteenth-century hucksters and mounte-banks, but what is new is its scale. The crowned heads of Europe were being signed up for testimonials (the Tsar of all the Russias took and recommended Revalenta Arabica, while the Balm of Syriacum, a 'sovereign remedy for both bodily and mental decay', was advertised as used in Queen Victoria's household). Holloway, of course a 'Professor', spent £5,000 a year, in the 1840s, spreading his Universal Ointment, and in 1855 exceeded £30,000.

Moreover, with the newspaper public still limited, the puffmen were going on the streets. Fly-posting, on every available space, was now a large and organized trade, though made hazardous by rival gangs (paste for your own, blacking for the others). It was necessary in 1837 to pass a London act prohibit-ing posting without the owner's consent (it proved extremely difficult to enforce). In 1862 came the United Kingdom Bill-posters Association, with an organized system of special hoardings, which had become steadily more necessary as the flood of paste swelled. Handbills ('throwaways') were distributed in the streets of Victorian London with extraordinary intensity of coverage; in some areas a walk down one street would collect as many as two hundred different leaflets. Advertising vans and vehicles of all sorts, such as the seven-foot lath-and-plaster Hat in the Strand, on which Carlyle commented, crowded the streets until 1853, when they were forbidden. Hundreds of casual labourers were sent out with placards and sandwich boards, and again in 1853 had to be officially removed from pavement to gutter. Thus the streets of Victorian London bore increasingly upon their face 'the impress of free trade', yet still, with such methods largely reserved to the sellers of pills, adornments and sensational literature, the basic relation between advertising and production had only partly changed. Carlyle said of the hatter, whose 'whole industry is turned to *persuade* us that he has made' better hats, that 'the quack has become God'. But as yet, on the whole, it was only the quack.

The period between the 1850s and the end of the century saw a further expan-sion in advertising, but still mainly along the lines already established. After the 1855 abolition of Stamp Duty, the circulation of newspapers rapidly increased, and many new ones were successfully founded. But the attitude of the Press to advertising, throughout the second half of the century, remained cautious. In particular, editors were extremely resistant to any break-up in the column layout of their pages, and hence to any increase in size of display type. Advertisers tried in many ways to get round this, but with little success.

As for products mainly advertised, the way was still led by the makers of pills, soaps and similar articles. Beecham's and Pears are important by reason of their introduction of the catch-phrase on a really large scale; 'Worth a Guinea a Box' and 'Good morning! Have you used Pears' Soap?' passed into everyday language. Behind this familiar vanguard came two heavily advertised classes: the patent food, which belongs technically to this period, and which by the end of the century had made Bovril, Hovis, Nestlé, Cadbury, Fry and Kellogg into 'household names'; and new inventions of a more serious kind, such as the sewing-machine, the camera, the bicycle and the typewriter. If we add the new department stores, towards the end of the century, we have the effective range of general advertising in the period, and need only note that in method the patent foods followed the patent

medicines, while the new appliances varied between genuine information and the now familiar technique of slogan and association.

The pressure on newspapers to adapt to techniques drawn from the poster began to be successful from the 1880s. The change came first in the illustrated magazines, with a crop of purity nudes and similar figures; the Borax nude, for example, dispelling Disease and Decay; girls delighted by cigarettes or soap or shampoos. The poster industry, with its organized hoardings, was able from 1867 to use large lithographs, and Pears introduced the 'Bubbles' poster in 1887. A mail-order catalogue used the first colour advertisement, of a rug. Slowly, a familiar world was forming, and in the first years of the new century came the coloured electric sign. The newspapers, with Northcliffe's *Daily Mail* in the lead, dropped their columns rule, and allowed large type and illustrations. It was noted in 1897 that '*The Times* itself' was permitting 'advertisements in type which three years ago would have been considered fit only for the street hoardings', while the front page of the *Daily Mail* already held rows of drawings of rather bashful women in combinations. Courtesy, Service and Integrity, as part of the same process, acquired the dignity of large-type abstractions. The draper, the grocer and their suppliers had followed the quack.

Transformation

The strange fact is, looking back, that the great bulk of products of the early stages of the factory system had been sold without extensive advertising, which had grown up mainly in relation to fringe products and novelties. Such advertising as there was, of basic articles, was mainly by shopkeepers, drawing attention to the quality and competitive pricing of the goods they stocked. In this comparatively simple phase of competition, large-scale advertising and the brand-naming of goods were necessary only at the margin, or in genuinely new things. The real signs of change began to appear in the 1880s and 1890s, though they can be correctly interpreted only when seen in the light of the fully developed 'new' advertising of the period between the wars.

The formation of modern advertising has to be traced, essentially, to certain characteristics of the new 'monopoly' (corporate) capitalism, first clearly evident in this same period of the end and turn of the nineteenth century. The Great Depression which in general dominated the period from 1875 to the middle 1890s (though broken by occasional recoveries and local strengths) marked the turning point between two modes of industrial organization and two basically different approaches to distribution. After the Depression, and its big falls in prices, there was a more general and growing fear of productive capacity, a marked tendency to reorganize industrial ownership into larger units and combines, and a growing desire, by different methods, to organize and where possible control the market. Among the means of achieving the latter purposes, advertising on a new scale, and applied to an increasing range of products, took an important place.

Modern advertising, that is to say, belongs to the system of market-control which, at its full development, includes the growth of tariffs and privileged areas, cartel-quotas, trade campaigns, price-fixing by manufacturers, and that form of

economic imperialism which assured certain markets overseas by political control of their territories. There was a concerted expansion of export advertising, and at home the biggest advertising campaign yet seen accompanied the merger of several tobacco firms into the Imperial Tobacco Company, to resist American competition. In 1901, a 'fabulous sum' was offered for the entire eight pages of *The Star*, by a British tobacco advertiser, and when this was refused four pages were taken, a 'world's record', to print 'the most costly, colossal and convincing advertisement ever used in an evening newspaper the wide world o'er'. Since the American firms retaliated, with larger advertisements of their own, the campaign was both heavy and prolonged. This can be taken as the first major example of a new advertising situation.

That this period of fundamental change in the economy is the key to the emergence of full-scale modern advertising is shown also by radical changes within the organization of advertising itself. From the eighteenth century, certain shops had been recognized as collecting agencies for advertisements, on behalf of newspapers. In the nineteenth century, this system (which still holds today for some classified advertisements) was extended to the buying of space by individual agents, who then sold it to advertisers. With the growth in the volume of advertising, this kind of space-selling, and then a more developed system of space-brokerage, led to a growth of importance in the agencies, which still, however, were virtually agents of the Press, or at most intermediaries. Gradually, and with increasing emphasis from the 1880s, the agencies began to change their functions, offering advice and service to manufacturers, though still having space to sell for the newspapers. By the turn of the century, the modern system had emerged: newspapers had their own advertising managers, who advanced quite rapidly in status from junior employees to important executives, while the agencies stopped selling space, and went over to serving and advising manufacturers, and booking space after a campaign had been agreed. In 1900 the Advertisers Protection Society, later the Incorporated Society of British Advertisers, was formed: partly to defend advertising against such attacks as those of SCAPA [Society for Checking Abuses of Public Advertising – founded 1898], partly to bring pressure on newspapers to publish their sales figures, so that campaigns might be properly planned. Northcliffe, after initial hesitations about advertising (he had wanted to run *Answers* without it), came to realize its possibilities as a new basis for financing newspapers. He published his sales figures, challenged his rivals to do the same, and in effect created the modern structure of the Press as an industry, in close relation to the new advertising. In 1917 the Association of British Advertising Agents was founded, and in 1931, with the founding of the Audit Bureau of Circulations, publishing audited net sales, the basic structure was complete.

It is in this same period that we hear first, with any emphasis, of advertising as a profession, a public service and a necessary part of the economy. A further aspect of the reorganization was a more conscious and more serious attention to the 'psychology of advertising'. As it neared the centre of the economy, it began staking its claims to be not only a profession but an art and a science.

The half-century between 1880 and 1930, then, saw the full development of an organized system of commercial information and persuasion, as part of the modern distributive system in conditions of large-scale capitalism. Although

extended to new kinds of product, advertising drew, in its methods, on its own history and experience. There is an obvious continuity between the methods used to sell pills and washballs in the eighteenth century ('promise, large promise, a quality truly wonderful') and the methods used in the twentieth century to sell anything from a drink to a political party. In this sense, it is true to say that all commerce has followed the quack. But if we look at advertising before, say, 1914, its comparative crudeness is immediately evident. The 'most costly, colossal and convincing advertisement' of 1901 shows two badly drawn men in tails, clinking port glasses between announcements that the cigarettes are five a penny, and the slogan ('The Englishman's Toast – Don't be gulled by Yankee bluff, support John Bull with every puff') is in minute type by comparison with 'Most Costly' and 'Advertisement'. Play on fear of illness was of course normal, as it had been throughout quack advertising, and there were simple promises of attractiveness and reputation if particular products were used. But true 'psychological' advertising is very little in evidence before the First War, and where it is its techniques, both in appeal and in draughtsmanship and layout, are crude. Appropriately enough, perhaps, it was in the war itself, when now not a market but a nation had to be controlled and organized, yet in democratic conditions and without some of the older compulsions, that new kinds of persuasion were developed and applied. Where the badly drawn men with their port and gaspers belong to an old world, such a poster as 'Daddy, what did YOU do in the Great War?' belongs to the new. The drawing is careful and detailed: the curtains, the armchair, the grim numb face of the father, the little girl on his knee pointing to her open picture-book, the boy at his feet intent on his toy soldiers. Alongside the traditional appeals to patriotism lay this kind of entry into basic personal relationships and anxieties. Another poster managed to suggest that a man who would let down his country would also let down his sweetheart or his wife.

Slowly, after the war, advertising turned from the simple proclamation and reiteration, with simple associations, of the earlier respectable trade, and prepared to develop, for all kinds of product, the old methods of the quack and the new methods of psychological warfare. The turn was not even yet complete, but the tendencies, from the 1920s, were evident. Another method of organizing the market, through consumer credit, had to be popularized, and in the process changed from the 'never-never', which was not at all respectable, to the primly respectable 'hire-purchase' and the positively respectable 'consumer credit'. By 1933, a husband had lost his wife because he had failed to take this 'easy way' of providing a home for her. Meanwhile Body Odour, Iron Starvation, Night Starvation, Listlessness and similar disabilities menaced not only personal health but jobs, marriages and social success.

These developments, of course, produced a renewed wave of criticism of advertising, and, in particular, ridicule of its confident absurdities. In part this was met by a now standard formula: 'one still hears criticism of advertising, but it is not realized how much has been done, within the profession, to improve it' (for example, a code of ethics, in 1924, pledging the industry, inter alia 'to tell the advertising story simply and without exaggeration and to avoid even a tendency to mislead'. If advertisers write such pledges, who then writes the advertisements?). The 'super-sensitive faddists' were rediscovered, and the 'enemies of

free enterprise'. Proposals by Huxley, Russell, Leavis, Thompson and others, that children should be trained to study advertisements critically, were described, in a book called *The Ethics of Advertising*, as amounting to 'cynical manipulation of the infant mind'.

But the most significant reply to the mood of critical scepticism was in the advertisements themselves: the development of a knowing, sophisticated, humorous advertising, which acknowledged the scepticism and made claims either casual and offhand or so ludicrously exaggerated as to include the critical response (for example, the Guinness advertisements, written by Dorothy Sayers, later a critic of advertising). Thus it became possible to 'know all the arguments' against advertising, and yet accept or write pieces of charming or amusing copy.

One sustained special attack, on an obviously vulnerable point, was in the field of patent medicines. A vast amount of misleading and dangerous advertising of this kind had been repeatedly exposed, and eventually, by Acts of 1939 and 1941, and by a Code of Standards in 1950, the advertisement of cures for certain specified diseases, and a range of misleading devices, was banned. This was a considerable step forward, in a limited field, and the Advertising Association was among its sponsors. If we remember the history of advertising, and how the sellers of ordinary products learned from the quack methods that are still used in less obviously dangerous fields, the change is significant. It is like nothing so much as the newly crowned Henry V dismissing Falstaff with contempt. Advertising had come to power, at the centre of the economy, and it had to get rid of the disreputable friends of its youth: it now both wanted and needed to be respectable.

Advertising in power

Of the coming to power there was now no question. Estimates of expenditure in the interwar years vary considerably, but the lowest figure, for direct advertising in a single year, is £85,000,000 and the highest £200,000,000. Newspapers derived half their income from advertising, and almost every industry and service, outside the old professions, advertised extensively. With this kind of weight behind it, advertising was and knew itself to be a solid sector of the establishment.

Some figures from 1935 are interesting, showing advertising expenditure as a proportion of sales:

Proprietary medicines	29.4	per cent
Toilet goods	21.3	per cent
Soaps, polishes etc.	14.1	per cent
Tobacco	9.3	per cent
Petrol and oil	8.2	per cent
Cereals, jams, biscuits	5.9	per cent
Sweets	3.2	per cent
Beer	1.8	per cent
Boots and shoes	1.0	per cent
Flour	0.5	per cent

The industry's connections with its origins are evident: the three leading categories are those which pioneered advertising of the modern kind. But more significant, perhaps, is that such ordinary things as boots, shoes and flour should be in the table at all. This, indeed, is the new economy, deriving not so much from the factory system and the growth of communications, as from an advanced system of capitalist production, distribution and market control.

Alongside the development of new kinds of appeal came new media. Apart from such frills as sky-writing, there was commercial radio, not yet established in Britain (though the pressure was there) but begun elsewhere in the 1920s and beamed to Britain from the 1930s. Commercial television, in the 1950s, got through fairly easily. Among new methods, in this growth, are the product jingle, begun in commercial radio and now reaching classic status, and the open alliance between advertisers and apparently independent journalists and broadcasters. To build a reputation as an honest reporter, and then use it either openly to recommend a product or to write or speak about it alongside an advertisement for it, as in the evening-paper 'special supplements', became commonplace. And what was wrong? After all, the crowned heads of Europe, and many of our own Ladies, had been selling pills and soaps for years. The extension to political advertising, either direct or by pressure groups, also belongs, in its extensive phase, to this period of establishment; in the 1950s it has been running at a very high rate indeed.

The only check, in fact, to this rapidly expanding industry was during the last war, though this was only partial and temporary, and the years since the war, and especially the 1950s, have brought a further spectacular extension. It is ironic to look back at a book published in wartime, by one of the best writers on advertising, Denys Thompson, and read this:

> A second reason for these extensive extracts is that advertising as we know it may be dispensed with, after the war. We are getting on very well with a greatly diminished volume of commercial advertising in wartime, and it is difficult to envisage a return to the 1919–1939 conditions in which publicity proliferated.

Mr Thompson, like Dr Johnson two centuries earlier, is a sane man, but it is never safe to conclude that puffing has reached its maximum distension. The history, rightly read, points to a further major growth, and to more new methods. The highly organized field of market study, motivation research, and retained sociologists and psychologists, is extremely formidable, and no doubt has many surprises in store for us. Talent of quite new kinds is hired with increasing ease. And there is one significant development which must be noted in conclusion: the extension of organized publicity.

'Public relations'

Advertising was developed to sell goods, in a particular kind of economy. Publicity has been developed to sell persons, in a particular kind of culture. The methods are often basically similar: the arranged incident, the 'mention', the advice on

branding, packaging and a good 'selling line'. I remember being told by a man I knew at university (he had previously explained how useful, to his profession as an advertiser, had been his training in the practical criticism of advertisements) that advertisements you booked and paid for were really old stuff; the real thing was what got through as ordinary news. This seems to happen now with goods: 'product centenaries', for example. But with persons it is even more extensive. It began in entertainment, particularly with film actors, and it is still in this field that it does most of its work. It is very difficult to pin down, because the border-line between the item or photograph picked up in the ordinary course of journalism and broadcasting, and the similar item or photograph that has been arranged and paid for, either directly or through special hospitality by a publicity agent, is obviously difficult to draw. Enough stories get through, and are even boasted about, to indicate that the paid practice is extensive, though payment, except to the agent, is usually in hospitality (if that word can be used) or in kind. Certainly, readers of newspapers should be aware that the 'personality' items, presented as ordinary news stories or gossip, will often have been paid for, in one way or another, in a system that makes straightforward advertising, by comparison, look respectable. Nor is this confined to what is called 'show business'; it has certainly entered literature, and it has probably entered politics.

The extension is natural, in a society where selling, by any effective means, has become a primary ethic. The spectacular growth of advertising, and then its extension to apparently independent reporting, has behind it not a mere pressure group, as in the days of the quacks, but the whole impetus of a society. It can then be agreed that we have come a long way from the papyrus of the runaway slave and the shouts of the town-crier: that what we have to look at is an organized and extending system, at the centre of our national life.

The system

In the last hundred years, then, advertising has developed from the simple announcements of shopkeepers and the persuasive arts of a few marginal dealers into a major part of capitalist business organization. This is important enough, but the place of advertising in society goes far beyond this commercial context. It is increasingly the source of finance for a whole range of general communication, to the extent that in 1960 our majority television service and almost all our newspapers and periodicals could not exist without it. Further, in the last forty years and now at an increasing rate, it has passed the frontier of the selling of goods and services and has become involved with the teaching of social and personal values; it is also rapidly entering the world of politics. Advertising is also, in a sense, the official art of modern capitalist society: it is what 'we' put up in 'our' streets and use to fill up to half of 'our' newspapers and magazines: and it commands the services of perhaps the largest organized body of writers and artists, with their attendant managers and advisers, in the whole society. Since this is the actual social status of advertising, we shall understand it with any adequacy only if we can develop a kind of total analysis in which the economic, social and cultural facts are visibly related. We may then also find, taking advertising as a major form of

modern social communication, that we can understand our society itself in new ways.

It is often said that our society is too materialist, and that advertising reflects this. We are in the phase of a relatively rapid distribution of what are called 'consumer goods', and advertising, with its emphasis on 'bringing the good things of life', is taken as central for this reason. But it seems to me that in this respect our society is quite evidently not materialist enough, and that this, paradoxically, is the result of a failure in social meanings, values and ideals.

It is impossible to look at modern advertising without realizing that the material object being sold is never enough: this indeed is the crucial cultural quality of its modern forms. If we were sensibly materialist, in that part of our living in which we use things, we should find most advertising to be of an insane irrelevance. Beer would be enough for us, without the additional promise that in drinking it we show ourselves to be manly, young in heart or neighbourly. A washing machine would be a useful machine to wash clothes, rather than an indication that we are forward-looking or an object of envy to our neighbours. But if these associations sell beer and washing machines, as some of the evidence suggests, it is clear that we have a cultural pattern in which the objects are not enough but must be validated, if only in fantasy, by association with social and personal meanings which in a different cultural pattern might be more directly available. The short description of the pattern we have is *magic*: a highly organized and professional system of magical inducements and satisfactions, functionally very similar to magical systems in simpler societies, but rather strangely coexistent with a highly developed scientific technology.

This contradiction is of the greatest importance in any analysis of modem capitalist society. The coming of large-scale industrial production necessarily raised critical problems of social organization, which in many fields we are still only struggling to solve. In the production of goods for personal use, the critical problem posed by the factory of advanced machines was that of the organization of the market. The modern factory requires not only smooth and steady distributive channels (without which it would suffocate under its own product) but also definite indications of demand without which the expensive processes of capitalization and equipment would be too great a risk. The historical choice posed by the development of industrial production is between different forms of organization and planning in the society to which it is central. In our own century, the choice has been and remains between some form of socialism and a new form of capitalism. In Britain, since the 1890s and with rapidly continuing emphasis, we have had the new capitalism, based on a series of devices for organizing and ensuring the market. Modern advertising, taking on its distinctive features in just this economic phase, is one of the most important of these devices, and it is perfectly true to say that modern capitalism could not function without it.

Yet the essence of capitalism is that the basic means of production are not socially but privately owned, and that decisions about production are therefore in the hands of a group occupying a minority position in the society and in no direct way responsible to it. Obviously, since the capitalist wishes to be successful, he is influenced in his decisions about production by what other members of the society need. But he is influenced also by considerations of industrial convenience

and likely profit, and his decisions tend to be a balance of these varying factors. The challenge of socialism, still very powerful elsewhere but in Britain deeply confused by political immaturities and errors, is essentially that decisions about production should be in the hands of the society as a whole, in the sense that control of the means of production is made part of the general system of decision which the society as a whole creates. The conflict between capitalism and socialism is now commonly seen in terms of a competition in productive efficiency, and we need not doubt that much of our future history, on a world scale, will be determined by the results of this competition. Yet the conflict is really much deeper than this, and is also a conflict between different approaches to and forms of socialism. The fundamental choice that emerges, in the problems set to us by modern industrial production, is between man as consumer and man as user. The system of organized magic which is modern advertising is primarily important as a functional obscuring of this choice.

PART NINE

Leisure

Pierre Bourdieu

HOW CAN ONE BE A
SPORTS FAN?

EDITOR'S INTRODUCTION

THIS ESSAY HAS BEEN chosen as much as an example of Pierre Bourdieu's thought and method as for its argument concerning sport. Indeed the value of the latter is rather diminished because sport in France (Bourdieu, of course, is a French theorist) has had a different social function from that in the US, Britain or Australia. Also the essay's historical claim that "sport" emerged as a partially autonomous field when elites began to organize folk games is problematic in the British context. It underestimates the pressures for profession-alization and organization from "below" – especially with football and cricket during the nineteenth century.

Bourdieu's is an analysis heavily dependent on notions of class and class frac-tions, especially that between the dominant (economic and symbolic capital-rich) and dominated (cultural capital-rich) fractions of the middle class. He argues, for instance, that workers engage in sports which depend upon, and place at risk, sheer bodily strength whereas the middle classes value sports which develop the body and skills as ends in themselves. He has made similar arguments about class differentiations in aesthetic taste (Bourdieu 1986). Indeed such homologies of dispositions and values constitute what he calls a "habitus." For him, class frac-tions differ by the amount of economic capital, symbolic capital (i.e., prestige) and cultural capital (tastes) they inherit or are in a position to acquire. Through strategies to gain advantage or to reconcile themselves to their conditions of life, a particular lifestyle "grounded in the unity of dispositions" (i.e., habitus) emerges for each group. These strategies involve "symbolic violence" – as in struggles between fractions of the middle class over sport's value.

Bourdieu's work is having increasing influence in Anglophone cultural studies and exchanges between this rather sociologically inclined research and adherents of the "culture of difference" are of vital importance for the discipline in the near future.

Further reading: Bourdieu 1990, 1993, 1996; H. Cunningham 1980; Frow 1995; Garnham and Williams 1980; Guillory 1993; D. Robbins 1991; J. B. Thompson 1984.

I think that, without doing too much violence to reality, it is possible to consider the whole range of sporting activities and entertainments offered to social agents – rugby, football, swimming, athletics, tennis, golf etc. – as a *supply* intended to meet a *social demand*. If such a model is adopted, two sets of questions arise. First, is there an area of production, endowed with its own logic and its own history, in which 'sports products' are generated, i.e. the universe of the sporting activities and entertainments socially realized and acceptable at a given moment in time? Second, what are the social conditions of possibility of the appropriation of the various 'sports products' that are thus produced – playing golf or reading *L'Équipe*, cross-country skiing or watching the World Cup on television? In other words, how is the demand for 'sports products' produced, how do people acquire the 'taste' for sport, and for one sport rather than another, whether as an activity or as a spectacle? The question certainly has to be confronted, unless one chooses to suppose that there exists a natural need, equally widespread at all times, in all places and in all social milieux, not only for the expenditure of muscular energy but, more precisely, for this or that form of exertion. (To take the example most favourable to the 'natural need' thesis, we know that swimming, which most educators would probably point to as the most necessary sporting activity, both on account of its 'life-saving' functions and its physical effects, has at times been ignored or refused – e.g. in medieval Europe – and still has to be imposed by means of national 'campaigns'.) More precisely, according to what principles do agents choose between the different sports activities or entertainments which, at a given moment in time, are offered to them as being possible?

The production of supply

It seems to me that it is first necessary to consider the historical and social conditions of possibility of a social phenomenon which we too easily take for granted: 'modern sport'. In other words, what social conditions made possible the constitution of the system of institutions and agents directly or indirectly linked to the existence of sporting activities and entertainments? The system includes public or private 'sports associations', whose function is to represent and defend the interests of the practitioners of a given sport and to draw up and impose the standards governing that activity, the producers and vendors of goods (equipment, instruments, special clothing etc.) and services required in order to pursue the sport

(teachers, instructors, trainers, sports doctors, sports journalists etc.) and the producers and vendors of sporting entertainments and associated goods (T-shirts, photos of stars etc.). How was this body of specialists, living directly or indirectly off sport, progressively constituted (a body to which sports sociologists and historians also belong – which probably does not help the question to emerge)? And, more exactly, when did this system of agents and institutions begin to function as a *field of competition*, the site of confrontations between agents with specific interests linked to their positions within the field? If it is the case, as my questions tend to suggest, that the system of the institutions and agents whose interests are bound up with sport tends to function as a field, it follows that one cannot directly understand what sporting phenomena are at a given moment in a given social environment by relating them directly to the economic and social conditions of the corresponding societies: the history of sport is a relatively autonomous history which, even when marked by the major events of economic and social history, has its own tempo, its own evolutionary laws, its own crises, in short, its specific chronology.

One of the tasks of the social history of sport might be to lay the real foundations of the legitimacy of a social science of sport as a *distinct scientific object* (which is not at all self-evident), by establishing from what moment, or rather, from what set of social conditions, it is really possible to speak of sport (as opposed to the simple playing of games – a meaning that is still present in the English word 'sport' but not in the use made of the word in countries outside the Anglo-Saxon world where it was introduced *at the same time* as the radically new social practices which it designated). How was this terrain constituted, with its specific logic, as the site of quite specific social practices, which have defined themselves in the course of a specific history and can only be understood in terms of that history (e.g. the history of sports laws or the history of *records*, an interesting word that recalls the contribution which historians, with their task of *recording* and celebrating noteworthy exploits, make to the constitution of a field and its esoteric culture)?

The genesis of a relatively autonomous field of production and circulation of sports products

It seems to be indisputable that the shift from games to sports in the strict sense took place in the educational establishments reserved for the 'elites' of bourgeois society, the English public schools, where the sons of aristocratic or upper-bourgeois families took over a number of *popular* – i.e. *vulgar* – *games*, simultaneously changing their meaning and function in exactly the same way as the field of learned music transformed the folk dances – bourrées, sarabands, gavottes etc. – which it introduced into high-art forms such as the suite.

To characterize this transformation briefly, i.e., as regards its *principle*, we can say that the bodily exercises of the 'elite' are disconnected from the ordinary social occasions with which folk games remained associated (agrarian feasts, for example) and divested of the social (and, *a fortiori*, religious) functions still attached to a number of traditional games (such as the ritual games played in a number of pre-capitalist societies at certain turning-points in the farming year). The school, the site of *skhole*, leisure, is the place where practices endowed with social functions and integrated into the collective calendar are converted into *bodily exercises*,

activities which are an end in themselves, a sort of physical art for art's sake, governed by specific rules, increasingly irreducible to any functional necessity, and inserted into a specific calendar. The school is the site, *par excellence*, of what are called gratuitous exercises, where one acquires a distant, neutralizing disposition towards language and the social world, the very same one which is implied in the bourgeois relation to art, language and the body: gymnastics makes a use of the body which, like the scholastic use of language, is an end in itself. (This no doubt explains why sporting activity, whose frequency rises very markedly with educational level, declines more slowly with age, as do cultural practices, when educational level is higher. It is known that among the working classes, the abandonment of sport, an activity whose playlike character seems to make it particularly appropriate to adolescence, often coincides with marriage and entry into the serious responsibilities of adulthood.) What is acquired in and through experience of school, a sort of retreat from the world and from real practice, of which the great boarding schools of the 'elite' represent the fully developed form, is the propensity towards activity for no purpose, a fundamental aspect of the ethos of bourgeois 'elites', who always pride themselves on disinterestedness and define themselves by an elective distance – manifested in art and sport – from material interests. 'Fair play' is the way of playing the game characteristic of those who do not get so carried away by the game as to forget that it *is* a game, those who maintain the 'rôle distance', as Goffman puts it, that is implied in all the rôles designated for the future leaders.

The autonomization of the field of sport is also accompanied by a process of *rationalization* intended, as Weber expresses it, to ensure predictability and calculability, beyond local differences and particularisms: the constitution of a corpus of specific rules and of specialized governing bodies recruited, initially at least, from the 'old boys' of the public schools, come hand in hand. The need for a body of fixed, universally applicable rules makes itself felt as soon as sporting 'exchanges' are established between different educational institutions, then between regions etc. The relative autonomy of the field of sport is most clearly affirmed in the powers of self-administration and rule-making, based on a historical tradition or guaranteed by the state, which sports associations are acknowledged to exercise: these bodies are invested with the right to lay down the standards governing participation in the events which they organize, and they are entitled to exercise a disciplinary power (banning, fines etc.) in order to ensure observance of the specific rules which they decree. In addition, they award specific titles, such as championship titles and also, as in England, the status of trainer.

The constitution of a field of sports practices is linked to the development of a philosophy of sport which is necessarily a *political* philosophy of sport. The theory of amateurism is in fact one dimension of an aristocratic philosophy of sport as a disinterested practice, a finality without an end, analogous to artistic practice, but even more suitable than art (there is always something residually feminine about art: consider the piano and watercolours of genteel young ladies in the same period) for affirming the manly virtues of future leaders: sport is conceived as a training in courage and manliness, 'forming the character' and inculcating the 'will to win' which is the mark of the true leader, but a will to win within the rules. This is 'fair play', conceived as an aristocratic disposition utterly opposed to the plebeian

pursuit of victory at all costs. What is at stake, it seems to me, in this debate (which goes far beyond sport), is a definition of bourgeois education which contrasts with the petty-bourgeois and academic definition: it is 'energy', 'courage', 'willpower', the virtues of leaders (military or industrial), and perhaps above all personal initiative, (private) 'enterprise', as opposed to knowledge, erudition, 'scholastic' submissiveness, symbolized in the great lycée-barracks and its disciplines etc. In short, it would be a mistake to forget that the modern definition of sport is an integral part of a 'moral ideal', i.e. an ethos which is that of the dominant fractions of the dominant class and is brought to fruition in the major private schools intended primarily for the sons of the heads of private industry, such as the École des Roches, the paradigmatic realization of this ideal. To value *education* over *instruction*, *character* or *willpower* over *intelligence*, *sport* over *culture*, is to affirm, within the educational universe itself, the existence of a hierarchy irreducible to the strictly scholastic hierarchy which favours the second term in those oppositions. It means, as it were, disqualifying or discrediting the values recognized by other fractions of the dominant class or by other classes (especially the intellectual fractions of the petty bourgeoisie and the 'sons of schoolteachers', who are serious challengers to the sons of the bourgeoisie on the terrain of purely scholastic competence); it means putting forward other criteria of 'achievement' and other principles for legitimating achievement as alternatives to 'academic achievement'. Glorification of sport as the training-ground of character, etc., always implies a certain anti-intellectualism. When one remembers that the dominant fractions of the dominant class always tend to conceive their relation to the dominated fraction – 'intellectuals', 'artists', 'professors' – in terms of the opposition between the male and the female, the virile and the effeminate, which is given different contents depending on the period (e.g. nowadays short hair/long hair; 'economico-political' culture/'artistico-literary' culture etc.), one understands one of the most important implications of the exaltation of sport and especially of 'manly' sports like rugby, and it can be seen that sport, like any other practice, is an object of struggles between the fractions of the dominant class and also between the social classes.

At this point I shall take the opportunity to emphasize, in passing, that the *social definition of sport* is an object of struggles, that the field of sporting practices is the site of struggles in which what is at stake, *inter alia*, is the monopolistic capacity to impose the legitimate definition of sporting practice and of the legitimate function of sporting activity – amateurism versus professionalism, participant sport versus spectator sport, distinctive (elite) sport versus popular (mass) sport; that this field is itself part of the larger field of struggles over the definition of the *legitimate body* and the *legitimate use of the body*, struggles which, in addition to the agents engaged in the struggle over the definition of sporting uses of the body, also involve moralists and especially the clergy, doctors (especially health specialists), educators in the broadest sense (marriage guidance counsellors etc.), pacemakers in matters of fashion and taste (couturiers etc.). One would have to explore whether the struggles for the monopolistic power to impose the legitimate definition of a particular *class* of body uses, sporting uses, present any *invariant* features. I am thinking, for example, of the opposition, from the point of view of the definition of legitimate exercise, between the professionals in physical

education (gymnasiarchs, gymnastics teachers etc.) and doctors, i.e., between two forms of specific *authority* ('pedagogic' versus 'scientific'), linked to two sorts of *specific capital*; or the recurrent opposition between two antagonistic philosophies of the use of the body, a more ascetic one (*askesis* = training) which, in the paradoxical expression *culture physique* ('physical culture') emphasizes culture, *antiphysis*, the counter-natural, straightening, rectitude, effort, and another, more hedonistic one which privileges nature, *physis*, reducing culture to the body, physical culture to a sort of '*laisser-faire*', or return to '*laisser-faire*' – as *expression corporelle* ('physical expression' – 'anti-gymnastics') does nowadays, teaching its devotees to unlearn the superfluous disciplines and restraints imposed, among other things, by ordinary gymnastics.

Since the relative autonomy of the field of bodily practices entails, by definition, a relative dependence, the development within the field of practices oriented towards one or the other pole, asceticism or hedonism, depends to a large extent on the state of the power relations within the field of struggles for monopolistic definition of the legitimate body and, more broadly, in the field of struggles between fractions of the dominant class and between the social classes over morality. Thus the progress made by everything that is referred to as 'physical expression' can only be understood in relation to the progress, seen for example in parent–child relations and more generally in all that pertains to pedagogy, of a new variant of bourgeois morality, preached by certain rising fractions of the bourgeoisie (and petty bourgeoisie) and favouring liberalism in child-rearing and also in hierarchical relations and sexuality, in place of ascetic severity (denounced as 'repressive').

The popularization phase

It was necessary to sketch in this first phase, which seems to me a determinant one, because, in states of the field that are none the less quite different, sport still bears the marks of its origins. Not only does the aristocratic ideology of sport as disinterested, gratuitous activity, which lives on in the ritual themes of celebratory discourse, help to mask the true nature of an increasing proportion of sporting practices, but the practice of sports such as tennis, riding, sailing or golf doubtless owes part of its 'interest', just as much nowadays as at the beginning, to its distinguishing function and, more precisely, to the *gains in distinction* which it brings (it is no accident that the majority of the most select, i.e., selective, clubs are organized around sporting activities which serve as a focus or pretext for elective gatherings). We may even consider that the distinctive gains are increased when the distinction between noble – distinguished and distinctive – practices, such as the 'smart' sports, and the 'vulgar' practices which popularization has made of a number of sports originally reserved for the 'elite', such as football (and to a lesser extent rugby, which will perhaps retain for some time to come a dual status and a dual social recruitment), is combined with the yet sharper opposition between participation in sport and the mere consumption of sporting entertainments. We know that the probability of practising a sport beyond adolescence (and *a fortiori* beyond early manhood or in old age) declines markedly as one moves down the social hierarchy (as does the probability of belonging to a sports club), whereas the probability of watching one of the reputedly most popular sporting spectacles,

such as football or rugby, on television (stadium attendance as a spectator obeys more complex laws) declines markedly as one rises in the social hierarchy.

Thus, without forgetting the importance of taking part in sport – particularly team sports like football – for working-class and lower middle-class adolescents, it cannot be ignored that the so-called popular sports, cycling, football or rugby, *also* function as spectacles (which may owe part of their interest to imaginary participation based on past experience of real practice). They are 'popular' but in the sense this adjective takes on whenever it is applied to the material or cultural products of mass production, cars, furniture or songs. In brief, sport, born of truly popular games, i.e., games produced by the people, returns to the people, like 'folk music', in the form of spectacles produced for the people. We may consider that sport as a spectacle would appear more clearly as a mass commodity, and the organization of sporting entertainments as one branch among others of show business (there is a difference of degree rather than kind between the spectacle of professional boxing, or Holiday on Ice shows, and a number of sporting events that are perceived as legitimate, such as the various European football championships or ski competitions), if the value collectively bestowed on practising sports (especially now that sports contests have become a measure of relative national strength and hence a political objective) did not help to mask the divorce between practice and consumption and consequently the functions of simple passive consumption.

It might be wondered, in passing, whether some recent developments in sporting practices are not in part an effect of the evolution which I have too rapidly sketched. One only has to think, for example, of all that is implied in the fact that a sport like rugby (in France – but the same is true of American football in the US) has become, through television, a mass spectacle, transmitted far beyond the circle of present or past 'practitioners', i.e., to a public very imperfectly equipped with the specific competence needed to decipher it adequately. The 'connoisseur' has schemes of perception and appreciation which enable him to see what the layman cannot see, to perceive a necessity where the outsider sees only violence and confusion, and so to find in the promptness of a movement, in the unforeseeable inevitability of a successful combination or the near-miraculous orchestration of a team strategy, a pleasure no less intense and learned than the pleasure a music-lover derives from a particularly successful rendering of a favourite work. The more superficial the perception, the less it finds its pleasure in the spectacle contemplated in itself and for itself, and the more it is drawn to the search for the 'sensational', the cult of obvious feats and visible virtuosity and, above all, the more exclusively it is concerned with that other dimension of the sporting spectacle, suspense and anxiety as to the result, thereby encouraging players and especially organizers to aim for victory at all costs. In other words, everything seems to suggest that, in sport as in music, extension of the public beyond the circle of amateurs helps to reinforce the reign of the pure professionals.

In fact, before taking further the analysis of the effects, we must try to analyse more closely the determinants of the shift whereby sport as an elite practice reserved for amateurs became sport as a spectacle produced by professionals for consumption by the masses. It is not sufficient to invoke the relatively autonomous logic of the field of production of sporting goods and services or, more precisely, the

development, within this field, of a sporting entertainments industry which, subject to the laws of profitability, aims to maximize its efficiency while minimizing its risks. (This leads, in particular, to the need for specialized executive personnel and scientific management techniques that can rationally organize the training and upkeep of the physical capital of the professional players: one thinks, for example, of American football, in which the squad of trainers, doctors and public-relations staff is more numerous than the team of players, and which almost always serves as a publicity medium for the sports equipment and accessories industry.)

In reality, the development of sporting activity itself, even among working-class youngsters, doubtless results partly from the fact that sport was predisposed to fulfil, on a much larger scale, the very same functions which underlay its *invention* in the late nineteenth-century English public schools. Even before they saw sport as a means of 'improving character' in accordance with the Victorian belief, the public schools, 'total institutions' in Goffman's sense, which have to carry out their supervisory task twenty-four hours a day, seven days a week, saw sport as 'a means of filling in time', an economical way of occupying the adolescents who were their full-time responsibility. When the pupils are on the sports field, they are easy to supervise, they are engaged in healthy activity and they are venting their violence on each other rather than destroying the buildings or shouting down their teachers; that is why, Ian Weiberg concludes, 'organized sport will last as long as the public schools'. So it would not be possible to understand the popularization of sport and the growth of sports associations, which, originally organized on a *voluntary* basis, progressively received recognition and aid from the public authorities, if we did not realize that this *extremely economical* means of mobilizing, occupying and controlling adolescents was predisposed to become an instrument and an objective in struggles between all the institutions totally or partly organized with a view to the mobilization and symbolic conquest of the masses and therefore competing for the symbolic conquest of youth. These include political parties, unions, and churches, of course, but also paternalistic bosses, who, with the aim of ensuring *complete and continuous containment* of the working population, provided their employees not only with hospitals and schools but also with stadiums and other sports facilities (a number of sports clubs were founded with the help and under the control of private employers, as is still attested today by the number of stadiums named after employers). We are familiar with the competition which has never ceased to be fought out in the various political arenas over questions of sport from the level of the village (with the rivalry between secular or religious clubs, or more recently, the debates over the priority to be given to sports facilities, which is one of the issues at stake in political struggles on a municipal scale) to the level of the nation as a whole (with, for example, the opposition between the Fédération du Sport de France, controlled by the Catholic Church, and the Fédération Sportive et Gymnique du Travail controlled by the left-wing parties). And indeed, in an increasingly disguised way as state recognition and subsidies increase, and with them the apparent neutrality of sports organizations and their officials, sport is an object of political struggle. This competition is one of the most important factors in the development of a social, i.e., socially constituted, need for sporting practices and for all the accompanying equipment, instruments, personnel and services. Thus the imposition of sporting needs

is most evident in rural areas where the appearance of facilities and teams, as with youth clubs and senior citizens' clubs nowadays, is almost always the result of the work of the village petty bourgeoisie or bourgeoisie, which finds here an opportunity to impose its political services of organization and leadership and to accumulate or maintain a political capital of renown and honourability which is always potentially reconvertible into political power.

It goes without saying that the popularization of sport, down from the elite schools (where its place is now contested by the 'intellectual' pursuits imposed by the demands of intensified social competition) to the mass sporting associations, is necessarily accompanied by a change in the functions which the sportsmen and their organizers assign to this practice, and also by a transformation of the very logic of sporting practices which corresponds to the transformation of the expectations and demands of the public in correlation with the increasing autonomy of the spectacle *vis-à-vis* past or present practice. The exaltation of 'manliness' and the cult of 'team spirit' that are associated with playing rugby – not to mention the aristocratic ideal of 'fair play' – have a very different meaning and function for bourgeois or aristocratic adolescents in English public schools and for the sons of peasants or shopkeepers in south-west France. This is simply because, for example, a sporting career, which is practically excluded from the field of acceptable trajectories for a child of the bourgeoisie – setting aside tennis or golf – represents one of the few paths of upward mobility open to the children of the dominated classes; the sports market is to the boys' physical capital what the system of beauty prizes and the occupations to which they lead – hostess, etc. – is to the girls' physical capital; and the working-class cult of sportsmen of working-class origin is doubtless explained in part by the fact that these 'success stories' symbolize the only recognized route to wealth and fame. Everything suggests that the 'interests' and values which practitioners from the working and lower-middle classes bring into the conduct of sports are in harmony with the corresponding requirements of *professionalization* (which can, of course, coexist with the appearances of amateurism) and of the rationalization of preparation for and performance of the sporting exercise that are imposed by the pursuit of maximum specific efficiency (measured in 'wins', 'titles', or 'records') combined with the minimization of risks (which we have seen is itself linked to the development of a private or state sports entertainments industry).

The logic of demand: sporting practices and entertainments in the unity of lifestyles

We have here a case of a supply, i.e., the particular definition of sporting practice and entertainment that is put forward at a given moment in time, meeting a demand, i.e., the expectations, interests and values that agents bring into the field, with the actual practices and entertainments evolving as a result of the permanent confrontation and adjustment between the two. Of course, at every moment new entrants must take account of a determinate state of the division of sporting activities and entertainments and their distribution among the social classes, a state which they cannot alter and which is the result of the whole previous history of

the struggles and competition among the agents and institutions engaged in the 'sporting field'. For example, the appearance of a new sport or a new way of practising an already established sport (e.g. the 'invention' of the crawl by Trudgen in 1893) causes a restructuring of the space of sporting practices and a more or less complete redefinition of the meaning attached to the various practices. But while it is true that, here as elsewhere, the field of production helps to produce the need for its own products, none the less the logic whereby agents incline towards this or that sporting practice cannot be understood unless their disposi- tions towards sport, which are themselves one dimension of a *particular relation to the body*, are reinserted into the unity of the system of dispositions, the habitus, which is the basis from which lifestyles are generated. One would be likely to make serious mistakes if one attempted to study sporting practices (more so, perhaps, than with any other practices, since their basis and object is the body, the synthesizing agent *par excellence*, which integrates everything that it incorpo- rates), without re-placing them in the universe of practices that are bound up with them because their common origin is the system of tastes and preferences that is a class habitus (for example, it would be easy to demonstrate the homologies between the relation to the body and the relation to language that are character- istic of a class or class fraction). Insofar as the 'body-for-others' is the visible manifestation of the person, of the 'idea it wants to give of itself', its 'character', i.e., its values and capacities, the sports practices which have the aim of shaping the body are realizations, among others, of an aesthetic and an ethic in the prac- tical state. A postural norm such as uprightness ('stand up straight') has, like a direct gaze or a close haircut, the function of symbolizing a whole set of moral 'virtues' – rectitude, straightforwardness, dignity (face-to-face confrontation as a demand for respect) – and also physical ones – vigour, strength, health.

An explanatory model capable of accounting for the distribution of sporting practices among the classes and class fractions must clearly take account of the positive or negative determining factors, the most important of which are *spare time* (a transformed form of economic capital), *economic capital* (more or less indis- pensable depending on the sport), and *cultural capital* (again, more or less necessary depending on the sport). But such a model would fail to grasp what is most essen- tial if it did not take account of the variations in the meaning and function given to the various practices by the various classes and class fractions. In other words, faced with the distribution of the various sporting practices by social class, one must give as much thought to the variations in the meaning and function of the different sports among the social classes as to the variations in the intensity of the statis- tical relationship between the different practices and the different social classes.

It would not be difficult to show that the different social classes do not agree as to the effects expected from bodily exercise, whether on the outside of the body (bodily hexis), such as the visible strength of prominent muscles which some prefer or the elegance, ease and beauty favoured by others, or inside the body, health, mental equilibrium etc. In other words, the class variations in these prac- tices derive not only from the variations in the factors which make it possible or impossible to meet their *economic or cultural costs* but also from the *variations in the perception and appreciation of the immediate or deferred profits* accruing from the different sporting practices. (It can be seen, incidentally, that specialists are able to make

use of the specific authority conferred by their status to put forward a perception and appreciation defined as the only legitimate ones, in opposition to the perceptions and appreciations structured by the dispositions of a class habitus. I am thinking of the national campaigns to impose a sport like swimming, which seems to be unanimously approved by the specialists in the name of its strictly 'technical' functions, on those who 'can't see the use of it'.) As regards the profits actually perceived, Jacques Defrance convincingly shows that gymnastics may be asked to produce either a strong body, bearing the outward signs of strength – this is the working-class demand, which is satisfied by body-building – or a healthy body – this is the bourgeois demand, which is satisfied by gymnastics or other sports whose function is essentially hygienic.

But this is not all: class habitus defines the meaning conferred on sporting activity, the profits expected from it; and not the least of these profits is the social value accruing from the pursuit of certain sports by virtue of the distinctive rarity they derive from their class distribution. In short, to the 'intrinsic' profits (real or imaginary, it makes little difference – real in the sense of being really anticipated, in the mode of belief) which are expected from sport for the body itself, one must add the social profits, those accruing from any distinctive practice, which are very unequally perceived and appreciated by the different classes (for whom they are, of course, very unequally accessible). It can be seen, for example, that in addition to its strictly health-giving functions, golf, like caviar, *foie gras* or whisky, has a *distributional significance* (the meaning which practices derive from their distribution among agents distributed in social classes), or that weight-lifting, which is supposed to develop the muscles, was for many years, especially in France, the favourite working-class sport; nor is it an accident that the Olympic authorities took so long to grant official recognition to weight-lifting, which, in the eyes of the aristocratic founders of modern sport, symbolized mere strength, brutality and intellectual poverty, in short the working classes.

We can now try to account for the distribution of these practices among the classes and class fractions. The probability of practising the different sports depends, to a different degree for each sport, primarily on economic capital and secondarily on cultural capital and spare time; it also depends on the affinity between the ethical and aesthetic dispositions characteristic of each class or class fraction and the objective potentialities of ethical or aesthetic accomplishment which are or seem to be contained in each sport. The relationship between the different sports and age is more complex, since it is only defined – through the intensity of the physical effort required and the disposition towards that effort which is an aspect of class ethos – within the relationship between a sport and a class. The most important property of the 'popular sports' is the fact that they are tacitly associated with youth, which is spontaneously and implicitly credited with a sort of *provisional licence* expressed, among other ways, in the squandering of an excess of physical (and sexual) energy, and are abandoned very early (usually at the moment of entry into adult life, marked by marriage). By contrast, the 'bourgeois' sports, mainly practised for their functions of physical maintenance and for the social profit they bring, have in common the fact that their age-limit lies far beyond youth and perhaps comes correspondingly later the more prestigious and exclusive they are

(e.g. golf). This means that the probability of practising those sports which, because they demand only 'physical' qualities and bodily competences for which the conditions of early apprenticeship seem to be fairly equally distributed, are doubtless equally accessible within the limits of the spare time and, secondarily, the physical energy available, would undoubtedly increase as one goes up the social hierarchy, if the concern for distinction and the absence of ethico-aesthetic affinity or 'taste' for them did not turn away members of the dominant class, in accordance with a logic also observed in other fields (photography, for example). Thus, most of the team sports – basketball, handball, rugby, football – which are most common among office workers, technicians and shopkeepers, and also no doubt the most typically working-class individual sports, such as boxing or wrestling, combine all the reasons to repel the upper classes. These include the social composition of their public which reinforces the vulgarity implied by their popularization, the values and virtues demanded (strength, endurance, the propensity to violence, the spirit of 'sacrifice', docility and submission to collective discipline, the absolute antithesis of the 'rôle distance' implied in bourgeois rôles etc.), the exaltation of competition and the contest, etc. To understand how the most distinctive sports, such as golf, riding, skiing or tennis, or even some less recherché ones, like gymnastics or mountaineering, are distributed among the social classes and especially among the fractions of the dominant class, it is even more difficult to appeal solely to variations in economic and cultural capital or in spare time. This is first because it would be to forget that, no less than the economic obstacles, it is the hidden entry requirements, such as family tradition and early training, and also the obligatory clothing, bearing and techniques of sociability which keep these sports closed to the working classes and to individuals rising from the lower-middle and even upper-middle classes; and second because economic constraints define the field of possibilities and impossibilities without determining within it an agent's positive orientation towards this or that particular form of practice. In reality even apart from any search for distinction, it is the relation to one's own body, a fundamental aspect of the habitus, which distinguishes the working classes from the privileged classes, just as, within the latter, it distinguishes fractions that are separated by the whole universe of a lifestyle. On one side, there is the *instrumental* relation to the body which the working classes express in all the practices centred on the body, whether in dieting or beauty care, relation to illness or medication, and which is also manifested in the choice of sports requiring a considerable investment of effort, sometimes of pain and suffering (e.g. boxing) and sometimes a *gambling with the body itself* (as in motorcycling, parachute-jumping, all forms of acrobatics, and, to some extent, all sports involving fighting, among which we may include rugby). On the other side, there is the tendency of the privileged classes to treat the body as an *end in itself*, with variants according to whether the emphasis is placed on the intrinsic functioning of the body as an organism, which leads to the macrobiotic cult of health, or on the appearance of the body as a perceptible configuration, the 'physique', i.e., the body-for-others. Everything seems to suggest that the concern to cultivate the body appears, in its most elementary form, i.e., as the cult of health, often implying an ascetic exaltation of sobriety and dietetic rigour, among the lower-middle classes, i.e., among junior executives, clerical workers in the medical

services and especially primary-school teachers, who indulge particularly inten-
sively in gymnastics, the ascetic sport *par excellence* since it amounts to a sort of
training (*askesis*) for training's sake.

Gymnastics or strictly health-oriented sports like walking or jogging, which,
unlike ball games, do not offer any competitive satisfaction, are highly rational and
rationalized activities. This is first because they presuppose a resolute faith in
reason and in the deferred and often intangible benefits which reason promises
(such as protection against ageing, an abstract and negative advantage which exists
only by reference to a thoroughly theoretical referent); second, because they
generally only have meaning by reference to a thoroughly theoretical, abstract
knowledge of the effects of an exercise which is itself often reduced, as in gymnas-
tics, to a series of abstract movements, decomposed and reorganized by reference
to a specific and technically defined end (e.g., 'the abdominals') and is opposed
to the total movements of everyday situations, oriented towards practical goals,
just as marching, broken down into elementary movements in the sergeant-major's
handbook, is opposed to ordinary walking. Thus it is understandable that these
activities can only be rooted in the ascetic dispositions of upwardly mobile indi-
viduals who are prepared to find their satisfaction in effort itself and to accept –
such is the whole meaning of their existence – the deferred satisfactions which
will reward their present sacrifice.

In sports like mountaineering (or, to a lesser extent, walking), which are most
common among secondary or university teachers, the purely health-oriented func-
tion of maintaining the body is combined with all the symbolic gratifications
associated with practising a highly distinctive activity. This gives to the highest
degree the sense of mastery of one's own body as well as the free and exclusive
appropriation of scenery inaccessible to the vulgar. In fact, the health-giving func-
tions are always more or less strongly associated with what might be called aesthetic
functions (especially, other things being equal, in women, who are more imper-
atively required to submit to the norms defining what the body ought to be, not
only in its perceptible configuration but also in its motion, its gait etc.). It is doubt-
less among the professions and the well-established business bourgeoisie that the
health-giving and aesthetic functions are combined with social functions; there,
sports take their place, along with parlour games and social exchanges (receptions,
dinners etc.), among the 'gratuitous' and 'disinterested' activities which enable the
accumulation of social capital. This is seen in the fact that, in the extreme form
it assumes in golf, shooting, and polo in smart clubs, sporting activity is a mere
pretext for select encounters or, to put it another way, a technique of sociability,
like bridge or dancing. Indeed, quite apart from its socializing functions, dancing
is, of all the social uses of the body, the one which, treating the body as a sign,
a sign of one's own ease, i.e., one's own mastery, represents the most accom-
plished realization of the bourgeois uses of the body: if this way of comporting
the body is most successfully affirmed in dancing, this is perhaps because it is
recognizable above all by its *tempo*, i.e., by the measured, self-assured slowness
which also characterizes the bourgeois use of language, in contrast to working-
class abruptness and petty-bourgeois eagerness.

Notes

1 A slightly longer version of this article first appeared in *Social Science Information* 17(6) (1978): 819–40.

2 This article is a translation of a paper given at the International Congress of the History of Sports and Physical Education Association, held in March 1978 at the Institut National des Sports et de l'Education Physique, Paris. The original title was 'Pratiques sportives et pratiques sociales'. The translation is by Richard Nice.

Dick Hebdige

THE FUNCTION OF SUBCULTURE

EDITOR'S INTRODUCTION

N O CULTURAL STUDIES BOOK has been more widely read than Dick
Hebdige's 1979 *Subculture: The Meaning of Style*, from which this essay is
taken. It brought a unique and supple blend of Althusser, Gramsci and semiotics
(as propounded by Barthes and the "Prague School") to bear on the world of, or
at any rate near to, the young British academics and students who first became
immersed in cultural studies. That was the world of "subcultures" more visible in
Britain than anywhere else: teds, skinheads, punks, Bowie-ites, hippies, dreads . . .

For Hebdige two Gramscian terms are especially useful in analyzing sub-
cultures: conjuncture and specificity. Subcultures form in communal and symbolic
engagements with the larger system of late industrial culture; they're organized
around, but not wholly determined by, age and class, and are expressed in the
creation of styles. These styles are produced within specific historical and cultural
"conjunctures;" they are not to be read as simply resisting hegemony or as magical
resolutions to social tensions – as earlier theorists had supposed. Rather subcul-
tures cobble together (or hybridize) styles out of the images and material culture
available to them in the effort to construct identities which will confer on them
"relative autonomy" within a social order fractured by class, generational differ-
ences, work etc.

In his later work, Hebdige (1988) was to rework his method, admitting that
he had underestimated the power of commercial culture to appropriate, and indeed,
to produce, counter-hegemonic styles. Punk, in particular, was a unique mixture
of an avant-garde cultural strategy, marketing savvy and working-class transgres-
sion produced in the face of a section of British youth's restricted access to
consumer markets. The line between subculture as resistance and commercial

culture as both provider of pleasures and an instrument of hegemony is in fact very hard to draw – especially when youth markets are in question.

It would be particularly interesting to apply Hebdige's methods to 1990s subcultures – the Goths and racist skinheads and, most of all, those groups where fanship, niche marketing and subcultures fuse (like Trekkies, football fans and ravers). And: do fans of high culture now make up a subculture?

Further reading: Clarke *et al.* 1976; Cohen 1980; Gelder and Thornton 1997; Hebdige 1979, 1988; Lipsitz 1990; McRobbie and Nava 1984; Redhead 1990, 1993, 1997b; Ross and Rose 1994.

The subcultures introduced in the previous sections [of Hebdige's book *Subculture: The Meaning of Style*] have been described as a series of mediated responses to the presence in Britain of a sizeable black community. The proximity of the two positions – white working-class youth and Negro – invites identification and even when this identity is repressed or openly resisted, black cultural forms (e.g., music) continue to exercise a major determining influence over the development of each subcultural style. It is now time to explore the relationship between these spectacular subcultures and those other groups (parents, teachers, police, 'respectable' youth etc.) and cultures (adult working-class and middle-class cultures) against which they are ostensibly defined. Most writers still tend to attribute an inordinate significance to the opposition between young and old, child and parent, citing the rites of passage which, even in the most primitive societies, are used to mark the transition from childhood to maturity. What is missing from these accounts is any idea of historical specificity, any explanation of why these particular forms should occur at this particular time.

It has become something of a cliché to talk of the period after the Second World War as one of enormous upheaval in which the traditional patterns of life in Britain were swept aside to be replaced by a new, and superficially less class-ridden system. Sociologists have dwelt in particular upon the disintegration of the working-class community and have demonstrated how the demolition of the traditional environment of back-to-backs and corner shops merely signified deeper and more intangible changes.

None the less, despite the confident assurances of both Labour and Conservative politicians that Britain was now entering a new age of unlimited affluence and equal opportunity, that we had 'never had it so good', class refused to disappear. The ways in which class was *lived*, however – the forms in which the experience of class found expression in culture – did change dramatically. The advent of the mass media, changes in the constitution of the family, in the organization of school and work, shifts in the relative status of work and leisure, all served to fragment and polarize the working-class community, producing a series of marginal discourses within the broad confines of class experience.

The development of youth culture should be seen as just part of this process of polarization. Specifically, we can cite the relative increase in the spending power of working-class youth, the creation of a market designed to absorb the

resulting surplus, and changes in the education system consequent upon the 1944 Butler Act as factors contributing to the emergence after the War of a generational consciousness amongst the young. This consciousness was still rooted in a generalized experience of class, but it was expressed in ways which were different from, and in some cases openly antithetical to, the traditional forms.

The persistence of class as a meaningful category within youth culture was not, however, generally acknowledged until fairly recently and, as we shall see, the seemingly spontaneous eruption of spectacular youth styles has encouraged some writers to talk of youth as the new class – to see in youth a community of undifferentiated Teenage Consumers. It was not until the 1960s that the myth of a classless youth culture was seriously challenged. This challenge is best understood in the context of the larger debate about the function of subculture which has, for many years, preoccupied those sociologists who specialize in deviancy theory. It would seem appropriate to include here a brief survey of some of the approaches to youth and subculture put forward in the course of that debate.

The study of subculture in Britain grew out of a tradition of urban ethnography which can be traced back at least as far as the nineteenth century: to the work of Henry Mayhew and Thomas Archer, and to the novels of Charles Dickens and Arthur Morrison. However, a more 'scientific' approach to subculture complete with its own methodology (participant observation) did not emerge until the 1920s when a group of sociologists and criminologists in Chicago began collecting evidence on juvenile street gangs and deviant groups (professional criminals, bootleggers etc.). In 1927, Frederick Thrasher produced a survey of over a thousand street gangs, and later William Foote Whyte described at length in *Street Corner Society* the rituals, routines and occasional exploits of one particular gang.

Participant observation continues to produce some of the most interesting and evocative accounts of subculture, but the method also suffers from a number of significant flaws. In particular, the absence of any analytical or explanatory framework has guaranteed such work a marginal status in the predominantly positivist tradition of mainstream sociology. More crucially, such an absence has ensured that while accounts based upon a participant observation approach provide a wealth of descriptive detail, the significance of class and power relations is consistently neglected or at least underestimated. In such accounts, the subculture tends to be presented as an independent organism functioning outside the larger social, political and economic contexts. As a result, the picture of subculture is often incomplete. For all the Chandleresque qualities of the prose; for all the authenticity and close detail which participant observation made possible, it soon became apparent that the method needed to be supplemented by other more analytical procedures.

During the 1950s, Albert Cohen and Walter Miller sought to supply the missing theoretical perspective by tracing the continuities and breaks between dominant and subordinate value systems. Cohen stressed the compensatory function of the juvenile gang: working-class adolescents who under-achieved at school joined gangs in their leisure time in order to develop alternative sources of self-esteem. In the gang, the core values of the straight world – sobriety, ambition, conformity etc. – were replaced by their opposites: hedonism, defiance of authority and the quest for 'kicks'. Miller, too, concentrated on the value system of the juvenile gang, but he underlined the similarities between gang and parent culture, arguing that

many of the values of the deviant group merely reiterated in a distorted or heightened form the 'focal concerns' of the adult working-class population. In 1961, Matza and Sykes used the notion of subterranean values to explain the existence of legitimate as well as delinquent youth cultures. Like Miller, the writers recognized that potentially subversive goals and aims were present in systems which were otherwise regarded as perfectly respectable. They found embedded in youth culture those subterranean values (the search for risk, excitement etc.) which served to underpin rather than undermine the day-time ethos of production (postponement of gratification, routine etc.).

Subsequently, these theories were tested in the course of British field work. In the 1960s, Peter Willmott published his research into the range of cultural options open to working-class boys in the East End of London. Contrary to the breezy assertions of writers like Mark Abrams, Willmott concluded that the idea of a completely classless youth culture was premature and meaningless. He observed instead that the leisure styles available to youth were inflected through the contradictions and divisions intrinsic to a class society. It was left to Phil Cohen to explore in detail the ways in which class-specific experience was encoded in leisure styles which after all had largely originated in London's East End. Cohen was also interested in the links between youth and parent cultures, and interpreted the various youth styles as sectional adaptations to changes which had disrupted the *whole* East End community. He defined subculture as a 'compromise solution between two contradictory needs: the need to create and express autonomy and difference from parents . . . and the need to maintain the parental identifications' (Cohen 1980). In this analysis, the mod, ted and skinhead styles were interpreted as attempts to mediate between experience and tradition, the familiar and the novel. And for Cohen, the 'latent function' of subculture was to 'express and resolve, albeit magically, the contradictions which remain hidden or unresolved in the parent culture' (Cohen 1980). The mods, for instance,

> attempted to realise, but in an imaginary relation, the condition of existence of the socially mobile white-collar worker . . . [while] . . . their argot and ritual forms . . . [continued to stress] . . . many of the traditional values of the parent culture.
>
> (Cohen 1980)

Here at last was a reading which took into account the full interplay of ideological, economic and cultural factors which bear upon subculture. By grounding his theory in ethnographic detail, Cohen was able to insert class into his analysis at a far more sophisticated level than had previously been possible. Rather than presenting class as an abstract set of external determinations, he showed it working out in practice as a material force, dressed up, as it were, in experience and exhibited in style. The raw material of history could be seen refracted, held and 'handled' in the line of a mod's jacket, in the soles on a teddy boy's shoes. Anxieties concerning class and sexuality, the tensions between conformity and deviance, family and school, work and leisure, were all frozen there in a form which was at once visible and opaque, and Cohen provided a way of reconstructing that history; of penetrating the skin of style and drawing out its hidden meanings.

Cohen's work still furnishes the most adequate model available for a reading of subcultural style. However, in order to underline the importance and meaning of class, he had been forced to lay perhaps too much emphasis on the links between the youth and adult working-class cultures. There are equally significant differences between the two forms which must also be acknowledged. As we have seen, a generational consciousness *did* emerge amongst the young in the postwar period, and even where experience was shared between parents and children this experience was likely to be differently interpreted, expressed and handled by the two groups. Thus, while obviously there are points where parent and adolescent 'solutions' converge and even overlap, when dealing with the spectacular subculture we should not grant these an absolute ascendancy. And we should be careful when attempting to tie back subcultural style to its generative context not to overstress the fit between respectable working-class culture and the altogether more marginal forms with which we are concerned here.

For example, the skinheads undoubtedly reasserted those values associated with the traditional working-class community, but they did so *in the face of* the widespread renunciation of those values in the parent culture – *at a time when* such an affirmation of the classic concerns of working-class life was considered inappropriate. Similarly, the mods were negotiating changes and contradictions which were simultaneously affecting the parent culture but they were doing so in the terms of their own relatively autonomous problematic – by inventing an 'elsewhere' (the weekend, the West End) which was defined *against* the familiar locales of the home, the pub, the working man's club, the neighbourhood.

If we emphasize integration and coherence at the expense of dissonance and discontinuity, we are in danger of denying the very manner in which the subcultural form is made to crystallize, objectify and communicate group experience. We should be hard pressed to find in the punk subculture, for instance, any symbolic attempts to 'retrieve some of the socially cohesive elements destroyed in the parent culture' (Cohen 1980) beyond the simple fact of cohesion itself: the expression of a highly structured, visible, tightly bounded group identity. Rather, the punks seemed to be parodying the alienation and emptiness which have caused sociologists so much concern, realizing in a deliberate and wilful fashion the direst predictions of the most scathing social critics, and celebrating in mock-heroic terms the death of the community and the collapse of traditional forms of meaning.

We can, therefore, grant only a qualified acceptance to Cohen's theory of subcultural style. Later, I shall be attempting to rethink the relationship between parent and youth cultures by looking more closely at the whole process of signification in subculture. At this stage, however, we should not allow these objections to detract from the overall importance of Cohen's contribution. It is no exaggeration to say that the idea of style as a coded response to changes affecting the entire community has literally transformed the study of spectacular youth culture. Much of the research extracted in *Resistance Through Rituals* was premised upon the basic assumption that style could be read in this way. Using Gramsci's concept of hegemony, the authors interpreted the succession of youth cultural styles as symbolic forms of resistance; as spectacular symptoms of a wider and more generally submerged dissent which characterized the whole post-war period. This reading of style opens up a number of issues which demand examination, and the approach

to subculture adopted in *Resistance Through Rituals* provides the basis for much of what follows. We begin with the notion of specificity.

Specificity: Two types of teddy boy

If we take as our starting point the definition of culture used in *Resistance Through Rituals* – culture is 'that level at which social groups develop distinct patterns of life and give *expressive form* to their social and material . . . experience', we can see that each subculture represents a different handling of the 'raw material of social . . . existence' (Hall and Jefferson 1976). But what exactly is this 'raw material'? We learn from Marx that 'Men make their own history, but they do not make it just as they please, they do not make it under circumstances chosen by themselves, but under circumstances directly encountered, given and trans- mitted from the past'. In effect, the material (i.e., social relations) which is continually being transformed into culture (and hence subculture) can never be completely 'raw'. It is always mediated: inflected by the historical context in which it is encountered; posited upon a specific ideological field which gives it a partic- ular life and particular meanings. Unless one is prepared to use some essentialist paradigm of the working class as the inexorable bearers of an absolute trans- historical Truth, then one should not expect the subcultural response to be either unfailingly correct about real relations under capitalism, or even *necessarily* in touch, in any immediate sense, with its material position in the capitalist system. Spectacular subcultures express what is by definition an imaginary set of relations. The raw material out of which they are constructed is both real and ideological. It is mediated to the individual members of a subculture through a variety of chan- nels: school, the family, work, the media etc. Moreover, this material is subject to historical change. Each subcultural 'instance' represents a 'solution' to a specific set of circumstances, to particular problems and contradictions. For example, the mod and teddy boy 'solutions' were produced in response to different conjunc- tures which positioned them differently in relation to existing cultural formations (immigrant cultures, the parent culture, other subcultures, the dominant culture). We can see this more clearly if we concentrate on one example.

There were two major moments in the history of the teddy boy subculture (the 1950s and the 1970s). But, whilst they maintained the same antagonistic rela- tion to the black immigrant community as their counterparts of the 1950s, the latter-day teds were differently positioned in relation to the parent culture and other youth cultures.

The early 1950s and late 1970s share certain obvious features: the vocabu- laries of 'austerity' and 'crisis', though not identical, are similar, and more importantly, anxieties about the effects of black immigration on employment, housing and the 'quality of life' were prominent in both periods. However, the differences are far more crucial. The presence in the latter period of an alterna- tive, predominantly working-class youth culture (i.e., the punks), many of whose members actively championed certain aspects of West Indian life, serve clearly to distinguish the two moments. The early teds had marked a new departure. They had represented, in the words of George Melly, 'the dark van of pop culture' and,

though few in number, they had been almost universally vilified by press and parents alike as symptomatic of Britain's impending decline. On the other hand, the very concept of 'revival' in the 1970s gave the teddy boys an air of legitimacy. After all, in a society which seemed to generate a bewildering number of fads and fashions, the teddy boys were a virtual institution: an authentic, albeit dubious part of the British heritage.

The youths who took part in this revival were thus guaranteed in certain quarters at least a limited acceptability. They could be regarded with tolerance, even muted affection, by those working-class adults who, whether original teds or straights, nostalgically inclined towards the 1950s and, possessed of patchy memories, harked back to a more settled and straightforward past. The revival recalled a time which seemed surprisingly remote, and by comparison secure; almost idyllic in its stolid puritanism, its sense of values, its conviction that the future could be better. Freed from time and context, these latter-day teds could be allowed to float as innocent pretenders on the wave of 1970s nostalgia situated somewhere between the Fonz of television's *Happy Days* and a recycled Ovaltine ad. Paradoxically then, the subculture which had originally furnished such dramatic signs of change could be made to provide a kind of continuity in its revived form.

In broader terms, the two teddy boy solutions were responses to specific historical conditions, formulated in completely different ideological atmospheres. There was no possibility in the late 1970s of enlisting working-class support around the cheery imperatives of reconstruction: 'grin and bear it', 'wait and see' etc. The widespread disillusionment amongst working-class people with the Labour Party and Parliamentary politics in general, the decline of the Welfare State, the faltering economy, the continuing scarcity of jobs and adequate housing, the loss of community, the failure of consumerism to satisfy real needs, and the perennial round of industrial disputes, shutdowns and picket line clashes, all served to create a sense of diminishing returns which stood in stark contrast to the embattled optimism of the earlier period. Assisted no doubt by the ideological constructions retrospectively placed upon the Second World War (the fostering around 1973 as a response to protracted industrial disputes, the oil crisis, the three-day week etc. of a patriotic wartime spirit in search of an enemy; the replacement of the concretization 'German' for the concept 'fascist') these developments further combined with the visibility of the black communities to make racism a far more respectable and credible solution to the problems of working-class life.

In addition, the teddy boys' dress and demeanour carried rather different connotations in the 1970s. Of course the 'theft' of an upper-class style which had originally made the whole teddy boy style possible had long been forgotten, and in the process the precise nature of the transformation had been irrevocably lost. What is more the strutting manner and sexual aggressiveness had different meanings in the two periods. The narcissism of the early teds and the carnal gymnastics of jiving had been pitted against what Melly describes as a 'grey colourless world where good boys played ping pong'. The second-generation teds' obstinate fidelity to the traditional 'bad-guy' stereotypes appeared by contrast obvious and reactionary. To the sound of records long since deleted, in clothes which qualified as virtual museum pieces, these latter-day teds resurrected a set of sexual mores

(gallantry, courtship) and a swaggering machismo – that 'quaint' combination of chauvinism, Brylcreem and sudden violence – which was already enshrined in the parent culture as *the* model of masculine behaviour: a model untouched by the febrile excesses of the post-war 'permissive society'.

All these factors drew the teddy boy subculture in its second incarnation *closer* to the parent culture and helped to define it against other existing youth cultural options (punks, Northern soul enthusiasts, heavy metal rockers, football fans, mainstream pop, 'respectable' etc.). For these reasons, wearing a drape coat in 1978 did not mean the same things in the same way as it had done in 1956, despite the fact that the two sets of teddy boys worshipped identical heroes (Elvis, Eddie Cochran, James Dean), cultivated the same quiffs and occupied approximately the same class position. The twin concepts of *conjuncture* and *specificity* (each subculture representing a distinctive 'moment' – a particular response to a particular set of circumstances) are therefore indispensable to a study of subcultural style.

The sources of style

We have seen how the experience encoded in subcultures is shaped in a variety of locales (work, home, school etc.). Each of these locales imposes its own unique structure, its own rules and meanings, its own hierarchy of values. Though these structures articulate together, they do so syntactically. They are bound together as much through difference (home versus school, school versus work, home versus work, private versus public etc.) as through similarity. To use Althusser's admittedly cumbersome terms, they constitute different levels of the same social formation. And though they are, as Althusser takes pains to point out, 'relatively autonomous', these structures remain, in capitalist societies, articulated around the 'general contradiction' between Capital and Labour. The complex interplay between the different levels of the social formation is reproduced in the experience of both dominant and subordinate groups, and this experience, in turn, becomes the 'raw material' which finds expressive form in culture and subculture. Now, the media play a crucial role in defining our experience for us. They provide us with the most available categories for classifying out the social world. It is primarily through the press, television, film etc. that experience is organized, interpreted and made to *cohere in contradiction* as it were. It should hardly surprise us then, to discover that much of what finds itself encoded in subculture has already been subjected to a certain amount of prior handling by the media.

Thus, in postwar Britain, the loaded content of subcultural style is likely to be as much a function of what Stuart Hall has called the 'ideological effect' of the media as a reaction to experienced changes in the institutional framework of working-class life. As Hall has argued, the media have 'progressively colonised the cultural and ideological sphere':

> As social groups and classes live, if not in their productive then in their 'social' relations, increasingly fragmented and sectionally differentiated lives, the mass media are more and more responsible (a) for providing the basis on which groups and classes construct an image of the lives,

meanings, practices and values of *other* groups and classes; (b) for providing the images, representations and ideas around which the social totality composed of all these separate and fragmented pieces can be coherently grasped.

(Hall 1977)

So a credible image of social cohesion can be maintained only through the appropriation and redefinition of cultures of resistance (e.g., working-class youth cultures) in terms of that image. In this way, the media not only provide groups with substantive images of other groups, they also relay back to working-class people a 'picture' of their own lives which is 'contained' or 'framed' by the ideological discourses which surround and situate it.

Clearly, subcultures are not privileged forms; they do not stand outside the reflexive circuitry of production and reproduction which links together, at least on a symbolic level, the separate and fragmented pieces of the social totality. Subcultures are, at least in part, representations of these representations, and elements taken from the 'picture' of working-class life (and of the social whole in general) are bound to find some echo in the signifying practices of the various subcultures. There is no reason to suppose that subcultures spontaneously affirm only those *blocked* 'readings' excluded from the airwaves and the newspapers (consciousness of subordinate status, a conflict model of society etc.). They also articulate, to a greater or lesser extent, some of the *preferred* meanings and interpretations, those favoured by and transmitted through the authorized channels of mass communication. The typical members of a working-class youth culture in part contest and in part agree with the dominant definitions of who and what they are, and there is a substantial amount of shared ideological ground not only between them and the adult working-class culture (with its muted tradition of resistance) but also between them and the dominant culture (at least in its more 'democratic', accessible forms).

For example, the elaboration of upward and downward options open to working-class youth does not necessarily indicate any significant difference in the relative status of the jobs available to the average mod of 1964 and the skinhead of 1968 (though a census might indeed reveal such a difference). Still less does it reflect *directly* the fact that job opportunities open to working-class youth in general actually diminished during the intervening period. Rather the different styles and the ideologies which structure and determine them represent negotiated responses to a contradictory mythology of class. In this mythology, 'the withering away of class' is paradoxically countered by an undiluted 'classfulness', a romantic conception of the traditional whole way of (working-class) life revived twice weekly on television programmes like *Coronation Street*. The mods and skinheads, then, in their different ways, were 'handling' this mythology as much as the exigencies of their material condition. They were learning to live within or without that amorphous body of images and typifications made available in the mass media in which class is alternately overlooked and overstated, denied and reduced to caricature.

In the same way, the punks were not only directly *responding* to increasing joblessness, changing moral standards, the rediscovery of poverty, the Depression etc., they were *dramatizing* what had come to be called 'Britain's decline' by

constructing a language which was, in contrast to the prevailing rhetoric of the Rock Establishment, unmistakably relevant and down to earth (hence the swearing, the references to 'fat hippies', the rags, the lumpen poses). The punks appropriated the rhetoric of crisis which had filled the airwaves and the editorials throughout the period and translated it into tangible (and visible) terms. In the gloomy, apocalyptic ambience of the late 1970s – with massive unemployment, with the ominous violence of the Notting Hill Carnival, Grunwick, Lewisham and Ladywood – it was fitting that the punks should present themselves as 'degenerates'; as signs of the highly publicized decay which perfectly represented the atrophied condition of Great Britain. The various stylistic ensembles adopted by the punks were undoubtedly expressive of genuine aggression, frustration and anxiety. But these statements, no matter how strangely constructed, were cast in a language which was generally available – a language which was current. This accounts, first, for the appropriateness of the punk metaphor for both the members of the subculture and its opponents and, second, for the success of the punk subculture as spectacle: its ability to symptomatize a whole cluster of contemporary problems. It explains the subculture's ability to attract new members and to produce the requisite outraged responses from the parents, teachers and employers towards whom the moral panic was directed and from the 'moral entrepreneurs' – the local councillors, the pundits and MPs – who were responsible for conducting the 'crusade' against it. In order to communicate disorder, the appropriate language must first be selected, even if it is to be subverted. For punk to be dismissed as chaos, it had first to 'make sense' as noise.

We can now begin to understand how the Bowie cult came to be articulated around questions of gender rather than class, and to confront those critics who relate the legitimate concerns of 'authentic' working-class culture exclusively to the sphere of production. The Bowie-ites were certainly not grappling in any *direct* way with the familiar set of problems encountered on the shop floor and in the classroom: problems which revolve around relations with authority (rebellion versus deference, upward versus downward options etc.). None the less, they were attempting to negotiate a meaningful intermediate space somewhere between the parent culture and the dominant ideology: a space where an alternative identity could be discovered and expressed. To this extent they were engaged in that distinctive quest for a measure of autonomy which characterizes all youth sub- (and counter) cultures. In sharp contrast to their skinhead predecessors, the Bowie-ites were confronting the more obvious chauvinisms (sexual, class, territorial) and seeking, with greater or lesser enthusiasm, to avoid, subvert or overthrow them. They were simultaneously, first, challenging the traditional working-class puritanism so firmly embedded in the parent culture; second, resisting the way in which this puritanism was being made to signify the working class in the media; and, third, adapting images, styles and ideologies made available elsewhere on television and in films (e.g., the nostalgia cult of the early 1970s), in magazines and newspapers (high fashion, the emergence of feminism in its commodity form, e.g., *Cosmopolitan*) in order to construct an alternative identity which communicated a perceived difference: an Otherness. They were, in short, challenging at a symbolic level the 'inevitability', the 'naturalness' of class and gender stereotypes.

Will Straw

CHARACTERIZING ROCK MUSIC CULTURE
The case of heavy metal

EDITOR'S INTRODUCTION

O N T H E F A C E O F I T, Will Straw's article, originally written about heavy metal in the 1970s and updated by the author for this collection, takes a sociological rather than a cultural studies approach. He does not write as a fan; he does not suppose that listening to heavy metal possesses any counter-hegemonic force; he is not concerned with it as a life-practice. But his point is that, despite appearances to the contrary, heavy metal is not a subculture. It is a musical genre which develops at the intersection between a particular moment in the music industry (the development of an "oligopoly") and a kind of social space (suburbanism).

In his essay, Straw is more interested in the music industry and its reception than in living in the suburbs, and his essay is particularly insightful on the effects of oligopoly on the industry. (In 1998, there are fewer major record companies globally than there were in the 1980s: large independents like Arista, Geffen, Island, and Virgin have all been swallowed up since.) He is especially concerned to argue that the usual Adorno-esque thesis that cultural-industry centralization leads to standardization of product does not work for heavy metal, largely because metal involves "craft-production" techniques.

He goes on to show how the ways in which it is possible to be a metal fan are organized from other areas in the cultural industry – in particular, an imagery which dissociates masculinity from being good at archival learning. This matters to metal, because it means that to be a metal fan doesn't require a sense of the history of rock and roll like the more marginal genres of punk, grunge, and thrash do. This makes it more available to those who live far from the centers of avant-garde rock action.

Further reading: Becker 1978; Born 1987; Chambers 1985; Frith 1996; Frith and Goodwin 1990; Ross and Rose 1994.

The decomposition of psychedelic music, in the late 1960s, followed three principal directions. The first of these, in the United States, involved a return to traditional, largely rural musical styles, with the emergence of country rock, of which the stylistic changes in the careers of the Byrds (in 1968) and the Grateful Dead (in 1970) offer examples. In Britain, a second tendency took the form of a very eclectic reinscription of traditional and symphonic musical forms within an electric or electronic rock context, with groups such as King Crimson, Jethro Tull, Genesis, Yes, and Emerson, Lake and Palmer. The third trend, which may be found in both American and British rock music of this period, was towards the heavy metal sound, frequently based in the chord structures of boogie blues, but retaining from psychedelia an emphasis on technological effect and instrumental virtuosity. In groups on the periphery of psychedelia – such as Blue Cheer, the Yardbirds, Iron Butterfly – many of the stylistic traits that would become dominant within heavy metal were already in evidence: the cult of the lead guitarist, the 'power trio' and other indices of the emphasis on virtuosity, the 'supergroup' phenomenon, and the importance in performance of extended solo playing and a disregard for the temporal limits of the pop song. Their coherence into a genre was reinforced, through the 1970s, by the sedimentation of other stylistic attributes (those associated with stage shows, album-cover design, and audience dress and lifestyle) and by the relatively stable sites of institutional support (radio formats, touring circuits, record industry structures).

Institutions and industries in the early 1970s

Heavy metal music came to prominence at a time when institutions associated with the psychedelic period were either disappearing or being assimilated within larger structures as part of widespread changes within the music-related industries. The overriding tendency in these changes was the diminishing role of local entrepreneurs in the processes by which music was developed and disseminated. The end of the 1960s meant the end of free-form radio, a large number of independent record labels, the ballroom performance circuit, and the underground press, all of which had contributed, at least initially, to the high degree of regionalization within psychedelia and associated rock movements.

For many record company analysts, the number of hit-making independent record labels is an index of the degree of 'turbulence' within the industry. The modern history of the American recording industry has thus been divided into three epochs: one running from 1940 to 1958, marked by concentration and integration within and between the electronics, recording, and publishing industries; the 1959 to 1969 period, characterized by the 'turbulence' associated with the introduction on a large scale of rock music; and, finally, the period that began in 1970, and that saw the return of oligopoly to the extent that, in 1979, the six largest corporations accounted for 86 per cent of *Billboard*'s total 'chart action'.

Two other statistics are worth noting: by the late 1960s, the album has displaced the single as the dominant format in record sales, and during the 1970s, in large part as a result of the overhead costs associated with oligopoly, the break-even point for album sales went from 20,000 to nearly 100,000 copies.

While the oligopolization of the American record industry in the 1970s is undeniable, this did not result in the industry becoming more conservative or its products more standardized. Writers such as Paul Hirsch have argued that the 'centralization' of decision making in the industries producing cultural 'texts' is rarely like that found in other businesses and that entertainment industries more closely resemble the house construction industry, with its organization of production along craft lines. Within the record industry, horizontal integration has frequently meant assimilating smaller, specialized labels within conglomerates (through purchases or licensing–distribution agreements), such that those involved in the selection and production of music stay in place. The record industry in the 1970s thus relied far more on outside, contracted producers or production companies than it did in the old days of the salaried artist and repertoire director.

The defining characteristic of much rock music production in the early 1970s was, further, its domination by rock elites, by people already established in creative capacities within the industry. The supergroup phenomenon of this period is symptomatic of this, as is the fact that most of the leading heavy metal bands (such as Humble Pie) were formed by remnants of groups popular in the 1960s. And many of the country-rock groups and singer-songwriters who achieved high market penetration in the early 1970s had in one capacity or another long been record company employees (for instance Leon Russell, Carole King, and the members of the Eagles).

The implications of this for the American record industry during these years are not obvious. The reliance on industry elites is indicative of industry conservatism insofar as it displaced 'street-level' talent-hunting and might be seen as a resistance to innovation. However it meant neglect too of the process whereby musicians with local followings and local entrepreneurial support established themselves regionally and proved their financial viability by recording first for minor labels. The majors were now signing acts without this form of market testing (a contributing factor in the increasingly high ratio of unprofitable to profitable records), and the selection and development of talent, the initiation of new styles, was increasingly the responsibility of the established creative personnel. Recording contracts in this period of growth gave artists unprecedented control over the choice of producers and material.

'Centralization' in this context meant, therefore, a *loosening* of divisions of labour. It is clear, for example, that many of those formerly involved in support capacities (songwriters, session musicians etc.) achieved star status because of the ease with which they could move between divisions or combine the production, composing, and performing functions (just as members of groups now took it for granted that they could record solo albums). A loosening of roles, and the continuing prosperity of performers and the industry as a whole, also encouraged international record production, with, as one of its effects, the free movement of session personnel (and their musical concerns) between Great Britain and North America (Joe Cocker's *Mad Dogs and Englishmen* album and film remains a useful

document of this). While the bases for comparison are limited, the American record industry in the 1970s was not unlike the American film industry following the anti-trust decisions of the 1940s, which divorced the production and distribution companies from those involved in exhibition: in both cases, one finds a high reliance on licensing agreements between major companies and smaller production outfits; in both cases, there is a fluidity of movement between roles and a tendency (for financial – often tax-related – reasons) for stars to build corporate entities around themselves and work in a variety of international locales. Much of the rock literature of the mid- to late 1970s, describing industry growth in terms of the co-optation and destruction of the energies unleashed in the 1960s, regards this as exemplifying a process inevitable within mass culture, but it can be argued that the changes are better understood as the triumph of craft-production structures. In this regard, the punk critique of early 1970s rock – which focused on its excesses and its eclecticism, on its 'empty' virtuosity and self-indulgence rather than on an assumed standardization – was a necessary counterweight to the recuperation argument.

The changes that occurred in the programming policies of FM radio stations in the United States and Canada between the late 1960s and mid-1970s are well documented elsewhere, as is the decline of the local underground press. In both cases, rising overhead costs and an increased reliance on large advertising accounts (with record companies the prominent spenders) grew out of and furthered the desire – or need – for market expansion. Either way, both radio stations and magazines paid less attention to marginal or regional musical phenomena. The rise of overhead costs and group performance fees were, similarly, the major factor in the replacement of the mid-sized performance circuit by the large arena or stadium, a process that continued throughout the 1970s, until the emergence of punk and new wave re-established the viability of certain types of small venues.

These developments certainly did lead to standardization on FM radio and in the rock press. Radio playlist consultants, automated stations, and satellite-based networks all became significant elements in the evolution of FM radio throughout the 1970s, and the development of the rock press from local, subculturally based publications to national magazines is evident in the history of *Rolling Stone*, one of the few rock papers to survive. It would be wrong, though, to see these developments as local examples of the general 'standardizing' trend. Radio playlist consultants became important because of the eclecticism and sheer bulk of record company product – individual station directors simply didn't have the time or skill to listen to and choose from all this product. At the same time the increasing rigidity of formats was an effect of demographic research into the expansion of the rock audience beyond its traditional youth boundaries – the recession of the 1970s called for a more accurate targeting of listening groups. It was because such targeting remained a minor aspect of record company strategy (except in the most general sense) that it became crucial in shaping the formats of radio stations and magazines, media commercially dependent on the delivery of audiences to advertisers.

Heavy metal audiences and the institutions of rock

On one level, Led Zeppelin represents the final flowering of the sixties'
psychedelic ethic, which casts rock as passive sensory involvement.

Jim Miller

In discussing heavy metal music, and its relationship to rock culture in a wider
sense, I am assuming a relative stability of musical style and of institutional struc-
tures from 1969–70 until 1974–6. (Near the end of this period, dance-oriented
music began to achieve popularity with segments of the white audiences, with a
variety of effects on the sites within which music was disseminated, while the
gradual acceptance, in the United States and Canada, of British symphonic or
progressive rock resulted in a generic cross-fertilization that eroded the stylistic
coherence of heavy metal.)

The processes described earlier as leading to the renewed importance of
the *national* rock audience also worked to constitute it as a 'mass' audience as the
media disseminating music or information about it (radio and the press) now relied
on national formats rather than on their ties to local communities. These devel-
opments made more important an audience segment that had been somewhat
disenfranchised by movements within rock in the late 1960s – suburban youth. In
the 1970s, it was they who were the principal heavy metal constituency.

In stressing the geographical situation of heavy metal audiences rather than
their regional, ethnic, racial, or class basis, I am conscious that the latter have
had wider currency in theoretical studies of rock, and it is obvious that race
and class are, for example, highly determinant in the audience profile for soul or
opera. Nevertheless, for reasons that should become evident, habitation patterns
are crucial for the relationship between music, the institutions disseminating it,
and lifestyles in a more general sense. The hostility of heavy metal audiences
to disco in the late 1970s is indicative in this respect; the demographics of disco
showed it to be dominated by blacks, Hispanics, gays, and young professionals,
who shared little beyond living in inner urban areas. The high degree of inter-
action between punk/new-wave currents and artistic subcultures in America
(when compared with Great Britain) may also be traced in large part to the basis
of both in inner urban areas such as New York's Soho; those living elsewhere
would have little or no opportunity to experience or become involved in either
of these cultures.

Suburban life is incompatible for a number of reasons with regular attendance
at clubs where one may hear records or live performers; its main sources of music
are radio, retail chain record stores (usually in shopping centres), and occasional
large concerts (most frequently in the nearest municipal stadium). These institu-
tions together make up the network by which major-label albums are promoted
and sold – and from which music not available on such labels is for the most part
excluded.

My argument is not that this institutional network gave major labels a free
hand in shaping tastes but that, in conjunction with suburban lifestyles, it defined
a form of involvement in rock culture, discouraging subcultural activity of the
degree associated with disco or punk, for example. Heavy metal culture may be

characterized in part by the absence of a strong middle stratum between the listener and the fully professional group. Only in rare cases in the early 1970s could there be found an echelon of local heavy metal bands performing their own material in local venues. What I have referred to as the dominance of music in general by elites, in conjunction with the overall decline in small-scale live performance activity in the early 1970s, worked to block the channels of career advancement characteristic of other musical currents or other periods within rock history. It might also be suggested that the economy of North American suburbs in most cases discourages the sorts of marginality that develop in large inner urban areas and foster musical subcultures. High rents and the absence of enterprises not affiliated with corporate chains mean that venues for dancing or listening to live music are uncommon. If, for the purposes of this discussion, a music-based sub-culture may be defined as a group whose interaction centres to a high degree on sites of musical consumption, and within which there are complex gradations of professional or semi-professional involvement in music together with relatively loose barriers between roles (such that all members will be involved, in varying degrees, in collecting, assessing, presenting, and performing music), then heavy metal audiences do not constitute a musical subculture.

The lack of intermediary strata between heavy metal audiences and groups was further determined by another characteristic of the music. Most of the groups that were predominant – Led Zeppelin, Black Sabbath, Uriah Heep, Humble Pie, Deep Purple, and so on – were British. They were instrumental in estab-lishing a major characteristic of North American rock culture in the 1970s: regular, large-scale touring. The dependence of certain British bands on the North American market has become a structural feature of the rock industry, and is quite different in its significance from the periodic 'British invasions' of the charts.

The American rock-critical establishment had a negative response to heavy metal, or at least to the form British musicians gave it. This had two effects on the place of heavy metal within rock culture and its discourse. On the one hand, critical dismissal encouraged heavy metal musicians to employ a populist argument, whose main tenet was that critics had lost touch with the tastes of broad sections of the rock audience. On the other hand, this placed critics in the dilemma of how to respond negatively to the music without employing the terms tradition-ally used to condemn rock overall (sameness, loudness, musical incompetence etc.). Those critical terms with greater acceptability in rock culture (commer-cialism, conservatism) were, at least initially, inappropriate. The explicitly sociological or ethnographic bent of critical writing on heavy metal, its attention to the social or political implications of the music, were symptomatic of the cleav-ages heavy metal had effected within rock discourse.

In the early and mid-1970s, and particularly in *Rolling Stone*, rock criticism adopted more and more of the terms of journalistic film criticism, valorizing generic economy and a performer's links with the archives of American popular music. (The consistent high regard for singers such as Bruce Springsteen, Emmylou Harris, and Tom Waits, for performers like Lou Reed who played self-consciously with rock and roll imagery, stands out in a re-reading of *Rolling Stone* from this period.) The emphasis on the individual career or the genre as the context within which records were meaningful accompanied the rise of the 'serious' record review. This not only

diminished the interest of heavy metal for its own sake but also made the audience a relatively minor focus of rock criticism, as the latter moved away from the pop-journalistic or countercultural concerns of a few years earlier.

A major characteristic of heavy metal was its consistent non-invocation of rock history or mythology in any self-conscious or genealogical sense. The iconography of heavy metal performances and album covers, and the specific reworking of boogie blues underlying the music, did not suggest the sorts of modalization (that is, ironic relationships to their design principles or retrospective evocation of origins) that country rock, glitter rock, and even disco (with its frequent play upon older motifs of urban nightlife) possessed. As well, there was nothing to indicate that heavy metal listeners were interested in tracing the roots of any musical traits back to periods preceding the emergence of heavy metal. While the terms 'rock and roll' recur within song lyrics and album titles, this is always in reference to the present of the performance and the energies to be unleashed now, rather than to history or to myth. Any 'rebel' or non-conformist imagery in heavy metal may be seen as a function of its masculine, 'hard' stances, rather than as a conscious participation in rock's growing self-reflexivity. That the recent neo-punk movements in Anglo-American rock have found much of their constituency within heavy metal audiences is partly due, I suspect, to the redefinition of punk's minimalism as the expression of raw energy.

Equally striking is the almost total lack of hobbyist activity surrounding heavy metal music. Observation suggests that heavy metal listeners rarely become record collectors to a significant extent, that they are not characterized by what might be called 'secondary involvement' in music: the hunting down of rare tracks, the reading of music-oriented magazines, the high recognition of record labels or producers. To the extent that a heavy metal 'archive' exists, it consists of albums from the 1970s on major labels, kept in print constantly and easily available in chain record stores. There is thus little basis for the presence in heavy metal audiences of complex hierarchies based on knowledge of the music or possession of obscure records, on relationships to opinion leaders as the determinants of tastes and purchases. An infrastructure of importers, speciality stores, and fanzines was almost non-existent in heavy metal culture during the early 1970s and emerged only in the 1980s, with the recent wave of newer heavy metal groups.

In its distance from both Top 40 pop culture and the mainstream of rock-critical discourse, heavy metal in the early 1970s was the rock genre least characterized by the culture's usual practices of contextualization. It is rarely the case, for example, that heavy metal pieces are presented on the radio for their nostalgic or 'oldie' value. Rather, they are presented as existing contemporaneously with recent material, with none of the transitory aspects of Top 40 or setting down in individual careers or generic histories which the rock press and radio bring to bear upon other forms. The specificity of the heavy metal audience, then, lies in, first, its non-participation in the two dominant components of rock culture, the Top 40 succession of hits and hobbyist tendencies associated with record and information collecting; and, second, its difference, nevertheless, from the casual, eclectic audience for transgeneric music (such as that of Carole King or more recently, Vangelis). It is this coexistence of relatively coherent taste,

consumption and, to a certain extent, lifestyle with low secondary involvement in rock culture that in the 1970s most strongly distinguished audiences for heavy metal from those for other sorts of rock music.

Heavy metal culture: masculinity and iconography

> On the whole, youth cultures and subcultures tend to be some form of exploration of masculinity.
>
> Mike Brake

That the audience for heavy metal music is heavily male-dominated is general acknowledged and easily observable, though statistical confirmation of this is based largely on the audiences for album-oriented rock (AOR). Clearly heavy metal performers are almost exclusively male (recent exceptions such as Girlschool being accorded attention most often for their singularity). Is it sufficient, then, to interpret heavy metal's gender significance simply in terms of its 'cock rock' iconography?

One problem here is how to reconcile the hypothesis that heavy involvement in rock music – as critic, record collector, reader of the rock press, or performer – is primarily a male pursuit with the observation that these activities are for the most part absent from the most 'masculine' of rock audiences, that for heavy metal. The point is that involvement in rock music is simply one among many examples of criteria by which status is assigned within youth peer groups, albeit one that involves a high degree of eroticization of certain stances and attributes.

Within male youth culture (particularly in secondary school or workplaces), a strong investment in archivist or obscurantist forms of knowledge is usually devalued, marginalized as a component of what (in North America, at least) is called 'nerd' culture. I would emphasize that this marginalization is not simply directed at intellectual or knowledgeable males; rather, it involves specific relationships between knowledge and the presentation of the physical body. In recent American youth films (such as *The Last American Virgin*), the nerd is stereotyped as unstylishly dressed and successful at school: it is precisely the preoccupation with knowledge that is seen as rendering the boy oblivious to dress, grooming, posture, and social interaction (particularly as related to sexuality).

If, within a typology of male identity patterns, heavy metal listeners are usually in a relationship of polar opposition to 'nerds', it is primarily because the former do not regard certain forms of knowledge (particularly those derived from print media) as significant components of masculinity – if the 'nerd' is distinguished by his inability to translate knowledge into socially acceptable forms of competence, heavy metal peer groups value competencies demonstrable in social situations exclusively. Interestingly, within rock culture, neither of these groups is seen to partake of what the dominant discourse surrounding rock in the 1970s has regarded as 'cool'.

'Cool' may be said to involve the eroticization and stylization of knowledge through its assimilation to an imagery of competence. There developed in the 1970s a recognizable genre of rock performance (Lou Reed, Patti Smith, Iggy Pop,

even, to a lesser extent, Rod Stewart) based on the integration of street wisdom, a certain ironic distance from rock mythology, and, in some cases, sexual ambiguity (whose dominant significance was as an index of experience) within relatively coherent musical styles and physical stances. The recurrence of black leather and 'rebel' postures in the iconography surrounding such music never resulted in its full assimilation in the more masculine tendencies of rock culture, since these motifs overlapped considerably with those of gay culture or involved a significant degree of intellectualization; but in North America much of the original constituency for punk and new wave included people whose archivist involvement in rock centred on a tradition dominated by the Velvet Underground and East Coast urban rock in general. Many of those in this current (such as Lenny Kaye and Lester Bangs) became important figures within American rock criticism, and it remains the purest example of secondary involvement in rock music becoming a component of a highly stylized subculture. Since the mid-1970s, performers on its fringes have contributed an alternative constellation of male images to those found in heavy metal, one that participates in what rock culture defines as 'cool', but that lacks the androgynous aspects of the bohemian underground. Bruce Springsteen, Bob Seger, and John Cougar Mellencamp are American rock performers who have all achieved mainstream AOR success while presenting, as important components of their styles, an archivist relationship to rock music and a tendency to play self-consciously with the mythologies that surround it.

The major stylistic components of heavy metal iconography may be inventoried as follows: long hair for both performers and audiences; denim jackets and jeans among audience members; smoke bombs as an element of stage performances; marijuana-smoking and the taking of depressant drugs (Quaaludes and alcohol etc.). On album covers: eclecticism at the beginning, but the gradual cohering of an iconography combining satanic imagery and motifs from heroic fantasy illustration, which could be found increasingly too on the backs of jean jackets, automobiles and vans, T-shirts, pinball machines (and, with the later influence of punk, on buttons and badges). The remarkable aspect of traits such as long hair and denim jackets is their persistence and longevity within heavy metal culture long after they had ceased to be fashionable across the wider spectrum of North American youth culture. This itself reflected a decade-long shift whereby the heavy metal look came to acquire connotations of low socioeconomic position. While this might seem incompatible with my characterization of heavy metal audiences as largely suburban – and therefore, presumably, middle-class – it would seem that the heavy metal audience, by the early 1980s, consisted to a significant extent of suburban males who did not acquire post-secondary education and who increasingly found that their socio-economic prospects were not as great as those of their parents.

The iconography prevalent in heavy metal culture may be seen as the development of, first, certain tendencies emergent within psychedelia, which were in part responsible for the popularization of, second, types of fantasy and science fiction literature and illustration, which, in heavy metal iconography, saw their, third, heroic or masculine features emphasized. It is well known, for example, that, within the hippie counterculture, fantasy literature such as Tolkien's *The Lord of the Rings* was widely read and provided motifs for a wide range of poster art,

songs, album covers, and so on. In progressive rock of the early 1970s, related themes dominated, and the commercialization (in poster and book form) of the album covers by artists such as Roger Dean testified to the market for this style. In many cases (Jethro Tull, Genesis) fantastic motifs accompanied the musical invocation of early British history or mythology.

However, the most successfully popularized of these styles was the 'heroic fantasy' associated with Conan and spin-off fictional characters. From the late 1960s through the 1970s, this form of fiction passed from paperback novel to high-priced illustrated magazine, to conventional comic book format to, ultimately, the cinema: each step was evidence of the genre's broadening appeal and entry into mainstream youth culture. By the mid-1970s, the artwork of Frank Frazetta and others associated with the genre was widely merchandized in poster and calendar form, and on the covers of heavy metal albums by such groups as Molly Hatchett. Highly masculine (dominated by an imagery of carnage) and mildly pornographic, this illustrative style has cohered around heavy metal music and its paraphernalia.

The satanic imagery associated with heavy metal iconography almost from its inception (by Black Sabbath) grew out of stylistic traits present within psychedelia (such as those found on early Grateful Dead albums), and its convergence with elements of heroic fantasy illustration came near the middle of the decade. However, it is arguable whether the readership of fantasy literature overlaps significantly with the audience for heavy metal music (though the audience for heroic fantasy films likely does). The readership of *Heavy Metal* magazine, for example, despite its title, includes more fans of progressive rock than of heavy metal, which is to be expected in that both the magazine and these types of music are the centres of subcultural activity. Studies have demonstrated the low involvement of heavy metal audiences in print media and their high movie attendance.

What heavy metal iconography did do was contribute to the development of a 1970s kitsch, to the proliferation of fantasy and satanic imagery as vehicle and pinball arcade decor, as poster art and T-shirt illustration. For the most part, this has meant inscribing a masculine-heroic element within the fantastic or mystical motifs that surrounded psychedelic and, later, progressive rock. These motifs increasingly stood out against the geometrical-minimalist and retro design principles that became widespread within rock music following the emergence of punk and new wave.

Conclusion

Heavy metal is at once the most consistently successful of forms within rock music and the most marginalized within the discourse of institutionalized rock culture. That literary criticism is not regularly unsettled by the popularity of Harlequin romances while American rock culture regards heavy metal as a 'problem' is symptomatic of the tension in the 1970s between the ascension of critical discourse on rock music to respectability and the importance to it of a rock populist reading.

Heavy metal in North America provides one of the purest examples of involvement in rock music as an activity subordinate to, rather than determinant of, peer group formation. While involvement in disco or punk may determine people's

choices of types and sites of love and friendship (and even the selection of places to live and work), heavy metal – perhaps because of the inaccessibility of the institutions that produce and disseminate it – does not.

For young men, at least, involvement in rock music is perhaps the most useful index of the relationship between knowledge or competence and physical or sexual presence. Despite my concentration on heavy metal, the most male-dominated of rock's forms, and the most blatant in its associations of masculinity with physical violence and power, I regard the 1970s as significant precisely for the ways in which certain types of rock (glitter, punk) accomplished important interventions in sexual politics. That these interventions and their effects were major, while heavy metal remained the most popular form of rock during this decade, is evidence of the complexity and breadth of rock culture.

Postscript

This article was written in the early 1980s; the rock music culture which it describes is that of the 1970s. Since then, of course, the place of heavy metal within musical culture has changed radically. Beginning in the late 1970s, an infrastructure of small-scale magazines, speciality stores and the accoutrements of fandom took shape around heavy metal. By the end of the 1980s, the gap between heavy metal and post-punk rock culture had narrowed, and heavy metal had emerged as one of the coolest, most critically respectable and most diverse of musical forms. These changes are themselves of great interest, but they are beyond the scope of my article.

Rey Chow

LISTENING OTHERWISE, MUSIC MINIATURIZED
A different type of question about revolution

EDITOR'S INTRODUCTION

REY CHOW'S ESSAY takes us directly into the difficult and exciting cultural politics and cultural analysis of a world in which the centrality of the West can no longer be taken for granted.

Befittingly, her arguments work on a number of registers. She begins by arguing against the Frankfurt school tradition for which a category like "distraction" is to be interpreted negatively. For Theodor Adorno, the kinds of cultural product which did not attract their audiences' entire attention were instruments of capitalism's disposition to induce passivity in consumers. For Chow, on the other hand, a mode of Chinese pop music which makes few claims for itself, and does not invite a fully concentrated response, in fact works effectively against the Chinese communist authorities.

The power of this rock music — whose mode she calls "miniature" or "partial" — exists in relation to two forces. The first is that kind of Western theorizing which does not grant "Third World" subjects full individuality — seeing them primarily just as instances or products of a culture, and, for the most part, a fundamentally non-global culture at that. The second is the kind of history-writing which thinks in monumental terms: in the Chinese context, in terms of anticolonial nation-building and the victory of the people. Here banality is dangerous — not banal at all.

So, Chow argues, Chinese rock music acquires an intensity and effectiveness out of sync with its lack of aura and cultural value. But, as Chow also reminds us, the power of the miniature is not only dependent on its cultural-political context. It belongs to technology and the body as well — here, to a particular conjunction between the two, enabled and made concrete by the Walkman. The Walkman

screens the world out, and, without veiling us, does not let the world look in at our experiences. Here we have a portable technology that produces a mode of subjectivity which is certainly not simply on the side of those who read history monumentally.

Further reading: Chow 1993, 1995, 1998; Clifford and Dhareshwar 1989; Du Gay 1996; Palumbo-Liu and Gumbrecht 1997.

> *Every time I close my eyes I think of you*
> *You are like a beautiful slogan that can't be waved away*
> *In this world of (political) criticism and struggle*
> *We need to learn to protect ourselves*
> *Let me believe you are true, comrade lover*
>
> from the song 'Comrade Lover'
> by Luo Dayou

Hong Kong 1990: a place caught in postcolonial nostalgia, the simulacra of late capitalist technological advancement, the terror of communist takeover in barely seven years, the continual influx of unwanted refugees, the continual outflow of prized citizens. Hardly a second goes by without some commercial transaction taking place. 'Merchandise for emigration' becomes the mainstay of many stores, which are chronically offering 'sales'. Who are the oppressed of this place? There are many. They are faceless, voiceless, living in refugee camps, housing estates, rented rooms, rented beds, and other unknown corners of the overcrowded colony. Inside the packed spaces of the working city, the oppressed one most commonly encounters are the keepers of ubiquitous department stores and supermarkets – bored, unpleasant, expressionless, unhelpful salesmen and women, earning minimum wages, doing hardly anything day in and day out. These 'sales specialists' neither make, finance nor earn profit from the merchandise they sell. To that extent they have a similar relationship to the merchandise as the buyer / consumer – with one significant difference: once the transaction is over the buyer or consumer can leave, while the sales specialists are stuck in their jobs and their boredom forever. What accompanies them is the eternal Muzak in the stores, or, if they are lucky, they might be able to listen to their Walkmans secretly once in a while.

In response to the imperative to give everyone 'a voice', it is now a trend to raise the question 'Who speaks?' in the investigations of oppressed peoples. Versions of this question include 'Can X speak?', 'What does it mean to speak?', 'Who has been silenced?', 'How to speak?', and so forth. These are questions of linguistics and narratology applied to issues of power. In one respect, such questions are based on the assumptions of classical – what some might call 'vulgar' – Marxism: superstructure (speaking) on top, infrastructure (economic privilege) at the bottom. I want to clarify at the outset that I have no problem with vulgar Marxism as such. For all the attacks it receives, the vulgar Marxist refusal to let go of economics' strategic role in shaping social *vocal* structures continues to yield some of the most powerful (!) results of cultural criticism to date.

But while it effectively raises our consciousness in regard to the privileged positions enjoyed by those who are economically successful, the question 'Who

speaks?' tends to remain useless in its capacity to change existing economic power relations. This is because the posing of the question itself is already a form of privilege, mostly affordable for those who can stand apart and view the world with altruistic concern. The question that this question cannot ask, since it is the condition of its own possibility, is the more fundamental inequality between theory – the most sophisticated *speaking* instance, one might say – and the oppressed.

Like anthropologists, medical doctors, zoological researchers, and their like, theorists need 'objects' to advance their careers. The current trend is for theorists in the humanities to discover objects of oppression for the construction of a guilt-tripping discourse along the lines of 'Who speaks?' and thus win for themselves a kind of moral and/or rhetorical victory. Strictly speaking, we are not only living in the age of 'travelling theories' and 'travelling theorists', but also of *portable oppressions* and *portable oppressed objects*. Our technology – including the technology that is the academic conference, the visual and aural aids with which we present our 'objects', the field trips we take for interviewing and for archaeological purposes of every kind – is what makes portability, a result of mechanization whose effects far exceed the personal mobility of speaking humans, an inherent part of 'voices', even though this portability is often ignored in our theorizing.

The problem with the question 'Who speaks?', then, is that it is still trying to understand the world in the form of a coherent narrative grammar, with an identifiable (anthropomorphic) subject for every sentence. The emphasis of the question is always on 'who'. From that it follows that 'Who speaks?' is a rhetorical question, with predetermined answers which, however, cannot change the structure of privilege against which it is aimed. Obviously, it is those who have power who speak – this is the answer this question is meant to provoke.

What if we were to attempt another type of question, one that is not centred on, first, the act of speaking and, second, the quest for a grammatical subject? How might the issue of oppression be approached? This brings us back to the scenario with which I began this essay. In Asian cities like Hong Kong, where oppression is multifarious and contradictory in nature, the question to ask, it seems to me, is rather: what are the forms of surplus? Further, how does surplus inhabit the emotions? What is the relationship between surplus, the emotions and the portability of oppression? *What plays?* I will lodge these questions in the realm of contemporary Chinese popular music.

The collective and the composite

Any attempt to construct a discourse about contemporary Chinese popular music needs to come to terms with the fact that many linguistically determined senses of 'discourse' do not work. One can go so far as to say that much of this music, which often blends lurid commodified feelings such as 'love' with a clichéd mockery of both capitalism and communism, is about the inability or the refusal to articulate and to talk. This is not simply because humans are, after all, animals that cannot be defined by their speech alone. It is also because inarticulateness is a way of combating the talking function of the state, the most *articulate* organ that speaks for everyone.

When you listen to the songs by mainland China's young singers such as Cui Jian, you'll find that they are lively, Westernized and full of the kind of physical, rhythmic quality that we associate with rock music. Cui Jian's music poses a familiar problem about the emotions involved in our listening – the problem of physicality. Theodor Adorno has warned us against such physicality: 'The physical aspect of music . . . is not indicative of a natural state – of an essence pure and free of all ideology – but rather it accords with the retrogression of society.' The diatribe of retrogression is a formidable heirloom in the house of popular culture theories. But treasures of the past are most valuable when they are pawned for the more pressing needs of the present. If the physicality of a particular music is indeed retrogressive, we need to ask why.

Contemporary popular Chinese music raises many issues similar to those of rock and roll in the West. Foremost among these is that of the music's critical function in regard to the dominant culture. Any consideration of popular cultural forms confronts questions like the following: if such forms provide alternative practical consciousness to the dominant ideology, are the modes of subversion and resistance in them not infinitely reabsorbed by the dominant culture? Are such forms capable of maintaining their autonomy? Furthermore, how do we come to grips with such practical consciousnesses when that category indispensable to traditional Marxist social analysis – class – seems no longer adequate in mapping the cultural differentiations that persist beyond class distinctions? Take the example of American popular music. For many critics, the problem posed by this music is how to locate in it a genuinely oppositional function when class distinctions in the United States are more often elided than clearly defined. One might say that it is the impossibility of identifying any distinct class struggle – and with that, the impossibility of legitimizing the notion of class struggle itself for social criticism – that in part accounts for Adorno's reading of American popular music as a massive numbing. The blurring of class distinctions – as reflected in 'easy listening' music – is inordinately discomforting for the sober Frankfurt School critic.

It is, thus, when we focus on what still remains for many as an indispensable category in social criticism – class struggle – that contemporary Chinese popular music, despite its resonances with Western popular music, poses the greatest enigma. China is a 'Third World' nation, and yet where do we find the expression of class struggle in its popular cultural forms these days? Instead of exhibiting the classic 'symptom' of a 'Third World' nation in the form of an obsession with 'class', contemporary Chinese popular culture 'speaks' a different language of 'oppressed' emotions. In the realm of music, we find the conscious adoption of Western models of rhythm, instrumentality, recording, and modes of distribution for the production of discourses which are *non-Western in the sense of an inattentiveness to class struggle*. Many of the motifs that surface in contemporary Chinese popular music, like their counterparts in fiction, television, and film, can be described as individualist and populist – troublesome terms for Western Marxists who at one point looked to Communist China for its utopian aspirations. Such motifs are surfacing at a time when the mainland Chinese official ideology is still firmly 'communist'. Therefore, while the perception of class is undoubtedly present in the subversive emotions of contemporary Chinese popular music, it is present less as an agency for struggle than as the disciplinary cliché of the dominant culture *to be*

struggled against. This is precisely because 'class struggle' has been lived through not merely in the form of critical talk but also in everyday experience, as official ideology and national culture. (In mainland China, 'struggle' is a transitive verb, an act one performs directly on another: thus, 'to struggle someone'.)

Speaking of his inability to deal with the directly political, Roland Barthes says (in an interview): 'these days a discourse that is not impassioned can't be heard, quite simply. There's a decibel threshold that must be crossed for discourse to be heard.' Barthes's statement offers us a way of defining 'dominant' culture in musical terms, not only as that which crosses a particular decibel threshold as a rule, but also as that which collectivizes and mobilizes with its particularly loud, indeed deafening, decibel level. If revolution is, among other things, a technology of sound, then its mode of implementation is that of mechanized and institutional-ized recording, repetition and amplification. As early as 1928, the Chinese writer and critic Mao Dun used the technology of sound in a discussion of 'proletarian literature' to indicate the danger of the new political orthodoxy which based its moves on prescriptive slogans: 'I . . . cannot believe that making oneself into a gramophone shouting "This is the way out, come this way!" has any value or can leave one with an easy conscience. It is precisely because I do not wish to stifle my conscience and say things I do not believe . . . that I cannot make the char-acters in my novelette [*Pursuit*] find a way out.'

The past forty years of Chinese communism can be described as a history in which class struggle is used as the foundation for the official culture of a nation state. The question 'Who speaks?' underlies the most brutal of political extermi-nations. The 'who' that is identified through arrests, purges, and murders as the landlords, capitalists, and running dogs is replaced with the 'who' that is 'the people'. Entwined with nationalism and patriotism, and strategically deployed by the state, 'the people's speech' that supposedly results from successful class struggle forms the cadences of a sonorous music. One thinks of pieces such as the 'International song', 'Dongfanghong' (The east is red), 'Meiyou gongchandang meiyou xin zhongguo' (There would be no new China without the Communist Party), and many others that are standardized for official celebrations to invoke patriotic sentiments. Official state culture champions an irresistible grid of emotions that can be defined by Susan Stewart's notion of 'the gigantic', which 'we find . . . at the origin of public and natural history' (Stewart 1984: 71). Gigantic emotions are the emotions of reverence, dedication, discipline, and nostalgia, all of which have to do with the preservation of history as it ought to be remem-bered. Such an institution of memory is, in the words of Friedrich Kittler, 'an act of sheer and external violence' (Kittler 1990: 201). In a 'third world' nation whose history is characterized by a struggle against imperialism as well as internal turmoil, the history that 'ought to be remembered' is the history of the successful collec-tivization of the people for the establishment of a national community.

Many examples of contemporary Chinese popular music, however, follow a very different trajectory of sound. Here, the question about popular cultural form is not a question of its ultimate autonomy from the official culture – since that official culture is omnipresent – but how, against the single audible decibel level amplified at random with guns and tanks, popular music strikes its notes of difference. The comments of Václav Havel on rock music in Czechoslovakia

before the fall of the authoritarian regime in 1989 speak germanely to the Chinese situation:

> In our former conditions, rock music acquired a special social function. And that's connected with the fact that culture and arts in general fulfill a different role in our country than they do in the Western world. Under a totalitarian regime, politics as such are eliminated and the resistance has to find substitute outlets of expression. One of those substitute channels was rock music. That's why its role here was more significant than it is where it's part of a general consumption.

The *words* of one of Cui Jian's most popular songs, 'Rock and Roll on the Road of the New Long March' (EMI Music Publishing Ltd, SE Asia, 1989), allude to one of the founding heroic events of the Chinese Communist state, the Long March to Yanan. The last few lines (which I translate from the Chinese) go as follows:

> What should I say, what should I do, in order to be the real me
> How should I play, how should I sing, in order to feel great
> I walk and think of snowy mountains and grasslands
> I walk and sing of our leader Chairman Mao
> Oh! one, two, three, four, five, six, seven.

By recalling the words, I don't mean to imply that the truth of Cui Jian's music lies in its verbal content. Rather, the disjuncturing of words from music points to the significance of the partial – of emotions as partializing rather than totalizing activities which jar with the symphonic effects of official culture.

There is, first of all, the difference between the 'decadence' of the music and the 'seriousness' of the subject matter to which the music alludes. Without knowing the 'language', we can dance to Cui Jian's song as we would to any rock and roll tune; once we pay attention to the words, we are in the solemn presence of history, with its insistence on emotional meaning and depth. This is why Cui Jian's music so deeply antagonized the officials in the Chinese state bureaucracy that he was dismissed from his post in the Beijing Symphony Orchestra and prohibited from performing in Beijing a couple of years ago. The official Chinese repudiation of his music is moralistic, aiming to reinforce a kind of obligatory cultural memory in which the founding deeds of communist ancestors are properly honoured instead of being 'played with' – least of all through a music imported from the capitalist West.

But as we look closely at the words themselves, we see that even the words – the medium in which solemn historical emotions can be respectably lodged – partake of the 'play' with tradition. Instead of words with sonorous historical meanings, Cui Jian's lyrics read more like grammatically incoherent utterances. Even though they conjure up 'historical' images, his words speak against literate and literary culture by their choppiness and superficiality. The Long March, one of the nation's best-selling stories since 1949, is a signifier for something vague and distant, and Chairman Mao a mere name to complete the rhyme. In

reacting against Cui Jian's music, the Chinese authorities were therefore not clinging to solemn words as opposed to flippant music but rather to what does not exist either in the words or in the music, namely an idealized notion of official history. Therefore, while the difference between the words and the music exists in terms of their different semiotic orders, the words and music are also mutual renditions of each other insofar as they both dis-member and dis-remember official history. The words, by becoming illiterate, turn into physical sound, thus joining the music in the production of a kind of emotion that is, one might say, 'beyond words'.

By associating emotion with musicality and physicality, I may be reinvoking many of the oldest myths about each of these terms. It is often argued that it is the association of music with emotionality that is responsible for its relegation to the realm of the irrational, the feminine and the simply pleasurable. At the same time, as we examine a non-Western culture such as the Chinese in the 1990s, we notice a resurfacing of precisely such notions about music and the emotions. The discoursing of the emotions here is therefore at an interesting crossroads. How do we describe the emotions of a music that is resistant to the oppression of communist state culture, but which seems to go against the theories of music in the West which are struggling to rescue music from the mythical paradigms in which it has been cast? In other words, how do we theorize the significance of music-as-emotion at a time when it is precisely the reduction of music to emotionality that must also be critiqued?

The problem of emotionality, it would seem, is the problem of surplus in the sense that it is what exceeds the limits by which its functions can be rationally charted. Music, it is well known, has always been theorized as a pure form, as that which signifies nothing. In the words of Julia Kristeva, for instance, music's semiotics is such that 'while music is a system of *differences*, it is not a system of *signs*. Its constitutive elements do not have a signified.' For Kristeva, music 'takes us to the limit of the system of the sign. Here is a system of differences that is not a system that *means* something, as is the case with most of the structures of verbal language' (Kristeva 1989: 309). Because of this 'empty', trans-linguistic status, music suits the theorizing of surplus the best because it provides a means of suggesting what goes *beyond*. One might say that it is the use of music's power as surplus – as that which cannot be safely contained – for a criticism of the strait-jacket of orthodox state ideology that is most evident in the making of Chinese popular music today. And it is this surplus which is commonly recognized as its emotionality.

Of course, no matter how excessive the emotions are, they can always be narrativized and thus attributed a more familiar purpose. Dong Wenhua's 'Xueyan de fengcai' (Blood-stained spirit) is a good example. This compelling song was first sung for Chinese soldiers fighting in the Sino-Vietnamese War of the 1970s. A newer version, resung by Wang Hong, has since then appeared and met with tremendous success among the Chinese especially around and after the Tiananmen Massacre of 1989. Other versions continue to be heard on major occasions such as the fund-raising concerts and gatherings held by Chinese communities around the world for China's flood relief in the summer of 1991. The song clearly demonstrates the power of music to harmonize populist emotions. To the extent that

it serves the function of patriotic unification, contemporary Chinese popular music shares with its many counterparts decidedly conventional and conservative moments as well.

In an account about rock and roll, pleasure and power, Lawrence Grossberg argues that 'The affective economy of rock and roll is neither identical to, nor limited to, the production of pleasure' (Grossberg 1984: 101). If there is an undeniable affinity between the emotionality and musicality, we must also add, in Grossberg's words, that 'the affective investment, while asignifying, is not a pristine origin (as the concept of libido might suggest) which precedes the ideological entanglements of the articulation of . . . differences. It is a plane of effects, a circuit of empowerment' (102). What kind of empowerment? Grossberg suggests it in these terms: 'In the rock and roll apparatus, you are not what you don't listen to (which is not necessarily the same as you are what you listen to)' (103).

This statement – 'You are not what you don't listen to' – signifies a view of human labor that is not positive but negative, but the meaning of this negativity is the defiant message that human labor cannot be reduced to a narrowly defined political goal. In contemporary Chinese fiction, the forty years of communist history are increasingly understood to be the alienation of human life *par excellence* through what poses as the 'collective' good. The collective is now perceived as that mysterious, objectified Other against which one must struggle for one's life. Such is the instinctual battle fought by the protagonist in the controversial novel *Half of Man Is Woman* by Zhang Xianliang. Working in a labor camp in the countryside where official instructions are regularly announced through loudspeakers, this man reflects on physical labor in the following terms. Describing hard labor as a 'trance', he distinguishes between hard labor and the officially assigned 'job': 'A job is for someone else. Labour is your own.' This insistence on the difference between the work that is performed for a public sphere with its clearly organized goals and the work that is one's own, is not an insistence on 'privacy' or private property, but rather a resistance against the coercive regimentation of emotions that is carried out under the massive collectivization of human lives in the Chinese Communist state. Contrary to orthodox Socialist beliefs, the protest made in contemporary Chinese popular culture is that such collectivization of human lives is what produces the deepest alienation ever, because it turns human labor into the useful job that we are performing for that 'other' known as the collective, the country, the people, and so forth. In his book *Noise*, Jacques Attali makes a point similar to that of Zhang Xianliang's protagonist when he comments on political economy. What Attali suggests is that 'use' itself, instead of being the original, inalienable part of labor, is actually the most basic form of alienation, for it is already an exchange for something else – in other words, it is predicated on an other, a collective (Attali 1985: 134).

At a time when we have become rightly alert to issues in the 'third world', it is precisely the problem of 'use' that has to be rethought. Something is 'useful', we tend to think, because it serves a collective purpose. While on many occasions I have no objections to this kind of thinking, it is when we deal with the 'third world' that we have to be particularly careful in resorting to paradigms of the collective as such. Why? Such paradigms produce stereotypical views of members of 'third world' cultures, who are always seen as representatives driven solely by

the cause of vindicating their own cultures. To the extent that such peoples are seen as representatives deprived of their individuality and treated as members of a collective (read 'third world') culture, I think that the morally supportive narrativizing of the 'third world' by way of utilitarianism, however sophisticatedly utilitarianism is argued, repeats what it tries to criticize, namely the subjection of entire peoples to conceptual paradigms of life activities that may have little relevance to such peoples' struggles for survival.

In the case of China, I read the paradigm of collectivity as part of the legacy of imperialism imposed upon a 'backward' nation. Like most countries in the post-imperialist era, the alternative to ultimate destruction in the early twentieth century was, for the Chinese, to 'go collective' and produce a 'national culture'. Collectivity as such was therefore never an ethnic empowerment without neuroses, and it is the neuroses which are now surfacing in popular cultural forms like music. At this point in time, the narrative of collectivity does little to explain the kinds of emotions that are played (upon) in contemporary Chinese music, apart from making us notice this music's negativity and, for some, nihilism. These emotions of negativity suggest a deliberate turning away from the collective's thematic burdens through lightheartedness, sarcasm, brutality and semantic vagueness.

While such emotions of negativity are not capturable in any one medium alone, in this essay I want to emphasize their special connection with music, in part to criticize the privilege enjoyed by visuality in most discussions of postmodern culture. Like popular culture elsewhere, popular culture in East Asia tends to gravitate toward the image. From large-scale concerts by stars to contests for young singers, to the 'self-service' performances of the Japanese-style 'Karaoke', to the equivalents of MTV programmes on Asian television, music is bound up with the fast-pace technologizing of a part of the world which relies on spectacular images for the sustenance of commodity culture. Music is always simply an accompaniment for the visual. Even when fans go to the concerts of their favourite singing stars, one feels that it is the stars' performance on stage, rather than their singing, that the fans have come to see. Music becomes a mere pretext, and singers, instead of performing with the voice, must excel more in their inventiveness with costumes, dancing and acrobatics.

Although contemporary Chinese popular music can definitely be pursued by way of the spectacle of performance, its interest for me lies elsewhere. While the image marks the body, in music one has to invent a different language of conceptualizing the body, that is, of perceiving its existence without marking and objectifying it as such.

The body's existence is here realized through what Attali calls 'composition', in which the body, instead of always living in an alienated relation to itself through the stockpiling effects of representation, is present for itself and for 'the pleasure outside of meaning, usage and exchange' (1985: 137).

For this new presence of the body to emerge, the previous codes in which it was written must be destroyed. We hear in a song like 'Rock and roll on the road of the new long march' the physicality of such a destruction, which comes to us in the form of a composite. Often, 'destructive' songs are made up of a mixture of voice, instruments, and versions of older songs, as well as previous sayings, proverbs, and idioms. Now, we may, if we are intent on reading in what I'd call

the Western Marxist way, dismiss this as a form of permissive 'pluralism'. At the same time this composite structure points to a kind of musical mutation, in which no single theme or event is allowed to monopolize the decibel level, so that it is precisely at the dissonance of these musical *parts* – in the form of debris – that the physicality of these songs makes itself heard. Often, therefore, 'destructive' songs do not distinguish themselves from noise. From the actual coarseness of a singer's voice to the insertion of moments of 'clearing the throat', from the disharmonious presence of a different musical background in the same song to the adaptation of familiar folk tunes and themes for a heavily electronic music, what we hear is a mutual 'plugging' between partial noises – between differences. This plugging is at the same time an unplugging of preceding codes, in which the fundamental distinction between the human voice and the musical instrument, between rehearsing and actual performing or recording, between traditional and contemporary musical forms, becomes itself a *part of playing*.

An example of such composition in East Asia is the form of entertainment, very popular of late, called 'Karaoke'. Originating in Japan, 'Karaoke' is the singing, done either in public (Karaoke bars and clubs) or in private (with individual machines for the home), which breaks down the traditional distinction between performing and listening. A person selects a song she or he likes to sing from a collection that accompanies the Karaoke machine, then sings by following the music and the images (with lyrics) on the video screen. What is most interesting is that the common requirements of 'good' performance, such as the excellence of the voice, adequate training and practice etc., no longer matter. The entire human body, together with its noise-producing capacity, follows the machine's sounds and images. The machine allows one to feel like – to be – an original performer, but one is literally performing as a listener, with all the 'defects' that a performer is not supposed to have. One is liberated from the myth of performance, and does not need to 'know how' in order to sing any more.

In the rest of this essay I will discuss two specific aspects of composition. First, what does it mean for composition to be read, as Attali suggests, 'as an indication of a more general mutation affecting all of the economic and political networks' (1985: 135)? Second, what does it mean to say (Attali is here referring to the musical theory of John Cage) that 'music is to be produced . . . everywhere it is possible to produce it, in whatever way it is wished, by anyone who wants to enjoy it' (137)?

Listening otherwise

The lyrics of the 'Song of the Dwarf' ('Zhuru zhi ge', Praiseplan Ltd, Hong Kong, 1989), by the Taiwanese singer Luo Dayou (who now bases his work in Hong Kong, go as follows:

> We must hold hands, hold hands tight
> Beware of the giants waving at you from far away
> These history-making faces, these figures of the times
> They are always carrying guns for the sake of the people

The road of the Long March is rough
Forcing their way into Tiananmen, they arrive at Beijing
The index is alluring in the market of 'struggle'
Revolutionary doctrines fluctuate like stock prices
Five thousand years of despotic rule await your cleansing
Beware:
The characters who revolt against others are themselves
 revolted against
They clutch at their clothes. They need to have face.
How many lives has Mr Marx destroyed
The glorious results of war are woven in our compatriots'
 blood
We dedicate the great victory to the people
Five thousand years of despotic rule await your cleansing
But who can wash the blood on your hands
We must hold hands, hold hands tight
Beware of the smile on the face of the dwarf who is
 approaching
These faces behind (him), these great figures –
They are always carrying guns for the sake of the people.

This song, once again, demonstrates that separation between musicality and verbality I mentioned as characteristic of many others. In the remarkable lines, 'The index is alluring in the market of "struggle"/Revolutionary doctrines fluctuate like stock prices', the mockery of the communist state is done by a clever combination of the languages of the revolution and the market economy, or rather, by a rewriting of revolution in terms of the market economy, effecting a demolition of the altruistic claims made by the practitioners of the Marxist ideology, which is included as part of the five-thousand-year-old Chinese despotic tradition.

The clashing of these two usually incompatible languages, revolution and the market, suggests a fundamental need to revamp the bases for both. Their clashing reveals the grounding of emotions not in 'nature' but in technology. Because of the ineluctability of technology, what clash are also the thematics of the 'third world' and the 'first world'. Technology is that collectivized goal to which East Asian cultures, as part of the non-Western world that survives in the backwash of imperialism, have no choice but to adopt. In the case of mainland China, the successful technologizing of an entire nation through the regimentation of life activities in collective form was accomplished through the communist revolution. In other, non-communist Chinese communities in East Asia, notably Taiwan, Hong Kong, and Singapore, the success of technology is evident in sophisticated modes of living, inseparable from the production and consumption of commodities. The co-presence of these two meanings of technology – as the collectivized and the commodified – constitutes a unique type of ethnicity in ways that exceed the orthodox paradigms of demarcating 'first world' and 'third world' economic and political networks.

Contrary to the paradigms of struggle and protest – the cultural stereotypes that are being laid across 'third world' peoples with uniformity, soliciting them into a *coded* narrative whether or not they are willing to participate in it – the

emotions that emerge here imply a new writing of ethnicity. This writing cannot consider the 'ethnic' person simply in the role of the oppressed, whom we in the West, armed with questions such as 'Who speaks?', attempt to 'liberate' by giving a voice, a voice that amounts to a kind of waged labour (the permit to participate in the working world with 'choice' and 'freedom'). The presence of technology means that the deeply historical perception of the unpredictable but oppressive nature of official culture is here conveyed through instruments that are accomplices as well as resisters to that culture. In 'Queen's Road East,' a song he sang with Jiang Zhiguang and produced through his company 'Music Factory' in 1991, Luo Dayou turns the knowledge and memory of local political history into the makings of an accessible and entertaining music. In the lyrics, written by Lin Xi, Hong Kong's colonial past and present, signified by the image of the 'friend' called 'the Queen' on money coins, are juxtaposed with Hong Kong's colonial future, which is signified by 'the comrades' who will stamp a new meaning on everything, even street names. In the production notes to the collection featuring the song, Luo Dayou writes about his ethnic agency in terms of a transaction with the unknown and unknowable. The historical predicament underlying this agency is spoken of almost beguilingly – as a dream:

> In the past hundred and fifty years or so, Hong Kong grew up in a state of abandonment, making her survival with compromises in the gaps between East and West. Her history is the orbit of a dream. . . . So the moment finally comes: the 1990s. I feel like a broker conducting the biggest transaction between the past and the future. Among those who live here at this time, who doesn't? . . . The shortest distance between two points is neither a straight line nor a struggle. It is a dream. . . . Between the past and the future, we are in the embrace of a dream, heading toward a time only it knows about.

Precisely because historical injustice is the very ground on which the struggle for survival takes place, such injustice is often alluded to indirectly rather than confronted directly. The music of Cui Jian and Luo Dayou is as semantically loaded with the feelings of oppression as it is electronically saturated, but the feelings of oppression impinge upon us as an inerasable, *because* invisible, referent, like a language with an insistent syntax but no obvious semiotics or signs with meanings. The dreaminess and emotional opacity of this music function like beautiful but illegible notes, defying us to make sense of them while retaining their power for combat through an amateurish crypticness and a posed abstractness. Official Chinese culture, on the other hand, does not only suppress such *emotions* in order to uphold the clear, glorious version of history; as usual, it would also criticize the *electronics* in the name of protecting the integrity of Chinese culture against excessive Westernization. Operating under the domination of a patriotic rhetoric that cannot be turned off, the counter-discourse we find in many popular songs is thus deliberately inarticulate, by way of a music that is lighthearted, decadent, playing to the rhythms of expensive lifestyles in forgetfulness of the wretched of the earth. The forms of nihilism are used consciously for enervation, producing moments of positivity that restructure relations to the political state.

On the streets of Hong Kong, Taipei and other East Asian cities, as one strolls along shop windows among crowds, in restaurants, bookstores, produce markets, streetside stalls, Chinese herbal teashops – in all such public places, it is not uncommon to hear this kind of popular music being played on the side for entertainment by the people tending the stores. What the music contributes to the public sphere is a kind of 'easy', non-verbal culture that conditions passers-by, who none the less never focus on it seriously. Unlike the overwhelming presence of commodified images, popular music leads a life on the side, as a kind of distraction made possible by technology, a distraction that, moreover, is not visible.

Such listening on the streets is not merely the substitution of one kind of attention for another, the aural for the visual. Instead, because it is always played on the side, as we are doing other things, it is what I would call a 'listening otherwise'. Listening otherwise changes the meaning of music from its traditional association with a plenitude that escapes concrete articulation on account of its affinity, to that of a part object whose field is always elsewhere. At the same time, this part object is surplus; it is not reducible or graspable in the form of an externalized image. Its *excessive partiality* requires a different kind of theorizing.

'Hear there and everywhere': music miniaturized

What we need, in other words, is a history of listening – a history of how listening and the emotions that are involved in listening change with the apparatuses that make listening possible. Traditionally, listening is, as a rule, public. For a piece of music to be heard – even under the most private circumstances – a certain public accessibility can always be assumed. Such public accessibility continues even when music becomes portable with the transistor radio and the portable cassette tape player. With the invention of headphones, on the other hand, listening enters an era of interiorization whose effect of 'privacy' is made possible by the thoroughly mechanized nature of its operation. But listening through headphones is still attached to relatively large pieces of machinery, which tend to remain stationary. (We use them when we don't want to disturb others occupying *the same space*.)

The form of listening that is a decisive break from the past is that made possible by the Walkman. One critic describes the Walkman this way: 'that neat little object . . . a pregnant zero . . . the unobtrusive link in an urban strategy, a semiotic shifter, the crucial digit in a particular organization of sense' (Chambers 1990: 1). Even though the popular songs I am discussing may not be consciously intended for playing on the Walkman alone, what I would argue is that the conception of the Walkman – as part of 'the equipment of modern nomadism' – is already written into these songs. The Walkman is implied in their composite mode of making, which corresponds to a composite mode of listening that involves multiple entries and exits, multiple turnings-on and turnings-off. If music is a kind of storage place for the emotions generated by cultural conflicts and struggles, then we can, with the new listening technology, talk about the production of such conflicts and struggles *on the human body* at the press of a button. In the age of the Walkman (or its more sophisticated affiliate, the Discman), the emotions have become portable.

In contrast to the gramophone or loudspeaker, without which the 'gigantic' history of the public would not have been possible, the Walkman ushers in the history of a miniaturized music. But the notion of miniature is useful here only indirectly, as a way to point to the need for us to invent another language that would more appropriately describe the partiality of music. Susan Stewart's study of the narratives of the miniature provides us with the necessary assistance. Among the most important characteristics of the miniature, according to Stewart, is that it establishes a correspondence with the things of which it is a miniature. The miniature is thus unimaginable without visuality: 'the miniature is a cultural product, the product of an eye performing certain operations, manipulating, and attending in certain ways to, the physical world' (Stewart 1984: 55). The miniature is the labour of multiplying and intensifying significance microscopically:

> 'That the world of things can open itself to reveal a secret life – indeed, to reveal a set of actions and hence a narrativity and history outside the given field of perception – is a constant daydream that the miniature presents. This is the daydream of the microscope: the daydream of life inside life, of significance multiplied infinitely *within* significance.
>
> (54, emphasis in original)

Insofar as Walkman music is shrunken music, music reduced to the size of the little portable machine that produces it, it is a kind of miniature. But the most important feature of music's miniaturization does not lie in the smallness of the equipment which generates it. Rather, it lies in the *revolution in listening* engendered by the equipment: while the music is hidden from others because it is compacted, this hiddenness is precisely what allows me to hear it full blast. The 'miniaturizing' that does not produce a visible body – however small – that corresponds with 'reality' leads to a certain freedom. This is the freedom to be deaf to the loudspeakers of history, even though 'deafness' is itself a simulacrum of our technologized fate. We do not return to real individual or private emotions when we use the Walkman: rather the Walkman's artificiality makes us aware of the impending presence of the collective, which summons us with the infallibility of a sleepwalker. At the same time, what the Walkman provides is the possibility of a barrier, a blockage between 'me' and the world, so that, as in moments of undisturbed sleep, I can disappear as a listener playing music. The Walkman allows me, in other words, to be missing – to be a missing part of history, to which I say: 'I am not there, not where you collect me.' In the Walkman, the hiding place for the music-operator, we find the music that 'is to be produced everywhere it is possible to produce it, by anyone who wants to enjoy it'. Here, Barthes's statement that 'Politics is not necessarily just talking, it can also be listening' takes on a new meaning. For listening is not, as Adorno describes popular music in America, 'a training course in . . . passivity'; rather it is a 'silent' sabotage of the technology of collectivization with its own instruments.

As the machine of what we might call 'automatic playing', the Walkman offers a means of self-production in an age when any emphasis on individualist positions amounts to a scandal. What is scandalous is that self-production is now openly autistic. The autism of the Walkman listener irritates onlookers precisely because

the onlookers find themselves reduced to the activity of looking alone. For once, voyeurism yields no secrets: one can look all one wants and still nothing is to be seen. The sight of the Walkman listener, much like the sight of some of our most brilliant scientists, artists and theorists, is one that we cannot enter even with the most piercing of glances. (The Walkman allows us for the first time to realize that our 'geniuses' have always lived with earphones on.) Critics of the Walkman, like critics of mass culture in general, are condemned to a position of exteriority, from which all kinds of ineffectual moralistic attacks are fired. This position of exteriority amounts to the charge: 'Look at yourself! Look how stupid you look!' But the autistic sight is the one which is free of the responsibility to look, observe, and judge. Its existence does not depend on looking, especially not on looking at oneself.

The music operator's activity frankly reveals that the 'collective' is not necessarily an 'other' to be idealized from afar but a mundane, mechanical, portable *part* of ourselves which can be tucked away in our pocket and called up at will. This 'self'-production through the collective requires not so much slogans as AA batteries, and it takes place in the midst of other, perhaps equally insignificant, activities. It substitutes listening for the writing of music and demolishes the myth of creativity through a composite discoursing of the emotions. The noises and voices of production become ingredients of self-making. Deprived of their images and their bodily presence in on-stage performances, even singers – 'stars' and 'icons' – become part of the technologically exteriorized 'inner speech' of the listener. As such, the emotions of music are dehydrated, condensed, and encapsulated, so that they can be carried from place to place and played instantly – at 'self-service'.

Culture – political economy and policy

Tony Bennett

PUTTING POLICY INTO
CULTURAL STUDIES

EDITOR'S INTRODUCTION

TONY BENNETT'S ESSAY argues the case for the defense in what has come to be called "the cultural policy studies debate" – cultural policy studies being the study of, and training in, the formulation and provision of cultural policy. He's on cultural policy's side. It's a rather confusing debate though, because it drifts somewhat haphazardly over three levels. The question is not so much (level 1) "should cultural policy be studied in universities?", the answer to which is pretty clearly "yes, where there is a demand for it". The question is rather (level 2) "should cultural studies as a whole move in the direction of cultural policy studies?" – or to state it in a rather more nuanced fashion, should cultural studies' habitual modes of more or less radical theoretical and utopian critique, which do not have to account for their practicability, be marginalized in favor of forms of cultural analysis which can feed into policy-formation? Behind this question lies a more theoretical one (level 3), drawn from the work of Foucault, which we can pose very starkly like this: "is the realm of modern culture independent of government, or is governmentality the condition of possibility for all modern culture?"

Tony Bennett takes the side of governmentality and policy at all three levels by arguing that it is wrong to believe that cultural policy studies are committed to a "top down" rather than a "bottom up" approach (i.e. are on the side of governments rather than communities) because in fact communities and their cultures are formed within governmental practices and (though Bennett emphasizes this less) vice versa.

This essay was written in Australia, traditionally a highly governed nation, where, particularly under 1980s' Labor Party rule (an equivalent to Britain's 1990s' New Labour), governments were committed to developing national and

regional cultural resources and institutions. Good pickings for left-leaning policy consultants. But this means that the hot issues on the American culture/government interface – censorship, withholding of public funding for so-called obscene or blasphemous works, the attack on multiculturalism, the questioning of the public funding of culture at all – do not really appear in Bennett's work. So, leaving theoretical questions aside, we can ask: what happens to left-ish cultural policy studies when a combine of right-wing, anti-statist, populist government and private or corporate patrons or sponsors are in control? In those circumstances, presumably, free-wheeling dissident cultural studies absorbs most of cultural policy studies once more, however we theoretically interpret the relation between governmentality and culture.

Further reading: Bennett 1992b; Burchell, Gordon and Miller 1991; S. Cunningham 1992; Donald 1992; Hunter 1988; Jameson 1993; Lloyd and Thomas 1998; T. Miller 1993, 1996; Morris 1992a; O'Regan 1992; N. Rose 1993.

In the first issue of *Text*, the newsletter of the Centre for Cultural and Media Studies at the University of Natal, Keyan Tomaselli describes the most important change of emphasis in the recent work of that Centre as being 'the dramatic shift from theories and strategies of resistance to policy research'. 'Where policy research prior to February 1990 was seen by some academics, as negatively "idealist" or pejoratively "utopian",' Tomaselli continues, 'policy research has now assumed major significance as the country desperately attempts to address vital problems' (Tomaselli 1992: 2). It is easy to see, given the changing political context of South Africa, why this shift 'from resistance to policy' should have taken place. It is also easy to see why, internationally, few intellectuals would object to the adoption of such a position in the contemporary South African context or, if they did, that they would be prepared to say so. To do so would be to place oneself on the wrong side in relation to the democratic process that has delivered the South African state into the new and, for the moment, benign form of an ANC government.

The response to similar suggestions in the Australian context – where the political conditions which make them intelligible can claim a longer history – has, by contrast, been a quite vexatious one. John Frow and Meaghan Morris have argued that the so-called 'policy debate' conducted in a range of fora – conferences, journals, the media – in the late 1980s and early 1990s, mainly in Australia but occasionally spilling over into the international circuits of cultural studies debate, 'produced much heat and less light' (Frow and Morris 1993: xxix). Perhaps so. My own assessment, though, is both that the debate was a necessary one and that it has proved productive.

It was necessary in the sense that it was not possible, in the mid-1980s, to connect policy work to the concerns of cultural studies except, more or less apologetically, as an aside from 'the real' theoretical and political issues which, it was assumed, lay elsewhere. This is not to say that policy concerns had not figured in earlier stages in the development of cultural studies. To the contrary, they were and remained central to the concerns of Raymond Williams. This was largely a

personal commitment, however, and one which had relatively little impact on debates within cultural studies. The most significant exception to this was comprised by the interest that was shown in the cultural policies of the Greater London Council as an important bulwark against the early phases of Thatcherism until, of course, the GLC was itself dismantled. In Australia, similarly, the only synthesising engagement with cultural policy was Tim Rowse's *Arguing the Arts* (1985), although there had been important work done in the field of media policy from at least the late 1970s. Policy issues, however, were not effectively knitted into the fabric of debate within Australian cultural studies during these early years of its emergence as a discipline. They did not figure prominently within conferences and were seldom aired in the pages of the *Australian Journal of Cultural Studies* or its successor, *Cultural Studies*, when it went international. In these circumstances, as Tom O'Regan describes them, those who wanted to engage with policy issues had found it necessary to 'set up shop somewhere else' by describing their work in other terms – as, in his case, variously that of 'cultural historian, film critic, sociologist and political scientist' (O'Regan 1992: 415–16). Policy issues, in short, had not been given in either the Australian or British contexts, any principled rationale or justification that defined a clearly articulated role for them within cultural studies. The same was true in the United States, where the disconnection of cultural studies from any effective socialist traditions has minimized the significance it accords the relations between culture and government. As a consequence, policy work could be, and too often clearly was, seen in all of those national contexts as a narrowly pragmatic activity lacking any broader theoretical or political interest. It also reeked of a politically unpalatable compromise with 'the state'. Against this background, the development of an argument which insisted on the need to locate a policy horizon within cultural studies as a necessary part of its theorization of, and effective practical engagement with, relations of culture and power was a necessary step if such concerns were to be placed effectively on the agendas of cultural studies.

I suggest that the debate has proved productive for two reasons. The first is that, at least in the Australian context, it has played a role in facilitating the development of new forms of collaboration between intellectuals working in the field of cultural studies as teachers and researchers and other cultural workers and intellectuals working within specific cultural institutions or in the branches of government responsible for the management of those institutions. Of course, more systemic tendencies have driven these developments which are best viewed as local manifestations of a more general response within the humanities academy to the requirement for greater relevance to contemporary practical needs and circumstances that governments now typically press for in return for the taxpayers' dollar. To recognize these new realities is not, of course, to idealize them as if every response for greater relevance were clearly formulated. Nor does it entail an overestimation of the kinds of contributions intellectuals can be expected to make to policy, as if these could – or, indeed, should – override the imperfect and compromised nature of any policy-making or political process. However, being sensibly cautious on these matters is a far cry from the kinds of wholesale regret with which some sections of the cultural left have responded to demands for the greater 'practicalization' of the academy unless those demands can meet the measure of

some ideal critical calculus of their own making. While such views still have their advocates, it can now confidently be expected that such advocacy will prove increasingly inconsequential, just as it can be expected that the locus of productively critical work will shift to the interface between pragmatically orientated theoretical tendencies and actually existing policy agendas.

This brings me to my second point, for, while the propositions I have just advanced would not recruit the support of the majority of those who locate their work within cultural studies, they would recruit *some* support and, if my antennae are reading the changing environment correctly, are likely to prove more successful in this regard. However, this is less to say that the advocates of cultural policy studies have proved successful in winning new converts to their case than it is to suggest that the 'policy debate' was itself a symptom of what was already a clearly emerging division between revisionist tendencies within cultural studies – tendencies, that is, wishing to embrace reformist rhetorics and programs – and tendencies still committed to the earlier rhetorics of revolution or resistance. The 'policy debate', viewed in this light, served a catalysing function in serving as a means of clarifying options which were already evident as emerging tensions within cultural studies. Be this as it may, policy-related arguments now occupy a recognizable position within the landscape of cultural studies debates, a position in which it is clear that the references to policy serve to flag a more general set of issues concerning the kinds of political stances, programs, styles of intellectual work and relations of intellectual production that can now cogently be claimed for cultural studies work.

These are the issues with which I want to engage here. However much heat or light it may once have generated, the 'policy debate' has been 'off the boil' for some time now and I have no wish to heat the topic up again by reviving the controversies which characterized it. There is some value, however, in looking beneath the surface of those controversies to identify some of the discursive antagonisms which the debate activated. For these have a longer history and, if we can identify the historical provenance of the discursive grid which places culture on one side of a discursive divide and policy on the other, we shall have gone a good way towards undermining the logic of this antagonism and the related oppositions which are frequently articulated to it.

This is not, I should stress, a matter of pointing an accusing finger at those who criticized the proponents of the 'policy case'. To the contrary, I want to take my initial bearings from two such critics – Meaghan Morris and, although he had earlier seen himself as a proponent of the 'cultural-policy push' (O'Regan 1992: 415), Tom O'Regan – both of whom, while supporting the view that cultural studies should concern itself with policy issues, registered their main concern (with some justice) as being with the polarized options which policy advocates seemed to be posing. Morris thus objected that 'the big dichotomy of "Criticism and Policy"' had proved unable to focus debate in a fruitful and realistic way and saw 'policy polemic' as 'haunted by phantom *tendencies* that never quite settle into a mundane human shape' (Morris 1992a: 548). Tom O'Regan's nuanced and challenging discussion of the 'policy moment' led in a similar direction. Objecting to the over-polarized option of 'criticism or policy', O'Regan rightly points out that the relations between these are both permeable and variable:

> As far as intervention and self-conduct are concerned, the very issue
> of choosing between policy and cultural criticism – which to write for,
> which to inhabit – must turn out to be a question admitting no general
> answer. There are no *a priori* principles for choosing policy over cultural
> criticism. Nor can any presumption be made about social utility and
> effectiveness as necessarily belonging to one or the other. Cultural
> policy and criticism are not hermetically sealed but are porous systems;
> open enough to permit transformation, incorporation and translation,
> fluid enough to permit a great range of practices and priorities. To put
> this crudely: words like 'social class' and 'oppression' (and their atten-
> dant rhetorics) may not enter the vocabulary of government policy, but
> without their social presence in credible explanatory systems, any policy
> directed towards securing equality and equal opportunity would be
> diminished in scope and power. The recognition of oppression informs
> the policy goal of access, the persistence of social class underwrites the
> goal of social equality. Cultural policy and criticism are different forms
> of life, but they often need each other, they use each other's discourses,
> borrowing them shamelessly and redisposing them.
>
> (O'Regan 1992: 418)

Given this, O'Regan argues, the call to change cultural critics into cultural bureau-
crats reflects a failure to identify correctly the often indirect, but none the less
real and consequential, contribution which cultural criticism makes to the policy
process in, through time, shifting the discursive grounds on which policy options
are posed and resolved.

I can find little to quarrel with here except to suggest the need for more
clearly stressing the two-way nature of this traffic if we are also to understand
how the discursive terms in which some forms of cultural criticism are themselves
conducted – those which speak in terms of cultural rights, for example – are often
a by-product of specific forms of governmental involvement in the sphere of culture.
Where I think O'Regan is mistaken is when, in the light of considerations of this
kind, he suggests that those who have argued that cultural studies should reorient
its concerns so as to accord policy issues a greater centrality have been 'attacking
phantom targets' in supposing that such concerns could not simply be accommo-
dated within existing traditions of work within cultural studies. Notwithstanding
his own good sense in stressing the permeability of the relations between cultural
policy and cultural criticism, there are versions of cultural criticism which *do* rest
on a principled rejection of any engagement with the mundane calculations of
bureaucratic procedures and policy processes. Fredric Jameson offered one version
of this position in his unqualified rejection of policy questions as of no possible
relevance to the critical intellectual. Nor was this an isolated instance: indeed, a
veritable cacophony of voices was raised in principled condemnation of the policy
option as such.

The difficulty which O'Regan's arguments tend to gloss over, then, is that
there have been influential traditions within cultural studies which have sought to
render criticism and policy constitutively impermeable to one another. The grounds
invoked for this have been variable, ranging from the anti-reformist heritage of

some traditions of Marxist thought to radical-feminist perceptions of the state as essentially patriarchal and, therefore, beyond the reach of useful engagement. These are, however, variants of more general positions which have been applied to justify the adoption of a position of critical exteriority in relation to other policy fields – those of economic or social policy, for example. Objections of this kind have usually been based on the grounds that any policies emerging from the state are bound to reflect the interests of a ruling class or of patriarchy rather than because of any intrinsic properties that are attributed to the economy or to the field of the social as such. The more distinctive reasons that have been advanced in opposition to an engagement with cultural policy, by contrast, have rested on a view of culture which is in some way intrinsically at odds with, and essentially beyond the reach of, the mundane processes of policy formation.

This, then, is one of the issues I want to look at: the respects in which the shape of the criticism–policy polarity has been configured by a unique constellation of issues, pertaining solely to the field of culture, which are the legacy, broadly speaking, of Romanticism. I shall broach these issues by reviewing what Theodor Adorno had to say about cultural policy in the context of his broader discussion of the relationships between culture and administration. The discussion in question has been referred to by a number of contributors to 'the cultural policy debate', mainly to suggest that we should view Adorno's account as exemplary in its refusal to dissolve the contradictory tensions between culture and administration (see, for example, Jones 1994: 410). I shall suggest, to the contrary, that the historical limitations of Adorno's account are only too apparent and that it is, accordingly, now possible to see beyond the rims of the polarities which sustained it.

I shall take my bearings for the second issue I want to discuss from a related polarity, and one O'Regan introduces in contrasting a 'bottom-up' concern with policy, which he argues has always characterized cultural studies, with the 'top-down' approach which he attributes to advocates of the 'cultural-policy push'. In the 'bottom-up' approach, policy is 'understood in terms of its consequences and outcomes, and in terms of the actions of those affected by it, as they exert some measure of influence upon the process' (O'Regan 1992: 409). The 'top-down' approach, by contrast, recommends that cultural studies 'should reorient its concerns so as to coincide with top-down programs and public procedures, become bureaucratically and administratively minded in the process' (412). In the course of his discussion, O'Regan draws on a term I had proposed in suggesting that intellectuals working in the cultural field should think of themselves as 'cultural technicians' – a concept which O'Regan interprets as being about 'securing policy resources, consultancies and engagements' (413). This is an unfortunate representation of the concept, since the context in which I had introduced it was as part of an argument that was intended to call into question the very construction of the kind of bottom-up–top-down polarity O'Regan proposes. For such polarities lose their coherence if the relations between the kinds of politics cultural studies has supported and modern forms of government can be seen as relations of mutual dependency to the degree that the former ('bottom-up' politics) often depend on, and are generated by, the latter ('top-down' forms of government).

'How cultural forms and activities are politicized and the manner in which their politicization is expressed and pursued: these,' I argued, 'are matters which emerge from, and have their conditions of existence within, the ways in which those forms and activities have been instrumentally fashioned as a consequence of their governmental deployment for specific social, cultural or political ends' (Bennett 1992b: 405). It was in this context that I proposed the term 'cultural technicians' as a description of the political role of intellectuals which, rather than seeing government and cultural politics as the *vis-à-vis* of one another, would locate the work of intellectuals within the field of government in seeing it as being committed 'to modifying the functioning of culture by means of technical adjustments to its governmental deployment' (1992b: 406).

This is not, of course, a matter of 'working for the government' (although it may include that) or of formulating policy in a 'top-down' fashion. To the contrary, my concern was with the ways in which the practice of intellectual workers both is, and is usefully thought of, as a matter of 'tinkering with practical arrangements' within the sphere of government – that is, the vast array of cultural institutions, public and private, that are involved in the cultural shaping and regulation of the population – in ways that reflect the genesis of cultural politics from within the processes of government, rather than viewing these in the form of a 'bottom-up' opposition to policy imposed from the top down. By way of making this argument clearer, I shall review a contemporary example of radical political engagement represented by those who argue that museums should be transformed into instruments of community empowerment and dialogue. I shall do so with a view to illustrating how this politics involves, precisely, a series of adjustments to the functioning of museums which, far from changing their nature fundamentally reconnects them to a new form of governmental program and does so – as any effective engagement with the sphere of culture must – precisely by tinkering with the routines and practices through which they operate.

The aesthetic personality and administration of culture

It is useful to recall that recent debates regarding the relations between culture and policy are not without historical precedent. Their closest analogue, perhaps, was the debate between the Frankfurt school and the American traditions of applied social research represented by Paul Lazarsfeld during the period when Lazarsfeld was seeking to involve the Frankfurt theorists, particularly Adorno, more closely in the work of the Office for Radio Research which he directed. The tensions this engendered were perhaps best summarized by Adorno's testy remark, recalling his rebuttal of a request from Lazarsfeld that he (Adorno) should aspire to greater empirical precision, that 'culture might be precisely that condition that excludes a mentality capable of measuring it' (cited in Jay 1973: 222). This tension between the aesthetic realm and the requirements of bureaucratic calculation and measurement was one to which Adorno returned in a later essay on the relations between culture and administration which, if its limitation is that its diagnosis is ultimately caught and defined by the terms of this antinomy, identifies its historical basis with unparalleled acuity. Adorno characteristically insists on retaining both aspects of

this antinomy, refusing both an easy resolution that would side, unequivocally, with the one against the other as well as the temptation to project their overcoming through the historical production of a higher point of dialectical synthesis. For Adorno, culture and administration, however much they might be opposites, are also systemically tangled up with one another in historically specific patterns of interaction from which there can be no escape.

The terms in which the tensions between the two are to be described are made clear in the opening moves of the essay:

> Whoever speaks of culture speaks of administration as well, whether this is his intention or not. The combination of so many things lacking a common denomination – such as philosophy and religion, science and art, forms of conduct and mores – and finally the inclusion of the objective spirit of an age in the single word 'culture' betrays from the outset the administrative view, the task of which, looking down from on high, is to assemble, distribute, evaluate and organize . . .
>
> At the same time, however – according to German concepts – culture is opposed to administration. Culture would like to be higher and more pure, something untouchable which cannot be tailored according to any tactical or technical considerations. In educated language, this line of thought makes reference to the autonomy of culture. Popular opinion even takes pleasure in associating the concept of personality with it. Culture is viewed as the manifestation of pure humanity without regard for its functional relationships within society.
>
> (Adorno 1991: 93)

This sense of a constitutive and inescapable tension ('culture suffers damage when it is planned and administered' but equally, culture, 'when it is left to itself . . . threatens to not only lose its possibility of effect, but its very existence as well' – 1991: 94) suffuses the essay, gaining in layers of complexity as the analysis develops. The two realms, Adorno argues, rest on antithetical norms:

> The demand made by administration upon culture is essentially heteronomous: culture – no matter what form it takes – is to be measured by norms not inherent to it and which have nothing to do with the quality of the object, but rather with some type of abstract standards imposed from without, while at the same time the administrative instance – according to its own prescriptions and nature – must for the most part refuse to become involved in questions of immanent quality which regard the truth of the thing itself or its objective bases in general. Such expansion of administrative competence into a region, the idea of which contradicts every kind of average generality inherent to the concept of administrative norms, is itself irrational, alien to the immanent ratio of the object – for example, to the quality of a work of art – and a matter of coincidence as far as culture is concerned.
>
> (1991: 98)

In a situation in which 'the usefulness of the useful is so dubious a matter', a line drawn 'strictly in ideology', the 'enthronement of culture as an entity unto itself' mirrors and mocks 'the faith in the pure usefulness of the useful' in being looked on 'as thoroughly useless and for that reason as something beyond the planning and administrative methods of material production' (99). At the same time, there can be no withdrawal from administration which, in the past as in the present, persists as a condition of art's possibility:

> The appeal to the creators of culture to withdraw from the process of administration and keep distant from it has a hollow ring. Not only would this deprive them of the possibility of earning a living, but also of every effect, every contact between work of art and society, something which the work of greatest integrity cannot do without, if it is not to perish.
>
> (1991: 103)

At the same time that art 'denounces everything institutional and official' (102), it is dependent on official and institutional support, just as administration invades the inner life as with the 'UNESCO poets' who 'inscribe the international slogans of high administration with their very hearts' blood' (107).

While thoroughly aware that the system he describes is historically specific, Adorno can see no way beyond it, no set of relations in which culture will not be, at the same time, critical of, while dependent on, an administrative and bureaucratic rationality, no way in which culture can escape the gravitational pull of the everyday forms of usefulness to which it presents itself as an alternative. The best that can be hoped for, Adorno argues, is the development, in the cultural sphere, of 'an administrative praxis' which, in being 'mature and enlightened in the Kantian sense', will exhibit a 'self-consciousness of this antinomy and the consequences thereof' (98). What Adorno has in mind here becomes clearer towards the end of his essay when he articulates his vision for a cultural policy. A cultural policy that is worthy of the name, that would respect the specific content of the activities it would administer, Adorno argues, must be based on a self-conscious recognition of the contradictions inherent in applying planning to a field of practices which stand opposed to planning in their innermost substance, and it must develop this awareness into a critical acknowledgment of its own limits. Practically speaking, this means that such a policy must recognize the points at which administration 'must renounce itself' in recognizing its need for 'the ignominious figure of the expert' (111). Adorno is, of course, fully aware of the objections this position might court and he rehearses them fully, particularly the 'notorious accusation . . . that . . . the judgement of an expert remains a judgement for experts and as such ignores the community from which, according to popular phraseology, public institutions receive their mandate' (111). Even so, the expert is the only person who can represent the objective discipline of culture in the world of administration where his (for such experts, Adorno assures us [113], are 'men of insight') expertise serves as the only force capable of protecting cultural matters from the market ('which today unhesitatingly mutilates culture' [112]) and democracy (in upholding 'the interest of the public against the public itself'

[112]). It is from this perspective that Adorno concludes his account of the rela-
tions between culture and administration in suggesting that there is still room for
individuals in liberal-democratic societies to unfreeze the existing historical rela-
tions between the two. 'Whoever makes critically and unflinchingly conscious use
of the means of administration and its institutions,' he suggests, in the slim ray of
hope he allows himself, 'is still in a position to realise something which would be
different from merely administered culture' (113). 'Whoever', in this context,
however, is not quite so open a category as it seems, for Adorno has in fact already
closed this down to the expert, the aesthetic personality who alone is able to act
in the sphere of administration in the name of values which exceed it, a lonely
historical actor destined to be lacerated by the contradictions he seeks to quell in
culture's favour.

It is easy to see why, in terms of both his intellectual formation and histori-
cal experience, Adorno would be driven to a conclusion of this kind. It is equally
clear, however, that the position is no longer – if ever it was – tenable. For, in
its practical effects, it amounts to an advocacy of precisely those forms of arts
administration that have been, in varying degrees, successfully challenged over the
postwar period because of the aesthetic, and therefore social, bias they entail. The
criticisms that have been made of the rhetorics of 'excellence', as interpreted by
expert forms of peer evaluation, within the evaluative criteria and processes of the
Australia Council are a case in point. The grounds for such criticisms, moreover,
have typically been provided by a commitment to those democratic principles of
access, distribution and cultural entitlement whose force, in Adorno's perspective,
the enlightened administrator was to mute and qualify in a cultural policy worthy
of the name. What has happened over the intervening period to make Adorno's
position pretty well uninhabitable, except for a few retro-aesthetes, has been that
culture has since been relativized – in policy procedures and discourses just as
much as in academic debate – and, except in the perspective of cultural conserva-
tives, relativized without any of the dire consequences Adorno predicted coming
true.

In the course of his essay, Adorno signals his awareness that the ground of
culture on which he takes his stand is giving way beneath him. 'The negation
of the concept of the cultural,' he writes, 'is itself under preparation' (106). He
suggests that this entails the death of criticism as well as the loss of culture's
autonomy.

> And finally, criticism is dying out because the critical spirit is as
> disturbing as sand in a machine to that smoothly-running operation
> which is becoming more and more the model of the cultural. The criti-
> cal spirit now seems antiquated, irresponsible and unworthy, much like
> 'armchair' thinking.
>
> (1991: 107)

The truth is the opposite. It is precisely because we can now, without regret, treat
culture as an industry and, in so doing, recognize that the aesthetic disposition
forms merely a particular market segment within that industry, that it is a particu-
lar form of life like any other, that it is possible for questions of cultural policy

to be posed, and pursued, in ways which allow competing patterns of expenditure, forms of administration and support to be debated and assessed in terms of their consequences for different publics, their relations to competing political values and their implications for particular policy objectives – and all without lacerating ourselves as lonely subjects caught in the grip of the contradictory pincers of culture and administration. There are no signs, either, that this has entailed the death of criticism if by this is meant taking particular policy and administrative arrangements to task because – from a stated perspective – they fail to meet specified political or cultural objectives, or because they are contradictory or technically flawed. If, by contrast, it means the death of criticism as an activity that proceeds from a position – Adorno's culture – that is located in a position of transcendence in relation to its object, we should not mourn its passing. That critics have had to forsake such high ground in recognizing 'the professional conditions they share, for the most part, with millions of other knowledge workers', Andrew Ross has argued (Ross 1990), is no cause for lament. To the contrary, the less academic intellectuals working in the cultural sphere are able to take refuge in antinomies of this kind, the less likely it is that their analyses will be eviscerated by a stance which, in their own minds, gives them a special licence never to engage with other intellectuals except on their own terms.

Community, culture and government

Let me go back to O'Regan and the role that he accords the concept of community in illustrating the differences between the 'bottom-up' and 'top-down' approaches to policy. From the former perspective, 'cultural studies engaged with the policy development of the state, from the point of view of disadvantaged recipients or those who are excluded from such policies altogether, and it sought to defend or to restore community' (O'Regan 1992: 410). For the latter, by contrast, the goal 'is no longer to celebrate and help restore the community which survives and resists manipulative social and cultural programs; it is rather to accept the necessary lot of intervention and to recognize that such communities are themselves the by-product of policy' (412). What this polarized construction misses, I think, are the more interesting issues, which O'Regan glimpses in his concluding formulations, concerning the respects in which what, at first sight, appear to be autochthonous forms of 'bottom-up' advocacy of community so often turn out to be generated from within, and as a part of, particular governmental constructions of community. Yet the antinomy is not, of course, of O'Regan's making. To the contrary, it is inscribed within the history of the concept of community which, as Raymond Williams has noted, is such a 'warmly persuasive' word that whatever is cast in the role of 'not community' is thereby, so to speak, linguistically hung, drawn and quartered by the simple force of the comparison. The state, in being portrayed as the realm of formal, abstract and instrumental relationships in contrast to 'the more direct, more total and therefore more significant relationships of community' (Williams 1983: 92) has fared particularly badly in this respect.

Whenever 'community' is drawn into the debate, then, we need to be alert to the fact that it brings with it layers of historical meaning that have become

sedimented in contemporary usage – the common people as opposed to people of rank or station; the quality of holding something in common; a sense of shared identity emerging from common conditions of life – which imply a condemnation of whatever has been constructed as its opposite. A few examples drawn from contemporary debates regarding the relations between museums and communities will show how this, the rhetorical force of the term, operates. Advocates of the community perspective within these debates typically speak of museums as means of empowering communities by encouraging their participation in, and control over, museum programmes. This perspective of museums as vehicles for discovering and shaping a sense of community, of a shared identity and purpose, has been developed as a criticism of earlier views of museums which saw their roles primarily in didactic terms. The ideals of the ecomuseum thus constitute an explicit break with, and critique of, the 'top-down' model of museums which sees museums as having a responsibility to instruct their publics in favour of a more interactive model through which the public, transformed into an active community, becomes the co-author of the museum in a collaborative enterprise 'designed to ensure "mutual learning" and the participation of all', whose ultimate goal is 'the development of the community' (Hubert, cited in Poulot 1994: 66). From this perspective, the administrative vocabulary which speaks of museums in terms of their relations to audiences, citizens or publics appears abstract and alienated, just as the realms of government or of the state stand condemned as external and impositional forms which are either indifferent or antagonistic to the creative cultural life of communities.

Yet it is also the case that it is precisely from within the practices of government that 'community' acquires this paradoxical value of something that is both to be nurtured into existence by government while at the same time standing opposed to it as its antithesis. The points Poulot makes in his discussion of the ecomuseum movement provide a telling example of this paradox. The distinguishing feature of the ecomuseum movement, Poulot argues, consists in the way it connects the concern with the preservation and exhibition of marginalized cultures which had characterized the earlier folk-museum and outdoor-museum movements to notions of community development, community empowerment and community control. The ecomuseum, as Poulot puts it, is 'concerned with promoting the self-discovery and development of the community' (Poulot 1994: 75); 'it aims not to attain knowledge but to achieve communication' (76); it is concerned less with representation than with involvement – 'the ecomuseum searches, above all, to engage (*voir faire*) its audience in the social process' (78); and its focus is on everyday rather than on extraordinary culture. And yet, Poulot argues, no matter how radically different the programme of the ecomuseum may seem from that of more traditional museum forms, it is one which, at bottom, is motivated by similar civic aspirations, albeit ones that are applied not universally to a general public but in a more focused way related to the needs of a particularly regionally defined community. The ecomuseum, he argues, embodies a form of 'civic pedagogy' which aims to foster self-knowledge on the part of a community by providing it with the resources through which it can come to know and participate in its culture in a more organized and self-conscious way. Viewed in this light, Poulot suggests, the ecomuseum is best seen as a 'kind of state-sponsored public works

project' which seeks to offer 'a program of "cultural development" of the citizen' (79).

This identifies precisely why equations which place museums and communities on one side of a divide as parts of creative, 'bottom-up' processes of cultural development and the state or government on another as the agents of external and imposed forms of 'top-down' cultural policy formation are misleading. However much the language of community might imply a critique of the more abstract relationships of government or of a state, what stands behind the ecomuseum are the activities of government which, in establishing such museums and training their staff, developing new principles for the exhibition of cultural materials and a host of related tinkerings with practical arrangements, organize and constitute the community of a region in a form that equips it to be able to develop itself as a community through acquiring a greater knowledge and say in the management of its shared culture. This is not to deny the reality of the existence of regions or, more generally, particular social groups outside and independently of particular governmental programmes – whether these are those of museums, programmes of community development or community arts programmes. Nor is it to suggest that the ways in which communities might be constructed and envisaged are restricted to such governmental practices – far from it. What it is to suggest, though, is that community can no more function as an outside to government than government can be construed as community's hostile 'other'. When, in the language of contemporary cultural debates, 'community' is at issue, then so also is government as parts of complex fields in which the perspectives of social movements, and of intellectuals allied to those movements, and shifts in the institutional and discursive fields of policy, interact in ways that elude entirely those theorizations which construct the relations between the fields of culture and politics and culture and policy in terms of a 'bottom-up'–'top-down' polarity. An adequate analytical perspective on cultural policy needs, then, to be alert to the patterns of these interactions. But then so, too, does an adequate practical engagement with cultural policy need to be alert to the fact that being 'for community' may also mean working through and by governmental means.

Nicholas Garnham

POLITICAL ECONOMY AND
CULTURAL STUDIES

EDITOR'S INTRODUCTION

NICHOLAS GARNHAM'S PROVOCATIVE plea for cultural studies to turn to (or, as he sees it, return to) a "political economy" orientation complains that cultural studies' claim to resistance and radicalness is gestural and complacent unless it is based on materialist, anti-capitalist (socialist?) analysis.

What would such an analysis involve, according to Garnham? First, placing cultural production rather than consumption or reception at the discipline's center; second, an acceptance of capitalism and the class hierarchies embedded in capitalism as the ultimate horizon and target of cultural analysis; third, reinstating "false consciousness" as a key category on the grounds that social and economic "structures of domination" are veiled by popular culture, it being the task of cultural studies intellectuals to lift that veil, and disseminate hidden truth through the education system; and fourth, marginalizing other, more or less emergent, social identities – feminist, ethnic, queer – on the grounds that they are insufficiently constituted in relation to the main game: class and capitalism.

Lawrence Grossberg, in his spirited rejoinder to Garnham's polemic (Grossberg 1998), points out that Garnham's concepts of capitalism, false consciousness and class are historically and spatially undifferentiated abstractions; that class, race, and gender are articulated with one another, and that, for Garnham, the market, and its opening out of possibilities, is reduced to a classical antagonism between capital and labor. One could add that Garnham is not at all clear about what his alternatives to capitalism are, and how academic political economics of culture might help to produce them. No doubt other difficulties with the essay will occur to readers, and indeed, in a revised and extended version of this essay (Garnham 1997) Garnham has begun to address its problematic himself. Certainly, as the idea and

reality of socialism fade (momentarily?) from history, it remains important to recognize, as Garnham cogently does, that cultural studies still needs to question capitalism in the interests of those it does not adequately reward economically.

Further reading: Clarke 1991; Du Gay 1997; Grossberg 1998; McGuigan 1992; McRobbie 1996.

In his recent book, *Cultural Populism*, Jim McGuigan identifies 'a discernible narrowing of vision in cultural studies, exemplified by a drift into an uncritical populist mode of interpretation' (McGuigan 1992: 244). He locates the sources of this drift in bracketing off economic determinations, 'because of some earlier traumatic encounter with the long redundant base-superstructure model of "orthodox" Marxism, a trauma represented symptomatically by a debilitating avoidance syndrome' (p. 245).

This article explores the implications of this founding antagonism between Marxist political economy and cultural studies. I will argue that the antagonism is based on a profound misunderstanding of political economy and that the project of cultural studies can be successfully pursued only if the bridge with political economy is rebuilt. I say 'rebuilt' because cultural studies as an enterprise came out of a set of assumptions about political economy. It continues to carry that paradigm within itself as its grounding assumption and its source of legitimation as a 'radical' enterprise, even if this paradigm is often suppressed or disguised behind a rhetorical smokescreen in order to avoid the dread accusation of economism or reductionism.

What do I mean? The founding thrust of cultural studies in the work of Raymond Williams and Richard Hoggart – itself drawing on the legacy of Leavis – was, first of all, the revalidation of British working class or popular culture against the elite, dominant culture. It was situated within the context of a class structure formed by industrial capitalism and an increasingly commercialized system of cultural production, distribution, and consumption. But this was not just a revalidation of popular culture for its own sake. It was an oppositional, broadly socialist political movement which saw the cultural struggle as part of a wider political struggle to change capitalist social relations in favor of this working class. The revalidation of working-class culture was a move to rescue this culture and those who practiced it from what E.P. Thompson called 'the immense condescension of posterity' and to provide this class with the self-confidence and energy to assert its own values – 'the moral economy of the working class' – against those of the dominant class. Thus cultural studies took for granted a particular structure of domination and subordination and saw its task as the ideological one of legitimation and mobilization. It clearly viewed itself as part of a wider political struggle, even if many of its practitioners saw education as a key site for their contribution to that struggle. It knew both the enemy and its friends.

I want to argue that cultural studies as a meaningful political enterprise is unsustainable outside this founding problematic. One can clearly see in contemporary writing from both British and US cultural studies that most of the current

practitioners still assume, indeed assert, that cultural studies is a broadly opposi-
tional political enterprise. It is to this that Stuart Hall, in the article reproduced
in this volume, refers when he talks about cultural studies' worldly vocation: 'I
don't understand a practice which aims to make a difference in the world, which
doesn't have some points of difference or distinction which it has to stake out,
which really matter.' It is to this idea that the cultural studies literature constantly
refers in its mantric repetitions of struggle, empowerment, resistance, subordina-
tion and domination.

Two developments

In the history of cultural studies there have been two main developments. First,
the question of ideology has been immensely complicated by developments
within the analysis of textuality. This analysis has brought into question the concepts
of truth and falsity, of intentionality and interpretation. It has incessantly posed
the difficult but unavoidable problem of the relationship between symbolic repre-
sentations and social action. Second and crucially, the concepts of domination and
subordination have widened from referring only to class to include also race
and gender. The enemy is now not just capitalism but what Fiske (1992: 161)
calls 'white patriarchal capitalism'. The question for my purposes is whether these
developments invalidate the original links of cultural studies with political economy.

To answer this question, it is necessary to explain what I think economy means.
I want to rescue the concept from the false image that circulates largely unques-
tioned within cultural studies, to rescue it from the immense and damaging
condescension of cultural studies.

The roots of political economy can be traced to the Scottish Enlightenment,
to the writings of Adam Ferguson and Adam Smith. Witnessing the early impact
of capitalist relations of production, they argued that societies could be distin-
guished on the basis of their 'modes of subsistence'. They insisted that without a
functioning mode of subsistence a society and its members could not survive and
that it was in this sense foundational, or the society's base. For them modes of
subsistence had key structural characteristics – whether in terms of the dominance
of pastoral, agricultural or industrial modes of production or in terms of differing
relations of production (feudal or capitalist or a combination of the two). Here
the crucial difference in analytical traditions has been and remains over what each
tradition holds as the source of historical change and the key defining character-
istic of modes of production. On one side are those who stress technology and
organizational forms of production, while on the other are those who emphasize
collaborative social relations.

Three crucial aspects of political economy follow from the perspective that
collaborative social forms are the key characteristic of production. First, such collabo-
ration requires a set of institutional forms and cultural practices – legal and
political forms, family structures, and so forth (what became known as the super-
structure) – in order to function. Moreover, different modes of production will
have different sets of superstructural forms and practices. Second, this necessary
structure of social collaboration is the form through which individual social agents

are shaped and relate to one another. Thus, identity formation and culture prac-
tices are not random. They are, in some sense, to be analyzed, determined. Third,
given the necessarily collaborative and supra-individual nature of the mode of
production, the normative question of justice must be addressed. That is to say,
how can inequitable distributions of the resources produced by the mode of produc-
tion be either justified or changed? Thus, the question of the distribution of the
surplus was central to political economy from the start. By what mechanisms was
it distributed and how was it justified? This was as crucial to Adam Smith as to
Marx. For Smith, rent and the unfair share of surplus being taken by landed capital
was the problem. For Marx, the problem was profit and the exploitation of wage
labor. Both attempted to develop a labor theory of value in order to explain the
existing pattern of distribution and the ways in which it diverged from the ideal
of social justice.

Classical sociology from Smith through Marx to Weber understood that the
distribution of social resources was not natural but resulted from political struggle.
Moreover, the positions that people took in such struggles were usually related to
the sources of their income or the nature of their stake in the given mode of
production. Thus, from the beginning, class was not simply an abstract analytical
category. It was a model of the link via ideology between relations of production
and political action. The link between base and superstructure was material interest.
The question for our purposes is whether this model is any longer valid and whether
it is compatible with the project of cultural studies.

It seems clear that most cultural studies practitioners do in fact accept the
existence of a capitalist mode of production. Although Fiske (1992: 157), for
instance, wishes to sever any determining link between 'the cultural economy' and
'the financial economy', he none the less constantly refers to something called
capitalism as the source of domination: 'The social order constrains and oppresses
the people, but at the same time offers them resources to fight against those
constraints. The constraints are, in the first instance, material, economic ones
which determine in an oppressive, disempowering way, the limits of the social
experience of the poor. Oppression is always economic.'

This sounds dangerously economistic to me. Similarly Larry Grossberg (1992:
100), while arguing for radically distinct 'economies of value' – money, meaning,
ideology, and affect – with no necessary determining relationship, at the same time
argues that the fact that 'people cannot live without minimal access to some material
conditions ensures only that economics (in a narrow sense) must always be
addressed in the first instance'. He talks elsewhere in the same book, in a very
deterministic manner, of the 'tendential forces' of capitalism, industrialism, and
technology (123).

The first problem in the relation between political economy and cultural
studies, then, is the refusal of cultural studies to think through the implications of
its own claim that the forms of subordination and their attendant cultural prac-
tices – to which cultural studies gives analytical priority – are grounded within a
capitalist mode of production. One striking result has been the overwhelming focus
on cultural consumption rather than cultural production and on the cultural prac-
tices of leisure rather than those of work. This in turn has played politically into
the hands of a right whose ideological assault has been structured in large part

around an effort to persuade people to construct themselves as consumers in opposition to producers. Of course, they are themselves at the same time producers, who must enter into an economic relation of production in order to consume. While not wishing to be economistic, would cultural studies practitioners actually deny that the major political or ideological struggles of the last decade in advanced capitalist countries have been around, for better or worse, narrowly economic issues – taxation, welfare, employment, and unemployment? Would they deny that much so-called identity politics, and the cultural politics of lifestyle associated with it, has its roots in the restructuring of the labor market – the decline of white male manual labor, increased female participation, the failure to incorporate blacks into the wage labor force, the growth of service employment, and so on?

By focusing on consumption and reception and on the moment of interpretation, cultural studies has exaggerated the freedoms of consumption and daily life. Yes, people are not in any simple way manipulated by the dominant forces in society. Yes, people can and often do reinterpret and use for their own purposes the cultural material, the texts, that the system of cultural production and distribution offers them. Yes, it is important to recognize the affective investment people make in such practices and the pleasures they derive from them. But does anyone who has produced a text or a symbolic form believe that interpretation is entirely random or that pleasure cannot be used to manipulative ends? If the process of interpretation were entirely random, and if, therefore we had to give up entirely the notion of intentionality in communication, the human species would have dropped the activity long ago.

Political economists recognize with Marx that all commodities must have a use-value; they must satisfy some need or provide some pleasure. There is no simple relationship between the unequal power relations embedded in the production, distribution and consumption of cultural forms as commodities – the overwhelming focus of cultural studies analysis – on the one hand, and the use-value of that commodity to the consumer on the other. But there is some relationship. A delimited social group, pursuing economic or political ends, determines which meanings circulate and which do not, which stories are told and about what, which arguments are given prominence and what cultural resources are made available and to whom. The analysis of this process is vital to an understanding of the power relationships involved in culture and their relationship to wider structures of domination. As Grossberg rightly argues, 'Daily life is not the promised land of political redemption. . . . By separating structure and power it [the focus on daily life] creates the illusion that one can escape them. But such fantasies merely occlude the more pressing task of finding ways to distinguish between, evaluate and challenge specific structures and organizations of power' (Grossberg 1992: 94). Certainly the cultural industries are such specific structures and organizations of power. Where in the contemporary cultural studies literature or research program are examinations of the cultural producers and of the organizational sites and practices they inhabit and through which they exercise their power?

There are two issues at stake here. First, what explanatory force does such economic analysis have at the cultural level? And second, in what way do people

come to understand and act upon their conditions of existence through cultural practices? Both of these issues are linked to the question of false consciousness.

While in the past, some from within political economy may have argued for a narrow reflectionist or determinist relationship between the mode of production and cultural practices, such a position is not necessarily entailed by the general approach. Political economy certainly does argue that some institutional arrangements, involving specific cultural practices, necessarily accompany a capitalist mode of production. Two examples are laws of private property and the legal practices within which such laws are enacted. These legal practices in turn require forms of legitimated coercion and definitions of criminality to support them. The cultural link between ownership and identity, so central to many consumption and lifestyle studies, will be part of such a formation. On the other hand, it is clear that while some political institutions and practices will be necessary – and the mode of production may place limits on the range of their viable forms – the capitalist mode of production does not demand, require, or determine any one form of politics. Some capitalist apologists have made that argument in relation to representative democracy, but it is obvious from the historical record that capitalism has been and is compatible with a range of political forms.

Nor is political economy a functionalism. It does not claim that certain superstructures will be created because the mode of production requires them. Again, it is clear from the historical record that the capitalist mode of production can grow within a variety of inherited superstructural forms. All that is required is that they be compatible with the mode of production. Thus, in addition to political systems, a range of kinship systems, religious beliefs and practices, and aesthetic traditions may happily coexist with the capitalist mode of production. Political economy does argue that once a mode is established, the general interest of the human agents living within it in their own material survival and reproduction will tend to coordinate human actions so as to ensure their maintenance. For this reason, critics of the dominant ideology thesis – such as Abercrombie *et al.* (1980) – have argued that the 'dull compulsion of economic relations', not ideological hegemony, explains the relative stability of the capitalist structure of domination, in spite of manifest inequalities. Thus, there is a strong inertia in modes of production. This in turn will entail the modification of cultural practices to maintain the dominant structure. Where these stress-points between base and superstructure will come and what forms of cultural change they will entail are matters for historical analysis. The historical analysis of the development of time discipline is a good example of this. So too are current analyses by scholars such as Giddens and Harvey of the impact of global post-Fordism on people's sense of space and time.

Political economy does not argue that attempts by human agents to maintain the system will be successful. The mode of production may well face insurmountable or unresolved tensions or contradictions between its various practices. For this reason, the regulation school argues that every regime of accumulation – the particular set of structural arrangements that at any time constitute the mode of production, involving the various possible relationships between labor and capital, and the associated patterns of distribution – will entail a corresponding mode of regulation. For instance, varying forms of welfare capitalism and social democracy developed to support the Fordist regime of accumulation. I should note

in passing that the recent work of Stuart Hall contains the strange cohabitation of a post-Fordist regulation school analysis of the so-called New Times with a denial of economic determinism. He cannot, in my view, have it both ways.

This relative autonomy of cultural practices from the mode of production entails the fact that – from the perspective dear to cultural studies of resisting, challenging, or changing the structure of domination based upon that mode of production – many cultural practices will simply be irrelevant. One of the problems with much cultural studies writing is that in fact it assumes a very strong form of the base/superstructure relationship, such that all the cultural practices of subordinate groups necessarily come into conflict with the structure of domination. As Fiske (1992: 161, 163) puts it, 'popular differences exceed the differences *required* by elaborated white patriarchal capitalism . . . Without social difference there can be no social change. The control of social difference is therefore *always* a strategic objective of the power bloc' (emphasis added).

False consciousness and intellectuals

This brings me to the question of the need – for purposes of the political project of cultural studies – for discriminating among cultural practices on the basis of their likely effectiveness, that is, their contribution to the general project of overthrowing domination. Such a project entails an analysis of the structure of domination to identify those practices that sustain domination and those that do not. This is what I take Grossberg (1992: 143) to mean when he writes: 'Identifying the politics of any struggle ultimately requires a map, not only of the actors and agents, but of what I shall call the agencies of this struggle.' This in turn brings us to the thorny problem of false consciousness and the role of intellectuals.

Cultural studies was founded on a turn from the analysis of dominant or elite cultural practices towards the analysis of popular cultural practices. There were two reasons for this turn. The first was to aid the working-class struggle by giving the working class a sense of the importance of its own experience, values, and voices as against those of the dominant class. In short, it was seen as a contribution to a classic Gramscian hegemonic struggle. But it assumed that the values embedded or enacted in these cultural practices were progressive and sprung directly from the experience of subordination. This was a classic Marxist view. A revolutionary consciousness would be produced by the direct experience of subordination. The problem was to mobilize it. This model was later used in the context of colonialism and race by Fanon and his followers and also within the feminist movement. It still runs powerfully through cultural studies, in particular through its increasing stress on the study of daily life. The project is then to give a voice to subordinate groups, a voice which stems from experience and therefore, is, by definition both authentic and progressive.

The second reason for the turn to popular culture derived from a different analytical tradition and from a different definition of the political problem. Here while rejecting their elitism, cultural studies shared the preoccupations of the Frankfurt School as well as those of Gramsci. The problem was the demonstrable lack of revolutionary consciousness, and the purpose of cultural studies was to

analyze the mechanisms by which people are mobilized or not behind those eman-
cipatory projects that aid progressive and combat reactionary action. There is, of
course, nothing original in this position. It merely recognizes Marx's own view
that in the ideological forms of the superstructure people become conscious of
economic conflicts and fight them out.

It does, however, have important consequences for the argument I am con-
ducting here. First, once political and cultural values are divorced from the neces-
sary authenticity of experience, some grounds for identifying positions as either
progressive or reactionary must be found. In short, we have to discriminate among
cultural practices. This in turn requires an analysis of the structure of domination,
which may be distinct from the perception of that domination by the social agents
subject to it. The concept of false consciousness makes people uncomfortable
because it seems to imply a rejection of the cultural practices of others as inauthen-
tic and the granting to intellectuals – or, more pertinently in the history of cultural
studies, a vanguard party – a privileged access to truth. However, once one accepts
the idea that on the one hand, our relations to social reality are mediated via sys-
tems of symbolic representation and, on the other hand, that we live within struc-
tures of domination – the mechanisms and effects of which are not immediately
available to experience – then a concept like false consciousness becomes necessary.
Moreover, only such a concept gives intellectuals a valid role. First, organic intel-
lectuals, in a necessary and legitimate division of labor, create the consciousness of
a class out of the fragments of that class's experience. Second, intellectuals provide
a political strategy by providing a map of the structure of domination and the ter-
rain of struggle.

In fact, most practitioners of cultural studies tacitly accept this; otherwise their
practice would be incomprehensible. But they have a debilitating guilty conscience
about it. Of course, this is not to say that the consciousness of subordinate groups
is necessarily false. That would be absurd. Whether a given consciousness is false
or not is a matter for analysis and demonstration and, politically, it entails accep-
tance by a given subordinate group. For that moment of recognizing false
consciousness is the basis for empowerment. At this moment, one lifts oneself out
of one's immediate situation and the limits of one's own immediate experience
and begins to grasp the idea of dominating structures. In this sense, the model of
the intellectual as a social psychoanalyst is both powerful and useful. And it is
indeed strange that a tradition of thought such as cultural studies, which has been
and remains so deeply influenced by psychoanalytical modes of thought, should
refuse to recognize false consciousness while recognizing repression in the psycho-
analytical sense.

This is not to deny the tensions implicit in the position of intellectuals as a
specific class fraction within the mode of production. But I am sure, if we are
honest, that we can all recognize the existence of false consciousness and thus the
fact that we do not always either know or act in our own best interest. I am sure,
in fact, we all recognize that there are those who know more about a subject than
we do and whose advice about how to cope with a given problem we would
accept. I am sure also that we are all aware of the ways in which the pressures of
everyday existence – of earning a living, of maintaining relationships, of bringing
up children – lead us to act in ways which we recognize, at least in retrospect,

as irrational and, to put it mildly, socially and personally suboptimal. The interesting question is why people, out of a misplaced sense of guilt or political correctness, choose to forget this when they put on their scholarly hats.

The refusal to recognize the possibility of false consciousness, the associated guilt about the status of intellectuals, and the fear of elitism have all contributed to undermining cultural studies' role within education. In its origins – and not just because its practitioners were located in academia – it saw education as a key site for its intervention. Educational policy and reform were a key focus of its activity.

Certainly, in the case of Williams, participation in the workers' education movement was formative and crucial. There were two aspects to this movement that cultural studies inherited. On the one hand, cultural studies wished to make education relevant to the experience of working people by recognizing their experiences, including their cultural practices, as valid subjects for study and as resources to draw upon in the classroom. Hence cultural studies' close association in its early days with the local and oral history movement as represented, for instance, by the journal *History Workshop*. But on the other hand, the movement by its very stress on education acknowledged that it was both possible and important politically to learn things that were not immediately available in experience and to reflect on that experience from the necessary distance that the classroom provides. The things to be learned included the valuable skills and knowledge which until then had been the reserve of the dominant class. Such a view of education – and of the role of cultural studies within it – claimed the whole of culture, including dominant cultural practices, for its field, provided a legitimate and valued role for intellectuals, and was not afraid to discriminate. Unfortunately, in my view, the educational influence of cultural studies has become potentially baleful and far from liberating because it has pursued the role of introducing popular cultural practices into the classroom indiscriminately at the expense of the wider political and emancipatory values of intellectual inquiry and teaching. The situation reminds me of a cartoon I saw some years ago in which two toddlers were playing in a sandpit overseen by a young female teacher. One toddler says to the other, 'Why is it always the ones with Ph.D.s who want us to make mud pies?' Whatever the reason, the tendency of cultural studies to validate all and every popular cultural practice as resistance – in its desire to avoid being tarred with the elitist brush – is profoundly damaging to its political project.

The rejection of false consciousness within cultural studies goes along with the rejection of truth as a state of the world, as opposed to the temporary effect of discourse. But without some notion of grounded truth the ideas of emancipation, resistance, and progressiveness become meaningless. Resistance to what, emancipation from what and for what, progression toward what? The cultural studies literature plays much with the word 'power'. The problem is that the source of this power remains, in general, opaque. And this vagueness about power and the structures and practices of domination allows a similar vagueness about resistance.

Here we need to make a distinction between resistance and coping. Much cultural studies literature focuses, quite legitimately and fruitfully, on the ways in which cultural practices can be understood as responding to and coping with people's conditions of existence. For Angela McRobbie and others, shopping grants

women a space for autonomous self-expression. For others, romance literature and soap operas provide the same function through fantasy. In the bad old days, we called this escapism; in those ascetic, puritan, socialist days escapism was a bad thing. Today, while it may be an understandable response to constrained social circumstances, and while it is clearly neither manipulated nor merely passive, and while these social subjects are not given any other options, escapism does little, it seems to me, to resist the structure of domination in which these subjects find themselves. In fact, escapism may (understandable as the practice is) contribute to the maintenance of that structure of power. This surely is Foucault's main theme – the widespread complicity of victims with the systems of power that oppress them. It is not a question of either patronizing this group or imposing one's own cultural standards on them, but of recognizing the systemic constraints within which they construct their forms of cultural coping and how unemancipative these can be. Surely the aim should not be to bow down in ethnographic worship of these cultural practices but to create a social reality in which there are wider possibilities for the exercise of both symbolic and (in my view more importantly) material power. Can we not admit that there are extremely constrained and impoverished cultural practices that contribute nothing to social change? We may wish to salute the courage and cultural inventiveness shown in such circumstances, but at the same time still wish to change them.

Structures of domination

Let me return to the question of power and the structure of domination, because here I think is possibly the main point of contention between political economy and cultural studies as it is presently constituted. To put the matter simply, political economy sees class – namely, the structure of access to the means of production and the structure of the distribution of the economic surplus – as the key to the structure of domination, while cultural studies sees gender and race, along with other potential markers of difference, as alternative structures of domination in no way determined by class.

That patriarchal and ethnically based structures of domination pre-existed the capitalist mode of production and continue to thrive within it is not in question. It is equally plausible to argue that forms of domination based on gender and race could survive the overthrow of capitalist class domination. Nor is the fact in question that until recently much political economic and Marxist analysis was blind to such forms of domination. But to think, as many cultural studies practitioners appear to do, that this undermines political economy and its stress on class is profoundly to misunderstand political economy and the nature of the determinations between economic and other social relations for which it argues.

There are two issues here. First, in what ways are the forms of this racial and gendered domination – and the awareness of and struggle against them – shaped determinately by the mode of production? Second, what might be the connections, if any, between the struggles against forms of domination based on class, gender, and race? Might there be any strategic priorities between them? Another way of putting this question is to ask whether the overthrow of existing class relations

would contribute to the overthrow of gender-and-race-based domination (or vice-versa) and to ask which forms of domination, if overthrown, would contribute most to human liberty and happiness.

It is hard to argue against the proposition that modern forms of racial domination are founded on economic domination. This is true in the slave trade and its aftermath in North America, in the form of immigrant labor in Western Europe, and in the various forms of direct and indirect colonialism throughout the world. While the forms of awareness of and struggle against such domination have been culturally varied, and will be so in the future, little dent will be made in domination if black is recognized as beautiful but nothing is done about processes of economic development, unequal terms of trade, global divisions of labor, and exclusion from or marginalization in labor markets.

The same goes for gender. Again, it would be hard to argue against the proposition that the forms of patriarchy have been profoundly marked by the ways in which the capitalist mode of production has divided the domestic economy from production as a site of wage labor and capital formation, by the ways in which women have been increasingly incorporated into the wage labor force often and increasingly at the expense of white male labor, and by changes in and struggles over the mode of reproduction and disciplining of labor power. It is plausible to argue, indeed I would argue, that contemporary feminism developed largely as a response to the growing tension between changes in the structure of the labor market and in the mode of reproduction of labor, driven by changes in the mode of production on the one hand and more traditional, inherited forms of patriarchy on the other. Again the cultural forms in which women and their allies come to recognize and struggle against this domination will be varied and of varying efficacy. But I am sufficiently old-fashioned to believe that no empowerment will mean much unless it is accompanied by a massive shift in control of economic resources. It is an interesting but open question whether such a shift is compatible with the existing class structure of developed capitalism.

In short, I would argue that one cannot understand either the genesis, forms, or stakes of the struggles around gender and race without an analysis of the political economic foundations and context of the cultural practices that constitute those struggles. The political economy of culture has never argued that all cultural practices are either determined by or functional for the mode of production of material life. But it has argued, and continues to do so, that the capitalist mode of production has certain core structural characteristics – above all that waged labor and commodity exchange constitute people's necessary and unavoidable conditions of existence. These conditions shape in determinate ways the terrain upon which cultural practices take place – the physical environment, the available material and symbolic resources, the time rhythms and spatial relations. They also pose the questions to which people's cultural practices are a response; they set the cultural agenda.

Political economists find it hard to understand how, within a capitalist social formation, one can study cultural practices and their political effectiveness – the ways in which people make sense of their lives and then act in the light of that understanding – without focusing attention on how the resources for cultural practice, both material and symbolic, are made available in structurally determined

ways through the institutions and circuits of commodified cultural production, distribution, and consumption. How is it possible to study multi-culturalism or diasporic culture without studying the flows of labor migration and their determinants that have largely created these cultures? How is it possible to understand soap operas as cultural practices without studying the broadcasting institutions that produce and distribute them, and in part create the audience for them? How is it possible to study advertising or shopping, let alone celebrate their liberating potential, without studying the processes of manufacturing, retailing, and marketing that make those cultural practices possible? How at this conjuncture is it possible to ignore, in any study of culture and its political potential, the development of global cultural markets and the technological and regulatory processes and capital flows that are the conditions of possibility of such markets? How can one ignore the ways in which changes in the nature of politics and of struggle are intimately related to economically driven changes in the relationship of politics to the institutions of social communication such as newspapers and broadcasting channels, and to the economically driven fragmentation of social groups and cultural consumers? If this is reductionist or economistic, so be it. It is, for better or worse, the world we actually inhabit.

Media and public spheres

Stuart Hall

ENCODING, DECODING

EDITOR'S INTRODUCTION

STUART HALL'S INFLUENTIAL essay offers a densely theoretical account of how messages are produced and disseminated, referring particularly to television. He suggests a four-stage theory of communication: production, circulation, use (which here he calls distribution or consumption) and reproduction. For him each stage is "relatively autonomous" from the others. This means that the coding of a message *does* control its reception but not transparently – each stage has its own determining limits and possibilities. The concept of relative autonomy allows him to argue that polysemy is not the same as pluralism: messages are not open to any interpretation or use whatsoever – just because each stage in the circuit limits possibilities in the next.

In actual social existence, Hall goes on to argue, messages have a "complex structure of dominance" because at each stage they are "imprinted" by institutional power-relations. Furthermore, a message can be received at a particular stage only if it is recognizable or appropriate – though there is space for a message to be used or understood at least somewhat against the grain. This means that power-relations at the point of production, for example, will loosely fit those at the point of consumption. In this way, the communication circuit is also a circuit which reproduces a pattern of domination.

This analysis allows Hall to insert a semiotic paradigm into a social framework, clearing the way for further work both textualist and ethnographic. His essay has been particularly important as a basis on which fieldwork like David Morley's has proceeded.

Further reading: Hall 1977, 1980; Jenkins 1992; Morley 1980, 1989, 1992; Nightingale 1996.

Traditionally, mass-communications research has conceptualised the process of communication in terms of a circulation circuit or loop. This model has been criticised for its linearity – sender/message/receiver – for its concentration on the level of message exchange and for the absence of a structured conception of the different moments as a complex structure of relations. But it is also possible (and useful) to think of this process in terms of a structure produced and sustained through the articulation of linked but distinctive moments – production, circulation, distribution, consumption, reproduction. This would be to think of the process as a 'complex structure in dominance', sustained through the articulation of connected practices, each of which, however, retains its distinctiveness and has its own specific modality, its own forms and conditions of existence.

The 'object' of these practices is meanings and messages in the form of sign-vehicles of a specific kind organised, like any form of communication or language, through the operation of codes within the syntagmatic chain of a discourse. The apparatuses, relations and practices of production thus issue, at a certain moment (the moment of 'production/circulation') in the form of symbolic vehicles constituted within the rules of 'language'. It is in this discursive form that the circulation of the 'product' takes place. The process thus requires, at the production end, its material instruments – its 'means' – as well as its own sets of social (production) relations – the organisation and combination of practices within media apparatuses. But it is in the *discursive* form that the circulation of the product takes place, as well as its distribution to different audiences. Once accomplished, the discourse must then be translated – transformed, again – into social practices if the circuit is to be both completed and effective. If no 'meaning' is taken, there can be no 'consumption'. If the meaning is not articulated in practice, it has no effect. The value of this approach is that while each of the moments, in articulation, is necessary to the circuit as a whole, no one moment can fully guarantee the next moment with which it is articulated. Since each has its specific modality and conditions of existence, each can constitute its own break or interruption of the 'passage of forms' on whose continuity the flow of effective production (that is, 'reproduction') depends.

Thus while in no way wanting to limit research to 'following only those leads which emerge from content analysis', we must recognise that the discursive form of the message has a privileged position in the communicative exchange (from the viewpoint of circulation), and that the moments of 'encoding' and 'decoding', though only 'relatively autonomous' in relation to the communicative process as a whole, are *determinate* moments. A 'raw' historical event cannot, *in that form*, be transmitted by, say, a television newscast. Events can only be signified within the aural-visual forms of the televisual discourse. In the moment when a historical event passes under the sign of discourse, it is subject to all the complex formal 'rules' by which language signifies. To put it paradoxically, the event must become a 'story' before it can become a *communicative event*. In that moment the formal sub-rules of discourse are 'in dominance', without, of course, subordinating out of existence the historical event so signified, the social relations in which the rules are set to work or the social and political consequences of the event having been signified in this way. The 'message form' is the necessary 'form of appearance' of the event in its passage from source to receiver. Thus the transposition into and out of the 'message form' (or

the mode of symbolic exchange) is not a random 'moment', which we can take up or ignore at our convenience. The 'message form' is a determinate moment; though, at another level, it comprises the surface movements of the communications system only and requires, at another stage, to be integrated into the social relations of the communication process as a whole, of which it forms only a part.

From this general perspective, we may crudely characterise the television communicative process as follows. The institutional structures of broadcasting, with their practices and networks of production, their organised relations and technical infrastructures, are required to produce a programme. Production, here, constructs the message. In one sense, then, the circuit begins here. Of course, the production process is not without its 'discursive' aspect: it, too, is framed throughout by meanings and ideas: knowledge-in-use concerning the routines of production, historically defined technical skills, professional ideologies, institutional knowledge, definitions and assumptions, assumptions about the audience and so on frame the constitution of the programme through this production structure. Further, though the production structures of television originate the television discourse, they do not constitute a closed system. They draw topics, treatments, agendas, events, personnel, images of the audience, 'definitions of the situation' from other sources and other discursive formations within the wider socio-cultural and political structure of which they are a differentiated part. Philip Elliott has expressed this point succinctly, within a more traditional framework, in his discussion of the way in which the audience is both the 'source' and the 'receiver' of the television message. Thus – to borrow Marx's terms – circulation and reception are, indeed, 'moments' of the production process in television and are reincorporated, via a number of skewed and structured 'feedbacks', into the production process itself. The consumption or reception of the television message is thus also itself a 'moment' of the production process in its larger sense, though the latter is 'predominant' because it is the 'point of departure for the realisation' of the message. Production and reception of the television message are not, therefore, identical, but they are related: they are differentiated moments within the totality formed by the social relations of the communicative process as a whole.

At a certain point, however, the broadcasting structures must yield encoded messages in the form of a meaningful discourse. The institution–societal relations of production must pass under the discursive rules of language for its product to be 'realised'. This initiates a further differentiated moment, in which the formal rules of discourse and language are in dominance. Before this message can have an 'effect' (however defined), satisfy a 'need' or be put to a 'use', it must first be appropriated as a meaningful discourse and be meaningfully decoded. It is this set of decoded meanings which 'have an effect', influence, entertain, instruct or persuade, with very complex perceptual, cognitive, emotional, ideological or behavioural consequences. In a 'determinate' moment the structure employs a code and yields a 'message': at another determinate moment the 'message', via its decodings, issues into the structure of social practices. We are now fully aware that this re-entry into the practices of audience reception and 'use' cannot be understood in simple behavioural terms. The typical processes identified in positivistic research on isolated elements – effects, uses, 'gratifications' – are themselves framed by structures of understanding, as well as being produced by social and

economic relations, which shape their 'realisation' at the reception end of the chain and which permit the meanings signified in the discourse to be transposed into practice or consciousness (to acquire social use value or political effectivity).

Clearly, what we have labelled in the diagram (below) 'meaning structures 1' and 'meaning structures 2' may not be the same. They do not constitute an 'immediate identity'. The codes of encoding and decoding may not be perfectly symmetrical. The degrees of symmetry – that is, the degrees of 'understanding' and 'misunderstanding' in the communicative exchange – depend on the degrees of symmetry/asymmetry (relations of equivalence) established between the positions of the 'personifications', encoder-producer and decoder-receiver. But this in turn depends on the degrees of identity or non-identity between the codes which perfectly or imperfectly transmit, interrupt or systematically distort what has been transmitted. The lack of fit between the codes has a great deal to do with the structural differences of relation and position between broadcasters and audiences, but it also has something to do with the asymmetry between the codes of 'source' and 'receiver' at the moment of transformation into and out of the discursive form. What are called 'distortions' or 'misunderstandings' arise precisely from the *lack of equivalence* between the two sides in the communicative exchange. Once again, this defines the 'relative autonomy', but 'determinateness', of the entry and exit of the message in its discursive moments.

The application of this rudimentary paradigm has already begun to transform our understanding of the older term, television 'content'. We are just beginning to see how it might also transform our understanding of audience reception, 'reading' and response as well. Beginnings and endings have been announced in communications research before, so we must be cautious. But there seems some ground for thinking that a new and exciting phase in so-called audience research, of a quite new kind, may be opening up. At either end of the communicative chain the use of the semiotic paradigm promises to dispel the lingering behaviourism which has dogged mass-media research for so long, especially in its approach to content. Though we know the television programme is not a behavioural input, like a tap on the kneecap, it seems to have been almost impossible for traditional researchers to conceptualise the communicative process without lapsing into one or other variant of low-flying behaviourism. We know, as Gerbner has remarked,

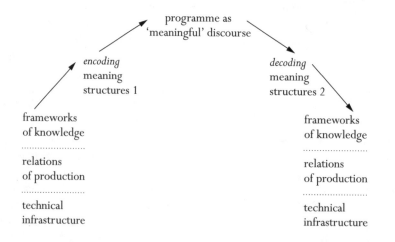

programme as
'meaningful' discourse

encoding
meaning
structures 1

decoding
meaning
structures 2

frameworks
of knowledge

frameworks
of knowledge

relations
of production

relations
of production

technical
infrastructure

technical
infrastructure

that representations of violence on the television screen 'are not violence but messages about violence': but we have continued to research the question of violence, for example, as if we were unable to comprehend this epistemological distinction.

The televisual sign is a complex one. It is itself constituted by the combination of two types of discourse, visual and aural. Moreover, it is an iconic sign, in Peirce's terminology, because 'it possesses some of the properties of the thing represented'. This is a point which has led to a great deal of confusion and has provided the site of intense controversy in the study of visual language. Since the visual discourse translates a three-dimensional world into two-dimensional planes, it cannot, of course, *be* the referent or concept it signifies. The dog in the film can bark but it cannot bite! Reality exists outside language, but it is constantly mediated by and through language: and what we can know and say has to be produced in and through discourse. Discursive 'knowledge' is the product not of the transparent representation of the 'real' in language but of the articulation of language on real relations and conditions. Thus there is no intelligible discourse without the operation of a code. Iconic signs are therefore coded signs too – even if the codes here work differently from those of other signs. There is no degree zero in language. Naturalism and 'realism' – the apparent fidelity of the representation to the thing or concept represented – is the result, the effect, of a certain specific articulation of language on the 'real'. It is the result of a discursive practice.

Certain codes may, of course, be so widely distributed in a specific language community or culture, and be learned at so early an age, that they appear not to be constructed – the effect of an articulation between sign and referent – but to be 'naturally' given. Simple visual signs appear to have achieved a 'near-universality' in this sense: though evidence remains that even apparently 'natural' visual codes are culture-specific. However, this does not mean that no codes have intervened; rather, that the codes have been profoundly *naturalised*. The operation of naturalised codes reveals not the transparency and 'naturalness' of language but the depth, the habituation and the near-universality of the codes in use. They produce apparently 'natural' recognitions. This has the (ideological) effect of concealing the practices of coding which are present. But we must not be fooled by appearances. Actually, what naturalised codes demonstrate is the degree of habituation produced when there is a fundamental alignment and reciprocity – an achieved equivalence – between the encoding and decoding sides of an exchange of meanings. The functioning of the codes on the decoding side will frequently assume the status of naturalised perceptions. This leads us to think that the visual sign for 'cow' actually *is* (rather than *represents*) the animal, cow. But if we think of the visual representation of a cow in a manual on animal husbandry – and, even more, of the linguistic sign 'cow' – we can see that both, in different degrees, are *arbitrary* with respect to the concept of the animal they represent. The articulation of an arbitrary sign – whether visual or verbal – with the concept of a referent is the product not of nature but of convention, and the conventionalism of discourses requires the intervention, the support, of codes. Thus Eco has argued that iconic signs 'look like objects in the real world because they reproduce the conditions (that is, the codes) of perception in the viewer'. These 'conditions of

perception' are, however, the result of a highly coded, even if virtually uncon-
scious, set of operations – decodings. This is as true of the photographic or televisual
image as it is of any other sign. Iconic signs are, however, particularly vulnerable
to being 'read' as natural because visual codes of perception are very widely distrib-
uted and because this type of sign is less arbitrary than a linguistic sign: the linguistic
sign, 'cow', possesses *none* of the properties of the thing represented, whereas the
visual sign appears to possess *some* of those properties.

This may help us to clarify a confusion in current linguistic theory and to
define precisely how some key terms are being used in this article. Linguistic theory
frequently employs the distinction 'denotation' and 'connotation'. The term 'deno-
tation' is widely equated with the literal meaning of a sign: because this literal
meaning is almost universally recognised, especially when visual discourse is being
employed, 'denotation' has often been confused with a literal transcription of
'reality' in language – and thus with a 'natural sign', one produced without the
intervention of a code. 'Connotation', on the other hand, is employed simply to
refer to less fixed and therefore more conventionalised and changeable, associa-
tive meanings, which clearly vary from instance to instance and therefore must
depend on the intervention of codes.

We do *not* use the distinction – denotation/connotation – in this way. From
our point of view, the distinction is an *analytic* one only. It is useful, in analysis,
to be able to apply a rough rule of thumb which distinguishes those aspects of a
sign which appear to be taken, in any language community at any point in time,
as its 'literal' meaning (denotation) from the more associative meanings for the
sign which it is possible to generate (connotation). But analytic distinctions must
not be confused with distinctions in the real world. There will be very few instances
in which signs organised in a discourse signify *only* their 'literal' (that is, near-
universally consensualised) meaning. In actual discourse most signs will combine
both the denotative and the connotative *aspects* (as redefined above). It may, then,
be asked why we retain the distinction at all. It is largely a matter of analytic
value. It is because signs appear to acquire their full ideological value – appear to
be open to articulation with wider ideological discourses and meanings – at the
level of their 'associative' meanings (that is, at the connotative level) – for here
'meanings' are *not* apparently fixed in natural perception (that is, they are not
fully naturalised), and their fluidity of meaning and association can be more fully
exploited and transformed. So it is at the connotative *level* of the sign that situa-
tional ideologies alter and transform signification. At this level we can see more
clearly the active intervention of ideologies in and on discourse: here, the sign is
open to new accentuations and, in Voloshinov's terms, enters fully into the struggle
over meanings – the class struggle in language. This does not mean that the deno-
tative or 'literal' meaning is outside ideology. Indeed, we could say that its
ideological value is strongly *fixed* – because it has become so fully universal and
'natural'. The terms 'denotation' and 'connotation', then, are merely useful analytic
tools for distinguishing, in particular contexts, between not the presence or absence
of ideology in language but the different levels at which ideologies and discourses
intersect.

The level of connotation of the visual sign, of its contextual reference and
positioning in different discursive fields of meaning and association, is the point

where *already coded* signs intersect with the deep semantic codes of a culture and take on additional, more active ideological dimensions. We might take an example from advertising discourse. Here, too, there is no 'purely denotative', and certainly no 'natural', representation. Every visual sign in advertising connotes a quality, situation, value or inference, which is present as an implication or implied meaning, depending on the connotational positioning. In Barthes's example, the sweater always signifies a 'warm garment' (denotation) and thus the activity or value of 'keeping warm'. But it is also possible, at its more connotative levels, to signify 'the coming of winter' or 'a cold day'. And, in the specialised sub-codes of fashion, the sweater may also connote a fashionable style of *haute couture* or, alternatively, an informal style of dress. But set against the right visual background and positioned by the romantic sub-code, it may connote 'long autumn walk in the woods'. Codes of this order clearly contract relations for the sign with the wider universe of ideologies in a society. These codes are the means by which power and ideology are made to signify in particular discourses. They refer signs to the 'maps of meaning' into which any culture is classified; and those 'maps of social reality' have the whole range of social meanings, practices, and usages, power and interest 'written in' to them. The connotative levels of signifiers, Barthes remarked, 'have a close communication with culture, knowledge, history, and it is through them, so to speak, that the environmental world invades the linguistic and semantic system. They are, if you like, the fragments of ideology.'

The so-called denotative *level* of the televisual sign is fixed by certain, very complex (but limited or 'closed') codes. But its connotative *level*, though also bounded, is more open, subject to more active *transformations*, which exploit its polysemic values. Any such already constituted sign is potentially transformable into more than one connotative configuration. Polysemy must not, however, be confused with pluralism. Connotative codes are *not* equal among themselves. Any society or culture tends, with varying degrees of closure, to impose its classifications of the social and cultural and political world. These constitute a *dominant cultural order*, though it is neither univocal nor uncontested. This question of the 'structure of discourses in dominance' is a crucial point. The different areas of social life appear to be mapped out into discursive domains, hierarchically organised into *dominant or preferred meanings*. New, problematic or troubling events, which breach our expectancies and run counter to our 'commonsense constructs', to our 'taken-for-granted' knowledge of social structures, must be assigned to their discursive domains before they can be said to 'make sense'. The most common way of 'mapping' them is to assign the new to some domain or other of the existing 'maps of problematic social reality'. We say *dominant*, not 'determined', because it is always possible to order, classify, assign and decode an event within more than one 'mapping'. But we say 'dominant' because there exists a pattern of 'preferred readings'; and these both have the institutional/political/ideological order imprinted in them and have themselves become institutionalised. The domains of 'preferred meanings' have the whole social order embedded in them as a set of meanings, practices and beliefs: the everyday knowledge of social structures, of 'how things work for all practical purposes in this culture', the rank order of power and interest and the structure of legitimations, limits and sanctions. Thus to clarify a 'misunderstanding' at the connotative level, we must refer, *through the*

codes, to the orders of social life, of economic and political power and of ideology. Further, since these mappings are 'structured in dominance' but not closed, the communicative process consists not in the unproblematic assignment of every visual item to its given position within a set of prearranged codes, but of *performative rules* – rules of competence and use, of logics-in-use – which seek actively to *enforce* or *pre-fer* one semantic domain over another and rule items into and out of their appropriate meaning-sets. Formal semiology has too often neglected this practice of *interpretative work*, though this constitutes, in fact, the real relations of broadcast practices in television.

In speaking of *dominant meanings,* then, we are not talking about a one-sided process 'which governs how all events will be signified. It consists of the 'work' required to enforce, win plausibility for and command as legitimate a *decoding* of the event within the limit of dominant definitions in which it has been connotatively signified. Terni has remarked:

> By the word *reading* we mean not only the capacity to identify and decode a certain number of signs, but also the subjective capacity to put them into a creative relation between themselves and with other signs: a capacity which is, by itself, the condition for a complete awareness of one's total environment.

Our quarrel here is with the notion of 'subjective capacity', as if the referent of a televisional discourse were an objective fact but the interpretative level were an individualised and private matter. Quite the opposite seems to be the case. The televisual practice takes 'objective' (that is, systemic) responsibility precisely for the relations which disparate signs contract with one another in any discursive instance, and thus continually rearranges, delimits and prescribes into what 'awareness of one's total environment' these items are arranged.

This brings us to the question of misunderstandings. Television producers who find their message 'failing to get across' are frequently concerned to straighten out the kinks in the communication chain, thus facilitating the 'effectiveness' of their communication. Much research which claims the objectivity of 'policy-oriented analysis' reproduces this administrative goal by attempting to discover how much of a message the audience recalls and to improve the extent of understanding. No doubt misunderstandings of a literal kind do exist. The viewer does not know the terms employed, cannot follow the complex logic of argument or exposition, is unfamiliar with the language, finds the concepts too alien or difficult or is foxed by the expository narrative. But more often broadcasters are concerned that the audience has failed to take the meaning as they – the broadcasters – intended. What they really mean to say is that viewers are not operating within the 'dominant' or 'preferred' code. Their ideal is 'perfectly transparent communication'. Instead, what they have to confront is 'systematically distorted communication'.

In recent years discrepancies of this kind have usually been explained by reference to 'selective perception'. This is the door via which a residual pluralism evades the compulsions of a highly structured, asymmetrical and non-equivalent process. Of course, there will always be private, individual, variant readings. But 'selective perception' is almost never as selective, random or privatised as the concept

suggests. The patterns exhibit, across individual variants, significant clusterings. Any new approach to audience studies will therefore have to begin with a critique of 'selective perception' theory.

It was argued earlier that since there is no necessary correspondence between encoding and decoding, the former can attempt to 'pre-fer' but cannot prescribe or guarantee the latter, which has its own conditions of existence. Unless they are wildly aberrant, encoding will have the effect of constructing some of the limits and parameters within which decodings will operate. If there were no limits, audiences could simply read whatever they liked into any message. No doubt some total misunderstandings of this kind do exist. But the vast range must contain *some* degree of reciprocity between encoding and decoding moments, otherwise we could not speak of an effective communicative exchange at all. Nevertheless, this 'correspondence' is not given but constructed. It is not 'natural' but the product of an articulation between two distinct moments. And the former cannot determine or guarantee, in a simple sense, which decoding codes will be employed. Otherwise communication would be a perfectly equivalent circuit, and every message would be an instance of 'perfectly transparent communication'. We must think, then, of the variant articulations in which encoding and decoding can be combined. To elaborate on this, we offer a hypothetical analysis of some possible decoding positions, in order to reinforce the point of 'no necessary correspondence'.

We identify *three* hypothetical positions from which decodings of a televisual discourse may be constructed. These need to be empirically tested and refined. But the argument that decodings do not follow inevitably from encodings, that they are not identical, reinforces the argument of 'no necessary correspondence'. It also helps to deconstruct the commonsense meaning of 'misunderstanding' in terms of a theory of 'systematically distorted communication'.

The first hypothetical position is that of the *dominant-hegemonic position*. When the viewer takes the connoted meaning from, say, a television newscast or current affairs programme full and straight, and decodes the message in terms of the reference code in which it has been encoded, we might say that the viewer is *operating inside the dominant code*. This is the ideal-typical case of 'perfectly transparent communication' – or as close as we are likely to come to it 'for all practical purposes'. Within this we can distinguish the positions produced by the *professional code*. This is the position (produced by what we perhaps ought to identify as the operation of a 'metacode') which the professional broadcasters assume when encoding a message which has *already* been signified in a hegemonic manner. The professional code is 'relatively independent' of the dominant code, in that it applies criteria and transformational operations of its own, especially those of a technico-practical nature. The professional code, however, operates *within* the 'hegemony' of the dominant code. Indeed, it serves to reproduce the dominant definitions precisely by bracketing their hegemonic quality and operating instead with displaced professional codings which foreground such apparently neutral-technical questions as visual quality, news and presentational values, televisual quality, 'professionalism' and so on. The hegemonic interpretations of, say, the politics of Northern Ireland, or the Chilean *coup* or the Industrial Relations Bill are principally generated by political and military elites: the particular choice of presentational occasions

and formats, the selection of personnel, the choice of images, the staging of debates are selected and combined through the operation of the professional code. How the broadcasting professionals are able *both* to operate with 'relatively autonomous' codes of their own *and* to act in such a way as to reproduce (not without contradiction) the hegemonic signification of events is a complex matter which cannot be further spelled out here. It must suffice to say that the professionals are linked with the defining elites not only by the institutional position of broadcasting itself as an 'ideological apparatus' but also by the structure of *access* (that is, the systematic 'over-accessing' of selective elite personnel and their 'definition of the situation' in television). It may even be said that the professional codes serve to reproduce hegemonic definitions specifically by *not overtly* biasing their operations in a dominant direction: ideological reproduction therefore takes place here inadvertently, unconsciously, 'behind men's backs'. Of course, conflicts, contradictions and even misunderstandings regularly arise between the dominant and the professional significations and their signifying agencies.

The second position we would identify is that of the *negotiated code* or position. Majority audiences probably understand quite adequately what has been dominantly defined and professionally signified. The dominant definitions, however, are hegemonic precisely because they represent definitions of situations and events which are 'in dominance' (*global*). Dominant definitions connect events, implicitly or explicitly, to grand totalisations, to the great syntagmatic views-of-the-world: they take 'large views' of issues: they relate events to the 'national interest' or to the level of geopolitics even if they make these connections in truncated, inverted or mystified ways. The definition of a hegemonic viewpoint is, first, that it defines within its terms the mental horizon, the universe, of possible meanings, of a whole sector of relations in a society or culture; and, second, that it carries with it the stamp of legitimacy – it appears coterminous with what is 'natural', 'inevitable', 'taken for granted' about the social order. Decoding within the *negotiated version* contains a mixture of adaptive and oppositional elements: it acknowledges the legitimacy of the hegemonic definitions to make the grand significations (abstract), while, at a more restricted, situational (situated) level, it makes its own ground rules – it operates with exceptions to the rule. It accords the privileged position to the dominant definitions of events while reserving the right to make a more negotiated application to 'local conditions', to its own more *corporate* positions. This negotiated version of the dominant ideology is thus shot through with contradictions, though these are only on certain occasions brought to full visibility. Negotiated codes operate through what we might call particular or situated logics: and these logics are sustained by their differential and unequal relation to the discourses and logics of power. The simplest example of a negotiated code is that which governs the response of a worker to the notion of an Industrial Relations Bill limiting the right to strike or to arguments for a wages freeze. At the level of the 'national interest' economic debate the decoder may adopt the hegemonic definition, agreeing that 'we must all pay ourselves less in order to combat inflation'. This, however, may have little or no relation to his or her willingness to go on strike for better pay and conditions or to oppose the Industrial Relations Bill at the level of shop-floor or union organisation. We suspect that the great majority of so-called 'misunderstandings' arise from the contradictions and disjunc-

tures between hegemonic-dominant encodings and negotiated-corporate decodings. It is just these mismatches in the levels which most provoke defining elites and professionals to identify a 'failure in communications'.

Finally, it is possible for a viewer perfectly to understand both the literal and the connotative inflection given by a discourse but to decode the message in a *globally* contrary way. He or she detotalises the message in the preferred code in order to retotalise the message within some alternative framework of reference. This is the case of the viewer who listens to a debate on the need to limit wages but 'reads' every mention of the 'national interest' as 'class interest'. He or she is operating with what we must call an *oppositional code*. One of the most significant political moments (they also coincide with crisis points within the broadcasting organisations themselves, for obvious reasons) is the point when events which are normally signified and decoded in a negotiated way begin to be given an oppositional reading. Here the 'politics of signification' – the struggle in discourse – is joined.

Note

This article is an edited extract from 'Encoding and Decoding in Television Discourse', CCCS Stencilled Paper no. 7.

Nancy Fraser

RETHINKING THE PUBLIC SPHERE
A contribution to the critique of actually existing democracy

EDITOR'S INTRODUCTION

ON THE FACE OF IT, Nancy Fraser's essay belongs more to social or critical theory than to cultural studies as usually conceived. None the less, as a canny and persuasive critique of Jürgen Habermas's concept of the "bourgeois public sphere" it finds its place in an anthology like this, just because Habermas's work, like that of Adorno, Benjamin, Williams or Bhabha, provides a theoretical substratum for contemporary cultural studies.

In his *Structural Transformations of the Public Sphere*, Habermas argued that the eighteenth-century world of London coffee-houses and clubs provided new occasions for free exchange of discourse as if between equals, and that from such exchanges emerged the possibility of reformist, egalitarian public debate and opinion-forming as well as, indirectly, governance. Fraser engages this idea critically, arguing that there never was, and never should be, just one "public sphere" but rather a number of public spheres. What is at stake, for her, is not just discourse-exchange but how stratified such publics should be, and how closely each is tied to the institutions of decision-making.

Further reading: Calhoun 1992; Eley 1992; Habermas 1991; Laclau 1994; McGuigan 1996; B. Robbins 1993b.

Today in the United States we hear a great deal of ballyhoo about 'the triumph of liberal democracy' and even 'the end of history'. Yet there is still quite a lot to object to in our own actually existing democracy, and the project of a critical

theory of the limits of democracy in late-capitalist societies remains as relevant as ever. In fact, this project seems to me to have acquired a new urgency at a time when 'liberal democracy' is being touted as the *ne plus ultra* of social systems for countries that are emerging from Soviet-style state socialism, Latin American military dictatorships and southern African regimes of racial domination.

Those of us who remain committed to theorising the limits of democracy in late-capitalist societies will find in the work of Jürgen Habermas an indispensable resource. I mean the concept of 'the public sphere', originally elaborated in his 1962 book, *The Structural Transformation of the Public Sphere*, and subsequently resituated but never abandoned in his later work.

The political and theoretical importance of this idea is easy to explain. Habermas's concept of the public sphere provides a way of circumventing some confusions that have plagued progressive social movements and the political theories associated with them. Take, for example, the longstanding failure in the dominant wing of the socialist and Marxist tradition to appreciate the full force of the distinction between the apparatuses of the state, on the one hand, and public arenas of citizen discourse and association, on the other. All too often it was assumed in this tradition that to subject the economy to the control of the socialist state was to subject it to the control of the socialist citizenry. Of course, that was not so. But the conflation of the state apparatus with the public sphere of discourse and association provided ballast to processes whereby the socialist vision became institutionalised in an authoritarian-statist form instead of in a participatory-democratic form. The result has been to jeopardise the very idea of socialist democracy.

A second problem, albeit one that has so far been much less historically momentous and certainly less tragic, is a confusion one encounters at times in contemporary feminisms. I mean a confusion that involves the use of the very same expression 'the public sphere' but in a sense that is less precise and less useful than Habermas's. This expression has been used by many feminists to refer to everything that is outside the domestic or familial sphere. Thus 'the public sphere' on this usage conflates at least three analytically distinct things: the state, the official economy of paid employment and arenas of public discourse. Now it should not be thought that the conflation of these three things is a merely theoretical issue. On the contrary, it has practical political consequences when, for example, agitational campaigns against misogynist cultural representations are confounded with programmes for state censorship or when struggles to deprivatise housework and child care are equated with their commodification. In both these cases the result is to occlude the question of whether to subject gender issues to the logic of the market or the administrative state is to promote the liberation of women.

The idea of 'the public sphere' in Habermas's sense is a conceptual resource that can help overcome such problems. It designates a theatre in modern societies in which political participation is enacted through the medium of talk. It is the space in which citizens deliberate about their common affairs, and hence an institutionalised arena of discursive interaction. This arena is conceptually distinct from the state; it is a site for the production and circulation of discourses that can in principle be critical of the state. The public sphere in Habermas's sense is also conceptually distinct from the official economy; it is not an arena of market relations

but rather one of discursive relations, a theatre for debating and deliberating rather than for buying and selling. Thus this concept of the public sphere permits us to keep in view the distinctions among state apparatuses, economic markets, and democratic associations, distinctions that are essential to democratic theory.

For these reasons I am going to take as a basic premise for this essay that something like Habermas's idea of the public sphere is indispensable to critical social theory and democratic political practice. I assume that no attempt to understand the limits of actually existing late-capitalist democracy can succeed without in some way or another making use of it. I assume that the same goes for urgently needed constructive efforts to project alternative models of democracy.

If you will grant me that the general idea of the public sphere is indispensable to critical theory, then I shall go on to argue that the specific form in which Habermas has elaborated this idea is not wholly satisfactory. On the contrary, I contend that his analysis of the public sphere needs to undergo some critical interrogation and reconstruction if it is to yield a category capable of theorising the limits of actually existing democracy.

Let me remind you that the subtitle of *Structural Transformation* is 'An Inquiry into a Category of Bourgeois Society'. The object of the inquiry is the rise and decline of a historically specific and limited form of the public sphere, which Habermas calls the 'liberal model of the bourgeois public sphere'. The aim is to identify the conditions that made possible this type of public sphere and to chart their devolution. The upshot is an argument that under altered conditions of late-twentieth-century 'welfare state mass democracy', the bourgeois or liberal model of the public sphere is no longer feasible. Some new form of public sphere is required to salvage that arena's critical function and to institutionalise democracy.

Oddly, Habermas stops short of developing a new, post-bourgeois model of the public sphere. Moreover, he never explicitly problematises some dubious assumptions that underlie the bourgeois model. As a result, we are left at the end of *Structural Transformation* without a conception of the public sphere that is sufficiently distinct from the bourgeois conception to serve the needs of critical theory today.

That, at any rate, is the thesis I intend to argue. To make my case, I shall proceed as follows: I shall begin by juxtaposing Habermas's account of the structural transformation of the public sphere with an alternative account that can be pieced together from some recent revisionist historiography. Then I shall identify four assumptions underlying the bourgeois conception of the public sphere, as Habermas describes it, that this newer historiography renders suspect. Next in the following sections I shall examine each of these assumptions in turn. Finally, I shall draw together some strands from these critical discussions that point toward an alternative, post-bourgeois conception of the public sphere.

The public sphere: alternative histories, competing conceptions

Let me begin by sketching highlights of Habermas's account of the structural transformation of the public sphere. According to Habermas, the idea of a public sphere

is that of a body of 'private persons' assembled to discuss matters of 'public concern' or 'common interest'. This idea acquired force and reality in early modern Europe in the constitution of 'bourgeois public spheres' as counterweights to absolutist states. These publics aimed to mediate between society and the state by holding the state accountable to society via publicity. At first this meant requiring that information about state functioning be made accessible so that state activities would be subject to critical scrutiny and the force of public opinion. Later it meant transmitting the considered 'general interest' of 'bourgeois society' to the state via forms of legally guaranteed free speech, free press and free assembly, and eventually through the parliamentary institutions of representative government.

According to Habermas, the full utopian potential of the bourgeois conception of the public sphere was never realised in practice. The claim to open access in particular was not made good. Moreover, the bourgeois conception of the public sphere was premised on a social order in which the state was sharply differentiated from the newly privatised market economy; it was this clear separation of society and state that was supposed to underpin a form of public discussion that excluded 'private interests'. But these conditions eventually eroded as non-bourgeois strata gained access to the public sphere. Then 'the social question' came to the fore, society was polarised by class struggle, and the public fragmented into a mass of competing interest groups. Street demonstrations and back-room, brokered compromises among private interests replaced reasoned public debate about the common good. Finally, with the emergence of welfare-state mass democracy, society and the state became mutually intertwined; publicity in the sense of critical scrutiny of the state gave way to public relations, mass-mediated staged displays and the manufacture and manipulation of public opinion.

Now let me juxtapose to this sketch of Habermas's account an alternative account that I shall piece together from some recent revisionist historiography. Briefly, scholars like Joan Landes, Mary Ryan and Geoff Eley contend that Habermas's account idealises the liberal public sphere. They argue that, despite the rhetoric of publicity and accessibility, the official public sphere rested on, indeed was importantly constituted by, a number of significant exclusions. For Landes, the key axis of exclusion is gender; she argues that the ethos of the new republican public sphere in France was constructed in deliberate opposition to that of a more woman-friendly salon culture that the republicans stigmatised as 'artificial', 'effeminate', and 'aristocratic'. Consequently, a new, austere style of public speech and behaviour was promoted, a style deemed 'rational', 'virtuous', and 'manly'. In this way masculinist gender constructs were built into the very conception of the republican public sphere, as was a logic that led, at the height of Jacobin rule, to the formal exclusion of women from political life (Landes 1988). Here the republicans drew on classical traditions that cast femininity and publicity as oxymorons; the depth of such traditions can be gauged in the etymological connection between 'public' and 'pubic', a graphic trace of the fact that in the ancient world possession of a penis was a requirement for speaking in public.

Extending Landes's argument, Geoff Eley contends that exclusionary operations were essential to liberal public spheres not only in France but also in England and Germany and that in all these countries gender exclusions were linked to other exclusions rooted in processes of class formation. In all these countries, he claims,

the soil that nourished the liberal public sphere was 'civil society', the emerging new congeries of voluntary associations that sprung up in what came to be known as 'the age of societies'. But this network of clubs and associations – philanthropic, civic, professional and cultural – was anything but accessible to everyone. On the contrary, it was the arena, the training ground and eventually the power base of a stratum of bourgeois men who were coming to see themselves as a 'universal class' and preparing to assert their fitness to govern. Thus the elaboration of a distinctive culture of civil society and of an associated public sphere was implicated in the process of bourgeois class formation; its practices and ethos were markers of 'distinction' in Pierre Bourdieu's sense, ways of defining an emergent elite, of setting it off from the older aristocratic elites it was intent on displacing on the one hand and from the various popular and plebeian strata it aspired to rule on the other. Moreover, this process of distinction helps explain the exacerbation of sexism characteristic of the liberal public sphere; new gender norms enjoining feminine domesticity and a sharp separation of public and private spheres functioned as key signifiers of bourgeois difference from both higher and lower social strata. It is a measure of the eventual success of this bourgeois project that these norms later became hegemonic, sometimes imposed on, sometimes embraced by, broader segments of society.

There is a remarkable irony here, one that Habermas's account of the rise of the public sphere fails fully to appreciate. A discourse of publicity touting accessibility, rationality and the suspension of status hierarchies is itself deployed as a strategy of distinction. Of course, in and of itself this irony does not fatally compromise the discourse of publicity; that discourse can be, indeed has been, differently deployed in different circumstances and contexts. Nevertheless, it does suggest that the relationship between publicity and status is more complex than Habermas intimates, that declaring a deliberative arena to be a space where extant status distinctions are bracketed and neutralised is not sufficient to make it so.

Moreover, the problem is not only that Habermas idealises the liberal public sphere but also that he fails to examine other, non-liberal, non-bourgeois, competing public spheres. Or rather, it is precisely because he fails to examine these other public spheres that he ends up idealising the liberal public sphere. In the case of elite bourgeois women, this involved building a counter civil society of alternative, woman-only, voluntary associations, including philanthropic and moral-reform societies. In some respects, these associations aped the all-male societies built by these women's fathers and grandfathers, yet in other respects the women were innovating, since they creatively used the heretofore quintessentially 'private' idioms of domesticity and motherhood precisely as springboards for public activity. Meanwhile, for some less privileged women, access to public life came through participation in supporting roles in male-dominated working-class protest activities. Still other women found public outlets in street protests and parades. Finally, women's rights advocates publicly contested both women's exclusion from the official public sphere and the privatisation of gender politics.

Even in the absence of formal political incorporation through suffrage, there were a variety of ways of accessing public life and a multiplicity of public arenas. Thus the view that women were excluded from the public sphere turns out to be ideological; it rests on a class- and gender-biased notion of publicity, one which

accepts at face value the bourgeois public's claim to be *the* public. The bourgeois public was never *the* public. On the contrary, virtually contemporaneous with the bourgeois public there arose a host of competing counter-publics, including nationalist publics, popular peasant publics, elite women's publics, and working-class publics. Thus there were competing publics from the start, not just in the late nineteenth and twentieth centuries, as Habermas implies (Ryan 1990).

Moreover, not only was there always a plurality of competing publics, but the relations between bourgeois publics and other publics were always conflictual. Virtually from the beginning, counter-publics contested the exclusionary norms of the bourgeois public, elaborating alternative styles of political behaviour and alternative norms of public speech. Bourgeois publics in turn excoriated these alternatives and deliberately sought to block broader participation. As Eley puts it, 'the emergence of a bourgeois public was never defined solely by the struggle against absolutism and traditional authority, but . . . addressed the problem of popular containment as well. The public sphere was always constituted by conflict' (Eley 1992).

In general, this revisionist historiography suggests a much darker view of the bourgeois public sphere than the one that emerges from Habermas's study. The exclusions and conflicts that appeared as accidental trappings from his perspective become constitutive in the revisionists' view. The result is a gestalt switch that alters the very meaning of the public sphere. We can no longer assume that the bourgeois conception of the public sphere was simply an unrealised utopian ideal; it was also a masculinist ideological notion that functioned to legitimate an emergent form of class rule. Therefore, Eley draws a Gramscian moral from the story: the official bourgeois public sphere is the institutional vehicle for a major historical transformation in the nature of political domination. This is the shift from a repressive mode of domination to a hegemonic one, from rule based primarily on acquiescence to superior force to rule based primarily on consent supplemented with some measure of repression. The important point is that this new mode of political domination, like the older one, secures the ability of one stratum of society to rule the rest. The official public sphere, then, was, and indeed is, the prime institutional site for the construction of the consent that defines the new, hegemonic mode of domination.

What conclusions should we draw from this conflict of historical interpretations? Should we conclude that the very concept of the public sphere is a piece of bourgeois, masculinist ideology so thoroughly compromised that it can shed no genuinely critical light on the limits of actually existing democracy? Or should we conclude rather that the public sphere was a good idea that unfortunately was not realised in practice but retains some emancipatory force? In short, is the idea of the public sphere an instrument of domination or a utopian ideal?

Well, perhaps both, but actually neither. I contend that both of those conclusions are too extreme and unsupple to do justice to the material I have been discussing. Instead of endorsing either one of them, I want to propose a more nuanced alternative. I shall argue that the revisionist historiography neither undermines nor vindicates *the* concept of the public sphere *simpliciter*, but that it calls into question four assumptions that are central to the *bourgeois*, *masculinist* conception of the public sphere, at least as Habermas describes it. These are as follows:

- The assumption that it is possible for interlocutors in a public sphere to bracket status differentials and to deliberate *as if* they were social equals; the assumption, therefore, that societal equality is not a necessary condition for political democracy
- The assumption that the proliferation of a multiplicity of competing publics is necessarily a step away from, rather than toward, greater democracy, and that a single, comprehensive public sphere is always preferable to a nexus of multiple publics
- The assumption that discourse in public spheres should be restricted to deliberation about the common good, and that the appearance of private interests and private issues is always undesirable
- The assumption that a functioning democratic public sphere requires a sharp separation between civil society and the state.

Let me consider each of these in turn.

Open access, participatory parity and social equality

Habermas's account of the bourgeois conception of the public sphere stresses its claim to be open and accessible to all. Indeed, this idea of open access is one of the central meanings of the norm of publicity. Of course, we know both from revisionist history and from Habermas's account that the bourgeois public's claim to full accessibility was not in fact realised. Women of all classes and ethnicities were excluded from official political participation on the basis of gender status, while plebeian men were formally excluded by property qualifications. Moreover, in many cases women and men of radicalised ethnicities of all classes were excluded on racial grounds.

What are we to make of this historical fact of non-realisation in practice of the bourgeois public sphere's ideal of open access? One approach is to conclude that the ideal itself remains unaffected, since it is possible in principle to overcome these exclusions. And in fact, it was only a matter of time before formal exclusions based on gender, property and race were eliminated.

This is convincing enough as far as it goes, but it does not go far enough. The question of open access cannot be reduced without remainder to the presence or absence of formal exclusions. It requires us to look also at the process of discursive interaction within formally inclusive public arenas. Here we should recall that the bourgeois conception of the public sphere requires bracketing inequalities of status. This public sphere was to be an arena in which interlocutors would set aside such characteristics as differences in birth and fortune and speak to one another as if they were social and economic peers. The operative phrase here is 'as if'. In fact, the social inequalities among the interlocutors were not eliminated but only bracketed.

But were they really effectively bracketed? The revisionist historiography suggests they were not. Rather, discursive interaction within the bourgeois public sphere was governed by protocols of style and decorum that were themselves correlates and markers of status inequality. These functioned informally to

marginalise women and members of the plebeian classes and to prevent them from participating as peers.

Here we are talking about informal impediments to participatory parity that can persist even after everyone is formally and legally licensed to participate. That these constitute a more serious challenge to the bourgeois conception of the public sphere can be seen from a familiar contemporary example. Feminist research has documented a syndrome that many of us have observed in faculty meetings and other mixed-sex deliberative bodies: men tend to interrupt women more than women interrupt men; men also tend to speak more than women, taking more turns and longer turns; and women's interventions are more often ignored or not responded to than men's. In response to the sorts of experiences documented in this research, an important strand of feminist political theory has claimed that deliberation can serve as a mask for domination. Theorists like Jane Mansbridge have argued that

> the transformation of 'I' into 'we' brought about through political deliberation can easily mask subtle forms of control. Even the language people use as they reason together usually favours one way of seeing things and discourages others. Subordinate groups sometimes cannot find the right voice or words to express their thoughts, and when they do, they discover they are not heard. [They] are silenced, encouraged to keep their wants inchoate, and heard to say 'yes' when what they have said is 'no.'
>
> (Mansbridge 1990: 127)

Mansbridge rightly notes that many of these feminist insights into ways in which deliberation can serve as a mask for domination extend beyond gender to other kinds of unequal relations, like those based on class or ethnicity.

Here I think we encounter a very serious difficulty with the bourgeois conception of the public sphere. In so far as the bracketing of social inequalities in deliberation means proceeding as if they don't exist when they do, this does not foster participatory parity. On the contrary, such bracketing usually works to the advantage of dominant groups in society and to the disadvantage of subordinates. In most cases it would be more appropriate to *unbracket* inequalities in the sense of explicitly thematising them – a point that accords with the spirit of Habermas's later communicative ethics.

The misplaced faith in the efficacy of bracketing suggests another flaw in the bourgeois conception. This conception assumes that a public sphere is or can be a space of zero degree culture, so utterly bereft of any specific ethos as to accommodate with perfect neutrality and equal ease interventions expressive of any and every cultural ethos. But this assumption is counterfactual, and not for reasons that are merely accidental. In stratified societies, unequally empowered social groups tend to develop unequally valued cultural styles. The result is the development of powerful informal pressures that marginalise the contributions of members of subordinated groups both in everyday contexts and in official public spheres. Moreover, these pressures are amplified, rather than mitigated, by the peculiar political economy of the bourgeois public sphere. In this public sphere

the media that constitute the material support for the circulation of views are privately owned and operated for profit. Consequently, subordinated social groups usually lack equal access to the material means of equal participation. Thus political economy enforces structurally what culture accomplishes informally.

If we take these considerations seriously, then we should be led to entertain serious doubts about a conception of the public sphere that purports to bracket, rather than to eliminate, structural social inequalities. We should question whether it is possible even in principle for interlocutors to deliberate *as if* they were social peers in specifically designated discursive arenas when these discursive arenas are situated in a larger societal context that is pervaded by structural relations of dominance and subordination.

What is at stake here is the autonomy of specifically political institutions *vis-à-vis* the surrounding societal context. Now one salient feature that distinguishes liberalism from some other political-theoretical orientations is that liberalism assumes the autonomy of the political in a very strong form. Liberal political theory assumes that it is possible to organise a democratic form of political life on the basis of socioeconomic and socio-sexual structures that generate systemic inequalities. For liberals, then, the problem of democracy becomes the problem of how to insulate political processes from what are considered to be non-political or pre-political processes, those characteristic, for example, of the economy, the family, and informal everyday life. The problem for liberals is thus how to strengthen the barriers separating political institutions that are supposed to instantiate relations of equality from economic, cultural and socio-sexual institutions that are premised on systemic relations of inequality. Yet the weight of circumstance suggests that to have a public sphere in which interlocutors can deliberate as peers, it is not sufficient merely to bracket social inequality. Instead, a necessary condition for participatory parity is that systemic social inequalities be eliminated. This does not mean that everyone must have exactly the same income, but it does require the sort of rough equality that is inconsistent with systemically generated relations of dominance and subordination. *Pace* liberalism, then, political democracy requires substantive social equality.

I have been arguing that the bourgeois conception of the public sphere is inadequate in so far as it supposes that social equality is not a necessary condition for participatory parity in public spheres. What follows from this for the critique of actually existing democracy? One task for critical theory is to render visible the ways in which societal inequality infects formally inclusive existing public spheres and taints discursive interaction within them.

Equality, diversity and multiple publics

So far I have been discussing what we might call 'intrapublic relations', that is, the character and quality of discursive interactions within a given public sphere. Now I want to consider what we might call 'interpublic relations', that is, the character of interactions among different publics.

Let me begin by recalling that Habermas's account stresses the singularity of the bourgeois conception of the public sphere, its claim to be *the* public arena, in

the singular. In addition, his narrative tends in this respect to be faithful to that conception, since it casts the emergence of additional publics as a late development signalling fragmentation and decline. This narrative, then, like the bourgeois conception itself, is informed by an underlying evaluative assumption, namely, that the institutional confinement of public life to a single, overarching public sphere is a positive and desirable state of affairs, whereas the proliferation of a multiplicity of publics represents a departure from, rather than an advance toward, democracy. It is this normative assumption that I now want to scrutinise. In this section I shall assess the relative merits of a single, comprehensive public versus multiple publics in two kinds of modern societies: stratified and egalitarian multicultural societies.

First, let me consider the case of stratified societies, by which I mean societies whose basic institutional framework generates unequal social groups in structural relations of dominance and subordination. I have already argued that in such societies, full parity of participation in public debate and deliberation is not within the reach of possibility. The question to be addressed here then is: What form of public life comes closest to approaching that ideal? What institutional arrangements will best help narrow the gap in participatory parity between dominant and subordinate groups?

I contend that in stratified societies, arrangements that accommodate contestation among a plurality of competing publics better promote the ideal of participatory parity than does a single, comprehensive, overarching public. This follows from the argument of the previous section. There I argued that it is not possible to insulate special discursive arenas from the effects of societal inequality and, that where societal inequality persists, deliberative processes in public spheres will tend to operate to the advantage of dominant groups and to the disadvantage of subordinates. Now I want to add that these effects will be exacerbated where there is only a single, comprehensive public sphere. In that case, members of subordinated groups would have no arenas for deliberation among themselves about their needs, objectives, and strategies. They would have no venues in which to undertake communicative processes that were not, as it were, under the supervision of dominant groups. In this situation they would be less likely than otherwise to 'find the right voice or words to express their thoughts' and more likely than otherwise 'to keep their wants inchoate'. This would render them less able than otherwise to articulate and defend their interests in the comprehensive public sphere. They would be less able than otherwise to expose modes of deliberation that mask domination by, in Mansbridge's words, 'absorbing the less powerful into a false "we" that reflects the more powerful'.

This argument gains additional support from revisionist historiography of the public sphere, up to and including that of very recent developments. This historiography records that members of subordinated social groups – women, workers, peoples of colour, and gays and lesbians – have repeatedly found it advantageous to constitute alternative publics. I propose to call these *subaltern counterpublics* in order to signal that they are parallel discursive arenas where members of subordinated social groups invent and circulate counter-discourses to formulate oppositional interpretations of their identities, interests and needs. Perhaps the most striking example is the late-twentieth-century US feminist subaltern

counter-public, with its variegated array of journals, bookstores, publishing companies, film and video distribution networks, lecture series, research centres, academic programmes, conferences, conventions, festivals and local meeting places. In this public sphere, feminist women have invented new terms for describing social reality, including 'sexism', 'the double shift', 'sexual harassment' and 'marital, date and acquaintance rape'. Armed with such language, we have recast our needs and identities, thereby reducing, although not eliminating, the extent of our disadvantage in official public spheres.

Let me not be misunderstood. I do not mean to suggest that subaltern counter-publics are always necessarily virtuous. Some of them, alas, are explicitly anti-democratic and anti-egalitarian, and even those with democratic and egalitarian intentions are not always above practising their own modes of informal exclusion and marginalisation. Still, in so far as these counter-publics emerge in response to exclusions within dominant publics, they help expand discursive space. In principle, assumptions that were previously exempt from contestation will now have to be publicly argued out. In general, the proliferation of subaltern counter-publics means a widening of discursive contestation, and that is a good thing in stratified societies.

I am emphasising the contestatory function of subaltern counter-publics in stratified societies in part to complicate the issue of separatism. In my view, the concept of a counter-public militates in the long run against separatism because it assumes a *publicist* orientation. In so far as these arenas are *publics*, they are by definition not enclaves, which is not to deny that they are often involuntarily enclav*ed*. After all, to interact discursively as a member of public, subaltern or otherwise, is to aspire to disseminate one's discourse to ever widening arenas. Habermas captures well this aspect of the meaning of publicity when he notes that, however limited a public may be in its empirical manifestation at any given time, its members understand themselves as part of a potentially wider public, that inde-terminate, empirically counterfactual body we call 'the public at large'. The point is that in stratified societies, subaltern counter-publics have a dual character. On the one hand, they function as spaces of withdrawal and regroupment; on the other hand, they also function as bases and training grounds for agitational activities directed toward wider publics. It is precisely in the dialectic between these two functions that their emancipatory potential resides. This dialectic enables subaltern counter-publics partially to offset, although not wholly to eradicate, the unjust participatory privileges enjoyed by members of dominant social groups in strati-fied societies.

So far I have been arguing that, although in stratified societies the ideal of participatory parity is not fully realisable, it is more closely approximated by arrangements that permit contestation among a plurality of competing publics than by a single, comprehensive public sphere. Of course, contestation among competing publics supposes interpublic discursive interaction. How, then, should we understand such interaction? Geoff Eley suggests that we think of the public sphere (in stratified societies) as 'the structured setting where cultural and ideo-logical contest or negotiation among a variety of publics takes place'. This formulation does justice to the multiplicity of public arenas in stratified societies by expressly acknowledging the presence and activity of 'a variety of publics'. At the same time, it also does justice to the fact that these various publics are

situated in a single 'structured setting' that advantages some and disadvantages others. Finally, Eley's formulation does justice to the fact that in stratified societies the discursive relations among differentially empowered publics are as likely to take the form of contestation as that of deliberation.

Let me now consider the relative merits of multiple publics versus a single public for egalitarian, multicultural societies. By 'egalitarian societies' I mean nonstratified societies, societies whose basic framework does not generate unequal social groups in structural relations of dominance and subordination. Egalitarian societies, therefore, are societies without classes and without gender or racial divisions of labor. However, they need not be culturally homogeneous. On the contrary, provided such societies permit free expression and association, they are likely to be inhabited by social groups with diverse values, identities and cultural styles, and hence to be multicultural. My question is: Under conditions of cultural diversity in the absence of structural inequality, would a single, comprehensive public sphere be preferable to multiple publics?

To answer this question, we need to take a closer look at the relationship between public discourse and social identities. *Pace* the bourgeois conception, public spheres are not only arenas for the formation of discursive opinion; in addition, they are arenas for the formation and enactment of social identities. This means that participation is not simply a matter of being able to state propositional contents that are neutral with respect to form of expression. Rather, as I argued in the previous section, participation means being able to speak in one's own voice, and thereby simultaneously to construct and express one's cultural identity through idiom and style. Moreover, as I also suggested, public spheres themselves are not spaces of zero-degree culture, equally hospitable to any possible form of cultural expression. Rather, they consist in culturally specific institutions, including, for example, various journals and various social geographies of urban space. These institutions may be understood as culturally specific rhetorical lenses that filter and alter the utterances they frame; they can accommodate some expressive modes and not others.

It follows that public life in egalitarian, multicultural societies cannot consist exclusively in a single, comprehensive public sphere. That would be tantamount to filtering diverse rhetorical and stylistic norms through a single, overarching lens. Moreover, since there can be no such lens that is genuinely culturally neutral, it would effectively privilege the expressive norms of one cultural group over others and thereby make discursive assimilation a condition for participation in public debate. The result would be the demise of multiculturalism (and the likely demise of social equality). In general, then, we can conclude that the idea of an egalitarian, multicultural society only makes sense if we suppose a plurality of public arenas in which groups with diverse values and rhetoric participate. By definition, such a society must contain a multiplicity of publics.

However, this need not preclude the possibility of an additional, more comprehensive arena in which members of different, more limited publics talk across lines of cultural diversity. On the contrary, our hypothetical egalitarian, multicultural society would surely have to entertain debates over policies and issues affecting everyone. The question is: Would participants in such debates share enough in the way of values, expressive norms, and therefore protocols of persuasion to lend

their talk the quality of deliberations aimed at reaching agreement through giving reasons?

In my view, this is better treated as an empirical question than as a conceptual question. I see no reason to rule out in principle the possibility of a society in which social equality and cultural diversity coexist with participatory democracy. I certainly hope there can be such a society. That hope gains some plausibility if we consider that, however difficult it may be, communication across lines of cultural difference is not in principle impossible, although it will certainly become impossible if one imagines that it requires bracketing of differences. Granted, such communication requires multicultural literacy, but that, I believe, can be acquired through practice. In fact, the possibilities expand once we acknowledge the complexity of cultural identities. *Pace* reductive, essentialist conceptions, cultural identities are woven of many different strands, and some of these strands may be common to people whose identities otherwise diverge, even when it is the divergences that are most salient. Likewise, under conditions of social equality, the porousness, outer-directedness and open-endedness of publics could promote intercultural communication. In addition, the unbounded character and publicist orientation of publics allows people to participate in more than one public and it allows memberships of different publics partially to overlap. This in turn makes intercultural communication conceivable in principle. All told, then, there do not seem to be any conceptual (as opposed to empirical) barriers to the possibility of a socially egalitarian, multicultural society that is also a participatory democracy. But this will necessarily be a society with many different publics, including at least one public in which participants can deliberate as peers across lines of difference about policy that concerns them all.

In general, I have been arguing that the ideal of participatory parity is better achieved by a multiplicity of publics than by a single public. This is true both for stratified societies and for egalitarian, multicultural societies, albeit for different reasons. In neither case is my argument intended as a simple post-modern celebration of multiplicity. Rather, in the case of stratified societies, I am defending subaltern counter-publics formed under conditions of dominance and subordination. In the other case, by contrast, I am defending the possibility of combining social equality, cultural diversity and participatory democracy.

What are the implications of this discussion for a critical theory of the public sphere in actually existing democracy? Briefly, we need a critical political sociology of a form of public life in which multiple but unequal publics participate. This means theorising about the contestatory interaction of different publics and identifying the mechanisms that render some of them subordinate to others.

Public spheres, common concerns and private interests

I have argued that in stratified societies, like it or not, subaltern counter-publics stand in a contestatory relationship to dominant publics. One important object of such interpublic contestation is the appropriate boundaries of the public sphere. Here the central questions are: What counts as a public matter? What, in contrast, is private? This brings me to a third set of problematic assumptions underlying the

bourgeois conception of the public sphere, namely, assumptions concerning the appropriate scope of publicity in relation to privacy.

Let me remind you that it is central to Habermas's account that the bourgeois public sphere was to be a discursive arena in which 'private persons' deliberated about 'public matters'. There are several different senses of 'private' and 'public' in play here. 'Public', for example, can mean, first, state-related; second, accessible to everyone; third, of concern to everyone; and, fourth, pertaining to a common good or shared interest. Each of these corresponds to a contrasting sense of 'private'. In addition, there are two other senses of 'private' hovering just below the surface here: fifth, pertaining to private property in a market economy; and, sixth, pertaining to intimate domestic or personal life, including sexual life.

I have already talked at length about the sense of 'public' as open or accessible to all. Now I want to examine some of the other senses, beginning with the third point, of concern to everyone. This is ambiguous between what objectively affects or has an impact on everyone as seen from an outsider's perspective, and what is recognised as a matter of common concern by participants. The idea of a public sphere as an arena of collective self-determination does not sit well with approaches that would appeal to an outsider's perspective to delimit its proper boundaries. Thus it is the second, participants' perspective that is relevant here. Only participants themselves can decide what is and what is not of common concern to them. However, there is no guarantee that all of them will agree. For example, until quite recently, feminists were in the minority in thinking that domestic violence against women was a matter of common concern and thus a legitimate topic of public discourse. The great majority of people considered this issue to be a private matter between what was assumed to be a fairly small number of heterosexual couples (and perhaps the social and legal professionals who were supposed to deal with them). Then feminists formed a subaltern counter-public from which we disseminated a view of domestic violence as a widespread systemic feature of male-dominated societies. Eventually, after sustained discursive contestation, we succeeded in *making* it a common concern.

The point is that there are no naturally given, *a priori* boundaries here. What will count as a matter of common concern will be decided precisely through discursive contestation. It follows that no topics should be ruled off limits in advance of such contestation. On the contrary, democratic publicity requires positive guarantees of opportunities for minorities to convince others that what in the past was not public in the sense of being a matter of common concern should now become so.

What, then, of the sense of 'publicity' as pertaining to a common good or shared interest? This is the sense that is in play when Habermas characterises the bourgeois public sphere as an arena in which the topic of discussion is restricted to the 'common good' and in which discussion of 'private interests' is ruled out. This is a view of the public sphere that we would today call civic-republican, as opposed to liberal-individualist. Briefly, the civic-republican model stresses a view of politics as people reasoning together to promote a common good that transcends the mere sum of individual preferences. The idea is that through deliberation the members of the public can come to discover or create such a common good. In the process of their deliberations, participants are transformed from a

collection of self-seeking, private individuals into a public-spirited collectivity, capable of acting together in the common interest. On this view, private interests have no proper place in the political public sphere. At best, they are the pre-political starting point of deliberation, to be transformed and transcended in the course of debate.

This civic-republican view of the public sphere is in one respect an improvement over the liberal-individualist alternative. Unlike the latter, it does not assume that people's preferences, interests and identities are given exogenously in advance of public discourse and deliberation. It appreciates, rather, that preferences, interests and identities are as much outcomes as antecedents of public deliberation; indeed, they are discursively constituted in and through it. However, the civic-republican view contains a very serious confusion, one that blunts its critical edge. This view conflates the ideas of deliberation and the common good by assuming that deliberation must be deliberation *about* the common good. Consequently, it limits deliberation to talk framed from the standpoint of a single, all-encompassing 'we', thereby ruling claims of self-interest and group interest out of order. Yet, as Jane Mansbridge has argued, this works against one of the principle aims of deliberation, namely, to help participants clarify their interests, when those interests turn out to conflict. 'Ruling self-interest [and group interest] out of order makes it harder for any participant to sort out what is going on. In particular, the less powerful may not find ways to discover that the prevailing sense of "we" does not adequately include them' (Mansbridge 1990: 131).

In general, there is no way to know in advance whether the outcome of a deliberative process will be the discovery of a common good in which conflicts of interest evaporate as merely apparent or the discovery that conflicts of interest are real and the common good is chimerical. But if the existence of a common good cannot be presumed in advance, then there is no warrant for putting any strictures on what sorts of topics, interests and views are admissible in deliberation.

This argument holds even in the best-case scenario of societies whose basic institutional frameworks do not generate systemic inequalities; even in such relatively egalitarian societies, we cannot assume in advance that there will be no real conflicts of interest. How much more pertinent, then, the argument is to stratified societies, which are traversed with pervasive relations of inequality. After all, when social arrangements operate to the systemic profit of some groups of people and to the systemic detriment of others, there are prima facie reasons for thinking that the postulation of a common good shared by exploiters and exploited may well be a mystification. Moreover, any consensus that purports to represent the common good in this social context should be regarded with suspicion, since this consensus will have been reached through deliberative processes tainted by the effects of dominance and subordination.

In general, critical theory needs to take a harder, more critical look at the terms 'private' and 'public'. These terms, after all, are not simply straightforward designations of societal spheres; they are cultural classifications and rhetorical labels. In political discourse they are powerful terms frequently deployed to delegitimate some interests, views, and topics and to valorise others.

This brings me to two other senses of 'private', which often function ideologically to delimit the boundaries of the public sphere in ways that disadvantage

subordinate social groups. These are the fifth sense, pertaining to private property in a market economy, and the sixth sense, pertaining to intimate domestic or personal life, including sexual life. Each of these senses is at the centre of a rhetoric of privacy that has historically been used to restrict the universe of legitimate public contestation.

The rhetoric of domestic privacy would exclude some issues and interests from public debate by personalising and/or familiarising them; it casts these as private, domestic or personal, familial matters in contradistinction to public, political matters. The rhetoric of economic privacy, in contrast, would exclude some issues and interests from public debate by economising them; the issues in question here are cast as impersonal market imperatives or as 'private' ownership prerogatives or as technical problems for managers and planners, all in contradistinction to public, political matters. In both cases, the result is to enclave certain matters in specialised discursive arenas and thereby to shield them from broadly based debate and contestation. This usually works to the advantage of dominant groups and individuals and to the disadvantage of their subordinates. If wife-battering, for example, is labelled a 'personal' or 'domestic' matter and if public discourse about it is channelled into specialised institutions associated with, say, family law, social work, and the sociology and psychology of 'deviance', then this serves to reproduce gender dominance and subordination. Similarly, if questions of workplace democracy are labelled 'economic' or 'managerial' problems and if discourse about these questions is shunted into specialised institutions associated with, say, 'industrial relations' sociology, labour law, and 'management science', then this serves to perpetuate class (and usually also gender and race) dominance and subordination.

This shows once again that the lifting of formal restrictions on public-sphere participation does not suffice to ensure inclusion in practice. On the contrary, even after women and workers have been formally licensed to participate, their participation may be hedged by conceptions of economic privacy and domestic privacy that delimit the scope of debate. These notions, therefore, are vehicles through which gender and class disadvantages may continue to operate subtextually and informally, even after explicit, formal restrictions have been rescinded.

Strong publics, weak publics: on civil society and the state

Let me turn now to my fourth and last assumption underlying the bourgeois conception of the public sphere, namely, the assumption that a functioning democratic public sphere requires a sharp separation of civil society and the state. This assumption is susceptible to two different interpretations, according to how one understands the expression 'civil society'. If one takes that expression to mean a privately ordered, capitalist economy, then to insist on its separation from the state is to defend classical liberalism. The claim would be that a system of limited government and *laissez-faire* capitalism is a necessary precondition for a well-functioning public sphere.

We can dispose of this (relatively uninteresting) claim fairly quickly by drawing on some arguments of the previous sections. I have already shown that participatory

parity is essential to a democratic public sphere and that rough socio-economic equality is a precondition of participatory parity. Now I need only add that *laissez-faire* capitalism does not foster socio-economic equality and that some form of politically regulated economic reorganisation and redistribution is needed to achieve that end. Likewise, I have also shown that efforts to 'privatise' economic issues and to cast them as off-limits with respect to state activity impede, rather than promote, the sort of full and free discussion built into the idea of a public sphere. It follows from these considerations that a sharp separation of (economic) civil society and the state is not a necessary condition for a well-functioning public sphere. On the contrary and *pace* the bourgeois conception, it is precisely some sort of interimbrication of these institutions that is needed.

However, there is also a second, more interesting interpretation of the bourgeois assumption that a sharp separation of civil society and the state is necessary to a working public sphere, one that warrants more extended examination. In this interpretation, 'civil society' means the nexus of non-governmental or 'secondary' associations that are neither economic nor administrative. We can best appreciate the force of the claim that civil society in this sense should be separate from the state if we recall Habermas's definition of the liberal public sphere as a 'body of private persons assembled to form a public'. The emphasis here on 'private persons' signals (among other things) that the members of the bourgeois public are not state officials and that their participation in the public sphere is not undertaken in any official capacity. Accordingly, their discourse does not eventuate in binding, sovereign decisions authorising the use of state power; on the contrary, it eventuates in 'public opinion', critical commentary on authorised decision-making that transpires elsewhere. The public sphere, in short, is not the state; it is rather the informally mobilised body of non-governmental discursive opinion that can serve as a counterweight to the state. Indeed, in the bourgeois conception, it is precisely this extra-governmental character of the public sphere that confers an aura of independence, autonomy and legitimacy on the 'public opinion' generated in it.

Thus the bourgeois conception of the public sphere supposes the desirability of a sharp separation of (associational) civil society and the state. As a result, it promotes what I shall call *weak publics*, publics whose deliberative practice consists exclusively in opinion formation and does not also encompass decision-making. Moreover, the bourgeois conception seems to imply that an expansion of such publics' discursive authority to encompass decision-making as well as opinion-making would threaten the autonomy of public opinion, for then the public would effectively become the state, and the possibility of a critical discursive check on the state would be lost.

That, at least, is suggested by Habermas's initial formulation of the bourgeois conception. In fact, the issue becomes more complicated as soon as we consider the emergence of parliamentary sovereignty. With that landmark development in the history of the public sphere, we encounter a major structural transformation, since a sovereign parliament functions as a public sphere *within* the state. Moreover, sovereign parliaments are what I shall call *strong publics*, publics whose discourse encompasses both opinion formation and decision-making. As a locus of public deliberation culminating in legally binding decisions (or laws), parliament was to be the site for the discursive authorisation of the use of state power. With

the achievement of parliamentary sovereignty, therefore, the line separating (associational) civil society and the state is blurred.

Clearly, the emergence of parliamentary sovereignty and the consequent blurring of the separation between (associational) civil society and the state represents a democratic advance over earlier political arrangements. This is because, as the terms 'strong public' and 'weak public' suggest, the force of public opinion is strengthened when a body representing it is empowered to translate such 'opinion' into authoritative decisions. At the same time, there remain important questions about the relation between parliamentary strong publics and the weak publics to which they are supposed to be accountable. In general, these developments raise some interesting and important questions about the relative merits of weak and strong publics and about the respective roles that institutions of both kinds might play in a democratic and egalitarian society.

One set of questions concerns the possible proliferation of strong publics in the form of self-managing institutions. In self-managed workplaces, child-care centres or residential communities, for example, internal institutional public spheres could be arenas both of opinion formation and decision-making. This would be tantamount to constituting sites of direct or quasi-direct democracy, wherein all those engaged in a collective undertaking would participate in deliberations to determine its design and operation. However, this would still leave open the relationship between such internal public spheres cum decision-making bodies and those external publics to which they might also be deemed accountable. The question of that relationship becomes important when we consider that people affected by an undertaking in which they do not directly participate as agents may none the less have a stake in its modus operandi; they therefore also have a legitimate claim to a say in its institutional design and operation.

Here we are again broaching the issue of accountability. What institutional arrangements best ensure the accountability of democratic decision-making bodies (strong publics) to *their* external, weak, or, given the possibility of hybrid cases, weak*er* publics? Where in society are direct democracy arrangements called for, and where are representative forms more appropriate? How are the former best articulated with the latter? More generally, what democratic arrangements best institutionalise co-ordination among different institutions, including co-ordination among their various complicated publics? Should we think of central parliament as a strong super-public with authoritative discursive sovereignty over basic societal ground rules and co-ordination arrangements? If so, does that require the assumption of a single weak(er) external super-public (in addition to, not instead of, various other smaller publics)? In any event, given the inescapable global interdependence manifest in the international division of labour within a single shared planetary biosphere, does it make sense to understand the nation state as the appropriate unit of sovereignty?

I do not know the answers to most of these questions, and I am unable to explore them further in this essay. However, the possibility of posing them, even in the absence of full, persuasive answers, enables us to draw one salient conclusion: any conception of the public sphere that requires a sharp separation between (associational) civil society and the state will be unable to imagine the forms of self-management, interpublic co-ordination and political accountability that are

essential to a democratic and egalitarian society. The bourgeois conception of the public sphere, therefore, is not adequate for contemporary critical theory. What is needed, rather, is a post-bourgeois conception that can permit us to envision a greater role for (at least some) public spheres than mere autonomous opinion formation removed from authoritative decision-making. A post-bourgeois conception would enable us to think about strong *and* weak publics, as well as about various hybrid forms. In addition, it would allow us to theorise the range of possible relations among such publics, which would expand our capacity to envision democratic possibilities beyond the limits of actually existing democracy.

Hamid Naficy

THE MAKING OF EXILE CULTURES
Iranian television in Los Angeles

EDITOR'S INTRODUCTION

THIS ESSAY, A CHAPTER from the book with the same title, is a
detailed, ethnographic case study of television produced for, and watched by,
Iranian exiles in Los Angeles. It tells the story of how television helps to trans-
form diasporic Iranians from exiles into ethnicity, from liminality to incorporation,
by carefully balancing the old and the new, individualism with traditionalism,
fetishization of the lost homeland with embrace of US consumerism.

While, as Naficy insists, it would be wrong to think of Los Angeles Iranians
as a homogeneous group, they are dominated by those who left after the fall of
the Shah, that is, they are predominantly a Westernized, bourgeois community,
unlike, say, the vast majority of the Filipino or Mexican migrant communities.
Their Iran is not Iran as it is: it's an imaginary Iran cleansed of the culture and
politics of the current Islamic theocracy.

Naficy's essay contributes to various strands of cultural studies – most obvi-
ously to the study of television, but also to analysis of globalization,
cosmopolitanism and multiculturalism. In that light it is sobering: there is not
much sustenance here for celebration of difference, of critique or of the undoing
of identity which are all so deeply embedded in the field.

Further reading: Anderson 1992; Burnett 1995; Jameson and Miyoshi 1998; D.
Miller 1992; Morley and Robins 1995; Sollors 1986.

How the shows are seen

For many Iranian exiles, Sunday lunches are big affairs, an occasion for the entire nuclear or extended family and friends to get together for a late meal. Up to the mid-1980s, many restaurants offering Iranian food in Los Angeles had installed in a prominent place a television set or a video projection system. On these screens, the customers could watch old music videos and television serials made before the revolution and imported from the homeland. They could also watch exile-produced television shows such as Iranian, Jonbesh-e Iran *and* Jam-e Jam, *which have for years been aired on Sundays in one block from 11 a.m. to 2 p.m. The narrow rooms typical of the restaurants and the symmetrical seating arrangement created a kind of classical quattrocento perspective, with the television screen forming its vanishing point. No matter where you sat, at least one side of the restaurant faced the screen squarely and you were forced to look at it. Even though the volume was often turned up so high as to interfere with conversation and the image broke up frequently, no one seemed to mind. It was as though the customers were facing an electronic altar or* qebleh *(prayer niche) that displayed sacred icons of an idealised homeland and an irretrievable past.*

Watching the Sunday shows during social functions, however, was not limited to public occasions and places. In homes, too, these programmes provided a moving background for Sunday lunches and children's birthday parties. Television thus became part of public and private rituals. Even during the inevitable dances and obligatory singing of the birthday songs, the set would remain on with the sound turned down. During periods of crises, such as the bombing of Iranian cities, Scud missile attacks and waves of assassinations and executions at home, television would suddenly move to the foreground. The news headlines or a particular film clip would bring a quick hush to the crowd. Eyes would be glued to the set, the silence broken by an occasional angry outburst. The celebration would resume, infected by the news of home.

Interestingly, not all viewers of Iranian programmes are Iranian or are of Iranian descent. Shared cultures and history allow cross-viewing among not only Iranian sub-ethnics but also other Middle Eastern populations in diaspora. My friend's mother, an elderly Jewish émigré from Palestine, likes to watch Iranian programmes even though she does not understand Persian at all. It seems the nostalgic music and visuals of exile music videos remind her of her childhood and homeland.

Exile television as a ritual genre

The approach to the analysis of television adopted here considers exile television as a genre, with its own televisual flow, textual strategies and signifying practices. This might be called a 'generic ritual' approach, since it seeks to understand not only the genre itself but also its interplay with the evolving community that produces and consumes it. For a community living in the liminality and anarchy of exile, the television that it produces and consumes is a vehicle through which the exile subculture and its members, collectively or individually, *construct* themselves in the new environment. Television for them not only reflects but also constitutes and transforms the community. The televisual exile genre is without precedence, as it is produced and consumed by people outside of their own culture and society. The long time frame, the critical apparatuses and the

common grounds necessary for codifying and internalising the genre conventions are largely absent.

As a ritual genre, exile television helps to negotiate between the two states of exile, *societas* and *communitas*. Societas is the rule-bound structured world both of the homeland from which the exiles are separated and the host society to which they are acculturating. Communitas, on the other hand, is the formless, liminal state in which the rules and structures of both home and host societies are suspended, and aspects of sacredness and religiosity – here, ritual – take their place. When social structures are threatened, communitas emerges, and helps the exiles maintain similarity through elaboration of differences based on ethnicity and locality. This is a concept that appears to fly in the face of attempts made by structuralists to negate the concept of community in favour of universal structures. We are in a historical period characterised by waning of traditional universalist ideologies such as colonialism, neocolonialism and communism, and we are witnessing the world over, in pre-industrial and post-industrial nations alike, people continuing aggressively to assert their locality and ethnicity through marking their boundaries. Such boundaries are largely symbolically constructed, sometimes imperceptible to outsiders, redefinable by the members of the community itself, and maintained through manipulation of symbols of that community.

Rituals gain additional prominence when the actual social boundaries of the community are undermined, blurred or weakened. Communal celebrations (weddings, barmitzvas, batmitzvas discos, political demonstrations, anniversaries, calendrical festivals) occupy a prominent place in the cultural repertoire of the exiles, and commercially driven exilic television as a ritual functions in parallel with these social rituals to maintain individual, communal and national boundaries. It introduces a sense of order and control into the life of the viewers by producing and replicating a variety of systematic patterns that set up continually fulfilled (or postponed) expectations: narratological and generic patterns (programme format, formulaic plots, stock characters, regular hosts and newscasters, a familiar studio set), patterns of consumption (scheduled airing and repeated airing of programmes, interruption of the text for commercials, household environment and viewer activity), and patterns of signification (subjectivity, mode of address, iconography).

Together all these narratological, consumption and signification patterns produce an electronic communitas, which creates for exilic producers and viewers alike a sense of stability out of instability and commonality out of alienation. Part of the work of exilic popular culture, including television, is to produce a repository of symbols and a web of signification with which exiles can think and through which they may differentiate themselves from the host society. That is why exile is such an intensely symbolic and semiotic space and exilic television so integral an element in it.

As ritual, exilic television not only aids in creating an exilic communitas but also facilitates the transformation of the communitas toward the host societas. As such, exilic television helps the exiles maintain a dual subjectivity and a syncretic identity. There are many characteristics that set apart the exilic genre from other televisual genres. At the level of texts and inter-texts, the exile genre is characterised structurally by nested texts, flow and schedule, and by the magazine format; narratologically and ideologically by the narratives and iconographies of fetishisation

and ambivalence; thematically by nostalgic longing for a reconstituted past and homeland and the metaphoric staging of return to the origin; and politically by the construction of a particular imaginary nation-at-a-distance in exile.

Televisual texts

Determining what the unit of analysis for television should be and what a televisual text is has proven to be a problem largely because television texts are so multipurpose, polyvalent and amorphous. Raymond Williams formulated the television text as a rather hermetic and seamless 'planned flow' in the construction of which viewers play a more or less passive part. Horace Newcomb's concept of the 'viewing strip', on the other hand, foregrounded the active role of viewers in constructing the texts they watch (1988). In an effort to move away from text-based analyses toward locating television within the political economy of production and consumption, Nick Browne proposed the concepts of the 'supertext' and the 'megatext' as textual units of analysis. The supertext includes the programme and all the interstitial materials surrounding it – teaser, titles, credits, advertisements, station identifications, programme promotions and public service announcements – its position within the schedule, and the relation of the schedule to the 'socially mediated workday and workweek'. The megatext consists of 'everything that has appeared on television' (1984: 177). Although these concepts take into account the television's textual environment and advance our understanding of the way the texts are linked with the political economy of consumerism, they fail to account for viewer activity, which, as will become evident, is much more complex in exilic than in mainstream television.

Much of the cultural studies work conducted in Britain, beginning with the work of the Centre for Contemporary Cultural Studies at Birmingham University, focused on establishing links between the production of television texts and their reception by audiences. The ideological, ethnographic and feminist analyses that followed explored the links between the signifying practices of production and the socially structured audiences, thus turning television texts into writerly (in Barthes's sense), open (in Eco's sense), and producerly (in Fiske's sense, 1987b), thereby accounting for multiple readings.

'Liveness' characterises the televisual flow and its textual components. Even when the event is pre-recorded, its simultaneous transmission and reception affirms its live ontology and the ideology embedded in it, which Jane Feuer has defined as 'the ideology of the live, the immediate, the direct, the spontaneous, the real' (1983: 14). This ideology dominates the magazine and the talk-show formats, the quintessential forms of both mainstream and exilic television. The liveness of exilic television, however, has a fundamentally different character in that it unfolds in a liminal space, activating memories of elsewhere, and it is received in an exilic household.

Nested exilic text, flow and schedule

The 'text' of exilic television is what might be called a 'nested text', in the sense that it is an exilic supertext nested within an exilic flow that is embedded within an ethnic flow which itself is nested within the mainstream television's megatext. The exilic supertext itself is a split or a double text because the programme (text) is infused with sounds, images and discourses primarily driven by the values, culture and language of the homeland while the interstitial materials, particularly commercials, are driven chiefly by the consumerist ideology, values and culture of the host society. Thus exilic television supertext is an instance of Derridean 'double reading and writing', in which neither of the adjacent texts obtains primacy, as each resonates with or against and deconstructs the other. Split subjects produce split texts, and exilic supertexts both inscribe and erase cultural, racial, ethnic, historical and linguistic differences and tensions which can be read when attention is paid to their interpermeability and resonances. The result is that the cohesiveness of the communitas created by televisual texts is threatened constantly by the implosion of the dominant host values by means of both the commercials interrupting the texts and the commodification practices of exile television itself.

Exile television programmes are usually broadcast by television stations not as single entities but in clusters, forming an exilic flow. Los Angeles cable companies schedule *Iran* and *Shahr-e Farang* programmes back to back on Friday nights and *Negah* and *Diyar* on Sunday nights; KSCI-TV schedules a series of Iranian programmes from 7.30 a.m. to 9.30 a.m. on weekdays and from 11 a.m. to 2 p.m. on Sundays. These exilic flows are themselves nested, particularly in the case of KSCI-TV, within an ethnic flow containing clusters of programmes from many national, ethnic and linguistic groups (programmes in sixteen languages are aired). The majority of these programmes are imported from home countries. Chinese programmes occupy the afternoon and early evening slots, Korean shows dominate the prime-time hours on weeknights and Japanese shows the prime-time hours on weekends.

This conception of a multilingual nested ethnic televisual flow is radically different from the monolingual, monochannel, monocultural flow that television scholars have formulated and studied. What is more, this ethnic flow is not insular. Through viewer activity and channel selection, it is inserted yet again into the larger megatext of television, which includes all broadcasts channels. Exile television programmes, therefore, are consumed within a triple-tiered viewer-strip selected by the audience. Exilic and ethnic viewers can travel across these nested flows (exilic, ethnic and mainstream) because they are generally familiar with more than one language. For a majority of the monolingual viewers, however, the exilic and ethnic flows remain generally unreadable.

The ethnic flow at multi-ethnic stations is characterised not so much by seamlessness as by segmentation. It is also intensely hermeneutic, as varied politics, nationalities, ethnicities, religions, cultures, languages, classes, news values, narrative strategies, modes of address, physical locations, tastes, gestures, faces, sights and sounds clash with one another. This segmentation penetrates to even below the level of nationality as many émigré and exile communities are themselves not homogeneous.

The diversity of the Iranian population in terms of internal ethnicity, religiosity and language allows its members to access not only Persian and English-language programmes but also Armenian, Arabic, Assyrian and Hebrew programmes not necessarily produced by Iranians. Access to multiple texts produced in multiple languages by multiple nationalities and ethnicities makes the flow not only inter-ethnic but also intra-ethnic. This textual access means that the ethnic flow is replete with excess and alternate meanings, going beyond either intent or hegemony.

The oppositional use of this excess is made possible by the differences and contradictions among the exilic, ethnic and dominant texts, which access brings to the fore. This semiotics of excess turns the viewer activity into a rather complex and intertextual one, both along the exilic and ethnic flows (syntagmatic inter-textuality) and across the nested texts (paradigmatic intertextuality). Because the exilic supertexts are nested within an ethnic flow, viewers are constantly made aware of the minor status of the exilic texts themselves and their own minority status as an audience in exile. A syntagmatic viewing of the exilic supertexts can serve to consolidate a sense of cohesion and hermeticity around the notions of exile and nationality. A paradigmatic intertextual reading of it, which places it within its commercial environment, the ethnic flow and the mainstream megatext, however, creates multiple splittings and deconstructive nuances across all the texts, which serve to continually problematise the cohesive exilic, ethnic, and national-istic readings. The exilic supertext and flow are thus not only excessive but also ambivalent and unstable.

Mainstream television establishes its relationship to the real world through the schedule, keyed to the workday and the workweek. As a result the schedule tends to reproduce and naturalise the 'logic and the rhythm of the social order' (Browne 1984: 176). However, the exilic and ethnic television schedule – at least that produced by multi-ethnic stations – reproduces a radically different logic. Multi-ethnic stations lease their time not to the most popular shows but to the highest bidder, regardless of the type of programming. The majority of exile and ethnic programmers, in turn, do not make their programmes with the schedule in mind, since the stations can change their airtime or bump them off the air at short notice. As a result, Iranian exile morning programmes are not vastly different from after-noon or evening programmes. The schedule then reflects the exile's own liminal condition, its formlessness, the endlessness of its time, its ambivalence.

The magazine format

The magazine format dominated exile television in the first decade of its existence. Like most genres and rituals, the magazine format is not unchanging; here, it is a symbolic construct that changes with time as it responds to and inscribes the evolu-tion of individual subjectivity and collective identity of the exiles. In this sense, exilic television by definition is both processual and contradictory as it encodes the tensions of exilic evolution, adaptation and resistance. In the magazine format, the programme unit typically consists of a collection of usually single-topic mini-programmes linked by commercials. Historically, the format's use in the public

affairs area resulted in talk shows and news magazines (the latter will be high-lighted here).

The magazine format is one of the most proliferating and least studied forms of television and it is central to my analysis of the exile genre. There are many variations, but in its classic form, the news magazine consists of several important structural features that set it apart from daily television newscasts and talk shows. Like its printed namesake, a television magazine is transmitted on a specific day and at a specific time on a daily, weekly or monthly schedule. Like printed maga-zines, it contains several self-contained segments, which are much longer than a typical item on a newscast. Unlike talk shows, which are usually studio-bound, the news magazine's segments are usually shot on location. Television magazines rely on a regular cast of anchors and reporters – stars of the format – who supply public image, a sense of continuity, calmness, knowledge, authority, reliability and humanity. The enunciative strategy of the format is generally as follows: the regular in-studio anchors or hosts introduce a segment, which is then reported by a corre-spondent in the field. In some cases (*60 Minutes*) the anchor and field reporter are the same, in others (*20/20*) they are different. Advertisements follow the comple-tion of one segment, to be followed by another in-studio introduction to the next segment.

The magazine's mode of address is live and direct, with anchors and corre-spondents facing the camera and speaking directly to the invisible audience at home. The programme's guests, likewise, speak without a written script to the hosts who act as intermediaries between them and the audience. The phatic banter and the 'ritual of hospitality' between the in-studio hosts and guests or between anchors and field reporters enhance the 'liveness' of the medium. All this is undergirded by the currency, urgency and 'realness' of the social issues the format usually tackles. The news magazine format can thus be characterised by immediacy, inti-macy and intensity.

A side effect of the ritual of hospitality is the creation of a sense of familiarity and familiality at the level of enunciation. At the reception end, too, these familiar and familial attributes are mobilised again by reception of the programme within the home environment and by the pattern of viewing, which is often collective. The direct address and the direct gaze of the anchors and reporters tend to suppress individual subjectivity obtainable through the primary process and suture. Instead, they foreground a kind of collective subjectivity, made available through the secondary process and through language.

The magazine's narrative regime is presentational, not representational. It is also self-reflexive and self-referential, and does not use the realist illusionism that dominates dramatic programming. Unlike these programmes, the magazine does not hide its narrative and enunciative apparatuses (direct address and presence of reporters, cameras, microphones) or its own existence. While dealing with the individual and social issues that real (empirical) people face in their daily lives, magazine shows do not ignore drama. News magazines generally do not use re-enactments (although there are recent tabloid exceptions in mainstream programming), but they inject drama into the treatment of their 'stories' by selecting sensational topics and exciting, villainous or heroic personalities, and

by employing classic dramatic structure. Further, although the magazines subscribe to the standard values of 'objectivity' and 'fairness', they do allow the expression of a wider and deeper range of opinions than do newscasts.

The magazine format's relationship to advertising was spelled out most clearly in the inception of the format by NBC in the early 1950s. Unlike the single-sponsor programmes, then usually produced by advertising agencies, the 'magazine concept' promoted the idea of inserting spot ads by multiple sponsors within programmes produced by the networks themselves. This arrangement allowed the networks to retain control of both the contents and the revenues. It is this same arrangement that drives exilic magazine programmes.

The exile magazine

Structurally and narratologically, the exile magazine format is a composite genre combining features of both hard-news and tabloid magazine formats. At the same time, it contains certain elements that differentiate it from both of these forms of mainstream television and mark its exile status. Typically, the exile magazine contains the following seven elements: a programme opening containing a visual logo and a musical signature; greetings by the programme host and introduction to the programme; advertisement, chiefly for ethnic products; then a newscast featuring news of the homeland, the world and the United States, delivered often by regular news readers different from the host. While news usually is defined as political news, when it comes to news of the community in Los Angeles, it is often limited to entertainment news. Various types of news are separated by advertisements. A segment containing one or more of these constituent elements follows: a comedy skit, a segment of a continuing satirical or soap-opera serial, news commentary, interviews with people in the news or with experts in law, medicine, real estate and financial matters. This segment may contain more than one commercial break. Then come current stocks, weather, sports and fashion reports, and then one or more musical numbers, including music videos. Often the musical numbers are preceded or followed by a publicity interview with the performer.

From this taxonomic listing of elements of the magazine supertext, it becomes clear that the exile magazine, unlike its mainstream television counterpart, is an extremely heterogeneous, composite genre, combining both fictional and expository narratives and their various subgenres. In essence, this is a 'montage' genre in which a number of genres and discourses meet head to head. Its principle of cohesiveness is not continuity but clash, not seamlessness but segmentation. The hosts and commercials are the chief producers of continuity within the exilic supertext and flow.

The segmentation of the format, and the multiple ownership of programmes by one producer, provide a built-in mechanism for intertextuality and self-referentiality, whereby producers and hosts can refer to and promote across a number of programmes (and even media) the various programmes in which they have an interest. This enhances discursive exposure, and also the earnings of the producers. That the 'magazine concept' forces the exile producers to rely on spot ads instead of single sponsors means that they are not theoretically very susceptible

to economic influence from a few powerful commercial sponsors. However, the exigencies and vulnerabilities of exile, at least in its early phase, open the producers to heavy political (even financial) influences brought on by powerful political factions.

Programme types

Throughout much of the 1980s and 1990s the magazine-style supertext dominated, although there were programmes that did not fit into the form as tightly as others. Reflecting the processual nature of the exile genre itself and of television in general, which must continually change to find new audiences, during this period producers attempted to differentiate their programmes from one another by varying the mix of the seven format elements noted above. This resulted in a gradual emergence of a number of types within the exile magazine format, which are listed here with one sample from among the current programmes: newscast (*Jong-e Bamdadi*), news-feature magazine (*Sima-ye Ashna*), news commentary magazine (*Cheshmandaz*), cultural talk show (*Harf va Goft*), news magazine (*Iranian*), variety magazine (*Jam-e Jam*), pop music magazine (*Diyar*), satirical magazine (*Shahr-e Farang*), serial magazine (*Negah*), live phone-in magazine (*Emshab ba Parviz*), women and family magazine (*Didar*), religious magazine (*Mozhdeh*), ethnic magazine (*Bet Naharin*), medical talk show (*You and the World of Medicine*), guerrilla magazine (*Sima-ye Azadi*), and programme-length advertising magazine (*Sobh-e Ruz-e Jom'eh*). It must be noted that each type of programme may not necessarily contain all of the elements of the magazine format, but it will contain many of them in varied combination. For example, a news magazine may contain more news than a variety magazine but it will also contain at least one musical number. Likewise, the variety magazine contains some hard news. In the same vein, the interview on the news magazine may be focused on news and current affairs, while that of the variety magazine would deal with the entertainment field.

Gradually, several programmes became so specialised that strictly speaking they can no longer be called magazines, but even these retained some of the features of the format. In the 1980s and early 1990s, for example, *Negah* devoted much of its half-hour broadcasts to airing two engaging soap-opera serials produced in exile, but it retained some of the format elements: opening logo and musical signature, greetings by the host, phatic banter with co-host, news, interview with a psychologist about the topics raised by the programme and advertisements. In 1992, the Assembly of God religious programme *Mozhdeh* came on board. Although the programme is commercial-free and devoted to proselytising, it uses a number of hosts, choral and musical religious numbers, and interviews with and testimonials from Iranians who have converted to Christianity. The basic structure of the magazine has remained remarkably intact principally because it is a flexible format capable of responding to and encoding the shifting and multiple exigencies of exile. This flexibility has allowed it to give access to diverse voices, even though the magazine's familiar format, regular daily or weekly broadcast schedule and longevity (some programmes have been on the air in the same time slot for over a decade) have served to regulate and contain the flux of exilic liminality.

Variation in the mix of format elements helped to recast the concept of audience from an amorphous, familial and homogeneous mass to a number of different

targetable clusters. The principles of variation were the broadcast time of the programme and gender, age, politics and ethno-religious affiliations of audience members. Significantly, language differences were suppressed. This is understandable; the first step in identity formation for most exiles is to differentiate themselves from the host society by reducing their own internal differences. Due to the absence of a reliable rating system, the producers were guided in this targeting practice more by trial and error than by demographic studies.

The exilic and ethnic television schedules are in considerable flux and although they are unable to replicate closely the social order of the workweek and the weekend, the producers of exilic television attempted throughout the years to link their shows to the time of broadcast, however loosely, and to the life patterns of their increasingly assimilating audiences.

Programme contents

The two daily morning programmes are current affairs programmes. *Jong-e Bamdadi* presents hard international, national and local news, including extensive coverage of Iran and Iranians abroad, while *Sima-ye Ashna* is chiefly a news magazine, emphasising soft feature stories and film clips from around the world. Both programmes target adults who view the programmes before leaving for work. The morning medical programmes (*Pezeshg-e Khub-e Khanevadeh*, *Mardom va Jahan-e Pezeshgi* and *You and the World of Medicine*), in relaxing talk-show and interview forms, offer medical and health tips to the eldest members of the family, those men and women who stay at home during the day. *Sobh-e Ruz-e Jom'eh* is an infomercial or advertising magazine, in which the host, using a talk-show format, talks amicably and persuasively to the camera or with a guest about an Iranian product or service, interspersing his presentations with well-known poetry and proverbs. These interviews and presentations are interrupted by pre-recorded spot commercials for products and services.

Prime-time programmes are generally more entertainment-oriented and can potentially attract audiences different from those of the morning shows. Of these, *Iran* seems to be targeting a younger viewer. Its younger host has an informal and hip style and his programme is loose in form, upbeat in tone, feature-oriented, music-dominated and less concerned with the politics of home. The programme has featured a number of television serials, such as the satirical serial *Da'ijan Napele'on* (Uncle Napoleon), produced in Iran before the revolution, and the drama serial *Amir Kabir*, made in post-revolutionary Iran. *Shahr-e Farang* is a satirical variety magazine. Its host is a well-known comic who mixes satirical commentaries about current events and personalities in Iran and the United States with dramatic serials he has produced on life in exile. *Iran va Jahan* is currently chiefly a variety magazine, containing news, news commentary, music videos and tourist films about Israel. The religious programme *Mozhdeh* carries no commercials but uses its magazine format to proselytise for the Assembly of God church.

Weekends for Iranians are traditionally occasions for visiting friends and for extended-family get-togethers. As a result, daytime Sunday programmes provide a very diverse mixture of adult and family programming. *Iranian* and *Jonbesh-e Iran* provide news, interviews with Iranian political and cultural figures and one or two

music videos, while *Jam-e Jam* provides news and many entertainment segments, particularly music videos. *Negah*'s most innovative feature has been the airing of a series of well-produced soap operas (*Ro'ya-ye Emrika'i* [The American dream] and *Payvand* [Connection]) that explore the tensions of Iranian families and young couples in the process of acculturation. Sometimes the serial is followed or preceded by an interview with an expert on immigration or family counselling. *Diyar* is a musical variety magazine targeting younger viewers, and it is devoted entirely to entertainment news, interviews with Iranian entertainers, and various types of music videos. *Aftab*, much of whose programmes are imported from Iran, attempts to stay away from straight political news and to operate instead in the cultural domain. Each week its host presents commentaries that attempt to link Iranians living abroad with those who have remained at home. The magazine format and the two-hour time slot allow him to present a melange of segments: dramatic and satirical serials, portions of feature films, and animated cartoons for children. (Although, over the years, a few of the exile programmes tried to target Iranian children, they failed to attract them because of a dearth of existing programming, the high cost of producing new materials and the impossibility of competing with American mainstream children's programmes.)

Following the model of American mainstream television, late-night exile programmes employ chiefly the talk-show form of the magazine, with the recent addition of the phone-in feature. Clearly, the intended audiences for these shows are adults. In *Emshab ba Parviz*, aired live nationally, the host interviews one guest each time about a single topic and takes phone calls from viewers. *Sokhani ba Ravanshenas*, too, is a live call-in show, during which audience members discuss with the psychiatrist-host of the show their personal and familial problems. *Harf va Goft* is a live interview show in which the host talks with one or more individuals about some aspect of culture and life in exile. Often films or other works of art are shown and the contents explored with the artist or a critic. *Midnight Show* is the longest-running talk show, the format of which is flexible enough to allow its host to interview his guests either in the studio or on location and to cover news and cultural events of interest to Iranians. *Pars* is a variety magazine, containing music videos, news, hard news, entertainment news and news commentary. *Agahi-ye Behtar* is a programme-length commercial for ethnic products and services, produced and hosted by the same person who runs *Sobh-e Ruz-e Jom'eh*. Although the guerrilla magazine, *Sima-ye Azadi*, does not carry advertisements for consumer products, the entire programme is a commercial for its producer, the Mojahedin guerilla organisation, which is engaged in armed struggle against the Islamic government in Iran. This programme, too, utilises a magazine format presided over by a host who links the various segments, including a newscast, videotaped reports of the Mojahedin activities, speeches by the organisation leaders, musical numbers and anti-government music videos.

Although women have produced three programmes (*Didar*, *Ma* and *Sima va Nava-ye Iran*), none has survived. Women's issues and tensions in the family structure in exile were foregrounded in *Didar* and *Sima va Nava-ye Iran*. The former dealt with them in a variety talk-show form while the latter used the soap-opera format as well.

Iranian ethno-religious groups have in the past produced a number of programmes. *Mozhdeh* is entirely devoted to preaching Christianity, while Assyrian programmes tend to focus on issues related to the Assyrian ethnic and religious communities in diaspora. Although various ethnic and religious minorities are represented among producers of other programmes, it cannot be said that these programmes are openly ethnic or religious. Rather, because of fear of bad publicity and persecution, ethnicity and religious affiliations have become submerged presences encoded at a latent level in the programmes. For example, the overall discourse of *Jam-e Jam* and *Iran va Jahan*, both produced by Jewish Iranians, is not religious or ethnic, but news and news commentary about Israel forms a greater part of their newscasts and they seem to carry more advertising from Jewish businesses. Satirical segments produced by the Armenian Rafi Khachaturian (*Jan Nesar* and *Khub, Bad, Zesht*) are not ethnic or religious. In fact, they are highly political, against the Islamic regime in Iran, and they poke fun at the foibles and frailties of all Iranians. Programmes produced by Iranian Baha'is, too, do not foreground their religion or ideology, although they may favour Baha'i concerns. For example, *Mona's Execution*, a harrowing music video recreating the execution of a Baha'i girl in Iran, was aired by *Cheshmak*, produced by an Iranian Baha'i. Finally, during much of the first decade of programming, none of the Muslim producers highlighted Islam in their discourse. Its presence was limited to references to the politics of the Islamic Republic in the news or the periodic condolences or congratulations offered audiences on the death days or birthdays of major Islamic religious figures. In the early 1990s with *Aftab*, the creation of an Islamic Centre in Beverly Hills by Iranian Muslims, and the gradual acculturation, depoliticisation and democratisation of the exiles, Islam and Islamic issues began to surface. *Sobh-e Ruz-e Jom'eh* dared to feature in June 1992 a religious sermon (*rowzeh*) to commemorate the death of imam Hosain, the slain martyr of Karbala.

The ethnic flows and the megatext of KSCI-TV and the cable companies in which exilic programmes are nested place at the disposal of Iranian ethno-religious minorities ethnic programmes produced by others with whom Iranians share cultural, linguistic or religious affiliations. Jewish Iranians may watch *Israel Today*, *Phil Blazer* or the Jewish Television Network; Armenian Iranians may watch *Armenian Teletime* or *ANC Horizon*; Assyrian Iranians may view *Bet Naharin*; Arab Iranians may watch *Arab American TV, Alwatan* or *Good News*; and those interested in the religion and practices of Islam may watch *Islam*.

The basic magazine format has endured, although many variations in the mix of its elements have been introduced. These variations and the differing signifying practices of the aforementioned programmes clearly demonstrate that the conception of Iranians as a homogeneous mass of exiles or as a cohesive biological or national family is no longer tenable. Programmers have succeeded by trial and error in segmenting and targeting their audience by age, politics, religion, profession, interests, ethnicity and gender. They do not usually couch their programming strategies in the cold and calculating terms of commerce, however. Instead, they often differentiate themselves and justify their format variation by claiming a greater stake in and allegiance to an 'essential' and 'authentic' Iranianness.

Subjectivity and mode of address

Televisual and cinematic signification differ from one another on a number of levels. The most significant of these is the process by which viewer subjectivity is formed. Theories of cinematic spectatorship have highlighted the function of vision and voyeurism in the constitution of the subject (Mulvey 1989). This function is said to be driven by the primary process, which Freud associated with the pre-language unconscious and with the pleasure principle. It is chiefly concerned with affect and sensory data, particularly visual. The primary process is remarkably single-minded and insatiable and does not distinguish between real objects and persons and their images. If it is blocked from attaching itself to one object, person or memory, it will seek another. As I have shown elsewhere, it is this process that is responsible for the fetishistic iconography of exile television, whereby the lost or absent homeland is recovered through over-investment in the signs that stand for it (such as the flag and its colours, the map of the country, dead and tortured bodies and national monuments). It is also the same process that drives the nostalgic narratives of return to the homeland and to nature. These processes are operative chiefly in the magazine format's logos, music videos and narrative portions which rely on vision and affect more than on words.

Freud also posited the secondary process, which works in tandem but in opposition to the primary process. This process, associated with the preconscious and the reality principle, tends to tame and hold in check the impulsiveness of the pleasure principle by 'binding' it chiefly to language. By submitting the unbounded pleasure principle to linguistic structuration, the secondary process tends to reduce the intensity of the affective and sensory values of the mnemic traces. This is the process that forms the basis of televisual subject positioning, particularly in the case of the magazine genre, which is driven chiefly by words and the direct address. Since the exile magazine contains both expository and fictional forms, however, it encourages a split subjectivity that must oscillate between the primary and the secondary processes, between affective sights and sounds and linguistic structuration, and between fictional and real-world issues. If the former promotes fetishisation within the visual track, the latter encourages fetishisation within the audio register. This is because while subject formation in the case of the narrative portions may occur primarily through scopophilia, in the case of expository sections it is driven primarily by epistephilia. This textual and subjective duality is undergirded by a further split in which programme matter is largely encoded by home while the ads inscribe host cultural values. These multiple dualities and splits resonate sympathetically with ambivalent identities – which typifies exilic liminality.

The direct address of the hosts, reporters, interviewees and commercials, which bare the device of enunciation, enhance the overall sense among viewers of being continually addressed. The direct address, moreover, tends to suppress individual identification by situating the viewers not only within language but also within the home. The 'leaky', segmented and contradictory supertext of television as well as the extratextual environment of the home in which it is received (telephone calls, doorbells ringing, lighted rooms, presence of children, availability of a kitchen nearby, neighbourhood noises) tend to suppress the intensive gaze

characteristic of cinematic viewing. Instead, a type of distracted and cursory gaze, what John Ellis has called 'glance', is encouraged (1982). In the case of ethnic and exilic television, the viewer's glance takes in not only the television set but also the home interior, which is ethnically and exilically coded by souvenirs, photographs, flags, maps, carpets, paintings, food, aromas, art objects and handicrafts from the homeland. The reconstitution of the television signal by viewers within such a highly coded environment tends to enhance the collective experience of being (dis)placed, in exile.

Viewers read exile television programmes not merely as textually positioned subjects but also as historically and socially located individuals who bring to their viewing their national, cultural, ethnic and ideological orientations. Spectatorship cannot be disengaged from the viewers' preconscious and conscious activity. Neither can it be divorced from the viewers' rules of social interaction, nor should we universalise the Western psychic structure, which is based on a strongly individuated self. Cinematic techniques of spectator positioning, such as shot reverse-shot – in film the armature of suture – are not universal and can be culturally coded and read. If rules of the Iranian system of courtesy (called *ta'arof*) are applied, for example, an over-the-shoulder shot in television can be read as an impolite gesture, because one character has his back to the viewers. Turning one's back to someone, especially a stranger, is considered very impolite in the discourse of ritual courtesy. An example of this type of reading is provided by *Zendegi-ye Behtar* (12 February 1990), in which the host interviewed a real-estate agent and the pop singer Martik. During both interviews, the host was taped from over his shoulder or from a three-quarter angle, with the result that his back was to the audience for much of the time. Noting that he had violated one of the key codes of courtesy, at the end of the programme the host faced the audience and apologised for having turned his back to them.

The spectator is positioned not only by the text but also by the orientational schemas of the society, which in the case of Iranians includes ritual courtesy, modesty of vision, and veiling and unveiling practices. These schemas and practices have a profound effect on the constitution of a communal subject in cinema. The familial and communal structure of the self among Iranians also works against the notion of television and cinema creating a unified, stable and individuated subjectivity.

Epistephilia and collective subjectivity

Words are necessary to express and shape both the fear of and the fact of the changed consciousness that exile engenders. Exilic television (along with independent transnational cinema, feminist films, and politically radical documentaries) relies greatly on such words. Epistephilia and the direct address of the exilic supertext destroy the distance and absence necessary for gaze-driven voyeuristic scopophilia. Instead, they institute glance-driven viewing, based on presence and on language. As a result, while in fictional narrative cinema the spectator is engaged through sexual pleasure, in expository non-fictional magazines the viewer draws pleasure through social engagement. Bill Nichols noted this difference in his discussion of documentary films:

The engagement stems from the rhetorical force of an argument about the very world we inhabit. We are moved to confront a topic, issue, situation, or event that bears the mark of the historically real. In igniting our interest, a documentary has a less incendiary effect on our erotic fantasies and sense of sexual identity but a stronger effect on our social imagination and sense of cultural identity.

(1991: 178)

In exile words play an important role in creating social imagination and cultural identity. There is an insatiable drive among Iranians in exile for information, knowledge and the exchange of ideas and words. Epistephilic desire is well suited to the television magazine because the magazine's expository form invokes and promises to gratify the desire to know. This desire and its expectation of fulfilment in exile sets into motion a generic contract between viewers and television producers that is not only binding but also spellbinding. This may partially account for the behaviour of Iranian audiences, who complain constantly about the number of commercials interrupting the programmes (sometimes totalling over forty minutes in an hour-long show) but who apparently cannot help but continue to watch. The spell, however, is cast not only by epistephilia but also by the segmentation of the televisual supertext itself, which tends to intensify psychologically the desire to watch, thereby making spectators continually available for commercial messages. In exilic television, each commercial interruption or delay in obtaining epistephilia constitutes a lack that tends to intensify the desire, thus encouraging continued viewing.

The status of the gaze requires further elaboration. As already noted, television suppresses the probing voyeuristic gaze and promotes the cursory glance. Moreover, the exilic magazine format, integrating a variety of genres and styles including documentary and non-fictional footage, accommodates a variety of what Nichols has called 'ethical looks', which link the style of filming and looking to the moral and political points of view of the film-makers and to their ethical implications. This is because the subjects in documentary cinema are usually social actors who live in history, not screen actors inhabiting the diegesis. What the viewer sees in this type of cinema is a record of how film-makers look at and regard their fellow human beings. There is considerable tension between an ethical and moral standard requiring those who film real events to place the public good uppermost, and the exigencies of producing commercially viable television, particularly in exile. The fact remains, however, that the magazine format's reliance on concern with the real, the social, and the collective, means that its credibility rests upon some fulfilment of public good.

Collective address and collective subjectivity

Television's direct address is a strategy of presence, while cinema's narrative address is one of absence. The narrative space of classic narrative cinema effaces the presence of the spectators and encodes it as absence; the expository space of the television magazine recognises and highlights the presence of the viewers. The televisual direct address has an added dimension of nowness, promoted by the

technology of the apparatus, which removes the distance between transmission and reception at home. As a result, the subjectivity that the television magazine cultivates, based on its live ontology, the co-presence of image and viewer, direct address, epistephilia, and the primacy of language and thus the secondary process is collective and in the present tense, while cinematic subjectivity, based on the separation of enunciation and reception, and the image and thus the primary process, is individualistic and in the past tense.

Because of its composite form, the exilic magazine encodes both absence and individual and presence and collective subjectivities. Collective subjectivity tended to dominate because of producers' previous conceptions of audience as a mass of homogeneous exiles, and because of the collective mode of address, which targeted neither individuals nor segments of the population but the entire family and exilic community. Early on, then, most exile programmes attempted to provide materials suited to all family members, including cartoons and special segments for children. In terms of the manner of address, many of the programme hosts continue to use either a collective term of endearment to address the audience such as 'you dear ones' or a familiar, poetic form of address reserved for intimate friends, such as 'greetings to you, my lovely, my fellow countryman, my unique one'. Likewise, many programme hosts use collective transitional phrases when going into commercials, such as 'let's watch the following messages *together*', '*we'll be together* again after these messages' (emphases added). These types of formulaic, collective and poetic forms of address, repeated many times during a show, encourage a familiar, familial, complicit, co-present discourse in which the relationship between programme hosts and viewers is based not so much on individual psychological identification driven by scopophilia as on a collective communitas developed by means of epistephilia, in the formation of which both the hosts and viewers participate. The direct address of the commercials, too, which regularly aim their sales pitches at what they call 'the Iranian community', further emphasises the collective conceptualisation of audiences. In this it can be seen that Iranian television is intensely communitarian.

Such efforts at creating a community of address are enhanced by the nature of the magazine format itself, characterised by what Michael Arlen has called the 'ritual of hospitality' between the hosts and guests (1981: 310–12). In this type of programme, in-studio hosts invite guests to visit the set, which is often made to look like a living room. In the case of exilic magazines, both the set and the ritual of hospitality are informed by the exiles' traditions and cultural orientations. Many early shows were staged in a set that resembled a typical Iranian drawing room in which non-family visitors are received formally: a sofa, a few comfortable chairs, a coffee table, a large bouquet of flowers on the coffee table and large plants in the background. The exilic format relies on life-size close shots, an expository form of enunciation, formal dress, composed posture, a formal style of communication characterised by literate language (not vernacular), and appropriate invocations of rules of ritual courtesy in introducing guests, speakers and programme segments. These rules require that, as guests who come to viewers' homes via the magic of television, the hosts camouflage their personal emotions under a veneer of politeness and civility. Programmes always begin with the hosts greeting the viewers, sometimes in effusive terms (which displays humility and

ritual courtesy). Even when Los-Angeles-produced programmes are syndicated to other cities in the United States, greetings specific to each city are inserted at the head of the programme. When viewers perceive that codes of courtesy have been violated, they complain to the producers:

> Sir, right now I am watching an Iranian television program and I see that the news anchor is appearing in front of the camera with a T-shirt. As long as I remember, television anchors have read the news to the camera wearing a proper suit, tie, and a clean shirt.
>
> (*Sobh-e Iran*, 3 February 1989: 15)

When there is bad news to impart, the system of courtesy authorises the display of personal emotions, particularly sadness and grief – core values for Iranians. In April 1988 during the bombing of Iranian cities by Iraqis, the news anchor of the morning programme *Jong-e Bamdadi* (Nureddin Sabetimani) began his newscast not with news about the incident but with a personal metadiscourse on the news designed to prepare the audience for the bad news he was about to read. He said:

> I would have preferred to begin the carefree hours of the morning with the most pleasant and comforting love poems instead of with disturbing news. But how can we sit back and witness our country becoming such an arena of battle for traders of war? . . . Has this spring morning in Iran begun with delicacy and freshness that we should begin ours with tranquillity? . . . Are we separate or different from the Iranian nation? So let me begin with a poem about spring, a spring without pansies.

Then he read a highly emotional, elegiac and patriotic poem about his homeland before presenting the news. With these statements he not only cushioned the bad news but also made himself vulnerable by revealing his inner self and his own personal emotions to his unseen audience – that is, he displayed intimacy and sincerity instead of objectivity and cleverness. When bad news is not properly processed through politeness it can lead to audience displeasure. Ali Limonadi, producer of *Iranian*, told me of an engineer who called him after a broadcast and threatened to sue him on the grounds that his newscast had caused his mother to faint and go into convulsions (4 February 1989). In the case of Sabetimani, who did deliver the news with appropriate processing, one would expect a sympathetic response. I do not know how the audience reacted to his presentation, but the only public reaction, printed in *Rayegan* magazine (22 April 1988: 22), corroborates the expectation. In an editorial, the weekly not only quoted the newsman and his poem at length but also praised him lavishly for his display of sincerity and patriotism.

Such a collective feedback completes the circle of courtesy, for ritual courtesy is not only a 'social contract' between interacting people in a face-to-face situation but also an 'implied contract' between viewer and programme, where the contract is implied not by the traditions of the text, as in film, but by the social context – the cultural orientation of both programme-makers and viewers.

In such a conception, every narrative may be considered to be a medium of exchange – 'determined not by a desire to narrate but by a desire to exchange'. What is being exchanged is not only textual pleasure but also social relations between two interactants: the viewing public and the film-television texts. This interaction, however, is not between two equal sides, since in an Islamist reading of the spectatorship the screen occupies a hierarchically more privileged position. Nor is it between familiar partners, since in such a reading the screen is considered to be unrelated or a stranger (namahram) to viewers. Ritual courtesy, designed to deal with hierarchical and formal relations, must be inscribed as a component of viewing, particularly in television and its most collective form, the magazine format. Television cannot then violate the protocol of formal relations between strangers without incurring the discomfort and criticism of its audience.

Even though formal and polite in its presentational mode, the exile magazine creates a familiar and familial community of address. What turns the formal into the familiar is exilic space, which in its liminal stage finds the formality of the ritual courtesy of the homeland to be comfortingly familiar. This is enhanced by the familiar form of address that some hosts occasionally use. What turns the polite into the familial is the sense that hosts and audience share not only the co-presence of the television medium but also a common language, culture, value system, and orientational framework. This concern with collective cultural institutions, particularly with the family structure and the native language, which are perceived to be threatened, tends to enhance the communitarian structure and discourse of exile television. I will deal first with the configuration of the family structure and then the native language as methods by which exile television creates a type of community of address.

Exile media repeatedly and regularly focus on the threat to the constitution of the family. Deterritorialisation problematises, even severs, the bonds with tradition, culture, ethnicity, language, status, family and nation that tend to interpellate individuals as subjects within ideologies and politics and locate them within the state or civil societies of the homeland. That many exiles enter the host society without their families elevates the threat of severance and deepens the sense of tragedy and loss. Even for those who leave their homeland with their families, the familial tensions are great because of the conflicts that exile sets into motion between generations and gender roles within the family, and the discrepancies it creates between here and there and now and then. These conflicts and discrepancies cause some Iranians to regard family life in exile as unmanageable and altogether undesirable. Consider, for example, the following desolate imaginary picture of a family in exile, which appeared in the weekly magazine *Javanan* (2 December 1988: 3):

> Whenever I was alone at home [in Los Angeles] I would imagine that I was married, that my wife would return home from work tired, take a shower without my noticing it, and cook her own meal and eat it alone. I would imagine my son dancing and stomping his feet with his girlfriend upstairs and when confronted with my protest he would shut his door and urge me to be quiet. I would imagine my daughter arriving home drunk and stupefied at midnight, turning the key in the door, and stumbling down the hall to her room. I would imagine the phone

ringing the next morning and the school counselor calling me for a new round of counseling, the police summoning me for investigation, and the psychologist urging me to pay his office a visit.

Since, in the case of Iranians in America, the exiles are moving from a familial culture to an individualistic culture, the self is under tremendous pressure to transform accordingly – a process fraught with fear and loathing. The symbiotic, reciprocal and emotionally intimate relationship that some nostalgic exiles think characterised family life in the homeland comes under serious questioning in the new environment, particularly by women and children, who seem to be the primary agents of acculturation and change. The self cannot maintain an intact sense of 'we-self', and, because of the change of social context, it loses the grounds on which contextual ego-ideals and successful hierarchical relationships are formed. Familial tensions in exile are so great that many exile periodicals and radio programmes carry regular sections in which psychologists and counsellors answer questions from readers and listeners about family problems. These professionals also appear regularly on exilic television for short interviews or full-hour discussions with in-studio audiences. *Sokhani ba Ravanshenas*, which began in 1992, is entirely devoted to phone-in questions and answers between audiences and the in-studio psychiatrist-host of the programme. The Christian programme *Mozhdeh* has attempted to deal with family tensions from a religious point of view.

The use of the native language is another significant marker in exile television's construction of a collective community of address. As I have noted, until recently, with the exception of Assyrian-language programmes, all other Iranian programmes in Los Angeles were in Persian. Exclusive use of the native tongue is caused not only by Iranians' recent arrival here (they are still liminars) and their nationalism, ethnocentrism and resistance to assimilation, but also by their desire to validate and consolidate an essentialist Iranian subjectivity in exile. In the discourse of Iranian ritual courtesy this is tantamount to 'raising' the exiles to a privileged status. Ignoring the native language causes negative audience reaction, particularly from the older generation. For example, when in the mid-1980s *Iranian* aired a five-minute English-language news commentary for six months, the producer received many negative comments from viewers, forcing him to discontinue the experiment. Over-reliance on the native language, however, discourages younger people from watching exilic television. Based on my interviews with programme producers and analyses of audience demography, it is evident that middle-aged and elderly people form the largest segment of the Iranian television audience. Young people, in their conversations with me, have shown a clear lack of interest in television programmes that fail to address them and their problems directly. Manuchehr Bibian, producer of *Jam-e Jam*, summed up the dilemma of generational division that television producers face:

> Young people who have learned the English language obtain their music and news from American television channels. Children watch cartoons on American television with which we cannot compete. But there are people who were twenty-five years or older when they left Iran; they are accustomed to Persian music and proverbs and they cannot

speak English as well as their mother tongue. There are those among
this group who cannot believe they will die in exile. Our television
programmes give these people what they want.

(Interview, 4 March 1989)

By foregrounding the Persian language, television producers cater to the older age
group who are their most loyal viewers, and leave the young people to the assim-
ilative power of American pop culture.

The ways exile producers and viewers use the magazine format to engage in
collective social construction and negotiation of reality turns exilic television into
a 'cultural forum'. Such a forum can disseminate information, express shared beliefs
and values, and assist the producers and viewers in their acculturation and their
construction of individual and collective identities. The magazine form can both
present ideologies and comment on ideological problems. By adding the live phone-
in format, the magazine has evolved into a multivocal cultural forum in which a
variety of views by various peoples of different ethno-religious affiliations are
exchanged in varied accents. In the process, perhaps more questions will be posed
than answered – even about exilic television – but this is precisely a chief func-
tion of television as a cultural forum, particularly in liminality, when there are
more questions and criticisms than answers.

The notion of cultural forum and collective subjectivity necessitates a reverse
flow of communication, from viewers to programmers. Such an exchange does
occur in exilic television, more directly and intimately than in mainstream
American television. Exile productions are often very small, one-person opera-
tions in which the producer is often host, director and advertising sales manager.
To obtain advertisements and audience feedback, exile producers, unlike their
mainstream television counterparts, urge advertisers, businesses and viewers to
contact them personally through the phone numbers that are flashed on the screen.
In their interviews with me many producers pointed to viewers' calls as signifi-
cant indicators of the size of their public or the popularity of certain topics or
personalities. This type of direct interaction increases discursive traffic and assists
in establishing a personal and collective link between programme producers and
their viewers.

Cultural productions not only air the tensions of communitarianism and frag-
mentation, ethnicity and acculturation, liminality and incorporation, but also often
disavow or displace them by ideological rearchaisation and reconstitution under
the sign of some type of essentialist collectivity, which may predate history and
time. The story of the Simorgh is invoked in exile as a way of reconstituting a
communal self and a national Iranian identity. This ancient story is best told by
the great twelfth-century Iranian mystic poet Faridoddin Attar, in his allegorical
epic *Manteq al-Teyr* (The conference of the birds), which tells the story of thou-
sands of birds on a quest for a legendary king of the birds called Simorgh (literally
'thirty birds'). After much hardship only thirty birds survive and arrive in the
Simorgh's palace, only to discover that the Simorgh they were searching for is
none other than the thirty surviving birds themselves, reflected in a mirror. This
and other mystical allegories are so well known to Iranians as to have become
encoded into their consciousness. One way to decode it is this: the Iranian self is

a communal one – all are one and one is all – and every one is potentially the bearer of a singular, unified truth or capable of absorption into the unique supreme Being. The homogenising work of the Simorgh paradigm in Iranian culture far surpasses Attar's allegory, as it shadows over myths and ideals of selfhood, heroism and nationalism that are drawn upon heavily in exile. The use of the paradigm in exile, where literary and business establishments are named after the Simorgh, would seem to either disavow the threat of fragmentation of individual and national identities by exile or rearchaise these identities by reconstituting them under the essentialist Iranian communal self, the Simorgh ideal.

The music video *Ma Hameh Irooni Hastim* (We're all Iranian), sung by Andy and Kouros, the duo rock stars of Iranian exiles, provides a rich televisual example for both fragmentation and reconstitution of the communal self and the collective national identity in exile. The video consists of a fast-paced collage of an Andy and Kouros concert in front of a tumultuous audience. It creates an alluring narrative charged with sex, mystery, power and wildness by means of huge, short-duration close-ups of body parts, musical instruments and a frenzied audience (mostly females) in an atmosphere saturated by rolling fog, flashing lights and chiaroscuro lighting. The two singers sing an up-tempo song in Persian that first differentiates Iranian exiles by naming the diverse regions of the country from which they have originated, and then reconstitutes them as a homogeneous population united in their desire for a return to the homeland:

> You are a native of Khuzestan
> You are a child of Abadan
> You are a native of Kermanshah
> You are a native of Kurdestan
> You are a native of Azarbaijan
> You are a child of Kerman
> You are a native of Baluchestan
> You are a child of Sistan.
> Regardless of where we are from,
> We are all Iranians
> Waiting to go back home.

Having united the exiles in their desire to return, the singers proceed to unify them further by suppressing regional differences. Here, the video becomes dialogic: the singers query the audience about their native regions, and the audience responds to each query en masse.

> | *Singers:* | Who is from Khuzestan? |
> | *Audience:* | We are from Khuzestan. |
> | *Singers:* | Who is from Kurdestan? |
> | *Audience:* | We are from Kurdestan. |
> | *Singers:* | Who is from Tehran? |
> | *Audience:* | We are from Tehran. |
> | *Singers:* | Who loves Iran? |
> | *Audience:* | We love Iran. |

This video posits that regardless of regional and ethnic differences, Iranians are all members of the same nation and national family. It becomes a modern reworking of the ancient Simorgh paradigm, at a time when the ideals encoded in it are threatened. In the liminality of exile, nationality supersedes ethnicity. It is only much later, and in order to gain political power in the host country, that the exiles will turn to ethnicity.

It is ironic, however, that exilic television tends to reconstitute the familial self and communal identity largely as a consuming self and identity. This is because the magazine format is disproportionately filled with expository materials and commercials for products and services, which impede individual subjectivity but aid the formation of collective subjectivity based on consumerism. In this case, it is not so much the intense emotional relations among family members and significant others that are responsible for creating unity as it is economic relations and the pleasures of consumption.

Exilic television's relationship with the familial self and its treatment of the family unit is made more complex because collective subjectivity, which television creates and caters to, is neither fully stable nor unitary. In it an individual subjectivity is unfolding. This is an uncertain, liminal subjectivity, one that is not always already in place. By and large, in its first decade, Iranian exilic television ignored the drama of this unfolding individual identity and the reconfiguration of the traditional patriarchal family structure demanded by it. Television was dominated by forms, such as the magazine, that usually give access to the public self, and there were very few examples of forms, such as dramas, more suitable for expressing emotions and exploring the dramas of self-fashioning and identity formation. With the exception of music videos and occasional serials – Ro'ya-ye Emrika'i (The American dream), Payvand (Connection), and Faseleh (Distance) – none of the other components of the magazine format explored in any extended, dramatic or narrative form the interior world of emotions, affect and the evolving self or the nuances of family life. In The Amercian Dream serial the unit of analysis is a transplanted family consisting of a young couple who must deal with their ties to the home country, their relatives abroad, and their own relationship with each other in the new society – all in the context of their status as foreigners forced to live in a society that is hostile to them and stereotypes them negatively. Among other issues, Distance also deals with a mother–daughter relationship in exile. By focusing on the dynamics of the family relations and by pitting the collective national identity against the individuating hybrid exilic identity, these shows express the instability and complexity of that identity.

Aesthetics of exilic repetition

In cybernetics redundancy and repetition ensure accurate transmission of signals. Redundancy reduces variability, indeterminacy, and unpredictability. If in times of normalcy humans seek the thrill of the unexpected, in times of chaos they seek certitude – the expected. Exile as a time of chaos demands stability, which can be found in television as ritual, fetish and nostalgia. Exilic television produces

discursive and symbolic order and rigidity in the face of personal and social disorder and fluidity.

Repetition and redundancy are encouraged by the exile magazine format and its postmodern pastiche style, which tend to suppress narrative singularity in favour of expository diversity and segmentation. Repetition takes many forms. Images are either replicated synchronically within the frame itself or repeated sequentially and diachronically within the flow. This is especially true of the commercials and certain fetishised and stereotyped icons, which are repeated a number of times during any one programme.

In exile, repetition is a way of reassuring the self that it will not disappear or dissolve: 'It is as if the activity of repeating prevents us, and others, from skipping us or overlooking us entirely' (Said 1986: 56). Two contradictory processes seem to be involved: one an affirmation of the 'old' identity in the homeland (relatively unified, usually familial), the other a confirmation of the 'new' identity in exile (syncretic and generally individuating). The nostalgic tropes of home that are circulated repeatedly within programme logos, texts and music videos in exile represent an affirmation of the old self, a way of reminding ourselves not to overlook ourselves. The validation of the new self figures the individual as a consumer; an individuating self in exile; and a member, if not of a physical community, at least of a symbolic community (communitas) in exile.

The formation of the new self as a consumer is evident predominantly in commercials. Recently arrived in this land of affluence and waste, the average exile from the Third World, who in the past more than likely cycled and recycled all products, from food cans to old tires, requires indoctrination through repetition to become a guiltless consumer. The incessant repetition of commercials on Iranian television not only makes economic sense for the advertisers and programme-makers but is productive ideologically, inculcating consumerism. The high educational level and financial resources of recently arrived exiles from Iran make them more receptive than some to the ideology of consumerism, and more adept at integration into that ideology and economic system. In postmodern consumer ideology the adoption of a consumer lifestyle and consumption of products extend to the creation and consumption of media for communication, propaganda and advertising so globally widespread and locally intense that it has been dubbed 'mediolatry' and 'semiotic fetishism' (W.J.T. Mitchell 1986: 202). The active Iranian popular culture in Los Angeles, which within less than a decade has produced the following varied menu of media, provides an instance of such mediolatry: nearly 80 periodicals, 62 regularly scheduled television programmes, 18 regularly scheduled radio programmes and 4 telephone newscasts were produced. During this period, some 180 feature films were screened in public theatres in Los Angeles and 26 features produced. By 1992, over 700 music cassettes had been produced in Los Angeles, half-a-dozen discos with a mixture of Iranian and Western music were in operation, and Iranian rock concerts were being staged in such bastions of American pop culture as the Shrine Auditorium and the Hollywood Palladium. The menu was rounded off with a plethora of poetry reading nights and academic and semi-academic conferences, seminars and lectures.

The affirmation of the individuating self in exile can be seen in many aspects of televisual production: changing programme format, from a general magazine catering to all family members to more specialised formats; evolution of the notion of audience from a homogeneous mass to targetable clusters; development of an advertising-driven schedule; syndication and networking of programmes; and increasing professionalisation, involving division of labour and inscription of aesthetics and ideological systems of mainstream cinema and television. The self in exile, however, is not an autonomous, always already individuated self; rather, it is a self in process of formation and differentiation and as such it is hybrid and ambivalent. The textual practices of the heterogeneous, segmented supertext and flow of exilic television inscribe and promote these multiple subjectivities.

The confirmation of the new communal identity, as a national group uprooted in exile or an ethnic group with roots within the host society, is also complex. The liminality and ambivalence of exile produce profound crises of identity and 'ethnic anxiety'. Living with such crises is painful, and they must be resolved. One way to accomplish this, suggests Michael Fischer, is through repetition of the individual experience, which 'cannot be accounted for by itself' (1986: 206). It must be repeated in order to establish its realness, its validity. Moreover, since the unitary experience of a single individual is deemed insignificant and insufficient in exile, televisual repetition is needed in order to establish the truth of living as a community in exile. By circulating fetishes of there and then and the nostalgic narratives of return, television tends to affirm the old 'authentic' self, and by repeating representations of consumer lifestyle here and now it tends to confirm a new emerging 'consumer' self. Taken together, it can be seen that television assists the exiles in constructing a hybrid self and identity, not by producing absences but by multiplying presences of the home and the past and of the here and the now through the magazine format and its ontology of liveness and co-presence.

This exilic recapitulation (affirmation of the old and confirmation of the new selves) is part of an aesthetics of seriality and intertextuality fostered by the postmodern world of late capitalism, characterised by dissolution of centres, amorphousness of texts and boundaries, indeterminacy of meanings and multiplicity of subjectivities. The pleasure of television's system of intertextual seriality and simulation is not so much derived from innovation and 'shock of the new' as it is from pull of the permanent, and 'return of the identical'.

These multiple notions of repetition characteristic of Western post-modernism provide the context in which the exiles, through their cultural productions, can stage repeatedly their own imaginary returns to their own originary schemas and values. For them, however, this 'return' is not wholehearted; it is charged with potential choices about which there is much ambivalence: a return to the old originary identity, or a turn toward consumerist subjectivity, or a move to construct a third, syncretic identity. Thus the repeated circulation of narratives and fetishes that embody both the exilic search for the schema and for the permanent, and the craving for the current and the new not only rewards our ability to textually foresee narrative developments but also serves to reinforce the internalisation of a split subjectivity and of a syncretic identity in exile.

The ideology of professionalism

With the development of structures of commodification and assimilation such as advertising-driven schedules, varied magazine formats, live transmission nation-wide, time-brokerage, syndication and audience segmentation, there has emerged not only a certain diversity in televisual discourse but also an ideology of professionalism – both of which have begun gradually to erode the authority and the univocality of the discourses of the first years of liminal exile. Stuart Hall defines professionalism as 'practical technical routinization of practice' (1977: 344), and it can be seen in the division of labour and the variety now becoming evident in Iranian television programmes. One person no longer produces, tapes, edits, hosts and distributes a programme by himself or herself. The number of producers has increased, as has the number of hosts, who are not necessarily producers any more. A single programme may contain a number of segments, each produced and presented by a different male or female host, thereby increasing not only the variety of faces and voices but also the polysemy of discourses. Likewise, the division of labour has extended to technical personnel, who have been growing in number, experience and specialisation. In addition, in Los Angeles a number of advertising agencies have emerged that obtain and place the majority of the ads on Iranian television.

Variety is another element in professionalisation, which is undergirded by the diversification of programme types and formats. The rigid magazine format evolved into other types, with many shows emulating mainstream American television. Experimentation with narrative forms led to the airing of over a dozen satirical serials and soap operas about exile. A new genre of exile-produced music videos influenced heavily by American music videos also emerged, which provides a discourse as well as a metadiscourse about assimilation and consumerism.

Professionalism entails internalisation of ideological, narrative and aesthetic codes of the profession. In Los Angeles, Iranian television is being produced, trans-mitted and consumed in a highly media-conscious and media-sophisticated context, whose codes and values have gradually been internalised by exile producers (and audiences). At the most obvious level, this entails simulation and imitation of the predominant televisual formats of mainline media. For example, *Midnight Show* seems to pattern itself after ABC's *Nightline* (in an ad its host is called 'Iran's Ted Koppel'); *Ma* (whose host is sometimes labelled 'the Iranian Barbara Walters') was modelled after the syndicated *Oprah Winfrey Show*; *Arya in L.A.* in much of 1989 resembled KABC-TV's tourist magazine show *Eye on L.A.* (taking its audience to various tourist spots around town); *Jong-e Bamdadi*, with its heavy news emphasis, is like *CBS Morning*; and *Sima-ye Ashna* resembles ABC's *Good Morning America*.

Internalisation of American ideologies of liberal democracy and consumerism and the codes of professionalism, intellectual property and ways of seeing and narrating the world does not occur automatically or naturally, especially for exile producers from non-Western worlds with vastly different cultural frameworks. They require training, which is often provided by the stations broadcasting exilic programmes. KSCI-TV's procedure for training, and in effect interpolating, foreign-language producers is inscribed in the Foreign Language Program Monitor Form, quoted in full overleaf.

KSCI-TV's Foreign Language Program
Monitor Form

Title of Show: Date:
Airtime: Length:

If the answer to any of the following questions is YES, please explain
on reverse side.

DID THE PROGRAM DEAL WITH A CONTROVERSIAL SUBJECT OF
PUBLIC IMPORTANCE?

DID THE PROGRAM CONTAIN OFFERS TO THE VIEWER INVOLVING
LOTTERIES OR GAMBLING?

WERE THERE ANY PERSONAL ATTACKS?

WAS THERE ANY OBSCENITY?

WAS THERE ANY OFFER TO THE VIEWER THAT MIGHT BE A
FRAUDULENT SCHEME?

DID THE PROGRAM HAVE ANY POLITICAL CONTENT, SUCH AS
PRESENTATION BY CANDIDATES FOR PUBLIC OFFICE?

WAS THERE ANY ADVERTISING THAT MIGHT HAVE BEEN FALSE OR
MISLEADING?

WAS THERE ANY ADVERTISING WHOSE SPONSORSHIP WAS NOT
CLEARLY EVIDENT?

HOW MANY MINUTES OF COMMERCIALS WERE SHOWN?

BRIEF DESCRIPTION OF THE CONTENTS:

SOURCE: KSCI-TV.

This form is given to the foreign-language monitors whom the station hires to
view and evaluate ethnic programmes as they are being aired. If a programmer
continually receives negative evaluations from the monitor, his contract can be
terminated by the station with a month's notice. The items in the questionnaire
are in effect the station's standards and norms of professionalism disguised in an
interrogative form, and the monitors are asked to judge adherence to them
carefully. According to a KSCI-TV official, Iranians were particularly singled out
for extended monitoring on a regular basis because of the volatility of their
politics; the antagonistic competition between exilic periodicals and television
programmes; and the excessive airing of commercials, far beyond the station's
standard fourteen minutes of ads per hour-long programme (extended to twenty
minutes for Iranians). In addition, extended monitoring was motivated by a desire
on the part of the station to avoid jeopardising its broadcast licence.

The criteria embedded in this form and the station's power to terminate a
show with a one-month notice place the programmers in a relatively vulnerable
financial and political position, with the result that they discourage substantial
investment due to fear of short-notice termination, and encourage short-term tactics
to maximise immediate profits. Timidity regarding controversial matters and a
reduction over time of partisan politics are also a result. Those US laws dealing

Janice A. Radway

THE INSTITUTIONAL MATRIX
OF ROMANCE

EDITOR'S INTRODUCTION

IN THIS ESSAY (a section of the first chapter of her book *Reading the Romance*), Janice Radway offers an analysis of the institutions in which the romance is produced. Asking the question: "what makes romances so popular?" she argues that it cannot simply be answered in terms of the pleasure the romance genre offers readers or the desires it satisfies. After all, a business intervenes between texts and their readers.

By sketching a history of the mass-market publishing industry she shows how it has become increasingly sophisticated and specialized as it attempts to reduce the risks that are so great a part of all cultural businesses. Modern popular romance develops as a genre through a series of strategical decisions by publishers. Yet it is important to emphasize that Radway does not conceive of romance readers as cultural dupes (any more than Will Straw does heavy metal listeners). For her, romance reading occurs in a tripartite structure in which readers' pleasure or choice, the publishing industry, and the writer each play a part in determining textual production.

Further reading: Cohn 1988; Lewis 1991; H. Jenkins 1992; Jenkins and Tulloch 1995; Modleski 1984, 1987; Radway 1984, 1988; Schwartz 1989.

Like all other commercial commodities in our industrial culture, literary texts are the result of a complicated and lengthy process of production that is itself controlled by a host of material and social factors. Indeed, the modern mass-market paperback was made possible by such technological innovations as the rotary magazine

with copyrights, libel, slander and obscenity are enforced by this regime, and 'professionalism' is inculcated in procedures by the fostering of appropriate routines and procedures of television production. All of this naturalises the codes and values of the dominant host culture.

The ideology of professionalism involves employing the dominant codes and rules of narration and representation. Increasingly Iranian television programmes have begun to subscribe to the routinised rules of the host country's discourses, encoded in the four narrative and programming regimes of mainstream television: classical Hollywood cinema style for narrative and dramatic serials; seamlessness and segmentation of the televisual flow; objective news value for newscasts and public affairs programming; and variation as a principle governing programming, counter-programming, presentation and format differentiation – all devices used to establish individual programme identity not through sameness, as was the case in the early phase of exile when home infused the discourse, but through difference. In effect, by adopting and routinising these regimes of professionalism in their practice, Iranian producers (and viewers) are interpellated unknowingly into American consumer capitalism, individuated subject positioning, and representative democracy. Significantly, however, the presence of such professionalism not only signals the incorporation of Iranian exilic television into the dominant cultural mode of production but also masks that incorporation by naturalising it.

Iranian exilic television in its first decade structurally reflected and shaped the lives of its producers and audiences. Reflecting the formlessness of liminality, it first emerged as a hermetically sealed collection of audiovisuals put together with great individual effort by producers and addressed to what was thought to be a homogeneous audience. A ritual exilic genre of television was developed with its own generic conventions, strategies of signification, viewer positioning and transmission and consumption patterns. The emergence of these strategies of structuration and commodification signals the evolution of Iranians from liminality toward incorporation, and from exile into ethnicity. This process, however, is neither linear nor consensual as much of the traditional sociological literature would seem to posit. It is, rather, a conflictual and dialectical process involving resistances, differences, reversals and leaps forward, during which features of both liminality and incorporation may coexist for quite some time – a truly syncretic culture.

press and synthetic glue as well as by organisational changes in the publishing and bookselling industries. One of the major weaknesses of the earlier romance critique has been its failure to recognise and take account of these indisputable facts in its effort to explain the genre's growing popularity. Because literary critics tend to move immediately from textual interpretation to sociological explanation, they conclude easily that changes in textual features or generic popularity must be the simple and direct result of ideological shifts in the surrounding culture. Thus, because she detects a more overtly misogynist message at the heart of the genre, Ann Douglas can argue in her widely quoted article 'Soft-porn culture' that the coincidence of the romance's increasing popularity with the rise of the women's movement must point to a new and developing backlash against feminism. Because that new message is there in the text, she reasons, those who repetitively buy romances must experience a more insistent need to receive it again and again.

Although this kind of argument sounds logical enough, it rests on a series of tenuous assumptions about the equivalence of critics and readers and ignores the basic facts about the changing nature of book production and distribution in contemporary America. Douglas's explanatory strategy assumes that purchasing decisions are a function *only* of the content of a given text and of the needs of readers. In fact, they are deeply affected by a book's appearance and availability as well as by potential readers' awareness and expectations. Book buying, then, cannot be reduced to a simple interaction between a book and a reader. It is an event that is affected and at least partially controlled by the material nature of book publishing as a socially organised technology of production and distribution.

The apparent increase in the romance's popularity may well be attributable to women's changing beliefs and needs. However, it is conceivable that it is equally a function of other factors as well, precisely because the romance's recent success *also* coincides with important changes in book production, distribution, advertising and marketing techniques. In fact, it may be true that Harlequin Enterprises can sell 168 million romances not because women suddenly have a greater need for the romantic fantasy but because the corporation has learned to address and overcome certain recurring problems in the production and distribution of books for a mass audience. If it can be shown that romance sales have been increased by particular practices newly adopted within the publishing industry, then we must entertain the alternative possibility that the apparent need of the female audience for this type of fiction may have been generated or at least augmented artificially. If so, the astonishing success of the romance may constitute evidence for the effectiveness of commodity packaging and advertising and not for actual changes in readers' beliefs or in the surrounding culture. The decision about what the romance's popularity constitutes evidence for cannot be made until we know something more about recent changes in paperback marketing strategies, which differ substantially from those that have been used by the industry for almost 150 years.

Standard book-marketing practices can be traced, in fact, to particular conceptions of the book and of the act of publication itself, both of which developed initially as a consequence of the early organisation of the industry. The output of the first American press, established at Cambridge, Massachusetts, in 1639, was largely the ecclesiastical work of learned gentlemen of independent means who

could afford to pay the printer to issue their books. Limitation of authorship to those with sufficient capital occurred generally throughout the colonies because most of the early presses were owned by combined printer-publishers who charged authors a flat fee for typesetting and distribution and a royalty for each book sold. Because it was the author who financed publication and thus shouldered the risk of unsold copies, the printer-publisher had relatively little interest in seeing that the book appealed to previously known audience taste. As a result, authors exerted almost total control over their works, which were then conceived as the unique products of their own individual intellects. Publication was concomitantly envisioned as the act of publicly issuing an author's ideas, an act that could be accomplished by the formal presentation of even one copy of those ideas for public review. In the early years of the printing industry, therefore, the *idea* of publication was not tied to the issue of sales or readership. As long as the work was presented in the public domain, it was considered published, regardless of whether it was read or not.

Of course, authors did concern themselves with readers, not least because they stood to lose a good deal if their books failed to sell. However, the problem was not a major one because the literate reading community was small and because publication itself was carried out on a local scale. The author very often knew who his readers were likely to be and could tailor his offering to their interests and tastes. Indeed, it was not uncommon for an early American writer to finance publication by soliciting contributions from specific, known subscribers whom he made every effort to please. It was thus relatively easy to match individual books with the readers most likely to appreciate the sentiments expressed within them.

Thus the concept of the book as a unique configuration of ideas conceived with a unique hypothetical audience in mind developed as the governing conception of the industry. Publishers prided themselves on the diversity of their offerings and conceived the strength of an individual house to be its ability to supply the American reading public with a constant stream of unique and different books. In addition, they reasoned further that because publishing houses issued so many different kinds of works, each of which was intended for an entirely different public, it was futile to advertise the house name itself or to publicise a single book for a heterogeneous national audience. In place of national advertising, then, publishers relied on editors' intuitive abilities to identify the theoretical audiences for which books had been conceived and on their skills at locating real readers who corresponded to those hypothetical groups. Throughout the nineteenth century and indeed well into the twentieth, authors, editors and publishers alike continued to think of the process of publication as a personal, discrete and limited act because they believed that the very particularity and individuality of books destined them for equally particular and individual publics.

Despite the continuing domination of this attitude, the traditional view of book publishing was challenged, even if only tentatively, in the early years of the nineteenth century by an alternative view which held that certain series of books could be sold successfully and continuously to a huge, heterogeneous, preconstituted public. Made possible by revolutionary developments in technology and distribution and by the changing character of the reading audience itself, this new idea of the book as a saleable commodity gradually began to alter the organisation of the

editorial process and eventually the conception of publishing itself. Although this new view of the book and of the proper way to distribute it was at first associated only with a certain kind of printer-publisher, it was gradually acknowledged and later grudgingly used by more traditional houses when it became clear that readers could be induced to buy quite similar books again and again.

The specific technological developments that prepared the way for the early rationalisation of the book industry included the improvement of machine-made paper, the introduction of mechanical typesetting and more sophisticated flatbed presses, and the invention of the Napier and Hoe cylinder press. The inventions of the steamboat and the railroad and the extension of literacy – especially to women – combined to establish publishing as a commercial industry with the technical capacity to produce for a mass audience by 1830. What this meant was that commercially minded individuals began to enter the business with the sole purpose of turning a profit.

The first production scheme designed specifically to mass produce cheap paperbound books and to utilise the magazine distribution system was not mounted until 1937 when Mercury Publications created American Mercury Books. In fact, according to Frank Schick, American Mercury was the first paperbound book series to employ magazine distribution successfully. Packaged to look like magazines, these books were sold at newsstands and, like periodicals, remained available only for a month: American Mercury's practices, which stressed the ephemerality of this literature, clearly differentiated this publishing venture from more traditional book production, which continued to focus on the establishment of a line of diverse books of lasting worth to be kept constantly in print on a backlist and in stock at the better retail establishments. Although the company at first published a variety of titles, by 1940 the editors had decided to concentrate on mysteries in the interest of establishing better control over their market. The new series, called Mercury Mysteries, differentiated its remarkably similar covers and titles by numbering each book for the reader's convenience.

The publishers of American Mercury Books hoped to sell their paperbacks in large quantities to readers who already knew their mystery magazines. Those magazines enabled the editors to take note of reader opinion and to gauge preferences that they then sought to match in their manuscript selection. In effect, American Mercury tried to control both its audience *and* the books produced especially for that group. Despite this successful formalisation of category publishing, the relatively small size of the American Mercury venture has prevented it from being credited with the mass-market paperback revolution. Although that honour is usually awarded to Robert de Graff for his founding of Pocket Books in 1939, his scheme introduced no new conceptual innovations to the industry. Like the editors at American Mercury, de Graff thought of the book as a commodity to be sold, relied on the magazine system of distribution and gradually turned to category publication. Still, it was de Graff's ability to institute this system on a large scale that set the stage for the romance's rise to dominance within the mass-market industry. To understand exactly how and why the romance has become so important in commodity publishing, it is necessary to understand first how the economics of paperback publishing and distribution created the industry's interest in the predictability of sales.

In the years immediately preceding de Graff's entry into the field, major improvements had been made in both printing and binding techniques. The invention of magazine rotary presses made high-speed production runs possible and profitable. Although the new machinery was very expensive, the cost was borne largely by the printers themselves who were, by tradition, independent from publishing firms. Because the printers had to keep the costly presses operating twenty-four hours a day to guarantee a return on their initial investment, they pressured de Graff and his competitors at Avon, Popular Library and Dell to schedule production tightly and regularly. This practice led to a magazine-like monthly production schedule similar to American Mercury's, a practice that fitted nicely with de Graff's intention to distribute his books through the magazine network. The regularisation of production further enabled the printers to buy large quantities of paper at lower rates without also having to pay to store it indefinitely. The publishers benefited in turn because they could sell their books at much lower prices.

Surprisingly enough, the invention of synthetic glue also helped to add speed to the publication of the mass-market paperback. Traditional book binding is accomplished by hand or machine sewing of folded signatures of paper to create the finished book. Even when carried out mechanically, the process is both expensive and time-consuming. 'Perfect' binding is an alternative procedure in which single leaves of paper are gathered together, cut uniformly, and then glued to the spine of the cover. The first adhesives used in the process of perfect binding were animal glues that were not only slow to dry but, once dried, were so inflexible that bindings often cracked, releasing individual pages. The glues made it necessary for a printer to obtain sufficient storage space for drying the perfect-bound books. The invention of quick-drying synthetic glues eliminated most of these problems. Fast-setting adhesives necessitated assembly-line procedures that simultaneously accelerated the whole production process and obviated the need for costly storage. The new binding machines were expensive but, once again, the printers shouldered the enormous costs and passed much of the benefit on to the publishers.

Together with the rotary presses, then, perfect binding and synthetic glues made possible the production of huge quantities of books at a very low cost per unit and contributed to the acceleration and regularisation of the acquisition and editorial processes. The consequent emphasis on speed caused the paperback publishers to look with favour on category books that could be written to a fairly rigid formula. By directing their potential writers to create in this way, mass-market houses saved the time and expense of editing unique books that had as yet not demonstrated their ability to attract large numbers of readers.

The particular step taken by de Graff that made this production of vast numbers of books financially feasible was his decision to utilise the extensive magazine distribution network that had developed during the past thirty years. De Graff reasoned that if he was actually to sell the large quantities of books he could now produce so effortlessly, he would have to place books in the daily paths of many more Americans. Because he was aware of the relative lack of bookstores in the United States and of the general population's feeling that those establishments were intimidating and inhospitable, he concluded that books would have to be marketed

somewhere else if they were to be sold on a grand scale. He turned to the American News Company, which had a virtual monopoly on the national distribution of magazines and newspapers, because it counted among its clients many thousands of newsstands, drugstores, candy stores and even food outlets. De Graff felt sure that if confronted with attractively packaged and very inexpensive books at these establishments, the American magazine reader could be persuaded to become a paperback book purchaser. The phenomenal sales of his first ten titles proved him right.

Despite the advantages it offered, however, magazine distribution also posed substantial problems. De Graff and his early competitors soon discovered that few of their new book retailers knew anything about books. Uneasy about purchasing materials they might not be able to sell, these individuals at first resisted efforts to get them to stock paperback books. To overcome their hesitation, de Graff and his counterparts at other houses proposed that the entire risk of unsold books be shouldered by the publishing firms themselves. As a result, they permitted all retail outlets to return any unsold books or to certify that the books themselves had been destroyed.

The returns policy had the desired effect in that it convinced retailers that they could not be harmed by stocking paperbacks, but it proved extremely troublesome to the publishers themselves. Because they had no way to track simultaneously progressing returns and new print orders or to shift the returns from one outlet to another, many publishers found themselves sending a book through a second printing to accommodate demand, only to discover later, after all returns were completed, that eventual total sales were less than the first print order. The resulting overproduction was very costly and caused the mass-market publishers to search for ways to make book sales more predictable. It was thus that category literature suggested itself as a means of gauging how a new version of an already-proved type of book might perform in the market.

Category or formulaic literature has been defined most often by its standard reliance on a recipe that dictates the essential ingredients to be included in each new version of the form. It therefore permits an editor to direct and control book creation in highly specific ways. It is worth emphasising, however, that the category literature is *also* characterised by its consistent appeal to a regular audience.

Not only does this kind of production obviate the need to set print orders solely on the basis of blind intuition, but it also reduces the difficulties of designing a proper advertising campaign. By relying on the subscription lists of related periodicals and on sales figures of earlier offerings in the genre, category publishers can project potential sales with some certainty. At the same time, they can use the periodicals for a specific advertising strategy and thus avoid the difficulty and expense of mounting a national effort in the hope of ferreting out the proper audience by chance.

To understand the importance of the fact that category publishing makes book advertising manageable, it is necessary to know that publishers have argued for years that books cannot be marketed or advertised as are other commodities. Because every book is individual and unique, the industry has maintained, all publishers must 'start from scratch' in the effort to build an audience for them. Assuming, therefore, that the discreteness of books necessitated that each be

advertised individually, publishers concluded that the enormous expense of advertising an entire month's offering ruled out the process entirely. Furthermore, because they believed that the variety of books offered by each firm made the creation of a single image of the house impossible, they also concluded that potentially less expensive national advertising of the house imprint would do nothing for the sales of individual books. Thus the publishing industry's advertising budget has been remarkably small for many years. The situation did not change until the 1970s when corporate takeovers of independent houses by large communications conglomerates resulted in the infusion of huge amounts of capital, some of which was directed to advertising budgets. However, before explaining how and why this has occurred and its relevance to our investigation of the romance, it is necessary to return to the early years of the third paperback revolution to trace the growing importance of the romance genre within the mass-market industry.

Although the early paperback publishers relied initially on proven hardcover bestsellers to guarantee large sales, they soon found that an insufficient number of these were available to supply the demand for cheap, paper-covered books. Wary of producing huge quantities of a title that had not yet demonstrated its saleability, these mass-market houses slowly began to rely on books that were examples of categories already proven to be popular with the reading public. The trend really began with the mystery or detective story that developed as the first dominant category in modern mass-market publishing. The genre was particularly well suited for semi-programmed issue because the writer–publisher–audience relationship had been formalised in the 1920s with the establishment of the pulps like *Black Mask*, *Dime Detective*, *Detective Story* and *Detective Fiction Weekly*. They helped to establish a generic orthodoxy which would then guide continuous novel production in hardcover format. Paperback mystery publishing developed simply as an extension of an already established literary practice.

Unfortunately, mystery popularity declined throughout the 1950s. Although the genre occasionally gained back the readers it lost, several publishers none the less began to look elsewhere for new material that they could sell on an even more regular and predictable basis. Troubled by this variability in mystery sales, Gerald Gross at Ace Books recalled the consistent reprint success of Daphne du Maurier's *Rebecca*. Wondering whether its long-standing popularity (it had been published first in 1938) indicated that it struck a universal chord in female readers, he attempted to locate previously published titles resembling du Maurier's novel, which he hoped to issue in a 'gothic' series. He settled upon Phyllis Whitney's *Thunder Heights,* which he then published in 1960 as the first title in his 'gothic' line.

Since Gross and other gothic publishers were not simply inserting mass-produced reading matter into a previously formalised channel of communication as had been done with paperback mysteries, it is necessary to ask why they were almost immediately successful in establishing the gothic romance as a particular category and in creating a growing demand for new titles. Their success cannot be attributed to the mere act of offering a new product to an audience already identified and therefore 'controlled' by the fact of its common subscription to the same magazines. Although confession and romance periodicals had been supplying love stories for faithful readers since their first appearance in the 1920s, these pulps were designed for a working-class audience. Because book reading has always

been correlated with high education and income levels, it seems probable that the gothic's extraordinary paperback success was the result of the publishers' ability to convert and then repetitively reach middle-class women. Although one might suspect that these publishers relied on the middle-class trade magazines – such as *Good Housekeeping* or the *Ladies' Home Journal* – to identify and retain its new audience, in fact, this does not appear to have been the case. Publishers used very little advertising to promote the sales of the early gothics.

What, then, accounts for the immediate success of the category? The achievement has much to do with the special characteristics of its audience, that is, with the unique situation of women in American society. The principal problem facing the publisher in a heterogeneous, modern society is finding an audience for each new book and developing a method for getting that book to its potential readers. By utilising the magazine distribution network, paperback publishers substantially increased their chances of finding buyers. But the use of this network proved especially significant for those paperback houses that were newly interested in female readers because it made available for book distribution two outlets almost always visited on a regular basis by women, the local drugstore and the food supermarket. Even the growing number of women who went to work in the 1960s continued to be held responsible for child care and basic family maintenance, as were their counterparts who remained wholly within the home. Consequently, the publishers could be sure of regularly reaching a large segment of the adult female population simply by placing the gothics in drug and food stores. At the same time, they could limit advertising expenditures because the potential or theoretical audience they hoped to attract already had been gathered for them. The early success of the gothic genre is a function of the *de facto* but none the less effective concentration of women brought about by social constraints on their placement within society. This concentration had the overall effect of limiting their diffusion throughout social space. In turn, this limitation guaranteed that, as a potential book-buying public, American women were remarkably easy to reach.

The popularity of gothic romances increased throughout the decade of the 1960s. While American college students were beginning to protest against American involvement in Vietnam and a gradually increasing number of feminists vociferously challenged female oppression, more and more women purchased novels whose plots centred on developing love relationships between wealthy, handsome men and 'spunky' but vulnerable women. The audience for gothics grew to such proportions that by the early 1970s works of top gothic authors outsold the works of equivalent writers in all other categories of paperback fiction, including mysteries, science fiction and Westerns. A typical Whitney or Holt paperback issued by Fawcett began with a first printing of 800,000 copies. Although most of the category's authors sold nowhere near that number, when taken together the gothic novels released by no fewer than eight paperback houses constituted an enormous total output.

This extraordinary sales success of gothics established them as a true cultural phenomenon and qualified them for endless analysis and satire in the news media. Many articles on 'How to write a gothic' can be found in the Sunday supplements and popular magazines of the period, attesting to widespread awareness of the phenomenon, if less than universal approbation of it.

The increased publicity notwithstanding, sales of gothic romances dropped off gradually between 1972 and 1974. Returns increased to such an extent that many houses cut back their gothic output. When asked to explain the decline in popularity, former publishers of gothics equivocate. Some feel that the market had simply been saturated, while others suspect that the growing visibility of the feminist movement and increasing openness about female sexuality led to a greater tolerance if not desire for stories with explicit sexual encounters. All seem to agree, however, that the nature of romance publishing changed dramatically in April 1972, when Avon Books issued *The Flame and the Flower* by Kathleen Woodiwiss.

Because Woodiwiss had sent her unsolicited manuscript to Avon without the usual agent introduction, it landed on the 'slush pile', usually considered an absolute dead end in contemporary publishing. Inexplicably, it was picked up by executive editor Nancy Coffey, who was looking for something to get her through a long weekend. As she tells the story, she could not put the manuscript down. She returned to Avon enthusiastically determined to get the book into print. Coffey eventually convinced others and the book was released in April as an Avon Spectacular. Although Woodiwiss's novel, like the gothics, followed the fortunes of a pert but feminine heroine, it was nearly three times as long as the typical gothic, included more explicit descriptions of sexual encounters and near rapes, and described much travel from place to place. Despite the differences, it ended, as did all gothics, with the heroine safely returned to the hero's arms.

A paperback original, *The Flame and the Flower* was given all the publicity, advertising and promotion usually reserved for proven bestsellers. Such originals had been issued continuously in small quantities throughout the early years of mass-market history, but concentration on them was not widespread for the simple reason that it cost more to pay out an advance to an author and to advertise an unknown book than to buy reprint rights to an already moderately successful hardback. Avon, however, under the direction of Peter Meyer, had begun to experiment with originals and different advertising campaigns in the mid-1960s. When Coffey agreed to publish *The Flame and the Flower* without previous hardcover exposure, she was simply following a practice that had become fairly common within her firm. The house's extraordinary success with Woodiwiss's novel soon caused industry-wide reconsideration of the possibilities of paperback originals as potential bestsellers. When Avon followed this success with two more bestseller romances in 1974, the industry was convinced not only of the viability of the original but also of the fact that a new category had been created. Within the trade, the genre was dubbed the 'sweet savage romance' after the second entrant in the field, Rosemary Roger's *Sweet Savage Love*.

Once Avon had demonstrated that original romances could be parlayed into ready money, nearly every other mass-market house developed plans to issue its own 'sweet savage romances', 'erotic historicals', 'bodice-rippers' or 'slave sagas', as they were variously known throughout the industry. Virtually all recognised, as Yvonne McManus of Major Books did, that 'Avon ha[d] smartly created a demand through heavy advertising and promotion'. As she commented further, 'it . . . invented its own new trend, which is clever paperback publishing'.

Although a few houses have developed bestsellers in the 'sweet savage' category, Avon has been most successful at identifying the house imprint with this kind of romance and has established close ties with its audience by compiling a mailing list from its fan letters. Several publishers have attempted to develop other sorts of romances with the idea of creating a series or 'line' that they hope to associate in readers' minds with the house name. The creation of 'line' fiction is one more example of the familiar attempt to identify a permanent base audience in order to make better predictions about sales and to increase profit. The growing proliferation and success of such schemes, often modelled after Avon's informal techniques or the more elaborate operations of Harlequin Enterprises, makes them an extremely important development in romance publishing specifically and in mass-market paperback publishing generally. Before assessing several of the most important of these, it will be helpful to mention two further developments, one in general publishing, the other in bookselling, that help to explain why so many paperback houses not only have found the romance market attractive but also have been able to appeal to it successfully.

The most significant development in American publishing in the twentieth century has been the assumption of control of once privately owned houses by vast communications conglomerates. Begun in 1960 with the Random House 'absorption' of Knopf and continued in 1967 when the Radio Corporation of America (RCA) purchased Random House, the merger trend has left only a few houses intact. In 1967, for instance, the Columbia Broadcasting System (CBS) acquired Holt, Rinehart & Winston and then later purchased Praeger Publishers, Popular Library and Fawcett Publications. Xerox has assumed control of Ginn & Company, R. R. Bowker and the trade periodical, *Publishers Weekly*. Dell is owned by Doubleday and Company, as is the Literary Guild. Gulf and Western has acquired both Simon & Schuster and Pocket Books. Although by no means exhaustive, this litany at least makes clear that the first impact of the merger trend has been the union of hardcover and mass-market paperback companies within a single corporate structure. Despite the fact that most individual houses have retained editorial control over what they produce, it is also apparently true that greater attention is paid to their profit-and-loss statements by corporate headquarters than the houses used to devote to them themselves.

It is not hard to understand why 'attention to the bottom line' has begun to dominate the publishing process when one considers that, despite increased profit consciousness within the mass-market segment of the industry, publishing remained a small, informally organised business well into the 1970s. Once referred to as 'seat-of-the-pants' publishing by its critics and supporters alike, the American industry continued to make decisions about manuscript selection, print orders and advertising campaigns on the basis of editors' intuitions, ignoring the availability of the computer and the development of sophisticated market-research techniques. Much of the reluctance to adopt these highly mechanical procedures can be traced to the lingering vision of publishing as the province of literary gentlemen seriously devoted to the 'cause' of humane letters. Editors worried that, if profit became the principal goal, publishers would be reluctant to sponsor the first novel of a promising young writer because its financial failure would be virtually guaranteed.

In recently assessing the impact of corporate takeovers on publishing, Thomas Whiteside has observed that the 'business was indeed riddled with inefficiency'. 'Sluggish management, agonizingly slow editorial and printing processes, creaky and ill-coordinated systems of book distribution and sales, skimpy advertising budgets, and . . . inadequate systems of financing', he claims, 'prevented many publishers from undertaking major long-range editorial projects that they knew were necessary to their companies' future well-being.' Traditionally a low-profit industry, trade-book publishing was also characterised by widely varying profits because each house's fortunes fluctuated rapidly in concert with its failure or success at selling its monthly list. When the corporate managers of the new conglomerates began to scrutinise the houses' financial practices and performances, they were appalled. Most responded by forcing the publishers to adopt the procedures long familiar to the corporate world: 'efficient accounting systems, long-range planning, elimination of waste, and unnecessary duplication of services'.

Although it seems obvious that conglomerate control has had the effect of forcing trade publishers to do away almost completely with 'mid-level' books – those that perform only moderately well in both the market and in critical opinion – it has had the additional effect of providing the paperback houses with large sums of money. This has enabled them to pay huge fees for the reprint rights to bestselling novels; it has also permitted them to devote a great deal of financial attention to planning category sales by commissioning market-research studies and to the advertising of the new 'lines' created as their consequence. The logic behind this kind of financial manoeuvre is grounded on the assumption that if paperback sales can be made more predictable and steady, the newly acquired mass-market section of a conglomerate can be used to balance out the necessarily unpredictable operation of the trade process.

Corporate takeovers have had the effect, then, of adding to the pressure on paperback houses to devote increasing amounts of time and money to category sales. At the same time, because reprint rights have grown enormously expensive, it has been necessary for them to place even more emphasis on the acquisition of original manuscripts. To avoid the difficulties of training inexperienced writers and the expense of introducing their works on an individual basis to new audiences, paperback publishers have consequently tended to seek out originals that fit closely within category patterns. They believe it is easier to introduce a new author by fitting his or her work into a previously formalised chain of communication than to establish its uniqueness by locating a special audience for it. The trend has proven so powerful, in fact, that as of 1980, 40 to 50 per cent of nearly every house's monthly releases were paperback originals. The conglomerates' quest for financial accountability has had another effect besides that of increasing the emphasis on category publishing with its steady, nearly guaranteed sales. Their overwhelming interest in predictability has also helped to forge an important link between the now more profit-minded paperback houses and the increasingly successful bookstore chains, B. Dalton, Bookseller and Waldenbooks. Together, these two developments have led to even greater industry interest in romantic novels and the women who purchase them.

Indeed, while the recent history of paperback publishing has been dominated by the rise to prominence of the blockbuster bestseller, it has also been charac-

terised by this slow but inexorable transformation of the business from a relatively small, informally run enterprise still focused on the figure of the author and the event of book *reading* into a consumer-oriented industry making use of the most sophisticated marketing and advertising techniques to facilitate simple commodity exchange. The extraordinary popularity of the romance is in part a function of this transformation, since those very techniques have been applied most energetically to this kind of category literature. Although publishers cannot explain adequately why marketing research was applied to romances rather than to spy thrillers or Westerns, it seems likely that the decision was influenced by two factors.

First, female readers constitute more than half of the book-reading public. More money is to be made, it seems, by capturing a sizeable portion of that large audience than by trying to reach nearly all of a smaller one. At the same time, women are remarkably available as a book-buying public in the sense that their social duties and habits make them accessible to publishers on a regular basis. The possibility of easy and extensive distribution to an audience inadvertently gathered for them by other forces thus tends to justify the mass production of romances. Currently, one-quarter to one-third of the approximately four hundred paperback titles issued each month are original romances of one kind or another. Almost all of the ten largest paperback houses include a fair proportion of romance fiction as part of their monthly releases. In addition, Harlequin now claims that its million-dollar advertising campaigns reach one out of every ten women in America and that 40 per cent of those reached can usually be converted into Harlequin readers. The huge sales figures associated with romance fiction seem to be the result of this all-important ability to get at a potential audience.

Second, romance novels obviously provide a reading experience enjoyable enough for large numbers of women so that they wish to repeat that experience whenever they can. To conclude, however, that the increasing domination of the paperback market by the romance testifies automatically to some *greater* need for reassurance among American women is to make an unjustified leap in logic. It is also to ignore the other evidence demonstrating that the domination is the consequence of a calculated strategy to make the largest profit possible by appealing to the single most important segment of the book-buying public. The romance's popularity must be tied closely to these important historical changes in the book publishing industry as a whole.

None the less, that popularity is also clearly attributable to the peculiar fact that much of book reading and book buying in America *is* carried on by women. Many observers of women and book publishing alike have concluded that middle-class women are book readers because they have both the necessary money and the time. They have the time, certainly, because, until recently, social custom kept them out of the full-time paid labour force and in the home where their primary duties involved the care and nurture of the family and, in particular, children. Because children are absent from the home for part of the day after the first several years, the reasoning proceeds, their mothers have blocks of time that can be devoted to the activity of reading.

Although not all women readers are represented by these conditions, it seems highly likely that they do provide the background for the majority of women who are romance readers. Actual demographic statistics are closely guarded within the

competitive publishing industry by executives who often insist that romances are read by a broad cross section of the American female population. Still, both Harlequin and Silhouette have indicated repeatedly that the majority of their readers fall within the twenty-five to forty-five age group. If this is true, the meaning of the romance-reading experience may be closely tied to the way the act of reading fits within the middle-class mother's day and the way the story itself addresses anxieties, fears and psychological needs resulting from her social and familial position. It is to these questions that we must turn, keeping in mind all the while that burgeoning sales do not necessarily imply increasing demand or need. Publishers and the profit motive must be given their due in any effort to explain the popularity of the romance or to understand its significance as a historical and cultural phenomenon. It should also be kept in mind that despite its relative success at gauging general audience interest, semi-programmed issue cannot yet guarantee perfect fit between all readers' expectations and the publisher's product.

Bibliography

Abbas, A. 1997. *Hong Kong: Culture and the Politics of Disappearance*. Minneapolis: University of Minnesota Press.

Abelove, H., Barale, M. A. and Halperin, D. (eds) 1993. *The Lesbian and Gay Studies Reader*. New York: Routledge.

Abercrombie, N., Hill, S. and Turner, B. S. 1980. *The Dominant Ideology Thesis*. London: George Allen & Unwin.

Abu-Lughod, J. 1989. 'On the remaking of history: how to invent the past', in *Remaking History*, ed. B. Kruger and P. Mariani. San Francisco: Bay Press.

Addison, W. 1953. *English Fairs and Markets*. London: Batsford.

Adorno, T. W. 1967. *Prisms*, trans. S. and S. Weber. London: Neville Spearman.

—— 1991. *The Culture Industry: Selected Essays on Mass Culture*, ed. with intro. J. M. Bernstein. London: Routledge.

Ahearne, J. 1995. *Michel de Certeau: Interpretation and its Other*. Cambridge: Polity Press.

Alcoff, L. 1988. 'Cultural feminism versus post-structuralism: the identity crisis in feminist theory', *Signs* 13/3.

Althusser, L. 1969. *For Marx*. London: Allen Lane.

Althusser, L. and Balibar, E. 1968. *Reading Capital*. London: New Left Books.

Ames, M. 1986. *Museums, the Public, and Anthropology: A Study of the Anthropology of Anthropology*. Vancouver: University of British Columbia Press.

Amin, S. 1989. *Eurocentrism*, trans. R. Moore. New York: Monthly Review Press.

Anderson, B. 1991. *Imagined Communities: Reflections on the Origin and Spread of Nationalism*, revised and extended edition. London: Verso.

—— 1992. 'Exodus', *Critical Inquiry* 20.

Ang, I. 1985. *Watching Dallas: Soap Opera and the Melodramatic Imagination*. London: Methuen.

—— 1991. *Desperately Seeking the Audience*. London: Routledge.

Appadurai, A. (ed.) 1986. *The Social Life of Things: Commodities in Cultural Perspective*. Cambridge: Cambridge University Press.

—— 1996. *Modernity at Large: Cultural Dimensions of Globalization*. Minneapolis: University of Minnesota Press.

Arendt, H. 1958. *The Human Condition*. Chicago: University of Chicago Press.

Arlen, M. J. 1981. *The Camera Age: Essays on Television*. New York: Penguin.

Attali, J. 1985. *Noise: The Political Economy of Music*, trans. Brian Massumi. Minneapolis: University of Minnesota Press.

Augé, M. 1996. *Non Places: Introduction to an Anthropology of Supermodernity*. London: Verso.

Bachelard, G. 1969. *The Poetics of Space*, trans M. Jolas. Boston: Beacon.

Baker, H. A., Jr, Diawara, M. and Lindeborg, R. H. (eds) 1997. *Black British Cultural Studies: A Reader*. Chicago: University of Chicago Press.

Bakhtin, M. 1981. *The Dialogic Imagination*. Austin: University of Texas Press.

—— 1986. *Speech, Genres, and Other Late Essays*. Austin: University of Texas Press.

—— 1987. *Rabelais and his World*. Bloomington: Indiana University Press.

Baldick, C. 1983. *The Social Mission of English Criticism*. Oxford: Clarendon Press.

Balibar, E. and Wallerstein, I. (eds) 1991. *Race, Nation, Class: Ambiguous Identities*. London: Verso.

Barber, E. L. 1959. *Shakespeare's Festive Comedies: A Study of Dramatic Form and its Relation to Social Custom*. Princeton: Princeton University Press.

Barthes, R. 1972. *Mythologies*. London: Jonathan Cape.

—— 1975. *The Pleasure of the Text*. New York: Hill.

—— 1977. *Image, Music, Text*. London: Fontana.

Baudrillard, J. 1968. *Le Système des objets*. Paris: Gallimard.

—— 1985. 'The ecstasy of communication', in *Postmodern Culture*, ed. Hal Foster. London: Pluto.

Baumann, Z. 1989. *Modernity and the Holocaust*. Ithaca: Cornell University Press.

Beck, U. 1992. *Risk Society: Towards a New Modernity*. London: Sage.

Becker, H. 1978. 'Arts and crafts', *American Journal of Sociology* 83.

—— 1982. *Art Worlds*. Berkeley: University of California Press.

Belsey, C. 1980. *Critical Practice*. London and New York: Methuen.

—— 1982. 'Re-reading the Great Tradition', in *Rereading English*, ed. P. Widdowson. London: Methuen.

Bender, G. and Druckrey, T. (eds) 1994. *Culture on the Brink: Ideologies of Technology*. Seattle: Bay Press.

Benjamin, W. 1969. *Illuminations*. New York: Schocken Books.

—— 1970. *Understanding Brecht*. London: NLB.

—— 1978. *Reflections*. New York: Harcourt Brace Jovanovich.

—— 1979. *One Way Street*. London: NLB.

Bennett, T. 1986. 'The politics of "the popular" and popular culture', in *Popular Culture and Social Relations*, ed. T. Bennett, C. Mercer and J. Woollacott. Milton Keynes: Open University Press.

—— 1990. *Outside Literature*. London: Routledge.

—— 1992a. 'Putting policy into cultural studies', in *Cultural Studies*, ed. L. Grossberg, C. Nelson and P. Treichler. New York: Routledge.

—— 1992b. 'Coming out of English: from cultural studies to cultural policy studies', in *Beyond the Disciplines: The New Humanities*. Canberra: Australian Academy of the Humanities.

—— 1998. *Culture: A Reformer's Science*, Sydney: Allen & Unwin.

Bennett, T. and Woollacott, J. 1988. *Bond and Beyond: The Political Career of a Popular Hero*. London: Macmillan.

Berlant, L. 1997. *The Queen of America Goes to Washington City: Essays on Sex and Citizenship*. Durham: Duke University Press.

Berlant, L. and Warner, M. 1995. 'What queer theory teaches us', *PMLA* 110.

Berman, M. 1982. *All that Is Solid Melts into Air: The Experience of Modernity*. New York: Simon & Schuster.

Berman, R. A. 1989. *Modern Culture and Critical Theory: Art, Politics and the Legacy of the Frankfurt School*. Madison: University of Wisconsin Press.

Bérubé, M. 1998. *The Employment of English: Theory, Jobs and the Future*. New York: New York University Press.

Bhabha, H. K. 1986. 'The other question: difference, discrimination and the discourse of colonialism', in *Literature, Politics and Theory: Papers from the Essex Conference 1976–1984*, ed. F. Barker, P. Hulme and M. Iversen. London: Methuen.

—— (ed.) 1990. *Nation and Narration*. London: Routledge.

—— 1994. *The Location of Culture*. New York: Routledge.

Black Public Sphere Collective. 1995. *The Black Public Sphere*. Chicago: University of Chicago Press.

Blanchot, M. 1987. 'Everyday speech', *Yale French Studies* 73.

Bloch, E. 1988. *The Utopian Function of Art and Literature: Selected Essays*, trans. J. Zipes and F. Mecklenberg. Cambridge, Ma: The MIT Press.

Bobo, J. 1995. *Black Women as Cultural Readers*. New York: Columbia University Press.

Boddy, W. 1985. '"The shining centre of the home": ontologies of television in the "golden age"', in *Television in Transition*, ed. P. Drummond and R. Paterson. London: BFI.

—— 1990. 'The seven dwarfs and the money grubbers: the public relations crisis of US television in the late 1950s', in *Logics of Television: Essays in Cultural Criticism*, ed. P. Mellencamp. Bloomington: Indiana University Press.

Born, G. 1987. 'Modern music culture: on shock, pop and synthesis', *New Formations* 1/2.

Bourdieu, P. 1977. *Outline of a Theory of Practice*. Cambridge: Cambridge University Press.

—— 1986. *Distinction. A Social Critique of the Judgement of Taste*, trans. R. Nice. Cambridge, Ma: Harvard University Press.

—— 1990. *In Other Words: Essays Towards a Reflexive Sociology*, trans. Matthew Adamson. Stanford: Stanford University Press.

—— 1993. *The Field of Cultural Production: Essays on Art and Literature*. Cambridge: Polity.

—— 1996. *The Rules of Art*. Cambridge: Polity.

Boyd-Barrett, O. 1977. 'Mass communication in cross-cultural contexts: the case of the Third World', in *Mass Communication and Society*, ed. J. Curran, M. Gurevitch and J. Woollacott. Milton Keynes: Open University Press.

—— 1982. 'Cultural dependency and the mass media', in *Culture, Society and the Media*, ed. M. Gurevitch, T. Bennett, J. Curran and J. Woollacott. London: Methuen.

Brake, M. 1980. *The Sociology of Youth Culture and Youth Subcultures*. London: Routledge & Kegan Paul.

Brantlinger, P. 1990. *Crusoe's Footsteps: Cultural Studies in Britain and America*. New York: Routledge.

Browne, N. 1984. 'The political economy of the television (super)text', *Quarterly Review of Film Studies* 9.

Brunsdon, C. 1990. 'Television: aesthetics and audience', in *Logics of Television: Essays in Cultural Criticism*, ed. P. Mellencamp. Bloomington: Indiana University Press.

Brunsdon, C. and Morley, D. 1978. *Everyday Television: Nationwide*. London: BFI.

Buckingham, D. 1987. *Public Secrets: EastEnders and its Audience*. London: BFI.

Buck-Morss, S. 1989. *The Dialectics of Seeing: Walter Benjamin and the Arcades Project*. Cambridge, Ma: The MIT Press.

Bukatman, S. 1993. *Terminal Identity*. Durham: Duke University Press.

Burchell, G., Gordon, C. and Miller, P. (eds) 1991. *The Foucault Effect: Studies in Governmentality*. London: Harvester/Wheatsheaf.

Burgin, V. 1990. 'Paranoiac space', *New Formations* 1/2.

Burnett, R. 1995. 'Postmodern image communities', in *Cultures of Vision: Images, Media and the Imaginary*. Bloomington: Indiana University Press.

Butler, J. 1991. *Gender Trouble: Feminism and the Subversion of Identity*. New York: Routledge.

—— 1993. *Bodies that Matter: On the Discursive Limits of 'Sex'*. New York: Routledge.

—— 1996. *Excitable Speech: Contemporary Scenes of Politics*. New York: Routledge.

—— 1997. *The Psychic Life of Power: Theories in Subjection*. Stanford: Stanford University Press.

Calhoun, C. (ed.) 1992. *Habermas and the Public Sphere*. Cambridge, Ma: The MIT Press.

Califia, P. 1994. *Public Sex: The Culture of Radical Sex*. Pittsburgh: Cleis Press.

Campbell, C. 1987. *The Romantic Ethic and the Spirit of Modern Consumerism*. Oxford: Basil Blackwell.

Carby, H. 1986a. 'Sometimes It Jus' Bes' dat Way', *Radical America* 20.

—— 1986b. '"On the threshold of woman's era": lynching, empire, and sexuality in black feminist theory', in *'Race,' Writing and Difference*, ed. H. L. Gates. Chicago: University of Chicago.

—— 1998. *Race Men*. Cambridge, Ma: Harvard University Press.

Carpenter, E. 1975. 'Collecting northwest coast art', in *Indian Art of the Northwest Coast*, ed. B. Holm and B. Reid. Seattle: University of Washington Press.

Carter, E., Donald, J. and Squires, J. (eds) 1995. *Cultural Remix: Theories of Politics and the Popular*. London: Lawrence & Wishart.

Case, S.-E., Brett, P. and Foster, S. (eds) 1995. *Cruising the Performative: Interventions in the Representation of Ethnicity, Nationality, and Sexuality*. Bloomington: University of Indiana Press.

Castels, M. 1989. *The Informational City*. Oxford: Blackwell.

Caughie, J. 1984. 'Television criticism: "a discourse in search of an object"', *Screen* 25/4.

CCCS (Centre for Contemporary Cultural Studies). 1981. *Unpopular Education: Schooling and Social Democracy in England since 1944*. London: Hutchinson.

—— 1982. *The Empire Strikes Back: Race and Racism in 70s Britain*, London: Hutchinson.

Chabram, A. 1990. 'Chican/o studies as oppositional ethnography', *Cultural Studies* 4/3.

Chakrabarty, D. 1994. 'Postcoloniality and the artifice of history: who speaks for "Indian" pasts?', in *The New Historicism Reader*, ed. H. Aram Veeser. New York: Routledge.

Chambers, I. 1985. *Urban Rhythms: Pop Music and Popular Culture*. London: Macmillan.

—— 1986. *Popular Culture: The Metropolitan Experience*. London: Methuen.

—— 1990. 'A miniature history of the Walkman', *New Formations* 1/1.

—— 1994. 'The broken world: whose centre, whose periphery?', in *Migrancy, Culture, Identity*. London: Routledge.

Chatterjee, P. 1993. *The Nation and its Fragments: Colonial and Postcolonial Histories*. Princeton: Princeton University Press.

Cheah, P. and Robbins, B. (eds) 1998. *Cosmopolitics: Thinking and Feeling Beyond the Nation*. Minneapolis: University of Minnesota Press.

Chow, R. 1993. *Writing Diaspora: Tactics of Intervention in Contemporary Cultural Studies*. Bloomington: Indiana University Press.

—— 1995. *Primitive Passions: Visuality, Sexuality, Ethnography, and Contemporary Chinese Cinema*. New York: Columbia University Press.

—— 1998. *Ethics after Idealism: Theory, Culture, Ethnicity, Reading*. Bloomington: Indiana University Press.

Christian, B. 1987. 'The race for theory', *Cultural Critique* 6.

Clarke, J. 1991. *Old Times and New Enemies*. New York: Routledge.

Clarke, J., Hall, S., Jefferson T. and Roberts, B. 1976. 'Subcultures, cultures and class', in *Resistance through Rituals: Youth Subcultures in Post-war Britain*, ed. S. Hall and T. Jefferson. London: Hutchinson.

Clifford, J. 1986. 'On ethnographic allegory', in *Writing Culture: The Poetics and Politics of Ethnography*, ed. J. Clifford and G. E. Marcus. Berkeley: University of California Press.

—— 1988a. 'Of other peoples: beyond the salvage principle', in *Discussions in Contemporary Culture*, ed. H. Foster. Seattle: Bay Press.

—— 1988b. *The Predicament of Culture*. Cambridge, Ma: Harvard University Press.

—— 1997. *Routes*. Cambridge, Ma: Harvard University Press.

Clifford, J. and Dhareshwar, V. 1989. *Traveling Theories: Traveling Theorists*. Santa Cruz: Centre for Cultural Studies.

Clifford, J. and Marcus, G. E. (eds) 1986. *Writing Culture: The Poetics and Politics of Ethnography*, Berkeley: University of California Press.

Cohen, P. 1980. 'Subcultural conflict and working-class community', in *Culture, Media, Language*, ed. S. Hall, D. Hobson, A. Lowe and P. Willis. London: Hutchinson.

Cohn, J. 1988. *Romance and the Erotics of Property: Mass Market Fiction for Women*. Durham: Duke University Press.

Collins, J. 1989. *Uncommon Cultures: Popular Culture and Post-modernism*. New York: Routledge.

—— 1995. *Architecture of Excess: Cultural Life in the Information Age*. New York: Routledge.

Collins, R., Garnham, N. and Locksley, G., 1988. *The Economics of Television: The UK Case*. London: Sage Publications.

Connerton, P. 1980. *The Tragedy of Enlightenment: An Essay on the Frankfurt School*. Cambridge: Cambridge University Press.

Connor, S. 1989. *Postmodern Culture: An Introduction to Theories of the Contemporary*. Oxford: Blackwell.

—— 1992. *Theory and Cultural Value*. Oxford: Blackwell.

Coward, R. 1984. *Female Desire: Women's Sexuality Today*. London: Paladin.

Creekmuir, C. K. and Doty, A. (eds) 1995. *Out in Culture: Gay, Lesbian, and Queer Essays on Popular Culture*. Durham: Duke University Press.

Crimp, D. 1987. 'How to have promiscuity in an epidemic', *October* 43.

Cunningham, H. 1980. *Leisure in the Industrial Revolution*. London: Croom Helm.

Cunningham, S. 1992. *Framing Culture: Culture and Policy in Australia*. Sydney: Allen & Unwin.

Curran, J. 1977. 'Capitalism and control of the press, 1800–1975', in *Mass Communication and Society*, ed. J. Curran, M. Gurevitch and J. Woollacott. London: Edward Arnold.

Curran, J. and Gurevitch, M. (eds) 1991. *Mass Media and Society*. London: Edward Arnold.

Cvetkovich, A. and Kellner, D. 1997. *Articulating the Global and the Local: Globalization and Cultural Studies*. Boulder: Westview Press.

Das, V. 1989. 'Subaltern as perspective', *Subaltern Studies* 6.

Davies, I. 1995. *Cultural Studies and Beyond: Fragments of Empire*. London: Routledge.

Davis, M. 1992. *City of Quartz: Excavating the Future in Los Angeles*. New York: Verso.

De Beauvoir, S. 1973. *The Second Sex*. New York: Vintage.

De Certeau, M. 1984. *The Practice of Everyday Life*. Berkeley: University of California Press.

—— 1997. *Cultures in the Plural*. Minneapolis: University of Minnesota Press.

De Lauretis, T. 1987. *Technologies of Gender: Essays on Theory, Film and Fiction*. Bloomington: Indiana University Press.

—— 1991. 'Queer theory: lesbian and gay sexualities', *differences: A Journal of Feminist Cultural Studies* 3/2.

—— 1994. *The Practice of Love: Lesbian Sexuality and Perverse Desire*. Bloomington: University of Indiana Press.

Deleuze, G. and Guattari, F. 1977. *Anti-Oedipus: Capitalism and Schizophrenia*. New York: Viking.

—— 1988. *A Thousand Plateaus: Capitalism and Schizophrenia*. London: Athlone Press.

Denning, M. 1997. *The Cultural Front: The Laboring of American Culture in the Twentieth Century*. London: Verso.

Derrida, J. 1985. 'Declarations of independence', *New Political Science* 15.

Dickson, D. 1988. *The New Politics of Science*. Chicago: University of Chicago Press.

Dimock, W. and Gilmore, M. (eds) 1994. *Rethinking Class: Literary Studies and Social Formations*. New York: Columbia University Press.

Dirlik, A. 1994. 'The postcolonial aura: Third World criticism in the age of global capitalism', *Critical Inquiry* 20.

—— 1997. *The Postcolonial Aura: Third World Criticism in the Age of Global Capitalism*. Boulder: Westview Press.

Docherty, T. (ed.) 1993. *Postmodernism: A Reader*. Hemel Hempstead: Harvester Wheatsheaf.

Donald, J. 1992. *Sentimental Education: Schooling, Popular Culture and the Regulation of Liberty*. London: Verso.

Doty, A. 1993. *Making Things Perfectly Queer: Interpreting Mass Culture*. Minneapolis: University of Minnesota Press.

Doyle, B. 1989. *English and Englishness*. London: Routledge.

Dreyfus, H. L. and Rabinow, P. 1983. *Michel Foucault: Beyond Structuralism and Hermeneutics Second Edition. With an Afterword by and an Interview with Michel Foucault*. Chicago: The University of Chicago Press.

Du Gay, P. 1996. *Consumption and Identity at Work*. London: Sage.

—— 1997. *Production of Culture/Cultures of Production*. London: Sage.

Du Gay, P., Hall, S., Janes, L. and Mackay, H. (eds) 1996. *Doing Cultural Studies: The Story of the Sony Walkman*. London: Sage.

Dunn, T. 1986. 'The evolution of cultural studies', in *Introduction to Contemporary Cultural Studies*, ed. D. Punter. London: Longman.

During, S. 1987. 'Postmodernism and postcolonialism today', *Textual Practice* 1/1.

—— 1996. 'From the new historicism to cultural studies', in *Institutions in Cultures: Theory and Practice*, ed. Robert Lumsden and Rajeev Patke. Amsterdam: Rodopi.

—— 1997. 'Popular culture on a global scale: a problem for cultural studies?', *Critical Inquiry* 23/4.

—— 1998. 'Postcolonialism and globalisation: a dialectical relation after all?', *Postcolonial Studies* 1/1.

Dworkin, D. 1997. *Cultural Marxism in Postwar Britain: History, the New Left, and the Origins of Cultural Studies*. London and Durham: Duke University Press.

Dwyer, K. 1979. 'The dialogic of ethnology', *Dialectical Anthropology* 4.

Dyer, R. 1979. *Stars*. London: BFI.

—— 1987. *Heavenly Bodies: Film Stars and Society*. London: BFI

—— 1997. *White*. London: Routledge.

Eagleton, T. 1981. *Walter Benjamin, or Towards a Revolutionary Criticism*. London: Verso.

—— 1991. *Ideology: An Introduction*. London: Verso.

Edelman, L. 1994. *Homographesis: Essays in Gay Literary and Cultural Theory*. New York: Routledge.

Eley, G. 1992. 'Nations, publics, and political cultures: placing Habermas in the nineteenth century', in *Habermas and the Public Sphere*, ed. C. Calhoun. Cambridge, Ma: The MIT Press.

Ellis, J. 1982. *Visible Fictions: Cinema, Television, Video*. London: Routledge.

Ewen, S. 1976. *Captains of Consciousness: Advertising and the Social Roots of Consumer Culture*. New York: McGraw-Hill.

Fabian, J. 1983. *Time and the Other: How Anthropology Makes its Object*. New York: Columbia University Press.

Fanon, F. 1967a. *The Wretched of the Earth*. Harmondsworth: Penguin.

—— 1967b. *Black Skin, White Masks*. New York: Grove Press.

Faure, A. 1978. *Paris Carême-prenant*. Paris: Hachette.

Featherstone, M. 1993. 'Global and local cultures', in *Mapping the Futures: Local Cultures, Global Change*, ed. Jon Bird, Barry Curtis, Tim Putnam and Lisa Tickner. London: Routledge.

Feld, S. 1988. 'Notes on world beat', *Public Culture* 1/1.

Ferguson, M. and Golding, P. 1997. *Cultural Studies in Question*. London: Sage.

Feuer, J. 1983. 'The concept of live television: ontology as ideology', in *Regarding Televisions: Critical Approaches – an Anthology*, ed. E. A. Kaplan. Los Angeles: The American Film Institute.

Fine, M., Weiss, L., Powell, L. C., Mun Wong, L. (eds) 1997. *Off White: Readings in Race, Power and Society*. New York: Routledge.

Fischer, M. 1986. 'Ethnicity and the post-modern arts of memory', in *Writing Culture: The Politics and Poetics of Ethnography*, ed. J. Clifford and G. E. Marcus. Berkeley: University of California Press.

Fiske, J. 1987a. 'British cultural studies and television', in *Channels of Discourse: TV and Contemporary Criticism*, ed. R. C. Allen. Chapel Hill and London: University of North Carolina Press.

—— 1987b. *Television Culture*. London: Methuen.

—— 1989. *Understanding Popular Culture*. Boston: Unwin Hyman.

—— 1992. 'Cultural studies and the culture of everyday life', in *Cultural Studies*, ed. L. Grossberg, C. Nelson and P. Treichler. New York: Routledge.

Fiske, J. and Hartley, J. 1978. *Reading Television*. London: Methuen.

Foucault, M. 1965. *Madness and Civilisation*, trans. Richard Howard. New York: Pantheon Books.

—— 1970. *The Order of Things: An Archeology of the Human Sciences*. London: Tavistock.

—— 1980a. *History of Sexuality*. New York: Pantheon.

—— 1980b. *Power/Knowledge: Selected Interviews and Other Writings 1972–1977*. New York: Pantheon.

—— 1986. 'Of other spaces', *Diacritics* 16.

—— 1988. *Politics, Philosophy, Culture: Interviews and Other Writings 1977–1984*, ed. with intro. by L. D. Kritzman. London: Routledge.

Fox-Keller, E. 1984. *Reflections on Gender and Science*. New Haven: Yale University Press.

Frankenberg, R. 1993. *White Women, Race Matters: The Social Construction of Whiteness*. London: Routledge.

Franklin, S. 1995. 'Science as culture, cultures of science', *Annual Review of Anthropology* 24.

Freud, S. 1954. *Sigmund Freud's Letters to Wilhelm Fliess, Drafts and Notes*, ed. M. Bonaparte, A. Freud and E. Kris, trans. E. Masbacher and J. Strachey. New York: Basic Books.

—— 1963. 'General remarks on hysterical attacks', in *Dora: An Analysis of a Case of Hysteria*, trans. D. Bryan. New York: Macmillan.

—— 1974. 'Studies on hysteria', in *Pelican Freud Library* 3, ed. A. Richards, trans. J. Strachey and A. Strachey. Harmondsworth: Penguin.

Friedberg, A. 1993. *Window Shopping: Cinema and the Postmodern*. Berkeley: University of California Press.

Friedman, J. 1994. *Cultural Identity and Global Process*. London: Sage.

Frith, S. 1983. *Sound Effects: Youth, Leisure and the Politics of Rock 'n' Roll*. London: Constable.

—— 1988. *Music for Pleasure*. Cambridge: Polity.

—— 1996. *Performing Rites: The Aesthetics of Popular Music*. Cambridge, Ma: Harvard University Press.

Frith, S. and Goodwin, A. (eds) 1990. *On Record: Rock, Pop and the Written Word*. London and New York: Routledge.

Frith, S. and McRobbie, A. 1978. 'Rock and sexuality', *Screen Education* 28.

Frow, J. 1991. 'Michel de Certeau and the practice of representation', *Cultural Studies* 5/1.

—— 1995. *Cultural Studies and Cultural Value*. Oxford: Clarendon Press.

—— 1997. *Time and Commodity Culture: Essays in Cultural Theory and Postmodernity*. Oxford: Clarendon Press.

Frow, J. and Morris, M. (eds) 1993. *Australian Cultural Studies: A Reader*. Sydney: Allen & Unwin.

Fuller, S. 1992. 'Social epistemology and the research agenda of science studies', in *Science as Practice and Culture*, ed. A. Pickering. Chicago: University of Chicago Press.

Fuss, D. 1989. *Essentially Speaking: Feminism, Nature and Difference*. New York: Routledge.

—— (ed.) 1991. *Inside/Out: Lesbian Theories, Gay Theories*. New York: Routledge.

—— 1995. *Identification Papers*. New York: Routledge.

Gallop, J. 1982. *The Daughter's Seduction: Feminism and Psychoanalysis*. Ithaca: Cornell University Press.

Gandhi, L. 1998. *Postcolonial Theory*. Sydney: Allen & Unwin.

Garber, M., Matlock, J. and Walkowitz, R. (eds) 1993. *Media Spectacles*. New York: Routledge.

Garber, M., Walkowitz, R. and Franklin, P. (eds) 1996. *Fieldwork: Sites in Literary and Cultural Studies*. New York: Routledge.

Garnham, N. 1990. *Capitalism and Communication: Global Culture and the Politics of Information*. London: Sage.

—— 1997. 'Dominance and ideology in culture and cultural studies' in *Cultural Studies in Question*, ed. M. Ferguson and P. Golding. London: Sage.

Garnham, N. and Williams, R. 1980. 'Pierre Bourdieu and the sociology of culture: an introduction', *Media, Culture and Society* 2.

Garratt, S. 1990. 'Teenage dreams', in *On Record: Rock, Pop and the Written Word*, ed. S. Frith and A Goodwin. London and New York: Routledge.

Gates Jr, H. L. (ed.) 1986. *'Race', Writing and Difference*. Chicago: University of Chicago Press.

—— 1987. 'Authority (white) power and the (black) critic; it's all Greek to me', *Cultural Critique* 7.

—— (ed.) 1990. *Reading Black, Reading Feminist: A Critical Anthology*. New York: NAL.

Gelder, K and Thornton, S. (eds) 1997. *The Subcultures Reader*. London: Routledge.

Gibian, P. (ed.) 1997. *Mass Culture and Everyday Life*. London: Routledge.

Giddens, T. 1979. *Central Problems in Social Theory: Action, Structure and Contradiction in Social Analysis*. Berkeley: University of California Press.

Gilroy, P. 1982. 'Against ethnic absolutism', in *Cultural Studies*, ed. L. Grossberg, C. Nelson and P. Treichler. New York: Routledge.

—— 1987. *There Ain't No Black in the Union Jack: The Cultural Politics of Race and Nation*. London: Hutchinson.

—— 1994. *The Black Atlantic: Modernity and Double Consciousness*. London: Verso.

Ginsburg, F. 1991. 'Indigenous media: Faustian contract or global village?', *Cultural Anthropology* 6/1.

Ginsburg, F. D. and Rapp, R. (eds) 1995. *Conceiving the New World Order: the Global Politics of Reproduction*. Berkeley: University of California Press.

Giroux, H. 1994. *Disturbing Pleasures*. London: Routledge.

Gitlin, T. 1983. *Inside Prime Time*. New York: Pantheon.

Godelier, M. 1970. 'Structure and contradiction in "Capital"', in *Structuralism: A Reader*, ed. M. Lane. London: Jonathan Cape.

Goldberg, D. T. (ed.) 1994. *Multiculturalism: A Critical Reader*. Oxford: Blackwell.

Golding, P. and Murdock, G. 1990. 'Screening out the poor', in *The Neglected Audience*, ed. J. Willis and T. Wollen. London: BFI.

Gordon, A. F. and Newfield, C. (eds) 1996. *Mapping Multiculturalism*. Minneapolis: University of Minnesota Press.

Graff, G. 1987. *Professing Literature: An Institutional History*. Chicago: University of Chicago Press.

—— 1992. *Beyond the Culture Wars: How Teaching the Conflicts Can Revitalize American Education*. New York: W. W. Norton.

Gramsci, A. 1971. *Selections from the Prison Notebooks*, ed. and trans. Q. Hoare and G. Nowell Smith. London: Lawrence & Wishart.

—— 1975. *Quaderni del carceri*. Turin: Einaudi.

——1978. *Selections from the Political Writings*, ed. and trans. Q. Hoare. London: Lawrence & Wishart.

——1985. *Selections from the Cultural Writings*, ed. D. Forgacs and D. Nowell-Smith. London: Lawrence & Wishart.

Gray, A. 1987. 'Behind closed doors: video recorders in the home', in *Boxed In: Women and Television*, ed. H. Baehr and G. Dyer. London: Pandora.

Gray, C. H. (ed.) 1997. *The Cyborg Handbook*. New York: Routledge.

Greimas, A. J. and Rastier, F. 1968. 'The interaction of semiotic constraints', *Yale French Studies* 4.

Griffin, J. H. 1961. *Black Like Me*. New York: NAL.

Gross, P. R. and Levitt, N. 1994. *Higher Superstition: The Academic Left and its Quarrels with Science*. Baltimore: Johns Hopkins University Press.

Grossberg, L. 1984. '"I'd Rather Feel Bad than Not Feel Anything At All": rock and roll, pleasure and power', *Enclitic* 8/1–2.

——1987. 'The in-difference of television', *Screen* 28/2.

——1988. 'Wandering audiences, nomadic critics', *Cultural Studies* 2/3.

——1992. *We Gotta Get Out of This Place*. New York: Routledge.

——1997. *Dancing in Spite of Myself: Essays on Popular Culture*. Durham and London: Duke University Press.

——1998. 'Cultural studies vs. political economy: is anybody else bored with this debate?', in *Cultural Theory and Popular Culture: A Reader (Second Edition)*, ed. J. Storey. London: Prentice Hall.

Grossberg, L., Nelson, C. and Treichler, P. (eds) 1992. *Cultural Studies*, New York: Routledge.

Grosz, E. and Probyn, E. (eds) 1995. *Sexy Bodies: The Strange Carnalities of Feminism*. London: Routledge.

Guha, R. 1983. 'The prose of counter-insurgency', in *Subaltern Studies* 2, ed. R. Guha. New Delhi: Oxford University Press.

Guillory, J. 1993. *Cultural Capital: The Problem of Literary Canon Formation*. Chicago: University of Chicago Press.

Gunew, S. 1990. 'Denaturalizing cultural nationalism: multicultural readings of "Australia"', in *Nation and Narration*, ed. H. Bhabha. London: Routledge.

Habermas, J. 1987. *The Philosophical Discourse of Modernity: Twelve Lectures*. Cambridge, MA: The MIT Press.

——1989. 'The new obscurity: the crisis of the welfare state and the exhaustion of utopian energies', in *The New Conservatism: Cultural Criticism and the Historians' Debate*, trans. S. Weber Nicholsen. Cambridge, Ma: The MIT Press.

——1991. *The Structural Transformation of the Public Sphere: An Inquiry into a Category of Bourgeois Society*. Cambridge, Ma: The MIT Press.

Hall, S. 1977. 'Culture, the media and the "ideological effect"', in *Mass Communication and Society*, ed. J. Curran, M. Gurevitch and J. Woollacott. London: Edward Arnold.

——1980. 'Cultural studies and the centre: some problematics and problems', in *Culture, Media, Language: Working Papers in Cultural Studies, 1972–79*, ed. S. Hall, D. Hobson, A. Love and P. Willis. London: Hutchinson.

——1981a. 'Notes on deconstructing the popular', in *People's History and Socialist Theory*, ed. R. Samuel. London: Routledge & Kegan Paul.

——1981b. 'Two paradigms in cultural studies', in *Culture, Ideology and Social Process*, ed. T. Bennett, S. Boyd-Bowman, C. Mercer and J. Woollacott. London: Batsford.

—— 1988. *The Hard Road to Renewal: Thatcherism and the Crisis of the Left*. London: Verso.

—— 1990. 'The emergence of cultural studies and the crisis of the humanities', *October* 53.

—— 1991. 'The local and the global: globalisation and ethnicity', in *Culture, Globalization, and the World-System*, ed. A. King. London: Macmillan.

—— 1996a. 'The new ethnicities', in *Stuart Hall: Critical Dialogues in Cultural Studies*, ed. D. Morley, and K.-H. Chen. London: Routledge.

Hall, S., Critcher, C., Jefferson, T., Clarke, J. and Roberts, B. 1979. *Policing the Crisis: Mugging, the State, and Law and Order*. London: Macmillan.

Hall, S. and Jefferson, T. (eds) 1976. *Resistance through Rituals: Youth Subcultures in Post-war Britain*. London: Hutchinson.

Hall, S. and Whannel, P. 1964. *The Popular Arts*. London: Hutchinson.

Halperin, D. 1989. *One Hundred Years of Homosexuality*. London and New York: Routledge.

—— 1995. *Saint Foucault: Towards a Gay Hagiography*. New York: Oxford University Press.

Handler, R. 1985. 'On having a culture: nationalism and the preservation of Quebec's patrimoine', in *History of Anthropology Vol. 3: Objects and Others*, ed. G. Stocking. Madison: University of Wisconsin Press.

Hannertz, U. 1996. *Transnational Connections: Culture, People, Places*. London: Routledge.

Hansen, M. 1993. 'Unstable mixtures, dilated spheres: Negt and Kluge's *The Public Sphere and Experience*, twenty years later', *Public Culture* 5/2.

Haraway, D. 1984. 'Teddy bear patriarchy: taxidermy in the Garden of Eden, 1908–1936', *Social Text* 11.

—— 1988. 'Situated knowledge', *Feminist Studies* 14/3.

—— 1991. *Simians, Cyborgs, and Women: the Reinvention of Nature*. New York: Routledge.

—— 1997. *Modest-Witness@Second-Millennium.FemaleMan©-Meets-OncoMouse™: Feminism and Technoscience*. New York: Routledge.

Harding, S. 1991. *Whose Science? Whose Knowledge? Thinking from Women's Lives*. Ithaca: Cornell University Press.

—— (ed.) 1995. *The 'Racial' Economy of Science: Towards a Democratic Future*. Bloomington: Indiana University Press.

Harris, D. 1992. *From Class Struggle to the Politics of Pleasure: The Effects of Gramscianism on Cultural Studies*. London: Routledge.

Harris, N. 1990. *Cultural Excursions, Marketing Appetites and Cultural Tastes in Modern America*. Chicago: University of Chicago Press.

Hartley, J. 1983. 'Encouraging signs: television and the power of dirt, speech and scandalous categories', *Australian Journal of Cultural Studies* 1/2.

—— 1992. *Tele-ology: Studies in Television*. London: Routledge.

—— 1996. *Popular Reality*. London: Arnold.

Hartmann, W. 1976. *Der Historische Festzug: Seine Entstehung und Entwicklung im 19. und 20. Jahrhunderts*, Studien zur Kunst des 19 Jahrhunderts 35. Munich: Prestel.

Harvey, D. 1985. *Consciousness and the Urban Experience*. Oxford: Basil Blackwell.

—— 1989. *The Condition of Postmodernity*. Oxford: Blackwell.

Hawkes, T. 1977. *Semiotics and Structuralism*. London: Methuen.

Hay, J., Grossberg, L. and Wartella, E. (eds) 1996. *The Audience and its Landscape*. Boulder: Westview Press.

Hayward, P. 1990. 'How ABC capitalised on cultural logic: the moonlighting story', in *The Media Reader*, ed. M. Alvarado and J. O. Thompson. London: BFI.

Healy, C. 1996. *From the Ruins of Colonialism: History as Social Memory*, Melbourne: Cambridge University Press.

Heath, S. 1982. *The Sexual Fix*. London: Macmillan.

Heath, S. and Skirrow, G. 1977. 'Television: a world in action', *Screen* 18/2.

Hebdige, D. 1979. *Subculture: the Meaning of Style*. London: Methuen.

—— 1988. *Hiding in the Light: Images and Things*. London: Routledge.

Hechter, M. 1974. *Internal Colonialism: The Celtic Fringe in British National Development, 1536–1966*. Berkeley: University of California Press.

Hindess, B. and Hirst, P. 1987. *Auto-critique of the Pre-capitalist Modes of Production*. Atlantic Highlands: Prentice Hall.

Hirsch, M. and Fox Keller, E. (eds) 1990. *Conflicts in Feminism*. London: Routledge.

Hobsbawm, E. and Ranger, T. (eds) 1983. *The Invention of Tradition*. New York: Columbia University Press.

Hobson, D. 1982. *Crossroads: the Drama of a Soap Opera*. London: Methuen.

Hoggart, R. 1958. *The Uses of Literacy*. Harmondsworth: Penguin. First published 1957.

—— 1966. 'Literature and society', *The American Scholar* 35.

Holub, R. 1992. *Antonio Gramsci: Beyond Marxism and Postmodernism*. London: Routledge.

Hunter, I. 1988. *Culture and Government: The Emergence of Literary Education*. London: Macmillan.

—— 1994. *Rethinking the School: Subjectivity, Bureaucracy and Criticism*. Sydney: Allen & Unwin.

—— 1996. 'Literary theory in civil life', *South Atlantic Quarterly* 95/4.

Hunter, I., Meredyth, D., Smith, B. and Stokes, G. (eds) 1991. *Accounting for the Humanities: The Language of Culture and the Logic of Government*. Brisbane: Institute for Cultural Policy Studies, Griffith University.

Huntingdon, S. 1997. *The Clash of Civilisations: Remaking of World Order*. New York: Touchstone.

Hutcheon, L. 1989. *The Politics of Postmodernism*. London: Routledge.

Inglis, F. 1995. *Raymond Williams*. London: Routledge.

Irigaray, L. 1985. *The Sex Which Is Not One*. Ithaca: Cornell University Press.

Isozaki, A. and Asada, A. 1992. 'Anywhere – problems of space', in *Anywhere*, ed. A. Isozaki and A. Asada. New York: Rizzoli.

Ivy, M. 1995. *Discourses of the Vanishing: Modernity, Phantasm, Japan*. Chicago: University of Chicago Press.

Jacka, E. 1994. 'Research audiences: a dialogue between cultural studies and social science', *Media Information Australia* 73.

Jagose, A. 1996. *Queer Theory*. Melbourne: Melbourne University Press.

Jameson, F. 1981. *The Political Unconscious: Narrative as a Socially Symbolic Act*. Ithaca: Cornell University Press.

—— 1989. 'Foreword', in R. Retamar, *Caliban and Other Essays*. Minneapolis: University of Minnesota Press.

—— 1990. *Postmodernism, or the Cultural Logic of Late Capitalism*. Durham: Duke University Press.

—— 1992. *The Geopolitical Aesthetic: Cinema and Space in the World System*. Bloomington: University of Indiana Press.

—— 1993. 'On cultural studies', *Social Text* 34.

Jameson, F. and Miyoshi, M. (eds) 1998. *The Cultures of Globalization*. Durham: Duke University Press.

JanMohamed, A. and Lloyd, D. 1987. 'Introduction: towards a theory of minority discourse', *Cultural Critique* (spring).

Jardine, A. 1985. *Gynesis: Configurations of Woman and Modernity*. Ithaca: Cornell University Press.

Jay, M. 1973. *The Dialectical Imagination: A History of the Frankfurt School and the Institute of Social Research 1923–50*. London: Heinemann Educational Books.

—— 1984a. *Adorno*. Cambridge, Ma: Harvard University Press.

—— 1984b. *Marxism and Totality: The Adventures of a Concept from Lukacs to Habermas*. Berkeley: University of California Press.

Jeffords, S. 1994. *Hard Bodies: Hollywood Masculinity in the Reagan Era*. New Brunswick: Rutgers University Press.

Jenkins, H. 1992. *Textual Poachers: Television Fans and Participatory Culture*. New York: Routledge.

Jenkins, H. and Tulloch, J. 1995. *Science Fiction Audiences: Watching* Dr Who *and* Star Trek. London: Routledge.

Jenkins, K. 1997. *The Postmodern History Reader*. London: Routledge.

Jhally, S. 1987. *The Codes of Advertising: Fetishism and the Political Economy in the Consumer Society*. London: Frances Pinter.

Johnson, R. 1987. 'What is cultural studies anyway?', *Social Text* 6/1.

Jones, P. 1994. 'The myth of "Raymond Hoggart": on "founding fathers" and cultural policy', *Cultural Studies* 8/3.

Joyrich, L. 1996. *Re-viewing Reception: Television, Gender and Postmodern Culture*. Bloomington: Indiana University Press.

Kaplan, A. and Pease, D. E. (eds) 1993. *Cultures of United States Imperialism*. Durham: Duke University Press.

Kaplan, Cora. 1986. *Sea Changes: Essays on Culture and Feminism*. London: Verso.

Kaplan, Caren. 1996. *Questions of Travel: Postmodern Discourses of Displacement*. Durham: Duke University Press.

Kappeler, S. 1986. *The Pornography of Representation*. Minneapolis: University of Minnesota Press.

Karp, I. and Lavine, S. D. 1991. *Exhibiting Cultures: The Poetics and Politics of Museum Display*. Washington, DC: Smithsonian Institution Press.

Katz, E. and Liebes, T. 1985. 'Mutual aid in the decoding of Dallas: preliminary notes from a cross-cultural study', in *Television in Transition: Papers from the First International Television Studies Conference*, ed. P. Drummond and R. Paterson. London: BFI.

Kellner, D. 1995. *Media Culture: Cultural Studies, Identity and Politics between the Modern and the Post-modern*. New York: Routledge.

Kern, S. 1983. *The Culture of Time and Space 1880–1918*. Cambridge, Ma: Harvard University Press.

King, A. 1990. *Urbanism, Colonialism, and the World Economy*. London: Routledge.

Kipnis, L. 1993. *Ecstasy Unlimited: On Sex, Capital, Gender, and Aesthetics*. Minneapolis: University of Minnesota Press.

—— 1996. *Bound and Gagged: Pornography and the Politics of Fantasy in America*. New York: Grove Press.

Kittler, F. 1990a. *Discourse Networks 1800/1900*. Stanford: Stanford University Press.

—— 1990b. 'The mechanized philosopher', in *Looking after Nietzsche*, ed. Laurence A. Rickels. Albany: State University of New York Press.

Kowinski, W. S. 1985. *The Malling of America: An Inside Look at the Great Consumer Paradise*. New York: Pantheon.

Kracauer, S. 1995. *The Mass Ornament: Weimar Essays*. Cambridge, Ma: Harvard University Press.

Kristeva, J. 1974. *La Révolution du langage poétique*. Paris: Seuil.

—— 1980. *Powers of Horror: An Essay on Abjection*. New York: Columbia University Press.

—— 1989. *Language – The Unknown: An Initiation into Linguistics*, trans. Anne M. Menke. New York: Columbia University Press.

Kroeber, A. L. and Kluckhohn, C. 1952. *Culture: A Critical Review of Concepts and Definitions*. New York: Vintage.

Lacan, J. 1977a. *The Four Fundamental Concepts of Psychoanalysis*. New York: Norton.

—— 1977b. *Ecrits*. London: Tavistock.

—— 1988. *The Seminars of Jacques Lacan, 1954–55*. Cambridge: Cambridge University Press.

LaCapra, D. 1985. *History & Criticism*. Ithaca: Cornell University Press.

Laclau, E. 1977. *Politics and Ideology in Marxist Theory*. London: New Left Books.

—— (ed.) 1994. *The Making of Political Identities*. London: Verso.

Laclau, E. and Mouffe, C. 1985. *Hegemony and Social Strategy: Towards a Radical Democratic Politics*. London: Verso.

Laing, S. 1986. *Representations of Working-class Life, 1959–64*. London: Macmillan.

Landes, J. 1988. *Women and the Public Sphere in the Age of the French Revolution*. Ithaca: Cornell University Press.

Langton, M. 1993. *Well I Heard it on the Radio and I Saw It on the Television*. Sydney: Australian Film Commission.

Lash, S. and Urry, J. 1987. *The End of Organized Capitalism*. Madison: University of Wisconsin Press.

Leal, O. F. 1990. 'Popular taste and erudite repertoire: the place and space of television in Brazil', *Cultural Studies* 4/1.

Lears, T. J. 1983. 'From salvation to self-realisation: advertising and the therapeutic roots of consumer culture, 1880–1930', in *The Culture of Consumption: Critical Essays in American History, 1880–1980*, ed. R. W. Fox and T. J. Lears. New York: Pantheon.

Lefebvre, H. 1971. *Everyday Life in the Modern World*. London: Allen Lane.

—— 1991a. *Critique of Everyday Life: Vol. 1*. London: Verso.

—— 1991b. *The Production of Space*. Oxford: Blackwell.

Levine, L. 1988. *Highbrow/Lowbrow: The Emergence of Cultural Hierarchy in America*. Cambridge, Ma: Harvard University Press.

Lévi-Strauss, C. 1960. *Structural Anthropology: Vol. 2*. New York: Basic Books.

—— 1985. *The View from Afar*. New York: Basic Books.

Lewis, J. 1990. *Art, Culture and Enterprise: The Politics of Art and the Cultural Industries*. New York: Routledge.

—— 1991. *The Ideological Octopus*, New York: Routledge.

Liebes, T. and Katz, E. 1990. *The Export of Meaning: Cross-cultural Readings of Dallas*. Cambridge: Polity Press.

Lipsitz, G. 1990. *Time Passages: Collective Memory and American Popular Culture*. Minneapolis: University of Minnesota Press.

—— 1994. *Dangerous Crossroads: Popular Music, Postmodernism, and the Poetics of Place*. London: Verso.

Lloyd, D. and Thomas, P. (eds) 1998. *Culture and the State*, New York: Routledge.

Long, E. (ed.) 1997. *From Sociology to Cultural Studies: New Perspectives*. Malden, Ma: Blackwell.

Lurie, C. 1996a. *Consumer Culture*. Cambridge: Polity Press.

—— 1996b. *Cultural Rights: Technology, Legality and Personality*. London: Routledge.

Lyotard, J. 1986. *The Postmodern Condition: A Report on Knowledge*. Manchester: Manchester University Press.

MacCabe, C. 1981. 'Memory, phantasy, identity: *Days of Hope* and the politics of the past', in *Popular Television and Film*, ed. T. Bennett, C. Mercer and J. Woollacott. London: BFI.

MacKinnon, C. 1987. *Feminism Unmodified: Discourses of Life and Law*. Cambridge, Ma: Harvard University Press.

Macpherson, C. B. 1962. *The Political Theory of Possessive Individualism*. Oxford: Oxford University Press.

Mailer, N. 1959. 'The white negro', in *Advertisements for Myself*. New York: Putnam's.

Mandel, E. 1978. *Late Capitalism*. London: Verso.

Mansbridge, J. 1990. 'Feminism and democracy', *The American Prospect* 1.

Marchand, R. 1985. *Advertising the American Dream: Making Way for Modernity 1920–1940*. Berkeley: University of California Press.

Marcus, G. 1986. *Lipstick Traces: A Secret History of the Twentieth Century*. Cambridge, Ma: Harvard University Press.

Marcus, G. and Fischer, M. 1986. *Anthropology as Cultural Critique*. Chicago: University of Chicago Press.

Marcuse, H. 1964. *One-dimensional Man*. Boston: Beacon Press.

Martin, B. 1994. 'Extraordinary homosexuals and the fear of being ordinary', *differences* 6.

Marx, K. and Engels, F. 1970. *The German Ideology*. London: Lawrence & Wishart.

Mattelart, A. 1991. *Advertising International: The Privatisation of Public Space*, trans. M. Chanan. London and New York: Routledge.

McClintock, A. 1994. 'The angel of progress: pitfalls of the term "postcolonialism"', in *Colonial Discourse / Postcolonial Theory*, ed. F. Barker, P. Hulme and M. Iversen. Manchester: Manchester University Press.

—— 1995. *Imperial Leather: Race, Gender and Sexuality in the Colonial Context*. London: Routledge.

McClintock, A., Mufti, A. and Shohat, E. (eds) 1997. *Dangerous Liaisons: Gender, Nation and Postcolonial Perspectives*. Minneapolis: University of Minnesota Press.

McGuigan, J. 1992. *Cultural Populism*. London: Routledge.

—— 1996. *Culture and the Public Sphere*. London: Routledge.

—— (ed.) 1997. *Cultural Methodologies*. London: Sage.

McRobbie, A. 1980. 'Settling accounts with subcultures', *Screen Education* 34.

—— 1984. 'Dance and social fantasy', in *Gender and Generation*, ed. A. McRobbie and M. Nava. London: Macmillan.

—— 1994. *Postmodernism and Popular Culture*. London: Routledge.

—— 1996. 'Looking back at new times and its critics', in *Stuart Hall: Critical Dialogues in Cultural Studies*, ed. D. Morley and K.-H. Chen. London: Routledge.

—— (ed.) 1997. *Back to Reality?: Social Experience and Cultural Studies*. Manchester: Manchester University Press.

McRobbie, A. and Nava, M. (eds) 1984. *Gender and Generation*. London: Macmillan.

Mead, M. 1971. *The Mountain Arapesh*, vol. 3. Garden City: Natural History Press.

Meehan, E. R. 1988. 'Technical capability vs. corporate imperatives: towards a political economy of cable television and information diversity', in *The Political Economy of Information*, ed. V. Mosco and J. Wasko. Madison: University of Wisconsin Press.

—— 1990. 'Why we don't count: the commodity audience', in *Logics of Television: Essays in Cultural Criticism*, ed. P. Mellencamp. Bloomington and London: Indiana University Press.

Mellencamp, P. 1992. *High Anxiety: Catastrophe, Scandal, Age & Comedy*. Bloomington: University of Indiana Press.

Mercer, K. 1987. 'Black hair/style politics', *New Formations* 3.

—— 1994. *Welcome to the Jungle: New Positions in Black Cultural Studies*. New York: Routledge.

Merchant, C. 1980. *The Death of Nature: Women, Ecology, and the Scientific Revolution*. San Francisco: Harper & Row.

Michaels, E. 1986. *The Aboriginal Invention of Television: Central Australia 1982–86*. Canberra: Australian Institute of Aboriginal Studies.

—— 1994. *Bad Aboriginal Art: Traditions, Media and Technological Horizons*. Sydney: Allen & Unwin.

Miller, D. 1992. 'The young and the restless in Trinidad: a case of the local and the global in mass consumption', in *Consuming Technologies*, ed. R. Silverstone and E. Hirsch. London: Routledge.

—— 1998. *A Theory of Shopping*. Cambridge: Polity.

Miller, T. 1993. *The Well-tempered Self: Citizenship, Culture and the Postmodern Subject*. Baltimore: Johns Hopkins University Press.

—— 1996. 'Cultural citizenship and technologies of the subject: or, where did you go, Paul Dimaggio?', *Culture and Policy* 7/1.

—— 1998. *Technologies of Truth: Cultural Citizenship and the Popular Media*. Minneapolis: University of Minnesota Press.

Mills, C. W. 1959. *The Sociological Imagination*. New York: Oxford University Press.

Mitchell, T. 1988. *Colonizing Egypt*. Cambridge: Cambridge University Press.

Mitchell, W. J. T. 1986. *Iconology: Image, Text, Ideology*. Chicago: University of Chicago Press.

Miyoshi, M. 1991. *Off Centre: Power and Culture: Relations between Japan and the United States*. Cambridge, Ma: Harvard University Press.

Modleski, T. 1982. *Loving with a Vengeance: Mass-produced Fantasies for Women*. Hamden: Archon Books.

—— 1983. 'The rhythms of reception: daytime television and women's work', in *Regarding Television. Critical Approaches – An Anthology*, ed. E. A. Kaplan. Frederick: University Publications of America.

—— 1984. *Loving with a Vengeance*. London: Methuen.

—— (ed.) 1987. *Studies in Entertainment: Critical Approaches to Mass Culture*. Bloomington: University of Indiana Press.

Mohanty, C. T. 1984. '"Under Western Eyes": feminist scholarship and colonial discourses', *Boundary 2* 12/3–13/1.

Moraga, C. and Anzaldúa, G. (eds) 1981. *This Bridge Called My Back: Writings of Radical Women of Color*. New York: Kitchen Table, Women of Color Press.

Morley, D. 1980. *The 'Nationwide' Audience: Structure and Decoding*, BFI Television Monographs, 11. London: BFI.

—— 1986. *Family Television: Cultural Power and Domestic Leisure*. London: Commedia.

—— 1989. 'Changing paradigms in audience studies', in *Remote Control: Television, Audiences and Cultural Power*, ed. E. Seiter, H. Borchers, G. Kreutzner and E.-M. Warth. London: Routledge.

—— 1990. 'Behind the ratings: the politics of audience research', in *The Neglected Audience*, ed. J. Willis and T. Wollen. The Broadcasting Debate, 5. London: BFI.

—— 1992. *Television, Audiences, and Cultural Studies*. London: Routledge.

Morley, D. and Chen, K.-H. (eds) 1996. *Stuart Hall: Critical Dialogues in Cultural Studies*. London: Routledge.

Morley, D. and Robins, K. 1995. *Spaces of Identity: Global Media, Electronic Landscapes and Cultural Boundaries*. London: Routledge.

Morris, M. 1988a. 'At Henry Parkes Motel', *Cultural Studies* 1/2.

—— 1988b. *The Pirate's Fiancée: Feminism, Reading, Postmodernism*. London: Verso.

—— 1990. 'Banality in cultural studies', in *Logics of Television: Essays in Cultural Criticism*, ed. P. Mellencamp. Bloomington and Indianapolis: Indiana University Press.

—— 1992a. 'A gadfly bites back', *Meanjin* 51/3.

—— 1992b. *Ecstasy and Economics: American Essays for John Forbes*. Sydney: Empress Publishing.

—— 1998. *Too Soon Too Late: History in Popular Culture*. Bloomington: Indiana University Press.

Mouffe, C. (ed.) 1979. *Gramsci and Marxist Theory*. London: Routledge.

—— 1994. 'For a politics of nomadic identity', in *Travellers' Tales: Narratives of Home and Displacement*, ed. G. Robertson, M. Mash, L. Tickner, J. Bird, B. Curtis and T. Putnam. London: Routledge.

Muckerji, C. and Schudson, M. (eds) 1991. *Rethinking Popular Culture: Contemporary Perspectives in Cultural Studies*. Berkeley: University of California Press.

Mulvey, L. 1989. *Visual and Other Pleasures*. Bloomington: Indiana University Press.

Naremore, J. and Brantlinger, P. (eds) 1991. *Modernity and Mass Culture*. Bloomington: Indiana University Press.

Nava, M. 1987. 'Consumerism and its contradictions', *Cultural Studies* 1/2.

Negt, O. and Kluge, A. 1993. *Public Sphere and Experience: Towards an Analysis of the Bourgeois and Proletarian Public Sphere*. Minneapolis: University of Minnesota Press.

Nelson, C. and Gaonkar, D. P. (eds) 1996. *Disciplinarity and Dissent in Cultural Studies*. New York: Routledge.

Newcomb, H. 1986. 'American television criticism 1970–1985', *Critical Studies in Communication* 3.

—— 1988. 'One night of prime time: an analysis of television's multiple voices', in *Media, Myths, and Narrative: Television and the Press*, ed. J. W. Carey. Beverley Hills: Sage.

Nichols, B. 1991. *Representing Reality: Issues and Concepts in Documentary*. Bloomington: Indiana University Press.

Nightingale, V. 1996. *Studying Audiences: The Shock of the Real*. London: Routledge.

O'Connor, A. 1989. 'The problem of American cultural studies', *Critical Studies in Mass Communication* 6.

Ohmann, R. 1991. 'History and literary history: the case of mass culture', in *Modernity and Mass Culture*, ed. J. Naremore and P. Brantlinger. Bloomington: Indiana University Press.

O'Regan, T. 1992. '(Mis)taking policy: notes on the cultural policy debate', *Cultural Studies* 6/3.

Ortner, S. 1984. 'Theory in anthropology since the sixties', *Comparative Studies in Society and History* 26.

Osborne, P. (ed) 1996. *A Critical Sense: Interviews with Intellectuals*. London: Routledge.

Palumbo-Liu, D. and Gumbrecht, H. U. (eds) 1997. *Streams of Cultural Capital: Transnational Cultural Studies*. Stanford: Stanford University Press.

Parker, A., Russo, M., Somer, D. and Yaeger, P. (eds) 1992. *Nationalisms and Sexualities*. New York: Routledge.

Penley, C. 1997. *NASA/TREK: Popular Science and Sex in America*. New York: Verso.

Penley, C. and Ross, A. (eds) 1991. *Technoculture*. Minneapolis: University of Minnesota Press.

Penley, C. and Willis, S. (eds) 1993. *Male Trouble*. Minneapolis: University of Minnesota Press.

Pensky, M. (ed.) 1997. *The Actuality of Adorno: Critical Essays on Adorno and the Postmodern*. New York: SUNY Press.

Petro, P. 1986. 'Mass culture and the feminine: the "place" of television in film studies', *Cinema Journal* 25/3.

Pickering, M. 1997. *History, Experience and Cultural Studies*. Houndmills: Macmillan Press.

Pillement, G. 1972. *Paris en fête*. Paris: Grasset.

Poole, M. 1984. 'The cult of the generalist: British television criticism 1936–83', *Screen* 25/2.

Pope, D. 1977. *The Making of Modern Advertising*. New York: Basic Books.

Porter, C. 1990. 'History and literature: after the new historicism', *New Literary History* 21/2.

Poulot, D. 1994. 'Identity as self-discovery: the eco-museum in France', in *Museum Culture: Histories, Discourses, Spectacles*, ed. D. Sherman and I. Rogoff. Minneapolis: University of Minnesota Press.

Prendegast, C. (ed.) 1995. *Cultural Materialism: On Raymond Williams*. Minneapolis: University of Minnesota Press.

Probyn, E. 1993. *Sexing the Self: Gendered Positions in Cultural Studies*. London: Routledge.

Rabinbach, A. 1985. 'Benjamin, Bloch and modern Jewish messianism', *New German Critique* 17.

Radway, J. A. 1984. *Reading the Romance: Women, Patriarchy and Popular Literature*. Chapel Hill: University of North Carolina Press.

—— 1988. 'Reception study: ethnography and the problems of dispersed audiences and monadic subjects', *Cultural Studies* 2/3.

Rai, A. 1994. 'An American Raj in Filmistan: images of Elvis in Indian films', *Screen* 35/1.

Ray, W. 1984. *Literary Meaning: From Phenomenology to Deconstruction*. Oxford: Blackwell.

Redhead, S. 1990. *The End of the Century Party: Youth and Pop towards 2000*. Manchester: Manchester University Press.

—— (ed.) 1993. *The Passion and the Fashion: Football Fandom in the New Europe*. Aldershot: Ashgate Publishing Co.

—— 1995. *Unpopular Cultures: The Birth of Law and Popular Culture*. Manchester: Manchester University Press.

—— (ed.) 1997a. *The Clubcultures Reader: Readings in Popular Cultural Studies*. Cambridge, Ma: Blackwell Publishers.

—— 1997b. *Post-fandom and the Millennial Blues: The Transformation of Soccer Culture*. London: Routledge.

—— 1997c. *Subculture to Clubcultures: An Introduction to Popular Cultural Studies*. Oxford: Blackwell Publishers.

Regan, S. 1993. *Raymond Williams*. Hemel Hempstead: Harvester Wheatsheaf.

Rigby, B. 1991. *Popular Culture in Modern France: A Study of Cultural Discourse*. London: Routledge.

Riviere, J. 1986. 'Womanliness as a masquerade', in *Formations of Fantasy*, ed. V. Burgin, J. Donald and C. Kaplan. London: Methuen.

Robbins, B. (ed.) 1990. *Intellectuals: Aesthetics, Politics, Academics*. Minneapolis: University of Minnesota Press.

—— 1993a. *Secular Vocations: Intellectuals, Professionalism, Culture*. London: Verso.

—— (ed.) 1993b. *The Phantom Public Sphere*. Minneapolis: University of Minnesota Press.

Robbins, D. 1991. *The Work of Pierre Bourdieu*. Milton Keynes: Open University.

Robbins, K. 1983. *The Eclipse of a Great Power: Modern Britain 1870–1975*. London: Longman.

Roberts, K., Cook, F. G., Clark, S. C. and Semeonoff, E. 1977. *The Fragmentary Class Structure*. London: Heinemann.

Robertson, G., Mash, M., Tickner, L., Bird, J., Curtis, B. and Putnam, T. (eds) 1996. *Future Natural: Nature/Science Culture*. London: Routledge.

Robertson, R. 1992. *Globalization: Social Theory and Global Culture*. London: Sage.

Rodinson, M. 1978. *Islam and Capitalism*. Austin: University of Texas Press.

Roediger, D. 1991. *The Wages of Whiteness: Race and the Making of the American Working Class*. London: Verso.

—— 1994. *Towards the Abolition of Whiteness: Essays on Race, Politics and Working Class History*. London: Verso.

Rorty, R. 1989. *Contingency, Irony and Solidarity*. Cambridge: Cambridge University Press.

Rosaldo, R. 1989. *Culture and Truth: The Remaking of Social Analysis*. Boston: Beacon Press.

Rose, H. and Rose, S. 1976. 'The radicalization of science', in *The Radicalization of Science: Ideology of/in the Natural Sciences*, ed. H. Rose and S. Rose. London: Macmillan.

Rose, N. 1990. *Governing the Soul: The Shaping of the Private Self*. London: Routledge.

—— 1993. 'Government, authority and expertise in advanced liberalism', *Economy and Society* 22/3.

Ross, A. 1988. 'The work of nature in the age of electronic emission', *Social Text* 18.

—— 1989. *No Respect: Intellectuals and Popular Culture*. London: Routledge.

—— 1990. 'Defenders of the faith and the new class', in *Intellectuals: Aesthetics, Politics, Academics*, ed. B. Robbins. Minneapolis: University of Minnesota Press.

—— 1991. *Strange Weather: Culture, Science and Technology in the Age of Limits*. London: Verso.

—— 1994. *The Chicago Gangster Theory of Life: Nature's Debt to Society*. London: Verso.

—— (ed.) 1996. *Science Wars*. Durham: Duke University Press.

—— 1998. *Real Love: In Pursuit of Cultural Justice*. New York: New York University Press.

Ross, A. and Rose, T. (eds) 1994. *Microphone Fiends: Youth Music and Youth Culture*. New York: Routledge.

Rubin, G. 1975. 'The traffic in women: notes on the political economy of sex', in *Toward an Anthropology of Women*, ed. R. R. Reiter. New York: Monthly Review Press.

—— 1984 'Thinking sex: notes for a radical theory of the politics of sexuality', in *Pleasure and Danger: Exploring Female Sexuality*, ed. C. Vance. Boston: Routledge & Kegan Paul.

Ryan, M. 1990. *Women in Public: Between Banners and Ballots, 1825–1880*. Baltimore: Johns Hopkins Press.

Sahlins, M. 1985. *Islands in History*. Chicago: University of Chicago Press.

Said, E. 1986. *Orientalism*. New York: Vintage Books.

—— 1990. 'Third World intellectuals and metropolitan culture', *Raritan* 9/3.

Sakai, N. 1997. *Translation and Subjectivity: On Japan and Cultural Nationalism*. Minneapolis: University of Minnesota Press.

Sangari, K. 1987. 'The politics of the possible', *Cultural Critique* 7 (fall).

Sassen, S. 1991. *The Global City: New York, London, Tokyo*. Princeton: Princeton University Press.

Scheff, T. J. 1979. *Catharsis in Healing, Ritual and Drama*. Berkeley: University of California Press.

Schivelsbusch, W. 1986. *The Railway Journey: The Industrialization of Time and Space in the 19th Century*. London: Berg.

Schneider, C. and Wallis, B. (eds) 1988. *Global Television*. Cambridge, Ma: The MIT Press.

Schorske, C. 1990. 'History and the study of culture', *New Literary History* 21/2.

Schwartz, B. 1989. 'Popular culture: the long march', *Cultural Studies* 3/2.

Sedgwick, E. K. 1987. 'A poem is being written', *Representations* 17.

—— 1990. *Epistemology of the Closet*. Berkeley: University of California Press.

—— 1993a. *Tendencies*. Durham: Duke University Press.

—— 1993b. 'Queer performativity: Henry James's *Art of the Novel*', *GLQ: A Journal of Lesbian and Gay Studies* 1/1.

Seiter, E., Borchers, H., Kreutzner, G. and Warth, E. (eds) 1989. *Remote Control: Television, Audiences, and Cultural Power*. London: Routledge.

Shiva, V. 1991. *Ecology and the Politics of Survival: Conflicts over Natural Resources in India*. London: Sage.

Shohat, E. and Stam, R. 1994. *Unthinking Eurocentrism: Multiculturalism and the Media*. London: Routledge.

Sidro, A. 1979. *Le Carnaval de Nice et ses fous*. Nice: Éditions Serre.

Slotkin, R. 1985. *The Fatal Environment: The Myth of the Frontier in the Age of Industrialism*. Middletown: Wesleyan University Press.

Smith, A. 1980. *The Geopolitics of Information: How Western Culture Dominates the World*. London: Faber.

—— 1990. 'Towards a Global Culture?', in *Global Culture: Nationalism, Globalization and Modernity*. London: Sage.

Smith, G. (ed.) 1988. *On Walter Benjamin: Critical Essays and Recollections*. Cambridge, Ma: The MIT Press.

Snitow, A., Stansell, C. and Thompson, S. (eds) 1983. *The Powers of Desire: The Politics of Sexuality*. New York: Monthly Review Press.

Sobchack, V. (ed.) 1996. *The Persistence of History: Cinema, Television, and the Modern Event*. New York: Routledge.

Sokal, A. and Bricmont, H. 1997. *Intellectual Impostures*. London: Profile.

Sollors, W. 1986. *Beyond Ethnicity: Consent and Descent in American Culture*. New York: Oxford University Press.

Sontag, S. 1979. *On Photography*. Harmondsworth: Penguin.

—— 1982. *A Susan Sontag Reader*. New York: Farrar, Straus & Giroux.

Spigel, L. 1988. 'Installing the television set: popular discourses on television and domestic space, 1948–1955', *Camera Obscura* 16.

—— 1990. 'Television in the family circle: the popular reception of a new medium', in *Logics of Television: Essays in Cultural Criticism*, ed. P. Mellencamp. Bloomington: Indiana University Press.

Spillers, H. 1989. 'Changing the letter', in *Slavery and the Literary Imagination*, ed. D. E. McDowell and A. Rampersad. Baltimore: Johns Hopkins University Press.

Spivak, G. C. 1988a. *In Other Worlds*. London: Routledge.

—— 1988b. 'Can the subaltern speak?', in *Marxism and the Interpretation of Culture*, ed. C. Nelson and L. Grossberg. Urbana: University of Illinois Press.

—— 1990. *The Postcolonial Critic: Interviews, Strategies, Dialogues*, ed. S. Harasym. London: Routledge.

—— 1993. *Outside in the Teaching Machine*. London: Routledge.

—— 1998. 'Cultural talks in the hot peace, revisiting the "Global Village"', in *Cosmopolitics: Thinking and Feeling Beyond the Nation*, ed. P. Cheah and B. Robbins. Minneapolis: University of Minnesota Press.

Stallybrass, P. and White, A. 1986. *The Politics and Poetics of Transgression*. London: Methuen.

Steele, T. 1998. *The Emergence of Cultural Studies: Adult Education, Cultural Politics and the 'English' Question*. London: Lawrence & Wishart.

Steinberg, M. 1996a. 'Cultural history and cultural studies', in *Disciplinarity and Dissent in Cultural Studies*, ed. C. Nelson and D. P. Gaonkar. New York: Routledge.

—— (ed.) 1996b. *Walter Benjamin and the Demands of History*. Ithaca: Cornell University Press.

Stewart, S. 1984. *On Longing: Narratives of the Miniature, the Gigantic, the Souvenir, the Collection*. Baltimore: Johns Hopkins University Press.

—— 1991. *Crimes of Writing: Problems in the Containment of Representation*. New York: Oxford University Press.

Stocking, G. 1968. 'Arnold, Tylor and the uses of invention', in *Race, Culture and Evolution*. New York: The Free Press.

Storey, J. (ed). 1998. *Cultural Theory and Popular Culture: A Reader*, 2nd edn. London: Prentice Hall.

Stratton, J. and Ang, I. 1996. 'On the impossibility of a global cultural studies', in *Stuart Hall: Critical Dialogues in Cultural Studies*, ed. D. Morley and K.-H. Chen. London: Routledge.

Sussman, G. and Lent, J. A. (eds) 1991. *Transnational Communications: Wiring the Third World*. Newbury Park: Sage.

Szwed, J. 1975. 'Race and the embodiment of culture', *Ethnicity* 2/1.

Taylor, C. 1985. *Philosophy and the Human Sciences*. Cambridge: Cambridge University Press.

Taylor, E. 1990. *Prime-time Families: Television Culture in Postwar America*. Berkeley: University of California Press.

Thompson, E. P. 1968. *The Making of the English Working Class*. Harmondsworth: Penguin. First published in 1963.

Thompson, J. B. 1984. 'Symbolic violence: language and power in the writings of Pierre Bourdieu', in *The Theory of Ideology*. Cambridge: Polity Press.

Thornton, S. 1995. *Club Cultures: Music, Media and Subcultural Capital*. Oxford: Polity Press.

Tomaselli, K. 1992. 'From resistance to policy research', *Text* 1.

Tomlinson, J. 1991. *Cultural Imperialism*. London: Pinter Publishers.

—— 1994. 'Mass communications and the idea of a global public sphere', *The Journal of International Communication* 1/2.

Treichler, P. A., Cartwright, L. and Penley, C. 1998. *The Visible Woman: Imaging Technologies, Gender, and Science*. New York: New York University Press.

Trinh, T. Minh-ha. 1989. *Woman, Native, Other: Writing Postcoloniality and Feminism*. Bloomington: Indiana University Press.

Tulloch, J. 1990. *Television Drama*. London: Routledge.

Tulloch, J. and Moran, A. 1986. *Quality Soap: A Country Practice*. Sydney: Currency.

Turner, G. 1990. *British Cultural Studies: An Introduction*. Boston: Unwin Hyman.

Urry, J. 1990. *The Tourist Gaze: Leisure and Travel in Contemporary Societies*. London: Sage.

Urry, J. and Lash, S. 1987. *The End of Organised Capitalism*. Cambridge: Polity Press.

Vattimo, G. 1988. *The End of Modernity*. Cambridge: Polity Press.

Vidler, A. 1992. *The Architectural Uncanny*. Cambridge, Ma: MIT Press.

Virilio, P. 1991a. *The Lost Dimension*. New York: Semiotext[e].

—— 1991b. *The Aesthetics of Disappearance*. New York: Semiotext[e].

Viswanathan, G. 1991. 'Raymond Williams and British colonialism', *Yale Journal of Criticism* 4/2.

Vitart-Fardoulis, Anne. 1986. 'L'Objet interrogé: Ou comment faire parler une collection d'ethnographie', *Gradhiva* 1 (autumn).

Voloshinov, V. N. 1973. *Marxism and the Philosophy of Language*. London: Seminar Press.

Walkerdine, V. 1986. 'Video replay: families, films and fantasy', in *Formations of Fantasy*, ed. V. Burgin, J. Donald and C. Kaplan. London: Methuen.

Wallace, M. 1990. *Invisibility Blues: From Pop to Theory*. London: Verso.

Wallerstein, I. 1974. *The Modern World-system*, 2 vols. New York: Academic Press.

—— 1990. 'Culture as the ideological background of the modern world system', *Theory, Culture and Society* 2–3.

Warner, M. 1990. *The Letters of the Republic: Publication and the Public Sphere*. Cambridge, Ma: Harvard University Press.

—— 1992. 'The mass public and the mass subject', in *Habermas and the Public Sphere*, ed. C. Calhoun. Cambridge, Ma: MIT Press.

—— (ed.) 1993. *Fear of a Queer Planet: Queer Politics and Social Theory*. Minneapolis: University of Minnesota Press.

Watney, S. 1987. *Policing Desire: Pornography, AIDS, and the Media*. Minneapolis: University of Minnesota Press.

Webster, D. 1988. *Looka Yonder: the Imaginary America of Popular Culture*. London: Routledge/Commedia.

Weedon, C. 1987. *Feminist Practice and Poststructuralist Theory*. Oxford: Blackwell.

Weeks, J. 1985. *Sexuality and its Discontents*. London: Routledge & Kegan Paul.

Wernick, A. 1987. 'Sign and commodity: aspects of the cultural dynamic of advanced capital', *Canadian Journal of Political and Social Theory* 8.

West, C. 1988. 'An interview with Cornel West', in *Universal Abandon*, ed. A. Ross. Edinburgh: Edinburgh University Press.

White, A. 1982. 'Pigs and pierrots: politics of transgression in modern fiction', *Raritan* 2/2 (fall).

—— 1983. 'The dismal sacred word: academic language and the social reproduction of seriousness', *Literature/Teaching/Politics* 2/4.

Williams, L. 1990. *Hard Core: Power, Pleasure and the 'Frenzy of the Visible'*. New York: Pandora.

Williams, P. 1991. *The Alchemy of Race and Rights: Diary of a Law Professor*. Cambridge, Ma: Harvard University Press.

Williams, R. 1960. *Culture and Society: 1780–1950*. Harmondsworth: Penguin. First published in 1958.

—— 1965. *The Long Revolution*. Harmondsworth: Penguin. First published in 1961.

—— 1974. *Television: Technology and Cultural Form*. London: Fontana.

—— 1977. *Marxism and Literature*. Oxford: Oxford University Press.

—— 1983. *Keywords: A Vocabulary of Culture and Society*, revised edition. London: Fontana.

—— 1989. *The Politics of Modernism*. London: Verso.

Williamson, J. 1978. *Decoding Advertisements: Ideology and Meaning in Advertising*. London: Marion Boyars.

—— 1986. *Consuming Passions: The Dynamics of Popular Culture*. London: Marion Boyars.

Willis, E. 1988. 'Feminism, moralism and pornography', in *Caught Looking: Feminism, Pornography and Censorship*, ed. K. Ellis *et al*. Seattle: Real Comet Press.

Willis, P. 1977. *Learning to Labour: How Working Class Kids Get Working Class Jobs*. New York: Columbia University Press.

Willis, S. 1991. *A Primer for Daily Life*. London: Routledge.

Wilson, R. and Dissanayake, W. (eds) 1996. *Global/Local: Cultural Production and the Transnational Imaginary*. Durham: Duke University Press.

Wolf, E. 1982. *Europe and the People without History*. Berkeley: University of California Press.

Wollen, P. 1993. *Raiding the Icebox*. London: Verso.

—— 1994. 'The cosmopolitan ideal in the arts', in *Travellers' Tales: Narratives of Home and Displacement*, ed. G. Robertson, M. Mash, L. Tickner, J. Bird, B. Curtis and T. Putnam. London: Routledge.

Woolf, J. 1988. 'The invisible *flâneuse*: women and the literature of modernity', *Culture and Society* 2/3.

Wright, G. and Rabinow, P. 1982. 'Spatialization of power: a discussion of the work of Michel Foucault', and 'Interview: space, knowledge and power', *Skyline* 1.

Wright, J. 1979. *Britain in the Age of Economic Management*. Oxford: Oxford University Press.

Young, R. 1995. *Colonial Desire: Hybridity in Theory, Culture, and Race*. London: Routledge.

Zizek, S. 1986. *The Sublime Object of Ideology*. Lincoln: University of Nebraska Press.

—— 1990. 'Eastern Europe's republics of Gilead', *New Left Review* 183.

Zukin, S. 1992. 'Postmodern urban landscapes: mapping culture and power', in *Modernity and Identity*, ed. S. Lash and J. Friedman. Oxford: Blackwell.

Index